# Modern Art in the USA

## Issues and Controversies
## of the 20th Century

### Patricia Hills
*Boston University*

Prentice
Hall

Upper Saddle River, New Jersey 07458

**Library of Congress Cataloging-in-Publication Data**

Hills, Patricia.
    Modern art in the USA: issues and controversies of the 20th century/Patricia Hills.
      p. cm.
    Includes bibliographical references and index.
    ISBN 0-13-036138-0 (pbk.)
      1. Art, American—Sources. 2. Art, Modern—20th century—United States—Sources. I.
Title.
    N6512.H47 2000
    700.973'09'04—dc21

                                                 00-044137

Editorial Director: Charlyce Jones Owen
Acquisitions Editor: Bud Therien
Assistant Editor: Kimberly Chastain
Director of Production and Manufacturing: Barbara Kittle
Production Editor: Louise Rothman
Prepress and Manufacturing Manager: Nick Sklitsis
Prepress and Manufacturing Buyer: Sherry Lewis
Marketing Director: Beth Gillett Mejia
Marketing Manager: Sheryl Adams
Cover Design: Bruce Kenselaar
Manager/Production, Formatting and Art: Guy Ruggiero

For permission to use copyrighted material, grateful acknowledgment is made to the copyright
holders listed on pages 465–468.

This book was set in 9/11.5 Frutiger by Carlisle Communications
and printed and bound by R.R. Donnelley/Harrisonburg.
The cover was printed by Phoenix Color Corp.

© 2001 by Prentice-Hall Inc.
A Pearson Education Company
Upper Saddle River, New Jersey 07458

Printed in the United States of America
10

0-13-036138-0

PrenticeHall International (UK) Limited, *London*
Prentice-Hall of Australia Pty. Limited, *Sydney*
Prentice-Hall Canada Inc., *Toronto*
Prentice-Hall Hispanoamerica, S.A., *Mexico*
Prentice-Hall of India Private Limited, *New Delhi*
Prentice-Hall of Japan, Inc., *Tokyo*
Pearson Education Asia Pte. Ltd., *Singapore*
Editora Prentice-Hall do Brasil, Ltda., *Rio de Janeiro*

# *Voices of the Twentieth Century*

"The function of art, before it disappears, is not to decorate or beautify life but to transform and organize it. The artist must change from one who represents existing objects into one who creates a world of new objects."

Louis Lozowick,
*Modern Russian Art,* 1925

"All renderings of objects, no matter how exact they seem, even photographs, proceed from values, methods and viewpoints which somehow shape the image and often determine its contents. On the other hand, there is no 'pure art,' unconditioned by experience; all fantasy and formal construction, even the random scribbling of the hand, are shaped by experience and by non-esthetic concerns."

Meyer Schapiro,
*Marxist Quarterly,* January–March 1937

"Art is under no categorical imperative to correspond point by point to the underlying tendencies of its age. Artists will do whatever they can get away with, and what they can get away with is not to be determined beforehand."

Clement Greenberg,
*The Nation,* April 15, 1944

"When we say 'culture,' we do not merely mean artistic forms. We mean, instead, the values, the life styles, and the feelings of the people as expressed in everyday life."

Larry Neal,
*Ebony,* August 1969

"Finally, art is—or should be—generous."

Lucy R. Lippard,
*The Lure of the Local,* 1997

This reader is dedicated to all my students,
former and present, who debated with me
many of the issues raised
by these readings during
the last twenty-five years of my teaching.

# Contents

## *Chapter 7    1980s – 1990s*  335

# *Preface*

This book focuses on the issues and controversies that have energized American art from 1900 to the present. The entries are contemporary with the art (except for a few excerpts from later memoirs) and include the views of artists, critics, exhibition organizers, poets, politicians, art activists, and writers on culture. The book is intended to serve as a handbook for courses on American and contemporary art and also as a guide to those interested in both the standard interpretations of American art and in alternative readings.

A great number and variety of voices have been included. This broad spectrum better achieves a replication of the artworld itself—a world made up of diverse practitioners who pursue many agendas and various points of view, and who influence and help direct both the production of the art of our time and its critical and popular reception.

These artworkers continually refer to and build on one another's ideas when engaged in, describing, or interpreting art and art activities. As Max Kozloff has observed, "What we feel about visual works of art is . . . conditioned by what has already been said about them."[1] It is the dialogue about art that enables a wide network of people to participate in art movements. These people include studio and art history teachers, dealers, museum directors, government funding officers, publishers, magazine editors, and individual enthusiasts who may also be collectors. They make possible the training and traveling opportunities for artists and critics; they host and finance exhibitions; they enable the distribution of new images and ideas. Both practioners and facilitators, with their complex network of social and professional relationships, are fully implicated in the consolidation and direction of art movements. Hence, the comments of all artworld people—writing contemporaneously with the new art—are considered as primary documents.

A new movement of artistic trends is not a one-dimensional linear progression, as art history books often present it, but rather an expanding and contracting process. There is a growth period, followed by a consolidation. Then a shifting—of people, ideas, styles—from the margins to the center, and often back to the margins as new people, ideas, styles emerge to challenge or to be absorbed into the previously dominant movements. The older movements, although still attracting loyal curators, dealers, and patrons, often move into the background—removed from all the buzz about the newer art. Galleries may go out of business as the novelty of their artists wanes, or they may establish niche markets for themselves. At the same time, artists may stay with their own

---

[1]Max Kozloff, "The Critical Reception of Abstract-Expressionism," *Arts* 40 (December 1965), p. 27.

cohort in defiance of new trends, or they may change styles—as did many during the 1950s when abstract expressionism swept the artworld. Writers and curators, too, are capable of shifting gears—of adopting new sensibilities and even ideologies as they position themselves to understand, interpret, and promote new movements in art.

During the twentieth century, theories about art, culture, and social life have increasingly and much more self-consciously influenced artworld participants, and, therefore, many theoretical essays are included here. Theories about art, however, need to be tested by the practices adopted by both artists and critics as they confront and question the relevance and applicability of those theories. What we find as the mediation between theory and practice is experience. Hence, many entries in this book focus on the immediately recalled experiences of artists and writers as they approach—both personally and collectively—the art of their time, or as they encounter the social, political, and economic conditions that encourage or suppress specific art ideas and subjects. These experiences, as well as the contested theories and beliefs, will give readers of this book a better understanding of the changing artworld.

Some art world people seem to be in the right place at the right time with the right blend of predispositions. Or, as George Kubler has observed, some artists seem to have a better "entrance" than others.[2] In other words, these artists spoke (and speak) to their contemporaries in ways that resonate with shared experiences. It is risky, however, to predict what will have staying power, since under some historical circumstances people become quick to deny those shared experiences. Documents included in this reader suggest the complex relationships that art has to its history.

\*\*\*

*Modern Art in the USA* presents themes and issues that have reappeared over the century, frequently erupting into highly publicized controversies.

The reigning phenomenon of the twentieth century has been modernism, which has generated a variety of changing definitions from the early decades to the present. Early in the century, modernism meant "to be of one's time" (much like the definition of realism in the nineteenth century). The definition was inclusive and hospitable to experimental techniques, materials, and concepts. It opposed academic rules and set ways of thinking. At mid-century, during the Cold War years and with the dominance of Clement Greenberg's critical authority, modernism came to have a more narrow, formalist definition with a set of seemingly inflexible rules. Greenberg then defined modernism as embodying "purity" of form and characterized by "self-referentiality." By the end of the twentieth century, however, many critics have reasserted the more inclusive definition of modernism that had characterized the earlier decades. Indeed, the term "postmodernism" has often been substituted to describe a modern art that also includes the traditions of realism and the vernacular.

Looking back on the twentieth century, we see that modernism (whatever its definitions) was not the only component to modern art in the USA. Throughout the history of the country, realism—in its many different visual styles—has persisted as a vital outlook. Even when the modernism of abstract expressionism seemed to be in ascendency,

---

[2]George Kubler, *The Shape of Time: Remarks on the History of Things* (New Haven: Yale University Press, 1962). Kubler's book was widely read in the 1960s and 1970s.

realists held their own. In 1955, when the Whitney Museum of American Art mounted the exhibition *The New Decade: 35 American Painters and Sculptors* and the Museum of Modern Art mounted *The New Decade: 22 European Painters and Sculptors,* it was the Whitney's show that made it a point to showcase contemporary realists along with the rising abstract expressionists. Whitney curator John I. H. Baur explained: "Our aim has been to record something of the diversity and vitality of American art . . . ."

Another component of modern art in the USA has been the continuing fascination artists have had for the commonplace: the vernacular, the practical, the mechanical, and the popular. This attraction to the commonplace results from the fact that many Americans—including a great number of artists—have held on to the ideal that the country is a democracy and that Americans are somehow equal. The French writer and traveler Alexis de Tocqueville noted this dogged belief back in 1832, when he published his *Democracy in America;* Americans, he observed, had contempt for aristocracy even when they secretly aspired to aristocracy's status. The ideal of democracy and egalitarianism has persisted through the end of the twentieth century, even in the face of the reality of huge income and net-worth differences between the wealthy and the working classes.[3]

A major recurring theme in art throughout the century has focused on the social dimensions of art and art making—of bringing social concerns into the content of art and of debating the relevance of politics to art. Do artists have an obligation to communicate uplifting and positive social and collective values? Or should socially concerned artists confine themselves to criticizing the negative and oppressively materialist aspects of life in the United States and around the globe in order to encourage social change? Such issues were especially debated in artistic and intellectual circles in the 1930s and again from the late 1960s to the present.

This issue of the social responsibility of art and artists ties in with the concept of the audience for art. Should that audience be the moneyed elites who can afford luxury items, that is, expensively priced paintings and sculpture to adorn their personal living spaces? Or should art be directed toward the general populace? And if the latter, what are the best means to reach and engage ordinary people?

Issues of "identity" weave through the art and the art commentary of the entire twentieth century. In the first three decades, questions of identity focused on nationalism. What does it mean to be "American" as opposed to European? With African Americans, identity issues revolved around race and W.E.B. Du Bois's concept of "double consciousness" (see Reading 8). From the 1930s to the mid-1950s social class loomed as a major factor of one's identity. Beginning in the mid-1950s, growing consumerism among the middle classes masked the poverty that still existed in the United States. However, prosperity and the prospect of prosperity encouraged hope. In the modern art of African Americans the theme of racial pride asserted itself.

By the late 1960s and early 1970s gender issues also began to preoccupy many women artists and critics. The continuing exploration of gender and racial identities, joined by critiques of neocolonialist power relations and criticism against norms for sexual

[3]To William B. Scott and Peter M. Rutkoff, *New York Modern: The Arts and the City* (Baltimore: The Johns Hopkins University Press, 1999), p. xvii, New York Modern emerged as "the confluence of a long-standing tradition of urban realism, a more recently arrived European modernism, and the ever present, ever changing American vernacular." Those remarks apply well to all of modern art in the United States.

behavior, infused much art of the 1980s and 1990s. Inevitably, this exploration of subject matter invited attacks and attempts at censorship from religious organizations and politicians. By the late 1990s, however, the rise of globalism encouraged a shift toward the recognition that people carry multiple identities. And, with the wars in the Balkans and in Africa, it became increasingly acknowledged that fixations on ethnicity and ethnic identity dangerously paved the way for "ethnic cleansing" and genocide.

As we review the century, we see modernism's inclusiveness has triumphed. Photography has rightly won its place as a category for serious art. Conceptual art, with its roots in the ideas of Marcel Duchamp and the Dadaists, has also found a permanent place in the artworld, as have installations, video, multimedia art, and performance art—in spite of admonishments in the 1960s to artists that such innovations were "theater" and should be avoided in the plastic arts. The digitized and computer generated arts will no doubt come into their own in the twenty-first century, for they are already firmly established in experimental labs in industry and have become part of the curriculum in many studio art programs. This expansion of the category of "art" to include all kinds of activities, processes, and objects will change the way we teach and think about visual culture in the future.

In conclusion, twentieth-century American art was forged in a cauldron of contentions, arguments, and ideological struggle. It is not a smooth, seamless history, but a history punctuated by controversy and debate. What arises as a fierce controversy in one generation becomes resolved, ignored, or absorbed into the next generation's art and art commentary. The art of the present is the richer for these controversies and struggles.

*** 

Note about the presentation of the text:

The readings are organized chronologically. Essays by the author introduce the **Chapters** of each of seven time periods. Essays introducing the various **Sections** place the issues in the context of the social history of each period. Brief introductions to the individual **Readings** comment on the writer (artist, critic, curator, collector, poet, writer on culture) and the context from which the entry has been taken.

I have used the convention for editing followed by Charles Harrison and Paul Wood in *Art in Theory, 1900-1990: An Anthology of Changing Ideas.* Their formatting is a model of clarity and deserves to be adopted by all anthologies: 1) the usual ellipsis " . . . " is used to indicate the omission of words or phrases within sentences; 2) the marking "[ . . . ]" indicates omissions of a complete sentence to a whole paragraph; 3) asterisks "* * *" indicate the cutting of more than one paragraph. Proper names and obvious typographical errors have been corrected; variant spellings remain as originally printed. When possible I have obtained permission from authors to edit or renumber endnotes in the Readings.

# Chapter One

# 1900–1920

## Cultural and Historical Context
## for the First Twenty Years

The visual arts experienced tremendous growth in the first two decades of the twentieth century. In 1901 Sadakichi Hartmann estimated that at least three thousand artists worked in New York, Boston, and Philadelphia. He noted the "restless activity, noticeable principally in the success of the World's Fair [Columbian Exposition, 1893], the two exhibitions of the Sculpture Society, the increase of public galleries, the opening of the Carnegie Art Institute [Pittsburgh] . . . and in the introduction of mural painting" (*The History of American Art,* 1901). At this time artists were also a significant presence in Washington, DC, Chicago, St. Louis, Cincinnati, and on the West Coast.

Clara Erskine Clement, in her *Women in the Fine Arts* (1904), also commented on the "activity and expansion" of contemporary art "quite in accordance with the spirit of the time." Clement credited the expansion to the willingness of artists to experiment with new kinds of subjects, to take advantage of travel opportunities, and to learn from the examples of Japanese art. But she recognized that new methods or media of artistic expression such as photography, posters, and illustrations in books, magazines, and newspapers were major factors.

The background for this "activity and expansion" in the arts was the Progressive Era, the period from about 1895 to 1920, chronicled by social, political, and business historians. First, there was the humanitarian side to the Progressive Era. With urbanization a group of reformers became dedicated to improving the living and working conditions of the working classes. Second, there was the efficiency movement and management reform side to the Progressive Era. With mechanization business reformers began to initiate a rationalization of the workplace through space and time management. Burgeoning immigration and an active and vocal labor force added to the issues and problems to be solved.

At the same time, the United States moved onto center stage as a player in international politics for the control of the world's natural resources and the expansion of trade and markets. When Theodore Roosevelt assumed presidential duties, following the assassination of President William McKinley in 1901, he saw his opportunity to advance the United States to a preeminent position. Already the country had acquired overseas territory: In 1898 the United States annexed the strategically located Hawaiian Islands,

1

and in 1899 gained Puerto Rico, the Philippines, and Guam. Roosevelt believed that building a strong navy, encouraging overseas trade, acquiring strategic properties (such as the Panama Canal), and mediating international disputes were essential for the economic and political interests of the country, and he plunged the United States into further involvement in Far Eastern, African, and Central American affairs.

Shrewd enough to sense the changes occurring within American society, Roosevelt promoted national unity as a first step toward international expansion. A strategy he adopted was to respond to the social reformers and spur government action in order to relieve some of the miseries of the poor and to regulate organized wealth. He urged child labor regulations, supported numerous land conservation measures and pure food acts, and initiated antitrust suits against the big corporations, all measures which met with popular support.

Two aspects of expansion were the new immigration of southern and eastern Europeans and Asians to America and the migration of workers from the farms to the cities. European peasants, impoverished and often persecuted in the Old World, were lured by promises of fresh opportunities in America and by the promotional efforts of American industrialists looking for cheap labor. In 1907, the year of highest immigration, over 1.25 million people came to the shores of the United States. Concurrently the period saw shifts of African Americans within the country. Driven by the increased terrorism of mob violence, lynchings, and Jim Crow laws, some 200,000 blacks migrated from the South to the North and West between 1890 and 1910. The numbers increased when factory jobs opened up in the big northern cities during World War I because of the curtailment of immigration from Europe. African Americans, as had European immigrants, experienced numerous hardships when they settled in the large cities. Overcrowded tenements with windowless rooms were breeding grounds for tuberculosis, and in bitter cold winters pneumonia took a fearful toll. Human and institutional adversaries were more formidable, and recent immigrants and African Americans found discrimination both on the job and in the unions. Yet their presence, their ways of relating to each other and enjoying their leisure hours, irrevocably changed the habits of all Americans.

The prolonged economic depression from 1893 to 1897 aggravated the contradictions of poverty amidst plenty. When workers suffered reductions in their wages, organized labor protested with its major weapon, the strike. Militant action won workers to the union cause and membership soared—from 447,000 in 1896 to 2,072,700 by 1904. The writer Upton Sinclair and the labor leader Eugene Victor Debs converted to socialism; other radicals also embraced Marxist ideology, especially after the Russian Revolution of 1905, which although unsuccessful, raised the possibility of worldwide revolution.

Working women came to the forefront of union agitation to raise wages and improve work conditions; in 1909, women shirtwaist makers in New York City organized a successful strike. Many artists were caught up in this movement. Dolly Sloan, wife of the artist John Sloan, helped organize living accommodations for children sent to New York City from Lawrence, Massachusetts, where mill workers under the leadership of the Industrial Workers of the World (I.W.W.) had gone on a prolonged strike in 1912.

Middle-class women involved themselves in the social reform movements of the Progressive Era and in the suffrage movement. They also found increased opportunities to complete a higher education, to enter the professions, and to succeed as artists. Wealthy Gertrude Vanderbilt Whitney trained herself as a sculptor of the first rank, and

without renouncing her obligations as a socialite, took on the project of encouraging the arts in the United States.

The spirit of expansion and innovation invaded other areas as well, and technology advanced in the field of communication. Electricity lit up the cities in the early twentieth century, and telephones became indispensable to businesses. In October 1899 the New York *Herald* invited Guglielmo Marconi to the United States to demonstrate his wireless device by giving on-the-spot reports of the America's Cup Race. The Navy took an interest, as did the United Fruit Company, which used the device to direct and coordinate its plantation operations in Central America. High speed presses allowed photographs to be printed along with the news. From 1900 to 1910 Reginald Aubrey Fessenden and Lee De Forest experimented with the transmission of human voices over the air waves, and in 1910, the voice of Enrico Caruso was broadcast over the air from the stage of the Metropolitan Opera.

Transportation experienced the greatest expansion. The subways of New York and Boston were built in the first decade of the century. In 1896 Henry Ford had completed his first automobile in Detroit. His Ford Motor Company, established in 1903, was producing 10,607 cars in 1908, the year it introduced the Model T at a sale price of $850. Ford's real achievement, however, was his perfection of the assembly line in 1913. By 1916 he could produce 730,041 automobiles at a sale price of $360. In 1903 Orville and Wilbur Wright flew their flying machine at Kitty Hawk, North Carolina; in 1908 the Wrights demonstrated an improved airplane to U.S. government officials.

The mechanical reproduction of images accelerated in the early twentieth century. George Eastman marketed his roll-film camera in 1888, and throughout the 1880s and 1890s magazines and newspapers made improvements in the mass reproduction of illustrations and photographs. New technology made possible moving pictures, and in 1903 the first story film, the 12-minute *Great Train Robbery,* was shown to a New York audience. Most of the movie industry moved to Los Angeles, where weather permitted uninterrupted shooting. There such early stars as Buster Keaton, Charlie Chaplin, and Mary Pickford made films—often sentimental, sometimes comedic—about working-class life.

When war came to Europe in 1914, the debate in the United States over America's neutrality became acrimonious and bitter; the sinking of the ocean liner *Lusitania* by a German submarine in May 1915 tipped public opinion against the Germans. Finally in April 1917 President Woodrow Wilson declared war.

One result of the war was the arrival of European emigré artists who sought refuge in New York. A cosmopolitan climate developed in art circles, with Marcel Duchamp and Francis Picabia as the stars of the salons of Walter and Louise Arensberg, Mabel Dodge, and the Stettheimer sisters. These European artists shaped the definition of what an American art might be in articulating a modern consciousness. Robert Coady in 1917 started *The Soil,* a periodical that lasted for five issues. Coady, along with his featured writer, the sometime pugilist Arthur Cravan, celebrated American technology and popular culture in Whitmanesque fashion.

Following the war, and in response to the Bolshevik Revolution of November 1917, the mood of the country turned toward conservativism. Attorney General Alexander Mitchell Palmer initiated his infamous raids in 1919 against radical aliens suspected of treasonous activity, as well as against native-born socialists, anarchists, and communists. By 1920 the humanitarian side of the Progressive Era had faltered, even while the

efficiency movement and corporate reforms moved ahead. Most European artists returned to their homelands, and many American artists went abroad in search of more sophisticated art and a more liberal political climate.

## Early Twentieth-Century Realists

In the early years of the twentieth century a group of artists gravitated to the personality and dynamic teaching of artist Robert Henri. He taught at the Pennsylvania Academy of the Fine Arts, then moved to New York in 1900 and taught at the New York School of Art from 1902 to 1908, and at his own school as well. Henri rejected the genteel styles of impressionism and academic painting and insisted on a realism that represented the "spirit" of the people and the new age of urbanization. His friends and students—all Philadelphia newspaper illustrators—George B. Luks, William J. Glackens, John Sloan, and Everett Shinn also moved to New York, and they too found inspiration in the poetry of Walt Whitman, the novels of the American realists, and the European tradition of graphic realism.

Sloan and Henri organized an exhibition at the Macbeth Gallery in 1908 with a view to countering the conservative taste of establishment artists of the National Academy of Design. The show, called "The Eight," included paintings by Sloan, Henri, Luks, Glackens, and Shinn, as well as the pictures of independent artists Arthur B. Davies, Ernest Lawson, and Maurice Prendergast. Two years later they and others organized a larger exhibition, the 1910 Independents Show. Dubbed the "black revolutionary" gang by the press, these artists willingly identified with the aims of the humanitarian progressive reformers.

Sloan went on to join the Socialist Party and became the unpaid art director, from 1912 to about 1916, of *The Masses,* the socialist publication reorganized in December 1912 and edited thereafter by Max Eastman. A number of artists contributed to that lively radical and bohemian journal of opinion, including Sloan [see Fig. 1-1], George Bellows, Art Young, and Stuart Davis. The masthead on the inside cover of each issue carried a manifesto, allegedly drafted by John Reed, that expresses the general political philosophy of the New York realists:

> A FREE MAGAZINE. This Magazine is Owned and Published Co-operatively by Its Editors. It has no Dividends to Pay, and We are not trying to make Money out of it. A Revolutionary and not a Reform Magazine; a Magazine with a Sense of Humor and no Respect for the Respectable; Frank; Arrogant; Impertinent; searching for the True Causes; a Magazine directed against Rigidity and Dogma wherever it is found; Printing what is too Naked or True for a Money-making Press; a Magazine whose final Policy is to do as it Pleases and Conciliate Nobody, not even its Readers—There Is a Field for this Publication in America. Help us to find it.

During World War I the magazine took an antiwar stance, was accused of sedition, and folded as a result of government censorship.

In sculpture, New York realism was represented by Mahonri Young, Saul Baizerman, and Abastenia St. Leger Eberle, who turned from large monumental public sculpture to genre scenes of everyday life, and who, like the painters, sought to capture the vital life of the working classes.

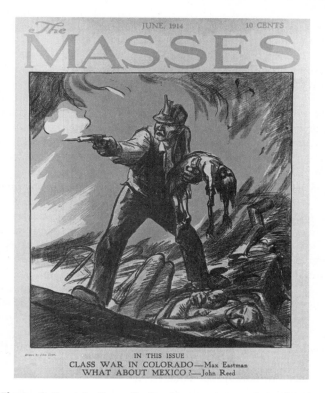

**Figure 1–1.**   John Sloan, "Ludlow Massacre," cover design for *The Masses,* June 1914. Delaware Art Museum, John Sloan Archives. In September 1913 miners went on strike against the Colorado Fuel and Iron Company, 40 percent of which was owned by John D. Rockefeller. Evicted from company housing, the miners set up a tent colony. On April 20, 1914, a gun battle was waged between the miners and state militiamen, who torched the tents. Known in labor history as the "Ludlow Massacre," 24 men, women, and children were either shot or died in the conflagration. Sloan drew the miner, not as a victim, but as a fighter for his rights—an uncommon image in art history.

*1* ✦ Giles Edgerton [Mary Fanton Roberts], "The Younger American Painters: Are They Creating a National Art?" *The Craftsman* 13, no. 5 (February 1908): 512–532.

Mary Fanton Roberts typified Progressive Era writers in that she believed art had a social and democratic purpose. She used the pen name Giles Edgerton when she wrote for *The Craftsman,* the progressive journal of the arts and crafts edited by Gustav Stickley from 1901 to 1916. In her long essay excerpted here, she praises the Eight for representing the uniqueness of everyday life in America without being nationalistic.

In America we have already produced our own type of men inevitable from a civilization crude, brilliant, selfish, kind, self-conscious, amiable, born out of physical conditions of a country of boundless wealth and boundless space, without traditions. Having evolved a type to suit the land, we have set ourselves to the development of a machinery requisite to meet an electric state of change in products and methods of production; we have created departures in agricultural enterprise; we have been fearless in revolutionizing educational processes; we have commenced to tell the truth in our architecture, to build shops and houses suited to our climate, our business and our home ideals; we have evolved a type of beauty that is born out of our own blue skies and mountain tops and wild winds; we have recreated athletics for our boys and girls, and the prize cups of many nations are in our club houses; Paris may no longer set our fashions; we think for ourselves along all these lines of national development.

But when it comes to the question of art, only the exceptional man or woman among us thinks at all. This is true even among our artists. In painting, sculpture and music the blight of imitation is still upon us. We are afraid, most of us, to think the truth or recognize the truth. [. . .]

But fortunately for the future of art conditions in this country, there has grown up among us a few artists who value the conviction that America has the same art prerogative as all other lands, primitive or civilized; namely that her art should be her own, achieved through the fulness or the meagerness of her own progress or failure, as inevitably related to her own conditions as an individual perfume is to its flower. [. . .] A man *must* paint best what he feels and knows and understands best. [. . .] No country can afford an expression in art, however clever or brilliant, that is purely artificial, superficial, unemotional, pedantic. [. . .]

Here in America such art [worth recognizing] must present from time to time a hillside green in misty spring; a lumberman working in russet woods; a farmhouse mossy, empty and still, with a fading garden; a roadway leading to a mysterious hilltop; men at work in the mines, reckless and frightened; ragged children romping on city squares, tawdry women singing to leering men in East Side cafés; city streets in snow and sleet at night; saturnine lines of cars rushing through dusk and shadow overhead; a cheerful apple woman in ragged clothes; a beggar pleading for alms, with one hand open to receive and the other clenched to strike; pretty women in Easter flower markets; men standing hopeless and sinister in the bread line on a rainy midnight; girls with haughty eyes and fluttering laces, motoring away to music and dances;—beauty very proud and very unheeding and sometimes cruel, if the artist sees it so; but still more often the humble folk and the vulgar folk, all finding their rightful place on the canvas that is to stand as a permanent expression of how the life of this period seemed to men of imagination and interesting individuality. Whatever sings among us or struggles or laughs or fights, whatever strikes a note of ecstasy or sinks back into bleak backgrounds, whatever shows joy and beauty or shuddering depths of pain or ignominy, all the warp and the woof of present-day human existence, these are the subjects and inspirations for the men who contend that while no true art can be historical, all great art must be history.

By these men, tradition and influence are relegated to their proper sphere, as important phases of culture, but never allowed to parade as an understudy to inspiration.

\* \* \*

But in so representing the need of an art for ourselves, there is perhaps danger of a slight misunderstanding; for instance, that we are suggesting that American art should be patriotic (!), limited to American subjects only, our artists forbidden to acquire knowledge in Paris or Munich, to paint a pretty Dutch girl, or sketch the Bay of Naples in twilight. And yet, according to Mr. Henri (one of the eight exhibitors), "although our artists must be individual, they must also be students, men who think a great deal about life, who read, study, men of the widest possible attainment, and who are constantly engaged in finding the special means of expression best suited to the thing they have to say." [. . .]

The exhibition of the American artists, whose work is illustrated in this magazine, seems to us to have acquired this very quality which Mr. Henri considers essential. The men themselves boast no special creed for their work, they are not a school. As one of them said, they "just paint the way they see things every day." [. . .] They are not consciously trying to create a new art for a country that needs one; yet they are every one of them (and quite a number of others besides) doing the kind of work that is essentially creative and absolutely typical of our own racial characteristics, our social conditions and our widely diversified country.

\* \* \*

**2 ✦** Robert Henri, "Progress in Our National Art Must Spring from the Development of Individuality of Ideas and Freedom of Expression: A Suggestion for a New Art School," *The Craftsman* 15, no. 4 (January 1909): 387–401.

Born in Cincinnati, Robert Henri studied at the Pennsylvania Academy of the Fine Arts from 1886 to 1888. He traveled to Paris and attended the Académie Julian and the École des Beaux Arts until 1891. Influential as a teacher in both Philadelphia and New York, his remarks on art and teaching were collected in Robert Henri, *The Art Spirit,* compiled by Margery Ryerson (Philadelphia: J. B. Lippincott Company, 1930).

Responding to Roberts's discussion about nationality (see Reading 1), Henri clarified his thoughts regarding the role of nationality in American art and advocated the notion of freedom of expression. Henri recommended a heroic individualism for artists, much like that espoused by the novelist Jack London.

◆

There has been much discussion within the last year on the question of a national art in America. We have grown to handle the subject lightly, as though it were a negotiable quantity, something to be noted in the daily record of marketable

goods. And the more serious have talked much about "subject" and "technique," as though if these were acquired, this desired thing, a national art, would flourish quickly and beautifully; whereas, as a matter of fact, a national art is not limited to a question of subject or of technique, but is a real understanding of the fundamental conditions personal to a country, and then the relation of the individual to these conditions.

And so what is necessary for art in America, as in any land, is first an appreciation of the great ideas native to the country and then the achievement of a masterly freedom in expressing them. Take any American and develop his mind and soul and heart to the fullest by the right work and the right study, and then let him find through this training the utmost freedom of expression, a fluid technique which will respond to every inspiration and enthusiasm which thrills him, and without question his art will be characteristically American, whatever the subject. For through his own temperament, coupled with the right power of utterance, he will, all unconsciously, express his own attitude toward life in whatsoever he creates, and his picture or statue or sonnet will testify to his nationality. For a man ceases to imitate when he has achieved the power to fully and freely express his own ideas; and every man with imagination who has given the best of himself to work, who has learned to think honestly and see clearly, can no more escape the possession of ideas than of ideals, and so the American painter, with brain and brush liberated by the greatest possible self-development, is just as certain to express the quality of his country as he is in himself to present an American type or speak the language of his native land.

Thus it is not possible to create an American art from the outside in. Art does not respond to the whim of the millionaire who would create art galleries as he does libraries. It is quite impossible to start out with a self-conscious purpose of springing a ready-made national art on the public simply because we are grown up enough to realize the value of such an expression. Art is too emotional to respond to coercion or discipline; and it cannot successfully become a whim of the rich, even in America. For successful flowering it demands deep roots, stretching far down into the soil of the nation, gathering sustenance from the conditions in the soil of the nation, and in its growth showing, with whatever variation, inevitably the result of these conditions. And the most showy artificial achievement, the most elaborate imitation of art grown in France or Germany, are valueless to a nation compared with this product that starts in the soil and blooms over it. But before art is possible to a land, the men who become the artists must feel within themselves the need of expressing the virile ideas of their country; they must demand of themselves the most perfect means of so doing, and then, what they paint or compose or write will belong to their own land. First of all they must possess that patriotism of soul which causes the real genius to lay down his life, if necessary, to vindicate the beauty of his own environment. And thus art will grow as individual men develop and become great as our own men learn to think fearlessly, express powerfully and put into their work all the strength of body and soul.

* * *

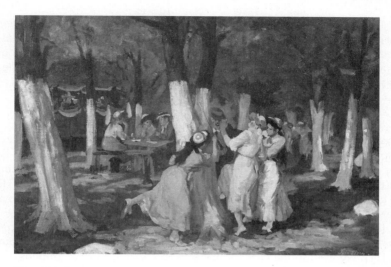

**Figure 1–2.** John Sloan, *The Picnic Grounds,* 1906–7. Oil on canvas, 24 × 36 in. The Whitney Museum of American Art.

*3* ✦ John Sloan, *John Sloan's New York Scene: From the Diaries, Notes and Correspondence 1906–1913,* ed. Bruce St. John with an introduction by Helen Farr Sloan (New York: Harper & Row, 1965).

Born in Lock Haven, Pennsylvania, John Sloan left school at an early age to support his family with his illustrating skills. He found work as an artist-reporter on Philadelphia newspapers, the *Inquirer* and then the *Press.* When he moved to New York in 1904, he worked as a free-lance illustrator for fiction published in New York magazines.

Sloan kept a diary from January 1906 through June 1912 and sporadically in the early months of 1913. The entries chronicle his friendships, art projects (paintings as well as commissioned illustrations for magazines), reading habits, occasional teaching, private thoughts, and his growing engagement with radical politics—an interest shared with his wife Dolly. Both joined the Socialist Party of Eugene Victor Debs in 1909; Sloan made drawings and cartoons for the socialist newspaper *The Call* and at least one poster for the Industrial Workers of the World (I.W.W., the "Wobblies"), and Dolly served on numerous committees as an activist and suffragist. As evident from the February 10, 1912, entry, both supported the famous strike of textile workers in Lawrence, Massachusetts. Sloan did posters, and Dolly volunteered to arrange housing for the strikers' children sent to New York to be cared for during the duration of the strike. On March 30, Dolly escorted 200 of the strikers' children back to Lawrence.

When *The Masses* magazine was reorganized in December 1912 under the editorship of Max Eastman, Sloan served as the unpaid art editor. But, however committed Sloan was to socialist causes, he refused to insert a political message into his etchings and paintings.

The following excerpts exemplify what he considered important to write down. When painting his pictures of everyday life, Sloan relied on his memory of scenes experienced rather than studio models, and he experimented with making photographs. Moreover, there seems to be a constant stream of visitors—artists, critics, intellectuals, socialists—in and out of the Sloans' apartment in Manhattan.

◆

[February 13, 1906] . . . Walked through the interesting streets on the East Side. Saw a boy spit on a passing hearse, a shabby old hearse. Doorways of tenement houses, grimy and greasy door frames looking as though huge hogs covered with filth had worn the paint away and replaced it with matted dirt in going in and out. Healthy faced children, solid-legged, rich full color to their hair. Happiness rather than misery in the whole life. Fifth Avenue faces are unhappy in comparison.

[May 30, 1906] "Decoration Day." We were invited to spend the afternoon at [Frank] Crane's in Bayonne. A walk to the shore with its yachts and boats launched now. Then we went to the Newark bay side and watched picnic grounds, dancing pavilion, young girls of the healthy lusty type with white caps jauntily perched on their heads. . . . [See Fig. 1–2]

[June 2, 1906] Started painting a memory of the little Picnic Grounds at Bayonne and think I have a good "go" at it. [. . .]

[January 11, 1908] Such a day—I went to [George] Luks' this morning . . . my purpose being to photograph a painting of his for the Herald and Press to use in notices of our show. [. . .] The whole of the afternoon was most interesting. He showed me his Wrestlers, a magnificent picture—one of the finest paintings I've ever seen—great. But he won't send it to our show at Macbeth's. He says, "I'll keep it till I'm invited to send to some big exhibition. Then this will show K. Cox, W. H. Low and the other pink and white idiots, that we know what anatomy is. I painted it to vindicate Henri in his fight for my work on the National Academy juries." I argued with him that he could never convince these people, they don't know great work when it is contemporary product. They bow, of course, when the celebrated work of the old masters is before them, but that's merely educated into them—they don't really see it. [. . .]

[January 16, 1908] Another attempt at photographing. . . . I've been thinking the last two days of Joseph Andrews by Fielding—having begun and half finished reading it again. Thinking how necessary it is for an artist of any creative sort to go among common people—not waste his time among his fellows, for it must be from the other class—not creators, nor Bohemians nor dilettantes that he will get his knowledge of life. I should like to know two or three plain homes—well. My own home was plain enough—and I have that subconsciously within me. [. . .]

[May 29, 1909] [. . .] Potts dropped in and . . . he and I argued on the Social problems of the day! He seems to think what's the use of trying to do anything to better the workers—they are not worth it. The rich have the money because they have the brains to get it—the others haven't the brains so they must pay the penalty. I feel that

if 5,000 people in this city are wealthy and content and two million are unhappy, something is wrong. [. . .]

[June 9, 1909] [. . .] Will the great mass of the workers, when they find the power of the united vote, stand for differences in the rewards between their ordinary labor and mental labor? Of course all will have every necessary to existence, and comfort—but should not the higher faculties have some higher reward? Or is this feeling in me, only a surviving view of the present upper class feeling?

[June 12, 1909] [. . .] The Evening Sun prints Edward Everett Hale's . . . "Man without a country." I am too old or too much convinced of the Socialist anti-military principle for this highly impossible tale to move me to a love of the plutocracy's government. Why should the workers fight each other in order to preserve or expand or destroy the trade relations in which they have no real interest? Suppose we agree to call this country a province of England or France or Germany? Does it make any difference to me? or to any laboring man?

[February 15, 1911] [. . .] Dolly and I went to see Isadora Duncan. It's hard to set down how much I enjoyed this performance. Isadora as she appears on that big simple stage seems like *all* womanhood—she looms big as the mother of the race. A heavy solid figure, large columnar legs, a solid high belly, breasts not too full and her head seems to be no more important than it should to give the body the chief place. In one of the dances she was absolutely nude save for a thin gauze drapery hanging from the shoulders. [. . .]

[February 10, 1912] Dolly out early to help with the little strikers children from Lawrence, Mass. Woolen Mills where 22,000 are out. The Fathers and Mothers speak sixteen languages! The strike is now in charge of Bill Haywood and the Industrial Workers of the World. Mrs. Malkiel and Dolly are on a committee of Socialist Party who have been asked to help with the children. [. . .] Train came, mob wild with excitement. [. . .] Children were fed and then distributed to persons who had volunteered to house them till after the strike is over (all had been investigated). The wild Italian element in the crowd made things exciting. Anarchists were there in force sneering at Socialists—they would have been in a fine fix without the Socialist women as it was fearful—children crying, crowd struggling to get in the rooms—photographers with flashlights glaring and banging—little tots and big, oldest about fourteen years.

---

# The Critical Issues: Modernism and American Consciousness

Artists and writers grappled with the idea of Americanism at the beginning of the new century. Some wanted to invent new definitions for an art that was antitraditional, anti-academic, experimental, and seemingly less grounded in narrative. Others focused on thinking through the issue of "Americanism"—a term that would fascinate Europeans as well as Americans. And yet others united the terms—modernism and Americanism.

Arthur Wesley Dow, a professor of art at Columbia University, turned his attention to the new art when he delivered a paper, "Modernism in Art," at the annual meeting of the College Art Association in 1916. Dow was one of the first to adopt the word "modernism," and his remarks, published in *The American Magazine of Art* (January 1917), provide us with the most succinct definition of early modernism. To Dow: "Modernism is an inclusive name applied to the many forms of rebellion against the accepted and the traditional." Familiar with the writings of both Roger Fry and Clive Bell, Dow saw seven "things generally desired by modernists," not all of which he agreed with:

1. Freedom from the restraint of juries, critics or any law making art-body, involving

2. The rejection of most of the traditional ideas of art, even to the denial that beauty is worth seeking. As this seems opposed to the principle of evolution, and is only negative, I do not see how it can be maintained.

3. Interest in the expression of each individual, whether it conforms to a school or not, whether it be agreeable or the reverse.

4. Less attention to subject, more to form. Line, mass and color have pure aesthetic value whether they represent anything or not. Ceasing to make representation a standard but comparing the visual arts with music. Finding a common basis for *all* the visual arts.

5. Convincing us that there are limitless fields yet unrevealed by art. [. . .]

6. New expression by color, not by the color of things, or color in historic art. Seeking hitherto unexpressed relations of color.

7. Approaching, through non-applied design and in other methods the creation of new types of design, decoration and craft work.

Dow observed that some characteristics had already been attained by the Japanese, the school of Siena, the Dutch, and others. He ended his address by urging: "Unprejudiced study of modern expression will soon enable us to sift the chaff from the wheat."

Some critics focused on the individualistic aspects of artmaking. Art patron and Chicago lawyer Arthur Jerome Eddy as well as magazine editor and art critic Willard Huntington Wright wrote art books celebrating the freedom that abstract styles offered to the artist. In Eddy's business books, such as *The New Competition* (1915) it is clear that the "assertion of freedom" he admired in the cubists conformed to his advice about responsible and free competition in Progressive Era corporate life. Wright, however, in his promotion of American art was driven by Woodrow Wilson's version of internationalism—American leadership in world affairs. Both Eddy and Wright believed that art followed the rules of evolution and strove toward a "pure art" of formal and coloristic relations.

To many other early advocates of experimental, contemporary art, modernism meant the celebration of feeling, emotion, and the senses—freed from the constraints of Victorian respectability and conformity. These modernists—both artists and writers—not only looked to the styles following postimpressionism in Western Europe and to contemporary thinkers and theorists such as Friedrich Nietzsche, Henri Bergson, and Wassily Kandinsky, but also came to venerate, as well as romanticize, the artifacts of other

cultures, for example, African art and native American art. Such "primitive" (as they then called it) art objects seemed more authentic and unalienated from social life.

Simultaneous with debates about modern art were questions and assertions as to American exceptionalism—that is, what is special about "American" consciousness and the American character, and from where does it draw its inspiration? Whereas Robert Henri, John Sloan, and other realists believed that the spontaneity and energy of the American working-class should be celebrated, they did not theorize about a specifically national, "American," character. To W. E. B. Du Bois, the leading African-American scholar, writer, and (later) social activist, the American character—whether black or white—was a major concern. In 1903 he published *The Souls of Black Folk,* a collection of essays about African Americans and black consciousness in America that has had enormous influence throughout the century. Robert Coady, editor of *The Soil,* understood that black consciousness was not limited to the African-American community but permeated all American life and artistic subject matter. Moreover, Coady was one of the first to attempt to break down the divisions between the high arts and the popular arts. To Coady, this democratizing impulse defined Americanism.

*4* ✦ Benjamin DeCasseres, "Art: Life's Prismatic Glass," *Camera Work* no. 32 (October 1910):33–34.

The debates surrounding modernism took place in newspapers, magazine articles, and particularly in Alfred Stieglitz's *Camera Work,* by an international group of critics. In the fifty issues of *Camera Work* appearing between its founding in 1903 and its demise in 1917, Stieglitz published the essays of leading critics, including Sadakichi Hartmann, Charles Caffin, John Weichsel, Benjamin DeCasseres, Marius DeZayas, and Paul Haviland.

Benjamin DeCasseres, a literary critic for various New York magazines and newspapers, contributed regularly to *Camera Work.* He represents an older, Europeanized, aestheticized modernism. According to Jonathan Green (*Camera Work: A Critical Anthology,* 1973), by 1915 Stieglitz began to realize that DeCasseres was not suited to the kind of criticism Stieglitz then wanted to encourage. At the time when modernism was in full swing and a world war was raging in Europe, DeCasseres seemed too much the late-nineteenth-century symbolist and aesthete. It is in DeCasseres's writings for *Camera Work* in the years before 1915 that we see the strongest influence from Nietzsche on American criticism.

———————————————— ✦ ————————————————

All great art conceals artfulness, but never conceals the artist.

The mission of genius is to transfix the universal as she peeps through the particular, to waylay the imperceptible.

In great art the part always contains the whole.

Where there are two persons in contact there is drama.

Men of action achieve the obvious; poets achieve the impossible.

There is no art without a moral. It is Knowledge defining Will, that is, a sudden flashlight poured suddenly on the dumb, brute thing we call Nature. Art renders the world fabulous, and the fable is the reality.

There are obtuse minds, but no obscure thoughts.

One should never paint or write with the thought of being understood, but only for those who understand.

The world without genius would be like the skull of poor Yorick without Hamlet's soliloquy.

The difference between the poet and the ordinary man is the difference between a piano and a cash register. The poet contains all the melodies that lie in infinite latency, and at a touch outwell the vibrant harmonies. The average man, touch whatsoever key you may, responds baldly, absolutely, like the latest total-adder, and with as much music.

All literature is a fishing for words; all thought a fishing for ideas; all labor a fishing for food. Opposed to all this is the attitude of receptivity. I will to be fished out of this dirty pool of a world. The ebbtide leads to the depths. My attractions shall be the bait I shall dart for.

There is a beauty that is blasphemous—the wild, savage, sacrilegious beauty of mountain ravines, of dark, desolate wastes.

Art is the everlasting protest of man's soul against this day's work, this lumpish experience on the earth. Man sides with Lucifer, but he does not know it; he flies in the face of the primal edict, but he never knows the significance of his protest. His religions are a kind of atheism. He repeats mechanically, "God's will be done," but he will not stop to find that Will out. Art, pleasure and other-world hankering are his consolations for the ruthless, pitiless exactions of that Will which is always being "done."

<div align="center">* * *</div>

---

**5 ✦** Willard Huntington Wright, Foreword to *Modern Painting: Its Tendency and Meaning* (New York: John Lane Company, 1915).

Willard Huntington Wright was a literary critic and editor of the cosmopolitan New York magazine *Smart Set,* from 1912 to 1914. His book *Modern Painting* surveys the art of Manet, Renoir, Cézanne, Gauguin, Degas, Matisse, Picasso, cubism, and futurism, and concludes with the "last advance in modern methods"—Synchromism—a movement "fathered" by the Americans Morgan Russell and his own brother, Stanton Macdonald-Wright. Wright believed that art had principles of form and organization that could be rationally discussed and that it progressed toward a goal of purity.

The formalist premise of Wright's book is that "modern art tends toward the elimination of all those accretions so beloved by the general—literature, drama, sentiment, symbolism, anecdote, prettiness and photographic realism." This was picked up by later writers and closely resembles the "self-referentiality" criterion of Clement Greenberg (see Chapter 4).

<div align="center">◆</div>

Any attempt to democratise art results only in the lowering of the artistic standard. Art cannot be taught; and a true appreciation of it cannot grow up without a complete understanding of the aesthetic laws governing it. Those qualities in painting by which it is ordinarily judged are for the most part irrelevancies from the standpoint of pure aesthetics. They have as little to do with a picture's infixed greatness as the punctuation in Faust or the words of the Hymn to Joy in the Ninth Symphony. Small wonder that modern art has become a copious fountain-head of abuse and laughter; for modern art tends toward the elimination of all those accretions so beloved by the general—literature, drama, sentiment, symbolism, anecdote, prettiness and photographic realism.

<div align="center">* * *</div>

In stripping art of its intriguing charm and its soothing vagueness it is not my intention to do away with its power to delight. To the contrary, I believe that only by relieving painting of its dead cargo of literature, archaeology and illustration can it be made to function freely. Painting should be as pure an art as music, and the struggles of all great painters have been toward that goal. Its medium—colour—is as elemental as sound, and when properly presented (with the same scientific exactness as the harmonies of the tone-gamut) it is fully as capable of engendering aesthetic emotion as is music. Our delight in music, no matter how primitive, is not dependent on an imitation of natural sounds. Music's pleasurable significance is primarily intellectual. So can painting, by its power to create emotion and not mere sensation, provoke deep aesthetic feeling of a far greater intensity than the delight derived from transcription and drama. Modern painting strives toward the heightening of emotional ecstasy; and my *esthétique* is intended to pave the way for an appreciation of art which will make possible the reception of that ecstasy. With this object ever in view I have weighed the painting of the last century, and have judged it solely by its ability or inability to call forth a profound aesthetic emotion. Almost any art can arouse pleasing sentiments. Only great art can give us intellectual rapture.

---

**6 ✦** John Weichsel, "Artists and Others," *Camera Work* no. 46 (April 1914; published October 1914):13–17.

Born in Poland, John Weichsel was a mathematics prodigy, who completed a degree at the University of Heidelberg at the age of thirteen. He went to Berlin to finish his studies but turned instead to psychology and aesthetics. He immigrated to New York, worked days as a machinist and studied at nights, eventually earning a doctorate in engineering from New York University.

"Artists and Others" was the last of four essays John Weichsel wrote for *Camera Work* and indicates his shift toward the theme of the artist's responsibility toward society. To Weichsel, modernism came to mean a democratic art for the people; artists had the responsibility to bring about "an ultimate victory of true art" by encouraging the "art-instinct" in all people. Weichsel put into practice his theories about art by founding, in

1915, the People's Art Guild, which mounted exhibitions of abstract and realist art in the ethnic neighborhoods of New York. Like others at the time, Weichsel's use of the term "racial" in this essay means "the human race."

Weichsel's viewpoint is quite the opposite from Willard Huntington Wright's belief that: "Any attempt to democratise art results only in the lowering of the artistic standard" (see Reading 5). The issue of whether art's audience should be an elite trained in art appreciation or everyday people has persisted throughout the twentieth century.

* * *

Our religious nurture [sic] has helped us wonderfully to preserve the notion of priesthoods in all fields of human endeavor. While there is an undeniable gain in life-economy accruing from an apportionment of social functions to specialists, there is a serious danger involved in such procedure. It tends to engender an uncritical submission to group-dictates at a cost of an impoverishment of personality. Such a result, generally following upon an unguarded allegiance to authority, is unmistakably apparent in our present art-life. Not only have we succeeded in establishing a tribe of aesthetic high priests but we have also reduced our art-feeling to catechismal form and limit.

* * *

Personally, I do not at all subscribe to the notion that nature really evolves an art hierarchy or priesthood. I believe that there is a universal, nonspecialized (that is non-technical) way of feeling and expressing human experience which alone is art. All else is the dress of art and not its body, its police-approved demeanor and not its free expression; or its business side rather than its human side. [. . .] Conventions, academic or not, have put their blinkers upon our vision through so long a period that they have robbed us of all power to see anything but what is prescribed by our aesthetic preceptors. They have stopped the flow of popular poetry and song and dance. They have drained the sources of popular plastic creativeness to such an extent that art coming directly from the people's spontaneous hands is now practically unthinkable. Our machine-fashioned industry has found in conventional art an efficient ally for the suppression of individualism. Art, the famed symbol of freedom, thus virtually became the instrument of sinister powers.

* * *

A great artist speaks the tongue of a thousand years and not the dialect of a generation. This does not at all imply that art is not social but just the contrary of this. It means that art is to reveal the fundamentally social forms, and not mere sportive mutations which appeal only to curiosity and are the material for sensation and not art. Such being the nature of art-activity, art for art's sake can only mean its existence for racial self-revelation's sake, while an exaltation of it to over-social heights is contrary to its quint-essential purpose. Only a perverted sort of art will lend itself without protest to an abuse of the kind practised by the aforementioned aesthetic glutton.

* * *

The artists and the others have equally a reason for demanding a revision of art-values. Both must seek to break down the barriers that now stand between them. The artists may lead in this by discarding technical and conventional masks and donning the racial attire of art. Then they will no longer blind human eyes by technical splendor but enlighten by their works' vivifying light. Then they will feed our senses with "pictures, musical compositions, pleasant houses and gardens, good clothes and fine implements, poems, fictions, essays, and dramas" for the purpose of opening people's mental as well as physical eyes; for speaking to their hearts as well as their ears; for awakening the creative springs of the people's souls, so that a fertile soil may come into being for the artists' racial growth and bloom.

* * *

---

**7 ✦** Marius DeZayas, *African Negro Art: Its Influence on Modern Art* (New York: Modern Gallery, 1916).

Marius DeZayas, a Mexican, came to New York in 1907. He worked as a critic and caricaturist and, along with Edward Steichen, helped Alfred Stieglitz acquire European art for Stieglitz's Little Galleries of the Photo-Secession at 291 Fifth Avenue. In 1915, along with Stieglitz regulars Agnes Ernst Meyer, Paul Haviland, and Francis Picabia, he opened The Modern Gallery, which showed African and modern art. He also edited the Vanguard publication *291*. When The Modern Gallery folded in 1918, he opened his own gallery. In 1918 the Negro Library Association mounted an exhibition of African and African-American literature and art, which included twenty-one pieces of African sculpture from DeZayas's collection.

In his book, *African Negro Art: Its Influence on Modern Art,* DeZayas marshalled prevailing pseudo-science to support his racialist views that Africans, as one of "the primitive races," were at the earliest stages of human development and, hence, were incapable of creating naturalist representations in art. (He ignored the art of Benin.) Today's readers will find his book offensive, with its charts and confident assertions of African inferiority and its simplistic and racist argument that Western European "civilized" men are inherently superior to Africans.

The book ends with the paragraph quoted here. The passage not only credits Negro art with awakening Europeans to the possibilities of abstraction, but with giving "us" a greater consciousness of "subjective truths."

* * *

It is certain that before the introduction of the plastic principles of Negro art, abstract representations did not exist among Europeans. Negro art has re-awakened in us the feeling for abstract form, it has brought into our art the means to express our purely sensorial feelings in regard to form, or to find new form in our ideas. The abstract representation of modern art is unquestionably the off-spring of the Negro Art, which has made us conscious of a subjective state, obliterated by objective education.

And, while in science the objective truths are the only ones that can give the reality of the outer world, in art it is the subjective truths that give us the reality of ourselves.

---

*8* ✦  W. E. B. Du Bois, "Of Our Spiritual Strivings," in *The Souls of Black Folk: Essays and Sketches* (Chicago: A. C. McClurg & Co., 1903).

A major thinker of the twentieth century, William Edward Burghardt Du Bois was born in Massachusetts, educated at Fisk University, Harvard, and the University of Berlin and became a prolific writer of history and sociology. He taught at Atlanta University and from 1910 to 1934 edited *The Crisis,* the monthly magazine of the National Association for the Advancement of Colored People (NAACP). He fell out with the NAACP in 1934 because of his radical politics. He returned to work for the NAACP in 1944, but renewed disputes led to his severing ties in 1948. During the 1950s he was harassed by federal agencies for his communist sympathies. In 1961 he settled in Ghana, where he became a citizen.

Like the other chapters, "Of Our Spiritual Strivings" begins with the lyrics of a "sorrow song," one of those songs sung by slaves in the fields as they worked. The book as a whole is part history, part sociology, part polemic, part fiction, and part meditation. As Henry Louis Gates, Jr., remarked in his introduction to the 1989 Bantam edition, "*The Souls* has functioned as an urtext of the African-American experience."

Du Bois here explores what it means to be an "American" when you are an African American, and he looks back to the Emersonian concept "double consciousness." (See Anita Haya Patterson, *From Emerson to King: Democracy, Race, and the Politics of Protest,* 1997.) That consciousness has become intrinsic to notions of modernity, and in our present day we recognize its having much broader application.

---✦---

Between me and the other world there is ever an unasked question: unasked by some through feelings of delicacy; by others through the difficulty of rightly framing it. All, nevertheless, flutter round it. They approach me in a half-hesitant sort of way, eye me curiously or compassionately, and then, instead of saying directly, How does it feel to be a problem? they say, I know an excellent colored man in my town; or, I fought at Mechanicsville; or, Do not these Southern outrages make your blood boil? At these I smile, or am interested, or reduce the boiling to a simmer, as the occasion may require. To the real question, How does it feel to be a problem? I answer seldom a word.

And yet, being a problem is a strange experience,—peculiar even for one who has never been anything else, save perhaps in babyhood and in Europe. [. . .]

After the Egyptian and Indian, the Greek and Roman, the Teuton and Mongolian, the Negro is a sort of seventh son, born with a veil, and gifted with second-sight in this American world,—a world which yields him no true self-consciousness, but only lets him see himself through the revelation of the other world. It is a peculiar sensation, this double-consciousness, this sense of always looking at one's self through

the eyes of others, of measuring one's soul by the tape of a world that looks on in amused contempt and pity. One ever feels his twoness,—an American, a Negro; two souls, two thoughts, two unreconciled strivings; two warring ideals in one dark body, whose dogged strength alone keeps it from being torn asunder.

The history of the American Negro is the history of this strife,—this longing to attain self-conscious manhood, to merge his double self into a better and truer self. In this merging he wishes neither of the older selves to be lost. He would not Africanize America, for America has too much to teach the world and Africa. He would not bleach his Negro soul in a flood of white Americanism, for he knows that Negro blood has a message for the world. He simply wishes to make it possible for a man to be both a Negro and an American, without being cursed and spit upon by his fellows, without having the doors of Opportunity closed roughly in his face.

This, then, is the end of his striving: to be a co-worker in the kingdom of culture, to escape both death and isolation, to husband and use his best powers and his latent genius. These powers of body and mind have in the past been strangely wasted, dispersed, or forgotten. The shadow of a mighty Negro past flits through the tale of Ethiopia the Shadowy and of Egypt the Sphinx. Throughout history, the powers of single black men flash here and there like falling stars, and die sometimes before the world has rightly gauged their brightness. Here in America, in the few days since Emancipation, the black man's turning hither and thither in hesitant and doubtful striving has often made his very strength to lose effectiveness, to seem like absence of power, like weakness. And yet it is not weakness,—it is the contradiction of double aims. The double-aimed struggle of the black artisan—on the one hand to escape white contempt for a nation of mere hewers of wood and drawers of water, and on the other hand to plough and nail and dig for a poverty-stricken horde—could only result in making him a poor craftsman, for he had but half a heart in either cause. [. . .] The innate love of harmony and beauty that set the ruder souls of his people a-dancing and a-singing raised but confusion and doubt in the soul of the black artist; for the beauty revealed to him was the soul-beauty of a race which his larger audience despised, and he could not articulate the message of another people. This waste of double aims, this seeking to satisfy two unreconciled ideals, has wrought sad havoc with the courage and faith and deeds of ten thousand thousand people. . . .

\* \* \*

Work, culture, liberty,—all these we need, not singly but together, not successively but together, each growing and aiding each, and all striving toward that vaster ideal that swims before the Negro people, the ideal of human brotherhood, gained through the unifying ideal of Race; the ideal of fostering and developing the traits and talents of the Negro, not in opposition to or contempt for other races, but rather in large conformity to the greater ideals of the American Republic, in order that some day on American soil two world-races may give each to each those characteristics both so sadly lack.

\* \* \*

**9 ✦**  R[obert] J. Coady, "American Art," *The Soil* 1 (December 1916):3–4.

Coady's avant-garde journal *The Soil* had only five issues, from December 1916 through April 1917. He attempted to break down the distinctions between high art and popular culture by reproducing children's drawings and industrial photographs, calling the depicted machines "moving sculptures," and by running feature articles on dressmaking, on the African-American comedian Bert Williams and the boxer Jack Johnson. In fact, he took many occasions to incorporate African-American issues, themes, and subjects into the contents of the magazine.

Coady's list of what constitutes "American art" is reminiscent of Ralph Waldo Emerson's essay "The Poet" (1842), in which Emerson exhorted American writers to turn to the subject matter of America: "Our logrolling, our stumps, and their politics, our fisheries, our Negroes and Indians, our boats . . . the northern trade, the southern planting, the western clearing, Oregon and Texas, are yet unsung." The poet Walt Whitman also enumerated worthy American subjects in *Leaves of Grass,* first published in 1855. Claes Oldenburg would later also provide a similar list for those elements in American life that had inspired him (see Reading 84).

<div align="center">✦</div>

There is an American Art. Young, robust, energetic, naive, immature, daring and big spirited. Active in every conceivable field.

The Panama Canal, the Sky-scraper and Colonial Architecture. The East River, the Battery and the "Fish Theatre." The Tug Boat and the Steam-shovel. The Steam Lighter. The Steel Plants, the Washing Plants and the Electrical Shops. The Bridges, the Docks, the Cutouts, the Viaducts, the "Matt M. Shay" and the "3000." Gary. The Polarine and the Portland Cement Works. Wright's and Curtiss's Aeroplanes and the Aeronauts. The Sail Boats, the Ore Cars. Indian Beadwork, Sculptures, Decorations, Music and Dances. Jack Johnson, Charlie Chaplin, and "Spike" in "The Girl in the Game." Annette Kellermann, "Neptune's Daughter." Bert. Williams, Rag-time, the Buck and Wing and the Clog. Syncopation and the Cake-walk. The Crazy Quilt and the Rag-mat. The Minstrels. The Cigar-store Indians. The Hatters, the Shoe-makers, the Haberdashers and the Clothiers. The Window Dressers. Helene the Seamstress. The Motor Boat and the Automobile. The Fife and Drum Corps. The Fiddlers. Christy Mathewson, Ty Cobb. Robert and Alfred Taylor, Prunnetta Henderson, Greatorex. Football. Mayor Gaynor's Letters. Chin Yin, Frank Tinney. The Clowns, the Jugglers, the Bareback and the Rough Riders. The Bull-doggers, the Ropers and the Hoolahanners. The Motorcycle. Coney Island, the Shooting Galleries, Steeplechase Park, the Beaches. Mount Washington Church and the Church of All Souls. "Others," "Poetry," "Boxing Record," "The Police Gazette," the Sporting Pages, Krazy Kat, Tom Powers. Old John Brown. Nick Carter, Deadwood Dick, Old King Brady, Tom Teaser, Walt Whitman and Poe. William Dean Howells, Artemus Ward and Gertrude Stein. Alfred McCann. "Dixie," "Nobody" and the "By Heck Foxtrot." The Toy Soldiers in the Hippodrome. Slivers. The Zoo. Staten Island Warehouses, Parkhurst's

Church and the Woolworth Building. The Metropolitan Tower. Prospect Park. The City Hall. Jim Duncan. The Pennsylvania Station, The Pullman, the Centipedes and the Camel-backs. The Electric Signs and the Railroad Signals. Colt's Revolvers, Savage Rifles. Willie Hoppe. Hans Wagner, Home-Run Baker. The Giant on Rogers Peet's. Stauch's. The Roller Coasters. The Gas House. Madison Square Garden on a fight night. The Runners, the Jumpers, the Swimmers, the Boxers, the Battle Ships and the Gunners. Shepard and Meredith. Kiviat. Thompson and Thorpe. Kahanamoku. Levinsky, Ahearn, McFarland. Dundee and Richie. The Movie Posters. The Factories and Mills. The Jack Pot. Dialects and Slang. Type. Jack Dillon, Leo Johnson. The Gowanus Canal and the Bush Terminal. The Batteries. Hooper, Duffy, Speaker. The Jockeys. The Carpenters, the Masons, the Bricklayers, the Chimney Builders, the Iron Workers. The Cement Mixers, the Uneeda Biscuit Building. The Pulleys and Hoists. The Buckets and Pumps and the Keyseaters. The Cranes, the Plows, the Drills, the Motors, the Thrashers, the Derricks, Steam Ham-mers, Stone Crushers, Steam Rollers, Grain Elevators, Trench Excavators, Blast Furnaces—This is American Art.

It is not a refined granulation nor a delicate disease—it is not an ism. It is not an illustration to a theory, it is an expression of life—a complicated life—American life.

The isms have crowded it out of "the art world" and it has grown naturally, healthfully, beautifully. It has grown out of the soil and through the race and will con-tinue to grow. It will grow and mature and add a new unit to Art.

---

# New Forms for a New Century

Artists debated about the ways that art should *look* in the twentieth century. What styles should be used to express the new energies, the new individualities, and the new sub-jectivities? Robert Henri, John Sloan, and the realists chose to continue a figurative style and to use a broad brush in order to emulate the spontaneity of everyday people living in the city and enjoying urban, leisure activities. Others wanted to focus on those aspects of city life that showed people in process and in motion, as well as the buildings, the el-evated railroad, and the bridges, while yet others wanted to invent forms most expres-sive of candid, subjective, even poetic, states of mind.

Artists such as Max Weber, Joseph Stella, John Marin, and Arthur Dove traveled to Europe in the early years of the twentieth century and took a great interest in the new European styles of fauvism and cubism. Back in New York each concluded that the new century demanded new forms and styles that would push those European styles even further.

For those who did not travel to Europe, the exhibitions mounted by Alfred Stieglitz at his Little Galleries of the Photo-Secession (known as "291" from its location at 291 Fifth Avenue) caught their attention. Stieglitz exhibited the vanguard photographers be-ginning in 1905, but branched out in 1908 with a show of Rodin drawings. Works by Matisse and Picasso followed, as well as the paintings of Marin, Weber, Dove, Abraham Walkowitz, Marsden Hartley, and Georgia O'Keeffe.

Many of the Americans, such as Weber, Marin, and Stella, painted expressive, semi-abstract representations of the city: the imposing forms of skyscrapers and the dynamic rhythms of people and vehicles moving along the streets and avenues. Others, such as O'Keeffe and Dove, were inspired by natural forms and organic processes which they transformed into personally expressive images that liberated feelings. Still others, such as Elie Nadelman and Stanton Macdonald-Wright, emphasized "significant form," "the plastic point of view," and "pure painting."

At times music was the art form invoked as analogous to the abstract compositions being created; at other times the rationale given for the new styles rested on popular conceptions of the new scientific principles of space and time. It was well known that the physicist Albert Einstein had discovered the theory of relativity. Sigmund Freud's psychoanalytic theories of the unconscious had also been introduced to America and were being assimilated into discussions of popular culture.

At times the language of artists seems common sensical; at other times it borders on the mystical and spiritual. In short, each artist was individually struggling with a personal way to express her or his ideas and emotions.

*10* ✦   Elie Nadelman, "Notes for a Catalogue," *Camera Work,* no. 32 (October 1910): 41.

Elie Nadelman was born in Poland and studied at the Warsaw Art Academy and in Munich. He lived for a time in Paris, where he developed his artistic reputation. He settled in America in 1914 and had an exhibition at Stieglitz's "291" in 1915. In his early career his artistic sources were cubism, American folk art, and classical sculpture. Nadelman's sculptural work was characterized by simplified lines. He is known today for the large twin figures that grace the lobby of the New York State Theater in Lincoln Center, New York.

Today the term "significant form," used in these "Notes," is associated with the English critic Clive Bell, who published *Art,* his essays on postimpressionist art, in 1913.

✦

I am asked to explain my drawings. I will try to do so, although form cannot be described. Modern artists are ignorant of *the true forms of art.* They copy nature, try to imitate it by any possible means, and their works are *photographic reproductions,* not works of art. They are works without style and without unity.

It is form in itself, not resemblance to nature, which gives us pleasure in a work of art.

But what is this true form of art? It is significant and abstract, i.e., composed of geometrical elements.

Here is how I realize it. I employ no other line than the curve, which possesses freshness and force. I compose these curves so as to bring them in accord or in oppo-

sition to one another. In that way I obtain the life of form, i.e., harmony. In that way I intend that the life of the work should come from within itself. The subject of any work of art is for me nothing but a pretext for creating significant form, relations of forms which create a new life that has nothing to do with life in nature, a life from which art is born, and from which spring style and unity.

From significant form comes style, from relations of form, i.e., the necessity of playing one form against another, comes unity.

I leave it to others to judge of the importance of so radical a change in the means used to create a work of art.

---

*11* ✦ Max Weber, "The Fourth Dimension from a Plastic Point of View," *Camera Work* no. 31 (July 1910): 25.

Max Weber studied with Arthur Wesley Dow at Pratt Institute in Brooklyn from 1898 to 1900. He taught in public schools and then went to Paris in 1905 and studied at the Académie Julian and Académie Colarossi. He met Georges Braque and Pablo Picasso, and he organized an art class where Matisse gave instruction. In 1909 he was back in New York and moving in Stieglitz's artistic circle. At Stieglitz's "291" Weber helped to organize a Rousseau exhibition. He had his own solo exhibition in 1911, before arguments with Steiglitz terminated the relationship. In 1915 he painted *Rush Hour, New York,* an Americanized cubist and futurist work, inspired by Marcel Duchamp's *Nude Descending a Staircase,* 1913, shown at the Armory Show (see Reading 21).

Weber's essay speaks of a "fourth dimension"—mystical, mysterious, and infused with energy. To Weber, when an artist composed a picture, he or she was not just arranging shapes and lines on the surface, but infusing the composition with special feeling.

---◆---

In plastic art, I believe, there is a fourth dimension which may be described as the consciousness of a great and overwhelming sense of space-magnitude in all directions at one time, and is brought into existence through the three known measurements. It is not a physical entity or a mathematical hypothesis, nor an optical illusion. It is real, and can be perceived and felt. It exists outside and in the presence of objects, and is the space that envelops a tree, a tower, a mountain, or any solid; or the intervals between objects or volumes of matter if receptively beheld. It is somewhat similar to color and depth in musical sounds. It arouses imagination and stirs emotion. It is the immensity of all things. It is the ideal measurement, and is therefore as great as the ideal, perceptive or imaginative faculties of the creator, architect, sculptor, or painter.

Two objects may be of like measurements, yet not appear to be of the same size, not because of some optical illusion, but because of a greater or lesser perception of this so-called fourth dimension, the dimension of infinity. Archaic and the best of

Assyrian, Egyptian, or Greek sculpture, as well as paintings by El Greco and Cézanne and other masters, are splendid examples of plastic art possessing this rare quality. A Tanagra, Egyptian, or Congo statuette often gives the impression of a colossal statue, while a poor, mediocre piece of sculpture appears to be of the size of a pin-head, for it is devoid of this boundless sense of space or grandeur. The same is true of painting and other flat-space arts. A form at its extremity still continues reaching out into space if it is imbued with intensity or energy. The ideal dimension is dependent for its existence upon the three material dimensions, and is created entirely through plastic means, colored and constructed matter in space and light. Life and its visions can only be realized and made possible through matter.

The ideal is thus embodied in, and revealed through the real. Matter is the beginning of existence; and life or being creates or causes the ideal. Cézanne's or Giotto's achievements are most real and plastic and therefore are they so rare and distinguished. The ideal or visionary is impossible without form; even angels come down to earth. By walking upon earth and looking up at the heavens, and in no other way, can there be an equilibrium. The greatest dream or vision is that which is *regiven* plastically through observation of things in nature. "Pour les progrès à réaliser il n'y a que la nature, et l'œil s'éduque à son contact." Space is empty, from a plastic point of view.

The stronger or more forceful the form the more intense is the dream or vision. Only real dreams are built upon. Even thought is matter. It is all the matter of things, real things or earth or matter. Dreams realized through plastic means are the pyramids and temples, the Acropolis and the Palatine structures; cathedrals and decorations; tunnels, bridges, and towers; these are all of matter in space—both in one and inseparable.

---

*12* ✦ John Marin, Statement for "291" Exhibition, January 1913, published in *Camera Work* no. 42–43 (April 1913):18.

Between 1899 and 1903 John Marin studied at the Pennsylvania Academy of the Fine Arts and at the Art Students League in New York. He lived in Europe from 1905 until 1910, where he came under the spell of Whistler's etchings. But he also met the American photographer Edward Steichen, who put him in touch with Alfred Stieglitz. His first solo exhibition at Stieglitz's "291" was in 1910. About 1912 Marin changed his style, moving away from atmospheric compositions toward a more linear style that seemed suitable for capturing the rhythms of the city. At the time he made this statement, Marin was doing paintings and etchings of the Woolworth Building.

Marin's "pull forces" were no different from the "force lines" of the Italian Futurists, but Marin was living in a city where every year new skyscrapers reached record heights, hourly rumbles were heard from passing elevated trains, and the very ground shook from the subways. It was this inner pulse of the city that Marin was attempting to express.

✦

The later pictures of New York shown in this exhibition may need the help of an explanation. These few words are written to quicken your response to my point of view.

Shall we consider the life of a great city as confined simply to the people and animals on its streets and in its buildings? Are the buildings themselves dead? We have been told somewhere that a work of art is a thing alive. You cannot create a work of art unless the things you behold respond to something within you. Therefore if these buildings move me they too must have life. Thus the whole city is alive; buildings, people, all are alive; and the more they move me the more I feel them to be alive.

It is this "moving of me" that I try to express, so that I may recall the spell I have been under and behold the expression of the different emotions that have been called into being. How am I to express what I feel so that its expression will bring me back under the spells? Shall I copy facts photographically?

I see great forces at work; great movements; the large buildings and the small buildings; the warring of the great and the small; influences of one mass on another greater or smaller mass. Feelings are aroused which give me the desire to express the reaction of these "pull forces," those influences which play with one another; great masses pulling smaller masses, each subject in some degree to the other's power.

In life all things come under the magnetic influence of other things; the bigger assert themselves strongly, the smaller not so much, but still they assert themselves, and though hidden they strive to be seen and in so doing change their bent and direction.

While these powers are at work pushing, pulling, sideways, downwards, upwards, I can hear the sound of their strife and there is great music being played.

And so I try to express graphically what a great city is doing. Within the frames there must be a balance, a controlling of these warring, pushing, pulling forces. This is what I am trying to realize. But we are all human.

---

**13** ✦ William Murrell Fisher, "The Georgia O'Keeffe Drawings and Paintings at '291'," *Camera Work* no. 49–50 (June 1917): 5.

Georgia O'Keeffe was born in Wisconsin and studied at the Art Institute of Chicago and the Art Students League in New York before working as a commercial artist from 1908 to 1912 and as a Texas school educator. She returned to New York in 1914 and studied with Arthur Wesley Dow at Columbia. Her work was shown at Stieglitz's gallery at 291 Fifth Avenue, which led to her long relationship with Stieglitz. They married in 1924. She visited New Mexico each year from 1929 to 1949, when she moved there permanently.

The writer William Murrell Fisher comments on O'Keeffe's work for the last issue of *Camera Work*. He interprets her abstract forms flowing from an unconscious source within her, much as music flows, and he quotes Walter Pater: "music is the condition towards which . . . all art aspires." At the time, the progressive art schools would play music in the classrooms and have students paint according to the ways that music inspired them to work with form, color, and line without the necessity of verbal communication.

---

*   *   *

Is it no longer good form, in this avid and impatient age, to mention the things that are God's? Must all tribute, then, go to Caesar? These reflections are forced upon the contemplative mind, and one must take counsel with one's own self in meeting them. And it is in so communing that the consciousness comes that one's self is other than oneself, is something larger, something almost tangibly universal, since it is en rapport with a wholeness in which one's separateness is, for the time, lost.

Some such consciousness, it seems to me, is active in the mystic and musical drawings of Georgia O'Keeffe. Here are emotional forms quite beyond the reach of conscious design, beyond the grasp of reason—yet strongly appealing to that apparently unanalyzable sensitivity in us through which we feel the grandeur and sublimity of life.

In recent years there have been many deliberate attempts to translate into line and color the *visual* effect of emotions aroused by music, and I am inclined to think they failed just because they were so deliberate. The setting down of such purely mental forms escapes the conscious hand—one must become, as it were, a channel, a willing medium, through which this visible music flows. And doubtless it more often comes from unheard melodies than from the listening to instruments—from that true music of the spheres referred to by the mystics of all ages. Quite sensibly, there is an inner law of harmony at work in the composition of these drawings and paintings by Miss O'Keeffe, and they are more truly inspired than any work I have seen; and although, as is frequently the case with "given writings" and religious "revelations," most are but fragments of vision, incompleted movements, yet even the least satisfactory of them has the *quality* of completeness—while in at least three instances the effect is of a quite cosmic grandeur. Of all things earthly, it is only in music that one finds any analogy to the emotional content of these drawings—to the gigantic, swirling rhythms, and the exquisite tendernesses so powerfully and sensitively rendered—and music is the condition towards which, according to Pater, all art constantly aspires. Well, plastic art, in the hands of Miss O'Keeffe, seems now to have approximated that.

---

# Photography as Art, Photography as a Tool for Reform

By 1900 critics advocating photography as a fine art included Charles Caffin and Sadakichi Hartmann. Opponents saw the camera's mechanical nature as antithetical to the creation of beauty and artistic effects. To answer such criticisms, Caffin wrote *Photography as a Fine Art* (1901). He contrasted "utilitarian" photography with "aesthetic" photography: "The goal of the one being a record of facts, and of the other an expression of beauty." Caffin singled out Alfred Stieglitz as a leader of the new photographic trends—a promise Stieglitz fulfilled through his own example as well as his editorship of the New York Camera Club's *Camera Notes,* his own publication *Camera Work* (1903–1917), his indepen-

dent curating, and his galleries—the Little Galleries of the Photo-Secession (1905–17), The Intimate Gallery (1925–29), and An American Place (1929–46).

During the early years of the twentieth century, fine arts photographers aimed to achieve "pictorial" effects through the manipulation of negatives during the darkroom process—exposing parts of the plate to light, dodging in shadows, rubbing the surface, and retouching. Gradually pictorial photography gave way to "straight" photography, so named because artistic effects were achieved solely through the selection of subject, props, setting, placement of lights, composition, and focusing.

Stieglitz himself rarely tampered with the fundamental processes. As Hartmann observed ("Alfred Stieglitz: An Art Critic's Estimate," 1898, in *Collected Writings,* 1991): "He never applied anything but photography 'pure and simple' and disdained the assistance of retouching. . . . He realizes that artistic photography, to become powerful and self-subsistent, must rely upon its own resources and not ornament itself with foreign plumes in order to resemble an etching, a charcoal or wash drawing, or the reproduction of an old master." Nevertheless, in the early years of *Camera Work,* Stieglitz championed pictorial photography by Edward Steichen, Gertrude Käsebier, and others. But by 1916 Stieglitz was promoting Paul Strand, whose seemingly objective images presented an unsentimentalized view of America.

Independent of Stieglitz, a number of photographers, known today as "documentary photographers," appeared with a different agenda. Jacob Riis, a newspaper reporter and author of *How the Other Half Lives* (1890) on the living conditions of the urban poor, took up photography because of its ability accurately to document, and thereby dramatize, the conditions he was campaigning against. Lewis Hine, a teacher at the Ethical Culture School in the early 1900s, also turned to photography to teach his pupils about the city's people. One of Hine's first projects was to photograph immigrants at Ellis Island. In 1907 he became associated with *Charities and the Commons,* a journal of social reform and made photographs for the ambitious undertaking called the Pittsburgh Survey, a compendium of essays and statistics, with photographs by Hine and drawings by Joseph Stella. Later he worked for the journal *The Survey,* and photographed Pittsburgh immigrant workers. In 1908 he went to work full time for the National Child Labor Committee and documented the working conditions of children.

*14* ✦  Charles H. Caffin, *Photography as a Fine Art: The Achievements and Possibilities of Photographic Art in America* (New York: Doubleday, Page & Company, 1901).

An art critic and writer, Charles Caffin came from England to the United States in 1892 as an artist to work on murals for the World's Columbian Exposition in Chicago and later for the Library of Congress. He began writing criticism for the New York *Evening Post* in 1897; he also wrote for the *New York Sun* and the *New York American.* He specialized in writing about new trends in painting, sculpture, and photography and wrote several art books. He was a frequent contributor to Alfred Stieglitz's *Camera Work.*

———————————————————  ✦  ———————————————————

Can photography be reckoned among the fine arts?

The great French painter, Paul Delaroche, seeing an example of Daguerre's new light-pictures, is said to have exclaimed, "Painting is dead." So far the prophecy has not been fulfilled; and it is safe to say that painting has less to fear from the competition of photography than from its own over-productiveness. The interest of the remark, therefore, consists in this—that Delaroche instinctively recognized in the new invention qualities and possibilities which would ultimately bring it within the pale of the other fine arts.

* * *

There are two distinct roads in photography—the utilitarian and the aesthetic; the goal of the one being a record of facts, and of the other an expression of beauty. They run parallel to each other, and many cross-paths connect them. Examples of utilitarian photographs are those of machinery, of buildings and engineering works, of war-scenes and daily incidents used in illustrated papers, of a large majority of the views taken by tourists, and of the greater number of portraits. In all these the operator relies upon the excellence of his camera, and in developing and printing aims primarily at exact definition. Examples of the intermediate class are photographs of paintings, sculpture and architecture, which, while first of all useful as records of works of art, are treated with so much skill and feeling for the beauty of the originals that they have an independent value as being themselves things of beauty. Preëminent in this class is the portrait, which gives a truthful record of the individual's characteristics, at the same time being so handsome as a picture that we enjoy it apart from any consideration of its being a good likeness. Lastly, there is the photograph whose motive is purely aesthetic: to be beautiful. It will record facts, but not as facts; it will even ignore facts if they interfere with the conception that is kept in view; just as Corot in his paintings certainly recorded the phenomena of morning and twilight skies and just as certainly left out a number of facts which must have confronted him as he sat before the scene, his object being not to get at facts, but to express the emotions with which the facts affected him.

The point to be noted is that, while in the first class the photographer succeeds by mechanical and scientific means, in the two latter he must also have sympathy, imagination, and a knowledge of the principles upon which painters and photographers alike rely to make their pictures. He must understand the laws of composition, those also which affect the distribution of light and shade; his eye must be trained to distinguish "values," that is to say, the varying effect of light upon objects of different material and the gradual changes in the color of an object according as it is nearer to or farther from the eye. These involve technical knowledge which may be acquired; in addition there must be the instinctive sense of what is beautiful in line and form and color, which may be developed by study, and, lastly, the natural gift of imagination which conceives a beautiful subject and uses technique and instinct to express it. The contention of what we have called the "advanced" photographers is that these qualities of temperament and training must be brought to the making of a picture-photograph.

* * *

*15* ✦ Paul Strand, "Photography," *Camera Work* 49–50 (June 1917):3–4; reprinted from *Seven Arts*.

Paul Strand was born and raised in New York City, where he studied at the Ethical Culture School under Lewis Hine. He became a protégé of Alfred Stieglitz, who in 1917 considered Strand to be the leading photographer working in the "straight" style—without the "artistic effects" of "pictorialism" achieved by manipulating the developing process in the darkroom. Indeed, here Strand urges the photographer to maintain "a real respect for the thing in front of him," and therefore to confine himself or herself to the objectivity—the "purity"—that is the photograph's uniqueness. Later, Strand broke with Stieglitz, and during the 1930s he became a documentary filmmaker.

———————————————— ✦ ————————————————

Photography, which is the first and only important contribution thus far, of science to the arts, finds its raison d'être, like all media, in a complete uniqueness of means. This is an absolute unqualified objectivity. Unlike the other arts which are really anti-photographic, this objectivity is of the very essence of photography, its contribution and at the same time its limitation. And just as the majority of workers in other media have completely misunderstood the inherent qualities of their respective means, so photographers, with the possible exception of two or three, have had no conception of the photographic means. The full potential power of every medium is dependent upon the purity of its use, and all attempts at mixture end in such dead things as the color-etching, the photographic painting and in photography, the gum-print, oil-print, etc., in which the introduction of hand work and manipulation is merely the expression of an impotent desire to paint. It is this very lack of understanding and respect for their material, on the part of the photographers themselves which directly accounts for the consequent lack of respect on the part of the intelligent public and the notion that photography is but a poor excuse for an inability to do anything else.

The photographer's problem therefore, is to see clearly the limitations and at the same time the potential qualities of his medium, for it is precisely here that honesty no less than intensity of vision, is the prerequisite of a living expression. This means a real respect for the thing in front of him, expressed in terms of chiaroscuro (color and photography having nothing in common) through a range of almost infinite tonal values which lie beyond the skill of human hand. The fullest realization of this is accomplished without tricks of process or manipulation, through the use of straight photographic methods. It is in the organization of this objectivity that the photographer's point of view toward Life enters in, and where a formal conception born of the emotions, the intellect, or of both, is as inevitably necessary for him, before an exposure is made, as for the painter, before he puts brush to canvas. The objects may be organized to express the causes of which they are the effects, or they may be used as abstract forms, to create an emotion unrelated to the objectivity as

such. This organization is evolved either by movement of the camera in relation to the objects themselves or through their actual arrangement, but here, as in everything, the expression is simply the measure of a vision, shallow or profound as the case may be. Photography is only a new road from a different direction but moving toward the common goal, which is Life.

<center>* * *</center>

The existence of a medium, after all, is its absolute justification, if as so many seem to think, it needs one and all, comparison of potentialities is useless and irrelevant. Whether a water-color is inferior to an oil, or whether a drawing, an etching, or a photograph is not as important as either, is inconsequent. To have to despise something in order to respect something else is a sign of impotence. Let us rather accept joyously and with gratitude everything through which the spirit of man seeks to an ever fuller and more intense self-realization.

---

**16** ✦ Lewis Hine, "Social Photography: How the Camera May Help in the Social Uplift," *Proceedings,* National Conference of Charities and Correction (June 1909): 50–54; reprinted in Alan Trachtenberg, ed. *Classic Essays on Photography* (New Haven: Leete's Island Books, c. 1989).

Trained in social work, Lewis Hine got a job teaching at the Ethical Culture School in the early 1900s. Photography became for him a means of teaching his pupils about the residents of New York, particularly the recent immigrants at Ellis Island. He later went on to work for the National Child Labor Committee, a progressive group proposing reforms in child labor laws.

Hine's essay was presented as a talk at a Round Table on photography. When he refers to "yellow photography," he is making a reference to "yellow journalism," which was sensationalized journalism as practiced in the newspapers owned by William Randolph Hearst.

Hine's remark, "while photographs may not lie, liars may photograph," has become famous in the annals of photography.

<center>✦</center>

For a moment, now, let us suppose that we as a body were working, against bitter opposition, for better conditions in the street trades of a certain state. In the heat of the conflict we have enlisted the services of a sympathetic photographer.

He has recorded some typical and appealing scenes in the life of the newsboy and his co-workers.

They show little chaps six years old selling until late at night; little girls exposed to public life with its temptations and dangers; school children starting out at 5 A.M. to peddle and going again after school and all day Saturday and Sunday; evening

scenes where the little fellows work late in and out of the saloons, learning the best way to get extra money from the drunks, and where they vary the monotony between hard-luck stories by pitching pennies, far into the night hours.

We might not agree as to their exact use, but surely we would not stand in the way if it were proposed that we launch them into every possible channel of publicity in our appeal for public sympathy. [. . .]

I wonder, sometimes, what an enterprising manufacturer would do if his wares, instead of being inanimate things, were the problems and activities of life itself, with all their possibilities of human appeal. Would he not grasp eagerly at such opportunities to play upon the sympathies of his customers as are afforded by the camera.

Take the photograph of a tiny spinner in a Carolina cotton mill. As it is, it makes an appeal. Reinforce it with one of those social pen-pictures of Buga's in which he says, "The ideal of oppression was realized by this dismal servitude. When they find themselves in such condition at the dawn of existence—so young, so feeble, struggling among men—what passes in these souls fresh from God? But while they are children they escape because they are little. The smallest hole saves them. When they are men, the millstone of our social system comes in contact with them and grinds them."

With a picture thus sympathetically interpreted, what a lever we have for the social uplift.

The photograph of an adolescent, a weed-like youth, who has been doffing for eight years in another mill, carries its own lesson. [. . .]

The photograph has an added realism of its own; it has an inherent attraction not found in other forms of illustration. For this reason the average person believes implicitly that the photograph cannot falsify. Of course, you and I know that this unbounded faith in the integrity of the photograph is often rudely shaken, for, while photographs may not lie, liars may photograph. It becomes necessary, then, in our revelation of the truth, to see to it that the camera we depend upon contracts no bad habits.

Not long ago, a leader in social work, who had previously told me that photographs had been faked so much they were of no use to the work, assured Editor Kellogg that the photographs of child labor in the Carolinas would stand as evidence in any court of law.

Moral: Despise not the camera, even though yellow-photography does exist.

With several hundred photos like those which I have shown, backed with records of observations, conversations, names and addresses, are we not better able to refute those who, either optimistically or hypocritically, spread the news that there is no child labor in New England?

Perhaps you are weary of child labor pictures. Well, so are the rest of us, but we propose to make you and the whole country so sick and tired of the whole business that when the time for action comes, child-labor pictures will be records of the past.

The artist, Burne-Jones, once said he should never be able to paint again if he saw much of those hopeless lives that have no remedy. What a selfish, cowardly attitude!

How different is the stand taken by Hugo, that the great social peril is darkness and ignorance. "What then," he says, "is required? Light! Light in floods!"

The dictum, then, of the social worker is "Let there be light;" and in this campaign for light we have for our advance agent the light writer—the photograph.

\* \* \*

Apart from the charitable or pathological phases of social work, what a field for photographic art lies untouched in the industrial world.

There is urgent need for the intelligent interpretation of the world's workers, not only for the people of today, but for future ages.

\* \* \*

## *Armory Show, Independents Show of 1917, and New York Dada*

Realists and semi-abstract artists and writers came together to organize the International Exhibition of Modern Art as early as December 1911. [See Fig. 1-3]. The Association of American Painters and Sculptors agreed to sponsor the event, and AAPS secretary Walt Kuhn and painter Arthur B. Davies traveled to Paris where they were joined by critic Walter Pach to scout out art. When Kuhn returned, he wrote to Pach with enthusiasm for the way the plans were progressing: "You have no idea how eager everybody is about this thing and the tremendous success it's going to be. Everybody is electrified when we quote the names, etc. The outlook is great. . . . We want this old show of ours to mark the starting point of the new spirit in art, at least as far as America is concerned" (December 12, 1912, quoted in Milton W. Brown, *The Story of the Armory Show,* 1988). Kuhn and others rallied the support of patrons Mabel Dodge, Gertrude Vanderbilt Whitney, and John Quinn, who contributed funds for expenses.

The show of some 1,300 art works opened at the 69th Regiment Armory in New York on February 17, 1913, and closed on March 15, whereupon a smaller version traveled on to Boston and then Chicago. The "Armory Show" introduced the American public to historic and contemporary European art as well as to recent American art. The exhibition received both high praise and virulent criticism in the press. Singled out for special attacks was Marcel Duchamp's *Nude Descending a Staircase* (1912), humorously referred to in the press as "Explosion in a Shingle Factory." Yet a total of 174 works sold, of which 123 were by foreign artists.

Duchamp, the Cuban-born Frenchman Francis Picabia, and the American artist Man Ray exemplified "New York Dada," which was not so much a movement as an attitude growing out of a wartime cultural malaise. They tweaked traditional art patrons by valorizing the mental (and often ironical) conception of an artwork over its craftsmanship. In New York, in 1915, Picabia contributed to Marius DeZayas's experimental portfolio magazine *291*. Picabia's artwork for *291* were "machine portraits" of Stieglitz, Paul Haviland, and others that consisted of drawings of machine parts (gleaned from order catalogues) suggestive of the person being portrayed. (For example, Picabia's portrait of Stieglitz consisted of a diagram of a nonfunctioning camera.)

Duchamp, in New York from 1915 to 1917, created a series of mysterious works that blended machine imagery with sexual content, culminating in his *Bride Stripped Bare by Her Bachelors, Even (The Large Glass)*. But perhaps his most notorious work of these years (after *Nude Descending a Staircase*), was *Fountain,* a men's room urinal, signed "R. Mutt." Submitted to the Society of Independent Artists for their premier exhibition in 1917, it was rejected. Duchamp argued his case (printed here) against such censorship in the little magazine *The Blind Man,* which also reproduced a photograph of *Fountain* by Alfred Stieglitz. Duchamp's statement that art is what the artist chooses has served as the motto for a major strain of late twentieth-century conceptual art.

Duchamp created not only new attitudes but new forms for the twentieth century. He called *Fountain* a "ready-made"—something found and declared "art" just as it was. Duchamp also fashioned "altered ready-mades," such as *Bicycle Wheel,* consisting of a bicycle wheel mounted on top of a stool so that both wheel and stool were rendered useless. He even altered himself and took on the identity of *Rrose Selavy,* when he cross-dressed as a demure and turbaned woman and was photographed by Man Ray.

## *17* ✦ Theodore Roosevelt, "A Layman's Views of an Art Exhibition," *The Outlook* 103 (March 29, 1913): 718–20.

Theodore Roosevelt served as U.S. president from 1901 to 1908. A progressive committed to expanded regulatory and welfare programs, he was also a prolific writer and historian, especially after leaving public office. His remarks typify the reaction of a great number of New Yorkers puzzled by the new art shown at the Armory Show. The "naked man going downstairs" refers to Duchamp's *Nude Descending a Staircase.*

———————————— ✦ ————————————

The recent "International Exhibition of Modern Art" in New York was really noteworthy.

\* \* \*

In some ways it is the work of the American painters and sculptors which is of most interest in this collection, and a glance at this work must convince any one of the real good that is coming out of the new movements, fantastic though many of the developments of these new movements are. There was one note entirely absent from the exhibition, and that was the note of the commonplace. There was not a touch of simpering, self-satisfied conventionality anywhere in the exhibition.

\* \* \*

Probably in any reform movement, any progressive movement, in any field of life, the penalty for avoiding the commonplace is a liability to extravagance. It is vitally necessary to move forward and to shake off the dead hand, often the fossilized dead hand, of the reactionaries; and yet we have to face the fact that there is apt to be a lunatic fringe among the votaries of any forward movement. In this recent art exhibition, the lunatic fringe was fully in evidence, especially in the rooms devoted to the Cubists and the Futurists, or Near-Impressionists. . . . Take the picture which for some reason is called "A naked man going down stairs." There is in my bath-room a really

**Figure 1–3.**   View of the Armory Show, 1913. Photograph courtesy the Walt Kuhn Armory Show Records, Archives of American Art, Smithsonian Institution.

good Navajo rug which, on any proper interpretation of the Cubist theory, is a far more satisfactory and decorative picture.

* * *

Very little of the work of the extremists among the European "moderns" seems to be good in and for itself: nevertheless it has certainly helped any number of American artists to do work that is original and serious; and this not only in painting but in sculpture.

* * *

All I am trying to do is to point out why a layman is grateful to those who arranged this exhibition.

---

*18* ✦ Arthur Jerome Eddy, *Cubists and Post-Impressionism* (Chicago: A. C. McClurg & Co., 1914).

Arthur Jerome Eddy, a Chicago lawyer, wrote prolifically on travel, law, business, and art, and even produced a novel. His early art books were *Design: The Soul of Art,* 1902, and *Recollections and Impressions of James A. McNeill Whistler,* 1903, based on his experience of sitting for a Whistler portrait. The Armory Show overwhelmed him, and in his enthusiasm he bought eighteen paintings and seven lithographs from the show for $5000.

His *Cubists and Post-Impressionism* reviews postimpressionism, fauvism, cubism, German expressionism, "color music," and futurism, and it ends with chapters on sculpture and American painting (called "virile impressionism"). His book serves as a scrapbook of the Armory Show, with lengthy quotations from contemporary newspaper reviews and critics' writings. His business reform books include *The New Competition,* first published in 1912, and *Property,* published in 1921, the year after he died.

Although usually uncredited, his ideas form the basis of many later histories of modern art. To Eddy, art should be individualistic, that is, centered on the individual's unique sensibility; the noblest art is abstract because non-mimetic, abstract art gives the surest evidence of the artist's freedom. Eddy did not restrict himself to discussions about painting, but saw the new spirit in all the arts, including the theater. He prided himself in the book's modern layout, which used short paragraphs and restricted the use of adjectives.

\* \* \*

The world is filled with ferment—ferment of new ideas, ferment of originality and individuality, of assertion of independence. This is true in religion, science, politics as well as in art. It is true in business. *New thought* is everywhere. The most radical suggestions are debated at the dinner table. In politics what would have been considered socialistic twenty years ago is accepted today as reasonable. To the conservative masses these new departures may seem like a wild overturning of all that is sacred, but there is no need for fear; all that *is really sound* will gain in the end.

\* \* \*

There are romanticists, realists, impressionists, futurists, cubists, in the theater.

The romantic play is an old, but still delightful story. We have had realism on the stage so long it has become almost academic. Just now there is coming from the Scandinavian countries and from Germany and Russia a form of dramatic representation that is essentially Cubist, Futurist, and Orphist in its expression.

This ferment of new ideas is very disturbing to men who are afraid of change, who favor things as they are, who like to go to bed at the same hour and get up at the same hour, to do today what they did yesterday. But the new ideas will not down; they are constantly breaking out in unexpected places and while they may seem to be different ideas when expressed in music, painting, sculpture, poetry, architecture, from those expressed in science, religion, politics, social reform, and business generally, they are not; they are all fundamentally the same, namely, they are the ideas of a progress so rapid and radical it may be revolutionary and in a measure destructive.

\* \* \*

I should be very sorry if any reader should take up this volume under the impression it is a plea for Cubism or any other "ism" in either art or life. If it is a plea for anything, it is for *tolerance and intelligent receptivity,* for an attitude of sympathetic

appreciation toward *everything that is new and strange and revolutionary in life*. Not that we will necessarily end by accepting the new and the strange and the revolutionary, but we cannot get the good there may be in them unless our attitude is one of sympathetic as well as critical receptivity.

It is something more than a mere coincidence that the upheaval in the art world has paralleled the upheaval in the political world. The exhibitions of extreme modern pictures were first held in England just when extreme radical theories were gaining the ascendancy. The International Exhibition in America followed hot in the footsteps of the split in the Republican party and the triumph of the Democratic along lines so progressive as to seem almost socialistic.

The artists who organized the exhibition did not realize it, but they were animated by precisely the same motive that animated the organizers of the Progressive party—an irresistible desire for a change.

<center>* * *</center>

People who looked at the cubist paintings and laughed did so through ignorance; the sad part was that many frankly said they did not care to understand; not a few insisted the paintings were quite without meaning, utterly devoid of sense.

In other words, the public, day after day and week after week, struggled and paid to see works that were *meaningless!*

Painters, sculptors, critics, argued and fought over canvases *devoid of significance!* A paradox! For if *devoid of significance,* why should the world of artists, critics, writers, argue, swear, and fight over them?

The question answers itself; the trouble is the works *do* possess a significance, a significance far beyond the merits of any particular one, far beyond the merits of cubism itself; they are significant of the spirit of change that is within and about us, the spirit of unrest, of the striving, of the searching for greater and more beautiful things.

<center>* * *</center>

---

**19** ✦   Marcel Duchamp, in Katherine S. Dreier, *Collection of the Société Anonyme: Museum of Modern Art 1920* (New Haven: Yale University Art Gallery, 1950), p. 148.

Although the most talked-about artist of the Armory Show, Marcel Duchamp did not come to New York until 1915, in part to escape World War I then raging in Europe. The handsome artist quickly charmed wealthy patrons interested in avant-garde art, such as Walter and Louise Arensberg, Katherine Dreier, and the Stettheimer sisters.

On the occasion of submitting a statement for the reprint of the 1920 catalogue of the Société Anonyme, Duchamp explained to Katherine Dreier his *Nude Descending a Staircase* [Fig. 1-4]. Duchamp may have been familiar with the writings of the French physiologist Jules-Étienne Marey. In the 1870s Marey studied animal locomotion and

**Figure 1–4.** Marcel Duchamp, *Nude Descending a Staircase No. 2,* 1912. Oil on canvas, 57 7/8 x 35 1/8 in. Philadelphia Museum of Art: The Louise and Walter Arensberg Collection. © 2000 Artists Rights Society, (ARS) New York/ADAGP, Paris/Estate of Marcel Duchamp.

published schematic, dotted line drawings of the human figure rising from a chair and engaged in other mundane activities. Duchamp's *Nude* has a striking resemblance to Marey's drawings.

Katherine Sophie Dreier, a progressive era social activist and an artist, founded the Société Anonyme in 1920. Duchamp, as well as Joseph Stella and Man Ray, took an interest in the project and helped her organize exhibitions of key European modernists for the Société's gallery in New York in the early 1920s. The following excerpt is quoted in Dreier's entry on Duchamp, dated 1949. In 1949, Representative George A. Dondero (Republican, Michigan) condemned the Société Anonyme for being the first Museum of Modern Art to introduce what he called communist-inspired "isms" (see Reading 79).

\* \* \*

. . . [*Nude Descending a Staircase*] is an organization of kinetic elements, an expression of time and space through the abstract presentation of motion. . . . But remember, when we consider the motion of form through space in a given time, we enter the realm of geometry and mathematics, just as we do when we build a machine

for that purpose. Now if I show the ascent of an airplane, I try to show what it does. I do not make a still-life picture of it.

When the vision of the Nude flashed upon me, I knew that it would break forever the enslaving chains of Naturalism.

---

**20 ✦** Paul B. Haviland, "We Are Living in the Age of the Machine," *291*, no. 7–8 (September–October 1915): cover.

Paul Haviland was born in France, the son of a porcelain manufacturer. After graduating from the University of Paris, he went to Harvard, where he graduated in 1901. He moved to New York and became the American representative for his father's company. He met Alfred Stieglitz about 1907 and became part of Stieglitz's inner circle, helping to edit *Camera Work*.

In 1915 Haviland, Marius DeZayas, and Agnes Ernst Meyer began printing issues of the witty picture magazine *291*, named after Stieglitz's gallery at 291 Fifth Avenue. Haviland's statement foregrounds photography as the appropriate art form for the modern age, since it is made by a mechanical device. Although serious, Haviland fashioned his words with typical Dada irony.

---✦---

We are living in the age of the machine.

Man made the machine in his own image. She has limbs which act; lungs which breathe; a heart which beats; a nervous system through which runs electricity. The phonograph is the image of his voice; the camera the image of his eye. The machine is his "daughter born without a mother." That is why he loves her. He has made the machine superior to himself. That is why he admires her. Having made her superior to himself, he endows the superior beings which he conceives in his poetry and in his plastique with the qualities of machines. After making the machine in his own image he has made his human ideal machinomorphic. But the machine is yet at a dependent stage. Man gave her every qualification except thought. She submits to his will but he must direct her activities. Without him she remains a wonderful being, but without aim or anatomy. Through their mating they complete one another. She brings forth according to his conceptions.

Photography is one of the fine fruits of this union. The photographic print is one element of this new trinity: man, the creator, with thought and will; the machine, mother-action; and their product, the work accomplished.

---

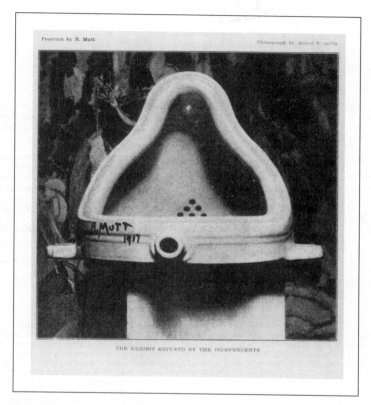

**Figure 1-5.** "The Richard Mutt Case" and "The Exhibit Refused by the Independents," Alfred Stieglitz's photo of R. Mutt's/Marcel Duchamp's "Fountain, (1917)." From *The Blind Man* (May 1917), pp. 4–5. Photograph courtesy of The Art Institute of Chicago.

**21 ✦** Duchamp's *Fountain,* photography by Alfred Stieglitz; Beatrice Wood/Marcel Duchamp, "The Richard Mutt Case"; and Louise Norton, "Buddha of the Bathroom" in *The Blind Man* 2 (May 1917): 4–5.

Alfred Stieglitz took a photograph of Duchamp's notorious *Fountain,* which was reproduced in the second and final issue of the avant-garde little magazine, *The Blind Man,* edited by Duchamp, Henri-Pierre Roché, and Beatrice Wood. "The Richard Mutt Case" has long been attributed to Marcel Duchamp, even though he had a very imperfect command of English. Beatrice Wood, a young American artist in the Duchamp circle, claimed authorship in her *I Shock Myself: The Autobiography of Beatrice Wood,* 1988. Art historian Francis M. Naumann surmises that Duchamp probably approved the text.

# THE BLIND MAN

## The Richard Mutt Case

*They say any artist paying six dollars may exhibit.*

*Mr. Richard Mutt sent in a fountain. Without discussion this article disappeared and never was exhibited.*

*What were the grounds for refusing Mr. Mutt's fountain:—*

1. *Some contended it was immoral, vulgar.*

2. *Others, it was plagiarism, a plain piece of plumbing.*

*Now Mr. Mutt's fountain is not immoral, that is absurd, no more than a bath tub is immoral. It is a fixture that you see every day in plumbers' show windows.*

*Whether Mr. Mutt with his own hands made the fountain or not has no importance. He CHOSE it. He took an ordinary article of life, placed it so that its useful significance disappeared under the new title and point of view—created a new thought for that object.*

*As for plumbing, that is absurd. The only works of art America has given are her plumbing and her bridges.*

### "Buddha of the Bathroom"

I suppose monkeys hated to lose their tail. Necessary, useful and an ornament, monkey imagination could not stretch to a tailless existence (and frankly, do you see the biological beauty of our loss of them?), yet now that we are used to it, we get on pretty well without them. But evolution is not pleasing to the monkey race; "there is a death in every change" and we monkeys do not love death as we should. We are like those philosophers whom Dante placed in his Inferno with their heads set the wrong way on their shoulders. We walk forward looking backward, each with more of his predecessors' personality than his own. Our eyes are not ours.

The ideas that our ancestors have joined together let no man put asunder! In *La Dissociation des Idees*, Remy de Gourmont, quietly analytic, shows how sacred is the marriage of ideas. At least one charm-

ing thing about our human institution is that although a man marry he can never be *only* a husband. Besides being a money-making device and the *one* man that *one* woman can sleep with in legal purity without sin he may even be as well some other woman's very personification of her abstract idea. Sin, while to his employees he is nothing but their "Boss," to his children only their "Father," and to himself certainly something more complex.

But with objects and ideas it is different. Recently we have had a chance to observe their meticulous monogomy. When the jurors of *The Society of Independent Artists* fairly rushed to remove the bit of sculpture called the *Fountain* sent in by Richard Mutt, because the object was irrevocably associated in their atavistic minds with a certain natural function of a secretive sort. Yet to any "innocent" eye

**Figure 1–5.** Continued

Louise Norton and her husband Allen Norton edited the little magazine *Rogue*. In 1917, when she wrote "Buddha of the Bathroom," she had become good friends with the avant-garde composer Edgard Varèse, whom she would soon marry. Her defense of *Fountain* continues on the page following the one reproduced here: "To those who say that Mr. Mutt's exhibit may be Art, but is it the art of Mr. Mutt since a plumber made it?

I reply simply that the *Fountain* was not made by a plumber but by the force of an imagination. . . . Then again, there are those who anxiously ask, 'Is he serious or is he joking?' Perhaps he is both! Is it not possible?"

## 22 ✦ Elsa von Freytag-Loringhoven, "Mefk Maru Mustir Daas," *The Little Review* 5, no. 8 (December 1918):41.

Vague about her European origins, financially on the margins once her businessman husband had died, but always called "the Baroness" by her friends, Elsa von Freytag-Loringhoven exemplified the Dada experimentalism and exhibitionism of Greenwich Village bohemia. As an artist's model she posed first for Robert Henri's friends, and later for a Man Ray film featuring a barber shaving her pubic hair. As an artist she used her own body as the canvas of her art— shellacking her shaven skull, staining it red-orange, and affixing such artifacts as metal tea-balls to her body. She also made some of the earliest sculptures constructed with found objects; most scholars now agree that it was she who made the famous *God* (circa 1916) long attributed to Morton Schamberg (because of his role in photographing the work and the inability of the artworld to recognize her as an innovative artistic talent). She also made a *Portrait of Marcel Duchamp,* circa 1919, described by William Carlos Williams: "I saw . . . under a glass ball, a piece of sculpture that appeared to be chicken guts, possibly imitated in wax. It caught my eye" (information and quotation in Robert Reiss, " 'My Baroness': Elsa von Freytag-Loringhoven," *Dada/Surrealism* 14, 1985). Like other Dada artists, she went to Europe in the early 1920s; there she became clinically depressed, committing suicide in 1927.

The Baroness's prolific Dada poetry was enthusiastically published by Margaret Anderson and Jane Heap, who moved their journal of poetry and essays, *The Little Review,* from Chicago to New York in 1916. *The Little Review* was one of several "little magazines" published on a shoestring (others were *Poetry, Rogue, The Glebe,* and *Others*) that showcased the avant-garde poetry of Williams, T. S. Eliot, Amy Lowell, Mina Loy, H.D., Alfred Kreymborg, Marianne Moore, and Wallace Stevens.

This poem by von Freytag-Loringhoven was dedicated to Marcel Duchamp, whose serene male beauty and ironic demeanor attracted both men and women, including Man Ray, who photographed Duchamp incessantly.

✦

### Mefk Maru Mustir Daas

*The sweet corners of thine tired mouth   Mustir*
*So world-old tired   tired to nobility*
*To more   to shame  to hatred of thineself*
*So noble soul   so weak a body*
*Thine body is the prey of mice*

*And every day the corners of thine tired mouth    Mustir*
*Grow sweeter helpless - sneer the more despair*
*And bloody pale-red poison foams from them*
*At every noble thing    to kill thine soul*
*Because thine body is the prey of mice*
*And dies so slowly*

*So noble is thine tired soul    Mustir*
*She cannot help to mourn out of thine eyes*
*Thine eyelids    nostrils    pallor of thine cheek*
*To mourn upon the curving of thine lip*
*Upon the crystal of thine pallid ear*
*To beg forgiveness with flashing smile*
*Like amber-coloured honey*

*The sweet corners of thine tired mouth    Mustir*
*Undo thine sin.    Thine pain is killed in play*
*Thine body's torture stimulates in play*
*And silly little bells of perfect tune*
*Ring in thine throat*
*Thou art a country devasted    bare    Mustir*
*Exhausted soil with sandy trembling hills*
*No food    no water    and ashamed of it*
*Thou shiver    and an amber-yellow sun*
*Goes down the horizon*
*Thou art desert with mirages which drive the mind insane*
*To walk    and die    a-starving.—*

# Chapter Two

# The 1920s

## Cultural and Historical Context for the Jazz Age

The 1920s as a unit—a wedge of time between the end of World War I in November 1918, and the Stock Market Crash of October 1929—was a time when jazz, popular music, and experimental literature flourished, and when "modernist" painters, sculptors, photographers, and architects rallied together to promote the new and the modern.

In this decade writers and artists discussed with renewed intensity what it meant to be an "American." Was it a common past? Or local customs unique to the regions? Did the exciting popular arts such as jazz or the commercial arts such as advertising and package design make for an American exceptionalism? And what about those Americans who felt the "double consciousness" described by W. E. B. Du Bois in *The Souls of Black Folk*? (See Reading 8.) What place did African American traditions, or those of Native Americans, have in "Americanism"? Could Europe still be an inspiration for the arts?

And what about the downside of "Americanism"? Patriotism could easily send chills to progressives who deplored the anti-immigrant and antiradical raids of Attorney General Alexander Mitchell Palmer conducted in 1919 and into the 1920s. The trial in 1921 of Italian immigrants Nicola Sacco and Bartolomeo Vanzetti, accused of robbing and killing a paymaster and guard at a shoe factory but with little convincing evidence, was affected by antiradical and anti-immigrant prejudice. Already there were restrictive immigration laws targeting Asians, and in 1921 more restrictions stemmed the flow from southern and eastern Europe as well. In 1924 a restrictive quota system was established, based on the national origins of people already citizens; this eliminated all but Northern Europeans and Britons. The popularity of the Ku Klux Klan, who marched twenty-thousand strong through the streets of Washington, DC, in the summer of 1925 was a measure of jingoistic Americanism, but also antimodernism.

In retrospect it seems the various issues of modernization dominated the spirit of the times. Certainly, by the 1920s mechanization had arrived in the American city, and it promised to bring about more efficient and comfortable ways of living and working. Telephones, increasingly common in the home, put people in touch with friends and loved ones, and radios connected people with the nation's culture and news. For example, news immediately spread over the airways of Warren G. Harding's election to the presidency on

November 2, 1920, thanks to an initial radio broadcast from Pittsburgh's KDKA. Entertainment and music programs filled the air; by 1922, three million homes had radios. Moreover, people went to the movies in greater and greater numbers; in 1922 an estimated 40 million went to the movies each week, and by 1930, 100 million. Automobiles profoundly affected both business and leisure life. In 1919 there were 6,771,000 passenger cars; the number climbed to 23,121,000 by 1929.[1]

Enthusiasm for the scientific outlook of modernity affected the arts. Louis Lozowick, one of the first artists to visit Soviet Russia, returned with enthusiasm for the Russian avant-garde, who then were the proletarian leaders creating an international art in the service of social revolution. In his *Modern Russian Art* (1925), Lozowick praised the Russian Constructivists who "go for instruction to science and borrow an example from industry. Like science, they aim at precision, order, organization; like industry, they deal with concrete materials: paper, wood, coal, iron, glass." His highest praise was for artist El Lissitzky: "Objectivity is one of the cardinal articles of his credo. Art is not a matter of inspiration or intuition but of logic and craftsmanship. The function of art, before it disappears, is not to decorate or beautify life but to transform and organize it. The artist must change from one who represents existing objects into one who creates a world of new objects." To Lozowick, art should serve to promote a beneficent social order.

Machine age art could also serve the selling of consumer goods. The 1920s was the age of business, the decade when Calvin Coolidge could say that "The man who builds a factory builds a temple." He added: "The man who works there worships there."[2] The products of that factory needed to be sold, and advertising agencies staffed by college-educated entrepreneurs blossomed. Advertising art took on clean lines and a sophisticated look as shrewd ad agencies probed the psychology of the buying public and turned to experienced photographers such as Edward Steichen to sell Pond's soap and Jergens lotion and to painters such as Rockwell Kent to promote Steinway pianos. The appeal of efficiency and comfort was supplemented by the public's desire for status and glamour, which the advertisers assured them could be theirs through the purchase of the advertised goods.

Thus many American artists in the 1920s, who found inspiration in ad layout and package design, who saw beauty in stylized machine forms, and/or believed in a future utopia of modern design encouraged by an enlightened government (whether the socialist state or a modern, reformed capitalism) saw no contradiction between high art, the practical arts, and the arts of commercial promotion. In this sense, they shared common ground with artists at the Bauhaus design school in Germany. But without a national art school given over to such a unified theory of the arts, the propagandizing of such theories of popular and democratic modernity in the United States had to wait until Bauhaus artists established architecture and design programs in this country in the post–World War II years.

---

[1] See William E. Leuchtenburg's *The Perils of Prosperity, 1914–32,* 2nd ed. 1993, and Frederick Allen Lewis, *Only Yesterday: An Informal History of the 1920's,* 1931.
[2] Quoted in Leuchtenburg, p. 188.

# Machine Age Modernism
## and Modernity

The modern age demanded a modern art and architecture, one which would exhibit, as Lewis Mumford urged in his essay "Machinery and the Modern Style" (*The New Republic,* August 3, 1921), "the characteristic achievements of technology by which our daily activities have been molded into a hundred new patterns." To Mumford, a new style would follow, one that is "fundamentally the outcome of a way of living, . . . of the complex of social and technological experience that grows out of a community's life."

In 1920 Charles Sheeler and Paul Strand made the short film *Manhatta,* which consisted of a montage of images of skyscrapers, steam vents, the port of New York, and employees hurrying through the canyons of lower Manhattan. Sheeler went on to photograph for industry as well as to develop a precise, reductive style for representing buildings in paintings. Charles Demuth also used flat color and hard edges when he rendered the buildings of Pennsylvania small towns and created his poster portraits. The art historical term "precisionism" defines both the look as well as the content of their work.

Avant-garde poets shared with artists the embrace of technology and the machine age. William Carlos Williams, the pediatrician from New Jersey who moved in avant-garde circles, forged a poetry that often emulated the sounds and the looks of machines. Artists inspired him, and he in turn inspired artists. Stuart Davis, upon reading Williams's *Kora in Hell: Improvisations* (1920), a book given to the young artist whose ink drawing graced the frontispiece, wrote to Williams of his own struggles with the concept of "simultaneity": "I see in it a fluidity as opposed to stagnation of presentation. . . . It opens a field of possibilities. To me it suggests a development toward word against word without any impediments of story, poetic beauty or anything at all except word clash and sequence" (quoted in Patricia Hills, *Stuart Davis,* 1996).

In architecture, design, and the decorative arts, the style that we identify for the period is Art Deco, a phrase adopted from the 1925 Paris Exposition International des Arts Decoratifs et Industriels Modernes. This style, which extended from the mid-1920s to the 1940s, is characterized by flat planes, often staggered behind one another; zigzags, chevrons, and semicircles; and plant and animal motifs flattened and made to look as if crafted by machine. In the industrial arts, Art Deco was followed by "streamlining" adapted from designers concerned with objects, such as airplanes, moving quickly and efficiently through space with a minimum of turbulence.

**23 ✦** Joseph Stella, "The Brooklyn Bridge," *transition* 16/17 (June 1929): 86–89; reprinted from *New York* (Privately printed, c. 1925).

Born in Italy, Joseph Stella had an early classical art education before he arrived in New York in 1896, when he enrolled in the Art Students League and then the New York School of Art. He subsequently worked as an illustrator for magazines and went to Pittsburgh in 1902 to work for *The Survey,* a progressive-era magazine. In 1909 he returned to Italy to

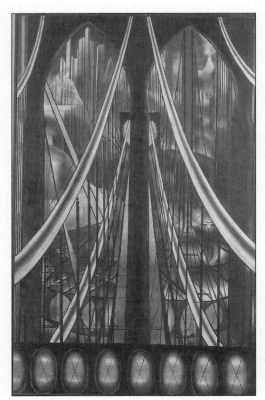

**Figure 2-1.** Joseph Stella, *The Voice of the City of New York Interpreted: Brooklyn Bridge,* 1920–22. Oil and tempera on canvas, 88 1/2 × 54 in. The Newark Museum, Newark, NJ. Photograph courtesy The Newark Museum and Art Resource, NY. This image was reproduced in *transition*.

study further old master techniques. Gradually he realized the old methods could not adequately provide him with the means to express his personal experiences. In 1911 he left for Paris, but returned to New York the following year, in time to see the Armory Show in February 1913. Awakened to the artistic possibilities of New York modernity, he painted *Battle of Lights, Coney Island,* 1913, and *Brooklyn Bridge,* 1919 (both Yale University Art Gallery), and *The Voice of the City of New York Interpreted: Brooklyn Bridge,* 1920–22 (Newark Museum) (see Fig 2-1).

The journal *transition: An International Quarterly for Creative Experiment* was published in Paris by expatriate Americans: Eugene Jolas was editor, with Harry Crosby and Matthew Josephson among the advisory editors. An editor's note states that Stella's essay was a reprint from a privately printed monograph called *New York*. Although probably written sometime in the mid-1920s, Stella recalls with great vividness the impression that the bridge made just as World War I was ending in 1918. To Stella, the modernity of the bridge and its forms—the arches and cables—were like music, and they inspired him to paint a heroic rendition of the bridge that would incorporate the "luminous dawn of

a new era." The Brooklyn Bridge also inspired Hart Crane, whose long epic poem *The Bridge* was published in 1930.

◆

During the last years of the war I went to live in BROOKLYN, in the most forlorn region of the oceanic tragic city, in Williamsburg, near the bridge.

Brooklyn gave me a sense of liberation. The vast view of her sky, in opposition to the narrow one of NEW YORK, was a relief—and at night, in her solitude, I used to find, intact, the green freedom of my own self.

It was the time when I was awakening in my work an echo of the oceanic polyphony (never heard before) expressed by the steely orchestra of modern constructions: the time when, in rivalry to the new elevation in superior spheres as embodied by the skyscrapers and the new fearless audacity in soaring above the abyss of the bridges, I was planning to use all my fire to forge with a gigantic art illimited and far removed from the insignificant frivolities of easel pictures, proceeding severely upon a mathematic precision of intent, animated only by essential elements.

War was raging with no end to it—so it seemed. There was a sense of awe, of terror weighing on everything—obscuring people and objects alike.

Opposite my studio a huge factory—its black walls scarred with red stigmas of mysterious battles—was towering with the gloom of a prison. At night fires gave to innumerable windows menacing blazing looks of demons—while at other times vivid blue-green lights rang sharply in harmony with the radiant yellow-green alertness of cats enjewelling the obscurity around.

Smoke, perpetually arising, perpetually reminded of war. One moved, breathed in an atmosphere of DRAMA—the impending drama of POE'S tales.

My artistic faculties were lashed to exasperation of production. I felt urged by a *force* to mould a compact plasticity, lucid as crystal, that would reflect—with impassibility—the massive density, luridly accentuated by lightning, of the raging storm, in rivalry of POE'S granitic, fiery transparency revealing the swirling horrors of the Maelstrom.

With anxiety I began to unfold all the poignant deep resonant colors, in quest of the chromatic language that would be the exact eloquence of steely architectures—in quest of phrases that would have the greatest vitriolic penetration to bite with lasting unmercifulness of engravings.

Meanwhile the verse of Walt Whitman—soaring above as a white aeroplane of Help—was leading the sails of my Art through the blue vastity of Phantasy, while the fluid telegraph wires, trembling around, as if expecting to propagate a new musical message, like aerial guides—leading to Immensity, were keeping me awake with an insatiable thirst for new adventures.

I seized the object into which I could unburden all the knowledge springing from my present experience—"THE BROOKLYN BRIDGE."

For years I had been waiting for the joy of being capable to leap up to this subject—for BROOKLYN BRIDGE had become an ever growing obsession ever since I had come to America.

Seen for the first time, as a weird metallic Apparition under a metallic sky, out of proportion with the winged lightness of its arch, traced for the conjunction of WORLDS, supported by the massive dark towers dominating the surrounding tumult of the surging skyscrapers with their gothic majesty sealed in the purity of their arches, the cables, like divine messages from above, transmitted to the vibrating coils, cutting and dividing into innumerable musical spaces the nude immensity of the sky, it impressed me as the shrine containing all the efforts of the new civilization of AMERICA—the eloquent meeting point of all forces arising in a superb assertion of their powers, in APOTHEOSIS.

To render limitless the space on which to enact my emotions, I chose the mysterious depth of night—and to strengthen the effective acidity of the various prisms composing my Drama, I employed the silvery alarm rung by the electric light.

Many nights I stood on the bridge—and in the middle alone—lost—a defenceless prey to the surrounding swarming darkness—crushed by the mountainous black impenetrability of the skyscrapers—here and there lights resembling suspended falls of astral bodies or fantastic splendors of remote rites—shaken by the underground tumult of the trains in perpetual motion, like the blood in the arteries—at times, ringing as alarm in a tempest, the shrill sulphurous voice of the trolley wires—now and then strange moanings of appeal from tug boats, guessed more than seen, through the infernal recesses below—I felt deeply moved, as if on the threshold of a new religion or in the presence of a new DIVINITY.

The work proceeded rapid and intense with no effort.

At the end, brusquely, a new light broke over me, metamorphosing aspects and visions of things. Unexpectedly, from the sudden unfolding of the blue distances of my youth in Italy, a great clarity announced PEACE—proclaimed the luminous dawn of A NEW ERA.

Upon the recomposed calm of my soul a radiant promise quivered and a vision—indistinct but familiar—began to appear. The clarity became more and more intense, turning into rose. The vision spread all the largeness of Her wings, and with the velocity of the first rays of the arising Sun, rushed toward me as a rainbow of trembling smiles of resurrected friendship.

* * *

---

**24 ✦** Louis Lozowick, "The Americanization of Art," in the catalogue for *Machine-Age Exposition,* ed. Jane Heap, New York: 119 West 57th Street, May 16-28, 1927, pp. 18–19.

Louis Lozowick, born and raised in Russia, came to the United States in 1906, when he was 14 years old. Traveling in Europe between 1919 and 1924, he became familiar with both the Russian and German avant-garde, and later wrote *Modern Russian Art* (1925) and *Voices of October* (1930). Lozowick saw machine age modernism as distinctly American. During the 1930s, Lozowick would take a more international outlook (see Reading 47).

In 1927 Jane Heap, editor of the avant-garde magazine *The Little Review,* organized the Machine-Age Exposition held in New York. This exhibition included an international offering of architectural plans, designs for automobiles, chemistry glass, cabinets, rifles, electric motors, oil burners, coffee grinders, propellers, sculpture by Gaston Lachaise, Alexander Archipenko, John Storrs, and Elie Nadelman, photographs by Ralph Steiner, a chess set by Man Ray, and paintings and designs by Charles Demuth, Theo Van Doesberg, and Louis Lozowick. Artists wrote for the catalogue and expressed their convictions about the future.

◆

If one were to grant the allegation that America possesses a meagre cultural heritage and lacks the weight of established tradition, it would by no means follow that material for creative activity is wanting. The intriguing novelty, the crude virility, the stupendous magnitude of the new American environment furnishes such material in extravagant abundance. To the truly creative artist the fallow rawness of the field should prove only an additional incentive to its intensive cultivation. The artist's task is to sift and sort the material at hand, mold it to his purpose by separating the plastically essential from the adventitious and, in this manner, enrich the existing culture and help to establish a new tradition.

The history of America is a history of stubborn and ceaseless effort to harness the forces of nature—a constant perfecting of the tools and processes which make the mastery of these forces possible. The history of America is a history of gigantic engineering feats and colossal mechanical construction.

The skyscrapers of New York, the grain elevators of Minneapolis, the steel mills of Pittsburgh, the oil wells of Oklahoma, the copper mines of Butte, the lumber yards of Seattle give the American industrial epic in its diapason.

Environment, however, is not in itself art but only raw material which becomes art when reconstructed by the artist according to the requirement of aesthetic form. The artist cannot and should not, therefore, attempt a literal soulless transcription of the American scene but rather give a penetrating creative interpretation of it, which, while including everything relevant to the subject depicted, would exclude everything irrelevant to the plastic possibilities of that subject.

Every epoch conditions the artist's attitude and the manner of his expression very subtly and in devious ways. He observes and absorbs environmental facts, social currents, philosophic speculation and then chooses the elements for his work in such fashion and focuses attention on such aspects of the environment as will reveal his own esthetic vision as well as the essential character of the environment which conditioned it.

The dominant trend in America of today is towards an industrialization and standardization which require precise adjustment of structure to function which dictate an economic utilization of processes and materials and thereby foster in man a spirit of objectivity excluding all emotional aberration and accustom his vision to shapes and color not paralleled in nature.

The dominant trend in America of today, beneath all the apparent chaos and confusion is towards order and organization which find their outward sign and

symbol in the rigid geometry of the American city: in the verticals of its smoke stacks, in the parallels of its car tracks, the squares of its streets, the cubes of its factories, the arc of its bridges, the cylinders of its gas tanks.

[. . . ] The artist who confronts his task with original vision and accomplished craftsmanship, will note with exactitude the articulation, solidity and weight of advancing and receding masses, will define with precision the space around objects and between them; he will organize line, plane and volume into a well knit design, arrange color and light into a pattern of contrast and harmony and weave organically into every composition [an] all pervading rhythm and equilibrium. The true artist will in sum objectify the dominant experience of our epoch in plastic terms that possess value for more than this epoch alone.

\* \* \*

**25 ✦** Samuel M. Kootz, "Ford Plant Photos of Charles Sheeler," *Creative Art* 8 (April 1931): 265–66.

Charles Sheeler studied at both the School of Industrial Art and the Pennsylvania Academy of the Fine Arts in Philadelphia, the city of his birth. In his early 20s he made several trips to Europe. On his 1908–10 sojourn, accompanied by artist Morton Schamberg, he encountered modernism. Back in the States he embarked on a career as a commercial photographer, while also developing a precise realist style. His paintings best exemplify the style that has become known as Precisionism.

In October 1927, N. W. Ayer & Son, the advertising agency for the Ford Motor Company, commissioned Sheeler to photograph Ford's new River Rouge plant in Dearborn, Michigan. At the time Ford had discontinued its boxy Model T automobile; its more stylish Model A was in production. On October 25, Sheeler wrote to the art patron Walter Arensberg: "My program as mapped out now will consist of photographs of details of the plants and portraits of machinery as well as the new Ford (take my word for it and order one now) and also the Lincoln" [Arensberg Archives, Philadelphia Museum of Art, quoted in Theodore E. Stebbins, Jr. and Norman Keyes, Jr., *Charles Sheeler: The Photographs* (Boston: Museum of Fine Arts, 1987), p. 26.]

Sheeler's photographs were thus part of a campaign to promote the new Fords and to celebrate the company. The pristine quality of Sheeler's industrial photographs appealed to art entrepreneur and critic Samuel Kootz, who saw in them "the very soul of steel . . . the truest portraits of our times."

✦

The photographs Charles Sheeler has made of the Ford plant in Detroit contain all the grammar so expertly used in making him one of America's finest artists.

The artist, the painter, is merely with us in another medium. All his lucid comprehension of composition and design; the subtlety, the variety of an intellectual arrangement of forms; his marvellously paced spacing; his feeling for depths, for bal-

ance; his interesting and completely personal use of color and texture; all these, his painting language, he brings to a different art—and in so doing elevates photography to a new beauty, to an exciting realization of its existing potentialities.

Sheeler's freshness of vision, the alertness of his eye, his sensitive, deliberate intelligence, combine to aid a definite attitude toward photography. That point-of-view may best be called truthfulness, for he believes in presenting the picture taken in naked reality, with no retouching and no sentimental overtones. His statements are crisp and plainspoken, edited only by the exposure of his eye to the objects to be portrayed. Before the camera's work comes into being, the scene or objects have gone through final arrangement in his own mind. When that arrangement is satisfying, inevitable, to him, the lens does its mechanical labor. The piercing integrity of its sight is unspoiled, unchanged, untouched. [. . .]

In the Ford plant Sheeler has beautiful working material. Designed by engineers interested primarily in function, the steel is pure, unornamented, faithful to its utilitarian purposes. Its ductile forms, at times slender, straight, virginal, change with rapid tempo into brutal, clutching, crushing symbols of power. But forms it does have, and these the photographer catches in all their bare economy. There is a rigid elimination of nonessentials, a leap straight to the scene's integrity, its own inner realism.

\* \* \*

If I were asked the origin of these photographs, I would not place them at the Ford plant. Rather would I trace them through the painting history of the artist, through his unceasing vigil to discover the straight way to paint, through his plastic philosophy of order, through his never-ending search for consistent formal harmony, and through his deeply civilized outlook upon life. Only through the combination, the fruition, of all these agents, could there emerge the photographer who in these Ford photographs has articulated the very soul of steel, in a series of the truest portraits of our times.

---

**26** ✦ William Carlos Williams, "The Great Figure" (1921),*William Carlos Williams Collected Poems,* Vol. I, 1909–1939, eds. A. Walton Litz and Christopher MacGowan (New York: New Directions, 1986). Copyright ©1938 by New Directions Publishing Corp. Reprinted by permission of New Directions Publishing Corp.

William Carlos Williams was a pediatrician who practiced in Paterson, New Jersey, and a poet who socialized with the New York avant-garde. He explained the genesis of his poem "The Great Figure" in his *Autobiography,* 1951: "Once on a hot July day coming back exhausted from the Post Graduate Clinic, I dropped in as I sometimes did at Marsden [Hartley]'s studio on Fifteenth Street for a talk, a little drink maybe and to see what he was doing. As I approached his number I heard a great clatter of bells and the roar of a fire engine passing the end of the street down Ninth Avenue. I turned just in time to see a golden figure 5 on a red background flash by. The impression was so sudden and forceful that I took a piece of paper out of my pocket and wrote a short poem about it."

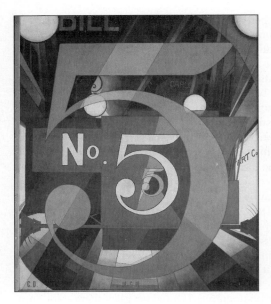

**Figure 2-2.**   Charles Demuth, *The Figure 5 in Gold,* 1928. Oil on composition board, 36 × 20 3/4 in. The Metropolitan Museum of Art, The Alfred Stieglitz Collection, 1949. Whereas the sounds and sights of a fire engine inspired Williams, the cadence and terse imagery of Williams's poem encouraged Charles Demuth to paint *I Saw the Figure 5 in Gold,* one of his "poster portraits." Fragments of "Bill," "Carlos," and "WCW" refer to Williams.

At various times in the twentieth century, artists, poets, and musicians have drawn inspiration not just from the subject matter of other art forms, but from the strategies of composition other art forms use. In the nineteenth century Charles Baudelaire called this "correspondences." However, another strain of artists and writers have held the view that each of the arts needs to be pure to its own unique processes, to be self-referential—a view extending from Willard Huntington Wright in the early years of the century (see Reading 5) to Clement Greenberg in the mid-1940s (see Reading 61).

◆

### The Great Figure

Among the rain
and lights
I saw the figure 5
in gold
on a red
firetruck
moving
tense
unheeded
to gong clangs
siren howls
and wheels rumbling
through the dark city.

# Cultural Nationalism—Defining American: The Usable Past, the Local, the Popular

While many artists and writers celebrated the new world of the machine, the city, and mechanization, others shunned it. Writer Van Wyck Brooks, disillusioned by World War I, looked toward art to keep alive the possibilities for idealism and, indeed, national redemption. In the April 1918 issue of *The Dial,* appearing one year after the United States entered World War I and seven months before the Armistice of November, Brooks expressed his hope that the creative minds of America would find something of value in the past to propel them boldly toward the future. It was Brooks who coined the term "usable past."

Hamilton Easter Field, painter, teacher, collector, writer, and editor of *The Arts,* turned to the question of creating a "national" tradition. Writing for *The Brooklyn Eagle* (May 9, 1920), he urged: "We should not allow ourselves to be drawn away from the task we have before us of creating a national tradition by sympathies for schools of art [European art movements] which are natural products of an over-ripe culture."

In admonishing artists to create a "national tradition," Field was proposing a *cultural nationalism,* although he and others did not use that phrase. This is the notion that artists need to encourage pride of country through cultural expressions.

Brooks and Field were following in a long line of cultural nationalists. In his 1837 Phi Beta Kappa address, "The American Scholar," Ralph Waldo Emerson observed: "We have listened too long to the courtly muses of Europe." In his 1842 essay, "The Poet," Emerson again urged poets to look to local subject matter:

> We have yet had no genius in America with tyrannous eye, which knew the value of our incomparable materials. . . . Our logrolling, our stumps, and their politics, our fisheries, our Negroes and Indians, our boats . . . the northern trade, the southern planting, the western clearing, Oregon and Texas, are yet unsung. Yet America is a poem in our eyes; its ample geography dazzles the imagination.

Walt Whitman, also, aimed to sing about America in his poetry.

In the minds of Brooks, Field, and others, the concept of a "usable past" merged with cultural nationalism. To create a tradition meant recalling America's rich heritage of artifacts, extending from the New England kitchens of the colonial era to the folk art of the Shakers and Pennsylvania Dutch. This American tradition, in the eyes of early twentieth-century cultural nationalists, was a tradition that valued domestic crafts, ingenuity, hard work, and folk wisdom. They also revered what they imagined as the "simple life" of colonial America. The notion that the simple life is more noble and authentic than the civilized one is a version of "cultural primitivism"—a concept that will be taken up in the next section.

Especially among art collectors of the Northeast, the colonial past had a strong appeal. The Colonial Revival of the late nineteenth century never really faded away; well into

the twentieth century colonial-style homes continued to be built in the streetcar suburbs of the big cities. Other cultural indicators include the founding of *Antiques* magazine in 1922 and the opening in November 1924 of the American Wing of the Metropolitan Museum of Art, which the critic Frank Jewett Mather, Jr., opposed for its "antiquarian sentimentality" of sterile, peopleless, reconstructed rooms. After successfully launching his Model A, Henry Ford built the Henry Ford Museum and Greenfield Village, which opened in 1929 on a 252-acre site. The facade of the museum building itself was a pastiche of replicas of Independence Hall, Congress Hall, and the old Philadelphia City Hall building. Greenfield Village erected building types typical of rural life of the eighteenth- and early-nineteenth centuries. By the end of the 1920s the restoration of Williamsburg, Virginia, was also underway, financed by money from the Rockefeller family.

Not surprisingly, this quest for an American "usable past" did not mean remembering the difficult or embarrassing aspects of American history, such as slavery, genocide of Native Americans, widespread ethnic prejudice, or the tribulations of recent European immigrants. (The romanticization by white writers of people of color will also be addressed in the next section, "Cultural Primitivism," whereas the critique of such cultural attitudes comes in the following section, "The New Negro.")

To many artists and writers the search for an American culture meant looking to the art and artifacts of ordinary, local "folk." Charles Sheeler was drawn to the simple styles of Shaker artifacts; Yasuo Kuniyoshi, who spent summers at Field's vacation home in Ogunquit, Maine, created fanciful children in the stiff, frontal poses of nineteenth-century portraits done by anonymous, itinerant painters [see Fig. 2-3]. And Elie Nadelman made wooden sculptures that have the rigid poses and whimsey of homespun folk sculpture.

Folk art also became collectable. As editor of *The Arts,* Field ran picture essays on folk art, such as American hooked rugs, which he considered "one of the most characteristic arts of America." In 1926 Edith Halpert opened her Downtown Gallery, which showed contemporary art as well as American folk art. She was joined in her enthusiasms by Holger Cahill, who in the 1930s would create for the Federal Art Project the ambitious Index of American Design, a compilation of some 22,000 watercolor paintings of Americana "folk" artifacts.

The "lure of the local" (to use the title of Lucy Lippard's 1997 book) motivated many writers and artists to search for an authentic "American" character in the "hometown" regions of the United States. Writing an essay, "Americanism and Localism," for the June 1920 issue of *The Dial,* the philosopher John Dewey observed that when one travels outside the United States, the local newspapers of the States bring the reader "back to earth," as opposed to the big New York or Chicago newspapers with their national reporting. Dewey continues: "Very provincial? No, not at all. Just local, just human, just at home, just where they live. . . . The typical newspaper editor doubtless sympathized with the feelings of the mass of the readers that a civic reformation at home was more important than a cabinet revolution in Washington; certainly more important for the 'home town,' and quite likely for the country—the country, mind you, not the nation, much less the state. For the country is a spread of localities, while the nation is something that exists in Washington and other seats of government."

Dewey touched on an important theme for many people—that only the local populace and their customs and institutions have authenticity, not the Washington politicians

**Figure 2-3.** Yasuo Kuniyoshi, *Child,* 1923. Oil on canvas, 30 × 24 in. The Whitney Museum of American Art, NY. Gift of Mrs. Edith Gregor Halpert. © Estate of Yasuo Kuniyoshi/VAGA, NY, NY.

nor the New York intelligentsia. Sociologists Robert S. and Helen M. Lynd undertook such a study of a generic, middle-America hometown; their *Middletown,* published in 1929, continues to be widely influential. Sherwood Anderson drew on themes of town life for *Winesburg, Ohio* (1919) and his other novels and short stories.

Nevertheless, the great urban centers of New York and Chicago continued to draw writers and artists. It was in these cities where contemporary popular and commercial culture heightened the sense of what was vitally American, as opposed to what was European. During the 1920s magazines such as *Vanity Fair* and *The Dial,* and Gilbert Seldes' *Seven Lively Arts,* promoted the popular arts and music. American musicians were already taking jazz to Europe, and American techniques of advertising and commercial display were revolutionizing European commerce.

Cultural nationalism, whether focused on the "usable past" or the local or popular culture, obfuscated the realities of artistic innovations. Although seldom acknowledged, Europeans were simultaneously developing new ideas and artistic practices in the fields of graphic design and photography. Because of the liveliness of the debates authors in this section reveal a polemical urgency in their points of view.

## 27 ✦ Van Wyck Brooks, "On Creating a Usable Past," *The Dial* 64 (April 11, 1918): 337–341.

Born in Plainfield, New Jersey, and educated at Harvard, Van Wyck Brooks was a critic who wrote several books on New England. He deplored the narrowness of Puritanism and urged a more inclusive, national culture. His books include *The Wine of the Puritans* (1909), *America's Coming of Age* (1915), *The Flowering of New England* (1936), for which he received a Pulitzer Prize, *New England: Indian Summer* (1940), and many others. In 1955 he wrote *John Sloan: A Painter's Life.*

*The Dial* began in 1880 as a conservative Chicago literary magazine. It moved to New York in 1918 and published radical authors, such as John Dewey and Thorstein Veblen. In 1920 the magazine was revamped as a leading journal for modernist writers. *The Dial* published drawings by Charles Demuth, John Marin, and Stuart Davis.

✦

\* \* \*

[T]he spiritual welfare of this country depends altogether upon the fate of its creative minds. If they cannot grow and ripen, where are we going to get the new ideals, the finer attitudes, that we must get if we are ever to emerge from our existing travesty of a civilization? [. . .] We want bold ideas, and we have nuances. We want courage, and we have universal fear. We want individuality, and we have idiosyncrasy. We want vitality, and we have intellectualism. We want emblems of desire, and we have Niagaras of emotionality. We want expansion of soul, and we have an elephantiasis of the vocal organs. Why? [. . .] The present is a void, and the American writer floats in that void because the past that survives in the common mind of the present is a past without living value. But is this the only possible past? If we need another past so badly, is it inconceivable that we might discover one, that we might even invent one?

Discover, invent a usable past we certainly can, and that is what a vital criticism always does. [. . .] The past is an inexhaustible storehouse of apt attitudes and adaptable ideals; it opens of itself at the touch of desire; it yields up, now this treasure, now that, to anyone who comes to it armed with a capacity for personal choices. If, then, we cannot use the past our professors offer us, is there any reason why we should not create others of our own?

\* \* \*

So far as our literature is concerned, the slightest acquaintance with other national points of view than our own is enough to show how many conceptions of it are not only possible but already exist as commonplaces in the mind of the world. Every people selects from the experience of every other people whatever contributes most vitally to its own development. The history of France that survives in the mind of Italy is totally different from the history of France that survives in the mind of England, and from this point of view there are just as many histories of America as there are nations to possess them. Go to England and you will discover . . . that an entire scheme of ideas and tendencies has survived there out of the American past to which the American academic point of view is wholly irrelevant. [. . .] Englishmen will ask you why

we Americans have so neglected Herman Melville that there is no biography of him. Russians will tell you that we never really understood the temperament of Jack London. And so on and so on, through all the ramifications of national psychology. By which I do not mean at all that we ought to cut our cloth to fit other people. I mean simply that we have every precedent for cutting it to fit ourselves.

\* \* \*

*What is important for us?* What, out of all the multifarious achievements and impulses and desires of the American literary mind, ought we to elect to remember? The more personally we answer this question, it seems to me, the more likely we are to get a vital order out of the anarchy of the present.

\* \* \*

---

**28** ✦ Thomas Hart Benton, "My American Epic in Paint," *Creative Arts* 3 (December 1928): xxxi–xxxvi.

Thomas Hart Benton studied at the Art Institute of Chicago before traveling to Paris in 1908, where he lived until 1911. Influenced by Cézanne and Matisse, he became interested in Synchromism and associated with Patrick Henry Bruce and Stanton Macdonald-Wright. After World War I, when he served in the U.S. Navy, he rejected European modernism and sought to establish an "American" art, based on the history and customs of Anglo-Americans. During the time that he was developing his nativist agenda, he was also teaching at the Art Students League in New York. Benton is here talking about mural panels begun in 1920, which he called the *American Historical Epic,* described by art historian Matthew Baigell as "a people's history rather than one glorifying great men and political or military events or representing abstract symbols such as Liberty Personified."

---✦---

[. . .]

When in 1919–20 I found myself growing out of my modern contempt for subject into a painter of histories, the question of the validity of my knowledge and interest did not occasion me any difficulty. I was too occupied with the discovery that what for me constituted an equivalent in painting for the ponderable world of experience could carry a specific human meaning. I was a child of that period when the painters of the modern world, seeking the "essentials" of their art, had cut off from all representation and isolated it in an abstraction. I was as naïvely belligerent in those days as anyone, though in actual practice I couldn't compare with my associates whom I desperately envied. My painting capacities—never fluent in the best of circumstances—and my theoretic development as an abstractionist were frustrated by a secret interest in objects and especially figures, as such, and, further, by a tenacious notion that if I wanted a real space in my pictures I would have to use real objects to get it. The ground I stood on was very poor logically, for I accepted the modern contention that painting was an abstraction from life and not a representation in the old sense of the word. But the idea that the further you abstracted, the purer and more functionally adaptable became your forms, while logically demonstrable, would not

go down and stay with me. My stubbornness on this subject kept me out of the real current of the movement, and I remember, on my return from France, how very lonely I used to feel in Stieglitz's "291," where others were practicing that to which I could only give an argumentative lip service. [. . .] The horse sense that still remained to a Missouri lawyer's son after five years of art revolted. [. . .]

\* \* \*

This brings me to the validity of my interest in historical painting and the reality of my knowledge. [. . .] The only thing that will stand objective scrutiny is the plain fact that I started painting histories when such things were anathema in the world I lived in. And that I started painting American histories rather than Greek or Roman or biblical ones.

I was raised in an atmosphere of violent political opinions, exploded when the Democrats of the East and West were at odds over President Cleveland's policies. I was in the habit of hearing these opinions bolstered by views of historical fact. This was always going on at the dinner table, where there was always company; and though it didn't have meaning for me in a political sense, it did have significance of an emotional sort. Grover Cleveland, Indian lands, Senator Vest, Eastern bankers, railway rights, and, later, Free Silver 16-to-1 were mysterious but real factors in a real world of be-whiskered toddy- and julep-drinking men who linked this up with a real past.

Furthermore, I was raised in a southwest Missouri town when the section reverberated with the great Oklahoma rushes. We always went hunting and fishing down in what was then Indian Territory (the part of Oklahoma adjacent to Missouri), and I learned to wonder why those fellows with braided hair, dirty pants, and calico shirts were wrongly occupying more good lands than they could use! The Senecas used to come up on the Fourth of July and give a green-corn dance in my home town, yelling and beating on drums and getting drunk and jailed. They all knew my father, for Indian law suits were constant. I went to innumerable old-settlers' and soldiers' reunions. My father, a veteran himself, was proud to parade his first son and always took me with him on his speaking trips over the rough red clay roads of the Missouri hills. And I was on the go a good part of the time after I was four years old. I heard a lot of hot stuff which the old boys thought I didn't understand. The Civil War was not a far-off thing to these old men but a living reality, and it was such to me who listened—for what did I know of time? [. . .] The stuff I soaked in, listening to my father's political constituents and to old Union soldiers laying out their pension claims, is vague emotional stuff, but it lights up the historical fact on which I base the progressions of the epic I have started.

In view of the foregoing, where do my living contacts end as they go back into history? What happened in Oklahoma in my lifetime happened in Missouri in my father's and in Kentucky and Tennessee in my grandfather's; and living words from people, not books, have linked them up in feeling and established their essential sameness. What constitutes the real break in this . . . historical progression is the machine, and I can almost fill that gap in direct experience, for I have ridden on, and well remember, the wood-burning locomotive that used to thump over the old split-log railway in southwest Missouri.

[. . .]

**29 ✦** Marsden Hartley, "American Values in Painting," and "Modern Art in America," published in *Adventures in the Arts* (New York: Boni and Liveright, 1921).

Born in Maine, Marsden Hartley was a poet and essayist as well as a modernist artist. He went to art school in Cleveland, then moved to New York in 1898 to study at the Chase School and the National Academy of Design. His early paintings were shown at Alfred Stieglitz's "291" gallery in 1909, and Stieglitz was always supportive of his art. Hartley traveled to Europe, spending time in Paris and Berlin, but returned after World War I broke out.

Hartley believed that the "real art of America" gives reference to the locale which inspired it. Hence, he always managed to include in his paintings something of the color, forms, or mood of the places which gave a context to his subjects—whether Berlin, the American Southwest, or Maine. In the essay "Modern Art in America" he also voices his concern that artists be supported by patrons in their own country, the United States.

✦

## From "American Values in Painting"

\* \* \*

So it is I feel that the real art of America, and it can, I think, justly be said that there is such, will be headed by the imaginative artists I have named in point of their value as indigenous creators, having worked out their artistic destinies on home soil with all the virility of creators in the finer sense of the term. They have assisted in the establishment of a native tradition which without question has by this time a definite foundation. The public must be made aware of their contribution to a native production. It will no doubt be a matter for surprise to many people in the world today that art in general is more national or local than it has ever been, due mostly to the recent upheaval, which has been of great service to the re-establishment of art interest and art appreciation everywhere in the modern world. Art, like life, has had to begin all over again, for the very end of the world had been made visible at last. The artist may look safely over an utterly new horizon, which is the only encouragement the artist of today can hope for.

## From "Modern Art in America"

The question may be asked, what is the hope of modern art in America? The first reply would be that modern art will one day be realized in America if only from experience we learn that all things happen in America by means of the epidemical principle. It is of little visible use that single individuals, by sitting in the solitary confinement of their as yet little understood enthusiasms, shall hope to achieve what is necessary for the American idea, precisely as necessary for us here as for the peoples

of Europe who have long since recognized that any movement toward expression is a movement of unquestionable importance. Until the moment when public sincerity and the public passion for excitement is stimulated, the vague art interests of America will go on in their dry and conventional manner. The very acute discernment of Maurice Vlaminck that "intelligence is international, stupidity is national, art is local" is a valuable deduction to make, and applies in the two latter instances as admirably to America as to any other country. Our national stupidity in matters of esthetic modernity is a matter for obvious acceptance, and not at all for amazement.

That art is local is likewise just as true of America as of any other country, and despite the judgment of stodgy minds, there is a definite product which is peculiar to our specific temper and localized sensibility as it is of any other country which is nameable. Despite the fact that impressionism is still exaggeration, and that large sums are still being paid for a "sheep-piece" of Charles Jacque, as likewise for a Ridgeway Knight, there is a well defined grouping of younger painters working for a definitely localized idea of modernism, just as in modern poetry there is a grouping of poets in America who are adding new values to the English language, as well as assisting in the realization of a freshly evolved localized personality in modern poetics.

Art in America is like a patent medicine, or a vacuum cleaner. It can hope for no success until ninety million people know what it is. The spread of art as "culture" in America is from all appearances having little or no success because stupidity in such matters is so national. [. . .] As a result of the war, there has been, it must be said, a heightening of national consciousness in all countries, because creative minds that were allowed to survive were sent home to struggle with the problem of their own soil.

There is no reason whatever for believing that America cannot have as many good artists as any other country. It simply does not have them because the integrity of the artist is trifled with by the intriguing agencies of materialism. Painters find the struggle too keen and it is easy to become the advertising designer, or the merchant in painting, which is what many of our respectable artists have become. The lust for prosperity takes the place of artistic integrity and courage. But America need not be surprised to find that it has a creditable grouping of artists sufficiently interested in the value of modern art as an expression of our time, men and possibly some women, who feel that art is a matter of private aristocratic satisfaction at least, until the public is awakened to the idea that art is an essentially local affair and the more local it becomes by means of comprehension of the international character, the truer it will be to the place in which it is produced.

\* \* \*

---

**30** ✦ Matthew Josephson, "The Great American Billposter," *Broom* 3 (November 1922): 304–12.

Matthew Josephson was a writer and literary critic who wrote on Zola, Stendhal, and Hugo. His most famous book is *The Robber Barons: The Great American Capitalists, 1861–1901*, published in 1934. Of all the expatriates living abroad, Josephson seemed

to specialize in exaggerating the technological progress of the United States, which he viewed from across the ocean with a mixture of irony and pride. He maintained that advertising was the most "American" of the arts. Inserted in his article are mock excerpts of advertisements, made to stand out from the text through indentations, a variety of eye-catching fonts, and shifting capital letters.

According to Malcolm Cowley, in *Exile's Return: A Literary Odyssey of the 1920s* (1934), the expatriate "little magazine" *Broom* was so named "to make a clean sweep of it." The first of the thirty issues of *Broom,* edited by Harold Loeb, was published in Rome in November 1921. The magazine moved to Berlin, publishing there between October 1922 and March 1923, before it moved to New York for its August 1923 issue, folding in January 1924.

---

\* \* \*

America will never enjoy an indigenous art, if, led by its Intellectuals, it adopts approved European methods of living or painting or writing. Poetry in America which imitates British romanticism is as sterile as that which imitates French symbolism is bastard. The prose in America which seeks to emulate the correct cold objectivity of a Flaubert or the ironic naturalism of a Turgenieff takes an equally false direction. An indigenous art is a permanent contribution to the world's knowledge, and an artist whose works are charged with the virtues peculiar to his *milieu is* an event of the first importance.

\* \* \*

A stranger, nearing the port of New York for the first time and peering anxiously toward this fabulous city, would perceive, as the first indications of its culture and personality, gigantic incandescent messages shooting fitfully over the dark waters: COL-GATES ... HECKER'S FLOUR ... AMERICAN SUGAR REFINERY. These solemn auguries of America, passing in brilliant illuminations across the sea, would serve as a majestic prelude to the strange music of this people. Thereafter, in every walk, in every ride in the subway, in every talk with a friend, some meaningful legend, some Open Sesame (as 57!) would be thundering softly in the back of his brain.

\* \* \*

The needs of an industry in America based upon the principle of quantity production, have brought into being the institution of Advertising. (Thus, "It Pays to Advertise.") Like all social or industrial institutions born of the American environment it reflects faithfully the character thereof. The Tired Business Man and the suburban wife are painted as never in any epic by Mary Roberts Rinehart. The dominant male, the Captain of Industry are pictured in concise vivid wireless messages such as:

> TO those who
> prefer to leave
> behind them "mon-
> uments in rows of

flaming smoke-
stacks" rather than
monuments of
marble, possession
of an H. C. S. fol-
lows as a matter of
course.

And note the virility of

DRIVEN
and loved
by men who
brook no short-
comings in man,
beast or motor.
They subject it
to hard tasks, and
it always meets
their moods.

The American athlete, lover of unwarlike violence and motion is supreme in a collection of automobile announcements. His bronzed, handsome, genial visage gleams unblemished in such a statement as

THE NEW BUICK SPORT ROADSTER FOR 1923
Built expressly for active out-of-doors men and women who regard a car as a companion and driving a pleasure. Every thing of strength power and speed suggested by its low hung graceful body is quickly re- alized on the open road.

\* \* \*

II.

The most striking conclusion drawn from a study of specimen advertisements is that the American business man, in the short daily time at his disposal, reads the most daring and ingenuous literature of the age. The particular restrictions of this medium make for extraordinary ingenuity in the "copy writer;" the call for vigor of style, conviction, and interest, are probably more stimulating by far toward creating beautiful conceptions than an intensive course in Victorian poetry at Harvard University. The terse vivid slang of the people has been swiftly transmitted to this class of writers, along with a willingness to depart from syntax, to venture sentence forms and word constructions which are at times breath-taking, if anything, and in all cases far more arresting and provocative than 99 per cent of the stuff that passes for poetry in our specialized magazines. They are a most amiable band of poets, without the pif- fle of the teacup type, their hair closely trimmed, their shoes thought-inspiring. All

design on immortality, on seats in the Academy, all schemes for hoodwinking posterity, have been renounced by them in favor of ample salaries and smoothly running motorcars.

<p style="text-align:center">* * *</p>

The language of modern poetry becomes thus enriched by the use of technical expressions and names which have attained significance in America. [. . .] It is a thrilling business, a fascinating genre, and it is easy to see *why our literature is so impoverished and where the creative genius has all gone.*

Contemporary American writing is at a very uncertain point in its career, bewildered for ways to follow. If our younger writers tend to become more sensitive to the particular qualities in their material environment, one might well imagine their giving and taking fresh stimulus and novelty of the literature of the billposter. What new devices and surprises might come of merely appreciating, for instance, the possibilities of the salesmanship principle for the technique of writing. The advertising columns in America are as "armies with banners."

---

# Cultural Primitivism—Defining Authenticity: The Usable "Other" and Natural Men and Women

In reaction to rapidly changing mechanization and the rationalization of the corporate world of business, many artists and writers (particularly those of European ancestry) searched for a more innocent, more natural, "authentic" art to which they could look for inspiration. These artists and writers did not necessarily want to leave the exciting world of urban modernity, they just wanted to believe that other cultures existed on the earth, where people lived in innocence of the complicated lifestyles of the modern world. This phenomenon, termed "cultural primitivism," has been defined by philosopher Arthur O. Lovejoy as "the belief of men living in a relatively highly evolved and complex cultural condition that a life far simpler and less sophisticated in some or in all respects is a more desirable life" (*Primitivism and Related Ideas in Antiquity,* 1935).

Cultural primitivism has a long history; the Greeks themselves had longed for a new Golden Age that would satisfy their "tribal memories" (memories in large part invented) of an older Arcadia. And when Columbus arrived in the New World, he was astonished by the noble simplicity of the Caribbean islanders and thought he had found that Golden Age. In the United States in the nineteenth century, Native Americans were often romanticized as the "Noble Savage"; however, when Native Americans became a threat to expansion, they were demonized as Savage Savages. Another construct for cultural primitivism was the landscape itself, which could be painted or photographed as a pristine site where one could vicariously retrieve a Golden Age.

During the 1920s, especially after the massive destruction of World War I, the yearning for the balm of the more innocent life became acute. The precision, order, and organization of machine-inspired art and design objects, such as those praised by Louis Lozowick (see Reading 24), were less than satisfying to the cultural primitivists, who yearned to flee the overcivilized cities of the East for the Pueblos of New Mexico, the Pacific Islands and Far East, and Africa. If they could not relocate to these places (because of business, professional, and family commitments), at least they could purchase and celebrate the curious and beautiful objects produced by the native peoples of such different and exotic places.

Indeed, the cultural primitivist romantics could also find within themselves strains of the natural, the spontaneous, the intuitive. According to Benjamin DeCasseres, Max Weber, a deep admirer of African sculpture, seems to have fashioned for himself a persona of primitiveness. And certainly women, who long had lived with the stereotype of the female as the emotional, irrational, earth-bound gender, could easily slip into the role of the "primitive" earth mother.

In spite of the fact that African American writers, artists, intellectuals, and musicians, many trained at the highest academies of learning, were forging an internationalist modernism and producing experimental works of wide appeal, the stereotype of the irrational, rhythmic child of the jungle continued to be imposed on the race. For example, historian David Levering Lewis in *When Harlem Was in Vogue,* 1979, has revealed the opinionated, patronizing attitudes of Charlotte Mason, a wealthy white Park Avenue dowager. Her hobby was financing the living expenses of young African American writers, such as Langston Hughes and Zora Neal Hurston. Mason called Alain Locke her "Brown Boy," and in a letter of 1929 (quoted in Lewis), she advised him to "slough off white culture—using it only to clarify the thoughts that surge in your being." Mason thought he would then discover that there "is harmony flowing toward you from the Souls of the Slaves from Africa that listen, quietly waiting in the Beyond."

It is difficult to fathom today the insensitivity on the part of Anglo-Americans in the early twentieth century toward the cultural situation of Native Americans. Assimilationists within the Bureau of Indian Affairs plotted to remove all traces of native culture by relocating the children to Eastern, white schools. Liberal romantics, on the other hand, sought to keep the tribes isolated from the "contamination" of white culture. However, the reality of tribal life (that is, living on reservations or in closed communities) compelled Native Americans to produce goods for sale—pots, rugs, paintings, and other artifacts—that would meet the expectations of art collectors and the tourist industry. But in the 1920s, the racism held by a majority of Anglo-Americans made them incapable of comprehending the truth that all humans are sentient and adaptable beings fully capable of negotiating the contemporary world as much to their advantage as possible.

Cultural primitivism also lay behind the romance of materials in the 1920s. Architect Frank Lloyd Wright praised the use of natural materials, while also appropriating the non-Western forms of pre-Columbian building and sculpture as he did for the Imperial Hotel (now destroyed) in Tokyo. Also in the 1920s, sculptors, such as William Zorach, took up direct carving techniques as part of their ambition to be more authentic to the origins of sculpture in preliterate, pre-Bronze Age societies.

**Figure 2-4.** Fred Kabotie, *Zuni Corn Dance,* 1920. Watercolor and tempera on paper, 16 5/8 × 24 3/4 in. Peabody Museum, Harvard University. © President & Fellows of Harvard College. As a teenager, Fred Kabotie, a Hopi, studied at the Santa Fe Indian School. He and other Hopi were encouraged to paint detailed and deft watercolors of the costumes and postures of ceremonial dancers of both the Hopi and the Pueblos. Kabotie's mature style, which omitted background detail and emphasized outline, continued to be encouraged by southwest museum directors, anthropologists, and patrons who considered the style to be authentically "Indian."

*31* ✦ Holger Cahill, "America Has Its Primitives: Aboriginal Water Colorists of New Mexico Make Faithful Record of Their Race," *International Studio* 75 (March 1922): 80–83.

John Sloan and his wife Dolly, good friends of Holger Cahill, first visited Santa Fe in 1919 and were introduced to the watercolors of Pueblo artists. Sloan arranged to have the works shown the following year in New York under the auspices of the Society of Independent Artists, the organization of which he was president. Exhibitions of Pueblo art were organized for subsequent years, and Holger Cahill reviewed the exhibition of March 1922. Cahill (see Reading 53 for biography) praises the art of the Pueblo watercolorists for its simplicity, beauty, and originality. He romanticizes the idea of the "Indian," and thus is patronizing to the actual Native Americans he talks about.

In his essay, Cahill singles out for praise the beginnings of the Native American watercolor movement and those who followed in this tradition: Awa Tsireh, Fred Kabotie [see Fig. 2-4], Velino Shije and Tonita Pean. Unlike today, rarely were the voices of Pueblo artists themselves heard in the 1920s; Anglos usually spoke for them.

✦

The American Indian of popular conception, a strange, ferocious creature, good only when dead, and utterly oblivious, as were most fiction heroes before Balzac, to any need for economic activity, is getting summary treatment these days at the hands of Indian scholars. In his place we see emerging a comparatively peaceful, industrious figure, a child of nature, close to the soil from which he wins his living, cultivating the earth with a rough hoe, hunting wild creatures, and living with his tribe in a free democratic association. How really fine was the American Indian civilization—for it was a civilization—and how many things it has added to our Caucasian world is just now beginning to dawn upon us.

* * *

The works of these Indian artists, on view at the exhibition of the Society of Independent Artists at the Waldorf-Astoria Hotel, March 11 to April 2, must be seen to be fully appreciated. They mark the birth of a new art in America, the expression by the Pueblo Indian of his amazingly rich ceremonial life in the art medium of the white man. The number and remarkable character of the ceremonial observances of the Pueblos has captured the imagination of all those whose good fortune it has been to know this wonderful Indian people.

* * *

An American or European painter trying to put down these Indian ceremonies would probably paint the time of day and the New Mexican sky. He would be struck by the nature of the sunlight, and would think the Indian blankets and costumes wonderful. He would handle his subject as masses of color in light and shade. That is, he would paint the phenomenon. The Indian concentrates on the thing itself. The European would record his visual sensations. The Indian records what he knows, emending his vision by his knowledge and his intuitive understanding—and art is usually in proportion as the artist does this. These water colors are an instinctive expression of the Indian's aesthetic life in a new dimension, the dimension of the European's art medium. These Pueblo Indians have made this medium their own, a part of their aesthetic and religious life.

The aesthetic and religious life of the Indian he feels to be an integral part of the nature with which he is at one. Nature, for him, is alive with beings like himself. The sun, the clouds, the rainbow, lightning and thunder, the fertility-bringing rain, and the Earth-Mother bearing grains and fruits for man, are venerated as the sustainers and enrichers of human life. To these animistically pictured forces the Pueblo Indian expresses his gratitude in song and dance and ceremony, in the decoration of sacred places and of his own body. Aestheticism and a deeply religious feeling permeate his culture, and find their best expression, perhaps, in dance dramas in which the actions of the beings that aid and sustain man are imitated. The inherent nobility and dignity of these Indian people is expressed in the magnificent gestures, the rhythmical movement, and the superb coloring of these dance dramas. The Pueblo Indian as an artist of symbolic pantomime has no superior on earth. His ceremonies show the play of a rich symbolic imagination, classic in dignity and in formalized spontaneity.

Someone—I think it was Waldo Frank—has pointed out that in certain of the Indian languages there is but one word for happiness and beauty. The Indian finds his joy in beauty, and in that he is unlike us. For though we may recite with pious unction

the line of Keats, "a thing of beauty is a joy forever," the walls of our sordid industrial Babel rise on all sides to give us the lie. We great Machine People, who have carried ugliness well-nigh to apotheosis in the fairest lands of earth, may well forego the conqueror's pride and learn wisdom from our humble brother of the pueblos, who has made the desert bloom with beauty.

These glowing Indian water colors show that the creative life of the redman of the pueblos is far from finished. The same genius which evolved his perfect ceremonial dramas, his gorgeous pottery designs, and the architecture of his community houses, lives on with renewed vigor in this new medium of expression. The ability of any race to create an art as great in its originality and its simple power as is this Indian water-color art is proof sufficient that it is far from its period of artistic senescence. These Pueblo Indian boys are the pioneers of a new race of American primitives. Primitives by virtue of a childlike vision and a delight in things seen, and not in any sophisticated or consciously cultivated naïveté.

---

**32** ✦ Edward Alden Jewell, "A Negro Artist Plumbs the Negro Soul," *The New York Times,* March 25, 1928, sec. 5, p. 8.

Archibald J. Motley, Jr., was born in New Orleans but brought up in Chicago, where he studied for four years at the School of the Art Institute of Chicago. His career blossomed in the 1920s, and he received a gold medal from the Harmon Foundation in 1928. The exhibition at the New Gallery in New York then followed, reviewed by Edward Alden Jewell, art critic for *The New York Times.*

The exhibition included portraits, genre scenes, and fantasy pictures, such as *Waganda Charm-Makers,* depicting imagined voodoo rites in Africa. Whereas most critics accepted Motley as an artist trained at the Art Institute of Chicago and focused on Motley's professionalism in handling color, form, and composition in the works, Jewell got carried away by the "jungle" qualities, which he viewed as characteristic of the essence of the African American artist. It may be, however, that Jewell was encouraged in his remarks by Motley's dealer, who perhaps packaged the artist as a "primitive" in order to enhance his press appeal and to encourage sales. At least one critic, writing in the March 10, 1928, issue of *The New Yorker* (which appeared prior to Jewell's review) alludes to this: "Why they decided to make an issue of Archibald Motley at the New Gallery, we do not know." The critic, "M.P.," concludes that the portraits compare favorably "with the best output of the Academy. We thought his best achievement was the canvas of the old lady mending socks. For the subjective things, boys' imaginings of Voodooland, we do not care at all. Such things, to be real primitives, could hardly be executed by the young man who painted the sophisticated Octoroon and the Black and Tan cabaret."

One wonders if Jewell caught the irony in Motley's remark that his race makes him a better artist, because he "had to work 100 percent harder to realize my ambition." Jewell's remarks, like those of Cahill's (in Reading 31) may well give offense to today's reader.

✦

Strange paintings, the work of a young American Negro Artist, Archibald J. Motley Jr., were shown recently in New York and they have set the art-critical world to wondering and talking. Vivid pictures they are and weirdly unique their subjects. Here are steaming jungles that drip and sigh and ooze, dank in the impenetrable gloom of palm and woven tropical verdure, or ablaze with light where the sun breaks fiercely in. Here are moons that rise, yellow and round, quizzical and portentous, aureoled with a pallor or sorcery; crescent moons with secrets cryptically packed in the shining simitar, and moons that wane and die with a shudder of spent prophecy.

There are mummified heads of enemies rudely cased in clay, embellished with gaudy colors. There are devil-devils watching in the solemn night or poised to swoop on hapless human prey. There are thunders and lightnings with revelation imprisoned in their heart of death. There are charms, simple or unsearchable, to lure a smile or to ravage with the hate of vampires.

Glistening dusky bodies, stamping or gliding, shouting or silent, are silhouetted against hot ritual fires. Myriad age-old racial memories drift up from Africa and glowing islands of the sea to color more recent ghostly memories of plantation days when black was black and slaves were slaves; and these memories sift, finally, through negro life in Northern cities of the present, leaving everywhere their imprint and merging with a rich blur of tribal echoes. Such are the themes, and the material that enter into this artist's work.

Mr. Motley appears to be forging a substantial link in the chain of negro culture in this country. The exhibition alluded to was significant both because of the quality of the paintings themselves and because it represented, so one understands, the first one-man show by a negro artist to be held in New York. This painter, fighting against perhaps more than the usual odds in his determination to liberate the creative urge within him, has already contributed eloquently to the artistic accomplishments of his race, and—since he is now only 37 years old—his future may be felt to hold promise of still richer achievement.

In his paintings of the Voodoo mysteries, the interpretations of modern American negroes at play in the weird allegorical canvases and in the portraits, Motley directly or by subtle indirection lays bare a generous cross-section of what psychologists call the subconscious—his own and that of his race. The ancient traits and impulses and superstititions of his ancestors in Africa, Haiti, or wherever they found their habitation, trace here a milestone on the unending march; but the phantasmagoria is fascinatingly spiced with modern molds into which so much of the old race-life has been poured. The same fundamental rhythms are found, whether the setting be a jungle presided over by witchcraft or a cabaret rocking to the syncopation of jazz.

* * *

Because Mr. Motley is a colored man his road has been harder than if he had been born white. Color can still make a difference, even in the realm of the arts. "I have found that, try as I will, I cannot escape the nemesis of my color," says Mr. Motley—though without any inflection of bitterness. He relates an instance. At one time he and another Art Institute student applied for a commercial art job. The other student, al-

though inferior as an artist (he had stood, it seems, at the bottom of his class), got the job. When asked why this choice had been made, the propriator of the concern admitted that it was because they could not take on a negro. Motley has frequently bumped against this barrier.

But he remains philosophical. "I am not complaining. I am satisfied to go quietly along, doing what I can, painting the things that suggest themselves to me. In fact," he says, "I believe deep in my heart that the dark tinge of my skin is the thing that has been my making. For, you see, I have had to work 100 percent harder to realize my ambition."

This ambition of his has been defined by a friendly critic: "It is to arouse in his own people a love of art; and he feels that his goal can be reached most effectively if his people see themselves as the centre of some artistic expression." Mr. Motley appreciates keenly the differences between education and culture; knows that a man may be highly educated without possessing culture in the true sense. He also believes that it is through culture alone that the colored race can work out its destiny.

For his work, as has been said, Motley chooses themes that run like strong, bright threads through the whole history of the negro. He looks back upon savagery and finds the same expression, if in other guise, that reasserts itself today. This, of course, is true of any race; for race rhythms do not die so long as the race endures. "There is something deeper than the sensuousness of beauty that makes for the possibilities of the negro in the realm of the arts," observes Benjamin Brawley in "The Negro in Literature and Art"; and that "is the soul of the race. The wall of the old melodies and the plaintive quality that is ever present in the negro's voice are but the reflections of a background of tragedy. No race can rise to the greatest heights of art until it has yearned and suffered. [. . .] There is something very elemental about the heart of the race; something that finds its origin in the African forest; in the sighing of the night wind; in the falling of the stars. There is something grim and stern about it all, too; something that speaks of the lash; of the child torn from its mother's bosom; of the dead body riddled with bullets and swinging all night from a limb by the roadside."

Yet Motley has caught as well the gayety, the child-like abandon of his people. He paints them at play, when the somberer side of existence is put by and laughter rules. Sometimes the scenes are lurid, and always they are imbued with the negro's natural love of bright colors. Frequently they are decorative rather than realistically compelling. But in all his work Motley shows an alert mind that draws its material from a sound esthetic fount. And, as was suggested in the beginning, in the Voodoo pictures he displays an imagination deeply stirred by conflicts that have torn the primitive soul of the black man. His fires are so hot that one hesitates, almost, while the initial impact remains sovereign, to touch the canvas on which they are depicted. Yet here there is not a trace of so-called realism. The wraiths that ascend in smoke are terrible. In "Spell of the Voodoo" we see the startled whites of eyes, and above, in the mysterious void of sky, are stars that gleam with the same whiteness—but so passionlessly [as] to stand as tokens of what in life is mocking and unplumbed.

*33* ✦ Benjamin DeCasseres, introduction to *Primitives: Poems and Woodcuts,* by Max Weber (New York: The Spiral Press, 1926), unpaginated.

During the 1920s Max Weber abandoned cubism and his studies of the fourth dimension (see Reading 11) and sought inspiration in the forms of "pre-civilized" peoples, relating their spirituality to his childhood religion, Judaism. The writer Benjamin DeCasseres (see Reading 4) penned the introduction to Weber's book of eleven woodcuts and free-verse poems.

✦

Max Weber is a veritable primitive. He has the child-mind, the Earth-mind, a mind innocent of the stupefying complications and complexities of civilization. His soul is always in the attitude of wonder, awe and worship. He sees the eternal through all time-forms. He is kin to William Blake and Henri Rousseau. He stammers out his wonder before the universe and the art of man.

His emotions are his thoughts. He is a curious reversion to beginnings. In his art, in his poetry he has pursued his private vision with a sublime disregard of opinion, "movements" or "fashions." He is a Holy Innocent of Art.

These poems and wood-cuts are therefore, to me at least, unique in that they reveal a soul. The poems have a strange, infantile, untutored flavor. They have instantaneity and spontaneity. They record the influence of exotic gods in a free verse that takes no thought of syntax or the formal music of poets. They haunt me with their imperfections as much as they do with their perfections—like Walt Whitman. Their total disregard of my poetic preconceptions captivated me. Those that I lay aside with misgivings I take up again and again, finding at last in their crude simplicity the very essence of First Speech.

[. . .]

Max Weber is a reaction against intellectualism. He is the uncorrupted baby-stare before the incarnations of the soul of man in art.

*34* ✦ Search-Light [Waldo Frank], "Georgia O'Keeffe: White Paint and Good Order," in *Time Exposures*  (New York: Boni and Liveright, 1926), pp. 31–35.

Waldo Frank was a native New Yorker who graduated from Yale in 1911. He joined the circle around Alfred Stieglitz and was a close friend of Paul Rosenfeld, who shared Frank's ambition to improve the cultural climate of the United States. In 1919 Frank published *Our America* in which he opposed puritanism and materialism and sought to find authenticity in American culture. In 1934, Frank, Rosenfeld and others published *America and Alfred Stieglitz,* a celebration of Stieglitz on his seventieth birthday. For *Time Exposures* Frank used the humorous pen name "Search-Light" to justify what he considered "impertinent portrayals" of some twenty men and women "famous in our day." These included writers, poets, actors, as well as O'Keeffe and Stieglitz.

The early writings on Georgia O'Keeffe often portrayed her as a "primitive"—a "glorified American peasant," as Frank here terms her. Although women had achieved the vote with the ratification of the Nineteenth Amendment in 1920, many men still considered women to be less rational, more intuitive and more innocent than men. O'Keeffe painted many New York city scenes with a hard-edge precisionist style, yet her flower paintings quickly became her signature subject matter. (Also see Reading 13.)

◆

She is a woman who has fused the dark desires of her life into a simplicity so clear that to most of her friends she is invisible. The smile on her face—half nun's, half Norn's—is due to this. She has fame as a painter: the name of Georgia O'Keeffe is known wherever people care for lovely things on canvas. But she is a woman. She dislikes this invisibility of hers. She wants to be *seen*.

So much love around her that does not touch her! So much ecstatic praise that warms her about as much as would fireworks in the air of a winter night. In the old days when she was a teacher of "art" in a Texas country school, she got used to solitudes. She dreamed not of fame then, but of a New York welcoming and appreciative. She did not guess that in this Manhattan vortex of artists, amateurs and critics she was to find a spiritual silence beside which the Texas prairies shouted with understanding.

So O'Keeffe smiles. It is a simple, kindling smile: it lights the face with a maternal splendor. But the confused men and women who behold it, will not have it so. They insist that her smile, like her pictures, is mysterious. The girl's work, they argue, is Kabala. The girl herself is the Sphinx. Really, O'Keeffe, despite her gifts and her benevolent spirit, has not had a chance.

Look at her. In her black dress, the body is subtly warm. The hands have a slow grace, as if their natural cleverness had all been turned into such arts as nursing and caressing. Her voice is like her hands. Her face is very dark and the eyes are deep: but there's a twinkle in them, both intelligent and humorous. Does a peasant want to be aloof? Does a woman want to be worshiped? Don't you believe it. It's far more fun to be seen—and to be understood. O'Keeffe's years have deepened, not complicated her. If this town were a bit simpler, a bit less impure, it might be at home with her simple purity. If it were less daft on polysyllables, it might hear her monosyllabic speech. If it were less noisy in its great affairs, it might hear her chuckle.

For O'Keeffe is a peasant—a glorified American peasant. Like a peasant, she is full of loamy hungers of the flesh. Like a peasant, she is full of star-dreams. She is a strong-hipped creature. She has Celt eyes, she has a quiet body. And as to her esoteric Wisdom, I suspect that it comes down to this: O'Keeffe has learned, walking through an autumn wood, how the seeming war of shapes and colors—the red and yellow leaves, the shrilling moods of sky—melts into a single harmony of peace. This is the secret of her paintings. Arabesques of branch, form-fugues of fruit and leaf, aspirant trees, shouting skyscrapers of the city—she resolves them all into a sort of whiteness: she soothes the delirious colors of the world into a peaceful whiteness.

* * *

## *The New Negro*

The years from 1923 to the mid-1930s saw a flowering of literature by African American writers such as novelists Jean Toomer (*Cane,* 1923), Jessie Fauset (*The Fire in the Flint,* 1924), and Claude McKay (*Home to Harlem,* 1928); ethnologist/novelist Zora Neale Hurston (*Jonah's Gourd Vine,* 1934, and *Mules and Men,* 1938); and poets Sterling Brown, Langston Hughes, Countée Cullen, and Gwendolyn Bennett. Intellectual leaders connected with activist organizations, such as W. E. B. Du Bois, who edited *The Crisis* for the National Association for the Advancement of Colored People (NAACP), and Charles S. Johnson, who edited *Opportunity* for the National Urban League, provided forums for the cultural issues debated in these literary circles. Little magazines (such as *Harlem* and *Fire*) devoted to African American authors sprang up. While much of the excitement centered in New York's Harlem, which by 1920 had an African American population of over 75,000, Chicago, Philadelphia, Washington, DC, and Boston also had their literary circles.

This creativity did not go unnoticed by influential white Americans. Paul Underwood Kellogg, editor of *Survey* magazine, planned a special issue of *Survey Graphic* for March 1924 on Harlem writers. On the recommendation of Johnson, Kellogg invited Alain Locke, who taught philosophy at Howard University, to pull together the issue, which became the basis of *The New Negro: An Interpretation* of 1925.[1]

In this compilation of essays and poetry, with art work by Aaron Douglas and Winold Reiss, Locke sought "to document the New Negro culturally and socially—to register the transformations of the inner and outer life of the Negro in America" that had recently made themselves manifest. In a sense Locke goes beyond Du Bois's "double consciousness" to suggest a consciousness *within* a consciousness—an African American cultural core within the larger multivalent American experience.

In the first essay, "The New Negro," written by Locke himself, he attributed the migration of African Americans from the rural South to the northern cities during and after World War I for having brought about a change of consciousness among African Americans. They were being introduced to modernity:

> With each successive wave of it, the movement of the Negro becomes more and more a mass movement toward the larger and the more democratic chance—in the Negro's case a deliberate flight not only from countryside to city, but from medieval America to modern.

Before the "New Negro," the "chief bond" between African Americans to Locke was one of "a common condition rather than a common consciousness; a problem in common rather than a life in common," but now in Harlem, Locke saw the "first chances for group expression and self-determination."

*The New Negro* included essays by both blacks and whites such as Albert C. Barnes and Paul Kellogg himself. Other white writers and publishers, including Carl Van Vechten,

---

[1]See Arnold Rampersad, intro. to *The New Negro,* ed. Alain Locke (New York: Atheneum, 1992): ix–xxiii.

Sherwood Anderson, Sinclair Lewis, H. L. Mencken, and publisher Alfred Knopf, kept abreast of the cultural, aesthetic, and sociological issues debated on the pages of the African American journals and at evening gatherings. Literary prizes, fellowships, and stipends for artists followed in time from organizations and patrons, which helped support the writers, and later artists, even though such largesse at times compromised the recipients (see Reading 59).

Throughout the 1920s writers debated the degree to which African American artists should be "race men" (the term "race women" was never used) striving in their creative work to "uplift the race" rather than merely attending to literary form. Discussions continued into the 1930s, with additional new themes, as we will see in Chapter 3.

*35* ✦ Alain Locke, "The Legacy of the Ancestral Arts," in *The New Negro: An Interpretation,* Alain Locke, ed. (New York: Albert and Charles Boni, 1925).

Locke's essay, "The Legacy of the Ancestral Arts," has often been misinterpreted to mean that it was Locke's wish that African Americans emulate African art. Locke's exhortation was more subtle. He surmised that since the discovery of African art by Europeans, African Americans would now take "a cultural pride and interest" in their African heritage and that African art should be considered every much as "classic" as the masterworks of Greece and Rome. What African Americans could learn is the discipline that African artists brought to their work and the "almost limitless wealth of decorative and purely symbolic material." To Locke, who was himself struggling to understand modernism, "it is for the development of this latter aspect [the decorative and purely symbolic material] of a racial art that the study and example of African art material is so important." By "racial art" he seems to mean an art expressive of the African American experience. In this essay, Locke also praises the illustrations, reproduced in color, of the portraits by the German artist Winold Reiss, who was a major influence on Aaron Douglas's developing modernism.

Locke became a leading advocate of Harlem's writers, poets and artists. During the 1930s and 1940s he worked tirelessly to promote art exhibitions of African American art, such as those mounted by the Harmon Foundation, and often wrote the introductions to their catalogues.

—————————————— ✦ ——————————————

Music and poetry, and to an extent the dance, have been the predominant arts of the American Negro. This is an emphasis quite different from that of the African cultures, where the plastic and craft arts predominate; Africa being one of the great fountain sources of the arts of decoration and design. Except then in his remarkable carry-over of the rhythmic gift, there is little evidence of any direct connection of the American Negro with his ancestral arts. But even with the rude transplanting of slavery, that uprooted the technical elements of his former culture, the American Negro brought over as an emotional inheritance a deep-seated aesthetic endowment. And

with a versatility of a very high order, this offshoot of the African spirit blended itself in with entirely different culture elements and blossomed in strange new forms.

There was in this more than a change of art-forms and an exchange of cultural patterns; there was a curious reversal of emotional temper and attitude. The characteristic African art expressions are rigid, controlled, disciplined, abstract, heavily conventionalized; those of the Aframerican,—free, exuberant, emotional, sentimental and human. Only by the misinterpretation of the African spirit, can one claim any emotional kinship between them—for the spirit of African expression, by and large, is disciplined, sophisticated, laconic and fatalistic. The emotional temper of the American Negro is exactly opposite. What we have thought primitive in the American Negro— his naïveté, his sentimentalism, his exuberance and his improvizing spontaneity are then neither characteristically African nor to be explained as an ancestral heritage. They are the result of his peculiar experience in America and the emotional upheaval of its trials and ordeals. True, these are now very characteristic traits, and they have their artistic, and perhaps even their moral compensations; but they represent essentially the working of environmental forces rather than the outcropping of a race psychology; they are really the acquired and not the original artistic temperament.

A further proof of this is the fact that the American Negro, even when he confronts the various forms of African art expression with a sense of its ethnic claims upon him, meets them in as alienated and misunderstanding an attitude as the average European Westerner. Christianity and all the other European conventions operate to make this inevitable. So there would be little hope of an influence of African art upon the western African descendants if there were not at present a growing influence of African art upon European art in general. But led by these tendencies, there is the possibility that the sensitive artistic mind of the American Negro, stimulated by a cultural pride and interest, will receive from African art a profound and galvanizing influence. The legacy is there at least, with prospects of a rich yield. In the first place, there is in the mere knowledge of the skill and unique mastery of the arts of the ancestors the valuable and stimulating realization that the Negro is not a cultural foundling without his own inheritance. Our timid and apologetic imitativeness and overburdening sense of cultural indebtedness have, let us hope, their natural end in such knowledge and realization.

Then possibly from a closer knowledge and proper appreciation of the African arts must come increased effort to develop our artistic talents in the discontinued and lagging channels of sculpture, painting and the decorative arts. If the forefathers could so adroitly master these mediums, why not we? And there may also come to some creative minds among us, hints of a new technique to be taken as the basis of a characteristic expression in the plastic and pictorial arts; incentives to new artistic idioms as well as to a renewed mastery of these older arts. African sculpture has been for contemporary European painting and sculpture just such a mine of fresh *motifs*, just such a lesson in simplicity and originality of expression, and surely, once known and appreciated, this art can scarcely have less influence upon the blood descendants, bound to it by a sense of direct cultural kinship, than upon those who inherit by tradition only, and through the channels of an exotic curiosity and interest.

But what the Negro artist of to-day has most to gain from the arts of the forefathers is perhaps not cultural inspiration or technical innovations, but the lesson of

a classic background, the lesson of discipline, of style, of technical control pushed to the limits of technical mastery. A more highly stylized art does not exist than the African. If after absorbing the new content of American life and experience, and after assimilating new patterns of art, the original artistic endowment can be sufficiently augmented to express itself with equal power in more complex patterns and substance, then the Negro may well become what some have predicted, the artist of American life.

\* \* \*

Indeed there are many attested influence of African art in French and German modernist art. [. . .] In Paris, centering around Paul Guillaume, one of its pioneer exponents, there has grown up an art coterie profoundly influenced by an aesthetic developed largely from the idioms of African art. And what has been true of the African sculptures has been in a lesser degree true of the influence of other African art forms— decorative design, musical rhythms, dance forms, verbal imagery and symbolism.

\* \* \*

There is a vital connection between this new artistic respect for African idiom and the natural ambition of Negro artists for a racial idiom in their art expression. To a certain extent contemporary art has pronounced in advance upon this objective of the younger Negro artists, musicians and writers. Only the most reactionary conventions of art, then, stand between the Negro artist and the frank experimental development of these fresh idioms. This movement would, we think, be well under way in more avenues of advance at present but for the timid conventionalism which racial disparagement has forced upon the Negro mind in America.

\* \* \*

A younger group of Negro artists is beginning to move in the direction of a racial school of art. The strengthened tendency toward representative group expression is shared even by the later work of the artists previously mentioned, as in Meta Warrick Fuller's "Ethiopia Awakening," to mention an outstanding example. But the work of young artists like Archibald Motley, Otto Farrill, Albert Smith, John Urquhart, Samuel Blount, and especially that of Charles Keene and Aaron Douglas shows the promising beginning of an art movement instead of just the cropping out of isolated talent. The work of Winold Reiss, . . . which has supplied the main illustrative material for this volume has been deliberately conceived and executed as a path-breaking guide and encouragement to this new foray of the younger Negro artists. In idiom, technical treatment and objective social angle, it is a bold iconoclastic break with the current traditions that have grown up about the Negro subject in American art. It is not meant to dictate a style to the young Negro artist, but to point the lesson that contemporary European art has already learned—that any vital artistic expression of the Negro theme and subject in art must break through the stereotypes to a new style, a distinctive fresh technique, and some sort of characteristic idiom.

While we are speaking of the resources of racial art, it is well to take into account that the richest vein of it is not that of portraitistic idiom after all, but its almost limitless wealth of decorative and purely symbolic material. It is for the development of this latter aspect of a racial art that the study and example of African art material is so important. The African spirit, as we said at the outset, is at its best in abstract decorative forms. Design, and to a lesser degree, color, are its original *fortes.* It is this aspect

of the folk tradition, this slumbering gift of the folk temperament that most needs reachievement and re-expression. And if African art is capable of producing the ferment in modern art that it has, surely this is not too much to expect of its influence upon the culturally awakened Negro artist of the present generation. So that if even the present vogue of African art should pass, and the bronzes of Benin and the fine sculptures of Gabon and Baoulé, and the superb designs of the Bushongo should again become mere items of exotic curiosity, for the Negro artist they ought still to have the import and influence of classics in whatever art expression is consciously and representatively racial.

---

## 36 ✦ Langston Hughes, "The Negro Artist and the Racial Mountain," *The Nation* 122 (June 23, 1926): 692–94.

Langston Hughes was born in Joplin, Missouri, and moved frequently as a youth, but graduated from Central High School in Cleveland in 1919. He went on to Columbia University and began to distinguish himself as a poet but left Columbia after one year to travel abroad. He went to West Africa and Europe, working on freighters and at odd jobs. He eventually found his way back to New York, where he became a leading poet of the Harlem Renaissance.

The week before Hughes's essay appeared in *The Nation,* the magazine published George S. Schuyler's "The Negro-Art Hokum." Schuyler argued against a Negro exceptionalism: "As for the literature, painting, and sculpture of Aframericans—such as there is—it is identical in kind with the literature, painting, and sculpture of white Americans: that is, it shows more or less evidence of European influence." This is because "the Aframerican is subject to the same economic and social forces that mold the actions and thoughts of the white Americans." To Schuyler, nationality takes precedence over race, and he insists that Alexander Dumas, père and fils, were Frenchmen rather than Africans. Schuyler disregards the lived experiences of African Americans and the legacy of racism and bigotry in the U.S.

Hughes articulates the opposite point of view in his *Nation* essay. He argues that in order for African Americans to discover themselves and their people, they have to acknowledge their racial roots, and that the individuality of African Americans cannot be forced into American standardization. Hughes calls for racial pride, and he asks the crucial question: "Why should I want to be white? I am Negro—and beautiful."

---

✦

---

One of the most promising of the young Negro poets said to me once, "I want to be a poet—not a Negro poet," meaning, I believe, "I want to write like a white poet"; meaning subconsciously, "I would like to be a white poet"; meaning behind that, "I would like to be white." And I was sorry the young man said that, for no great

poet has ever been afraid of being himself. And I doubted then that, with his desire
to run away spiritually from his race, this boy would ever be a great poet. But this
is the mountain standing in the way of any true Negro art in America—this urge
within the race toward whiteness, the desire to pour racial individuality into the
mold of American standardization, and to be as little Negro and as much American
as possible.

But let us look at the immediate background of this young poet. His family is of
what I suppose one would call the Negro middle class: people who are by no means
rich yet never uncomfortable nor hungry—smug, contented, respectable folk, mem-
bers of the Baptist church. The father goes to work every morning. He is a chief stew-
ard at a large white club. The mother sometimes does fancy sewing or supervises par-
ties for the rich families of the town. The children go to a mixed school. In the home
they read white papers and magazines. And the mother often says "Don't be like nig-
gers" when the children are bad. A frequent phrase from the father is, "Look how well
a white man does things." And so the word white comes to be unconsciously a sym-
bol of all the virtues. It holds for the children beauty, morality, and money. The whis-
per of "I want to be white" runs silently through their minds. This young poet's home
is, I believe, a fairly typical home of the colored middle class. One sees immediately
how difficult it would be for an artist born in such a home to interest himself in inter-
preting the beauty of his own people. He is never taught to see that beauty. He is
taught rather not to see it, or if he does, to be ashamed of it when it is not according
to Caucasian patterns.

For racial culture the home of a self-styled "high-class" Negro has nothing bet-
ter to offer. Instead there will perhaps be more aping of things white than in a less cul-
tured or less wealthy home. The father is perhaps a doctor, lawyer, landowner, or
politician. The mother may be a social worker, or a teacher, or she may do nothing and
have a maid. Father is often dark but he has usually married the lightest woman he
could find. The family attend a fashionable church where few really colored faces are
to be found. And they themselves draw a color line. In the North they go to white the-
aters and white movies. And in the South they have at least two cars and a house "like
white folks." Nordic manners, Nordic faces, Nordic hair, Nordic art (if any), and an
Episcopal heaven. A very high mountain indeed for the would-be racial artist to climb
in order to discover himself and his people.

But then there are the low-down folks, the so-called common element, and they
are the majority—may the Lord be praised! The people who have their nip of gin on
Saturday nights and are not too important to themselves or the community, or too well
fed, or too learned to watch the lazy world go round. They live on Seventh Street in
Washington or State Street in Chicago and they do not particularly care whether they
are like white folks or anybody else. Their joy runs, bang! into ecstasy. Their religion
soars to a shout. Work maybe a little today, rest a little tomorrow. Play awhile. Sing
awhile. O, let's dance! These common people are not afraid of spirituals, as for a long
time their more intellectual brethren were, and jazz is their child. They furnish a
wealth of colorful, distinctive material for any artist because they still hold their own
individuality in the face of American standardizations. And perhaps these common

people will give to the world its truly great Negro artist, the one who is not afraid to be himself. Whereas the better-class Negro would tell the artist what to do, the people at least let him alone when he does appear. And they are not ashamed of him—if they know he exists at all. And they accept what beauty is their own without question.

\* \* \*

The Negro artist works against an undertow of sharp criticism and misunderstanding from his own group and unintentional bribes from the whites. "O, be respectable, write about nice people, show how good we are," say the Negroes. "Be stereotyped, don't go too far, don't shatter our illusions about you, don't amuse us too seriously. We will pay you," say the whites. Both would have told Jean Toomer not to write "Cane." The colored people did not praise it. The white people did not buy it. Most of the colored people who did read "Cane" hate it. They are afraid of it. Although the critics gave it good reviews the public remained indifferent. Yet (excepting the work of Du Bois) "Cane" contains the finest prose written by a Negro in America. And like the singing of Robeson, it is truly racial.

But in spite of the Nordicized Negro intelligentsia and the desires of some white editors we have an honest American Negro literature already with us. Now I await the rise of the Negro theater. Our folk music, having achieved world-wide fame, offers itself to the genius of the great individual American Negro composer who is to come. And within the next decade I expect to see the work of a growing school of colored artists who paint and model the beauty of dark faces and create with new technique the expressions of their own soul-world. And the Negro dancers who will dance like flame and the singers who will continue to carry our songs to all who listen—they will be with us in even greater numbers tomorrow.

Most of my own poems are racial in theme and treatment, derived from the life I know. In many of them I try to grasp and hold some of the meanings and rhythms of jazz. I am sincere as I know how to be in these poems and yet after every reading I answer questions like these from my own people: Do you think Negroes should always write about Negroes? I wish you wouldn't read some of your poems to white folks. How do you find anything interesting in a place like a cabaret? Why do you write about black people? You aren't black. What makes you do so many jazz poems?

But jazz to me is one of the inherent expressions of Negro life in America: the eternal tom-tom beating in the Negro soul—the tom-tom of revolt against weariness in a white world, a world of subway trains, and work, work, work; the tom-tom of joy and laughter, and pain swallowed in a smile. Yet the Philadelphia clubwoman is ashamed to say that her race created it and she does not like me to write about it. The old subconscious "white is best" runs through her mind. Years of study under white teachers, a lifetime of white books, pictures, and papers, and white manners, morals, and Puritan standards made her dislike the spirituals. And now she turns up her nose at jazz and all its manifestations—likewise almost everything else distinctly racial. She doesn't care for the Winold Reiss portraits of Negroes because they are "too Negro." She does not want a true picture of herself from anybody. She wants the artist to flatter her, to make the white world believe that all Negroes are as smug and as near white in soul as she wants to be. But, to my mind, it is the duty of the younger Negro artist, if he accepts any duties at all from outsiders, to change through the force of his

art that old whispering "I want to be white," hidden in the aspirations of his people, to "Why should I want to be white? I am a Negro—and beautiful!"

So I am ashamed for the black poet who says, "I want to be a poet, not a Negro poet," as though his own racial world were not as interesting as any other world. I am ashamed, too, for the colored artist who runs from the painting of Negro faces to the painting of sunsets after the manner of the academicians because he fears the strange un-whiteness of his own features. An artist must be free to choose what he does, certainly, but he must also never be afraid to do what he might choose.

Let the blare of Negro jazz bands and the bellowing voice of Bessie Smith singing Blues penetrate the closed ears of the colored near-intellectuals until they listen and perhaps understand. Let Paul Robeson singing Water Boy, and Rudolph Fisher writing about the streets of Harlem, and Jean Toomer holding the heart of Georgia in his hands, and Aaron Douglas drawing strange black fantasies cause the smug Negro middle class to turn from their white, respectable, ordinary books and papers to catch a glimmer of their own beauty. We younger Negro artists who create now intend to express our individual dark-skinned selves without fear or shame. If white people are pleased we are glad. If they are not, it doesn't matter. We know we are beautiful. And ugly too. The tom-tom cries and the tom-tom laughs. If colored people are pleased we are glad. If they are not, their displeasure doesn't matter either. We build our temples for tomorrow, strong as we know how, and we stand on top of the mountain, free within ourselves.

---

**37 ✦** Augusta Savage, "An Autobiography," *The Crisis: A Record of the Darker Races* 36, no. 8 (August 1929): 257.

While African American intellectuals and writers were debating the issues about style and content in African American art, sculptor Augusta Savage was experiencing limited opportunities because of her race. Nevertheless, she became a leading artist in Harlem during the Harlem Renaissance period of the 1920s and through the 1930s, known not only for her sculpture but for her fierce activism on behalf of artists in the Harlem community. She opened the Savage Studio of Arts and Crafts in a basement apartment on West 143rd Street, and she obtained $1500 from the Carnegie Corporation to teach Harlem children. Her adult students included Norman Lewis, William Artis, Ernest Chrichlow, Elton C. Fax, and Gwendolyn Knight. She also helped to organize the Harlem Artists Guild and pressured the government to support the arts. After the Federal Art Project of the Works Progress Administration was launched in 1935, she was employed as an assistant supervisor and in that capacity helped to get young Jacob Lawrence on the Project. Later she was named Director of the WPA's Harlem Community Art Center (see Chapter 3), but she resigned in 1938 when she received a commission from the New York World's Fair Committee to sculpt The Harp.

The Harp depicted African American singers in choir robes as the strings of a harp, while the forearm and cupped hand of the Creator formed its base. The work was inspired by James Weldon Johnson's famous anthem "Lift Every Voice and Sing" and stood

outside the Contemporary Art Building at the Fair. Because Savage could not raise funds for a bronze casting, *The Harp* was destroyed at the conclusion of the Fair; nevertheless, a small bronze replica, *Lift Every Voice and Sing* survives.

W. E. B. Du Bois (see Reading 8), editor of *The Crisis,* became outraged over the denial of a fellowship for Savage to study abroad, discussed in this entry. He worked tirelessly to help her obtain funds to go abroad. In the "Autobiography" Du Bois, as editor, published the names of the American Committee members. Du Bois headed the "Autobiography" with the announcement: "The Rosenwald Fund has recently given Miss Savage a two years' Travelling Fellowship to study sculpture in Paris." The Julius Rosenwald Foundation, like the Harmon Foundation, assisted African American artists.

Among the names of the American Committee is the sculptor Herman MacNeil, who had actually protested against the racist decision and had invited Savage to study in his studio that summer. In her letter to the Committee, printed in the *New York World* (May 20, 1923), Savage asked: "My brother was good enough to be accepted in one of the regiments that saw service in France during the war, but it seems his sister is not good enough to be a guest of the country for which he fought . . . How am I to compete with other American artists if I am not to be given the same opportunity?" In the early 1940s, embittered by the lack of financial support to cast into bronze her plaster casts, she left the artworld and moved to upstate New York. The author wishes to thank The Crisis Publishing Co., Inc., the publisher of the magazine of the National Association for the Advancement of Colored People, for authorizing the use of this work.

◆

I was born in Florida of poor parents. I am the seventh child in a family of fourteen. Nine of us reached maturity. My father, who was burned to death in January this year, was a minister and very fond of good books. At the mud pie age, I began to make "things" instead of mud pies. I had very little schooling and most of my school hours were spent in playing hookey in order to go to the clay pit—we had a brick yard in our town—and made ducks out of clay.

Our family moved to West Palm Beach in 1915, and as there was no clay soil down there, my clay modeling was at a standstill, until I chanced to pass a pottery on the outskirts of the town and having begged a bit of clay from the potter, I resumed my modelling. The objects created from this clay was brought to the attention of the superintendent of the county fair which was due to open within three weeks. This man, the late Mr. George Graham Currie, persuaded me to enter my models in the fair, which I did. Being the only work of its kind on exhibit, it created a small sensation. A special prize of $25 was awarded me, and this together with public contributions donated by the tourists with the admonition to go to New York and study art, netted me $175.

I persuaded my family to let me go to Jacksonville, Florida, where I hoped to "do" the busts of all of our rich colored people there and so make enough money to finance my art career. I am thankful to say that the said rich folks refused to be "done" and I was soon almost stranded. I managed to pay my fare to New York and arrived with a balance of $4.60 and a determination to learn sculpturing in six months. I was directed to Cooper Union by the late Solon Borglum and was accepted on the merits of my work. After three

months, I was forced to quit school and go to work, but was recalled and offered a working scholarship, which provided for my room and board and carfare, 1921–1922.

In 1923, I applied for and was granted a scholarship which entitled me to study at Fountainebleau, France. [On the American Committee was Whitney Warren, Ernest C. Peixotto, Edwin Blashfield, Howard Greenley, Thomas Hastings, Herman MacNeil and James Gamble Rogers.] When it was discovered that I was black, the Committee withdrew the scholarship.

In 1925, through the efforts of Dr. W. E. B. Du Bois, I was granted a working scholarship which entitled me to study at the Royal Academy of Fine Arts at Rome, Italy; but as I had to pay my travelling expenses and as that was impossible to me, I was unable to take it.

In 1929, through the efforts of Mr. John E. Nail and Mr. Eugene Kinckle Jones of the National Urban League, I have been granted the Julius Rosenwald Fellowship for two years' study abroad. The Fellowship was originally for $1,500 per year, but has been raised to $1,800.

I have exhibited at the 135th Street Branch Library, New York; Douglas High School, Baltimore, Maryland; and at the Sesqui-Centennial, Philadelphia.

---

## Artists Abroad

The 1920s saw a steady stream of American artists and writers traveling to Europe—to Paris, to Berlin, and even to Russia where they could observe at first hand the economic and political transformations brought about by the 1917 revolution. Many went not just as tourists, but as a conscious act of expatriation—to escape from the materialism and philistinism of the United States. Neither machine age advocates, nor cultural nationalists, nor cultural primitivists, these artists and writers aimed to soak up Old World culture, to adopt European sophisticated ways, to participate in the excitement of European artistic circles, and, perhaps, to imbibe a good glass of wine, legally unavailable in the United States during Prohibition.

The rate of exchange favored the American dollar, most welcomed by Europeans recovering from World War I. In Germany, runaway inflation made the dollar stretch even further. Malcolm Cowley observed the lifestyle in Berlin of Matthew Josephson, one of the editors of *Broom*: "For a salary of a hundred dollars a month in American currency, Josephson lived in a duplex apartment with two maids, riding lessons for his wife, dinners only in the most expensive restaurants, tips to the orchestra, pictures collected, charities to struggling German writers—it was an insane life for foreigners in Berlin and nobody could be happy there" (*Exile's Return: A Literary Odyssey of the 1920s,* 1934/1951).

In Paris the American expatriate Gertrude Stein and her brother Leo had since the beginning of the century lived at 27 rue de Fleurus, where they displayed their art collection and held Saturday evening "Salons" attended by Matisse, Picasso, and assorted writers and artists. Gertrude Stein, in particular, held a fascination for artists because she seemed to understand experimental modernism and held out the promise of patronage to young Americans. Before the war she promoted Marsden Hartley and Patrick Henry Bruce and corresponded with Alfred Stieglitz. After the war she told Ernest Hemingway

that he and other survivors were "a lost generation," a phrase that, according to Malcolm Cowley, younger writers wore as a badge of pride.

Contradictions developed in the attitudes toward their own country by Americans living in Europe. Josephson, in one of his frequent essays in *Broom* (June 1922), observed of the Americans abroad: "They 'hate' the United States, nation of bad taste, shorn of liberty, ungentle to their paranoias and inhibitions. . . . In Paris they are subject to the precise influences of the glittering French mind. Good Heavens! America is now all the rage here: The American cinema, American shows, skyscrapers, business methods, even American drinks." Indeed, Charlie Chaplin movies played at Parisian theaters, the African American dancer Josephine Baker performed with La Revue Nègre and jazz musicians filled the cabarets with their syncopated rhythms.

This *américanisme* alarmed some Frenchmen. As art historian Wanda Corn observed: "By the late 1920s, the influence of popular culture was so great in France that intellectual debates began to be conducted on whether the Americanization of France was or was not destroying French civilization."[1] *Américanisme* did not, of course, destroy French culture, but Americans felt that they could command a measure of prestige, and African Americans were relatively free of demeaning Jim Crow attitudes they daily confronted back in the States.

The writers and artists who spent extensive periods or even settled permanently in Europe during the 1920s have been exhaustively studied. Besides Cowley, Josephson, and Hemingway, they included Ezra Pound, E. E. Cummings, Henry Miller, Kay Boyle, F. Scott Fitzgerald, John Dos Passos, Harry Crosby, and Archibald MacLeish. Photographers included Man Ray, Berenice Abbott, Lee Miller, and Edward Steichen, before he took his Condé Nast job in New York in 1923, and sculptors were Alexander Calder and Isamu Noguchi, who worked for about six months in Brancusi's studio. Painters were more numerous and included Romaine Brooks, Jan Matulka, Niles Spencer, Hilaire Hiler, Archibald J. Motley, Jr. [see Fig. 2-5], William H. Johnson, Paul Burlin, Stuart Davis, Jules Pascin, Adolf Dehn, and Yasuo Kuniyoshi. The last five were included in an exhibition, "Paris by Americans," organized by Edith Halpert for her Downtown Gallery in the fall of 1928. But nothing could match being invited to show one's work at the prestigious Paris exhibitions, where the European avant-garde were being shown, as a way to establish one's cachet as an international artist.

For the April 1929 issue of *The Dial,* the art critic Henry McBride wrote "American Expatriates in Paris," in which he issued a call for American artists to come home. One notes his own cultural nationalism in boosting New York:

> The times, as a matter of fact, have changed. There is no longer the necessity (if there ever was) to study art abroad. . . . The reason for this, to put it in a nutshell, is that the centre of the world has shifted. Paris is no longer the capital of Cosmopolis. All the intelligence of the world is focused on New York; it has become the battleground of modern civilization; all the roads now lead in this direction, and all the world knows this save the misguided artists who are jeopardizing their careers for the dubious consummations of the Café de la Rotonde.

[1]Wanda M. Corn, "Identity, Modernism, and the American Artist after World War I: Gerald Murphy and *Américanisme,*" in *Nationalism in the Visual Arts* issues, *Studies in the History of Art* 29 (Washington, D.C., 1991): 157.

**Figure 2-5.** Archibald Motley, Jr. *The Jockey Club,* 1929. Oil on canvas, 25 $\frac{3}{4}$ × 32 in. Collection of and photograph courtesy the Art & Artifacts Division, Schomburg Center for Research in Black Culture, The New York Public Library, Astor, Lenox and Tilden Foundations. Gift of Judge and Mrs. Irwin C. Mollison.

Awarded a Guggenheim Fellowship, Motley traveled to Paris in 1929 and, like other expatriate Americans, was stimulated by the art and cultural life of the city. He painted café scenes, including the exterior of the popular Jockey Club in Montparnasse, which played jazz and decorated its walls with pictures of Indians and cowboys.

Artists began returning to the States by the end of the decade, and the pace accelerated during the 1930s, but not because of McBride's call. With the Wall Street crash in October of 1929, both the United States and Europe were plunged into a deep economic depression. Artists found it easier to be down and out in the States than in a foreign country. Moreover, the rise of fascism and its culture in Germany and Italy made experimentalism in the arts risky business in Europe.

*38* ✦ Statements from Robert McAlmon, Leigh Hoffman, Pierre Loving, Berenice Abbott, and Harry Crosby in answer to questions posed by the editors, "Why Do Americans Live in Europe?" *transition* 14 (Fall 1928):96–119.

During the 1920s, *transition* was one of many "little magazines" published abroad; others were *Broom, 1924, Secession, Transatlantic Review, Gargoyle,* and *This Quarter.* Malcolm Cowley, in *Exile's Return,* 1934/1951, recalled that the *transition* contributors included "many of the dyed-in-the-wool expatriates, those who had deliberately cut every tie binding them to the homeland except one tie: their incomes still came from the United States."

The editors posed four questions to American writers and artists then living abroad. The first: "Why do you prefer to live outside America?" The other three questions solicited comments on "the spiritual future of America in face of a dying Europe"; "the revolutionary spirit" of the age; and their own "particular vision . . . in relation to twentieth century reality." The first question engaged the respondents the most, and almost all admitted that the economic situation was a major factor. What follows are a sampling of the answers to "Why do you prefer to live outside America?"

---

### *Robert McAlmon*

[ . . . ] I prefer Europe, if you mean France, to America because there is less interference with private life [in France]. There is interference, but to a foreigner, there is a fanciful freedom and grace of life not obtainable elsewhere. From various Frenchmen I gather that these statements do not apply to French citizens in a strong sense. [ . . .]

### *Leigh Hoffman*

My principal reason for living abroad is that I prefer to live, insofar as such a thing is possible, with the maximum of pleasure and the minimum of friction. The struggle for existence in America, into which I early plunged, reached such an intensity that it finally became intolerable, hence I fled. Call it an evasion or what you will, but I, for one, can see little reason for remaining in a land where the people are dominated by a single and basic idea—that of making a living. This is the fundamental motive underlying all American life, despite the country's vaunted wealth, which, it seems at least, should make living comparatively easy there. [ . . .]

What America needs is a gospel of laziness. How can a country develop either spiritually or artistically until it has learned how to live and has evolved the art of social amenities? What can be expected of a people who know so little about the fine art of eating and drinking, who know nothing of the subtle and leisurely fashion of diverting themselves, and who have not mastered the art of relaxation and rest? Art can never flourish in such an environment. Not until America knows how to loaf, not until it has drawn that finer distinction between leisure and mere idleness, can much be expected from it. [ . . . ]

### *Pierre Loving*

[ . . . ] New York, I am told by a friend who has just come from there, is divided into two classes; those who can afford to buy a ticket to Europe and those who cannot. [ . . . ]

### *Berenice Abbott*

[ . . . ] I do not prefer to live outside America indefinitely. To live in Europe—in flight—as a solution cannot satisfy. All this talk of deracination in this particular post-war exodus seems greatly overestimated. The very complex nature of America is, if possible, better understood from a distance than at close range. The extent of one's Americanism is put to a severe test, and that extent denotes the depth of

the artist's capacity. What is more Irish than Joyce, more Spanish than Cervantes? To learn from Europe by affiliation-imitation and not by contrast is negation. America's artists must evolve from a civilization new-revolutionary in short, vastly different. [ . . . ]

*Harry Crosby*

> Why do you prefer to live outside America?
> I prefer to live outside America

(1) because in America the *stars* were all suffocated inside

(2) because I do not wish to devote myself to perpetual hypocrisy

(3) because outside America there is nothing to remind me of my childhood

(4) because I prefer perihelion to aphelion

(5) because I love flagons of wine

(6) because I am an enemy of society and here I can hunt with other enemies of society

(7) because I want to be in at the death (of Europe)

(8) because I like tumults and chances better than security

(9) because I prefer transitional orgasms to atlantic monthlies

(10) because I am not coprophagous

(11) because I would rather be an eagle gathering sun than a spider gathering poison

(12) because by living outside of America New York can still remain for me the City of a Thousand and One Nights

(13) because the Rivers of Suicide are more inviting than the Prairies of Prosperity

(14) because I prefer explosions to whimperings

---

**39** ✦ Stuart Davis, Letters from Paris to his mother and father, September 17, 1928, November 5, 1928, and January 25, 1929, courtesy Earl Davis.

Stuart Davis was born into an artist family; his father was a friend of Robert Henri and Dolly and John Sloan. Thus, Davis went to New York to study at Henri's school, and Sloan invited Davis to submit drawings to *The Masses*. The Armory Show turned Davis toward modernism and encouraged him to experiment with various cubist-based styles for about fifteen years. In early 1928 he had a successful showing of his "Egg Beater" series of paintings at the Valentine Gallery. Juliana Force, acting on behalf of Gertrude Vanderbilt Whitney, bought two paintings and urged Davis to go abroad. With additional funds from Mrs. Whitney, Davis arrived in France in mid-June 1928. He moved into Jan Matulka's studio in the Montparnasse district, where a lively group of Americans lived and socialized, including Elliot Paul, who edited *transition,* and artists Alexander Calder, Isamu Noguchi, John Graham, George Biddle, Emil Ganso, and Yasuo Kuniyoshi.

Davis was very much a part of the American-in-Paris scene. Ione Robinson, a young American art student studying in Paris, was shocked by Davis's Parisian Bohemia. In a letter to her parents of September 20, 1928, she lamented:

> Just looking at some of the people who sit in the cafés is enough to frighten the life out of you. I really believe most of the queerness is affected, but it is beyond me why people should want to affect such distorted appearances. . . . Last night . . . we went back to the Café Select and met an American painter named Steuart [sic] Davis and his wife [Bessie Chosak], who took us all to a place where they said we would see African sculpture in the flesh, the Bal Nègre. I was so frightened at what I saw. . . . Mr. Davis asked me to dance, but it didn't work very well as he was trying to dance like the Negroes, who were as wild as anything I have ever seen. Mrs. Davis was wearing a hat of jet beads that made her head shine in the colored lights, and the Negro women, who come from French Martinique, wore large, bright-colored bandanas tied high on their heads. . . . I felt so completely out of place that nothing anyone could say would make me stay at the Bal Nègre. Mr. Davis kept trying to persuade me that this was a wonderful experience, and the way to understand Negro sculpture, but I had had enough, and I finally got home (Ione Robinson, *A Wall to Paint On.* New York: E. P. Dutton and Company, Inc., 1946).

Davis's own letters to his parents portray an exciting time of painting, sightseeing, nightclubbing, and going to gallery openings. Some unedited samples are excerpted here.

◆

[Sept. 17, 1928] It is a tremendously interesting place over here. I am principally interested in the streets. There is great variety, from the most commonplace to the unique. A street of the regular French working class houses of 100 years ago is always interesting because they are all different in regard to size, surface, number of windows etc. . . . I am painting street scenes such as they are . . . now.

. . . I went to the studio of Fernand Leger, internationally famed modernist painter. He showed me all his newest work. Very strong. Next day he came to see my work. He liked the Egg Beaters very much and said they showed a concern of space similar to his latest development. Said it was interesting that 2 people who did not know each other should arrive at similar ideas. He thought the street scenes I am doing here too realistic for his taste but said they were drawn with fine feeling. He invited me to send something to a show he is organizing in January. I am going to Picasso's studio as soon as he comes back to town. . . . The next number of [*transition*], a quarterly magazine published in Paris by Americans, will have a lot of my work in it. A painting of mine on the cover, four reproductions inside, a photo of me and an article about my work by Eliot Paul. . . . The dealer Borowski came to my studio & will give me a 2 weeks show for $100 including catalogue and payment of critics. I have other possibilities of exhibition also but the prices are very low here. . . .

. . . The attitude toward artists is very different here than in America. They regard it as a reasonable way for a man to spend his time. In America it is regarded as eccentricity unless it shows a 10,000 a year income. I am awfully glad I came here. . . .

[November 5, 1928] . . . Gertrude Stein came to see my paintings. She is the famous patron of Picasso. And I went to her place and saw all her Picassos and Gris paintings. I am going again tomorrow night. I think she will buy one [of] mine.

[January 25, 1929] . . . Tonight we are going to the opening of Sandy Calders exhibit in the Rue de Boethe. . . . Nobody is much interested in his work but it is an excuse for a lot of people to bump into each other. Theres no use talking, Paris is the place for artists. Here, an artist is accepted as a respectable member of the community whether he is good or bad. In the swellest cafes one can set all afternoon with a 6¢ glass of coffee without anything being thought of it. Clothes mean nothing; you can be well dressed or badly dressed nobody cares or pays any attention.

---

# Chapter Three

# The 1930s

## Cultural and Historical Context for the Depression Years

The Great Depression profoundly changed the lives of most Americans. Although no consensus points to the causes of the Depression, economists agree that even during the mid-1920s overproduction and low wages meant that goods were not moving; hence, orders were cut back. With "Black Thursday," October 24, 1929, an alarm sounded; on the following Tuesday, October 29, the stock market collapsed, with trading breaking records on the New York Stock Exchange. Large and small investors who had traded on margin were wiped out. The market failed to recover as stock prices continued to fall throughout the next decade.

As the years 1930 and 1931 passed, the economy worsened. From 1929 to 1933 the Gross National Product (GNP) declined 31.2 percent. President Herbert Hoover's measures to deflect the downward plunge came too late and were of too little consequence. For example, the Ford Motor Company had 128,000 workers in the spring of 1929, at about the time that Charles Sheeler was printing up promotional photographs for Ford. After layoffs, which prompted a major strike and a bloody retaliation (known in labor history as the "Ford Massacre"), the workforce at Ford was reduced to 37,000 by August 1931. With men and women out of work and unable to pay the rent, families found themselves evicted from their homes. Before the enactment of effective legislation for work relief and before the social security laws were passed, few resources were available to the unemployed other than occasional doles from private charities and from overburdened public welfare agencies.

Faced with desperate circumstances, people took to the streets to protest against evictions and the lack of jobs. In the spring of 1931 the Unemployment Councils organized masses of workers demanding jobs to march on Washington, DC. In June of 1932 over 20,000 veterans participated in the Bonus March in the nation's capital. Since the end of World War I they had been promised bonuses, but Congress delayed the disbursement of funds until 1936. The veterans wanted immediate payment. Hoover, out of touch with the extent of human misery brought on by the Depression, ordered General Douglas MacArthur to evict the veterans living in unoccupied downtown buildings and those encamped on Anacostia Flats across the Potomac River. Aided by his officers Dwight Eisenhower and George S. Patton, MacArthur assembled four troops of cavalry,

four companies of infantry, a machine gun squadron, and six tanks. The Army used tear gas to rout the veterans out of the shanties that the veterans' families had erected, and then set the buildings on fire. By the end of the day, at least two veterans had been killed and a thousand had been injured. That event alone irreparably damaged Hoover's hope for reelection.

Many of the jobless took to the roads simply to find employment. Historian William E. Leuchtenburg (*The Perils of Prosperity, 1914–32,* 2nd ed., 1993) estimated that "At least a million, perhaps as many as two millions were wandering the country in a fruitless quest for work or adventure or just a sense of movement." The transients, the homeless, and the unemployed became the subjects of countless paintings, novels, and movies during the Depression years.

Elected president in November 1932, Franklin Delano Roosevelt was installed in office in March 1933. In his first hundred days he and his New Deal lieutenants pushed legislation through Congress to create agencies and to provide funding intended to alleviate the economic crisis: the National Recovery Act (NRA), the Emergency Banking Relief Act (ERA), the Civilian Conservation Corps (CCC), the Federal Emergency Relief Act, which set up the Federal Emergency Relief Administration (FERA), the Agricultural Adjustment Act, the Tennessee Valley Authority (TVA), the Farm Credit Act, the Civil Works Administration (CWA). Other programs followed in subsequent years.

Eventually the government addressed the needs of artists. In December 1933 the Public Works of Art Project (PWAP) was set up as the first federal non-relief project to employ artists; the program lasted until July 1934. Then in August 1935 the Work Projects Administration (WPA, its name was subsequently changed to Works Progress Administration) set up the Federal Art Project (FAP), which employed destitute artists to work in a variety of media. Projects were also created at this time for musicians, writers, and theater people. The Treasury Department initiated its own program and commissioned well-known artists through jury selection to paint murals for post offices and other public buildings; known as the "Section," proof of economic need was not a requirement for employment.

As the 1930s unfolded, international events increasingly preoccupied Americans. Just when Roosevelt was being sworn into office, Adolf Hitler was assuming the chancellorship of Germany. He and his Nazi Party swiftly took control of the economic and cultural life of Germany with the goal of creating a "one-thousand-year" empire, the Third Reich. Necessary to their political strategies and their will to power were the persecution of Jews and the destruction of any political opposition that might be mounted by communists, social democrats, trade unionists, and liberal priests and ministers. In 1935 the anti-Semitic Nuremberg Laws stripped Jews of their citizenship and forbade intermarriage with Germans. Moreover, many professions were closed to Jews.

Paul Joseph Goebbels, Hitler's propaganda minister, launched a propaganda machine to elevate the ideology of racism and Aryan superiority, and Hermann Wilhelm Goering, Hitler's Gestapo (secret police) chief, prepared for war. Heinrich Himmler, head of the SS took over the Gestapo in 1936, and Goering assumed the duties of Air Minister. Goering seized the opportunity to test his weaponry when he sent the Luftwaffe (Air Force) to the aid of the fascist insurgent General Francisco Franco in the Spanish Civil War of 1936–39; the saturation bombing of the Basque town of Guernica in April 1937 was a particularly vicious act.

In March 1938 Germany annexed Austria. Although Hitler made a deal with the British and French at Munich in September 1938, he betrayed the terms of this agreement and marched into Czechoslovakia. The following year, in late August 1939, Hitler secured another nonaggression agreement, this time with the Soviet Union, that paved the way for his invasion of Poland on September 1, 1939, a date marking the beginning of World War II. Hitler invaded Russia in June 1941.

American artists and intellectuals were drawn into the politics of the decade, which were increasingly influenced by a militant labor movement strongly influenced by the Communist Party (CPUSA). To the party and its growing base of adherents and sympathizers, the Depression heralded the collapse of capitalism all over the world and the beginning of a new society which they saw as being realized in the Soviet Union.

For various political reasons an international group of left-leaning artists and intellectuals came to live and work in New York during the 1930s. They provided a stimulating environment for American artists. In the early and mid-1930s the Mexicans came, leaving behind the unstable political situation in Mexico. José Clemente Orozco and Diego Rivera executed mural commissions from California to New York. In 1936 David Siqueiros ran an experimental workshop in New York which included young artists such as Jackson Pollock. Other Mexican and Latin American artists went to various parts of the United States throughout the decade. In the late 1930s, as fascism extended across Europe, immigration accelerated. European art dealers Curt Valentiner and Pierre Matisse set up galleries in New York, and European artists Max Ernst, Max Beckmann, Piet Mondrian, Hans Hofmann, and many others also arrived. These recent arrivals were modernists, including the "degenerate artists" featured in Hitler's infamous "Entartete Kunst" ("Degenerate Art") show held in Munich in 1938. With these infusions of the talent and genius of Mexico, Latin America, and Europe, New York would become the art capital of the world in the 1940s.

## *The Depression Experience*

During the 1930s writers, poets, artists, and photographers sought to create an imagery of the Depression experiences they were witnessing and simultaneously living. Studs Terkel, in *Hard Times: An Oral History of the Great Depression,* 1970, published interviews with people in the general population who recalled those times, but no single study has gathered together interviews with people in the arts. Instead, we need to look at the radical novelists, who immersed themselves in the struggles of the homeless, of workers on strike, and of the unemployed riding boxcars, in order to produce the "proletarian novel." Amy Godine, in her "Notes Toward a Reappraisal of Depression Literature" (*Prospects,* 1981), characterizes three types of such novels: "the explicitly political novel of the Communists and their sympathizers," by authors such as Michael Gold, John Steinbeck, Grace Lumpkin, Robert Cantwell, and Tillie Olsen; "the nonpolitical novels of the 'Bottom Dogs' writers," such as Nelson Algren, Edward Dahlberg, Daniel Fuchs, Horace McCoy, and Tom Kromer, and the literature of documentary.

In visualizing the Depression experience for their audience, painters and photographers developed similar categories. Paintings with overtly political messages were created by Philip Evergood, Joe Jones, Ben Shahn, the Mexican muralists, and others. More

naturalist ("Bottom Dogs") images were painted by artists such as Raphael Soyer and Reginald Marsh, who focused on the pathos of homeless men loitering on park benches. The third category is characterized by the documentary work of photographers, many of whom drew a paycheck from Roy Stryker of the Farm Security Administration for photographing rural and agricultural conditions or from Henry R. Luce, who published photo essays in his *Fortune* and *Life* magazines.

The attitude toward subject varies with each writer, painter, or photographer. The close scrutiny which many artists directed to their subjects suggests strongly empathetic feelings, for example, Evergood's recollections of meeting homeless men in the "Hoovervilles" near his West Village apartment. Raphael Soyer's memories—although distanced in time from the actual 1930s experiences—explain his broadly sympathetic rendering of his homeless friend, Walter Broe. Jacob Lawrence felt he could give back to the Harlem community that nurtured him by being its pictorial narrator ("griot") and telling the histories of heroic struggles of African Americans.

In the Government Projects section, a sample of Roy Stryker's scripts for photo shoots are reproduced. To Stryker, working for the government, Depression experiences had to be told in photographs that were poignant or sharp in order to propagandize the federal government's efforts for agricultural recovery. If Stryker was not satisfied, more telling images had to be produced, and he sent photographers back into the field.

*40* ✦ Raphael Soyer, "An Artist's Experiences in the 1930s," in Patricia Hills, *Social Concern and Urban Realism: American Painting of the 1930s* (Boston: Boston University Art Gallery and the Bread and Roses Cultural Project of the National Union of Hospital and Health Care Employees, 1983), pp. 27–30.

Raphael Soyer and his brothers Moses and Isaac, also artists, were born in Russia and came with their family to the United States in 1912. Soyer studied at Cooper Union, at the National Academy of Design, and at the Art Students League. A member of both the John Reed Club and the American Artists' Congress, he taught as well as painted. His art showed homeless men sitting on park benches, but his style was one of a gentle naturalism.

On the occasion of an exhibition focused on socially concerned painters of the 1930s, I asked Soyer to write his recollections of the Depression years. In common with many 1930s artists whom I have interviewed, Soyer expresses—and more succinctly than most—his vivid memories, not just of the hardships and struggles but of the camaraderie of artists during those years.

———————————————◆———————————————

More than half a century ago, in 1929, I had my first exhibition at the Daniel Gallery just before the fateful "crash" of that year. It was a modest show of about a dozen paintings that revealed no hint of the hard times which followed: a genre painting of some members of my family, one of my first nudes, a still life, several street scenes, etc.

The famous 1929 "crash" came soon after, but did not affect me or anyone else I knew. We were all poor and had nothing to lose. The Daniel Gallery soon folded up without ever being able to re-open, but I had no trouble finding another gallery.

I was twenty-nine years old, self-centered and alienated. I was aware of, but not involved in, the events in this country and in the world. Fascism had already been established. Hitler and Nazism were gaining strength. In our country the long supression of blacks was brought into focus by the Scottsboro case. Intellectuals were interested in the Russian "experiment," and in 1936 the Spanish Civil war began.

The significance of these events was brought home to me first by Nicolai Cikovsky, and later by Rebecca, who became my wife. Nicolai and I met at the Daniel Gallery. He had already lived through the upheavals in his native Russia. Naive as I was then, he represented to me sophistication in art, life, and political outlook. It was he who introduced me to the John Reed Club of Artists and Writers, which gave me a chance to participate as an artist with other artists. It offered me an outlet from my own self-involvement.

I vividly recall my first meeting at this Club. It was held in a large, bare room in a downtown building. The walls were covered with American and foreign posters against war and fascism. At a long table sat William Gropper, Adolph Wolff, Walter Quirt, Nemo Piccoli, and Anton Refregier. I remember them so accurately because I made several sketches of them that evening. In those days I sketched wherever I found myself. As a matter of fact, one of these sketches still hangs in our apartment.

The John Reed Club of Writers and Artists helped me to acquire a progressive world view, but I did not let it change my art, which never became politically slanted. I painted what I knew and what I saw around me—many pictures of the unemployed, of homeless men, because I saw them everywhere, in parks, on sidewalks, sleeping on girders of abandoned construction sites. I sympathized with them, identified with them to the extent of including myself yawning in a painting I called *Transients* [Huntington Art Gallery, University of Texas at Austin] to emphasize the boredom in their lives.

I met one of these homeless men outside my studio, "fishing" for a coin with a piece of chewing gum attached to string under a subway grating. There was an air of loneliness about him which moved me. I offered him fifty cents and asked him to pose for me. We became friends. He lived in and took care of my studio until he died a few years later. He also became the model and friend of Isabel Bishop, Reginald Marsh, Katherine Schmidt, Minna Citron, and other artists. His name was Walter Broe. We called him "The Orphan," for he was raised in an orphanage and his pursuit in life was to find his mother.

Some of the well-known artists of today were members of the John Reed Club. We held exhibitions at the Club. We painted collective pictures satirizing the political scene of those days, signed "John Reed Club," and sent them to national exhibitions. The initial sketches for these collective paintings were usually by William Gropper, known for his biting political cartoons.

Often other well-known writers and artists, not members of the Club, were invited to speak. [. . .]

Lewis Mumford lectured eloquently on Orozco and showed slides of his work. It was my first acquaintance with the work of this Mexican draftsman and mural painter, and I still recall one side of a gigantic Christ chopping up his own cross [mu-

ral in the Baker Library, Dartmouth College, Hanover, N.H.]. Once I heard a familiar-looking young man talk about art. After the lecture he greeted me and I recognized Meyer Schapiro, a former classmate of mine at the National Academy of Design, who was becoming known as an art historian and teacher. One of his comments, probably made in criticism of the Club's philosophy of social realism, impressed me: "No *Kapital* on art has yet been written." Ironically, he and others were soon to formulate an art dogma of their own, preaching the "truth" of abstract art, and claiming it to be the valid art of our time.

Mexican art was popular then. The John Reed Club artists painted murals under the influence of Orozco, Rivera, and Siqueiros, depicting the imprisoned Tom Mooney, the Scottsboro boys, and marchers with placards demanding their freedom. Like Rivera we painted one another and our self-portraits into these murals. I remember posing for a young painter, Hideo Noda, who put me into such a Rivera-esque mural. The Museum of Modern Art put on a comprehensive exhibition of Rivera's work.

About this time, Rivera painted the Rockefeller Center mural, which was soon destroyed by his wealthy patron because the face of Lenin was in it. This act of vandalism created great consternation among us artists and we demonstrated outside the building, with tall, young Ben Shahn leading.

Rivera continued to work here. Without remuneration he painted a series of murals depicting the history of social struggle in the United States. He worked long hours in the New Workers School on Fourteenth Street. In the evening I would come to watch and make sketches of this fat, patient, industrious artist as he worked on his complex composition with, what seemed to me, tiny brushes.

The flamboyant and didactic Siqueiros was also in New York at about this time. He organized a workshop for young artists, who painted murals and posters under his supervision.

The John Reed Club established its own art school in which I was invited to teach. Completely unprepared, I timidly embarked upon my long extracurricular career of teacher. We had many talented, enthusiastic, and socially aware young students.

\* \* \*

Some former members of the John Reed Club, together with other artists, organized the Artists' Union. Its purpose was to perform the functions of a union, such as establishing a grievance committee, cooperating with other unions on picket lines, etc., but also to combat discrimination against racial minorities. I recall a picket line outside the newly established Museum of Modern Art, protesting the showing of foreign abstract artists while ignoring the American abstract artists. The Artists' Union published a magazine called *Art Front* [. . .]

I was a member of the Artists' Union, but an inactive one.

In 1935 another organization was founded—the American Artists' Congress. It held meetings in New York at Town Hall and the New School for Social Research in February 1936, with a call "to all artists of recognized standing . . . who are aware of the critical conditions existing in world culture in general, and in the field of the Arts in particular." The stated purpose of this organization was "to achieve unity of action among artists . . . on all issues which concern their economic and cultural security and freedom, and to fight War, Fascism and Reaction, destroyers of art and culture."

\* \* \*

I remember the deep concern of American artists for the Loyalist cause in the Civil War in Spain. Some even joined the Abraham Lincoln Brigade to fight the Fascists, and some gave up their lives. Artists such as William Gropper, Anton Refregier, Philip Evergood, Phil Bard (one of those who fought in Spain) expressed their sympathy with the Loyalists in their paintings. Isaac Soyer painted a large canvas called *Where Next?* anticipating World War II. I painted a group of armed men going off to fight Fascism called *Workers Armed.*

The Soviet-Nazi Pact of 1939 and other events created great dissension among the leadership and the membership of the American Artists' Congress, and so it gradually died.

The art world is now different from what it was in the 1930s. It was less confusing then; there was not the restless succession of "isms"; it was easier for young artists to find themselves, to find a place in the mainstream of art. Art was not the big business it has become. There was no such thing as "blue chips" in art. Well-known artists worked daily in modest studios; they were not the "celebrities" and "personalities" they are today.

I feel nostalgic about the 1930s. Those were economically difficult times, but spiritually exhilarating. We looked forward to a bright future. We had hopes that when Fascism and Nazism would be overcome we would have a good world. We had no idea of what would follow, that the nuclear age would be upon us. When I walk the New York streets crowded with young people I wonder what kind of life they will have half a century from now.

**41 ✦** Philip Evergood, in "Interview with Philip Evergood," 1960. Frances Mulhall Achilles Library, Philip Evergood Exhibition, 1960; Archives Whitney Museum of American Art.

Born in New York, Philip Evergood's father, Miles Evergood Blashki, was a bohemian, expatriate Australian artist and his mother was an aristocratic Englishwoman, who insisted on private schools for young Evergood, including Eton in England. Evergood studied at the Slade School in London and returned to the United States in 1923 for further study at the Art Students League. During the 1930s he worked on the FAP/WPA mural section and executed murals for the public library at Richmond Hill, Queens, and for the post office in Jackson, Georgia. A political radical, he taught at the John Reed Club Art School and was president of the Artists Union in 1936–37, at the time the Union affiliated with the Congress of Industrial Organizations (CIO).

On the occasion of a major retrospective exhibition at the Whitney Museum, curator John Baur interviewed Evergood. In this passage from the original typed Transcript I, pp. 69–70, Evergood describes an epiphanic moment when he saw with clarity the humanity of the homeless. Evergood describes an environment of crates and pieces of tin chaotically rigged to serve as shelters; these communities were called "jungles" or "Hoovervilles," in honor of Herbert Hoover, who from 1930 until he lost the election in November 1932 predicted that "recovery is just around the corner."

\* \* \*

I think that, as you know, this period in 1930, 1931 . . . was really [the] very terrible depression days. I think one of the things that I saw that impressed me and probably drove me faster into this way of [socially concerned] thinking was a cold winter night I . . . went out for a walk about 10 o'clock at night towards the North River [Hudson River] down Christopher Street and I came to the end of Christopher Street past the post office and government building there and came to a big area, a big empty lot with about 50 little shacks, erected on that lot, all made of old tin cans, mattresses for roofs, crates, orange boxes for sides. Most of the shacks were not even as tall as a man. You would have to crawl in on hands and knees, the snow was on the ground, the fire was lit and there were these negroes and white men huddled around that fire and all towards the North River the snow was drifting and you could see the water and see the lights on the piers out there. All seemed to be exposed to the weather terribly. These were the outcasts of New York. The outcasts of civilization. Right there. This was it. The only food they had was from garbage cans, the only fire they had was from bits of sticks they picked up around the wharfs, and I . . . went over to the fire and talked to them. They didn't seem to resent me talking to them and I felt that they were all very cold, so I went through my pockets and brought out 2 or 3 dollars and told them to go and get some gin and they went and bought a big bottle of gin. All had a drink and warmed themselves up. We talked and sat around the fire and then I got a brain wave. It seemed to me that I should be involved with . . . my work so I told them that I would be back so I walked to 49 Seventh Ave. [Evergood's apartment] and got some drawing materials, came back and sat with them and drew all night long until dawn. Listening to their tales about their wanderings and some had come from the South and bummed their way up, ridden under freight cars. Some had worked their way up on fruit ships and they all had different stories. And they all had different weird names. They couldn't call themselves by ordinary names. Old Foot was one, Terrapin was another, etc. and they were all very interesting people to me but their tragedy hit me between the eyes. Because I had never been as close to it quite as that before.

\* \* \*

---

**42 ✦** Kenneth Fearing, "American Rhapsody (2)," 1940, from *Collected Poems of Kenneth Fearing* (New York: AMS Press, Inc., 1977); first version "American Rhapsody" printed in *New Masses* (July 31, 1934).

Kenneth Fearing never claimed to be a "proletarian poet," but nevertheless he expressed sentiments about Depression conditions similar to those of the "proletarian novelists." Like the writer John Dos Passos, Fearing blends words and phrases from his experiences of urban living: screaming newspaper headlines, unemployment forms, imagined police interrogations, and the rambling words of homeless men loitering on the streets and nearing the edge of psychosis. Thus, Fearing writes in stream-of-consciousness free verse with a colloquial style and an often satirical edge.

**Figure 3–1.**   Alice Neel, *Kenneth Fearing,* 1935. Oil on canvas, 30 1/8 × 26 in. The Museum of Modern Art, NY. Gift of Hartley S. Neel and Richard Neel.

*American Rhapsody (2)*

*She said did you get it, and he said did you get it,*
  *at the clinic, at the pawnshop, on the breadline, in jail,*
  *shoes and a roof and the rent and a cigarette and bread*
    *and a shirt and coffee and sleep—*

*Reaching at night for a bucket of coal among the B & O*
    *flats in the B & O yards,*
  *they said there's another one, get him they said,*
  *or staring again at locked and guarded factory gates;*
    *or crouched in a burglarproof loft, hand around a*
    *gun; or polite, urgent, face before a face behind a*
    *steelbarred cage:*

*All winter she came there, begging for milk. So we had*
    *the shacks along the river destroyed by police. But*

*at the uptown exhibit a rich, vital sympathy infused*
*the classic mood. When muriatic acid in the whiskey*
*failed, and running him down with an auto failed,*
*and ground glass failed, we finished the job by*
*shoving a gastube down his throat*
*Next year, however, we might have something definite,*

*Mountains or plains, crossroads, suburbs, cities or the sea,*
*did you take it, was it safe, did you buy it, did you beg*
*it, did you steal it, was it known,*

*Name, address, relatives, religion, income, sex, bank*
*account, insurance, health, race, experience, age,*
*out beyond the lunatic asylum, on the city dump; on*
*the junkheap past the bank, past the church, past*
*the jungle, past the morgue,*

*where rats eat the crusts and worms eat the satins and*
*maggots eat the mould*
*and fire eats the headlines, eats the statements and the*
*pictures, eats the promises and proofs, eats the rind*
*of an orange and a rib and a claw and a skull and*
*an eye,*

*Did you find it, was it there, did they see you, were they*
*waiting, did they shoot, did they stab, did they*
*burn, did they kill—*
*one on the gallows and one on the picketline and one*
*in the river and one on the ward and another one*
*slugged and another one starved and another insane*
*and another by the torch.*

---

*43* ✦ Jacob Lawrence, "An Interview with Jacob Lawrence" conducted by David C. Driskell and James Buell, February 4, 1982; reprinted in Jacob Lawrence, *The "Toussaint L'Ouverture" Series* (New York: Church Board for Homeland Ministries, 1982).

Jacob Lawrence was born in Atlantic City, New Jersey. His parents were part of the migration of African Americans from the South seeking jobs in the North during World War I. Lawrence, with his mother and siblings, settled in Harlem in 1929, where he was enrolled in after-school programs. Encouraged in art by Charles Alston and Augusta Savage, he also attended on scholarship the American Artists School (formerly the John Reed

Club Art School) during 1936–38. In Harlem in 1937 the WPA Living Theater produced a play popularizing the history of the Haitian liberator Toussaint L'Ouverture. That year Lawrence began his own *Toussaint L'Ouverture* project of 41 panels, the first in a text/image series he did on African American history. Other series followed: *Frederick Douglass,* 1938–39; *Harriet Tubman,* 1939–40; *The Migration,* 1940–41; and *John Brown,* 1941–42. In 1941 he married artist Gwendolyn Knight.

In 1982 David Driskell and James Buell published a catalogue with Lawrence's original texts for each panel in the *Toussaint* series, as well as an interview in which Lawrence acknowledges the positive influence the Harlem community had on his development as an artist. To Lawrence and other young artists, such as Knight, Romare Bearden, and Robert Blackburn, the art centers were central to the cultural life of Harlem.

◆

*Buell:* Where were you when you painted *The Toussaint L'Ouverture Series?*

*Lawrence:* I was in Harlem. There was quite a bit of interest in black history at that time—street corner orators talking about social issues and things of that kind. It was 1938 and I was 21 years old. And there was a lot of activity in the Harlem community. We were in the Depression. And this kind of thing, I guess attracted me. We had Negro history clubs in the schools and the libraries. And teachers and various people were speaking of Frederick Douglass, Toussaint L'Ouverture, Harriet Tubman. That was the motivation.

*Buell:* That was one of the questions I wanted to ask. How did you know about Toussaint L'Ouverture?

*Lawrence:* Out of the community. People speaking about these things, about liberation, and people like this became the symbol of what people would talk about. As a youngster I guess I wanted an identity. I didn't think in those terms then, but in retrospect, analyzing my motivation, I think that is what it was. And it made for a very colorful method, working in a series form, telling a story.

\* \* \*

*Buell:* Did you study art with anybody as a kid?

*Lawrence:* Yes. There were many centers as you know, throughout the country. In the depth of the Depression the Roosevelt administration established various programs and centers throughout the country. If you were interested in music or dance or theatre or art, you could go to one of these centers. I went into one of them, and the first person with whom I came into contact wasn't much older than I. That was Charles Alston. He was studying at Columbia University, taking his master's degree there. I went into the Utopia Children's House—it was an after school center. And he was like a counselor there while he was going to school. They offered us arts and crafts. That was my first contact.

\* \* \*

*Buell:* You were 21 years old when you did this. Had you ever shown anything anywhere?

*Lawrence:* Well, the Harlem community was very supportive—people like Augusta Savage and various people in the community older than myself. And this

was all part of the centers, the art centers that were established through the WPA and that sort of thing. So people were very supportive and very encouraging to youngsters like myself.

<center>* * *</center>

*Buell:* What was Harlem like in those years?

*Lawrence:* To me in retrospect it was a great community; it was a very fascinating community. If you had asked me this forty years ago, I couldn't have used these terms. It was my life. It was a very exciting place. I never lived any place else where I had this kind of rapport with the community. It was a very cohesive community. You knew people. You didn't know their names, but you'd pass people on the street and see the face over and over agin. It was that kind of a community. It was a very vital, exciting community. At least it was for me, and from what I hear from many other people my age. You knew the police, you knew the firemen, you knew the teachers, the people on the street. You knew the peddlars. It was *me* I'll put it that way.

*Buell:* And you knew other painters and writers and dancers?

*Lawrence:* People would come up to the centers. People like Katherine Dunham, Countee Cullen, Langston Hughes. They may not have talked to me because I was too young, but I would hear their conversations with each other. And not just blacks, but people from outside the black community—very interested artists. There was this interchange. And, being a youngster, I guess subconsciously I was influenced by this. They would talk about their involvement in the arts and things like that.

<center>* * *</center>

These people came before me, but they were very important to me. I didn't realize at that time. It is only in retrospect that I realize this. This was all part of the Harlem Renaissance, it was a part of that period. Locke was the first black critic to articulate and interpret and intellectualize the black artist.

# Revolutionary Theory and Practice
# —The Search for Styles

In 1929 a group of left-wing artists and writers, meeting informally in the offices of *New Masses,* a magazine sponsored by the Communist Party, agreed to rent their own space and organize a club devoted to cultural matters. They named their new club after the journalist John Reed, a founder of the American Communist Party, who had been a regular contributor of the old *Masses* and had covered the 1917 Russian Revolution. The preamble of the John Reed Club outlined its founders' aims to develop "a cultural movement dedicated to advancing the interests of the working class . . . [and] the defense of the achievements of the Union of Soviet Socialist Republics [and] the development of new working class writers and artists, as well as alignment of all artists, writers and intellectuals to the side of the revolutionary working class, stimulating their participation in revolutionary activity."

**Figure 3–2.**    Artists Union demonstration, cover of *Art Front* 2, no. 12 (January 1937). Shortly after the government announced cutbacks in the Federal Art Project, artists responded by staging demonstrations and a sit-down strike at the New York FAP offices on December 1, 1936. Police arrested 219 artworkers, but protests and rallies continued.

Writers and artists of the John Reed Clubs, including William Gropper, attended the Second World Plenum of the International Bureau of Revolutionary Literature held in Kharkov, U.S.S.R., in November 1930. They returned with plans to create a cultural program with revolutionary goals. By 1932 John Reed Club chapters had sprung up across the nation. In New York the artists met separately and organized exhibitions as well as an

art school with Nicolai Cikovsky, Anton Refregier, Louis Lozowick, and Raphael Soyer as instructors.

In line with the Popular Front policy formulated by the Communist Party in August 1935 the John Reed Clubs were disbanded. This new policy called for modifying anti-capitalist revolutionary rhetoric and, instead, building broad alliances with socialist and democratic groups throughout the world to fight against the growing threat of fascism. Party leaders and radical artists and writers met that autumn to found two organizations: the American Writers' Congress and the American Artists' Congress.

The American Artists' Congress held a three-day convention in February 1936 and again in December 1937 and was active in organizing artists' exhibitions. In April 1940 a split occurred as the result of debates at a Congress meeting about whether or not a vote should be taken to support Herbert Hoover's Finnish Relief Committee, an anti-Soviet organization formed to assist refugees after the Soviet Army sent troops into Finland. Such a vote would politicize the Congress, a move that Davis, as Executive Director, sought to avoid, since the Congress aimed to embrace all points of view on the liberal-to-left spectrum (see Stuart Davis Papers, Archives of American Art). However, when a small, but vocal and influential, contingent resigned in protest against the failure to force the vote, the Congress lost many other members and never fully recovered.

Artists and writers also debated revolutionary theory and practice in meetings and on the pages of *Art Front,* which had begun as the joint publication of the Artists Committee of Action (a political group which protested the destruction of Diego Rivera's Rockefeller Center mural) and the Artists' Union (originally formed in September 1933 as the Emergency Work Bureau Artists Group to bargain for artists on the government projects). The first issue appeared in November 1934; subsequent issues appeared almost monthly until December 1937, when it ceased publication.

*Art Front* reported on news of special interest to artists, such as congressional debates over WPA funding and the Spanish Civil War, where many artists had volunteered to fight and for which fundraising efforts were made for ambulances. *Art Front* also carried exhibition and book reviews and announcements of meetings and rallies for the membership of the Artists' Union, and it reproduced a variety of paintings, sculpture, posters and graphic art by contemporary artists. Polemical essays on the relationship of art to politics were written by the editors, including Davis, Joseph Solman, and Clarence Weinstock as well as other contributors, such as Meyer Schapiro, Harold Rosenberg, William Phillips, Kenneth Rexroth, Elizabeth McCausland, and artists Louis Lozowick, Philip Evergood, Charmion von Wiegand, Isamu Noguchi, Balcomb Greene, Max Weber, Fernand Léger, and many others.

Regarding the actual influence of the Communist Party, many radical artists at the onset of the 1930s believed that capitalism was in its death throes and that the example of the Soviet Union promised a "better world." Such artists delighted in painting outrageous caricatures of the rich and mighty, such as J. P. Morgan and John D. Rockefeller. The shifts in policies from support of the sectarian John Reed Clubs to the left-liberal American Artists' Congress of 1936, with its Popular Front message of fighting fascism not capitalism, did not make a significant difference in either the essays in *Art Front* or the subjects of most artists in the late 1930s. Like the leadership of the John Reed Clubs, Popular Front advocates dictated no style, although they cautioned artists not to be

overtly revolutionary in their subjects so as not to alienate the non-communist support-
ers. Fifty years later, artists Raphael Soyer, Philip Reisman, and Harry Gottlieb recalled to
me in interviews that the Party exerted more pressure on them to join picket lines for
workers' strikes than to paint specific subjects.

A significant block of writers and artists who rejected the Party's new Popular
Front politics also broke with the Soviet Union over the Moscow trials of 1936–38, the
Nazi-Soviet Nonaggression Pact of August 1939, and the Soviet invasion of Finland in
November 1939. Many of these individuals coalesced around a new anti-communist
left movement sympathetic to the ideas of Leon Trotsky. This new anti-Stalinist Left rep-
resented a competing ideological approach, one more radical than the New Deal ide-
ology that the Party embraced in the late 1930s. Anti-Stalinist and Trotskyist views were
published by editors Philip Rahv and William Phillips in *Partisan Review.* To the literary
Trotskyists, "revolutionary practice" came to mean artistic and stylistic innovations—
"a revolution in form"—as economic issues and working-class struggles faded from
their concerns.

**44** ✦  "The World Crisis Expressed in Art . . . on the Theme Hunger
Fascism War," Catalogue for John Reed Club Exhibition, December 1933.
Philip Evergood Papers, Archives of American Art, Smithsonian Institution.

The statement is typical of the introductory texts to many John Reed Club exhibition
brochures. The organizers of such exhibitions generally cast a wide net, often includ-
ing amateur artists as well as professionals in their efforts to reach out to artists re-
sponding to their political ideas, and hence, wide variations in style and quality char-
acterized the shows.

———————————————————◆———————————————————

In holding exhibitions on specific themes related to the social struggle, the John Reed
Club hopes to collect and show in one Exhibition works of artists who have been mo-
tivated by the militant upsurge of the workers. We hope that these exhibitions serve
not only to show what has already been done, but exert an influence which may in-
spire and encourage artists to express their reactions to economic turmoil. Since tense,
deeply felt material demands new means of effective expression it is expected that the
influence of these exhibitions will be felt in the creation of new adequate art forms as
well as in the realm of subject matter.

We cannot say what style, manner, school or form is best suited to the artistic
expression of the struggles of the oppressed. That is the artist's problem. We do say
however, that it is not sufficient merely to record the scene, to describe it or illustrate
it. The artist to be artistically and socially vital must use his art forms to comment, to
satirize, to condemn or praise. He is never passive. He takes sides, not only thru his
subject matter, but in his treatment. He is on one side or the other of the historic class
struggle. The John Reed Club Gallery shows and encourages artists who take the side
of the revolutionary working class in its fight against hunger, fascism and war.

———————————————————————————————————

**45 ✦** Stuart Davis, "Why an Artists' Congress?" *First American Artists' Congress 1936.* (New York: American Artists' Congress, 1936), pp. 3–6.

Stuart Davis, a student of Robert Henri and a protégé of John Sloan, had contributed illustrations to *The Masses* during the 'teens. In the 1920s he developed into a modernist artist, but always remained an activist in art organizations. During 1935 he edited *Art Front,* the Artists' Union monthly, a job he left in order to organize the first convention of the American Artists' Congress. At that three-day affair in February 1936 leading artists and critics, including Lewis Mumford, Rockwell Kent, Aaron Douglas, Margaret Bourke-White, Heywood Broun, Meyer Schapiro, José Clemente Orozco, and David Siqueiros spoke to the artist delegates. Close to 400 artists and artworld personalities signed the AAC call—a veritable "who's who" of American art. The introduction to the published papers stated: "The purpose of this organization is to achieve unity of action among artists of recognized standing in their profession on all issues which concern their economic and cultural security and freedom, and to fight War, Fascism and Reaction, destroyers of art and culture." Thus, membership did not entail any political affiliation, but it did require evidence of professionalism.

In Davis's remarks, which followed the opening address by Lewis Mumford, Davis attacks "a prominent art critic, associated with the Hearst press." Without a doubt, this was Thomas Craven, a cultural nationalist and promoter of the art of Thomas Hart Benton (see Reading 57), who was generally disliked by artists on the left.

---

The American Artists' Congress is unique in the history of American art. That it takes place now is no accident. For it is the response of artists to a situation facing them today. How can we describe this situation?

Its immediate background is a depression unparalleled in the history of this country. The cracks and strains in the general social fabric resulting from the economic crisis inevitably reached the world of art, shaking those psychological and esthetic certainties which had once given force and direction to the work of artists.

In order to withstand the severe shock of the crisis, artists have had to seek a new grip on reality. Around the pros and cons of "social content," a dominant issue in discussions of present day American art, we are witnessing determined efforts by artists to find a meaningful direction. Increasing expression of social problems of the day in the new American art makes it clear that in times such as we are living in, few artists can honestly remain aloof, wrapt up in studio problems.

But the artist has not simply looked out of the window; he has had to step into the street. He has done things that would have been scarcely conceivable a few years back.

\* \* \*

[T]he liberal New Deal Government awakened artists to the realization that they had every right to go to the Government when all other resources and prospects had been exhausted, to demand support for their continued functioning as creative workers.

Artists at last discovered that, like other workers, they could only protect their basic interests through powerful organizations. The great mass of artists left out of the project found it possible to win demands from the administration only by joint and militant demonstrations. Their efforts led naturally to the building of the Artists' Union.

The relatively greater scope of the present art projects is due, in large measure, to the militant stand of the various artists' unions, on behalf of all unemployed artists.

The unions have also gone a long way toward showing that the best American art cannot be developed by merely encouraging a hand-picked few. Their insistence on a democratic extension of Government support to young and unknown artists has brought out a vast variety of talent completely ignored by private patronage and commercial galleries. For the young generation of American artists there is no visible hope except continuation and expansion of Government art projects.

\* \* \*

It is probably no accident that a prominent art critic, associated with the Hearst press, [William Randolph Hearst's *New York American*] writes of his disgust with the work produced on the projects. He advises the young artists to disperse, return home, admit they were not intended to be artists, and take up pursuits more suited to their abilities.

Hearst, today the spearhead of the sharpest attacks upon intellectual freedom in this country, focuses his drive against the artists at just that point where they have made their only real advance toward economic security, namely, the Government projects.

This attack is part of a general drive by powerful vested interests to perpetuate exploitation by smashing the efforts of the underprivileged American masses to gain security and a decent living standard. The goal of intrenched interests is a regime founded on suppression of all those liberties which Americans fought to establish and are today struggling to maintain. This goal is shrewdly screened with such slogans as "Back to the Constitution" and "Save America for Democracy," and hypocritical appeal to Americanism and love of country.

The examples of the so-called national resurgence that were accompanied by the most brutal destruction of the economic and cultural standards of the masses of people in Italy and Germany through the introduction of Fascism should warn us of the real threats that lie behind the rabidly nationalistic movements in this country.

There is a real danger of Fascism in America.

How Fascism is plunging headlong toward a devastating new World War is evident to every reader of the daily press. Fascists have no other solution for the crying needs of their people than an outburst of war.

To carry out their program of death and destruction they would enlist the services of even the artists.

\* \* \*

The members of this Congress who have come together to discuss their problems in the light of the pressing social issues of the day are representative of the most progressive forces in American art today. The applicants for membership were accepted on the basis of their representative power, which simply means that they had already achieved a degree of recognition and esteem as artists in the spheres in which they function.

We, members of the Congress, have recognized that we are not alone in this fight. We recognize that our basic interests are not remote from those who do the work of the world. And with this recognition comes the realization that if we are to be seri-

ous, we can only attack even the most highly specialized problems that confront us, in relation to our main objective, which is to build a bulwark for the defense of intellectual freedom, for economic security.

Even if we were to rally all the American artists to our cause, we would achieve little working as an isolated group. But we have faith in our potential effectiveness precisely because our direction naturally parallels that of the great body of productive workers in American industrial, agriculture and professional life.

The Congress will enable us to focus our objectives.

To realize them, we plan to form a permanent organization on a national scale.

It will not be affiliated with any political group or clique of sectarian opinion.

It will be an organization of artists which will be alert to take action on all issues vital to the continued free functioning of the artist.

It will be alert to ways and means for extending this freedom and for making contact with a broader audience.

It will be a strengthening element to the whole field of progressive organization against War and Fascism.

It will be another obstacle to the reactionary forces which would rob us of our liberties.

I call on all artists of standing to join the permanent organization which will carry out the program planned by the succeeding sessions of the Congress.

---

**46** ✦ Grace Clements, "New Content—New Form," *Art Front* 2, no. 4 (March 1936): 8–9.

Grace Clements was active in organizing the California branch of the American Artists' Congress and became its executive director. In this *Art Front* essay, she confronts the issue of revolutionary politics and the search for appropriate styles. "It is puerile to expect a revolutionary art to spring into existence merely on the strength of good intentions or sincere convictions. These are only the motivating forces." She urges artists to draw on the legacy of the cubists and the surrealists, and she suggests montage, "a method not unsympathetic to adaptability in the field of painting."

The debates about style/revolutionary content continued in many of the issues. In an article, "Expressionism and Social Change," published in the November 1936 issue of *Art Front,* Charmion Von Wiegand reminded her readership of Hitler's suppression of the German expressionists, and argued that expressionism's "destructive activism is necessary in clearing the ground for future building." Fernand Léger, in a February 1937 *Art Front* issue, championed a "new realism," (an art like his own) as the art of the people. In subsequent issues, particularly lively debates centered on surrealism as a social art. Clements's essay, however, touched on all the different styles.

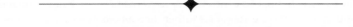

A new aesthetic, stemming from surrealism, cubism, and Cezanne's classicism, is finding expression in so remote a place as Hollywood, California. The exponents of this "subjective-classicism" who call themselves post-surrealists, are working for the

creation of an art which achieves classical unity through multiple perception—visual, psychological and philosophical.

<center>* * *</center>

No longer is mere technical facility a sufficient excuse for a work of art. No longer does the old premise of balanced composition, linear design, spatial relationship, or color harmony serve to reflect the conflict which the socially conscious artist strives to express and so often miserably fails in achieving.

[. . .]

In Western art, the cubists were probably the first to break away from the tradition of the fixed *visual* perception, but, being so wholly absorbed with their new technical problem, they experimented only with the customary "props" of the studio. Their chief contribution has been an enriched vocabulary created by a *complex* visual concept. It was left to the surrealists to abandon the norm in subject, making excursions into the field of psychology and the subconscious, employing the complexity of objects, both related and unrelated in form, function or idea.

Abstractionism (cubism, purism, etc.) and surrealism have obvious deficiencies for the socially conscious artist. In the former, subject has been annihilated. In the latter, aesthetic unity has been destroyed. However both take their place in historical development, neither can be ignored for what it has contributed.

The question still remains—what will be the forms in which the new content may be expressed? It is puerile to expect a revolutionary art to spring into existence merely on the strength of good intentions or sincere convictions. These are only the motivating forces. An examination of *cause and effect* is of primary importance to the understanding and interpreting of the material from which we are to create. Next is the necessity of projecting this knowledge *plastically.* Since cause and effect embrace a multiple concept, it is inevitable that the old art forms concerned with a uni-visual concept are hopelessly inadequate.

Let us take a phenomenon of our present social system—a bread line—as a subject for a painting. Will the mere picturization or even dramatization of a bread line convey the *reasons* for its existence? We must answer—no. These people waiting for a bowl of soup might be too indolent to work for it! There is nothing in the *appearance* of these men and women to show that *through no fault of their own* they are unable to procure employment. There is nothing to show the suffering from starvation and deprivation. The outward effect of ragged and emaciated forms does little to distinguish these as disemployed persons. Is it not the existence of capitalism revealing its inherent contradictions which is responsible for this bread line? Here is the point of differentiation in *content.* It must also be the point of differentiation in *form.*

Actually the surrealists have given us the key to the answer. Their weakness was their attempt to make an automatic art, uncontrolled by the conscious mind. Their significance was their use of psychological phenomena, especially through their use of associative ideas. We, too, must deal with subjective associative ideas, but ideas of extreme complexity which must be controlled by the *head* no matter how much fire the *heart* may contain. It will be a cerebral art rather than an emotional one; that is, an art *calculated* in its organization. Because we must observe the limitations of our medium, we must convey ideas which can be optically apprehended. But, most important, we must *direct* the comprehension of the idea so that our meaning will be precise and clear.

*Montage,* a term borrowed from the cinema, which, by *conflict* of two or more factors unlike in kind but united in idea, create a *climax,* is a method not unsympathetic to adaptability in the field of painting. There is much to be learned about kinetic values and their use. This does not mean that a painting should be expected to compete with the motion picture, and certainly not to imitate it. But insofar as both mediums are concerned with ideas expressed through form, and the visual and subjective perception of it, it is inevitable that they shall exert an influence upon each other.

\* \* \*

Form and content will always remain inseparable parts of a work of art. For the vital role demanded of art today we must develop a vital form, based on the scientific and dialectic material which creates this new content.

---

*47* ✦ Louis Lozowick, "Towards a Revolutionary Art," *Art Front* 2, no. 7 (July–August 1936): 12–13.

Louis Lozowick understood Marxist theories and had clearer ideas about its practice than probably any other American artist. One of his main points, to which most radical artists would then agree, is that "revolutionary art is not the task to be achieved by one work or even by one artist. It is the labor of a movement."

The reader might want to compare this essay with his "The Americanization of Art" of 1927 (see Reading 24). By the mid-thirties Lozowick was clearly an internationalist.

◆

[. . .] [T]he emergence of a revolutionary art in the Soviet Union as in Japan, in Mexico as in Hungary, in Holland as in the United States, points to the presence of a revolutionary world situation, is in fact both a symbol and a product of that situation.

The capitalist press in a moment of unconscious clairvoyance has referred to the revolutionary artist as "class-struggle" artists. Excellent appelation, for it identifies the revolutionary artist unmistakably.

In all parts of the world there are signs of incipient and open revolt against the system. The organized working class, joined by growing numbers of intellectuals, farmers and other elements, and guided by the philosophy of Karl Marx, is the only force that can abolish it. Artists like others, whether they want it or not, whether they know it or not cannot remain outside of the situation described. We notice, in fact, everywhere the parallel process of fascization and radicalization of art as representative of the two forces in conflict. [. . .]

When the revolutionary artist expresses in his work the dissatisfaction with, the revolt against, the criticism of the existing state of affairs, when he seeks to awaken in his audience a desire to participate in his fight, he is, therefore, drawing on direct observation of the world about him as well as on his most intimate, immediate, blistering, blood-sweating experience, in the art gallery, in the bread line, in the relief office. But as already indicated experience to him is not a chance agglomeration of impressions but is related to long training, to habits formed, to views assimilated and

entertained at a definite place and time; to him experience acquires significant meaning by virtue of a revolutionary orientation. In sum, revolutionary art implies open-eyed observation, integrated experience, intense participation and an ordered view of life. And by the same token revolutionary art further implies that its provenance is not due to an arbitrary order from any person or group but is decreed by history, is a consequence of particular historic events.

Although the revolutionary artist will admit partisanship he will most emphatically deny that it need affect unfavorably his work. Obviously, if disinterestedness were in itself a guarantee of high achievement all the tenth-rate Picassos would be geniuses; if social partisanship resulted necessarily in inferior art Goya and Daumier would have to be erased from the pages of art history. Nor does partisanship narrow the horizon of revolutionary art. Quite the contrary, the challenge of a new cause leads to the discovery of a new storehouse of experience and the exploration of a new world of actuality.

\* \* \*

Beginning with Marx and Engels (who presumably knew their own minds) the importance of formal excellence in art has been stressed by every Marxist who has written on the subject. The Marxists maintain, however, that while all artistic creation implies formal organization, it cannot be reduced to it, much less exhausted by it. Content and form are mutually interpenetrating; both derive from social practice, are outgrowths of social exigencies.

\* \* \*

The formation of a revolutionary art is not the task to be achieved by one work or even by one artist. It is the labor of a movement; whether one member or another occasionally paints a still life or a landscape is, viewed in large perspective, of little consequence.

\* \* \*

Whatever else might be said about revolutionary art, it does not play sycophant to "disinterested" collectors, nor cater to the speculative needs of the dealers. It grows out of profound conviction of the artist and the living issues of society. Fortified by a revolutionary tradition (present—if neglected—in American art as in the art of other countries) the revolutionary artist stands before an ideal and a task to which all artists not directly interested in the maintenance of the *status quo* can rally. To make art auxiliary to the building of a new society is not to degrade but to elevate it. An art to be valuable must be historically on time. Revolutionary art makes sure to be in the vanguard rather than in the rearguard of history.

---

**48** ✦  Isamu Noguchi, "What's the Matter with Sculpture," *Art Front* 2 no. 9 (September–October 1936):13–14.

Isamu Noguchi was the son of a famous Japanese poet and an American mother, who brought him as a child to live in the United States. He studied art in New York and with Brancusi in Paris in 1927, where he was part of the expatriate scene. Not only did he sculpt, but he became a well-known designer of furnishings, playgrounds, and gardens; his inexpensive lamps are still sold today.

He begins this essay with the complaints often lodged against sculpture in the 1930s—that it has no relevance to the social life of people. He then answers those objections with reference to a major sculptural relief he had just constructed in Mexico City in 1936.

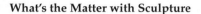

## What's the Matter with Sculpture

First. Its subject matter, whether imaginative or realistic, has no relation to life of today.

Second. It is usually not finished by the artist and therefore does not reflect the occupation of man with matter and space, is therefore essentially not sculpture at all.

Third. It lacks color, an element which greatly enhances its appeal to the average man. The appeal of texture is at best a precious one.

Fourth. Because of its indirect and unscientific method of procedure, the finished object involves a terrific waste of time and money. This not only prevents its popular consumption, but restricts the artist to producing the safe and tried, prevents the imaginative and experimental.

In answer:

First. Let us make sculpture that deals with today's problems. Draw on the form content so plentiful in science, micro- and micro-cosmic; life from dream-states to the aspirations, problems, sufferings and work of the people.

Second. We must become familiar with the modern ways of handling plastic and crystalline matter (the spray-gun, pneumatic hammer, etc.). For any given work we should use that precise material best suited to its size, to cost and durability.

Third. Be not afraid to be even "vulgar" in the use of color. Study how color can enhance rather than detract from form. Like harmony in music, color plays with its other aspect form.

Fourth. The scientific method is necessarily the cheap method. The cheap and quick method will rescue sculpture from preciousness. Why not paper or rubber sculpture?

In conclusion, it is my opinion that sculptors as well as painters should not forever be concerned with pure art or meaningful art, but should inject their knowledge of form and matter into the everyday, usable designs of industry and commerce. This necessitates their learning why things are the way they are, why the bend of a road, why the streamline of airplanes.

The sculpture here reproduced of the wall which was made in the Mercado Abelardo L. Rodriquez, was made in cement mixed with color applied on a built-up and cut brick base. It is part of the general artistic embellishment of the market by ten workers in the arts. All designs required approval by the group and was more or less cooperative in layout although not in conception or execution. In my case, I am especially indebted to suggestions and advice as to color given me by Antonio Pujol and Paul O'Higgins.

First, the sketch was enlarged onto the brick wall. Then bricks built in where thickness was required, then carved in and out. This took about two months. After this, cement, large marble aggregate, and lime was thrown on and the forms defined. The final coat contained fine aggregate color and cement mixed dry to assume

accurate color when applied with a trowel and polished. The job was completed seven months after starting.

It is 22 meters long, 2.2 meters high, and in parts as much as 60 cm. thick.

The subject matter is the general one of "against war and fascism," specifically, "History as seen from Mexico in 1936."

---

*49* ✦  Berenice Abbott, "Civic Documentary History," from the *Proceedings of the Conference on Photography,* The Institute of Women's Professional Relations (New York City: The Biltmore Hotel, Feb 9, 1940).

Berenice Abbott worked as a photographer in Paris before returning to the United States in 1929. *Changing New York,* 1939, for which she took the photographs and Elizabeth McCausland wrote the essay, was a publication of the Federal Art Project.

The published papers in the Proceedings of the Conference on Photography include essays by Edward Steichen, Roy Stryker, and Beaumont Newhall, among others. Berenice Abbott, like her long-time companion McCausland, promoted the idea that art should serve "the people." A firm believer in the necessity of aesthetic quality, she, like Lewis Hine before her, felt that the camera was a powerful tool for recording conditions that needed to be improved and for encouraging civic responsibility (see also Reading 16).

---

◆

---

**"Civic Documentary History."**

What does this phrase mean? Obviously, it implies a specialized and sharply defined function of photography. Roughly, for purposes of immediate definition, we may say that the function of photography for Civic Documentary History is to record, to interpret, to comment. But—from what angle is the record, interpretation, comment, to be made?

First, let us consider what these words mean in their common usage. The word "civic" suggests the human being in relation to his social environment. It implies that he, as a citizen, has a responsibility for this environment, its status quo and the possibilities of its improvement in the future.

In a broad sense, every product of human culture is a "Document." Even trifles help us to recreate the character and color of past ages. However, in recent years the adjective "documentary" has come to have a more scientific meaning in photography. It is that sense which is applicable here.

"Documentary" photography is realistic, objective—the more realistic, the better—as opposed to pictorial exploitation of visual subject matter. It seeks to reach the roots, to get under the very skin of reality. Because of its emphasis on realism, documentary photography has an intimate and organic relation with its subject matter. One might argue that in documentary photography subject matter controls the photograph to a great extent. Certainly the "form" of the resulting photographic picture must grow out of a clear understanding of the meaning of the thing photographed, whether urban or rural, slum or depressed farm area, high life or low life.

Though there is sociological value to documentary photography—for example, Lewis Hine's "photo-documents" printed in the *Survey* 30 years ago—yet the sum total of the impact of documentary photography is more than sociology. Atget's remarkable photographs of Paris from the '90s to 1927 prove the point. The plus which makes the difference between statistics and an expressive creative statement is that sense of life, without which all art forms are valueless. This sense of life is produced when the photographer or writer has a dynamic conviction that his theme is important, and when he can translate this conviction into strong and moving visual terms.

The history the camera can write is the visual record of the present. The camera cannot reconstruct the past or imagine the future. But the camera CAN see and record the instant NOW.

\* \* \*

## Mexican Artists in the United States

Among the leading contemporary influences on socially concerned artists in the United States were the Mexican muralists Diego Rivera, José Clemente Orozco, and David Alfaro Siqueiros, all of whom lived in or visited the United States during the 1930s. To New York artists, they were bona fide *revolutionary* artists, who had revived Renaissance mural techniques and on the empty walls of government buildings had painted murals of and for the people of Mexico. Siqueiros was an outspoken Communist Party member. Rivera, on the other hand, was more individualistic in his Marxism and was thrown out of the Communist Party in the 1930s. He continually attempted to get back into the Party's good graces but was eventually drawn into the orbit of Leon Trotsky, who had himself been expelled in 1927 and who was eventually assassinated in Mexico in 1940. Orozco was less politically partisan but no less anticapitalist. Rivera's young wife, Frida Kahlo, who joined her husband during his sojourns in the States, was also a fervent leftist.

The presence of these Mexicans in the United States had great consequences. Orozco first made a trip to the West Coast in 1917 and returned there in 1927 to paint a mural at Pomona College in California. Before returning to Mexico in 1934, he had also painted murals at the New School for Social Research in New York City and at Dartmouth College in Hanover, New Hampshire.

In 1930 Rivera went to San Francisco, where he painted murals at the Stock Exchange Building and at the California School of Fine Arts. He then moved on to paint murals for the Detroit Institute of Arts. In spite of his radical politics, which he did not hide, Nelson Rockefeller commissioned him to paint a mural for Rockefeller Center on the theme "Man at the Crossroads Looking with Uncertainty but with Hope and High Vision to the Choosing of a Course Leading to a New and Better Future." In the 17-foot-high by 63-foot-wide mural, Rivera included a portrait of Lenin to which Rockefeller objected. When Rivera refused to remove the offending portrait, a delegation of Rockefeller agents visited him on-site the evening of May 9, 1933. They handed him $14,000, the final payment of the $21,000 commission, and workmen began covering over the mural, which was two-thirds completed. According to the *New York Herald,* one hundred art students and "other admirers" were inside the building. They were ushered out by Rockefeller agents, with mounted policemen outside to prevent a demonstration, which occurred anyway. News of the vandalism spread quickly, the Artists' Committee for Action was formed, and several more demonstrations

took place, including a meeting at Town Hall on May 16. Rivera took the Rockefeller money and painted murals for the New Workers School in New York. The covered-over, nearly-finished Rockefeller mural was subsequently destroyed the night of February 14, 1934.

In 1932 Siqueiros went to Los Angeles, where he painted public murals with students at the Chouinard Art School and at the Plaza Art Center on Olvera Street. He traveled briefly to New York in 1934 when he had a solo exhibition, and in 1936 he again returned and established an experimental workshop where industrial materials and commercial paints were used. Many artists, including Jackson Pollock, studied with Siqueiros, even helping him to build a float for the Communist Party's May Day parade of 1937. Shortly thereafter Siqueiros left for Spain to join the Republican forces fighting Franco, and the workshop broke up.

Orozco, Rivera, and Siqueiros were not the only Mexican artists in the United States during the 1930s; others who had exhibitions, taught in art schools, and worked on mural commissions included Rufino Tamayo, Alfred Ramos Martínez, Roberto Montenegro, Jean Charlot, Antonio Ruiz, Julio Castellanos, Leopoldo Méndez, José Chávez Morado, and Jesús Guerrero Galván.

But it was Orozco, Rivera, and Siqueiros who made the biggest impact; they not only introduced new mural techniques, styles appropriate to architectural settings, and a vigorous revolutionary content, but they also exemplified the way artists could be heroic, outspoken, and seasoned political activists. And it was they who inspired American artists, such as Pablo O'Higgins, Marion and Grace Greenwood, Isamu Noguchi, Philip Guston, and Reuben Kadish to go to Mexico and try their hand at mural work.

Frida Kahlo, although she painted small, very private pictures, would, in time, also serve as an important role model for feminists in the 1970s. Her paintings—drawing upon Mexican folk imagery and dwelling on her physical pain and the stormy relationship with her husband Rivera—exemplified the slogan "the personal is the political."

*50* ✦ Diego Rivera, "The Radio City Mural," *Workers Age* 2, no. 15 [Rivera Supplement] (June 15, 1933), unpaginated.

Diego Rivera studied art in Mexico with Posada and others. He lived in Europe from 1907 to 1909 and again from 1912 to 1921 and developed into an accomplished cubist painter. Back in Mexico in 1921 he helped spearhead the Mexican fresco mural movement with its focus on Mexican history and life. Following the completion of his mural at the Detroit Institute of Arts, Rivera and Frida Kahlo came to New York to work on the Rockefeller commission.

Rivera stopped work on his Radio City Mural at Rockefeller Center the evening of May 9, 1933, when Rockefeller agents handed him his final paycheck and ordered him off the premises. The newspapers carried news about demonstrations as well as commentary. Rivera released a letter that Nelson Rockefeller had sent him prior to the event, published in *The News-week in Entertainment* (May 20, 1933). The letter read in part:

> I noticed that in the most recent portion of the painting you had included a portrait of Lenin. This piece is beautifully painted, but it seems to me that his portrait, appearing in this mural, might very easily seriously offend a great

many people. If it were in a private house it would be one thing, but this mural is in a public building, and the situation is therefore quite different. As much as I dislike to do so, I am afraid we must ask you to substitute the face of some unknown man where Lenin's face now appears.

*The New York Times* published a protest letter on May 28, 1933, signed by about four dozen artists, while William Randolph Hearst editorialized in the *New York American* (June 11, 1933): "Inasmuch as Rockefeller Center is a private enterprise, its owners have some rights." E. B. White penned his amusing poem, "I Paint What I See," for *The New Yorker.*

Rivera stayed on in New York and painted another mural for the New Workers' School. A duplicate of *Man at the Crossroads* was painted in 1934 for the Palacio de Bellas Artes in Mexico City. *Workers Age,* a Trotskyist newspaper, published Rivera's version of the controversy. When Rivera describes the "left" in the painting, he means the viewers' right; "right" means the viewers' left.

———————————————◆———————————————

[. . .] The most important and complete of my American paintings is the series of frescoes in Detroit in which I realized as correctly as possible an analysis of the relations of the worker to the means of production and the natural forces and materials involved, creating a beauty appropriate to the proletariat.

\* \* \*

## The Case of Rockefeller Center

Those who gave me the work at Radio City knew perfectly well my artistic tendencies and my social and political opinions. And the Detroit affair had just served to make very clear the nature of my reaction to the environment of the United States. They did much urging to persuade me to accept the work, which i finally did only on condition that they would give me full liberty to paint as I saw fit. My interpretation of the theme and my sketches for the painting were discussed and approved. The theme they assigned was: Man at the crossroads, looking with uncertainty but with hope to a better world. My interpretation, naturally, portrayed the crossroads with the road to the left as the socialist world, that to the right, the world of capitalism. The steel worker, in the midst of a connected system of machines which give him control of energy and means of knowledge of the various aspects of life, the infinitely great and the infinitely small, and a simultaneous vision of the most distant and the nearest things, and power over the forces of nature and the vegetable products and mineral wealth of the earth. [. . .] At the sides, arranged in horizontal zones like the floors of a building, were, at the left, an image of a May Day demonstration in Moscow, projected by television, and below, the workers of a factory gathered during the lunch hour to listen to a working class leader. At the right, in the upper part, war—at attack of infantry equipped with masks and flame-throwers, and supported by tanks and areoplanes. And, below that, as a consequence, a demonstration of unemployed workers in Wall Street corner of South Street, with the mounted police just in the act of attacking and dispersing the

**Figure 3–3.**   Diego Rivera, *Man at the Crossroads,* Rockefeller Center, New York City (unfinished/destroyed), 1933. Fresco. Photograph by Lucienne Bloch, courtesy Old Stage Studios, Gualala, CA. Archives of the Detroit Institute of Arts. Bloch, her husband Stephen Dimitroff, and Ben Shahn assisted Rivera on his mural in New York.

demonstration; in the background, crossed, an elevated structure and the steeple of a church. In the ellipses, representing the microscopic and telescopic views, on the side nearest the war, the wounds and the microbes of decomposition and infection and those of the typical plagues and diseases of war. On the lower edge of the ellipse, the microbes of venereal disease, syphilis, etc., and adjoining a sector showing a scene of gaming, drinking and dancing of members of the bourgeoisie, reminiscent of Marx's observation that such a scene was the overflowing scum of capitalist decay. Beneath this, in the astronomic field, was represented the moon, dead planet, and near the center, the sun, in eclipse. In the same field, on the left, constellations and nebulas in ascending evolution. Near this, a group of young women, youth and pioneers of the Communist movement. [. . .]

Since, as much for my personal sentiments and opinions as for the historical truth, the outstanding leader of the proletariat is Lenin, I could not conceive or represent the figure of the worker-leader as any other than that of Lenin. [. . .]

As the best answer to the financial dictatorship of the Rockefellers my co-workers and I have decided to make the revolutionary painting accessible to the New York workers which the Rockefellers tried to shut off from them. Therefore, we have decided to use the money that the Rockefellers paid to paint without charge in workers schools. Thus the Rockefellers have been stripped of their assumed mask of liberalism as art patrons and yet are paying for revolutionary art in the workers headquarters much against their will. At the same time, the whole incident has served to stir the in-

terest of great numbers of workers in the development of proletarian art and the storm aroused demonstrates the living character of the art of the working class as against the art of the bourgeoisie which is no longer capable of stirring controversy.

We are confident that the workers will yet unveil our buried mural and, if it be destroyed or incomplete, they will create out of their own midst the artists of tomorrow who will fulfil our intentions and carry revolutionary art to far greater heights.

---

**51 ✦** E. B. White, "I Paint What I See: A Ballad of Artistic Integrity," *The New Yorker* 9, no. 14 (May 20, 1933):25. Reprinted by permission; ©1933 E. B. White. All rights reserved.

Elwyn Brooks White was a poet, essayist, and editor for *The New Yorker.* He is best remembered as the author of *Stuart Little* and for his updating of William Strunk's *The Elements of Style,* a much-consulted handbook on good writing.

✦

**I Paint What I See**
A Ballad of Artistic Integrity

"What do you paint, when you paint a wall?"
    Said John D.'s grandson Nelson.
"Do you paint just anything there at all?
"Will there be any doves, or a tree in fall?
"Or a hunting scene, like an English hall?"

*"I paint what I see," said Rivera.*

"What are the colors you use when you paint?"
    Said John D.'s grandson Nelson.
"Do you use any red in the beard of a saint?
"If you do, is it terribly red, or faint?
"Do you use any blue? Is it Prussian?"

*"I paint what I paint," said Rivera.*

"Whose is that head that I see on my wall?"
    Said John D.'s grandson Nelson.
"Is it anyone's head whom we know, at all?
"A Rensselaer, or a Saltonstall?
"Is it Franklin D? Is it Mordaunt Hall?
"Or is it the head of a Russian?"

*"I paint what I think," said Rivera.*

*"I paint what I paint, I paint what I see,*
  *"I paint what I think," said Rivera,*
*"And the thing that is dearest in life to me*
*"In a bourgeois hall is Integrity;*
  *"However . . .*
*"I'll take out a couple of people drinkin'*
*"And put in a picture of Abraham Lincoln,*
*"I could even give you McCormick's reaper*
*"And still not make my art much cheaper.*
*"But the head of Lenin has got to stay*
*"Or my friends will give me the bird today,*
  *"The bird, the bird, forever."*

"It's not good taste in a man like me,"
  Said John D.'s grandson Nelson,
"To question an artist's integrity
"Or mention a practical thing like a fee,
"But I know what I like to a large degree,
  "Though art I hate to hamper;
"For twenty-one thousand conservative bucks
"You painted a radical. I say shucks,
  "I never could rent the offices—
  "The capitalistic offices.
"For this, as you know, is a public hall
"And people want doves, or a tree in fall,
"And though your art I dislike to hamper,
"I owe a *little* to God and Gramper,
  "And after all,
  "It's *my* wall . . ."

  *"We'll see if it is," said Rivera*

**52** ✦ André Breton, "Frida Kahlo de Rivera," in *Surrealism and Painting,* trans. Simon Watson Taylor, 1938 (London: Macdonald, 1972): 141–44.

André Breton, one of the leaders of the French Surrealist movement, traveled to Mexico in 1938 to visit Leon Trotsky, living in exile from the Soviet Union. Mexico was obviously exotic to Breton, as was Frida Kahlo, the wife of Diego Rivera. Breton, nevertheless, recognized in Kahlo's art a unification of the artistic and the political.

Born in Mexico, Frida Kahlo suffered permanent injuries in a streetcar accident when she was a teenager. She nevertheless went to art school and also joined the Young Communist League. In 1929 she married Diego Rivera. Their stormy relationship ended in divorce in 1939, but they remarried in 1940. During the 1930s she accompanied Rivera when he came to the United States to paint his murals in San Francisco, Detroit, and New York.

Her constant pain, frequent hospitalizations, and intense emotional life with Rivera are the subjects of many of her paintings; she worked in a style that combined the elements of European realism and Mexican retablos. Kahlo's life and art were celebrated in the 1970s by feminists, who admired her endurance and struggles.

\* \* \*

I have for long admired the self-portrait by Frida Kahlo de Rivera that hangs on a wall of Trotsky's study. She has painted herself dressed in a robe of wings gilded with butterflies, and it is exactly in this guise that she draws aside the mental curtain. We are privileged to be present, as in the most glorious days of German romanticism, at the entry of a young woman endowed with all the gifts of seduction, one accustomed to the society of men and genius. [. . .] Frida Kahlo de Rivera is delicately situated at that point of intersection between the political (philosophical) line and the artistic line, beyond which *we hope that they may unite in a single revolutionary consciousness while still preserving intact the identities of the separate motivating forces that run through them.* Since this solution is being sought here on the plane of plastic expression, Frida Kahlo's contribution to the art of our epoch is destined to assume a quite special value as providing the casting vote between the various pictorial tendencies.

My surprise and joy was unbounded when I discovered, on my arrival in Mexico, that her work has blossomed forth, in her latest paintings, into pure surreality, despite the fact that it had been conceived without any prior knowledge whatsoever of the ideas motivating the activities of my friends and myself. Yet, at this present point in the development of Mexican painting, which since the beginning of the nineteenth century has remained largely free from foreign influence and profoundly attached to its own resources, I was witnessing here, at the other end of the earth, a spontaneous outpouring of our own questioning spirit: what irrational laws do we obey, what subjective signals allow us to establish the right direction at any moment, which symbols and myths predominate in a particular conjunction of objects or web of happenings, what meaning can be ascribed to the eye's capacity to pass from visual power to visionary power? [ . . . ]

This art even contains that drop of cruelty and humour uniquely capable of blending the rare affective powers that compound together to form the philtre which is Mexico's secret. The power of inspiration here is nourished by the strange ecstasies of puberty and mysteries of generation, and, far from considering these to be the mind's private preserves, as in some colder climates, she displays them proudly with a mixture of candour and insolence.

While I was in Mexico, I felt bound to say that I could think of no art more perfectly *situated* in time and space than hers. I would like to add now that there is no art more exclusively feminine, in the sense that, in order to be as seductive as possible, it is only too willing to play alternately as being absolutely pure and absolutely pernicious.

The art of Frida Kahlo is a ribbon around a bomb.

## Government Projects

Before the New Deal even got underway, there were relief programs for artists. In December 1932, the College Art Association began a limited work relief program called the Emergency Work Bureau (EWB; later the Emergency Relief Bureau, ERB) directed by Audrey McMahon and Frances Pollak of the CAA offices in New York. It was at first financed by a private agency and then by the Temporary Emergency Relief Administration (TERA), an agency of New York State created in September 1931 and directed by Harry Hopkins.

In December 1933 the Public Works of Art Project was set up as the first federal non-relief project. The national director was Edward Bruce, working under the auspices of the U.S. Treasury Department. The funding came from the Civil Works Administration (CWA), and Juliana Force, then director of the Whitney Museum, was appointed the New York regional director, with Lloyd Goodrich, then curator at the Whitney, as her assistant. Bruce was proud of both the mission of PWAP and the results, as he wrote in *American Magazine of Art* (March 1934):

> Here in America a great democracy has become the patron of its artists. It has selected a group of the most competent people in America to select the artists who will receive this patronage, and it has given the artist the widest possible scope in the selection of what he wants to do. Nothing like it . . . has ever been done in history. The very method of payment is democratic. The artist is paid the highest craftsman's wages allowed under existing conditions and the product of his work becomes the property of the government. He is assured an income, providing he works faithfully and his product measures up to a reasonable standard of what art should be. . . . Masterpieces and great geniuses are not produced from isolated efforts; . . . they come only from large art movements. . . . This movement should be fostered and extended by the government wherever possible.

During its seven-month existence the PWAP employed 3,749 artists across the country.

Bruce also took charge of the Treasury Section of Painting and Sculpture (from October 1934 to 1938), renamed the Treasury Section of Fine Arts of the Public Buildings Administration of the Federal Works Agency (from 1939 to July 1943). On the basis of competitions, not need, the Section awarded commissions for murals and sculptures placed in post offices across the country and in federal buildings in Washington, DC.

However, after the PWAP folded, the relief needs of artists, as well as writers, musicians, and theater people, still needed to be addressed. With the experimental climate of the New Deal still energizing legislation, the Works Progress Administration (WPA) under Harry Hopkins set up Federal Project No. 1 in August 1935, which was to have the most far-reaching cultural impact on the country. There were four cultural projects; Art, Music, Theater, and Writers. For the art project (FAP), Holger Cahill was named national director, and Audrey McMahon was regional director in New York. Under the WPA/FAP artists were placed in eight divisions: murals, easel paintings, photographs, sculptures, graphics, posters, motion pictures, and the Index of American Design. Other divisions directed teaching at art centers, exhibitions, and other related activities. Artists on the WPA/FAP were continuously under attack by Congressmen and a public unsympathetic to artists making art as their work-relief. Nevertheless, the agency stayed in existence until 1943.

Another organization, the Treasury Relief Art Project (TRAP), existed from 1935 to 1939, funded by the WPA but administered by the Treasury Department. A final agency, the Farm Security Administration (FSA), under the direction of Roy Stryker from 1937 to 1942, employed photographers to record conditions in rural regions. From 1942 to 1943 Stryker's unit was under the direction of the Office of War Information (OWI).

The number of artists employed and the volume of art produced under the auspices of these various agencies is staggering. The Treasury Section, which hired artists solely on the basis of their entries in open and anonymous competitions, produced 1,116 murals and 301 sculptures. TRAP had 446 artists on the payrolls, who turned in about 10,000 easel paintings and 43 sculptures and completed 89 murals. At the height of the WPA/FAP, in 1936, there were over 5,000 artists on the project, yet they were but a small percentage of the overall WPA. It is estimated that the combined figure of artists, musicians, actors, writers, and researchers accounted for only 2 percent of the 3 million people on the WPA between 1935 and 1943. WPA/FAP artists produced some 2,500 murals; over 17,000 sculptures, 108,000 paintings, 200,000 prints from 11,000 designs, 2 million silkscreen posters from 35,000 designs, and more than 22,000 plates for the Index of American Design. About two million children were taught in WPA classes.[1]

The people who ran these agencies could be proud of their accomplishments. The support of public art by government has never since been equalled. Although Bruce and others thought that the programs were necessary in a democracy, many worried about socialism and whether such programs would undercut the free enterprise system.

## 53 ✦ Holger Cahill, "American Resources in the Arts," [speech delivered in 1939]. Reprinted in Francis V. O'Connor, ed., *Art for the Millions: Essays from the 1930s by Artists and Administrators of the WPA Federal Art Project* (Boston: New York Graphic Society, 1973).

Born in Iceland and essentially self-educated, Cahill was a museum curator and arts administrator. His ideas about art were shaped by John Cotton Dana, the director of the Newark Art Museum, where Cahill worked from 1922 to 1931; Dana believed that the mission of small urban museums should be to serve the community. During 1932–33, when Cahill filled in as Director of Exhibitions at the Museum of Modern Art, he mounted the exhibitions *American Painting and Sculpture 1862–1932, American Folk Art,* and *American Sources of Modern Art,* which included Mayan, Incan, and Aztec art.

In 1935 Cahill was asked to head up the Federal Art Project of the WPA. Unlike Edward Bruce, who held up standards of "quality" for the murals commissioned by the Treasury Section, Cahill believed, like John Dewey, that the *process* of making art had more value to individuals and the community than a finished commodity, and moreover, art in a democracy should be an art for all the people. Cahill also believed that great art was the result of a movement. Many of the ideas expressed here were first articulated in his introduction to *New Horizons in American Art,* a 1936 exhibition of WPA art held at the Museum of Modern Art. Cahill's speech was first delivered at the John Dewey Eightieth Birthday Celebration in October 1939.

[1]McKinzie, *The New Deal for Artists,* 1973; O'Connor, *Art for the Millions,* 1973; Park and Markowitz, *New Deal for Art,* 1977.

---◆---

\* \* \*

It seems to me that the ideas of John Dewey, probably more than those of any other philosopher of our time, have been taken as plans of action in the field of everyday activity, and have been translated rather freely into the common sense of the American people. This is due partly to the fact that they are sound, workable ideas. But it is due also to the fact that they are very much in the American grain that they have been put forward without pretension, and that their author has been neither detached nor withdrawn but has been an active participant in the life and thought and movement of the human society in which his ideas have been born.

[. . .] John Dewey and his pupils and followers have been of the greatest importance in developing American resources in the arts, especially through their influence on the school systems of this country. They have emphasized the importance and pervasiveness of the aesthetic experience, the place of the arts as part of the significant life of an organized community, and the necessary unity of the arts with the activities, the objects, and the scenes of everyday life. They have insisted that the teaching of the arts should not be relegated to the frills and the extras, but that it is central in any system of education. They have shown that art education, like art itself, involves activity, that art appreciation can best be taught through doing. Their thought and activity have been of the greatest significance in the organization of contemporary art programs which are stimulating the development of American art resources and making these resources available to wide publics. Among these is the WPA/FAP, of which I shall speak later.

If art is defined, as John Dewey defines it, as a mode of interaction between man and his environment, then we may say that our art resources will fall into three categories: the resources in man himself, the resources in the environment, and the resources which come about through the methods and techniques developed in this particular type of interaction between man and his environment.

\* \* \*

Art is not a matter of rare occasional masterpieces. The emphasis on masterpieces is primarily a collectors' idea and is related to a whole series of commercial magnifications which have very little to do with the needs of society as creator or as participant in the experience of art. [. . .] One of the things which the history of art indicates is that great art arises only in situations where there is a great deal of art activity, and where the general level of art expression is high. [. . .]

The creative activity in American art today is enormous. What of the public as appreciator and participant? The history of art seems to indicate that where the general level of art production is high the artist is reaching publics whose standards of taste are equal to his performance. Great traditions of art must have great audiences. As Walt Whitman said, there is a close relationship always between the creative artist and the group for which he creates. In the past the artist usually has produced for minority groups within the community. The standards of his art have been the standards of these groups.

[. . .] That a large section of the American people is developing standards is indicated in the wealth and the general high level of our art production today. Certainly

the American public shows great liberality and catholicity of taste. So far as technique and point of view are concerned the artist should not be held in any conventional channel. He should be free to range from the most conservative academicism to surrealism, abstraction and non-objectivism, and while he may not find a large following everywhere, he is sure of some following, and of a friendly and sympathetic interest. [. . .]

This wide interest in the arts, this democratic sharing of the art experience, is a comparatively recent development in American life. It is the devoted work of people who, like John Dewey, believe that democracy should be the name of a life of "free and enriching communion" in which everyone may have a part. Certainly this broad, democratic community participation in the creative experience is not implicit in the very form of our society, nor in the European societies from which it developed. In the modern period, up to our time, the opportunities provided for the people as a whole to share in the experience of art have been very few. Even today, many persons in the art field in Europe and America cannot go the whole democratic way in the arts. They cannot bring themselves to admit, somehow, that art, the highest level of creative experience, should belong to everybody. Many American artists, many American museum directors and teachers of art, people who would lay down their lives for political democracy, would scarcely raise a finger for democracy in the arts. They say that art, after all, is an aristocratic thing, that you cannot get away from aristocracy in matters of aesthetic selection. They have a feeling that art is a little too good, a little too rare and fine, to be shared with the masses.

\* \* \*

The emphasis upon the universal and the eternal in art too often has meant that our interest has become attached to aesthetic fragments lost from their contexts in time and in human society.

This exoticism has had serious results for the American artist. During the past seventy-five years there developed in this country a tremendous trafic in aesthetic fragments torn from their social background, but trailing clouds of vanished aristocratic glories. Fully four-fifths of our art patronage has been devoted to it. Now I would be the last person to disparage the work of the masters of past time, but it seems to me that it is a very strange affair when a country neglects its living artists and gives most of its support to artists long dead.

\* \* \*

During this century, government support of art has differed considerably from other art programs, both in extent and significance. At its very beginning it received the impetus of two powerful forces which helped to establish its character. One of these is the Mexican mural program of which we have spoken. The other is the philosophy of John Dewey. The Mexican mural program revealed to us the spirit of a nation, gave us a more profound understanding of the people of our sister republic, and at the same time enriched the creative life of our own land by giving us a living example of an art of native social meaning. Here is a dramatic illustration of John Dewey's saying that art is the most civilized form of communication and the best means for entering sympathetically into the deepest life experience of other peoples.

\* \* \*

*54*  Gwendolyn Bennett, "The Harlem Community Art Center" [circa 1939]. Reprinted in Francis V. O'Connor, ed., *Art for the Millions: Essays from the 1930s by Artists and Administrators of the WPA Federal Art Project* (Boston: New York Graphic Society, 1973).

A poet and an artist, Gwendolyn Bennett was born in Texas and raised in Washington, DC, Harrisburg, Pennsylvania, and Brooklyn, New York. She attended Teachers College at Columbia University and Pratt Institute, where she pursued her interest in art. She taught at Howard University in Washington, DC, for a year, and then was awarded a scholarship to travel to Paris to study. Returning to New York, she worked for *Opportunity* magazine. During the 1930s she also obtained a teaching degree at Columbia and took graduate classes at New York University.

Augusta Savage (see Reading 37) was the driving force behind the Harlem Community Art Center. In 1936 Savage was an assistant supervisor for the FAP/WPA, a position that allowed her to hire Harlem artists. Savage was appointed the first director of the Harlem Community Center. When the Center opened on December 20, 1937, Eleanor Roosevelt attended the festivities. Then when Savage took a leave of absence to work on a sculptural commission for the New York World's Fair, Bennett assumed the directorship.

Over ninety art centers and galleries were set up across the country from 1936 to 1941. In New York, in addition to Harlem, there were the Contemporary Art Center in midtown Manhattan, the Brooklyn Community Art Center, and the Queensboro Community Art Center. However, the community art centers were continuously under attack in Congress for what many considered their communist politics. In fact, Bennett's directorship ended in 1941 when she was accused of being a communist. By 1943 the government had withdrawn its support of the FAP centers, although some communities managed to keep their art centers alive with local funding.

---◆---

\* \* \*

The Harlem Community Art Center, . . . was a dream when Negro artists forming the Harlem Artists' Guild met to pool their experiences in a discussion of ways to bring about the establishment of a permanent art center for Harlem. The individual experiences of several artists had led this group to believe that there was a real necessity for such a center. Augusta Savage had been holding art classes for years; first Lessene Welles, then Charles Alston and Henry W. Bannarn had cooperated with the 135th Street Branch of the New York Public Library in the program of the Harlem Workshop; and many other artists in smaller ways had been at work in the fulfillment of a community need for a place where those who wished to learn might study free of cost, and where instruction in the use of creative materials might be made available to a wide public. And so in a dream motivated by the urgency of fact many of the precepts governing the program of the Harlem Community Art Center were laid down.

When classes were organized by the WPA/FAP, first in a renovated garage known as the Uptown Art Laboratory, and later in the Music-Art Center, this dream

began to take shape. Working closely with Augusta Savage, who was in charge of both of these ventures, I began to see an ideal acquire bone and sinew. The establishment of the Harlem Community Art Center in a large empty loft at the corner of 125th Street and Lenox Avenue began to symbolize the growth and maturity of this ideal. The coming of eager children to register in the classes, the formation of a sponsoring committee, the long line of visitors from Harlem and from the rest of the country, and the growing enthusiasm among the people who worked in the Center acted like a strong tonic on the entire community.

In January, 1938, when I became acting director of the Center, and later when I was made the director, I found that I had brought to the task a whole set of ideals and ideas born in the minds of many people and deriving from many sources. So impelling were these ideals and so important was the work at hand that individuals willingly identified themselves with the collective will of the many. Many minds became one. As a result, the Harlem Community Art Center is becoming not only a cultural force in its particular locale, but a symbol in the culture of a race. [. . .]

What did the Center's cumulative report show?

First, and possibly the most important fact: 70,592 people by actual count had attended the Center's activities during the sixteen months it had been in operation. Apologies for saying and believing that the Center meets a community need are no longer necessary when facts prove that it has reached an average of more than 4,000 people a month.

And who are these people who have been reached by the Center? Exactly 2,467 children and adults have registered in the art classes. More than 23,989 people have participated in the Center's extension activities, lectures, and demonstrations. Thousands of others come to the Center regularly to see the exhibitions and to attend other special events. [. . .]

Within this rank-and-file sponsorship there exists a genuine consciousness of what the Center means as a necessary stimulant to the development of Negro culture in America.

\* \* \*

More important than all of these things has been the developing philosophy and understanding behind the work of the Center. In each person at work in the Center there has grown a new selflessness and dignity in the performance of the smallest task. A new understanding of the value and meaning of art teaching in the cultural scheme of things has been engraved on the consciousness of every person associated with the Center.

---

**55** ✦ Elizabeth Noble [Elizabeth McCausland], " 'Official Art'," *Art Front* 2, no. 10 (November 1936):8–10.

Elizabeth McCausland wrote regular art criticism for the *Springfield (Massachusetts) Republican* and consistently praised socially concerned painters. For *Art Front* she used the pen name "Elizabeth Noble." In the previous issue of *Art Front,* she had reviewed Holger Cahill's exhibition of Federal Art Project art, *New Horizons in American Art,* then on view

at the Museum of Modern Art. Although enthusiastic about the FAP endeavors, she warned against a bland "official art," or the tendency of artists to self-censor their art: "Perhaps generally there has been an effort to make the conceptions and designs as affirmative in mood as possible. This is natural enough, since the creative spirit does not thrive on constant thoughts of death and frustration. The result in the case of the works of art shown is that they seem gayer and less socially critical than one might have expected in a world where an artist plies his brush and mallet at the price of possible blows from a cop's billy." To McCausland, an artist needs "economic security and permanence of jobs, freedom from needless interruption and diversions of energy, freedom from the mental uncertainty that constant threats to the Federal Art Project cannot help but generate, and most of all freedom freely to observe and record the world. If it is a world of bitter struggle and conflict that the artist observes, he has a right, no, rather he has a duty, to set down the world he sees, not some imagined idyll."

In this review of *Sculpture and Paintings for Federal Buildings,* sponsored by the Treasury Department, then on view at the Whitney Museum of American Art, McCausland focuses on government personnel who foster what she calls a puerile art. She calls for judges more open to new ideas and varied subject matter. In the same issue of *Art Front,* Meyer Schapiro wrote "Public Use of Art," in which he sharpens McCausland's argument, but aims his remarks toward artists.

\* \* \*

[W]hen the economic crisis forced the government to become a patron of art on a far wider scale than ever before, the public began to hope for better times, chiefly because the official promoters of the various government programs spoke so largely of the artistic "renaissance" about to dawn on the country. Therefore the acute disappointment occasioned by the first public showing here of the fruits of the Treasury Department program.

\* \* \*

To be sure, these are but a handful of the 350 artists working throughout the Union in some hundred cities for the Treasury Art Projects. Nevertheless these buildings, located in the national capital and representative of the highest official architectural excellence, indicate what the Treasury wants in the way of art. It certainly does not want art of a radical experimental nature, certainly nothing like the duco-airbrush murals of Siqueiros or the carved brick-painted cement sculptures of Noguchi. It does not want anything as provocative as the cartoons of Gropper; for when this artist works for the government he has to tone himself down and turn out a nice winter country scene, gifted but scarcely his best manner. [. . .]

On the contrary, the government wants from art safe and harmless clichés, allegorical justice triumphing over a fictitious evil. [. . .] Today we have injustice in the cruelest and most brutal forms, racking its victims on the subtlest instruments of torture. We have everywhere the most overt and violent expressions of the crying ills of society. [. . .] The real social commentator in art today must portray his subject with

great objectivity and realism; from the specific instance he may hope to proceed to the general principle. [. . .]

The artist is up against the most difficult question of all, how to find a contemporary statement for a contemporary theme. This is a question not only of aesthetics, but also of social and economic considerations.

It is possible that the government might be able to manage the aesthetics, but certainly it has never been the habit of official groups to encourage consideration of social and economic problems. The chief function of academies and institutes and ecoles dex [sic] beaux arts is to maintain the status quo on the art front. And unfortunately the Treasury Department art projects seem on the way to taking over this function for the United States.

\* \* \*

In all this jeremiad, it must be emphasized that the criticism is not leveled at the artists per se. They obviously could have done much better work than they have been permitted to do. If there are victims of social injustice, the artists might well be numbered among them for having had to bow to the will of the bureaucracy. The criticism here is the same old story, the complaint against a system of art administration and control which puts laymen in power and which permits lay opinion to rule. [. . .]

Plainly, if the United States is to have a permanent section of painting and sculpture . . . it is time for artists and all others who love art to consider seriously in whose hands its guidance should be. [. . .]

---

*56* ✦ Roy Stryker, "Memorandum," dated February 19, 1942, Farm Security Administration. Roy E. Stryker Papers, Special Collections, Ekstrom Library, University of Louisville. [Fig. 3–4]

Roy Stryker directed the photographic section, a unit of the Resettlement Administration (1935–37), then the Farm Security Administration (1937–1942), and the Office of War Information (1942–43). He hired photographers with reputations, such as Ben Shahn, John Vachon, Dorothea Lange, Walker Evans, Arthur Rothstein, Marion Post Wolcott, Russell Lee, Gordon Parks, Marjory Collins, and Jack Delano, for the purpose of documenting the sites and the local people in the areas in which the government planned to, or had already become, involved: resettlement or agricultural New Deal programs. Strycker's section kept a file of the photographs, which were used not only to document the agencies' activities and for news releases, but were also supplied to newspapers and mass-circulated magazines as part of the government's public relations efforts. Once World War II began, the photographs were also used for propaganda purposes to promote the government's role in the war effort.

Stryker had tremendous power—to fashion an image of America that would propagandize the government's economic recovery. The "shooting scripts" he sent out to the field guided the photographers for the government's narrative: before the New

F. S. A.                        ✓

(R. Lee, Arthur Rothstein in Particular)        February 19, 1942

( Midwest and West)

I   Production of foods -- fruits, vegetables, meat, poultry,
                          eggs, milk and milk products, miscellaneous
                          products.

    a.  Packing and processing of above
    b.  Picking, Hauling, sorting, preparing
        drying, canning, packaging, loading
        for shipping
    c.  Field operations -- planting; cultivation; spraying
    d.  Dramatic pictures of fields, show "pattern" of the country;
        get feeling of the productive earth, boundless acres.
    e.  Warehouses filled with food raw and processed, cans, boxes,
        bags, etc.

II  Poultry -- large scale operations
    Hatching, shipping chicks
    Get a few pictures "cute" of little chicks
    Real close-ups
    Eggs - get "pictorial" shots of eggs in baskets, in piles,
        in crates (get pattern pictures for posters)
    Dressed poultry
    Chickens in pens and yards
    Feeding operations

III General farming - get pictures of representative small farms
    (California - Texas) General farming, Buildings, farmer
    & family, farmer at work.

IV  Small town under war conditions
    Select a small town some distance from large cities and make
    a camera study of how this town looks under war conditions.

    Civilian Defense Activities
    Meetings of all kinds -- Red Cross
    Farm Groups, etc.
    Look for a town near an Army Camp
    Signs -- stores, filling stations, etc.
    Selective Service
    Registration of new age groups
    Home gardens, Civilian Defense Activities
    Schools More neighborliness  (Any evidence of this)

V   Auto and auto tire rationing.  A civilian population gets off
    rubber tires.  (Many things should be photographed now before
    disappearance or marked decline)
    Old tires piles.
    Used car lots.  Especially when enormous number of cars are
    stored.
    Signs-any sign which suggests rubber (or other commodity)
    shortage, rationing, etc.  Horse drawn vehicles.  Blacksmith
    shops, harness shops, buggies, delivery wagons, horse drays
    (for trucks) bicycles.

    (What will happen to roadside hamburger stand)  Watch for
    closed filling stations or eat joints.

**Figure 3-4.**   Roy Stryker, "[Memorandum] R. Lee, Arthur Rothstein in Particular,
February 19, 1942." Photograph courtesy Photographic Archives, Special
Collections, Ekstrom Library, University of Louisville, KY.

VI   The Highway

    Watch for any signs which indicate a country at war

    "Man at Work" pictures.  We are still short of these
    pictures.  These should include (1) highway building
    big stuff e.g., in the Rocky Mts. or major highways.
    (2)  Repair and maintenance.
    (3)  Emphasize the men

VII  (for R. Lee)  Mining, California, Arizona, New Mexico

    Get pictures showing increased activities among prospective
    and small operating outfits.
    Mercury -- near San Jose California.  Cement,
    Kaiser's cement plant near San Jose California.
    (See Jack Tolan.  Also Sat. Eve. Post
    article on Kaiser.)

    Miners - faces & miners at work

VIII The land

    The long shots for a "feel" of the country
    Details

IX   People  we must have at once

    Pictures of men, women and children who appear as if they
    really believed in the U. S.  Get people with a little
    spirit. Too many in our file now paint the U. S. as an
    old person's home and that just about everyone is too old
    to work and too malnourished to care much what happens.
    (Don't misunderstand the above.  FSA is still interested
    in the lower income groups and we want to continue to
    photograph this group.)  We particularly need young men
    and women who work in our factories, the young men who
    build our bridges, roads, dams and large factories.

    Housewives in their kitchen or in the yard picking flowers.

    More contented-looking old couples - woman sewing, men
    reading, sitting on porch, working in garden; sitting in
    park; coming from church; at picnics at meetings.

**Figure 3-4.**   *Continued*

**Figure 3-5.**   Russell Lee, *Child Tagged for Evacuation, Salinas,* 1942. FSA-OWI Collection. Photograph reproduced from the Collections of the Library of Congress. Although Stryker admonished Lee and others to shoot "pictures of men, women and children who appear as if they really believed in the U.S.," Lee's photographs (as well as those made by Dorothea Lange and Hansel Meith) of 110,000 Japanese Americans being rounded up and sent to ten "war relocation" camps in 1942 are grim reminders of the government's Executive Order 9066.

Deal stepped in, the Middle West and the South stood for the "not modern"; after the government became involved, those areas became "modern." Above all, people who showed endurance should be photographed. In this script [Fig. 3–4], sent to the attention of Russell Lee and Arthur Rothstein "in Particular," Stryker asks for "Pictures of men, women and children who appear as if they really believed in the U.S. Get people with a little spirit."

Stryker culled over thousands of photographs sent to him from the field and discarded those that did not suit his purposes. The rest went into the active file, which totaled some 77,000 photographs when the section folded and the file was transferred to the Library of Congress.

The "shooting scripts" challenge what is meant by an "objective documentary." Stryker and his photographers gave the country images of Depression experiences, which have come down to us as the "truthful" image of rural America in the 1930s. As the impresario of the Historic Section, he was perhaps more the author/photographer than the person snapping the shutter.

# *Nationalism and Racialism in the Arts as Issues in the 1930s*

## Cultural Nationalism

While artists often painted the landscapes and the people of the United States in the 1930s, as they had in other decades, and dealers such as Edith Halpert of the Downtown Gallery promoted "American scene" painting in order to help artists sell their works, cultural nationalism held less appeal in the 1930s to artists, most of whom were disinclined to celebrate a country in the throes of the Depression. As we have seen in the previous sections, many artists, especially New Yorkers, were instead drawn to the internationalism of Marxism.

The exceptions, such as the supporters of the Regionalists—that is, the midwestern painters John Steuart Curry, Grant Wood, and Thomas Hart Benton—voiced their cultural nationalism in terms of their antimodernism and anti-intellectualism. *Time* magazine, in its December 24, 1934, issue, celebrated the "U.S. Scene" in art in a seven-page layout. *Time* presented a paragraph with their version of American art history:

In 1913 France conquered the U.S. art world. At the famed Manhattan Armory show . . . the U.S. public got its first big dose of the arbitrary distortions and screaming colors which were making France's crop of artists the most spectacular in the world. The War took the public's mind temporarily off art but at its end French artists were sitting on top of the world. U.S. painters, unable to sell at home or abroad, tried copying the French, turned out a profusion of spurious Matisses and Picassos, cheerfully joined the crazy parade of Cubism, Futurism, Dadaism, Surrealism. Painting became so deliberately unintelligible that it was no longer news when a picture was hung upside down.

In the next paragraph *Time* pointed to the painters who would rescue American art from such hated foreign influences:

In the U.S. opposition to such outlandish art first took root in the Midwest. A small group of native painters began to offer direct representation in place of introspective abstractions. To them what could be seen in their own land—streets, fields, shipyards, factories and those who people such places—became more important than what could be felt about far off places. From Missouri, from Kansas, from Ohio, from Iowa, came men whose work was destined to turn the tide of artistic taste in the U.S. Of these earthy Midwesterners none represents the objectivity and purpose of their school more clearly than Missouri's Thomas Hart Benton.

A long biographical sketch on Benton, whom *Time* featured on the cover of the issue and had dubbed the "most virile of the U.S. painters of the U.S. scene," was followed by thumbnail biographies on Charles Burchfield, Reginald Marsh, Curry, and Wood, along with reproductions of all their work.

The assessment of the *Time* writer relies directly on Thomas Craven's *Modern Art: The Men, The Movements, The Meaning,* which had a large print run when published in 1934. Craven's ally was Peyton Boswell, an antimodernist, who published *Art Digest,* a bimonthly New York magazine that reprinted news items and articles clipped from newspapers and contemporary art magazines.

The cultural nationalism of Craven, Boswell, and Benton championed individualism and deplored modernism as well as socialism and communism. The New York modernists and internationalists, many of whom were in the Artists' Union and wrote for *Art Front,* retaliated. They particularly disliked Benton, whose murals contained what they felt were racist and anti-Semitic caricatures. Hence, a spirited exchange took place between the scrappy Stuart Davis, editor of *Art Front,* and the belligerent Thomas Benton, duly reported in *Art Digest.*

## Cultural Racialism

During the early years of the twentieth century "race" was an often vague concept among the non-social science writers; "race" often naively meant the "human race," or it meant a category of people who are born in the same place and grow up together, such as the "American race" as opposed to "the European race." But whenever "Negro race" was raised, the concept sharpened, particularly after the spread of scientific racism and the growth of the eugenics movement. Concepts and theories of race by the scientific racists became the institutional rationales for segregation and discrimination.

"Race" clearly dominated many discussions among African American intellectuals and artists, some of whom focused on the historical experiences of African Americans, others, on the sociological and psychological aspects. Almost all were cautious or ironic about "genetic" characteristics (e.g. "natural rhythm"). Arthur Schomburg, who amassed a large archive of books and papers on African American history and literature for the Harlem branch of the New York Public Library, was known as a "race" man, because he thought about and wanted to educate African Americans about their social and cultural history.

Throughout the 1930s debates about Alain Locke's earlier manifesto (see Reading 35) continued about the usefulness of Africanisms and African art—its forms, its style, its example—to contemporary African Americans.

*57* ✦ Thomas Craven, *Modern Art: The Men, The Movements, The Meaning* (New York: Simon and Schuster, 1934).

Craven was educated at Kansas Wesleyan University. In the mid-1920s he went to Paris where he lived the Bohemian life. Back in New York's Greenwich Village, he tried painting, wrote poetry, and roomed with Thomas Hart Benton. He wrote an unsuccessful first novel and was mentored by the peppery conservative H. L. Mencken, the editor of the *American Mercury.* Craven then began writing art books: *Men of Art* (1931) and *Modern Art* (1934). He wrote regularly for the *New York American,* a Hearst newspaper.

Craven was a vigorously opinionated critic. Early chapters of *Modern Art* indicate his anti-French sentiments (to Craven's credit, he deplored French anti-Semitism); however, entire chapters are devoted to Van Gogh, Gauguin, Matisse, Picasso, and Modigliani. In the last half of the book he hit his stride in his praise for American artists. A vigorous exponent of cultural nationalism, he exhorted American artists "to remain at home in a familiar background, to enter emotionally into strong native tendencies, to have done with alien cultural fetishes." Craven admired John Sloan, Charles Burchfield, John Steuart Curry, and Reginald Marsh, but especially Thomas Hart Benton. To Craven, these artists "are forming the new generation."

\* \* \*

In the United States we enter a new background for the growth of art, and in one respect a unique background. The American is born and bred with no cultural memories in his heart. He is the child of a civilization in which things are built for service, to be scrapped and replaced by more efficient models when the day of their usefulness is over. It follows that he cannot, unless he is a parvenu, be expected to practise art for art's sake, or beauty's sake, or for the sake of any abstraction whatever. But it does not follow that he is left with nothing to paint, and that he must go to Europe for his inspiration. For the genuine artist, America holds an unprecedented variety of experiences, an untilled field of overwhelming richness. [. . .]

There are, at present, American painters who, by trial and error under the stress of genuine interests, are recasting their habits and producing evidence of new forms. But they are few and far between, and assuredly not popular. The majority are content to copy the current mannerisms of Europe, and to sell their souls to international dealers. [. . .]

The American scene is perverted into a technical pattern. Instead of surrendering to the scene and allowing it to modify the pattern, they impose an imported pattern on indigenous materials, with the result that the New Mexican desert resembles the Provençal landscape of Cézanne, and the Indian is chopped into the cubes and cones of Paris.

\* \* \*

Benton, mural painter, draughtsman, anthropologist, and interpreter of the American civilization, falls into none of the neat categories of modern art. To the conservatives, he is a Red; to the radicals, he is a chauvinist. His art is too specifically real, too deeply impregnated with what I shall risk calling *the collective American spirit*, to touch the purists, methodists, and doctrinaires—those whose idealism kneels to international panaceas and European formula. Yet his reputation somehow increases, and he is esteemed by the younger generation of painters as a master. Discerning foreign visitors are startled by the power of his native style—for Benton is American. He has the rawhide individualism, the cynical laugh, the rough humor, the talent for buffoonery, and something of the typical Westerner's sentimental slant on life. And he has, to the full, the American's distrust of ideas divorced from facts, a healthy realism which, whether our social soothsayers like it or not, may carry us safely into a better society.

Benton's art, apparently, is a direct and unblushing representation of American life. The average person regards him simply as a reporter of his time, and is attracted or repelled by the subject-matter which, according to temperament, is true or false, in good taste or bad, commonplace or exceptional. So pronounced and factual are his representations that even those conversant with the intricacies of formal structure tend to overlook his power as a designer.

\* \* \*

What is chaotic in Benton is his modern America, and who can deny the factual and spiritual truth of this aspect of his work? It is my guess that in a more sensibly planned and orderly society of the future, this great drama of lawless change, which he has painted, will stand as one of the supreme arts of the transitional period, and will be valued because it is veracious experience and not futile prophecy. He has painted our capitalist America and the America of the pioneer and the individualist—its history and its current phenomena, all of which he knows and understands. The rushing energy of America, the strength and vulgarity, the collective psychology, are embodied in his art. The subordination of artistic tradition to actual experience with American life has enabled Benton to create the outstanding style in American painting, perhaps the only style.

\* \* \*

From time to time, one hears or reads the criticism that Benton debases America, that his painting is ignoble caricature, an insult to our high ideals and sterling sentiments. These strictures, as a rule, have their origin in the cliques of New York—the indoor esthetes and neuralgic professors to whom art is an excuse for verbal exercise, the display of dead learning, and the cautious manipulation of "advanced" attitudes. Truly, Benton's America is not their world; their America is the sidewalks of New York, the gallery, and the high tea. They will never know anything about America, for they are incapable of entering into any form of American life outside their own little circles. Benton, at home anywhere, goes happily about his business, adding to his fund of knowledge and painting America as he understands and enjoys it. He has not slandered our country, but by the volume, truth, and power of his art, he has done more than his share to discredit the East Side-Harvard school of esthetics.

---

*58* ✦  Stuart Davis, "Reviews: The New York American Scene in Art," *Art Front* 1, no. 3 (February 1935):3.

The first big picture spread that *Time* magazine gave to American art was in its December 24, 1934, issue, in which it reported on "the U.S. opposition to outlandish art" done by American painters who had "cheerfully joined the crazy parade of Cubism, Futurism, Dadaism, Surrealism." *Time* then celebrated the American regionalists, John Steuart Curry, Grant Wood, and Thomas Hart Benton, "men whose work was destined to turn the tide of artistic taste in the U.S." Although *Time* did mention one New York artist, Reginald Marsh, it ignored the lively New York art scene of social realists and modernists.

Davis recognized that behind the *Time* piece was the centrist ideology of Thomas Craven, the critic who excoriated both modernism and socially concerned realism.

◆

. . . The magazine *Time* gives a short resume of the life and work of Thomas Benton, Reginald Marsh, Charles Burchfield, John Steuart Curry, Grant Wood and others. These artists are reported to have in common, first—a passion for local Americana, and second—a contempt for the foreign artist and his influence. They have the "my country right or wrong" attitude and are suspicious of strangers. New-fangled ideas in art are not for them. . . . They demand that the artist paint the American scene, although their works suggest that what they really mean is Hearst's *New York American* scene. They paint burlesque shows, Civil War architecture, the wonderful meals that farm help receives under the New Deal, Mother Nature acting tough in Kansas, and caricatures of Negroes and farmers. . . .

This is the work of the men who, to quote *Time*, "are destined to turn the tide of artistic taste in the United States." They offer us, says *Time*, "direct representation in place of introspective abstractions." Is the well-fed farm-hand under the New Deal, as painted by Grant Wood, a direct representation or is it an introspective abstraction?

Are the gross caricatures of Negroes by Benton to be passed off as "direct representation"? The only thing they directly represent is a third-rate vaudeville character cliche with the humor omitted. Had they a little more wit, they would automatically take their place in the body of propaganda which is constantly being utilized to disfranchise the Negro politically, socially and economically. The same can be said of all people he paints including the portrait of himself which is reproduced on the cover of *Time*. We must at least give him credit for not making any exceptions in his general under-estimation of the human race.

\* \* \*

Painting the American scene is not a new manifestation. George Bellows, John Sloan, Glenn Coleman, John Marin are a few who have done so from their various viewpoints. [. . .] The earlier group, however, had the advantage of not being burdened by the vicious and windy chauvinistic ballyhoo carried on in their defense by a writer like Thomas Craven whose critical values may possibly be clouded by a lively sense of commercial expediency. His efforts to bring art values to the plane of a Rotarian luncheon are a particularly repellent form of petty opportunism and should be so understood and explained whenever one has the misfortune to slip on them. Craven's ideas are unimportant, but the currency given to them through the medium of the Hearst press means that we must not underestimate their soggy impact. Artists are warned not to be complacent in the face of these insults.
[. . .]

The slight burp which this school of the U.S. scene in art has made, may not indicate the stomach ulcer of Fascism. I am not a political doctor, but I have heard the burp and as a fellow artist I would advise those concerned to submit themselves to a qualified diagnostician, other than witch doctor Craven, just to be on the safe side.

***59*** ✦ Romare Bearden, "The Negro Artist and Modern Art,"
*Opportunity* 12 (December 1934):371–72.

Only twenty-three years old when he wrote this article, Romare Bearden was bold enough to mount a critique against the influential Harmon Foundation, which had been supportive of African American artists through exhibitions, purchases, and grants. Although Bearden praised the spirit of the founders in wanting to help young African Americans, he accused the Harmon Foundation of "coddling and patronizing" artists long before they had mastered their techniques and materials.

Bearden reviews attitudes in the 1930s regarding the necessity, or not, of a racialized art. Like Alain Locke, Bearden thought that lessons could be learned from African art, and that "the artist with vision, sees his material, chooses, changes, and by integrating what he has learned with his own experiences, finally molds something distinctly personal." He concludes the essay by calling for an engaged art—one engaged in social issues whether they be race related or not. The issue picked up by other writers is that those "experiences," of which Bearden speaks, ought to include the experience of being black in America.

*Opportunity,* the monthly journal of the Urban League, edited by the sociologist Charles S. Johnson, reproduced the work of African American artists, such as Aaron Douglas.

\* \* \*

Modern art has borrowed heavily from Negro sculpture. This form of African art had been done hundreds of years ago by primitive people. It was unearthed by archaeologists and brought to the continent. During the past twenty-five years it has enjoyed a deserved recognition among art lovers. Artists have been amazed at the fine surface qualities of the sculpture, the vitality of the work, and the unsurpassed ability of the artists to create such significant forms. Of great importance has been the fact that the African would distort his figures, if by so doing he could achieve a more expressive form. This is one of the cardinal principles of the modern artist.

It is interesting to contrast the bold way in which the African sculptor approached his work, with the timidity of the Negro artist of today. His work is at best hackeneyed and uninspired, and only mere rehashings from the work of any artist that might have influenced him. They have looked at nothing with their own eyes—seemingly content to use borrowed forms. They have evolved nothing original or native like the spiritual, or jazz music.

Many of the Negro artists argue that it is almost impossible for them to evolve such a sculpture. They say that since the Negro is becoming so amalgamated with the white race, and has accepted the white man's civilization he must progress along those lines. Even if this is true, they are certainly not taking advantage of the Negro scene. The Negro in his various environments in America, holds a great variety of rich experiences for the genuine artists. One can imagine what men like Daumier, Grosz, and Cruickshanks might have done with a locale like Harlem, with all its vitality and tempo.

\* \* \*

Practically all the great artists have accepted the influence of others. But the difference lies in the fact that the artist with vision, sees his material, chooses, changes, and by integrating what he has learned with his own experiences, finally molds something distinctly personal. Two of the foremost artists of today are the Mexicans, Rivera and Orozco. If we study the work of these two men, it is evident that they were influenced by the continental masters. Nevertheless their art is highly original, and steeped in the tradition and environment of Mexico. It might be noted here that the best work of these men was done in Mexico, of Mexican subject matter. It is not necessary for the artist to go to foreign surroundings in order to secure material for his artistic expression. [. . .]

Several other factors hinder the development of the Negro artist. First, we have no valid standard of criticism; secondly, foundations and societies which supposedly encourage Negro artists really hinder them; thirdly, the Negro artist has no definite ideology or social philosophy.

Art should be understood and loved by the people. It should arouse and stimulate their creative impulses. Such is the role of art, and this in itself constitutes one of the Negro artist's chief problems. The best art has been produced in those countries where the public most loved and cherished it. [. . .]

I am not sure just what form this system of criticism will take, but I am sure that the Negro artist will have to revise his conception of art. No one can doubt that the Negro is possessed of remarkable gifts of imagination and intuition. When he has learned to harness his great gifts of rhythm and pours it into his art—his chance of creating something individual will be heightened. At present it seems that by a slow study of rules and formulas the Negro artist is attempting to do something with his intellect, which he has not felt emotionally. In consequence he has given us poor echoes of the work of white artists—and nothing of himself.

\* \* \*

There are quite a few foundations that sponsor exhibitions of the work of Negro artists. However praise-worthy may have been the spirit of the founders the effect upon the Negro artist has been disastrous. Take for instance the Harmon Foundation. Its attitude from the beginning has been of a coddling and patronizing nature. It has encouraged the artist to exhibit long before he has mastered the technical equipment of his medium. By its choice of the type of work it favors, it has allowed the Negro artist to accept standards that are both artificial and corrupt.

\* \* \*

The artist must be the medium through which humanity expresses itself. In this sense the greatest artists have faced the realities of life, and have been profoundly social.

I don't mean by this that the Negro artist should confine himself only to such scenes as lynchings, or policemen clubbing workers. From an ordinary still life painting by such a master as Chardin we can get as penetrating an insight into eighteenth century life, as from a drawing by Hogarth of a street-walker. If it is the race question, the social struggle, or whatever else that needs expression, it is to that the artist must surrender himself. An intense, eager devotion to present day life, to study it, to help relieve it, this is the calling of the Negro artist.

*60* ✦  Meyer Schapiro, "Race, Nationality and Art," *Art Front* 2, no. 4 (March 1936):10–12.

As a young man Meyer Schapiro studied art at the Educational Alliance in New York. He later studied art history at Columbia University, where he received his doctoral degree. During the early 1930s he reviewed John Reed Club exhibitions, using the pen name "John Kwait," for *New Masses*. In these reviews he urged artists to develop an effective revolutionary art. Schapiro was an independent Marxist, not politically affiliated. Hence, he did not soften his revolutionary critique of art and society during the Popular Front period, as did those critics close to the Communist Party.

In this essay Schapiro sharply relates the issues of race and nationalism to fascism: "The arguments for racial and national peculiarity are supported by the most reactionary groups in America."

In the May 1936 issue of *Art Front*, Schapiro elaborated on his ideas in response to criticism from the artist Jennings Tofel. A shared culture, Schapiro emphasized, is more important than race in determining artistic production. Moreover, "traditional customs and institutions are double-edged; they may serve as the basis for asserting the human capacities of the oppressed group and its claims to political and cultural autonomy. But these customs and traditions may also be a brake on such aspirations; they may teach passivity, conservatism, submission." Schapiro points out the many instances when European colonialists encouraged native art and customs "as a means of retarding the struggle for independence." And finally, to designate nationalism as good or bad merely confuses the issues. Schapiro finishes with a Marxist analysis of the current situation in 1936: "Wars are not due to 'avaricious nations', but to the needs of the dominating classes of capitalist nations; they need new lands for raw materials, for new markets or new fields of investment. Or they fight in order to consolidate their possessions or to maintain a threatened status quo."

Schapiro's thesis should be kept in mind when reading the section "Identities Unmasked" in Chapter 7.

✦

Many artists agree as a matter of course that the art of a German must have a German character, of a Frenchman, a French character, of a Jew, a Jewish character. They believe that national groups, like individual human beings, have fairly fixed psychological qualities, and that their art will consequently show distinct traits, which are unmistakable ingredients of a national or racial style. They assume that French art throughout its long history is distinguished from all of German art by qualities of elegance, tastefulness, formality, which no German can ever acquire, unless he has French blood; and, similarly, they attribute to German art a necessary violence, exaggeration, fantasy, realism and irrationality, which are repugnant to French taste.

Such distinctions in art have been a large element in the propaganda for war and fascism and in the pretense of peoples that they are eternally different from and superior to others and are therefore, justified in oppressing them. The racial theories

of fascism call constantly on the traditions of art; its chief emblems are drawn from ancient motifs of ornament. [. . .]

From such views important consequences are drawn for American art and society. It is taught that the great national art can issue only from those who really belong to the nation, more specifically, to the Anglo-Saxon blood; that immigration of foreigners, mixture of peoples, dilutes the national strain and leads to inferior hybrid arts; that the influence of foreign arts is essentially pernicious: and that the weakness of American art today is largely the result of alien influences.

These opinions are only part of a larger view of American society as a whole, a view which condemns Negroes, Indians, Japanese, Mexicans, Jews, Italians, and Slavs, as inferior elements, and which justifies their oppression as an economic and cultural necessity of the dominant "race." As political reaction grows, every argument which supports the notion of fixed racial and national differences, acquires a new relevance. It provokes powerful divisions within the masses of the people, who are becoming more articulate and aggressive in their demands for a decent living and control over their own lives. The basic antagonism of worker toward capitalist, debtor toward creditor, is diverted into channels of racial antagonism, which weakens and confuses the masses, but leaves untouched the original relations of rich and poor. A foreign enemy is substituted for the enemy at home, and innocent and defenseless minorities are offered as victims for the blind rage of economically frustrated citizens. The defenders of existing conditions are enabled to stigmatize as un-American, and therefore useless to the United States, whatever successful efforts the workers and farmers of other countries have made in the struggle for their own well-being. No wonder that the arguments for racial and national peculiarity are supported by the most reactionary groups in America.

But many liberal, and even radical, artists who uncompromisingly reject nationalism, share the belief in fixed racial or national characters in art. It permits an easy explanation of the differences in the arts of modern peoples. It enables one, in ignorance of the complexity of factors which determine the forms of art, to refer the art of a country to a permanent local character, as one refers a single work to the personality of its author. The artist unconsciously supports the very theories which will threaten his artistic independence. He may denounce the view that Negroes and Jews are inherently inferior to Europeans, but he accepts the distinctions between Negro, Italian, German and French art as a matter of permanent psychological traits.

There are Negro liberals who teach that the American Negro artist should cultivate the old African styles, that his real racial genius has emerged most powerfully in those styles, and that he must give up his effort to paint and carve like a white man. This view is acceptable to white reactionaries, who desire, above all things, to keep the Negro from assimilating the highest forms of culture of Europe and America. It is all the more dangerous because it appears on first thought to be an admission of the greatness of African Negro art, and therefore favorable to the Negro. But observed more closely, it terminates in the segregation of the Negro from modern culture. African Negro art is the product of the past conditions of African tribal life. To impose such an art on the modern American Negro is to condemn him to an inferior cultural status. Moreover, the modern Negro, whether

African or American, could not possibly reproduce the classical African art; he could turn out only inferior pastiches, like the European fakers who fabricate pseudo-African sculpture for ignorant tourists.

The conception of racial or national constants in art, considered scientifically, has three fatal weaknesses.

In the first place, the empirical study of the art of highly civilized countries during a long period of time has shown beyond question that great historical changes in society are accompanied by marked changes in the character of the arts. Because of the real historical diversity of styles within a single nation, its art cannot be significantly described by a dominant or constant psychological trait.

* * *

In the second place, the character of an art at a given moment cannot be said to reflect the psychology of a whole people or nation; it reflects more often the psychology of a single class, the class for which such art is made, or the dominant class, which sets the tone of all artistic expression. Thus the art of German peasants in the 18th century is more like that of French peasants than the art of German noblemen. And, in turn, the art of German noblemen is closer to that of the French court than the latter is to the art of French peasants. We see in such examples how crucial are the specific social and economic differences, how they obliterate the supposed racial and national constants.

* * *

The writers who try to explain modern art as the evil work of the Jews, attack Jewish intellectualism as the cause of abstract art, Jewish emotionalism as the cause of expressionistic art, and Jewish practicality as the cause of realistic art. This ridiculous isolation of the Jews as responsible for modern art is of the same order as the Nazi charge that the Jews as a race are the real pillars of capitalism and also, at the same time, the Bolsheviks who are undermining it.

The third defect of racial interpretations of art lies within the very concept of race. The idea of a pure race is a myth scorned by honest anthropologists. [...] The differences between the cultures of primitive and civilized peoples today are more adequately explained by differences in natural environment, by historical circumstances, by the effects of favorable and limiting conditions. Psychological tests have revealed no significant inherited inferiority of the so-called backward peoples.

[...]

What unites these artists stylistically is the common culture in which they grew up and produced their art. It is more important to recognize that Monet, Sisley, Degas and Pissarro were the sons of merchants, and that all four painted for Parisian society in the last third of the nineteenth century, than it is to observe the shapes of their skulls or noses or to determine their ultimate racial origin.

If this analysis is correct, then we must denounce appeals for an American art which identify the American with a specific blood group or race, or which identify American art with supposedly fixed and inherent psychological characters inherited from the past. [...]

On the other hand, it is evident that the effort to create art in America will proceed from the conditions of life in this country, conditions which, far from being sta-

ble or uniform, are varied and in constant change. The American character is as varied as the American scene. The conception of what is or should be American is determined in the last analysis by the history, tradition, means, interests and mode of life of the different classes in society.

<div align="center">* * *</div>

Such an art will be uniform or varied, not because there is only one race or there are many races, but according to the nature of social life—uniform to the degree that social and economic differences have been destroyed, varied to the degree that regional, occupational and individual differences have real liberty of expression.

---

# Chapter Four

## 1940s to Mid-1950s

### Cultural and Historical Context for
### World War II and the Cold War

The United States was gearing up for defense even before the Japanese air force attacked Pearl Harbor in Honolulu, Hawai'i, on December 7, 1941. Europe had been at war since September 1939; in Asia Japan had invaded Manchuria and was at war with China. Hence, even though the United States entered the war over two years later, armaments and munitions were under production to help the Allies. This burst of industrial activity effectively pulled the country out of the Depression and eliminated the need for such programs as the Works Progress Administration. After severe cutbacks, the Federal Art Project came to a close in 1943.

Artists had a wide range of responses to the war and its immediate aftermath. Many of the American Scene painters and the socially concerned realists and expressionists of the 1930s, those who did not serve in the armed forces, continued representational painting during the war years, with occasional references to the conflict. Other artists at home, such as Jackson Pollock and Arshile Gorky, began to shift toward a surrealizing abstraction, influenced by European artists who had immigrated to New York in the 1930s and early 1940s. These Europeans included the abstract modernists Hans Hofmann, Josef Albers, Piet Mondrian, Laszlo Moholy-Nagy, Fernand Léger, Amadée Ozenfant, and Naum Gabo, as well as the surrealists Salvador Dali, Max Ernst, Kurt Seligmann, Yves Tanguy, and André Masson. Add to this roster Roberto Matta, the Chilean surrealist who came to New York in 1939, who frequented art circles. He, like others, experimented with automatism—the attempt to paint automatically as if inspired only by the subconscious.

Artists who joined the armed forces and went overseas found limited opportunities to make use of their artistic skills, although some found assignments in the graphic departments of the armed services and made signs, designed camouflage, and produced propaganda art. Most artist-soldiers were simply GIs (derived from "government issue") absorbing the experiences of basic training, shipping out, trench warfare, and the liberation of towns, villages, and cities from the Axis forces. Some even took the opportunity at war's end, as Philip Pearlstein did, to study Old Master painting and sculpture in the European churches that survived.

The full horror of the war and the Nazi nationalist and racist program, however, did not hit most American civilians until Margaret Bourke-White's photographs of the liberation of Jewish prisoners from the Buchenwald concentration camp appeared in *Life* magazine shortly after the Allies achieved victory in Europe in May 1945. Images of heaped corpses in the alleyways of the camps and of emaciated victims staring at their liberators through barbed-wire fences were seared into the collective consciousness of Americans. Equally horrifying were accounts and pictures of the U.S. atomic bombing of Hiroshima and Nagasaki on August 6 and 9, 1945. For the first anniversary of the Hiroshima bombing, John Hersey wrote on the experiences and responses of civilians living in Hiroshima—an essay which filled the August 31, 1946, issue of *The New Yorker.* Hersey's remarkable narrative wove together the subjective impressions of six survivors with the raw physical facts of the leveling of all buildings and all forms of life at ground zero, statistics of the human toll, and medical descriptions of radiation sickness. The potential destructiveness of the atomic age had been made viscerally clear.

By the end of the 1940s it became clear also that a new war, the Cold War, had brought a new set of tensions to American culture. Old antagonisms between the capitalist and communist countries intensified. In March 1946 Winston Churchill gave his famous "iron curtain" speech in Fulton, Missouri. In June 1948 the Soviets blockaded all exits from Berlin; the United States and Britain responded with the Berlin air lift, until the blockade was lifted in May 1949. By 1949 Mao Zedong and Communist forces had triumphed over Chiang Kai-shek in China; also in 1949 the USSR exploded an atomic bomb. In 1950 the United States entered the Korean War, which lasted until 1953.

These international strains were intensified on the domestic front. In March 1947 President Harry Truman signed Executive Order 9835, which denied government jobs to communists and those associated with them. The House Committee on Un-American Activities (HUAC), which had become a permanent committee in 1945 charged with investigating "subversives," moved into high gear. HUAC collected a file of over a million names of suspects considered to be communists, "fellow travelers," "dupes," and "bleeding-heart liberals." In December 1948, Alger Hiss, an employee of the State Department, was indicted on two counts of perjury on the basis of Whittaker Chambers's testimony that Hiss had been spying for the Russians. After two trials Hiss was found guilty and sent to prison in January 1950. HUAC also conducted public hearings on "communism" in the film industry; and alleged that communist ideas were being smuggled into mass-audience films. Congress charged ten writers, who had refused to testify, with contempt and sent them to prison; the first two began serving their sentences in June 1950. Senator Joseph McCarthy (Wisconsin, Republican) and his Senate investigations subcommittee made similar investigations into alleged communist activity in the State Department and the Army. McCarthy's outspoken accusations continuously made headlines in the nation's newspapers.

Erik Barnouw, in *Tube of Plenty: The Evolution of American Television* (1975), described the political climate, where talented people lost their jobs and their friends overnight: "Hollywood entered a period of fear. Political discussion tended to vanish, but silence itself could seem suspicious. The patrioteering speech was much in evidence. A blacklist developed."

**Figure 4-1.**   Philip Guston, *If This Be Not I,* 1945. Oil on canvas, 42 $\frac{3}{8}$ × 55 $\frac{1}{4}$ in. Collection Washington University Gallery of Art, St. Louis. University Purchase, Kende Sale Fund, 1945. Photograph Courtesy McKee Gallery, NY. *Life* magazine featured Guston, "Carnegie Winner's Art Is Abstract and Symbolic," in its May 27, 1946, issue. *Life'*s caption for this painting read in part: "With the semisymbolism which Guston often uses, he shows children at play, wearing masks to emphasize the child's wish to get away from reality." Themes of masked children, carnivals, and labyrinths were common among artists of the post–World War II period.

At the same time, the literature, philosophical outlook, and language of European existentialism began to attract intellectuals to its view that human existence precedes human essence. In other words, the conditions under which people live will determine their character and world outlook. To existentialists, our essential nature was one of alienation, a condition universal to all men and women. In her study, *The New York School: A Cultural Reckoning* (1972), Dore Ashton drew the connection between the acceleration of anticommunism and the attraction of existentialism:

> As such sensational events as the Alger Hiss case swept the red scare into prominence, and as McCarthy easily destroyed the solidarity of the professionals he attacked, the malaise of the intellectuals deepened. Silence fell. Marxism, which had once been so vital to artistic discourse, faded into the background of new discussions of existentialism. The old conflict between individualism and the collective ethic was interiorized.

Social issues and collective goals were deemed too dangerous or were rationalized into the background as less pressing than personal and psychological self-awareness. Freud,

and to a lesser extent Jung, replaced Marx, while Jean-Paul Sartre and Albert Camus supplied the Western intelligentsia with a new rhetoric of despair.

Meanwhile, business and industry were booming, suburban tract homes sprang up, television stations spread across the country, and home appliances came off the assembly lines in increasing numbers. Henry R. Luce, the founder of *Time, Fortune,* and *Life,* had declared in an editorial in the February 17, 1941, issue of *Life* that the world was entering the era of "the American Century," and he forecast that Americans would lead in an international free-market economy. In the 1950s Luce's forecast seemed a reality. But the rising prosperity tended further to alienate many artists inclined to see a society wallowing in philistinism.

The Truman administration focused on situating the United States in a position of leadership. Truman realized that the Cold War in Europe could not be won by the threat of mass destruction alone. To secure hegemony on the international scene, the United States needed to ensure that Europe became a viable customer for American goods. Through the Marshall Plan, known as the European Recovery Program, the United States pumped over $13 billion into Europe between 1948 and 1951. Such largesse was meant to promote capitalism and stem the spread of communism.

The United States also got into the culture business. By executive order in 1946 a new agency was created within the State Department—the Office of International Information and Cultural Affairs, later to be called the United States Information Agency (USIA). This office merged the responsibilities of the Office of War Information, the Coordinator of Inter-American Affairs, and the Division of Libraries and Institutes. USIA encouraged cultural exchanges and sent exhibitions abroad during the 1950s and 1960s. Eventually the Museum of Modern Art took over the organizing of exhibitions to travel overseas. Porter McCray, who directed the International Program for MoMA, circulated exhibitions of paintings not considered political, including *The New American Painting,* which went abroad in 1958-1959.

Arguments were advanced by Alfred H. Barr, Jr. and others to pacify anticommunists opposed to featuring abstract art in cultural exchanges. The main argument offered to the media was that abstract art better expressed the "freedom" existing in democratic countries like the United States, where artists were free to do as they wished in art. In other words, the very fact that American artists were "free" to paint abstractly marshalled evidence that the American capitalist system was superior to the Soviet communist system.[1]

Against this background abstract painting and sculpture came to dominate the late-1940s and 1950s international artworld, by then located in New York. But this did not happen overnight. The selections in this chapter chart that transition, from surrealizing and expressionist abstraction to "pure" abstract painting and nonobjective forms in sculpture. Realist and expressionist figurative painting and sculpture continued, but those artists found it more and more difficult to find galleries and to exhibit. Although socially concerned art was also made—especially by African American artists—such works had a

---

[1]See, for example, Alfred H. Barr, Jr., "Is Modern Art Communistic?" *The New York Times Magazine* (December 14, 1952):22–23, 28–30. See also Serge Guilbaut, *How New York Stole the Idea of Modern Art: Abstract Expressionism, Freedom, and the Cold War,* 1983.

specialized clientele and were not often shown in the trend-setting Madison Avenue art galleries or reviewed in the big New York newspapers.

# *Critical Responses: The Transition to Abstract Expressionism and "Pure" Painting*

Critics Clement Greenberg and Harold Rosenberg became the New York School's most influential supporters, joined by Thomas Hess, editor of *Art News*. Meyer Schapiro, who taught medieval art at Columbia University and was on friendly terms with many artists and dealers, also turned his intellectual insights toward a defense of the new abstract art. Alfred H. Barr, Jr., and Dorothy C. Miller, who curated the major shows of abstract art at the Museum of Modern Art, gave the art international visibility.

Greenberg's influence lasted longest, in part because he developed a coherent, if narrow, theory of modernism that provided a set of criteria with which to evaluate abstract art. As Charles Harrison has observed in his essay, "Modernism and the 'Transatlantic Dialogue,'" (*Pollock and After: The Critical Debate*, ed. Francis Frascina, 1985): "However one moralises the development of Greenberg's criticism through the late thirties into the fifties, it has to be said that no art critic at the time did more to preserve the integrity of the modern tradition." Harrison then adds: "But it has also to be said that a high price was paid. . . . The more troubling restrictions which were imposed upon criticism by Greenberg's relatively systematic Modernism were these: firstly that aesthetic judgements had to be represented as involuntary and disinterested; and secondly that consideration of the causal conditions of art had to be largely restricted to a consideration of artistic causes as the only cognitive ones—at least for the purposes of criticism itself."

Unreceptive to realist painting, pop art, and other experimental forms, Greenberg nevertheless maintained his influence into the 1960s. Others, such as critics Rosenberg, Hess, Dore Ashton, Brian O'Doherty, and Robert Coates, wrote without Greenberg's formalist theoretical apparatus. Artist Fairfield Porter and the poet Frank O'Hara also wrote with a heightened sensitivity toward the art of the postwar period. Art historian Leo Steinberg, who wrote for *Arts* in the 1950s, was one of the first to challenge Greenberg's theories in public lectures in the late 1960s; Steinberg's collected essays were called, significantly, *Other Criteria* (1972). The early writings of Michael Fried, Rosalind Krauss, and Barbara Rose followed the lead of Greenberg, although all three eventually moved away from the older critic's influence. Fried has openly acknowledged ("An Introduction to My Art Criticism," *Art and Objecthood: Essays and Reviews*, 1998), that "Greenberg's writings provided the framework within which my own thought gradually found its voice."

## A Historiography of Abstract Expressionism

Although this reader focuses on writings contemporaneous with the art of its time, mention needs to be made of the ongoing fascination shown by writers, critics, and art historians since the 1960s toward the phenomenon of abstract expressionism.

The first art history book to celebrate the movement was Irving Sandler's *The Triumph of American Painting: A History of Abstract Expressionism* (1970), which looked at the art of the period from the mid-1940s to the early 1950s in terms of the artists' intentions. Kenworth Moffett, in his review of Sandler's book for *The Art Quarterly* (Autumn 1972), brought up what he saw as telling differences in the abstract expressionist movement—differences that Moffett maintained were neglected and hence had skewed Sandler's art historical assessment. Moffett's reflections are worth repeating at length:

> Abstract Expressionism is unique among modern art movements in having elicited diametrically opposed interpretations of its genesis, nature and importance. These two approaches are reflected in the name "Abstract Expressionism" itself. The expressionist reading, by far the most popular and the one which accompanied the full emergence of the movement in the 1950s, was put forward by such critics as Harold Rosenberg and Thomas Hess, and indeed by many of the artists themselves. This view held that Abstract Expressionism was a response to "crisis" in values and that a search for "subject-matter" determined its evolution. Surrealism is stressed as the central influence shaping the new style, as helping to foster the new importance given to "subject-matter" in abstract art: subject or content, according to this reading, is a means of re-establishing a lost contact with the unconscious, an existential self-revelation, or the expression of a transcendental, abstract sublime. Emphasizing a break with European modernism, such criticism has tended to be poetic and evocative in an effort to get at the "content" of the art it discusses.

Indeed, what strikes the reader today is the use of an expressive language by Rosenberg and Hess that continually heroicizes the individual painters and their works.

Moffett then goes on to capsulize the Greenbergian view:

> The opposing view, simultaneously championed by Clement Greenberg in the fifties, gained far greater acceptance in the 1960s. Here the "abstract" side is concentrated on, and in place of "expressionism" the more neutral "painterliness" is substituted. Stress is placed on the direct continuity of Abstract Expressionism with French modernism and particularly Cubism. . . . Automatism is not so much a means of exploring the unconscious or of revealing inner truth as a stimulus to formal invention. The development of Abstract Expressionism itself is discussed mainly in terms of a series of formal innovations. . . .

Moffett's remarks need to be kept in mind as one reads the major essays of the period.

In 1980, curator Phyllis Rosenzweig organized an exhibition, *The Fifties: Aspects of Painting in New York* for the Hirshhorn Museum and Sculpture Garden in Washington, DC. Her catalogue essay focuses on the critical writing of the fifties—a criticism that continued into the 1960s—and charts the shift away from the language of Thomas Hess, Harold Rosenberg, and Alfred Barr, which sought to emulate the expressive qualities of 1950s paintings, and toward a formalist language, associated with Clement Greenberg, Michael Fried, and Moffett himself. Along with this shift came the shift from "abstract expressionism" to "New York School," a term which seemed more inclusive—even if it left out artists from other parts of the country.

Dore Ashton in *The New York School: A Cultural Reckoning,* 1972, offered the first serious contextual study of the New York School. Also in the early 1970s, articles appeared that problematized the "triumph" of American painting, relating that "triumph" to the Cold War political climate. Articles published by William Hauptman, Max Kozloff, and Eva Cockcroft in *Artforum* in 1973 and 1974 sparked controversies. Serge Guilbaut's, *How New York Stole the Idea of Modern Art: Abstract Expressionism, Freedom, and the Cold War,* 1983, the first full revisionist history of the period, also drew heated fire; Robert Asahina, writing for *Art and Antiques* (March 1984) called Guilbaut's study a "fairy tale."

None of these recent and embattled revisionist writers maintained that it was *only* Cold War politics that gave the New York School a privileged spot in the canon of American art. Such revisionist interpretations have not detracted from what was, and will always remain, a major art movement; they have just enriched our respect for the contradictions and complexities of cultural and art history.

*61* ✦ Clement Greenberg, "Abstract Art," *The Nation* 158 (April 15, 1944):450–451.

Clement Greenberg developed as a critic in New York during the 1930s and became associated with the independent, left-wing journal, *Partisan Review.* His most famous essays for the journal, "Avant-Garde and Kitsch" (1939) and "Towards a Newer Laocoon" (1940), set the terms of the debate about the avant-garde and modernism for years to come.

Given the context of the issues of the very late 1930s and early 1940s, in which left-wing writers urged artists to align themselves with the political struggles of the working class (see Chapter 3), Greenberg's 1939–40 essays provide a noteworthy contrast. 1) He offers a determinist reading of the historical relationship of artists to their patrons—the cultivated elite within the bourgeoisie. (In "Avant-Garde and Kitsch" he observes that the avant-garde "has always remained attached by an umbilical cord of gold" to this cultivated elite.) 2) He accepts the artist/private patron situation at the very time when left-wing artists hoped to establish a permanent government Art Project (thus freeing themselves from the arbitrary taste and/or ideological demands of an élite bourgeoisie). 3) He theorizes that the avant-garde's acceptance of that élite-patron situation leads away from "subject matter or common experience" and toward "art-for-art's sake" (as a strategy of resistance toward bourgeois manipulation). 4) He excoriates "kitsch"—the commercial, popular art and ersatz culture that, to Greenberg, has been forced on the masses by the ruling classes. To Greenberg, "Kitsch is the epitome of all that is spurious in the life of our times. Kitsch pretends to demand nothing of its customers except their money." Taking a swipe at academic art training, he adds: "Self-evidently, all kitsch is academic, and conversely, all that's academic is kitsch."

Greenberg wrote art criticism for *The Nation* during the 1940s. Visits to galleries and artists' studios afforded him the opportunity to test his ideas about the direction of contemporary art. Although Greenberg's most frequently anthologized essay on modernism is "Modernist Painting" (1961), published in *Art and Literature* 4 (Spring 1965), this essay, "Abstract Art," encapsulates a major theme of his criticism—that painting is self-referential: "Let painting confine itself to the disposition pure and simple of color and

line, and not intrigue us by associations with things we can experience more authentically elsewhere."

The reader might want to compare Greenberg with Willard Huntington Wright, who voiced the same ideas in his foreword to *Modern Painting* (1915) (see Reading 5). Like Wright, Greenberg sees the history of art as teleological, with the trajectory from Renaissance realism and representational art to present-day abstract art, which, he concludes, is "the most ambitious and effective pictorial art of these times." Such statements came to have enormous influence on painters, sculptors, and a generation of critics. The author recommends for further reading: Clement Greenberg, *The Collected Essays and Criticism,* 4 vols. John O'Brian, ed. (Chicago: University of Chicago Press, 1986–1993).

<hr />

The full significance of the revolution in Western painting during the last sixty years will not become apparent for some time. But that part of its meaning which concerns the concrete medium itself is already plain. It is only necessary to put it in historical perspective.

The previous great revolution in Western painting led from the hieratic flatness of Gothic and Byzantine to the three-dimensionality of the Renaissance. Its stimulus was a fresh awareness of space provoked by expanding economic and social relations in the late Middle Ages and by the growing conviction that man's chief mission on earth is the conquest of his environment. The immediate problem in painting was to fit the new perception of depth and volume into the flatness of the picture surface; the less obvious though more difficult and crucial problem was to synthesize depth, volume, and surface in both dramatic and decorative unity. Within the conservative format of the wall painting, Giotto created a synthesis which, through simplification of shapes and surfaces and the exclusion of small detail, made his murals hieratic and decorative, yet at the same time dramatic and three-dimensional. The profane appetite for the round was disciplined, volumes were inflated at low pressure to acknowledge the flatness of the wall, and the background was pushed no deeper than the backdrop on a stage.

The Sienese a little later arrived at perhaps an even more conservative synthesis in the altar piece and easel picture. Sassetta subordinated three-dimensionality to decorative principles borrowed from the Gothic or Oriental miniature. The format of his *Journey of the Magi*—in the recent Griggs bequest to the Metropolitan—is surprisingly small: the spectator has to get close enough to *read* it. Against a neutral-toned background in low relief, color is picked out in a staccato pattern of flat notes by forms handled with a slight attempt at volume. The drawing is fairly correct, but the claims of correctness are not allowed to interfere with the decorative function of line. For the moment Sassetta's art has arrested the transition, having found a style in which the artist is fairly sure of saying exactly what he wants to. This contrasts with the insecure style of another fifteenth-century Sienese, Giovanni di Paolo, in his *Presentation in the Temple* (in the Blumenthal bequest to the Metropolitan), where the old tradition of the Gothic and Oriental miniature is shown in outright conflict with the new one of naturalism. The flat, shallow, but richly detailed architectural background does not provide room for the figures in the foreground; the sculptural modeling of their garments

bulges from the picture surface and creates an effect of overcrowding. In his figures Giovanni has explored the illusion of the third dimension farther than Giotto, but since his background is even more strictly two-dimensional, he has failed to attain either structural or decorative unity.

With the aid of the flexible medium of oil, the conflict between three-dimensional form and the plane surface was resolved finally by the annihilation of the second. The Italian or Flemish painter of the fifteenth century managed so to immerse himself in the illusion of the third dimension that he instinctively conceived of his canvas as a transparent rather than an opaque surface. Yet some of the difficulty of controlling the emphasis on volumes still remained. There was a tendency to insist simultaneously on the brilliance of surface which oil permitted and on highly sculptural modeling, a combination often too rich. But the Quattrocento was preoccupied with techniques and the accumulation of data: its painters preferred, for instance, to portray old people because their faces offered more details to the brush. They had not yet reached that point of repletion at which there is a readiness to sacrifice and simplify for the sake of large effects.

It was only toward the close of the fifteenth century and in the sixteenth that Verrocchio, Leonardo, Perugino, Raphael, Michelangelo, Correggio, Giovanni Bellini, Giorgione, and Titian perfected means of consistently achieving structural, tonal, and decorative unity in three-dimensional painting. These were—aside from scientific perspective, which could disorganize as well as organize a picture—the indication and ordering of the illusion of vacant three-dimensional space which forms interrupt (Raphael), the subordination of local color to a dominant tone or key, and the patterning of shade and light. It was necessary to believe enough in the illusion of depth to organize elements within the illusion and at the same time to suspend the illusion sufficiently to see them as the flat forms they are in physical reality. But the tendency was to forget almost all about the last, and thus there was a loss involved here as well as a gain. Post-Renaissance painting sacrificed too many of the qualities intrinsic to its medium. Pictures were organized too exclusively on the basis of the illusionist effect and with too little reference to the physical conditions of the art.

The nineteenth century began to dissolve the facts and make obsolete the general conceptions under which illusionist art had functioned. It came to be realized that the earth could no longer afford to Western man, or his economy, indefinite space in which to expand; that verified facts were the only certainties; that each of the activities of culture could be exercised with assurance only within its own province and only when that province had been strictly defined. The age of specialization and of limited intellectual and spiritual objectives sets in—after Hegel, for instance, philosophers stopped constructing world systems.

And with Manet and Courbet Western painting reversed its direction. Impressionism pushed the faithful reproduction of nature so far that representational painting was turned inside out. Incited by a positivism borrowed from science, the impressionists made the discovery—stated more clearly in their art than in their theories—that the most direct interpretation of visual experience must be two-dimensional. The new medium of photography helped provide evidence for that. Sensations of a third dimension are not given by sight *qua* sight but by acquired associations with the experience of movement and touch. The data of sight, taken most

literally, are nothing but colors. Notice, therefore, how a flatness begins to creep into impressionist paintings, how close to the surface they stay, in spite of "atmospheric perspective," and how openly the physical nature of the canvas and of the paint on it is confessed—by way, too, of emphasizing the difference between painting and photography.

The successors to impressionism have made all this more explicit. Painting, become anti-idealist, has surrendered itself once more to the literal plane surface. Correctness of drawing, black-and-white chiaroscuro, three-dimensional light effects, atmospheric and linear perspective, etc., etc., have been progressively, though not consistently, eliminated. The uniformly smooth and transparent surface behind which the picture used to take place has been made the actual locus of the picture instead of its window pane. To acknowledge the brute flatness of the surface on which he was trying to create a new and less deceptive illusion of the third dimension, Cézanne broke up the objects he depicted into multiplicities of planes that were as closely parallel as possible to the canvas's surface; and to show recession, the planes were stepped back with comparative abruptness—even the receding edges of objects keep turning full-face to the spectator like courtiers leaving the presence of royalty. Furthermore, Cézanne's parallel, roughly rectangular touches of the brush echo the outline of the canvas. And it was the new realization of the importance of every physical factor that also compelled the distortions of his drawing, and of Van Gogh's and Gauguin's—determined just as much by the tensions between the frame of the picture and the forms within it as by expressive compulsions. There were still other ways in which the physical nature of the medium and the materialism of art were asserted: pigment was sometimes applied so thinly that the canvas showed through, or it was piled in such impastos that the picture became almost a kind of relief. (There was a paradox in the fact that both Van Gogh and Gauguin were trying to rescue painting from the materialism into which they accused the impressionists of having sunk it.)

The Fauves, early in the first decade of this century, constructed pictures with flat, high-keyed color which was arbitrary in any representational sense and more or less dissociated from contour. Cubism, parodying by exaggeration the traditional methods of rendering volume and light in a despairing effort to restore the third dimension by Cézanne's method, finished by annihilating the third dimension; resulted in paintings that were completely flat—and thus accomplished the counter-revolution in principle. Picasso, Braque, Gris, and the others through whose art cubism evolved refused to accept its ultimate conclusions, and once they had arrived at pictures from which the identities of objects had disappeared, they did an about-face and returned to representation; other artists, however, later on accepted in full the logic of cubism and became outright abstractionists, resigning themselves to the non-representational and the inviolability, more or less, of the plane surface. With a speed that still seems amazing one of the most epochal transformations in the history of art was accomplished.

The deeper meaning of this transformation is that in a period in which illusions of every kind are being destroyed the illusionist methods of art must also be renounced. The taste most closely attuned to contemporary art has become positivist, even as the best philosophical and political intelligence of the time. Fiction, under which illusionist art can be subsumed, is no longer able to provide the intensest aesthetic experience.

Poetry is lyric and "pure"; the serious novel has become either confession or highly abstract, as with Joyce and Stein; architecture subordinates itself to function and the construction engineer; music has abandoned the program. Let painting confine itself to the disposition pure and simple of color and line, and not intrigue us by associations with things we can experience more authentically elsewhere. The painter may go on playing with illusions, but only for the sake of satire. If he finds the limited depth of the plane surface too confining, let him become a sculptor—as Arp, originally a painter, has done.

But even as a sculptor the artist can no longer imitate nature. There is nothing left in nature for plastic art to explore. The techniques of art founded on the conventions of representation have exhausted their capacity to reveal fresh aspects of exterior reality in such a way as to provide the highest pleasure. But the trouble lies also with exterior reality itself. Byzantine art was abstract in tendency because it subordinated exterior reality to a dogma. In any case reality was not appearance. Naturalist art submits itself to appearance; if any dogma is involved it flows from appearance and appearance is assumed to be the true and the real. Today we know that the question of what a corporeal object is can be answered in many different ways, depending on the context, and that appearance is only one context among many, and perhaps one of the less important ones. To give the appearance of an object or a scene at a single moment in time is to shut out reference to too many of the other contexts in which it simultaneously exists. (And have not science and industry dissolved the concept of the entity into the concept of a process?) Instead of being aroused, the modern imagination is numbed by visual representation. Unable to represent the exterior world suggestively enough, pictorial art is driven to express as directly as possible only what goes on inside the self—or at most the ineluctable *modes* by which that which is outside the self is perceived (Mondrian).

Painting approaches the condition of music, which according to Aristotle is the most direct and hence the most subjective means of expression, having least to do with the representation of exterior reality. The gain that helps cancel the loss entailed by the restriction of painting and sculpture to the subjective lies in the necessity that painting become, in compensation, all the more sensitive, subtle, and various, and at the same time more disciplined and objectivized by its physical medium.

Art is under no categorical imperative to correspond point by point to the underlying tendencies of its age. Artists will do whatever they can get away with, and what they can get away with is not to be determined beforehand. Good landscapes, still lifes, and torsos will still be turned out. Yet it seems to me—and the conclusion is forced by observation not by preference—that the most ambitious and effective pictorial art of these times is abstract or goes in that direction.

---

**62** ✦ Harold Rosenberg, "The American Action Painters," *Art News* 51, no. 8 (December 1952): 22–23, 48–50. © 1952 ARTnews L.L.C.

Harold Rosenberg was hired as a muralist on the Federal Art Project of the WPA during the 1930s and often wrote on art for *Art Front*. His essay "The Wit of William Gropper" for the March 1936 *Art Front* argued that not one painting would necessarily lead toward a "revolutionary conclusion," but that a "picture-world [the oeuvre of one painter or the

collection of many painters], as an entirety, deflects the mentality of society in one direction or another." Rosenberg, no doubt, believed that the "picture-world" of gestural abstract art of the 1950s was also deflecting the artworld toward greater "liberation from Value—political, aesthetic, moral."

This essay on American "action painting" was Rosenberg's most famous essay. Thomas Hess, who edited *Art News,* provided a header for the article, in which he said: "The poet gives his answers to the increasingly difficult and important questions raised by the paintings which have been produced in such confusing quantity in America since the War and which have been labeled variously 'Abstract-Expressionism,' 'Drip School,' 'the most significant contribution of America to modern civilization' and 'Pretentious mockery.' Here the clue comes from the motives of the painters, many of whom are friends of our author, and sharp distinction is made between sheep and goats, art and the Modern Art Cult."

* * *

What makes any definition of a movement in art dubious is that it never fits the deepest artists in the movement—certainly not as well as if successful, it does the others. Yet without the definition something essential in those best is bound to be missed. The attempt to define is like a game in which you cannot possibly reach the goal from the starting point but can only close in on it by picking up each time from where the last play landed.

## Modern Art? Or an Art of the Modern?

Since the War every twentieth-century style in painting is being brought to profusion in the United States: thousands of "abstract" painters—crowded teaching courses in Modern Art—a scattering of new heroes—ambitions stimulated by new galleries, mass exhibitions, reproductions in popular magazines, festivals, appropriations.

Is this the usual catching up of America with European art forms? Or is something new being created? . . . For the question of novelty, a definition would seem indispensable.

Some people deny that there is anything original in the recent American painting. Whatever is being done here now, they claim, was done thirty years ago in Paris. You can trace this painter's boxes of symbols to Kandinsky, that one's moony shapes to Miró or even back to Cézanne.

[. . .]

At the center of this wide practicing of the immediate past, however, the work of some painters has separated itself from the rest by a consciousness of a function for painting different from that of the earlier "abstractionists," both the Europeans themselves and the Americans who joined them in the years of the Great Vanguard.

This new painting does not constitute a School. To form a School in modern times not only is a new painting consciousness needed but a consciousness of that consciousness—and even an insistence on certain formulas. A School is the result of the linkage of practice with terminology—different paintings are affected by the same words. In the American vanguard the words, as we shall see, belong not to the art but to the individual artists. What they think in common is represented only by what they do separately.

## Getting Inside the Canvas

At a certain moment the canvas began to appear to one American painter after another as an arena in which to act—rather than as a space in which to reproduce, re-design, analyze or "express" an object, actual or imagined. What was to go on the canvas was not a picture but an event.

The painter no longer approached his easel with an image in his mind; he went up to it with material in his hand to do something to that other piece of material in front of him. The image would be the result of this encounter.

<p style="text-align:center">* * *</p>

If a painting is an action, the sketch is one action, the painting that follows it another. The second cannot be "better" or more complete than the first. There is just as much significance in their difference as in their similarity.

[. . .]

Call this painting "abstract" or "Expressionist" or "Abstract-Expressionist," what counts is its special motive for extinguishing the object, which is not the same as in other abstract or Expressionist phases of modern art.

The new American painting is not "pure art," since the extrusion of the object was not for the sake of the aesthetic. The apples weren't brushed off the table in order to make room for perfect relations of space and color. They had to go so that nothing would get in the way of the act of painting. In this gesturing with materials the aesthetic, too, has been subordinated. Form, color, composition, drawing, are auxiliaries, any one of which—or practically all, as has been attempted, logically, with unpainted canvases—can be dispensed with. What matters always is the revelation contained in the act. It is to be taken for granted that in the final effect, the image, whatever be or be not in it, will be a *tension.*

## Dramas of As If

A painting that is an act is inseparable from the biography of the artist. The painting itself is a "moment" in the adulterated mixture of his life—whether "moment" means, in one case, the actual minutes taken up with spotting the canvas or, in another, the entire duration of a lucid drama conducted in sign language. The act-painting is of the same metaphysical substance as the artist's existence. The new painting has broken down every distinction between art and life.

It follows that anything is relevant to it. Anything that has to do with action—psychology, philosophy, history, mythology, hero worship. Anything but art criticism. The painter gets away from Art through his act of painting; the critic can't get away from it. The critic who goes on judging in terms of schools, styles, form, as if the painter were still concerned with producing a certain kind of object (the work of art), instead of living on the canvas, is bound to seem a stranger.

<p style="text-align:center">* * *</p>

Criticism must begin by recognizing in the painting the assumptions inherent in its mode of creation. Since the painter has become an actor, the spectator has to think in a vocabulary of action: its inception, duration, direction—psychic state, concentration and relaxation of the will, passivity, alert waiting. He must become a connoisseur of the gradations between the automatic, the spontaneous, the evoked.

### *"It's Not That, It's Not That, It's Not That"*

With a few important exceptions, most of the artists of this vanguard found their way to their present work by being cut in two. Their type is not a young painter but a reborn one. The man may be over forty, the painter around seven. The diagonal of a grand crisis separates him from his personal and artistic past.

Many of the painters were "Marxists" (W.P.A. unions, artists' congresses)—they had been trying to paint Society. Others had been trying to paint Art (Cubism, Post-Impressionism)—it amounts to the same thing.

The big moment came when it was decided to paint. . . . Just TO PAINT. The gesture on the canvas was a gesture of liberation, from Value—political, aesthetic, moral.

\* \* \*

Painting could now be reduced to that equipment which the artist needed for an activity that would be an alternative to both utility and idleness. Guided by visual and somatic memories of paintings he had seen or made—memories which he did his best to keep from intruding into his consciousness—he gesticulated upon the canvas and watched for what each novelty would declare him and his art to be.

\* \* \*

A good painting in this mode leaves no doubt concerning its reality as an action and its relation to a transforming process in the artist. The canvas has "talked back" to the artist not to quiet him with Sibylline murmurs or to stun him with Dionysian outcries but to provoke him into a dramatic dialogue. Each stroke had to be a decision and was answered by a new question. By its very nature, action painting is painting in the medium of difficulties.

\* \* \*

An action is not a matter of taste.
You don't let taste decide the firing of a pistol or the building of a maze.

\* \* \*

---

**63 ✦** Thomas B. Hess, with photographs by Rudolph Burckhardt, "de Kooning Paints a Picture," *Art News* 52, no.1 (March 1953):30–33+. © 1953 ARTnews L.L.C.

Willem de Kooning came to the United States from the Netherlands in 1926. During the 1930s he briefly worked on the WPA/FAP. During the late 1930s he began painting women, an image which became increasingly abstract and expressionist in the early 1950s. With Jackson Pollock he is considered a leading abstract expressionist painter.

As editor of *Art News,* Thomas Hess was in a position to promote the new American painters. For the May 1951 issue, painter Robert Goodnough wrote "Pollock Paints a Picture," an article that closely relied on interviews with the artist and that was accompanied by photographs by Hans Namuth. Hess followed this format when he wrote his own essay on Willem de Kooning, except that Burckhardt's photographs focus on the paintings and their various stages, with only one showing the artist at his easel. Hess emphasizes the process of painting—a process apparently agonizing to de Kooning—with little analysis of the actual imagery. The influence of existentialism on Hess's approach to art is revealed in his valorization of ambiguity as "a crucial element" in "almost all important art."

---

◆

**Figure 4-2.** Willem de Kooning, *Woman and Bicycle,* 1952–53. Oil on canvas, 76 1/2 × 49 in. Collection the Whitney Museum of Art, New York; purchase 55.35. © 2000 Willem de Kooning Revocable Trust/Artists Rights Society (ARS), New York. de Kooning's *Woman I,* 1950-52, Museum of Modern Art, is the specific subject described in Hess's article; Hess's remarks relate also to later *Woman* images, such as *Woman and Bicycle.*

In the first days of June, 1950, Willem de Kooning tacked a 7-foot-high canvas to his painting frame and began intensive work on *Woman*—a picture of a seated figure, and a theme which had preoccupied him for over two decades. He decided to concentrate on this single major effort until it was finished to his satisfaction.

The picture nearly complied to his requirements several times in the months that followed, but never wholly. Finally, after a year and a half of continuous struggle, it was almost completed; then followed a few hours of violent disaffection; the canvas was pulled off the frame and discarded. [. . .]

A few weeks later, the art historian Meyer Schapiro visited De Kooning's Greenwich Village studio and asked to see the abandoned painting. It was brought out and re-examined. Later it was put back on the frame, and after some additional changes was declared finished—i.e., not to be destroyed. This was mid-June 1952. [. . .]

The painting's energetic and lucid surfaces, its resoundingly affirmative presence, give little indication of a vacillating, Hamlet-like history. *Woman* appears inevitable, like a myth that needed but a quick name to become universally applicable. But like any myth, its emergence was long, difficult and (to use one of the artist's favorite adjectives) mysterious.

## Invitation au Voyage

It would be a false simile to compare the two years' work that resulted in *Woman* to a progress or a development. Rather there was a voyage; not a mission or an errand, but one of those Romantic ventures which so attracted poets, from Byron, Baudelaire, through Lewis Carroll's *Snark*, to Mallarmé and Rimbaud . . . [. . .]

The stages of the painting which are reproduced on these pages illustrate arbitrarily, even haphazardly, some of the stops en route . . . They are memories which the camera has changed to tangible souvenirs. Some might appear more satisfactory than the ending, but this is irrelevant. The voyage, on the other hand, is relevant; the exploration for a constantly elusive vision; the solution to a problem that was continually being set in new ways.

\* \* \*

De Kooning has devised a method of a continuous series of drawings which are cut apart, reversed, exchanged and otherwise manipulated on the painting.

\* \* \*

Before making changes, De Kooning frequently interrupted the process of painting to trace with charcoal on transparent paper large sections of, or the whole composition. These would be cut apart and taped on the canvas in varying positions.

\* \* \*

De Kooning often paints on the paper overlays, testing differences of color and drawing. Furthermore, when he goes back to the canvas it can be in relation to an area of two different stages of development—the overlay and the state beneath it. Off-balance is heightened; probabilities increase; the painter makes ambiguity into actuality. And ambiguity, as we shall see, is a crucial element in this (and almost all important) art. [. . .]

One approach to "intimate" perception is by interchanging parts of the anatomy. The artist points out that a drawing of a knuckle, for example, could also be that of a thigh; an arm, that of a leg. Exactly such switches were often made during the painting of *Woman*, attempting always, in the continual shifts, re-creations, replacements, substitutions, to arrive at a point where a sense of the intimate (i.e., what is seen and familiar in everyday observation) is conveyed by proportion—among other means.

\* \* \*

## The skin

The physical appearance of *Woman*, as has been mentioned, gives no clue to the length of its history. Paint is applied in consistent impastos which thin out to the canvas in a few places and rise elsewhere to heavy ridges. "I like a nice, juicy, greasy surface," says the artist, who refused to capitalize on the process of correction and the happy accidents it so often produces. Changes, made after prolonged study or in moments of emphatic refusal, are preceded by scraping back to the canvas.

The pigments employed are a wide variety of standard tube colors. . . . Surfaces are kept fresh and evenly moist. In this respect it should be noted that although *Woman* took two years to complete, De Kooning is a fast worker, and the entire picture frequently changed in a few hours time. The voyage may have been long, but its tempo was hectic.

[. . .]

"Impossible" passages often appear; a torrent of color will suddenly disappear into strokes of other hues running at right angles. Some of these effects are deliberately produced by masking—i.e., placing paper over the surface adjacent to the one being painted and running the strokes over the paper, which is then removed, leaving a clean edge. More of them—and more important—have a sort of montage effect, a jump in focus, as if someone had abruptly changed the lens through which you were looking. [. . .] The record of a shift in a unit's position is retained in perceptible but unaccountable shifts of plane. Here the masking is not in paint, but in ideas. The effect, however, is similar, and gives an illusion of shallow space in which edges flicker up and down the surface as they do in some Cubist painting.

Color has been called De Kooning's weakness by some of his colleagues. . . . The artist himself freely admits he is not a colorist as moderns have come to accept this term as equivalent to Matisse or Bonnard. [. . .] As work progresses, colors change with shape and meaning of shape, fluctuating as delicately as they might in a Mondrian. They give hints of location, space and texture on the figurative level; they differentiate and accentuate the tensions established on the surface; they relate to each other in the various contradictions of flat surface and apparent depth. In the entity of *Woman,* they become unanalyzable components of form which add to its air of opulence, violence and laughter.

\* \* \*

## Woman

*Woman* and the pictures related to it should be fixed to the sides of trucks, or used as highway signs, like those more-than-beautiful girls with their eternal smiles who do not tempt, but simply point to a few words or a beer or a gadget. Like the girl at the noisy party who has misplaced her escort, she simply sits, is there, and smiles because that is the proper thing to do in America. The smile is not fearful, aggressive, particularly significant, or even expressive of what the smiler feels. It is the detached, semi-human way to meet the world, and because of this detachment it has a touching irony and humanity. It can be properly compared to the curling lips of the Greek Kouros and the medieval Virgin.

\* \* \*

## The Triple Thinker

[. . .]

Ambiguity exactingly sought and exactingly left undefined has been the recurrent theme in *Woman.* Ambiguity appears in surface, parts, illusion of space, in masking, overlays, interchangeable anatomies, intimate proportions and colors, no-environment, etc. The artist suggests a further complication of meaning, and points out that his "idolized" *Woman* reminds him strongly of a landscape with arms like lanes and a body of hills and fields, all brought up close to the surface, like a panorama squeezed together (or like Cézanne). Then you notice again the openness of certain forms, where contiguous objects seem set in different planes, and the width of the eyes opens up the face to a vista.

[. . .]

The fact that the picture was never really ended—never satisfied—and that it brought a number of paintings and sketches through with it, might have been predicted from the conditions laid down by the artist at the start. But all that we need care about is that the image, in all its complexity, came through to the end. [. . .]

---

**64** ✦ Meyer Schapiro, "The Liberating Quality of Avant-Garde Art," *Art News* 56, no.4 (Summer 1957):36–42; reprinted as "Recent Abstract Painting," in Meyer Schapiro, *Modern Art: 19th and 20th Centuries* (New York: George Braziller, 1978).

In the postwar years, Meyer Schapiro (see Reading 60) became good friends with some of the abstract expressionists and helped to organize exhibitions of their work.

In this essay Schapiro praised "painters who freed themselves from the necessity of representation." This new line of thinking reverses his views expressed in *Art Front,* in which he urged painters to make an art understandable to workers. In the 1950s he was joining a group of critics who saw in abstract art the expression of the individual validating the self in rebellion against mechanization and automation in an increasingly industrialized and militarized world (see Craven, *Abstract Expressionism as Cultural Critique,* 1999).

✦

In discussing the place of painting and sculpture in the culture of our time, I shall refer only to those kinds which, whether abstract or not, have a fresh inventive character, that art which is called "modern" not simply because it is of our century, but because it is the work of artists who take seriously the challenge of new possibilities and wish to introduce into their work perceptions, ideas and experiences which have come about only within our time.
[. . .]

There is a sense in which all the arts today have a common character shared by painting; it may therefore seem arbitrary to single out painting as more particularly modern than the others. In comparing the arts of our time with those of a hundred years ago, we observe that the arts have become more deeply personal, more intimate, more concerned with experiences of a subtle kind. We note, too, that in poetry, music and architecture, as well as in painting, the attitude to the medium has become much freer, so that artists are willing to search further and to risk experiments or inventions which in the past would have been inconceivable because of fixed ideas of the laws and boundaries of the arts. I shall try to show however that painting and sculpture contribute qualities and values less evident in poetry, music and architecture.

It is obvious that each art has possibilities given in its own medium which are not found in other arts, at least not in the same degree. Of course, we do not know how far-reaching these possibilities are; the limits of an art cannot be set in advance. Only in the course of work and especially in the work of venturesome personalities do we discover the range of an art, and even then in a very incomplete way.

In the last fifty years, within the common tendency towards the more personal, intimate and free, painting has had a special role because of a unique revolutionary change in its character. In the first decades of our century painters and sculptors broke with the long-established tradition that their arts are arts of representation, creating images bound by certain requirements of accord with the forms of nature.

That great tradition includes works of astounding power upon which artists have been nourished for centuries. Its principle of representation had seemed too self-evident to be doubted, yet that tradition was shattered early in this century. The change in painting and sculpture may be compared to the most striking revolutions in science, technology and social thought. It has affected the whole attitude of painters and sculptors to their work. To define the change in its positive aspect, however, is not easy because of the great diversity of styles today even among advanced artists.

<div align="center">* * *</div>

In the course of the last fifty years the painters who freed themselves from the necessity of representation discovered whole new fields of form-construction and expression (including new possibilities of imaginative representation) which entailed a new attitude to art itself. The artist came to believe that what was essential in art—given the diversity of themes or motifs—were two universal requirements: that every work of art has an individual order or coherence, a quality of unity and necessity in its structure regardless of the kind of forms used; and, second, that the forms and colors chosen have a decided expressive physiognomy, that they speak to us as a feeling-charged whole, through the intrinsic power of colors and lines, rather than through the imaging of facial expressions, gestures and bodily movements, although these are not necessarily excluded—for they are also forms.

That view made possible the appreciation of many kinds of old art and of the arts of distant peoples—primitive, historic, colonial, Asiatic and African, as well as European—arts which had not been accessible in spirit before because it was thought that true art had to show a degree of conformity to nature and of mastery of representation which had developed for the most part in the West. The change in art dethroned not only representation as a necessary requirement but also a particular standard of decorum or restraint in expression which had excluded certain domains and intensities of feeling. The notion of the humanity of art was immensely widened. Many kinds of drawing, painting, sculpture and architecture, formerly ignored or judged inartistic, were seen as existing on the same plane of human creativeness and expression as "civilized" Western art. That would not have happened, I believe, without the revolution in modern painting.

The idea of art was shifted, therefore, from the aspect of imagery to its expressive, constructive, inventive aspect. That does not mean, as some suppose, that the old art was inferior or incomplete, that it had been constrained by the requirements of representation, but rather that a new liberty had been introduced which had, as one of its consequences, a greater range in the appreciation and experience of forms.

The change may be compared, perhaps, with the discovery by mathematicians that they did not have to hold to the axioms and postulates of Euclidian geometry, which were useful in describing the everyday physical world, but could conceive quite other axioms and postulates and build up different imaginary geometries.

<div align="center">* * *</div>

In a number of respects, painting and sculpture today may seem to be opposed to the general trend of life. Yet, in such opposition, these arts declare their humanity and importance.

Paintings and sculptures, let us observe, are the last handmade, personal objects within our culture. Almost everything else is produced industrially, in mass, and through a high division of labor. Few people are fortunate enough to make something that represents themselves, that issues entirely from their hands and mind, and to which they can affix their names.

Most work, even much scientific work, requires a division of labor, a separation between the individual and the final result; the personality is hardly present even in the operations of industrial planning or in management and trade. Standardized objects produced impersonally and in quantity establish no bond between maker and user. They are mechanical products with only a passing and instrumental value.

What is most important is that the practical activity by which we live is not satisfying: we cannot give it full loyalty, and its rewards do not compensate enough for the frustrations and emptiness that arise from the lack of spontaneity and personal identifications in work: the individual is deformed by it, only rarely does it permit him to grow.

The object of art is, therefore, more passionately than ever before, the occasion of spontaneity or intense feeling. The painting symbolizes an individual who realizes freedom and deep engagement of the self within his work. It is addressed to others who will cherish it, if it gives them joy, and who will recognize in it an irreplaceable quality and will be attentive to every mark of the maker's imagination and feeling.

The consciousness of the personal and spontaneous in the painting and sculpture stimulates the artist to invent devices of handling, processing, surfacing, which confer to the utmost degree the aspect of the freely made. Hence the great importance of the mark, the stroke, the brush, the drip, the quality of the substance of the paint itself, and the surface of the canvas as a texture and field of operation—all signs of the artist's active presence. The work of art is an ordered world of its own kind in which we are aware, at every point, of its becoming.

All these qualities of painting may be regarded as a means of affirming the individual in opposition to the contrary qualities of the ordinary experience of working and doing.

[. . .] The artist's power of creation seems analogous here to the designer's and engineer's. That art, in turn, avowed its sympathy with mechanism and industry in an optimistic mood as progressive elements in everyday life, and as examples of strength and precision in production which painters admired as a model for art itself. But the experiences of the last twenty-five years have made such confidence in the values of technology less interesting and even distasteful.

\* \* \*

Automatism in art means the painter's confidence in the power of the organism to produce interesting unforeseen effects and in such a way that the chance results constitute a family of forms; all the random marks made by one individual will differ from those made by another, and will appear to belong together, whether they are highly ordered or not, and will show a characteristic grouping. (This is another way

of saying that there is a definite style in the seemingly chaotic forms of recent art, a general style common to many artists and unique individual styles.) This power of the artist's hand to deliver constantly elements of so-called chance or accident, which nevertheless belong to a well defined, personal class of forms and groupings, is submitted to critical control by the artist who is alert to the rightness or wrongness of the elements delivered spontaneously, and accepts or rejects them.

No other art today exhibits to that degree in the final result the presence of the individual, his spontaneity and the concreteness of his procedure.

This art is deeply rooted, I believe, in the self and its relation to the surrounding world. And the pathos of the reduction or fragility of the self within a culture that becomes increasingly organized through industry, economy and the state intensifies the desire of the artist to create forms that will manifest his liberty in this striking way—a liberty that, in the best works, is associated with a sentiment of harmony, and the opposite stability, and even impersonality through the power of painting to universalize itself in the perfection of its form and to reach out into common life. It becomes then a possession of everyone and is related to everyday experience.

\* \* \*

If the painter cannot celebrate many current values, it may be that these values are not worth celebrating. In the absence of ideal values stimulating to his imagination, the artist must cultivate his own garden as the only secure field in the violence and uncertainties of our time. By maintaining his loyalty to the value of art—to responsible creative work, the search for perfection, the sensitiveness to quality—the artist is one of the most moral and idealistic of beings, although his influence on practical affairs may seem very small.

Painting by its impressive example of inner freedom and inventiveness and by its fidelity to artistic goals, which include the mastery of the formless and accidental, helps to maintain the critical spirit and the ideals of creativeness, sincerity and self-reliance, which are indispensable to the life of our culture.

---

# *New York School: Voices of Individual Artists*

Although much has been written about the New York School and the development of abstract expressionism in the late 1940s and early 1950s, it is well to remember that the artists in these years did not give themselves a group name, nor were they a "school" in any sense. As Ann Gibson (*Issues in Abstract Expressionism: The Artist-Run Periodicals,* 1990) has observed: "Although they showed at the same galleries in New York, summered at the same beaches on Long Island and in Provincetown, and contributed to the same publications, they hesitated to name themselves. Willem de Kooning, for instance, said that to do so would be 'disastrous.'"

An extensive literature arose by artists explaining their motives and intentions and by critics describing in poetic and formal terms the paintings and sculpture. In the artist-run periodicals, such as *Iconograph, The Tiger's Eye, possibilities, Instead,* and *Modern*

*Artists in America,* many artists during the 1940s and early 1950s sought to clarify their ideas about their own and contemporary art. They met in places like "The Club" and in the Cedar Tavern; they participated in panel discussions at museums, transcripts of which were often published. Exhibition catalogues also provided spaces where artists could express their ideas.

What should not be lost sight of are the connections with representational painting at the time. As Rothko stated in his *possibilities* essay (Reading 68), "I do not believe that there was ever a question of being abstract or representational. It is really a matter of ending this silence and solitude, of breathing and stretching one's arms again." In the postwar years both representational and abstract art sought to express feelings and human values. Artists of both camps were affected by an international world of suppressed antagonisms, conflicting ideologies, and ambiguous diplomacy, and by a domestic world of rising prosperity, imposed conformity, and subtle, but oppressive, censorship. The language of existentialism permeated the writing of both artists and art critics. Painting became the "gratuitous act," and "ambiguity," "alienation," and "anxiety" became catch words to define the nuances of artistic endeavor.

Kenworth Moffett, one of the younger critics to adopt a Greenbergian approach—an approach antipathetic to "extra-aesthetic" criteria in the analysis of paintings—nevertheless provides us with a useful cautionary note (*The Art Quarterly,* Autumn 1972) as we read the artists' statements in this section: "Ideas and statements of artists certainly constitute important evidence, but only so long as they are studied historically and critically and not accepted as absolute revelation about the works of art—only so long as the works themselves are not reduced to the role of secondary proofs." Of course there is no reason not to approach art from all angles: the artists' intentions, the aesthetic qualities of the art itself, and the circumstances of the historical contexts. A balanced view is always important, and one needs to consider a myriad of factors when analyzing the origins of the movement and the excitement that such pictures engendered when shown in galleries and museums.

Issues to explore when we consider the phenomena of the rise of the New York School include 1) the presence of European surrealist and abstract artists in New York during the late 1930s and 1940s; 2) the continuing fascination that American artists had about the works of Pablo Picasso; 3) the large and expressive murals of the Mexican artists in the United States and the experiences of Americans working on large murals; 4) the New York workshop of David Siqueiros, who encouraged experimentalism; 5) the influence of jazz with its improvisational qualities; 6) the preoccupation with the unconscious and psychological analyses through the theories of Freud (the libido) and Jung (the collective unconscious) and the practice of automatism; 7) the interest in myth, prehistory, and Native American rituals through exposure to these and the books of Joseph Campbell; 8) the influence of postwar European existentialism with its rhetoric of alienation; 9) a romantic rejection of materialist values represented by the flood of commodities that filled the department stores and by slick Madison Avenue advertising promoting these commodities;10) the desire to develop an art of subjectivity instead of an art of social commitment; and 11) the fact that many concluded that abstract art could better convey the anxieties of the postwar world than could realism.

However, it is well to remember that in the era of the Cold War, when socially concerned art—by and large representational and figurative—began to seem suspect (too much like Soviet socialist realism), abstract art seemed to offer an "art of freedom" to counter what was considered the art of totalitarianism (see section The Cold War and the Arts).

## 65 ✦  Arshile Gorky, "Garden in Sochi," Collection File [Artist's Statement, June 1942], The Museum of Modern Art, New York, Department of Painting and Scupture.

Arshile Gorky was born in Armenia and studied art there as a child. In 1916 the family fled the Turkish occupation and lived as refugees for three years. In 1919 Gorky's mother died of starvation; in 1920 he and his sister came to the United States to join other family members. He studied art in Providence, taught briefly in Boston, and moved to New York in 1925, where he settled into the artistic life of Greenwich Village. During the 1930s he was employed by the Federal Art Project of the Works Progress Administration and painted a mural for the Newark, New Jersey, Airport. Although critically acclaimed as a painter in the 1940s, his life was characterized by a series of personal tragedies. A few months after Gorky committed suicide, Willem de Kooning wrote a letter to *Art News* (January 1949), praising Gorky as the only surrealist artist "who maintains direct contact with nature." De Kooning explained that Gorky did not revere nature as an end in itself: "rightly he demands of her that she provide sensations that can serve as springboards for both knowledge and pleasure in fathoming certain profound states of mind."

Gorky is not often included in anthologies or history surveys of abstract expressionism, perhaps because he died before the movement crested. Yet, he provides an important link from the surrealizing abstraction of the late 1930s to the gestural painting of Pollock, Kline, and de Kooning in the late 1940s.

The following remarks were written in response to a questionnaire sent to him by Dorothy C. Miller, curator at the Museum of Modern Art, which had purchased his *Garden in Sochi,* 1942. The painting, Gorky explains, was inspired by memories of his village in Armenia. Printed here is Gorky's complete statement.

---◆---

*I like the heat the tenderness the edible the lusciousness the song of a single person the bathtub full of water to bathe myself beneath the water. I like Uccello Grunewald Ingres the drawings and sketches for paintings of Seurat and that man Pablo Picasso.*
*I measure all things by weight.*
*I love my Mougouch. What about Papa Cezanne.*
*I hate things that are not like me and all the things I haven't got are god to me.*
*Permit me-*
*I like the wheatfields the plough the apricots the shape of apricots those flirts of the sun. And bread above all.*
*My liver is sick with the purple.*

About 194 feet away from our house on the road to the spring my father had a little garden with a few apple trees which had retired from giving fruit. There was a ground constantly in shade where grew incalculable amounts of wild carrots and porcupines had made their nests. There was a blue rock half buried in the black earth with a few patches of moss placed here and there like fallen clouds. But from where came all the shadows in constant battle like the lancers of Paolo Uccello's painting? This garden was identified as the Garden of Wish Fulfillment and often I had seen my mother and other village women opening their bosoms and taking their soft and dependable breasts in their hands to rub them on the rock. Above all this stood an enormous tree all bleached under the sun the rain the cold and deprived of leaves. This was the Holy Tree. I myself do not know why this tree was holy but I had witnessed many people whoever did pass by that would tear voluntarily a strip of their clothes and attach this to the tree. Thus through many years of the same act like a veritable parade of banners under the pressure of wind all these personal inscriptions of signatures very softly to my innocent ear used to give echo to the sh-h-h of silver leaves of the poplars.

---

**66 ✦** Norman Lewis, "Thesis," 1946. Reprinted in *Norman Lewis: From the Harlem Renaissance to Abstraction,* essays by Ann Gibson and Julian Euell (New York: Kenkeleba Gallery, 1989).

Norman Lewis, who studied at Columbia University and the John Reed Club Art School, was on the Federal Art Project during the late 1930s, a member of the Harlem Artist's Guild, and one of the teachers at Augusta Savage's Studio and later at the Harlem Community Art Center. Like Elizabeth Catlett (see Reading 74), he also taught at the George Washington Carver School. In 1946 he joined the Willard Gallery, which showed the work of abstract painters and sculptors, and he had his first solo show at Willard in 1949. Lewis was the only African American to be included in the famous Studio 35 discussions moderated by Alfred H. Barr, Jr., in 1950.

His statement, made in 1946, indicates one artist's decision to turn away from the pressures to produce a social art and to pursue new individual concepts, and thereby strengthen himself as a painter.

◆

During the past fourteen years, I have devoted the major part of my attention and as much time as finances made possible to becoming a painter. For about the last eight of these years, I have been concerned not only with my own creative and technical development but with the limitations which every American Negro who is desirous of a broad kind of development must face—namely, the limitations which come under the names, "African Idiom," "Negro Idiom" or "Social Painting." I have been concerned therefore with greater freedom for the individual to be publicly first an artist (assuming merit) and incidentally, a Negro.

For the attainment of such a condition, I believe that it is within the Negro artist himself that the greatest possibilities exist since the excellence of his work will be the

most effective blow against stereotype and the most irrefutable proof of the artificiality of stereotype in general.

Believing this as well as desiring a degree of artistic excellence for myself as an individual, I have tried to maintain at least enough curiosity to keep my work moving in new directions and I have seen it pass almost automatically from careless reproduction and then strictly social art to a kind of painting which involves discovery and knowledge of new trends. I, in the process, grew from an over-emphasis on tradition and then propaganda to develop a whole new concept from myself as a painter.

This concept treats art not as reproduction or as convenient but entirely secondary medium for propaganda but as the production of experiences which combine intellectual and emotional activities in a way that may conceivably add not only to the pleasure of the viewer and the satisfaction of the artist but to a universal knowledge of aesthetics and the creative faculty which I feel exists for one form of expression or another in all men. In this sense, art comes to have a life of its own; to be evidence of the emotional, intellectual and aesthetic level of men in a specific era; to be always changing and going towards greater understanding of human beings; to enrich living for everyone. It comes to be an activity of discovery in that it seeks to find hitherto ignored or unknown combinations of forms, colors, and textures and even psychological phenomena, and perhaps to cause new types of experience in the artist as well as the viewer. Above all, it breaks away from its stagnation in too much tradition and establishes new traditions to be broken away from by coming generations of artists, thus contributing to the rise of cultural and general development.

In view of this concept of art and the function of the artist, it is my desire to work not only for myself as an artist but for broader understanding as a teacher, in a manner as free from public pressures and faddish demands as possible and with an understanding of cultures other than my own. Thus, I am particularly interested at this time in working for at least a year in Europe, hoping that this may do much towards achievement not only of my own aims, but for the increased awareness towards the Negro artist and among Negro artists themselves.

---

*67* ✦  Robert Motherwell, "The Modern Painter's World," *DYN* 1, no. 6 (November 1944):9–14.

Hailing from the West Coast, Robert Motherwell graduated from Stanford University in 1937, traveled in Europe, and attended Columbia University in 1940-41. In 1944 he had a solo show at Peggy Guggenheim's Art of This Century Gallery in New York. In 1947 he and Harold Rosenberg co-edited the only issue of *possibilities*, published by Wittenborn and Schultz. In 1948 Motherwell, William Baziotes, David Hare, and Mark Rothko founded a school at 35 East 8th Street, later known as Studio 35; he was also active in "the Club" with its weekly meeting of avant-garde artists. (See Irving Sandler, *The Triumph of American Painting*, 1970.)

One of the most intellectual of the New York School artists, Motherwell originally delivered this essay as a lecture at Mt. Holyoke College on August 10, 1944. As an overview of the artist's relationship to the public, Motherwell's remarks express some of the ideas

advanced by Clement Greenberg's "Avant-Garde and Kitsch," notably the historical assessment that the artist is alienated from the middle classes because of their "property-loving" materialism and spiritual emptiness and from the working classes because of the latter's seeming "inertness." Hence, the artist had no choice but to turn away from social–content art, which would speak to and for those classes. To Motherwell, the freedom of the modern artist, frequently an issue during the 1940s, had to be individualistic, since it could no longer be social.

The new direction, to Motherwell, was a nonsocial, abstract art. But in pursuing this path Motherwell warned that the artist would discover insoluable contradictions—whether the artist turned toward structured formalism or toward automatism to express unconscious emotions. Of the first, Motherwell said: "But the fundamental criticism of the purely formalist position is how it reduced the individual's ego, how much he must renounce." And of the second: "The fundamental criticism of automatism is that the unconscious cannot be *directed,* that it presents none of the possible choices which, when taken, constitute any expression's form. To give oneself over completely to the unconscious is to become a slave." The virtue of automatism, to Motherwell, is that it becomes "a plastic weapon with which to invent new forms."

Motherwell's attitude toward working-class activism and his embrace of Freudian terminology (id, ego, super-ego) reflect the shift of many artists away from politics and toward subjectivity and aesthetics at a time of world crisis.

---

I MUST APOLOGIZE FOR MY SUBJECT, which is that of the relation of the painter to a middle-class world. This is not the most interesting relation by which to grasp our art. More interesting are the technical problems involved by the evolution of artistic structure. More fundamental is the individual problem, the capacity of an artist to absorb the shocks of reality, whether coming from the internal or external world, and to reassert himself in the face of such shocks, as when a dog shakes off water after emerging from the sea. The twentieth century has been one of tremendous crises in the external world, yet, artistically speaking, it has been predominantly a classic age. In such epochs it is architecture, not painting or poetry or music, which leads. Only modern architecture, among the great creations of twentieth-century art, is accepted quite naturally by everyone. Both Surrealist and "non-figurative" painting, with which I am concerned in this lecture, are the feminine and masculine extremes of what, when we think of the post-impressionists, the fauves, the cubists, and the art which stems, in conception, from them, has been a classic age.

\* \* \*

The function of the *modern* artist is by definition the felt expression of modern reality. This implies that reality changes to some degree. This implication is the realization that history is "real," or, to reverse the proposition, that reality has a historical character. Perhaps Hegel was the first fully to feel this. With Marx this notion is coupled with the feeling of how *material* reality is . . .

It is because reality has a historical character that we feel the need for new art. The past has bequeathed us great works of art; if they were wholly satisfying, we should not need new ones. From this past art, we accept what persists qua eternally

valuable, as when we reject the specific religious values of Egyptian or Christian art, and accept with gratitude their form. Other values in this past art we do not want. To say this is to recognize that works of art are by nature pluralistic: they contain more than one *class* of values. It is the eternal values that we accept in past art. By eternal values are meant those which, humanly speaking, persist in reality in any space-time, like those of aesthetic form, or the confronting of death.

Not all values are eternal. Some values are historical—if you like, *social,* as when now artists especially value personal liberty because they do not find positive liberties in the concrete character of the modern state. It is the values of our own epoch which we cannot find in past art. This is the origin of our desire for new art. In our case, for *modern art . . .*
[. . .]

The remoteness of modern art is not merely a question of language, of the increasing "abstractness" of modern art. Abstractness, it is true, exists, as the result of a long, specialized internal development in modern artistic structure. But the crisis is the modern artists rejection, almost *en toto,* of the values of the bourgeois world. In this world modern artists form a kind of *spiritual underground . . .*

Modern art is related to the problem of the modern individual's freedom. For this reason the history of modern art tends at certain moments to become the history of modern freedom. It is here that there is a genuine rapport between the artist and the working-class. At the same time, modern artists have not a social, but an individualist experience of freedom: this is the source of the irreconcilable conflict between the Surrealists and the political parties of the working-class.

The social condition of the modern world which gives every experience its form is the spiritual breakdown which followed the collapse of religion. This condition has led to the isolation of the artist from the rest of society. The modern artist's social history is that of a spiritual being in a property-loving world.

No synthesized view of reality has replaced religion. Science is not a view, but a method. The consequence is that the modern artist tends to become the last active spiritual being in the great world. It is true that each artist has his own religion. It is true that artists are constantly excommunicating each other. It is true that artists are not always pure, that some times they are concerned with their public standing or their material circumstance. Yet for all that it is the artists who guard the spiritual in the modern world.

The weakness of socialists derives from the inertness of the working-class. The weakness of artists derives from their isolation. Weak as they are, it is these groups who provide the *opposition.* The socialist is to free the working-class from the domination of property, so that the spiritual can be possessed by all. The function of the artist is to make actual the spiritual, so that is it there to be possessed. It is here that art instructs, if it does at all.

\* \* \*

The present ruling class was able to gain its freedom from the aristocracy by the accumulation of private property. *Property is the historical base of contemporary freedom.* The danger lies in thinking we own only our private possessions. Property creates the

unfreedom of the majority of men. "When this majority in turn secures its freedom by expropriating the bourgeoisie, the condition of its freedom is the unfreedom of the bourgeoisie; but whereas the bourgeoisie like all ruling classes, requires an unfree exploited class for its existence, the proletariat does not require to maintain the bourgeoisie in order to maintain its own freedom." (Caudwell, *Illusion and Reality.*) There is hope therefore of ending the conflict inherent in class society.

     The artist's problem is *with what to identify himself.* The middle-class is decaying, and as a conscious entity the working-class does not exist. Hence the tendency of modern painters to paint for each other . . .

<div align="center">* * *</div>

     Empty of all save fugitive relations with other men, there are increased demands on the individual's own ego for the content of experience. We say that the individual withdraws into himself. Rather, he must draw from himself. If the external world does not provide experience's content, the ego must. The ego can draw from itself in two ways: the ego can be the subject of its own expression, in which case the painters' personality is the principal meaning expressed; otherwise the ego can socialize itself—i.e., become mature and objectified—through formalization.

     In terms of Freud's fictions, the ego is the synthesis of the "super-ego" and the "id." The super-ego represents the external world: the father, the family, society, in short, authority. The id represents the inner world: our basic animal drives. In the situation in which the ego rebels against the authority of the external world, but still retains an aspect of that world which is eternal, the aesthetic, the super-ego is the effect of society; in the present case those values have been reduced to that of form. Form, like the influence of society in the usual super-ego, comes from the outside, the world. It is in this sense that formalization represents a socialization of the ego. In rejecting the values of middle-class society, as a historical event, the aesthetic, and other eternal values, like chance, love, and logic, are what remain.

     It is the nature of such art to value above all the eternal, the "pure," the "objective." Thus Mondrian used to speak of the "universal." Thus the notion of "pure form" among the non-figurative painters, and Valéry's idea of the "pure self." Thus the modern sculptor's admiration for the purity of materials. Thus Arp's violent attacks on romantic painters' egoism; and the general admiration of abstract painters for an art without a Self . . . The desire for the universal is that for one of its forms, the aesthetic; the desire for purity is the rejection of contemporary social values for the aesthetic; the desire for objectivity is that for the socialization of the ego through the aesthetic. Lissitisky's white square on a white ground contains the logic of the aesthetic position in its most implacable form.

     The power of this position must not be underestimated. It has produced some of the greatest creations of modern art. But the fundamental criticism of the purely formalist position is how it reduces the individual's ego, how much he must renounce. No wonder there is such insistence among formalists on perfection. Such limited material is capable of perfection, and with perfection it must replace so much else.

<div align="center">* * *</div>

The argument of this lecture is that the materialism of the middle-class and the inertness of the working-class leave the modern artist without any vital connection to society, save that of the *opposition;* and that modern artists have had, from the broadest point, to replace other social values with the strictly aesthetic. Even where the Surrealists have succeeded, it has been on technical grounds. This formalism has led to an intolerable weakening of the artist's ego; but so long as modern society is dominated by the love of property—and it will be, so long as property is the only source of freedom—the artist has no alternative to formalism. He strengthens his formalism with his other advantages, his increased knowledge of history and modern science, his connections with the eternal, the aesthetic, his relations with the folk (e.g., Picasso and Miro), and, finally his very opposition to middleclass society gives him a certain strength. Until there is a radical revolution in the values of modern society, we may look for a highly formal art to continue. We can be grateful for its extraordinary technical discoveries, which have raised modern art, plastically speaking, to a level unreached since the earlier Renaissance. [. . .]

---

*68* ✦ Mark Rothko, "The Romantics Were Prompted," *possibilities* 1 (Winter 1947–48).

Mark Rothko was born in Russia and, while still a young child, emigrated to Portland, Oregon, with his family. In 1925 he moved to New York and studied at the Art Students League. Along with Adolph Gottlieb he founded The Ten, a group of expressionist artists. During the 1930s Rothko was employed by the Federal Art Project of the Works Progress Administration, and in the 1940s he taught at the California School of Fine Arts.

Rothko's work evolved from an expressive figuration to biomorphic forms and finally to the large floating rectangles of pure color for which he became famous. At the point at which he wrote this essay he was shifting toward that mature, non-gestural style.

Like other artists, Rothko was searching for a transcendental content divorced from obvious references to things in the world.

---◆---

THE ROMANTICS WERE PROMPTED to seek exotic subjects and to travel to far off places. They failed to realise that, though the transcendental must involve the strange and unfamiliar, not everything strange or unfamiliar is transcendental.

The unfriendliness of society to his activity is difficult for the artist to accept. Yet this very hostility can act as a lever for true liberation. Freed from a false sense of security and community, the artist can abandon his plastic bankbook, just as he has abandoned other forms of security. Both the sense of community and of security depend on the familiar. Free of them, transcendental experiences become possible.

I think of my pictures as dramas; the shapes in the pictures are the performers. They have been created from the need for a group of actors who are able to move dramatically without embarrassment and execute gestures without shame.

Neither the action nor the actors can be anticipated or described in advance. They begin as an unknown adventure in an unknown space. It is at the moment of

completion that in a flash of recognition, they are seen to have the quantity and function which was intended. Ideas and plans that existed in the mind at the start were simply the doorway through which one left the world in which they occur.

The great Cubist pictures thus transcend and belie the implications of the Cubist program.

The most important tool the artist fashions through constant practice is faith in his ability to produce miracles when they are needed. Pictures must be miraculous: the instant one is completed, the intimacy between the creation and the creator is ended. He is an outsider. The picture must be for him, as for anyone experiencing it later, a revelation, an unexpected and unprecedented resolution of an eternally familiar need.

On shapes:

They are unique elements in a unique situation.

They are organisms with volition and a passion for self-assertion.

They move with internal freedom, and without need to conform with or to violate what is probable in the familiar world.

They have no direct association with any particular visible experience, but in them one recognizes the principle and passion of organisms.

The presentation of this drama in the familiar world was never possible, unless everyday acts belonged to a ritual accepted as referring to a transcendent realm.

Even the archaic artist, who had an uncanny virtuosity found it necessary to create a group of intermediaries, monsters, hybrids, gods and demigods. The difference is that, since the archaic artist was living in a more practical society than ours, the urgency for transcendent experience was understood, and given an official status. As a consequence, the human figure and other elements from the familiar world could be combined with, or participate as a whole in, the enactment of the excesses which characterize this improbable hierarchy. With us the disguise must be complete. The familiar identity of things has to be pulverized in order to destroy the finite associations with which our society increasingly enshrouds every aspect of our environment.

Without monsters and gods, art cannot enact our drama: art's most profound moments express this frustration. When they were abandoned as untenable superstitions, art sank into melancholy. It became fond of the dark, and enveloped its objects in the nostalgic intimations of a half-lit world. For me the great achievements of the centuries in which the artist accepted the probable and familiar as his subjects were the pictures of the single human figure—alone in a moment of utter immobility.

But the solitary figure could not raise its limbs in a single gesture that might indicate its concern with the fact of mortality and an insatiable appetite for ubiquitous experience in face of this fact. Nor could the solitude be overcome. It could gather on beaches and streets and in parks only through coincidence, and, with its companions, form a *tableau vivant* of human incommunicability.

I do not believe that there was ever a question of being abstract or representational. It is really a matter of ending this silence and solitude, of breathing and stretching one's arms again.

**69** ✦  Jackson Pollock, "My Painting," *possibilities* 1 (Winter 1947–48):79.

Born in Cody, Wyoming, Jackson Pollock lived in Arizona and California before coming in 1929 to New York, where he studied with Thomas Hart Benton at the Art Students League. During the later 1930s he was on the Federal Art Project and also participated in the workshop organized by the Mexican muralist David Siqueiros. In the early 1940s he worked for Peggy Guggenheim and showed at her Art of This Century Gallery. His work of the early 1940s contains figurative elements, perhaps inspired by the Jungian analysis he was then undergoing. By the winter of 1946–47 he moved toward his allover drip style.

In the popular imagination he quickly became the most famous painter of the abstract expressionists. *Life* magazine ran a story on him in August 1949, "Is he the greatest living painter in the United States?" with photographs by Arnold Newman. In 1950-51 Hans Namuth and Paul Falkenberg made a ten-minute movie, *Jackson Pollock,* which has introduced Pollock's working methods to thousands of art students. In May 1951 *Art News* published Namuth's photographs of Pollock working in his studio. Yet for all his success and fame, Pollock's personal life was in shambles. He was plagued by alcoholism, which produced aberrant behavior and depression and which contributed to his death in a car accident in 1956.

Parts of the *possibilities* essay were included as dialogue in the Namuth/Falkenberg movie, and also in the section devoted to his painting in the Museum of Modern Art catalogue *New American Painting* (1959).

———————————————— ✦ ————————————————

My painting does not come from the easel. I hardly ever stretch my canvas before painting. I prefer to tack the unstretched canvas to the hard wall or the floor. I need the resistance of a hard surface. On the floor I am more at ease. I feel nearer, more a part of the painting, since this way I can walk around it, work from the four sides and literally be *in* the painting. This is akin to the method of the Indian sand painters of the West.

I continue to get further away from the usual painter's tools such as easel, palette, brushes, etc. I prefer sticks, trowels, knives, and dripping fluid paint or a heavy impasto with sand, broken glass, and other foreign matter added.

When I am *in* my painting, I'm not aware of what I am doing. It is only after a sort of "get acquainted" period that I see what I have been about. I have no fears about making changes, destroying the image, etc., because the painting has a life of its own. I try to let it come through. It is only when I lose contact with the painting that the result is a mess. Otherwise there is pure harmony, an easy give and take, and the painting comes out well.

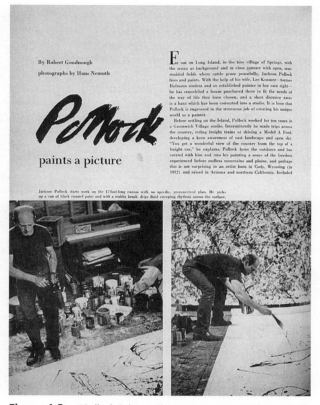

**Figure 4-3.**   "Pollock Paints a Picture," *Art News* 50 (May 1951),
pp. 38–39. Photographs by Hans Namuth, courtesy Hans Namuth Ltd.
Robert Goodnough article courtesy *Art News*.

*70* ✦  Barnett Newman, "Artist's Statement," *The Ideographic Picture.*
Betty Parsons Gallery, January 20–February 8, 1947; reprinted in John P.
O'Neill, ed. *Barnett Newman: Selected Writings and Interviews* (Berkeley, CA:
University of California Press, 1992).

Barnett Newman was born in New York and studied at the Art Students League during
the early and the late 1920s. During the years of World War II he stopped painting, but
took it up again with renewed determination to shed the influence of European art
and to create new forms. In 1948 he painted the first of what he would call his "zip"
paintings—compositions with a broad colored stripe rising vertically through the middle
of a field of color.

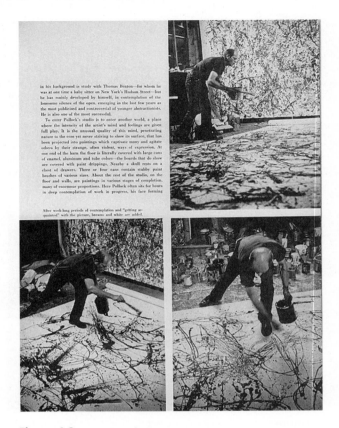

**Figure 4-3.**  Continued

Newman's interest in the art of the Northwest Indians, particularly the Kwakiutl, was sparked when he helped to install an exhibition of Northwest artifacts for the Betty Parsons Gallery in 1947. The interest that Newman, as well as Jackson Pollock and Adolph Gottlieb, had in the art of Native Americans was not an expression of the kind of cultural primitivism characteristic of the 1920s (see Chapter 2). These abstract expressionists were not romanticizing "the other," but rather, were appropriating the forms—the ideographs, the flat designs, and the basic colors—which they saw as characteristic of the "primitive" art impulse.

◆

The Kwakiutl artist painting on a hide did not concern himself with the inconsequentials that made up the opulent social rivalries of the Northwest Coast Indian scene, nor did he, in the name of a higher purity, renounce the living world for the meaningless materialism of design. The abstract shape he used, his entire plastic lan-

guage, was directed by a ritualistic will towards metaphysical understanding. The everyday realities he left to the toymakers; the pleasant play of nonobjective pattern to the women basket weavers. To him a shape was a living thing, a vehicle for an abstract thought-complex, a carrier of the awesome feelings he felt before the terror of the unknowable. The abstract shape was, therefore, real rather than a formal "abstraction" of a visual fact, with its overtone of an already-known nature. Nor was it a purist illusion with its overload of pseudo-scientific truths.

The basis of an aesthetic act is the pure idea. But the pure idea is, of necessity, an aesthetic act. Here then is the epistemological paradox that is the artist's problem. Not space cutting nor space building, not construction nor Fauvist destruction; not the pure line, straight and narrow, nor the tortured line, distorted and humiliating; not the accurate eye, all fingers, nor the wild eye of dream, winking; but the idea-complex that makes contact with mystery—of life, of men, of nature, of the hard, black chaos that is death, or the grayer, softer chaos that is tragedy. Everything else has everything else.

Spontaneous, and emerging from several points, there has arisen during the war years a new force in American painting that is the modern counterpart of the primitive art impulse. [. . .][V]arious critics and dealers have tried to label it, to describe it. It is now time for the artist himself, by showing the dictionary, to make clear the community of intention that motivates him and his colleagues. For here is a group of artists who are not abstract painters, although working in what is known as the abstract-style.

---

**71 ✦** Grace Hartigan, "Artist's Statement," *12 Americans* (New York: The Museum of Modern Art, 1956).

Grace Hartigan was part of the second generation of abstract expressionists because she did not start showing her work until the 1950s. She called herself "George" when she first began exhibiting her art, but by 1954 was using her real name.

Like Willem de Kooning, who openly acknowledged his inspiration from newspaper imagery—both photographs and advertisements, she admits that she finds her subjects in "that which is vulgar and vital in American modern life." It is in ordinary, everyday visual culture, such as shop windows, that she seeks a beautiful "transcendence."

Her statement was reprinted in *The New American Painting*, the MOMA exhibition that toured Europe in 1958-59 to critical acclaim.

---✦---

Gide said an artist should want only one thing and want it constantly. I want an art that is not "abstract" and not "realistic"—I cannot describe the look of this art, but I think I will know it when I see it.

I no longer invite the spectator to walk into my canvases. I want a surface that resists, like a wall, not opens, like a gate.

I have found my "subject," it concerns that which is vulgar and vital in American modern life, and the possibilities of its transcendence into the beautiful. I do not wish to *describe* my subject matter, or to reflect upon it—I want to distil [sic] it until I have its essence. Then the rawness must be resolved into form and unity; without the "rage for order" how can there be art?

---

## 72 ✦ David Smith, "Notes for David Smith Makes a Sculpture" (1951)
*Art News* 67, no. 9 (January 1969): 46–48, 56. © 1969 ARTnews L.L.C.

As a young man David Smith worked for a summer at a Studebaker plant in South Bend, Indiana, where he learned machine shop skills. In 1926 he moved to New York and studied painting at the Art Students League. He began making sculptural constructions in 1931 and in 1933 rented space in Brooklyn at the Terminal Iron Works. He was one of the first American sculptors to use extensive welding techniques to make his sculpture.

His notes were prepared for an article by Elaine de Kooning which appeared in *Art News* in September 1951. He describes himself as an artist workman, with a project and a schedule. In a speech he gave at Deerfield, Massachusetts, on September 24, 1952, he said: "To the creative artist, in the making of art it is doubtful whether aesthetics have any value to him. . . . Aesthetics are written conclusions or directives. The creative artist should not be impressed by verbal directives. His aesthetics are primarily unconscious and of a visual recording. No words or summations are involved." Smith is admired as the mid-century sculptor who most successfully brought together surrealism, cubism, and constructivism.

Smith's remarks give the reader a sense of what it means to be an artist and to be physically involved in the planning and making of sculpture.

---

I follow no set procedure in starting a sculpture. Some works start out as chalk drawings on the cement floor, with cut steel forms working into the drawings. When it reaches the stage that the structure can become united, it is welded into position upright. Then the added dimension requires different considerations over the more or less profile form of the floor drawing assembly.

Sometimes I make a lot of drawings using possibly one relationship in each drawing which will add up in the final work. Sometimes sculptures just start with no drawing at all. This was the case of *The Fish*, which is some 6 feet high and about 5 feet long. My drawings are made either in work books or on large sheets of linen rag. I stock bundles of several types, forgetting the cost so I can be free with it. The cost problem I have to forget on everything, because it is always more than I can afford—more than I get back from sales, most years, more than I earn. My shop is somewhat like the Federal Government, always running with greater expenditures than income and winding up with loans.

[. . .] When I'm involved aesthetically I cannot consider cost; I work by the need of what each material can do. Usually the costly materials do not even show, as their use has been functional.

The traditions for steel do not exist that govern bronze finishes, patinas, or casting limits. There are no preconceived limits established as there are for marble: the aesthetics of grain and surface or the physical limits of mass to strength. Direction by natural grain, hand rubbing, monolithic structure, or the controls of wood do not apply physically or traditionally to steel.

Steel has the greatest tensile strength, the most facile working ability, as long as its nature relates to the aesthetic demand. It can join with its parent metal or other metals varying in colors, or act as a base for metal deposition, paint, or its own natural oxide. . . .

I have two studios. One clean, one dirty; one warm, one cold. The house studio contains drawing tables, etching press, cabinets for work records, photos, and drawing paper stock. The shop is a cinderblock structure, transite roof and a full row of north window skylights set at a 30 degree angle. With heat in each end it is usable to zero weather.

I do not resent the cost of the best material or the finest tools and equipment. Every labor-saving machine, every safety device I can afford I consider necessary. Stocks of bolts, nuts, taps, dies, paints, solvents, acids, protective coatings, oils, grinding wheels, polishing discs, dry pigments, waxes, chemicals, spare machine parts, are kept stocked on steel shelving, more or less patterned after a factory stockroom.

\* \* \*

When I make sculpture all the speeds, projections, gyrations, light changes are involved in my vision, as such things I know in movement associate with all the possibilities possible in other relationships. Possibly steel is so beautiful because of all the movement associated with it, its strength and function. Yet it is also brutal, the rapist, the murderer, and death-dealing giants are also its offspring. But in my Spectre series, I speak of these things and it seems most functional in its method of statement. Since 1936 I have modeled wax for single bronze castings. I have carved marble and wood but the major number of works have been steel, which is my most fluent medium and which I control from start to completed work without interruption. There is gratification of being both conceiver and executor without intrusion. A sculpture is not quickly produced, it takes time, during which time the conviction must be deep and lasting. Michelangelo spoke about noise and marble dust in our profession, but I finish the day more like a greaseball than a miller. But my concepts still would not permit me to trade it for cleaner pursuits.

\* \* \*

Sometimes I work on two and possibly four pieces at one time, conceptually involved on one, conceptually in abeyance on another, waiting for relationships to complete; and on one or two others finished but for a casting to come from the foundry or grinding, finishing and a few hours of manual labor waiting to be done. Sometimes it's only a matter of mounting, weighing, measuring and naming; such detail work fits in schedule when the muse has gone. I maintain my identity by regular work. There is always labor when inspiration has fled, but inspiration returns quicker when identity and the work stream [are] maintained. Actually time overtakes much of my

projects. I get only half of my vision into material form. The rest remain as drawings, which after a certain time growth, I cannot return to because the pressing demand is the future. I have no organized procedure in creating. *The Fish* went through from start to finish with a small drawing in my work book, during its middle stage. *The Cathedral* matured from start to finish with no drawings. Usually there are drawings, anything from sketches in pocket notebooks to dozens of big sheet paintings.

## *The Figurative Artists in the Postwar Years*

Although many art history textbooks claim that abstract expressionism "triumphed" in the 1950s, the victory was neither swift nor long-lasting (except in terms of the market). A substantial minority of figurative artists weathered the changing artworld climate. Mature figurative artists such as Philip Evergood, Edward Hopper, Yasuo Kuniyoshi, Robert Gwathmey, Isabel Bishop, Raphael Soyer, Jack Levine, and Alice Neel continued to paint social themes, ironic views of American life, portraits, or studio pictures with only slight modifications, as they had in the 1930s and early 1940s. Evergood and Levine were direct in satirizing those who, to them, were the agents of corruption—capitalists, gangsters, policemen, the military—although even they softened the bitter specificity of their 1930s work during the 1940s and 1950s. And slightly younger artists such as John Wilson, Elizabeth Catlett, Jacob Lawrence, and Hughie Lee-Smith continued to focus on the social reality of African American life.

These artists remained popular in the late 1940s. *Look* magazine asked sixty-eight "leading museum directors, curators of paintings and art critics across the country" to participate in a poll to name the top ten American painters. The results were published in *Look's* February 3, 1948, issue. The winners were, in order: John Marin, Max Weber, Yasuo Kuniyoshi, Stuart Davis, Ben Shahn, Edward Hopper, Charles Burchfield, George Grosz, Franklin Watkins, and, tying for tenth place, Lyonel Feininger and Jack Levine. When *Look* asked artists to rate their favorites, the results were much the same, with the addition of Max Beckmann, Philip Evergood, John Sloan, and Rufino Tamayo. *Look* congratulated the poll respondents:

> Imaginative and highly individual work has been chosen. Almost totally rejected among the winners are the surrealists and very abstract work. Results also show no high regard for old-fashioned, ultra-realistic painting still favored by large sections of the public. This is a high quality, middle-of-the-road selection . . .

In point of fact, figurative art in the late 1940s and into the 1950s maintained its popularity with museum directors, curators, and the readerships of such mass-audience magazines as *Life, Look,* and *Colliers.* But there were changes, with evidence again coming from the mass-circulation magazines.

In its March 20, 1950, issue, *Life* ran a spread called "Nineteen Young Americans," a selection of paintings from American artists under age 36. None of the paintings was completely abstract. All contained recognizable images, often architectural or landscape

forms, although paintings by Hedda Sterne and Theodoros Stamos came closest to nonobjective. Only six paintings contained the human figure, and only the picture by the African American artist Eldzier Cortor represented a human nude, albeit with attenuated torso. Of this situation, *Life* commented:

> The traditional studio nude is almost a rarity in contemporary American painting. Under the influence of European moderns the nude became less an ideal of beauty and more a laboratory specimen to be dissected and its parts distorted and moved about to create new effects. Yet the young Americans, with a native love of natural forms behind them, have not entirely renounced the human figure. They use it as a decorative and recognizable element in their compositions and as a vehicle to express the ideas, emotions and responses to the state of the world today.

An exhibition of the works selected opened at the Metropolitan Museum of Art that month.

What emerged in the early 1950s was a middle range of American artists—neither totally abstract nor traditional—such as the "nineteen younger Americans" and older artists Evergood, Levine, Kuniyoshi, Shahn, and Hopper. Some responded to the postwar "state of the world," beleaguered by anxiety, ambiguity, alienation, and even cynicism. They probed themes that used the figure to express these moods or feelings—choosing styles that combined characteristics of naturalism, cubism, expressionism, and surrealism.

Others explored the possibilities of the new painterly abstraction for investigating and pushing the human form to its formal and expressive limits. The first group, maintaining its commitment to content over form, stayed within the mainstream tradition of humanism, although they strained and deflected that tradition. The commitment of the second group was primarily to exploring form and artistic process even while retaining figurative elements. These artists included Willem de Kooning, Elaine de Kooning, Hans Hofmann's student Jan Müller, and the California artists David Park, Richard Diebenkorn, and Elmer Bischoff. This latter group would maintain their position in the art history textbooks in tandem with the abstract expressionists.

Within the first group—the humanist group—many of the younger artists resorted to ambiguous metaphors and veiled allusions. Whereas most figurative artists of the 1930s shared an optimistic belief in progress and social justice, the mood of these figurative artists in the postwar period changed to one of pessimism and defeatism. Whereas Marxists had maintained that there were "human situations" specific to time and place, the new phrase in the late 1940s and 1950s was "the human condition"—a phrase that suggested a universalized state of being, alienated in an irrational and absurd world.

Hence, the major postwar themes in figurative painting included crucifixion scenes, a single figure alone in a vast space or lost in a literal or symbolic labyrinth, and ambiguous rituals and sinister revelries of figures, frequently masked. Artists who painted such pictures included Shahn, Alton Pickens, Stephen Greene, Hyman Bloom, Robert Vickrey, George Tooker, Jared French, Mitchell Siporin, Karl Zerbe, George Grosz, Peter Blume, Siegfried Reinhardt, Joe Lasker, O. Louis Guglielmi, Henry Koerner, David Aronson, and Rico Lebrun.

These artists found favor with most museum directors and curators across the country. One gauge of their popularity is that all these figurative artists were included in Whitney annuals and their works purchased for the permanent collection. Indeed, the Whitney Museum of American Art, since its founding by Gertrude Vanderbilt Whitney,

had always collected realist and figurative art, even while, in the late 1940s and 1950s, the Museum increasingly collected abstract art.

Whitney Director Lloyd Goodrich, trained as an artist and self-trained as an art critic, and curator John I. H. Baur, trained in art history at Yale University, had no ideological stake in one style or another. The annuals and biennials they organized always attempted to show the diversity of artistic styles in the country. Writing for the December 1954 issue of *Art in America,* Baur laid out the Whitney's position:

> While stylistic trends are not the principal concern of a museum, they are nevertheless reflected, almost automatically, in its purchases and exhibitions. Thus the Whitney annual of 1934 and that of 1954 were very different shows, the former heavily weighted with American Scene painting, the latter with abstractions. But the point is that a preponderance of one style or another meant only that more creative artists seemed to us to be working in that direction at that time. . . . [S]tylistic trends do concern the museum, not so much for themselves but because their power to attract and inspire creative minds has a direct relation to the museum's search for quality.

Yet when Baur organized *The New Decade: 35 American Painters and Sculptors* for a Whitney Museum exhibition held in early 1955, he included not only abstract sculptors Herbert Ferber, Sue Fuller, David Hare, Ibram Lassaw, Richard Lippold, and Seymour Lipton; expressionist painters Willem de Kooning, Franz Kline, Robert Motherwell, Jackson Pollock, and Ad Reinhardt; but also realists Stephen Greene, Walter Murch, Bernard Perlin, Alton Pickens, Honoré Sharrer, George Tooker, and Robert Vickrey. Baur assured his viewers in his foreword: "No conscious effort has been made to interpret the period in terms of stylistic tendencies . . . Our aim has been to record something of the diversity and vitality of American art in the last ten years, a decade rich in creative talent."

It is no coincidence that the Museum of Modern Art mounted its own exhibition, *The New Decade: 22 European Painters and Sculptors,* which opened later in 1955. The curator, Andrew Carnduff Ritchie, emphasized abstract art, with a larger component of sculpture in his selection than the exhibition at the Whitney. In his foreword to the catalogue, Ritchie confronted the political associations of realism to Europeans:

> The greatest tensions during the decade have been political. One by-product has been that in art the Communists have sought to steal the term "realism," just as they have sought to appropriate the words "peace" and "democracy." . . . It would be foolish to suggest that many painters have turned to some kind of non-objective or non-figurative art only to avoid the social realism of the Communists or the Fascists. The beginnings of abstract art pre-date the Soviet revolution by a number of years. One may speculate, however, that the weakness, even sterility, of most non-Communist figurative painting is in part the result of stronger minded artists having chosen an extreme reactionary or advanced position, leaving the middle ground to become impoverished.

"Extreme reactionary" means, to Ritchie, the realist art of the fascists and the communists; "advanced position" means the abstract art of Western European countries.

The equation of realism with the totalitarianism of the Soviet Union was made more explicit when Alfred H. Barr revised his *What Is Modern Painting?* for its 1956 edition and added the sentence: "Soviet artists . . . are now enjoined—and well paid—to paint propaganda pictures in a popular realistic style" (see Reading 80).

Thus as the decade of the 1950s came to a close, it was clear that the more abstract styles had moved to center stage. (The degree to which this was political is still heatedly debated.) Goodrich, in agreement with his Whitney colleague, John Baur, nevertheless felt obliged to speak out for figurative art in his editorial for the "New Talent" issue of *Art in America* (September/October 1960):

> In our present-day concern with advanced trends, we are apt to forget that representational art is still very much alive, and has many exponents. . . . Its exponents today are in a difficult position: a minority, attacking some of the most complex pictorial problems, in the face of relative indifference or opposition from influential critics, museums and powers-that-be.
>
> If the history of past successive schools has any bearing on the present situation, the current predominance of abstract art is not necessarily permanent. . . . [T]here are increasing signs of other tendencies making themselves felt—some as outgrowths of abstraction, some as reactions from it. What further forms they will take, who can predict? We can be sure of only one thing: they will not be what we expect.

For the new directions of the late 1950s and 1960s, which would have surprised even Goodrich, we must turn to Chapter 5. Suffice it to say that realism and figurative painting, which has been so much a component of modern art in the U.S.A., held its course.

**73** ✦ Henry Koerner, "Interview between Henry Koerner and Dr. Paul A. Chew," in *Henry Koerner Retrospective Exhibition*. (Greensburg, PA: Westmoreland County Museum of Art, 1971).

Henry Koerner, born of Jewish parents in Austria, studied at the Vienna Academy of Design. When Hitler annexed Austria in 1938, he fled to Italy. He arrived in New York in April 1939 and resumed his career as a graphic designer. He joined the Office of War Information (OWI) and in 1943 was inducted into the Army. His wartime experience in Europe with the Office of Strategic Services (OSS, predecessor to the CIA) made a lasting impression on him. His 1947 painting, *Vanity Fair,* was purchased by the Whitney Museum of American Art from its annual of that year.

In London I started to draw in earnest filling five sketch books of war-torn London. Since part of the veneer of civilization was bombed off, love, eating, sleeping, merrymaking, and the absurdity of Hyde Park speakers was going on right before my

eyes. In 1945, we came to Germany . . . Berlin and the Nurenburg Trials. With all the tragedy in England, there had been still humor left. But Germany now was completely morbid. . . . You could see the raw flesh and bones. Through the hole made by a Russian gun, you could glimpse into the bedroom of a woman without a man. Reality had turned into surreality . . . "normal" life into existentialism. People with starved earthen faces and sores stood in the rubble . . . warriors coming home with feet wrapped in rags and newspapers . . . a faint memory had come to life again.

---

*74* ✦ Elizabeth Catlett, "Negro Artists," *New Masses* 59 (April 30, 1946):27–28.

When she wrote this review, Catlett, an African American sculptor and printmaker, was teaching sculpture and dressmaking at the George Washington Carver School, a progressive community art center in Harlem, run on a shoestring, that emerged to fill the vacuum when the Harlem Community Art Center folded. She was, in other words, not in an ivory tower, but down in the trenches with those struggling to make better lives for themselves. The following year, however, she moved to Mexico to work on a printmaking project funded by the Julius Rosenwald Foundation.

*New Masses* consistently ran reviews of art exhibitions during the early 1940s. Editorial board members, contributing editors, and writers included artists Ad Reinhardt, Raphael Soyer, William Gropper, Charles Keller, Philip Evergood, Robert Gwathmey, Rockwell Kent, Charles White, and Elizabeth Catlett. The issue in which Catlett's review appears also reported on the *New Masses'* Cultural Conference and the symposium "Art as a Weapon," in which representatives from labor unions participated and papers were delivered by Dalton Trumbo, Howard Fast, and the Communist Party leader William Z. Foster. In 1946 domestic anti-Communism was on the rise, but not yet at the stage it reached in 1947 with loyalty oaths and the HUAC hearings on communism. Hence, in 1946 many artists still had no qualms about associating with *New Masses*.

Without belaboring the theoretical ramifications of whether or not race should be an issue for African American artists when they paint and sculpt, Catlett simply states that what unites the artists in the exhibition she reviews, *The Negro Artist Comes of Age*, is that "they show that the Negro artist uses subject matter that he knows best—the struggle of the Negro people for equality of opportunity and full democratic rights." However, she is critical of exhibitions that ghettoize artists in such "Negro" shows.

The American Federation of Arts has, for the second time in five years, assembled an all-Negro art exhibit which it is circulating throughout the country. The present exhibit, which has just left the Brooklyn Museum after a month's stay, is called "The Negro Artist Comes of Age."

The title in itself is an insult. Negro artists have contributed to American culture since the late eighteenth century when Joshua Johnston, a well-known and skilled portrait painter, worked in Baltimore. And there seems to be little purpose in such a

separate exhibit. Were there a school of Negro art there might be some justification for it. But the wide diversity of style here displayed proves there is no Negro art as such in America.

Most of the paintings and sculpture have one thing alone in common. They show that the Negro artist uses subject matter that he knows best—the struggle of the Negro people for equality of opportunity and full democratic rights. Artists represented in this category are well known—Romare Bearden, Eldzier Cortor, Ernest Crichlow, Sargent Johnson, Jacob Lawrence, Hughie Lee Smith, Charles White, John Wilson and Hale Woodruff, among others.

There is in my mind, and possibly in those of the majority of young Negro artists, no reason for such all-Negro art exhibits, unless to show, in some way, the continuous struggle of Negro artists against tremendous economic and cultural barriers. Such a show as this one adds to the cultural restrictions and lessens to an extent cultural equality of opportunity.

The work in this show is generally of a very high caliber. The American Federation of Art would do a much greater service to art in America if it would scatter these paintings by Negroes through some of its other travelling exhibitions. Let us do away with restrictions once and for all.

---

**75** ✦  "Statement," *Reality: A Journal of Artists' Opinions* 1, no. 1 (Spring 1953): [1]

In the face of what they considered the onslaught of abstract expressionism, the realists fought back. In March 1950 Raphael Soyer sent postcards to many of his friends asking them to join him to discuss the current art situation whereby realist and figurative artists found themselves passed over and ignored. About ten artists met at the Del Pizza restaurant, including Soyer, Yasuo Kuniyoshi, Sol Wilson, Edward Hopper, Leon Kroll, Lee Hirsch, and Philip Evergood. Evergood recalled the occasion: "We thought non-objective painting was a blind alley." The group met regularly to work on a statement, which was issued in March 1951. One draft read in part (Raphael Soyer Papers, Cornell University Library):

We are passing thru [sic] a period of anarchy in the fine arts today. Many artists have lost their way and are wandering in an alley where life has ceased. By making a fetish of form, some of them have enclosed themselves in a private world with its own rules, above criticism and without responsibility. Man's reason and his will, his capacity to understand life and to mould it to his purpose have come to be considered unimportant. In their place we find the cult of the irrational and an emphasis on the so-called instinctual and primitive drives. This is a hollow art.

We believe that the artist sensitive to what is happening around him can re-affirm those human values without which our civilization will disintegrate. In doing so, he can deepen among his fellows that faith in man which today is so necessary to a healthy world.

We believe that art should be directed to the people. We believe that nature and man are the heart and focus of art, and that their interpretation thru forms which do not obscure[,] dehumanize or mystify, is the very essence of artistic activity. We invite the support of all those who believe in the imperative need at the moment to revive the humanist spirit which has inspired so much of the art of the past and which the present so desperately needs.

Ralph Pearson, a writer close to the realists, in an address called "The Cult of the Beginner," delivered at the third Annual Convention of the Association of Critics of Art at Amsterdam, held in July 1951, objected to the use of the term "avant-garde" to define the abstract expressionists. At one meeting of the realists, Jack Levine quipped that the abstract expressionists should be called "space cadets." Eventually they published *Reality: A Journal of Artists' Opinions,* in the spring of 1953, which toned down some of the language of the draft statement. The third and last issue of the 12-page journal appeared in the summer of 1955.

—————————————————◆—————————————————

A group of artists have joined together to discuss their problems. The work of the members of this group is highly diverse in style and conception. Their kinship is a respect and love for the human qualities in painting. The following statement represents their concerted opinion.

All art is an expression of human experience. All the possibilities of art must be explored to broaden this expression. We nevertheless believe that texture and accident, like color, design, and all the other elements of painting, are only the means to a larger end, which is the depiction of man and his world.

Today, mere textural novelty is being presented by a dominant group of museum officials, dealers, and publicity men as the unique manifestation of the artistic intuition. This arbitrary exploitation of a single phase of painting encourages a contempt for the taste and intelligence of the public. We are asked to believe that art is for the future, that only an inner circle is capable of judging contemporary painting, that everybody else must take it on faith. These theories are fixed in a ritual jargon equally incomprehensible to artist and layman. This jargon is particularly confusing to young artists, many of whom are led to accept the excitation of texture and color as the true end of art, even to equate disorder with creation. The dogmatic repetition of these views has produced in the whole world of art an atmosphere of irresponsibility, snobbery, and ignorance.

We say, in the words of Delacroix: "The men of our profession deny to the fabricators of theories the right to thus dabble in our domain and at our expense." We believe that art cannot become the property of an esoteric cult. We reaffirm the right of the artist to the control of his profession. We will work to restore to art its freedom and dignity as a living language.

| | | | |
|---|---|---|---|
| Milton Avery | Ernest Fiene | Leon Kroll | Sigmund Menkes |
| Isabel Bishop | Joseph Floch | Yasuo Kuniyoshi | Henry Varnum Poor |
| Aaron Bohrod | Xavier Gonzalez | Joe Lasker | Anton Refregier |
| Louis Bosa | Dorothea Greenbaum | Sidney Laufman | Honoré Sharrer |

| | | | |
|---|---|---|---|
| Louis Bouché | Stephen Greene | Jacob Lawrence | Joseph Solman |
| Charles Burchfield | William Gropper | Jack Levine | Moses Soyer |
| Nicolai Cikovsky | Chaim Gross | Oronzio Maldarelli | Raphael Soyer |
| Gladys Rockmore Davis | Maurice Grosser | Reginald Marsh | William Thon |
| Joseph De Martini | Robert Gwathmey | Henry Mattson | Anthony Toney |
| Alexander Dobkin | Joseph Hirsch | Edward Melcarth | Howard Warshaw |
| Guy Pène du Bois | Edward Hopper | Paul Mommer | Sol Wilson |
| Philip Evergood | Karl Knaths | | |

**76** ✦ Stephen Greene, "Artist's Statement," Whitney Museum of American Art, *The New Decade: 35 American Painters and Sculptors* (New York: The MacMillan Company, 1955), p. 38.

Born in New York, Stephen Greene studied art at the National Academy of Design, the Art Students League, and the College of William and Mary at Richmond, VA. He earned his BFA and MFA at the University of Iowa, where he studied with Philip Guston. He then taught at Indiana University, Washington University, and the Parsons School of Design. His work was included in the *Life* magazine picture spread of March 20, 1950, "Nineteen Young Americans." The artists had been selected as the result of a poll of heads of museums, art schools, and college art departments. The editors of *Life* had posed the questions: "Do they have anything worthwhile to express and do they get it across? Do they reflect feelings of hope, or are they harsh expressions of despair?" Such questions were important considerations in that post–World War II period.

Greene was subsequently featured in *Life*'s issue of October 23, 1950, in which the commentator wrote: "Greene's canvases are not ingratiating. Peopled by sad, mannikin-like men, they have a strained and morbid cast. Many of them are based on religious subjects. Greene does not call himself a religious man but, because biblical stories are universally recognized and easily understood, he used them to communicate his own feelings of the state of modern man—a state Greene considers to be chaotic and insecure."

✦

I was born on New York City's Lower East Side. . . . of Polish immigrant parents. The earliest stories told me were from the Old Testament. This and the values of my family helped me form a strong moral sense. It is the examination of the moral order that has been my main theme. The most important aspects of life for me are those which pertain to the moral and emotional (psychological); therefore the world I paint must always be a product of the imagination; the actual and real become merely the outward vestments of the inner, intangible reality. Man often reveals himself in a gesture, the revelation itself is the subject, not his outward aspect as a member of a given society. In my earlier paintings I was concerned with man's final isolation, man suffering not so much for others but for himself and his own sense of incompleteness. My concept of man is essentially a tragic one. It is derived from the idea that man is

**Figure 4-4.**  Stephen Greene, *The Burial,* 1947. Oil on canvas, 42 × 55 in. Collection the Whitney Museum of American Art, New York; purchase 49.16. Photograph © 2000: Whitney Museum of American Art, New York.

inherently and originally good and that he subsequently falls into evil. At times, my subjects may seem over-personal and private but the conviction that as a private man my necessities are as ordinary and unspecial as those of most people leads me to explore a larger order that includes all men.

Because many of my paintings deal with religious subjects, I have often been asked whether or not I am a religious man. I would like to answer that. In the forties I was obsessed in my life as well as my work (there is no separation) by the massacre of the Jews in Europe. This led me to reinterpret the story of Christ, particularly the events centering around the Crucifixion. Christ is no longer the central figure and torturers are equally involved and the tragedy was theirs as well. No one is saved. Finally it is my necessity to observe and to sit in judgment. To feel that way and to be a painter is a religious matter, and in that sense I am a religious man.

---

**77 ✦**  David Park, excerpts from a statement, quoted in Alfred Frankenstein, "Northern California," *Art in America* 42, no. 1 (Winter, 1954): 48–49; 74.

On the West Coast three painters, David Park, Richard Diebenkorn, and Elmer Bischoff, developed at the California School of Fine Arts in San Francisco what has become known as Bay Area Figurative Painting. All three were teachers there at one time or another, and

by the 1950s all three had fashioned a figurative style that adapted abstract expressionism to the studio picture—studies of posed figures in a controlled or structured environment, such as a studio classroom.

Throughout the 1940s, Park painted abstractly, influenced by Mark Rothko and Clyfford Still, who taught with him at the CSFA. At the end of 1949, he reputedly unloaded his expressionist abstractions in the Berkeley dump and turned to the figure.

Alfred Frankenstein, who wrote a regular column for the *San Francisco Chronicle,* was the major art critic on the West Coast. In his essay, which includes the following quotation from Park, Frankenstein notes that a vast majority of members of the San Francisco Art Association were teachers. In most art departments, even during the "reign" of abstract painting, the tradition of painting from the figure was kept alive, especially in those schools removed from the immediate New York area.

Frankenstein observes that Park called his figurative work "pictures" in contrast to the "paintings" of his abstract period. These remarks lead into Park's own remarks reprinted here.

———————————◆———————————

For more than twenty years, . . . I had preferred other qualities than those of representation.

During that time I was concerned with big abstract ideals like vitality, energy, profundity, warmth. They became my gods. They still are. I disciplined myself rigidly to work in ways I hoped might symbolize those ideals. I still hold to those ideals today, but I realize that those paintings practically never, even vaguely, approximated any achievement of my aims. Quite the opposite: what the paintings told me was that I was a hard-working guy trying to be important. . . . I have found that in accepting and immersing myself in subject matter I paint with more intensity and that the "hows" of painting are more inevitably determined by the "whats." I believe that my work has become freer of arbitrary mannerisms. . . .

Great artists have always changed the succeeding tradition by giving whole new concepts to art, but I believe that they became great artists with complete naturalness and inevitability simply by painting each day for the present day's painting. I think that I, three years ago, was too much concerned with the direction that art would or might take, too much with my thoughts on the future of painting and not enough on the present. I believe that we are living at a time that overemphasizes the need of newness, of furthering-concepts. [. . .]

The implication is always "I, too, must be great." Well, darn it, I think that greatness is a lot like sex appeal, an enviable characteristic, but a characteristic that exists in the sight of others and not in one's self. . . . Painting is a fascinating, challenging, and absorbing activity. My job, it seems to me, is to paint with as much completeness of energy, insight, enthusiasm, and so on as possible, and if today I feel that I achieve this more nearly by using subjects, that's what I'm going to do today. . . . That my recent pictures haven't as yet developed the nasty trait of mocking me has been a positive encouragement.

———————————————————————————

*78* ✦ Leon Golub, "Artist's Statement," *New Images of Man* (New York: The Museum of Modern Art, 1959).

From the vantage point of today, the *New Images of Man* exhibition, curated by Peter Selz for the Museum of Modern Art in 1959, brought to an end a fifteen-year period of intensely expressionist art. There was no doubt that it gathered together a stellar group of both American and European painting and sculpture. The American painters included Richard Diebenkorn, Leon Golub, Balcomb Greene, Willem de Kooning, Rico Lebrun, James McGarrell, Jan Müller, Nathan Oliveira, and Jackson Pollock; they were in the company of such Europeans as Karel Appel, Francis Bacon, and Jean Dubuffet. The sculptors included the Americans Leonard Baskin, Cosmo Campoli, Theodore Roszak, and H. C. Westermann, joined by the Europeans Kenneth Armitage, Reg Butler, César, Alberto Giacometti, Eduardo Paolozzi, Germaine Richier, and Fritz Wotruba. What the exhibition meant to do was to give a name—"new image of man"—to the direction which the pessimistic side of humanist painting had taken since the war. What unified the artists was less a style, a technique, or an iconography than what Selz perceived was a shared sensibility that drew on the ideas of existentialism. But the critics were not convinced.

The thesis centered on the ideas of existentialism. Indeed, the exhibition's organizer, Peter Selz, had asked Paul Tillich, a Christian existentialist theologian, to write the two-page preface to the catalogue. Tillich blamed the continuing Cold War for polarizing artists into two groups: those who ignore dehumanizing world situations and those who resist by publicly despairing or rebelling. To Tillich:

> One need only look at the dehumanizing structure of the totalitarian systems in one half of the world, and the dehumanizing consequences of technical mass civilization in the other half. In addition, the conflict between them may lead to the annihilation of humanity. The impact of this predicament produces, on the one hand, adaptation to the necessities of present-day living and indifference to the question of the meaning of human existence, and on the other, anxiety, despair and revolt against this predicament. The first group resigns itself to becoming things amongst things, giving up its individual self. The second group tries desperately to resist this danger.

Both Tillich and Selz hoped to regain the image of man as a powerful symbol of protest against potential human annihilation in the atomic age. Tillich's rhetoric, similar to that of many other Christian existentialists, had a romantic ring, with its gloomy prediction that ultimately the problem rested on the demonic and irrational forces within each of us.

The exhibition was not a success. Manny Farber, writing in *Art News* (October 1957), called it a "side show." He elaborated: "Included are some insectile women, a full female torso swinging on an iron spit, several Frankenstein figures and some terribly swollen heads, in all of which the outstanding feature is a notably rough skin texture suggesting

leprosy in late stages." Fairfield Porter wrote in *The Nation* (October 24, 1959) that "the common superficial look of the exhibition is that it collects monsters of mutilation, death and decay. It is less an exhibition for people interested in painting and sculpture than an entertainment for moralists."

Trained at the Art Institute of Chicago and then teaching at the University of Indiana, Leon Golub was indeed a moralist. One of the few artists who understood abstract expressionism and who could articulate its inherent contradictions and limitations (which he did in a critique published in the Winter 1955 issue of the *College Art Journal*), Golub wanted to create a powerful art of universal significance through use of the human figure. He never abandoned the figure through the next three decades; in the 1980s he became a major neoexpressionist, political artist with his "mercenary series."

My recent paintings can be viewed in various ways:

1. Man is seen as having undergone a holocaust or facing annihilation or mutation. The ambiguities of these huge forms indicate the stress of their vulnerability versus their capacities for endurance.
2. Man is seen in an heroic gesture of the very beauty and sensuous organic vitality of even fragmented forms. The enlarged carnal beauty of the fragment is contrasted to its pathos and monumentality.
3. These paintings attempt to reinstate a contemporary catharsis, that measure of man which is related to an existential knowledge of the human condition—a recognition that looks back to the symbolic incarnation of classic art.
4. The figures are implacable in their appearance and resistance, stance or stare. They are implacable in the compacted wearing down of surfaces and forms to simpler forms but with more complicated surfaces. They are implacable as they take on the resistance of stone as against the undulations of flesh. They are implacable as they know an absolute state of mind (on the edge of nothingness) just as they know a nearly absolute state of massiveness.

## The Cold War and the Arts

The introduction to this chapter touched on the USIA's troubled traveling exhibition *Advancing American Art* of 1946–47. In 1984, the Montgomery Museum of Fine Arts in Alabama mounted an exhibition devoted to the USIA exhibition and its controversy in the late 1940s. Curators Margaret Lynne Ausfeld and Virginia Mecklenburg reviewed the aims of the original organizers, the enthusiastic critical reception from abroad, the negative response from politicians within the United States, and the abrupt cancellation of the tour by the State Department. One of the problems, as Mecklenburg observed in the 1984 catalogue, was the exhibition's focus: "In emphasizing abstraction and Expressionism, styles that were intellectually and stylistically associated with European prototypes,

J. LeRoy Davidson, the show's organizer, tacitly rejected a nativist philosophical slant that would probably have ensured his project's success. In fact, the charge most frequently leveled at the show—that *Advancing American Art* failed to embody American democratic values—related in part to the dearth of American Scene imagery."

Davidson wanted to showcase an American art that was international in character—in both styles and content. Mecklenburg points out that when Hugo Weisgall wrote the USIA catalogue for the Prague venue of *Advancing American Art,* he understood the premise and praised the artists' rejection of narrow cultural nationalism. In Weisgall's words: "As the idea of America has subordinated the concept of racial origins, so the growing international fabric of culture has subordinated nationality in the arts to the individual."

But the Senators, the Congressmen, and the Hearst press were not ready for this internationalism—even though it was predicated on *individualism.* To them internationalism smacked of communism. The *New York Journal-American,* a Hearst paper, went full throttle in its attack; a December 3, 1946, unsigned article, "Exposing the Bunk of So-Called Modern Art," declared that the paintings were "not American at all. The roots of the State Department collection . . . are not in America—but in the alien cultures, ideas, philosophies and sickness of Europe. Those paintings that try to tell a story at all, give the impression that America is a drab, ugly place, filled with drab, ugly people. They are definitely leftish paintings. . . . " Later the red-baiters discovered that twenty-four of the artists were on HUAC's list of subversives (a list forwarded to them by the FBI). President Truman, in one of his more notorious statements, referred to Yasuo Kuniyoshi's *Circus Girl Resting* as "a fat, semi-nude circus girl" and said that "the artist must have stood off from the canvas and thrown paint at it . . . if that's art, I'm a Hottentot" (above quotations from *Advancing American Art*, 1984).

Secretary of State George C. Marshall ordered "no more taxpayer's money for modern art."[1] His Assistant Secretary, William Benton, already sensitive to accusations that the State Department harbored communists, cancelled the tour and directed that the paintings be sold. Another exhibition, *Sport in Art,* organized for the Olympic Games of 1956, suffered a similar fate. At about this time the Museum of Modern Art, through its International Programs, stepped in as the primary impresario of exhibitions circulating in Latin America and Europe.

The anticommunists turned their attention to the WPA/Federal Art Project murals and interpreted the images of community as communist propaganda. One well-publicized anti-art campaign focused on responses to Anton Refregier's murals for the Rincon Annex Post Office in San Francisco. Refregier had won the competition in 1941 to design a mural representing the history of California. Because of bureaucratic delays brought on by World War II, the mural of 27 panels was not finished until 1949. Immediately protests were staged by various groups, such as the American Legion, the Daughters of the American Revolution, and the Sailors' Union. For example, the Veterans of Foreign Wars objected to images of striking laborers, so Refregier took out the picket signs held by the laborers; a church group felt that the priests were too fat, so Refregier repainted them slimmed down. Congressman Richard M. Nixon joined the fray. On July 18, 1949, he wrote a past commander of the American Legion post:

---

[1] Quoted in William Hauptman, "The Suppression of Art in the McCarthy Decade," *Artforum* 12 (Oct. 1973).

I wish to thank you for your letter as to whether anything can be done about re-
moval of communist art in your Federal Building . . . I realize that some very ob-
jectionable art, of a subversive nature, has been allowed to go into federal build-
ings in many parts of the country.[. . .] I believe a committee of Congress should
make a thorough investigation of this type of art in government buildings with a
view to obtaining removal of all that is found to be inconsistent with American
ideals and principles.[2]

At about the same time that Nixon wrote this letter, Congressman George A. Dondero
(Republican, Michigan) was accusing modern art of being communistic during one of his
many diatribes on the floor of the House of Representatives (see Reading 79).

   In both its crude and its refined versions, anticommunism intensified. Mike Ham-
mer, protagonist of Micky Spillane's 1951 bestseller, *One Lonely Night,* brags to a friend:
"I killed more people tonight than I have fingers on my hands. I shot them in cold blood
and enjoyed every minute of it. I pumped slugs into the nastiest bunch of bastards you
ever saw and here I am calmer than I've ever been and happy too. They were Commies,
Lee. They were red sons-of-bitches who should have died long ago." As crude as are
Hammer/Spillane's words, the anticommunist intellectuals articulated the same views,
even if in more polished language. Irving Kristol, writing "Civil Liberties," for the March
1952 issue of *Commentary,* deplored Joseph McCarthy as a "vulgar demagogue." Yet
Kristol's anticommunism was just as strong, only more nuanced:

Communism is an idea . . . and it is of the essence of this idea that it is also a con-
spiracy to subvert every social and political order it does not dominate. It is, fur-
thermore, an Idea that has ceased to have any intellectual status but has become
incarnate in the Soviet Union and the official Communist parties, to whose infalli-
ble directive unflinching devotion is owed. . . . If a person is held by the Idea—he
is, all appearances to the contrary, a person with different loyalties, and with dif-
ferent canons of scrupulousness, from ours.

Many writers for *Commentary* associated themselves with the American Committee for
Cultural Freedom (ACCF), a Cold War organization set up by ex-OSS operatives. One of
those writers, Sidney Hook, argued in a ACCF pamphlet that academic freedom need not
apply to communist teachers. Only after Senator Joseph McCarthy's performance on tel-
evision during the Army hearings demolished his credibility and he was subsequently cen-
sured in the Senate in December 1954, did such widespread red-baiting cease.[3]

   In reality, the House Committee on Un-American Activities and Senator McCarthy's
investigative subcommittee were more interested in going after high-profile celebrities
than artists. When artists were persecuted, however, they turned out to be the socially

[2]Quoted in "George V. Sherman", "Dick Nixon: Art Commissar," *The Nation* (Jan 10, 1953). See also
Jane de Hart Mathews, "Art and Politics in Cold War America," *American Historical Review* 81 (October
1976).

[3]See Christopher Lasch, "The Cultural Cold War: A Short History of the Congress for Cultural Freedom, "
in Barton J. Bernsteid, ed. *Towards a New Past* (New York: 1967).

concerned artists from the 1930s. Ben Shahn and Philip Evergood were subpoenaed to testify before HUAC in the summer of 1959, at the time when their paintings were being sent to a Moscow exhibition as part of a cultural exchange. HUAC's chairman, Rep. Francis E. Walter, had charged that more than half of the 67 painters and sculptors in the Moscow exhibition had records indicating their "affiliation with Communist fronts and causes" (quoted in *The New York Times,* June 27, 1959).

In 1959, the State Department held fast. The agency realized the propaganda value of showing American art in the Soviet Union, even when some of that art seemed critical of life in the United States. The reasoning: only in America could the citizenry freely criticize their country. And as for abstract art, it then seemed obvious to all but the most intractable anticommunists that the position arguing for abstract art—as an art symbolizing political freedom—might have validity and/or political usefulness. The *Washington Post* editors observed in their July 2, 1959, issue:

[T]here is special irony in Mr. Walter's ill-advised attempt to impose a political varnish on these works of art. Few aspects of Communist conformity have aroused as much ridicule as the deadening official insistence on what is called "Socialist realism" in art. Abstractions and any other experimental forms have been proscribed with a vigor that has been endlessly embarrassing to such fellow-traveling painters elsewhere as Picasso. . . . It would be a pity if this unique opportunity to bring a little esthetic ferment into Russia were clouded over by a quixotic crusade aimed at preventing Soviet citizens from seeing any pink in a painting.

The Cold War had not ended, it had simply entered a new and more sophisticated phase. But after 1959, censorship by government of art and artists would no longer be directed toward the issue of communist politics. Censorship would reemerge in the 1980s, but focused instead on sexual and religious politics.

*79* ✦ Representative George A. Dondero (Michigan), "Modern Art Shackled to Communism," *Congressional Record*—House, 81st Congress, 1st Session, V. 95, Parts 8–9 (August 16, 1949), 11584–87.

Congressman George A. Dondero, Republican from Royal Oak, Michigan, served in Congress from 1935 through 1956, and took up the anticommunist fight begun in the House by Congressman Martin Dies. Dondero made several diatribes in Congress, this being the most famous. The text is rambling, but it names American artists and museum people. The reader should note that Dondero marshals the words of Thomas Craven (see Reading 57) to support his case against Paul J. Sachs, the Director of Harvard's Fogg Art Museum, who had trained a generation of museum directors in the "isms." Countering the argument that abstract art represents an art of "freedom"—an argument that Alfred Barr, Jr., would later make (see Reading 80), Dondero replies that all the "isms" are communist inspired, and, therefore, deny men their freedom.

Dondero's counterpart in the Senate was Senator Joseph McCarthy, Republican from Wisconsin, but Senator McCarthy did not achieve power until 1953, when he was named chairman of the Senate permanent investigations subcommittee. Dondero is here speaking from the floor.

◆

*Mr. Dondero.* Mr. Speaker, quite a few individuals in art, who are sincere in purpose, honest in intent, but with only a superficial knowledge of the complicated influences that surge in the art world of today, have written me—or otherwise expressed their opinions—that so-called modern or contemporary art cannot be Communist because art in Russia today is realistic and objective.

The left-wing art magazines advance the same unsound premises of reasoning, asserting in editorial spasms that modern art is real American art. They plead for tolerance, but in turn tolerate nothing except their own subversive "isms."

The art termites, disciples of multiple "isms" that compose so-called modern art, boring industriously to destroy the high standards and priceless traditions of academic art, find comfort and satisfaction in the wide dissemination of this spurious reasoning and wickedly false declaration, and its casual acceptance by the unwary.

This glib disavowal of any relationship between communism and so-called modern art is so pat and so spontaneous a reply by advocates of the "isms" in art, from deep, Red Stalinist to pale pink publicist, as to identify it readily to the observant as the same old party-line practice. It is the party line of the left wingers, who are now in the big money, and who want above all to remain in the big money, voiced to confuse the legitimate artist, to disarm the . . . academician, and to fool the public.

As I have previously stated, art is considered a weapon of communism, and the Communist doctrinaire names the artist as a soldier of the revolution. It is a weapon in the hands of a soldier in the revolution against our form of government, and against any government or system other than communism.

\* \* \*

What are these isms that are the very foundation of so-called modern art? [. . .] I call the roll of infamy without claim that my list is all-inclusive: dadaism, futurism, constructionism, suprematism, cubism, expressionism, surrealism, and abstractionism. All these isms are of foreign origin, and truly should have no place in American art. While not all are media of social or political protest, all are instruments and weapons of destruction. [. . .]

Cubism aims to destroy by designed disorder.

Futurism aims to destroy by the machine myth. The futurist leader, Marinetti, said: "Man has no more significance than a stone."

Dadaism aims to destroy by ridicule.

Expressionism aims to destroy by aping the primitive and insane. Klee, one of its founders, went to the insane asylums for his inspiration.

Abstractionism aims to destroy by the creation of brainstorms.

Surrealism aims to destroy by the denial of reason.

\* \* \*

Add to this group of subversives the following American satellites, and the number swells to a rabble: [Robert] Motherwell, [Jackson] Pollock, [William] Baziotes, David Hare, and Marc Chagoll [sic]. The last name is lauded by Communist publications and is a sponsor of the School of Jewish Studies, cited by Attorney General Tom Clark "as an adjunct in New York City of the Communist Party." At this school [Chagall] is associated with some of the old gang, including Minna Harkavy, Louis Lozowick, William Gropper, Phillip [sic] Evergood, Raphael Soyer, and Lena Gurr.

Abstractivism, or nonobjectivity, in so-called modern art was spawned as a simon pure, Russian Communist product.

\* \* \*

The Museum of Modern Art has published and distributed a booklet on Ben Shahn, that proponent of social protest in art, whom we have tagged as a Communist-fronter and member of the John Reed Club . . . . Does the museum approve, as well, of the company he keeps? Ben Shahn, Diego Rivera, Jose Clement Orozco, and David A. Siqueiros are among the most outstanding proponents of social protest in art in North America. The three last named are Mexican Communists, but all have been active in the United States. As I have previously stated, Shahn aided Rivera in painting the murals at Rockefeller Center, which were removed as Communist, and unacceptable.

\* \* \*

. . . Paul J. Sachs, head of the Fogg Museum at Harvard, is an honorary trustee of the Museum of Modern Art . . .

Thomas Craven, foremost art critic in the United States, refers to the Fogg Museum as "the rendezvous of an effeminate and provincial tribe." Under the administration of Paul J. Sachs it has accepted, nurtured, and exalted the whole school of so-called modern and contemporary art, but more catastrophic than that, the Fogg Museum has trained many of its effeminate elect to be directors of museums throughout our land. These individuals have gone forth predisposed to promote the art of the "isms". . . .

\* \* \*

We are now face to face with the intolerable situation, where public schools, colleges, and universities, art and technical schools, invaded by a horde of our foreign art manglers, are selling to our young men and women a subversive doctrine of "isms," Communist-inspired and Communist-connected, which have one common, boasted goal—the destruction of our cultural tradition and priceless heritage.

\* \* \*

Communist art, aided and abetted by misguided Americans, is stabbing our glorious American art in the back with murderous intent.

*80* ✦ Alfred H. Barr, Jr., "Truth, Freedom, Perfection," *What Is Modern Painting?*, rev. ed. (New York: Museum of Modern Art, 1952). Reprinted by permission from an essay by Alfred H. Barr, Jr. in *What Is Modern Painting?* © 1943, 1952, The Museum of Modern Art.

Alfred H. Barr, Jr., the first director of the Museum of Modern Art and its intellectual on aesthetic matters, championed "freedom in the arts" in the various versions of the Museum's booklet, *What Is Modern Painting?*, first published in 1943 and printed three more times before its revision in 1952—a revision that afforded Barr the opportunity to praise the abstract expressionist artists whom the Museum had added to their collections. The editions were large by museum standards, with 45,000 copies printed from 1943 to 1949; the 1952 revised edition saw a print run of 20,000, and a sixth edition, revised in 1956, produced 25,000 copies.

Like Willard Huntington Wright and Arthur Jerome Eddy (see Readings 5 and 18), in the 1943 version Barr used "freedom" to mean the ability to choose between styles and to exercise one's individuality. Also like Wright and Eddy, Barr advanced the idea that freedom in art is primarily expressed when the artist moves away from realism. Barr, however, introduced a new notion of "freedom," that freedom is not only what painters exercise, but what a nation allows.

In the 1943 version, during World War II, Barr attacked Nazi Germany. In the Cold War atmosphere of 1952, Barr also attacked the Soviet Union—for curtailing the freedom of artists. The 1952 edition is where Barr first linked realism with the ideologies of totalitarian regimes, although three years earlier (*Magazine of Art,* March 1949) he had written of the parity between realism and abstraction and that "both directions are valid and useful." By the time of the 1956 revised edition of *What Is Modern Painting?* Barr tilted more explicitly against non-modern art. The message to young artists embarking on careers became clear: to prove your independence from communism avoid realist styles. Instead, choose to be "modern."

On connections made between Cold War policies and abstract expressionism, see Guilbaut in "For Further Reading"; also Max Kozloff *Artforum* (May 1973), Eve Cockcroft *Artforum* (June 1974), and David and Cecile Shapiro *Prospects* (1977).

\*\*\*

The truth which plumbs deeply, brings joy to the heart or makes the blood run chill is not always factual; indeed it is rarely to be found in newsreels, statistics or communiqués. The soothsayer, that is, the truth-sayer, the oracle, the prophet, the poet, the artist, often speak in language which is not matter-of-fact or scientific. They prefer the allegory, the riddle, the parable, the metaphor, the myth, the dream, for, to use Picasso's words, "Art is a lie that makes us realize the truth."

In order to tell this truth the artist must live and work in *freedom*. President Roosevelt, with the totalitarian countries in mind, put it clearly, "The arts cannot thrive except where men are free to be themselves and to be in charge of the discipline

of their own energies and ardors. . . . What we call liberty in politics results in freedom in the arts. . . . Crush individuality in the arts and you crush art as well."[1]

* * *

When [Hitler] became dictator he passed laws against modern art, called it degenerate, foreign, Jewish, International, Bolshevik; forced modern artists such as Klee, Kandinsky, Beckmann out of art schools, drove them from the country and snatched their pictures from museum walls, to hide them or sell them abroad. [. . .]

Similarly the Soviet authorities, even earlier than the Nazis, began to suppress modern art, calling it leftist deviation, Western decadence, bourgeois, formalistic. About 1921 such painters as Chagall and Kandinsky left the U.S.S.R. in frustration. The Soviet artists who remained are now enjoined—and well paid—to paint propaganda pictures in a popular realistic style. Other subjects and styles have long been virtually forbidden.

* * *

Why do totalitarian dictators hate modern art?

Because the artist, perhaps more than any other member of society, stands for individual freedom—freedom to think and paint without the approval of Goebbels or the Central Committee of the Communist Party, to work in the style he wants, to tell the truth as he feels from inner necessity that he must tell it.

In this country there is little danger that the arts will suffer from the tyranny of a dictator but there are other less direct ways of crushing freedom in the arts. In a democracy the original, progressive artist often faces the indifference or intolerance of the public, the ignorance of officials, the malice of conservative artists, the laziness of the critics, the blindness or timidity of picture buyers and museums.

[. . .]

Freedom of expression, freedom from want and fear, these are desirable for the artist. But why should the artist's freedom particularly concern the rest of us? Because the artist gives us pleasure or tells us the truth? Yes, but more than this: his freedom as we find it expressed in his work of art is a symbol, an embodiment of the freedom which we all want but which we can never really find in everyday life with its schedules, regulations and compromises. Of course we can ourselves take up painting or some other art as amateurs and so increase our sense of personal freedom; but even in a nation of amateur artists there would still be a need for the artist who makes freedom of expression his profession. For art cannot be done well with the left hand: it is the hardest kind of work, consuming all a man's strength, partly for the very reason that it is done in greater freedom than other kinds of work.

For the arts thrive, to repeat President Roosevelt's phrase, where men are free "to be in charge of the discipline of their own energies and ardors." The greater the artist's freedom the greater must be his self-discipline. Only through the most severe self-discipline can he approach that excellence for which all good artists strive. And in approaching that goal he makes of his work of art a symbol not only of truth and freedom but also of perfection.

* * *

Yet the artist, free of outer compulsion and practical purposes, driven by his own inner passion for excellence and acting as his own judge, produces in his work

---

[1]From a broadcast upon the opening of the new building of the Museum of Modern Art, May 11, 1939.

of art a symbol of that striving for perfection which in ordinary life we cannot satisfy, just as we cannot enjoy complete freedom or tell the entire truth.

*Truth,* which in art we often arrive at through a "lie," *freedom,* which in art is a delusion unless controlled by self-discipline, and *perfection,* which if it were ever absolute would be the death of art—perhaps through pondering such ideas as these we can deepen our understanding of the nature and value of modern painting; but for most people the direct experience of art will always be more pleasurable and more important than trying to puzzle out its ultimate meaning.

\* \* \*

*81* ✦ Federal Bureau of Investigation, Newark branch, File on Ben Shahn, dated 10/3/51.[Fig. 4-5]

J. Edgar Hoover was Director of the FBI from 1924 until his death in 1972. In August 1936, according to Steven Rosswurm (in Mari Jo Buhle, et. al., *Encyclopedia of the American Left*, 1990), President Franklin D. Roosevelt requested a "survey" of organizations connected to fascist and Communist groups. Hoover took on the job of reviewing organizations and publications. By 1943 the FBI had 180,000 files on organizations and people considered subversive. In the decades since, the FBI has continued to open and maintain files on citizens and foreign residents. The Freedom of Information Act has allowed researchers to obtain, albeit with some difficulty, the censored files of individuals.

The reader will note from the two pages reproduced here that the FBI considered the friends of Shahn who lived in Roosevelt, New Jersey, to be a "tightly knit organization which has continually backed Communist projects." One of the activities of the Roosevelt, New Jersey, residents was to protest the war in Korea.

Another page transmitted the information that "although BEN SHAHN has definitely been identified with Pro-Communistic activities, it is not known that he has actually been a member of the Communist Party." Indeed, Shahn maintained that he had never been a member. Shahn's file was still active as late as 1964.

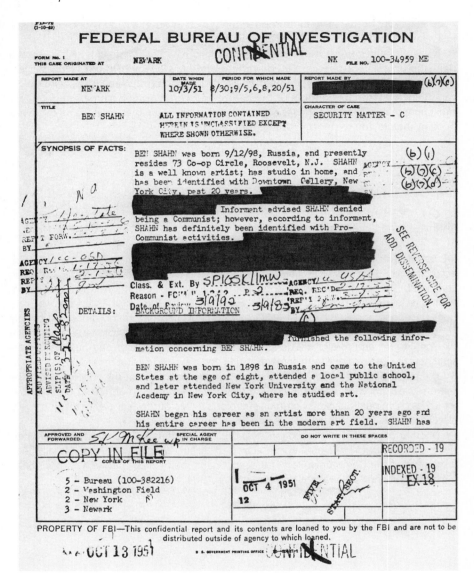

**Figure 4-5.** Federal Bureau of Investigation, Newark branch, File on Ben Shahn, dated October 3, 1951.

NK 100-34959

CONFIDENTIAL

been identified with the Downtown Gallery in New York City for the past 20 years and this organization acts as his agent. SHAHN's early work was in making posters for various trade unions in New York City, and he has been very successful in the modern art field.

SHAHN has been married on two occasions and has two children from his first marriage which terminated more than ten years ago by divorce. He now has three children with a second marriage and resides in Roosevelt, N.J. SHAHN's second wife was a well known artist who was painting under the name of BERNARDA SHAHN.

SHAHN originally became acquainted with the community of Roosevelt, N.J. in 1936. This community was founded as the Jersey Homesteads in 1936 as a project of the U.S. Government and at that time SHAHN did mural paintings for the local school and later for government buildings in Washington, D.C.

SHAHN has a studio in his home in Roosevelt, N.J. and most of his art work is done there.

COMMUNIST ACTIVITY

(C)         (b)(1)
                    (b)(6)(b)

████████ received the following information in March, 1951 from informants and various sources whose reliability are unknown.

Communism became a vital issue in Roosevelt, N.J. after World War II and it was then that an influx of professional people began, all of whom have remained intimate with BEN SHAHN, artist of Roosevelt, N.J. This group is a tightly knit organization which has continually backed Communist projects; further that they have been active in the World Peace Petition sponsored by Moscow, and have attempted to have the same endorsed by the community as a whole through legislative process.

(C)

████████ this group has circulated various leaflets advocating "stop the war in Korea", and two of the group members, ROSE MINTZ and HELEN KLEINEMAN, were identified with PAUL ROBESON and other Communist sympathizers at Madison Square Garden advocating withdrawal of troops in Korea. Further, that this group has acted as backers of a local chapter of the Civil Rights Congress, which has been espousing the cause of the "Trenton Six" in which the "Trenton Six" is a group of six local negroes who were originally convicted and sentenced to die for the murder of a Trenton, N.J. storekeeper in a holdup attempt in 1948. The "Trenton Six" has received considerable favorable publicity in the Daily Worker and has received wide spread support from the Civil Rights Congress of N.J.

2

CONFIDENTIAL

**Figure 4-5.** Continued

# Chapter Five

## 1955–1967

### Cultural and Historical Context for a Consumer and Technological Society

The end of the Korean War (1950–53) clarified the positions of the United States and the U.S.S.R. in the Cold War. Both superpowers sought to control military sites from which to launch sophisticated weaponry for both offense and defense: by making strategic alliances with the existing neutral nations, by disciplining their smaller allies, or by working covertly through the CIA or KGB to initiate coups in order to install political allies. For example, the United States bolstered its commitment to the North Atlantic Treaty Organization (NATO), signed a peace treaty with Japan, organized the South East Asia Treaty Organization (SEATO), and initiated security pacts with Japan, Australia, New Zealand, and the Philippines. The U.S.S.R. also made its moves to consolidate its allies. It set up the Warsaw Treaty in 1955, signed by Albania, Bulgaria, Czechoslovakia, East Germany, Hungary, Poland, and Rumania, and tightly monitored those nations.

A site of contention that had an immediate effect on U.S. citizens was Cuba. When Fidel Castro and his guerrilla fighters seized the government at Havana in 1959, the Soviet Union offered assistance. The fact that Cuba lay in North American waters—only 90 miles from Florida—aroused the U.S. government, especially after spy planes discovered, in the late summer of 1962, the covert installation of Soviet missile sites on the island. The Cuban Missile Crisis almost brought the two superpowers to blows and exacerbated the anxieties of civilians already worried that American urban centers were "ground zero" for nuclear attack.

The rationale for defense preparation had already led to the production of bigger, more sophisticated atomic bombs requiring testing, in spite of lethal consequences from fallout. When in 1954 a hydrogen bomb was detonated at Bikini Atoll in the Pacific, radioactive "rain" fell as far away as Chicago. Later, nuclear testing was conducted in the deserts of Nevada and continued until 1963, when test bans presumably halted them. The U.S.S.R. conducted its own tests of nuclear bombs, most of which were only vaguely reported in the U.S. press. But most disturbing to the United States was the Soviets' launching in 1957 of the satellite Sputnik, which gave visible evidence of the superior space physics of the U.S.S.R.

A collorary to testing were preparations for nuclear attack at home. Even before the Cuban crisis, the January 12, 1962, issue of *Life* magazine ran a cover story, "New

**Figure 5-1.**   Ken Riley, "Cutaway Plan of Community Shelter under Bridge," *Life*
52, no. 2 (January 12, 1962): cover. Credit: Illustration by Ken Riley, *Life* magazine ©
Time Inc. Ten pages of text, photographs and drawings in *Life* focused on the
planning of community shelters to protect civilians from both atomic attack and
fallout. One solution for an impromptu shelter was a city bus driven into a trench
and covered with wooden planks.

Facts You Must Know about Fallout: The Drive for Mass Shelters," with detailed draw-
ings of the ideal bomb shelter [see Fig. 5-1]. Nelson Rockefeller, then Governor of New
York, promoted the building of family bomb shelters. The ensuing debates as to whether
or not one ought to gun down one's bomb-shelterless neighbor seeking refuge took on
a surreal quality and prompted ordinary American citizens (those not able to afford bomb
shelters) to feel personally powerless or collectively part of an absurd situation. Historians
Douglas T. Miller and Marion Nowak (*The Fifties: The Way We Really Were,* 1977) point
out that although some learned to live with the bomb, "other persons experienced in-
tense and almost constant anxiety." To Miller and Nowak, "the fiction of holocaust and
deformity was one expression of such fears."

There was, however, resistance against the facade of peaceful "normalcy" and re-
sentment against what President Dwight D. Eisenhower called the "military-industrial
complex." Critics held the government responsible for bending to that military-industrial
complex and perpetuating Cold War tensions. The protests of the National Committee
for a Sane Nuclear Policy (SANE), whose members included distinguished scientists and

concerned citizens, provided a venue for personal dissent. Few artists, however, joined SANE in the early 1960s.

Benefitting from the general anxieties about nuclear holocaust was a corporate world that demanded compliance and loyalty. Although Senator Joseph McCarthy was censured by the Senate in December 1954 for his out-of-control crusade against reputed communist subversives, domestic surveillance did not abate, as has been subsequently revealed in the recent histories of J. Edgar Hoover and the Federal Bureau of Investigation. In this atmosphere many young people either conformed to standards of behavior and speech or stifled their impulse to speak out. In fact, the generation that graduated from college in the mid-1950s was called by the press pundits, the "Silent Generation," represented in fiction by Sloan Wilson's The Man in the Gray Flannel Suit (1955) and analyzed by William H. Whyte, Jr., in The Organization Man (1956), which included a section on how to cheat on the personality tests corporations administered to prospective employees.

At the end of the 1950s and into the 1960s, the material rewards for such conformity promised a comfortable life. The economy was booming: jobs seemed plentiful, especially in defense; with low inflation, pay raises meant an increased standard of living; new construction provided affordable housing; factories sent automobiles rolling off assembly lines; frozen foods cut the time of meal preparation; electrical appliances eliminated the drudgery of household tasks; and bland television programs, such as "Father Knows Best," blared from sets in almost every home, celebrating the middle-class family (white and assumed to be Protestant) protected by a benevolent patriarch with a well-paying job and nourished by a stay-at-home mom.

We ask today: Did anyone really believe the myth of "the American dream"? Was the general population so blinkered that they did not acknowledge the clear evidence of the realities of racism, of the unfair and demeaning discrimination against women, of the growing gap between rich and poor—articulated in Michael Harrington's devastating 1962 portrait of poverty, The Other America?

In the mid-1950s there was, in fact, a cultural underground that formed to escape conformity and complacency. Self-described as the Beats (for "Beatific" as well as "broken-down"), they were poets and writers who inhabited lofts and small apartments in New York's Greenwich Village and San Francisco's North Beach. At a poetry reading held on October 13, 1955, organized by artists Manuel Neri and Bruce McGaw for an alternative San Francisco art gallery, Allen Ginsberg read his epic "Howl." The audience was electrified. City Lights Bookshop published the poem the following year, and the police vice squad moved in. But San Francisco, a haven for nonconformists and a nascent gay community, provided a supportive venue for Ginsberg and his New York friends, who imbibed the nonmaterialist philosophy of Zen while also responding to the excitement of motorcycles and free love. When Ginsberg's good friend, Jack Kerouac, published On the Road in 1957, it became a siren call for a younger generation of artists; Williams Burroughs's Naked Lunch (1959), with its dark tones of anomie, also became a cult classic.

Hollywood capitalized on the antiestablishment sentiment among youth and young adults with Marlon Brando's The Wild One (1954) and James Dean's Rebel without a Cause (1955). And academic and social commentators were also bringing a similar message to college students. Paul Goodman's Growing up Absurd: Problems of Youth in the Organized System (1960) and Herbert Marcuse's One Dimensional Man: Studies in the Ideology of Advanced Industrial Society (1964) called attention to the systemic and

systematic nature of the Cold War capitalist economic system and its repressed and con-formist culture. On the other hand Thomas S. Kuhn's *The Structure of Scientific Revolutions* (1962), Marshall McLuhan's *Understanding Media: The Extensions of Man* (1964), and Morse Peckham's *Man's Rage for Chaos* (1967) would point youth toward the age of systems and information distribution that would become explicit in the 1970s.

The Civil Rights movement, documented on the nightly news throughout the mid-1950s and 1960s, certainly contradicted the complacent "American dream" television image. With television the nation saw the unfolding of real events. In 1954 the Supreme Court ruled, in the *Brown v. Board of Education of Topeka* decision, that "separate but equal" was a sham; public school systems were mandated to speed up integration. The movement gained real momentum, however, after the Montgomery bus boycott of 1955, triggered by the jailing of civil rights activist Rosa Parks after she refused to move to the back section of a segregated bus. In 1957 Little Rock, Arkansas, became the site of confrontations between racists and African Americans who attempted to desegregate the school system. In 1961 Freedom Riders—integrated groups of black and white youth—began to go to the South to work on voter registration and the integration of public facilities such as lunch counters. Civil Rights organizations, such as the National Association for the Advancement of Colored People (NAACP), the Southern Christian Leadership Conference (SCLC), the Congress on Racial Equality (CORE), the Student Non-Violent Coordinating Committee (SNCC), and grass roots groups galvanized protestors to march in support of the end to segregation in housing and jobs. The "I have a dream" speech of Martin Luther King, Jr., delivered at the March on Washington in August 1963, inspired a generation of Americans of all races to the urgency of full integration.

The government finally woke up to the fact that great masses of the African American population had continued to migrate from the South to northern cities in the two decades following World War II and were in need of affordable housing. President Lyndon Johnson vowed a "War on Poverty," and pledged government action to ameliorate ghetto conditions in those cities. But in the local communities, hope bred impatience and frustration at the slow pace of social reforms. The entrenched racism of those in power (local politicians, the police) was nowhere more evident than in Birmingham, Alabama, in May 1963, when police turned on fire hoses and used police dogs to break up protest marches; or in Selma, Alabama, in March 1965, when mounted police used tear gas and clubs to stop the Selma-to-Montgomery March. In large urban centers, anger inevitably erupted into full-scale riots: in Rochester in 1963, in Harlem in 1964, at Watts in Los Angeles in 1965, in Chicago in 1965, in Detroit in 1967. Nicholas Lemann, in *The Promised Land: The Great Black Migration and How It Changed America* (1991), notes that with 164 race riots across the nation in the first nine months of 1967, "it seemed at least possible that a full-scale national race war might break out." Obviously, many leaders, such as those in the Black Panther Party, had begun to advocate more radical and/or more separatist measures than the moderate, gradualist King.

It is against this general background that the artworld saw divisions developing in what had seemed a monolithic American art. Abstract expressionism was generating two different strains of art. On the one hand there was the Dionysian mode of seemingly impromptu and anarchistic happenings and performances, messy assemblages and collages of cast-off junk and ephemera; on the other hand, there developed the more Apollonian mode of concrete poetry, minimalist dance movements,

and high-modernist painting with controlled shapes and spaces and uniformly applied colors. Negotiating those two modes was an emerging group of Pop artists, who brought to their art modernist control and a flat, hard-edged style of painting along with a mock-celebration of the banalities of popular culture, a glorification of household commodities, and a nonpolitical irony.

Revisionist reassessments of the art of the period have engendered controversies about the nature and ideologies of the movements. Fruitful discussions might focus on 1) the ways male artists who organized antiestablishment "happenings" and events excluded women from decision-making roles; and, 2) the degree to which the high modernists and Pop artists (both artists and critics) accommodated themselves to the market and the world outlook of the military-industrial complex. Art historian Thomas Crow is not the first to see the links between high modernism, the artmarket, Wall Street, and international corporations. Crow writes about the final years of the 1960s in *The Rise of the Sixties* (1996):

> Within the confines of the art world, the painting and sculpture that came under the umbrella of Modernism began to suffer dismissal, in part because its exclusion of the outside world and its cult of fine discrimination seemed a mocking irrelevance in a time of political crisis. But just as important were its indelible associations with the interlocking structures of power in America, which linked the White House, Congress and official agencies to Wall Street banks and law firms to international corporations to universities and charitable foundations to the governing boards of the great museums.

Not all historians agree with Crow. Certainly conceptual art (discussed in Chapter 6), was profoundly antimaterialist in its nature (because of its resistance to commodification) and therefore especially resistant to corporate America.

*** 

We end the section with 1967—just before new ways of thinking about American art, culture, and social and political life were taking hold. The anti-Vietnam War protests catalyzed profound changes in the art world. Therefore, we will wait until Chapter 6 to reach back to the mid-1960s to discuss, among other movements, the artists of the black arts movement, the feminist movement, and the antiwar movement, as well as an antimaterialist, conceptual art movement.

**82 ✦** Allen Ginsberg, "America," in *Howl and Other Poems* (San Francisco: City Lights Pocket Bookshop, 1956). Credit: All lines from "AMERICA" from COLLECTED POEMS 1947–1980 by ALLEN GINSBERG."

Allen Ginsberg was one of the leading Beat poets of the 1950s. His father, Louis Ginsberg, was a poet and schoolteacher from Paterson, New Jersey. Allen Ginsberg went to Columbia College, traveled and worked at odd jobs, and in 1954 settled in San Francisco. In 1959, he starred in Robert Frank and Alfred Leslie's film made in New York City, *Pull My Daisy,* along with Larry Rivers, Peter Orlovsky, Gregory Corso, and Alice Neel, with Jack Kerouac narrating. Ginsberg was later active in the antiwar and the gay rights movements.

"America" was included with "Howl," "A Supermarket in California," and "Sunflower Sutra" in a dittographed handout, dated May 16, 1956, and distributed to Ginsberg's friends. In November of that year, City Lights Pocket Bookshop issued *Howl and Other Poems* in an edition of 1000, which included six more poems. "America," in its use of imagery and syntax, will remind the reader not only of Walt Whitman's verse, but also of Kenneth Fearing's poetry, such as "American Rhapsody (2)" (see Reading 42). In fact, Ginsberg referred to Fearing in the film *Pull My Daisy*.

---

### america

*America I've given you all and now I'm nothing.*
*America two dollars and twentyseven cents January 17, 1956.*
*I can't stand my own mind.*
*America when will we end the human war?*
*Go fuck yourself with your atom bomb.*
*I don't feel good don't bother me.*
*I won't write my poem till I'm in my right mind.*
*America when will you be angelic?*
*When will you take off your clothes?*
*When will you look at yourself through the grave?*
*When will you be worthy of your million Trotskyites?*
*America why are your libraries full of tears?*
*America when will you send your eggs to India?*
*I'm sick of your insane demands.*
*When can I go into the supermarket and buy what I need*
    *with my good looks?*
*America after all it is you and I who are perfect not the*
    *next world.*
*Your machinery is too much for me.*
*You made me want to be a saint.*
*There must be some other way to settle this argument.*
*Burroughs is in Tangiers I don't think he'll come back it's*
*sinister.*
*Are you being sinister or is this some form of practical joke?*
*I'm trying to come to the point.*
*I refuse to give up my obsession.*
*America stop pushing I know what I'm doing.*
*America the plum blossoms are falling.*
*I haven't read the newspapers for months, everyday somebody*
    *goes on trial for murder.*
*America I feel sentimental about the Wobblies.*
*America I used to be a communist when I was a kid I'm not*
    *sorry.*
*I smoke marijuana every chance I get.*

*I sit in my house for days on end and stare at the roses in*
     *the closet.*
*When I go to Chinatown I get drunk and never get laid.*
*My mind is made up there's going to be trouble.*
*You should have seen me reading Marx.*
*My psychoanalyst thinks I'm perfectly right.*
*I won't say the Lord's Prayer.*
*I have mystical visions and cosmic vibrations.*
*America I still haven't told you what you did to Uncle Max*
     *after he came over from Russia.*

*I'm addressing you.*
*Are you going to let your emotional life be run by Time*
     *Magazine?*
*I'm obsessed by Time Magazine.*
*I read it every week.*
*Its cover stares at me every time I slink past the corner*
     *candystore.*
*I read it in the basement of the Berkeley Public Library.*
*It's always telling me about responsibility. Businessmen are*
     *serious. Movie producers are serious. Everybody's serious*
     *but me.*
*It occurs to me that I am America.*
*I am talking to myself again.*

*Asia is rising against me.*
*I haven't got a chinaman's chance.*
*I'd better consider my national resources.*
*My national resources consist of two joints of marijuana*
     *millions of genitals an unpublishable private literature that*
     *goes 1400 miles an hour and twenty-five-thousand mental*
     *institutions.*
*I say nothing about my prisons nor the millions of under-*
     *privileged who live in my flowerpots under the light of*
     *five hundred suns.*
*I have abolished the whorehouses of France, Tangiers is*
     *the next to go.*
*My ambition is to be President despite the fact that I'm a*
     *Catholic.*

*America how can I write a holy litany in your silly mood?*
*I will continue like Henry Ford my strophes are as individual*
     *as his automobiles more so they're all different sexes.*
*America I will sell you strophes $2500 apiece $500 down*
     *on your old strophe.*

*America free Tom Mooney*
*America save the Spanish Loyalists*
*America Sacco & Vanzetti must not die*
*America I am the Scottsboro boys.*
*America when I was seven momma took me to Communist*
   *Cell meetings they sold us garbanzos a handful per ticket*
   *a ticket costs a nickel and the speeches were free*
   *everybody was angelic and sentimental about the workers*
   *it was all so sincere you have no idea what a good thing*
   *the party was in 1935 Scott Nearing was a grand old man*
   *a real mensch Mother Bloor made me cry I once saw*
   *Israel Amter plain. Everybody must have been a spy.*
*America you don't really want to go to war.*
*America it's them bad Russians.*
*Them Russians them Russians and them Chinamen. And*
   *them Russians.*
*The Russia wants to eat us alive. The Russia's power mad. She*
   *wants to take our cars from out our garages.*
*Her wants to grab Chicago. Her needs a Red Readers' Digest.*
   *Her wants our auto plants in Siberia. Him big bureaucracy*
   *running our fillingstations.*
*That no good. Ugh. Him make Indians learn read. Him need*
   *big black niggers. Hah. Her make us all work sixteen*
   *hours a day. Help.*
*America this is quite serious.*
*America this is the impression I get from looking in the*
   *television set.*
*America is this correct?*
*I'd better get right down to the job.*
*It's true I don't want to join the Army or turn lathes in*
   *precision parts factories, I'm nearsighted and psychopathic*
   *anyway.*
*America I'm putting my queer shoulder to the wheel.*

# Assemblage, Installations, Happenings, Events, Performance

In October 1958 *Art News* published Allan Kaprow's "The Legacy of Jackson Pollock," in which Kaprow argued that Pollock's value to artists was in showing the way to bring life into their art. At that time the memory of Pollock—in the minds of Kaprow and others—was kept vivid not just by his paintings, but by widely circulated and well-remembered photographs of the artist at work which Kaprow reproduced in his article. Arnold Newman's spread of photographs for an article, "Jackson Pollock: Is he the greatest living painter in the United States?" had already been published in the August 8, 1949, issue of *Life* magazine. Hans Namuth's photographs

were included in "Pollock Paints a Picture," for the May 1951 issue of *Art News* (Fig. 4-3). Namuth also filmed the artist at work for the Hans Namuth/Paul Falkenberg 1950–51 film, *Jackson Pollock,* which premiered at the Museum of Modern Art on June 14, 1951. In Namuth's still photographs Pollock is literally "in" the paintings, dancing around a canvas laid out on the floor and making arabesques with his arms as he slings skeins of paint across an expanse of canvas. These photographs remained the visible evidence that Pollock's canvases were, in the words of Harold Rosenberg, "an arena in which to act" (see Reading 62).

To Kaprow: "Pollock . . . left us at the point where we must become preoccupied with and even dazzled by the space and objects of our everyday life, either our bodies, clothes, rooms, or, if need be, the vastness of Forty-Second Street." He continued:

> Objects of every sort are materials for the new art: paint, chairs, food, electric and neon lights, smoke, water, old socks, a dog, movies, a thousand other things which will be discovered by the present generation of artists. Not only will these bold creators show us, as if for the first time, the world we have always had about us, but ignored, but they will disclose entirely unheard of happenings and events, found in garbage cans, police files, hotel lobbies, seen in store windows and on the streets, and sensed in dreams and horrible accidents. An odor of crushed strawberries, a letter from a friend or a billboard selling Draino; three taps on the front door, a scratch, a sigh or a voice lecturing endlessly, a blinding staccato flash, a bowler hat—all will become materials for this new concrete art.

In other words, the new performative art depended on the chaotic disorder and anarchic exuberance of everyday life—without the ordering factors of historical relevance, aesthetic refinement, narrative coherence, yearnings toward transcendence, or personal expressiveness. There are, however, dark references in Kaprow's list, such as the "three taps on the front door," suggesting visits from the police or FBI agents.

The installations, Happenings, and events of the late 1950s and early 1960s can be seen as larger and more public forms of collage. Collage—those cut out pieces of paper and small objects affixed to a support—traced its heritage back to Picasso, Max Ernst, and Kurt Schwitters, who sought to bring bits of the real world into their art. Quieter and naturally more intimate than the art Kaprow had in mind, the collages of New York "correspondence artist" Ray Johnson and the California artist Jess (Burgess Collins) used and altered comics and glossy magazine reproductions to create ironic and, with Jess, occasionally homoerotic images.

The collage aesthetic became three-dimensional in the collage-boxes of Joseph Cornell, who, beginning in the 1930s, arranged in his glass-fronted boxes fetishized objects and memory-laden keepsakes. He also teased his audiences with ambivalent meanings by incorporating reproductions of movie stars and elements from popular culture. Assemblage is the three-dimensional collage blown to life-sized proportions and often placed on the floor, such as Robert Rauschenberg's *Monogram,* 1955–59 (Moderna Museet, Stockholm). Rauschenberg called these painting/sculpture hybrids "combines."

Pollock, however, was not the only influence on Kaprow. The avant-garde composer John Cage, who taught at the New School from 1956 to 1958, also inspired Kaprow, Rauschenberg, and other artists. Cage's concept that chance noise, as occurs in the urban environment, could be incorporated into a musical score was appropriated by

the artists for the visual arts. Hence, when Kaprow created an environment of hanging junk and strips of cloth at the Hansa Gallery in 1958, he also included electronic music periodically and erratically playing from tape machines placed around the gallery.

A lively group gathered at Hansa, including Robert Whitman and George Segal, who organized a Happening at his farm in New Jersey. In 1958 Red Grooms started showing figurative artists in his studio, which attracted Jim Dine and Claes Oldenburg. The next year Grooms moved to the Lower East Side, where he opened the "Delancy Street Museum." The Reuben Gallery, which Anita Reuben opened in 1959, focused on the same artists and hosted Kaprow's *18 Happenings in Six Parts* in October 1959.

The most famous venue for exhibitions and performances was the Judson Gallery, which opened in the basement of Judson Memorial Church on Washington Square in Greenwich Village. The minister, Reverend Howard Moody, and his assistant, Bud Scott, felt it part of their social mission to reach out to the artists of the Village. Soon Kaprow, Dine, Whitman, Oldenburg, Grooms, George Brecht, and Lucas Samaras were staging events and happenings at the Judson Gallery. Dine's *The House* and Oldenburg's *The Street* were installed at the Judson Gallery in February–March 1960. Oldenburg did an improvisational, non-narrative performance, *Snapshots from the City,* within the confines of his *Street* environment, in which he wrapped himself in old rags as he sat among the debris of junk, charred wooden boards, and crude cut-out figures made from corrugated cardboard. Although many of the artists staging Happenings at the Judson, Hansa, and Reuben Galleries and in artists' lofts may have had scripts, there was an improvisational quality to the actions of the participants.

In contrast to Kaprow and Oldenburg, Robert Rauschenberg staged performance work that was more carefully choreographed. Long before Kaprow discovered Cage, Rauschenberg had been involved with the professional world of avant-garde music and dance. In 1949 Rauschenberg attended the experimental art school at Black Mountain, North Carolina, to study with Josef Albers, and there he met Cage and choreographer Merce Cunningham. For long periods throughout the 1950s and 1960s he did sets, costumes, and posters for the Merce Cunningham Dance Company and also danced in Cunningham's productions; from 1961 to 1965 he was lighting director and stage manager for Cunningham and went on tour with the company. He also designed sets and costumes for the Paul Taylor dance company and performed with Yvonne Rainer. His curiosity about dance and movement extended to science. In 1966, Rauschenberg cofounded Experiments in Art and Technology (E.A.T.) with Billy Klüver, an electronics engineer at Bell Laboratories. He also performed in "9 Evenings: Theatre and Engineering," held at the 69th Regiment Armory in New York in October 1966.

A neo-Dada group, Fluxus, organized a few years earlier in New York, formed international ties with poets and artists from Europe, Japan, Korea, and the United States, such as George Maciunas (Lithuania), Wolf Vostell (Germany), Nam June Paik (Korea), Yoko Ono (Japan), and, occasionally, Joseph Beuys (Germany). They produced concrete poetry and performed in a more minimalist or intellectualized manner than the Grooms and Oldenburg crowd. Maciunas acted as impresario for staged events in Europe, such as the Fluxus Internationale Festspiele Neuester Music held in Wiesbaden in 1962, and published manifestos, Dada-like periodicals, and word-play games. Often events staged by a loose roster of neo-Dada international artists adopted the Fluxus name. In Yoko

Ono's 1965 *Cut Piece,* the artist sat on a stage at Carnegie Hall and invited audience members to cut off pieces of her clothing. The naked body of Carolee Schneemann eroticized Fluxus happenings and introduced another level of content, of which Maciunas allegedly disapproved.

Many of the Fluxus-associated artists, such as Maciunas, Ono, and Robert Watts made "fluxfilms"; others, such as George Brecht and Robert Morris, participated in activities at the Judson Memorial Church, which welcomed young dancers and musicians. They, too, were influenced by Cage's ideas of concrete music (that is, ordinary noise) and duration (of often arbitrary lengths). La Monte Young, Brecht, and Morris produced "scores" for audiences who were key participants in the events. For example, La Monte Young's composition "1960 #4" (published in George Maciunas's *An Anthology,* 1963), reads as follows:

> Announce to the audience that the lights will be turned off for the duration of the composition (it may be any length) and tell them when the composition will begin and end. Turn off all the lights for the announced duration. When the lights are turned back on, the announcer may tell the audience that their activities have been the composition, although this is not at all necessary.

A group of trained dancers—Deborah Hay, Trisha Brown, Yvonne Rainer, and Simone Forti—joined by Young, Morris, Alex Hay and Walter De Maria formed the Judson Dance Theater about 1962. Influenced by Cage and choreographer Merce Cunningham, they rejected the history of emotionally expressive dance that Martha Graham and other modernist dancers had engaged in for fifty years. Instead, their choreography consisted of concrete quotidian movements, such as going through the motions of an ordinary task (swinging a golf club) or of handling an object (pouring water from a pitcher), and they emphasized phrasing (slow movements and prolonged pauses). This "New American Dance" has had lasting influence on the dance world.

The exchange of ideas among the artists, dancers, and musicians of the period was marked by fluidity and mutual inspiration. As Jill Johnston, dance critic of *The Village Voice* summed up, when reviewing the history of the Judson Dance Theater for an exhibition held at Bennington College in 1981: "The Judson choreographers, the Pop artists, the Cage/Cunningham axis, the Lower East Side society, the Happenings creators and the Neo-Dada or Fluxus performers mixed incestuously in a broad network of social/personal/professional interests" (quoted in Barbara Haskell, *Blam!,* 1984).

*83* ✦   Allan Kaprow, "Happenings in the New York Scene," *Art News* 60, no. 3 (May 1961):36–39. © 1961 ARTnews L.L.C.

Allan Kaprow studied with the avant-garde composer John Cage at the New School from 1956 to 1958. Cage, who had a profound impact on other visual artists as well, extended the ideas of Duchamp: 1) that art was what the artist wanted art to be; which meant, 2) that found objects and chance situations qualified as art—either on their own or in combination with specially crafted objects and constructed situations.

When Kaprow produced *18 Happenings in Six Parts* at the Reuben Gallery in New York in 1959, Fairfield Porter reviewed the event for *The Nation*. He described it as follows:

> During the performance different things go on in each of three different rooms, which are separated by semi-transparent plastic partitions. After two sets of events, you move, during an intermission, to another room, according to instructions given you at the door. After two more events you move to the remaining room, and so each member of the audience sees one-third of all that goes on; but you can hear and partly see what is happening in the other rooms. Actors come in, read or speak or play a musical instrument, or paint, or just move; and accompanying this are tape-recorded sounds and the activity and noise of wound-up mechanical toys. . . . The movements are military, disciplined and solemn. . . .

Although Porter found the event to be disappointing, the term "Happenings" became the label for the new kind of art, which Kaprow here elaborates.

———————————————◆———————————————

If you haven't been to the Happenings, let me give you a kaleidoscope sampling of some of their great moments.

Everybody is crowded into a downtown loft, milling about, like at an opening. It's hot. There are lots of big cartons sitting all over the place. One by one they start to move, sliding and careening drunkenly in every direction, lunging into people and one another, accompanied by loud breathing sounds over four loudspeakers. Now it's winter and cold and it's dark, and all around little blue lights go on and off at their own speed, while three large, brown gunny-sack constructions drag an enormous pile of ice and stones over bumps, losing most of it, and blankets keep falling over everything from the ceiling. A hundred iron barrels and gallon wine jugs hanging on ropes swing back and forth, crashing like church bells, spewing glass all over. Suddenly, mushy shapes pop up from the floor and painters slash at curtains dripping with action. A wall of trees tied with colored rags advances on the crowd, scattering everybody, forcing them to leave. There are muslin telephone booths for all with a record player or microphone that tunes you in to everybody else. Coughing, you breathe in noxious fumes, or the smell of hospitals and lemon juice. A nude girl runs after the racing pool of searchlight, throwing spinach greens into it. Slides and movies, projected over walls and people, depict hamburgers: big ones, huge ones, red ones, skinny ones, flat ones, etc. You come in as a spectator and maybe you discover you're caught in it after all, as you push things around like so much furniture. Words rumble past, whispering, dee-daaa, baroom, love me, love me; shadows joggle on screens, power saws and lawnmowers screech just like the I.R.T. at Union Square. Tin cans rattle and you stand up to see or change your seat or answer questions shouted at you by shoeshine boys and old ladies. Long silences, when nothing happens, and you're sore because you paid $1.50 contribution, when bang! there you are facing yourself in a mirror jammed at you. Listen. A cough from the alley. You giggle because you're afraid, suffer claustrophobia, talk to some one nonchalantly, but all the time you're

*there,* getting into the act. . . . Electric fans start, gently wafting breezes of "New-Car" smell past your nose as leaves bury piles of a whining, burping, foul, pinky mess.

\* \* \*

Happenings are events which, put simply, happen. Though the best of them have a decided impact—that is, one feels, "here is something important"—they appear to go nowhere and do not make any particular literary point. In contrast to the arts of the past, they have no structured beginning, middle or end. Their form is open-ended and fluid; nothing obvious is sought and therefore nothing is won, except the certainty of a number of occurrences in which one is more than normally attentive. They exist for a single performance, or only a few more, and are gone forever, while new ones take their place.

These events are essentially theater pieces, however unconventional. That they are still largely rejected by most devotees of the theater may be due to their uncommon power and primitive energy, and to the fact that the best of them have come directly out of the rites of American Action Painting. But by widening the concept "theater" to include them (like widening the concept "painting" to include collage) it is possible to see them against this basic background, and to understand them better.

To my way of thinking, Happenings possess some crucial qualities which distinguish them from the usual theatrical works, even the experimental ones of today. First, there is the *context,* the place of conception and enactment. The most intense and essential happenings have been spawned in old lofts, basements, vacant stores, in natural surroundings and in the street, where very small audiences, or groups of visitors, are commingled in some way with the event, flowing in and among its parts. There is thus no separation of audience and play (as there is even in round or pit theaters), the elevated picture-window view of most playhouses, is gone, as are the expectations of curtain-openings and *tableaux-vivants* and curtain-closing. . . . The sheer rawness of the out-of-doors or the closeness of dingy city quarters, in which the radical Happenings flourish, are more appropriate, I believe, in temperament and unartiness, to the materials and directness of these works.

\* \* \*

Happenings invite one to cast aside for a moment these proper manners and partake wholly in the real nature of the art and (one hopes) life. Thus a Happening is rough and sudden and it often feels "dirty." Dirt, we might begin to realize, is also organic and fertile, and everything, including the visitors, can grow a little in such circumstances.

To return to the contrast between Happenings and plays, the second important difference is that a Happening has no plot, no obvious "philosophy," and is materialized in an improvisatory fashion, like jazz, and like much contemporary painting, where one does not know exactly what is going to happen next. The action leads itself any way it wishes, and the artist controls it only to the degree that it keeps on "shaking" right. A modern play rarely has such an impromptu basis, for plays are still *first written.* A Happening is *generated in action* by a headful of ideas or a flimsily-jotted-down score of "root" directions.

A play assumes words to be the almost absolute medium. A Happening will frequently have words, but they may or may not make literal sense. [. . .]

Indeed, the involvement in chance, which is the third and most problematical quality found in Happenings, will rarely occur in the conventional theater. When it does, it usually is a marginal benefit of *interpretation.* In the present work, chance (in conjunction with improvisation) is a deliberately employed mode of operating that penetrates the whole composition and its character. [. . .]

The word "chance," then, rather than "spontaneity," is a key term, for it implies risk and fear (thus reestablishing that fine *nervousness* so pleasant when something is about to occur). It also better names a *method* which becomes manifestly unmethodical if one considers the pudding more a proof than the recipe.

\* \* \*

The final point I should like to make about Happenings as against plays is . . . their impermanence. By composing in such a way that the unforeseen has a premium placed upon it, no Happening can be reproduced. The few performances given of each work are considerably different from each other; and the work is over before habits begin to set in. In keeping with this, the physical materials used to create the environments of Happenings are of the most perishable kind: newspapers, junk, rags, old wooden crates knocked together, cardboard cartons cut up, real trees, food, borrowed machines, etc. They cannot last for long in whatever arrangement they are put. A Happening is thus at its freshest, while it lasts, for better or worse.

Here we need not go into the considerable history behind such values as are embodied in Happenings. It is sufficient to say that the passing, the changing, the natural, even the willingness to fail, are not unfamiliar. They reveal a spirit that is at once passive in its acceptance of what may be, and heroic in its disregard of security. One is also left exposed to the quite marvelous experience of being *surprised.* This is, in essence, a continuation of the tradition of Realism.

---

*84* ✦ Claes Oldenburg, "I am for an art . . . ," in Claes Oldenburg and Emmett Williams *Store Days* (New York and Villefranche-sur-mer, Frankfurt am Main: Something Else Press, Inc., 1967), 39–42; first version published in *Environments, Situations, Spaces* (New York: Martha Jackson Gallery, 1961).

Claes Oldenburg studied at Yale and, from 1952 to 1954, at the School of the Art Institute of Chicago, a stronghold of figurative and imagist art. He came to New York in 1956 and eventually joined a group of other artists, poets, and dancers, such as Jim Dine, Allan Kaprow, Red Grooms, Al Hansen, Dick Higgins, and Robert Whitman, along with dancers Yvonne Rainer and Lil Picard, who participated in the lively cultural program at Judson Memorial Church, an independent Baptist church in Greenwich Village. On three consecutive days in the winter of 1960, he organized "Ray Gun Spec," a series of six performances. Also in 1960, at the Judson Gallery, he installed *The Street,* an environment made of charred boards and cutout cardboard that exaggerated the typical Lower East Side sites of urban squalor and trash that homeless men inhabited. Within this site he performed *Snapshots from the City,* a series of tableaux.

In a 1969 *Artforum* essay, critic Barbara Rose succinctly described Oldenburg's transition from the squalor of *The Street* to a 1961 upbeat environment, *The Store*, which "sold" crudely fashioned and painted plaster "commodities."

> In contrast to the pessimism and morbidity of The Street, which was a metaphor for the anxiety of city life, The Store presented "power vitality health (hope hope)." . . . With its brilliant color, sensuous surfaces, and abundance of goods, The Store hinted at the joys and pleasures that industrial civilization *might* bring; it was the popular museum where art was democratically available. . . . It was also both a satire on the American obsession to consume and the newly won status of American art as a commodity, and a celebration of the vitality of American culture.

It was but a step before Oldenburg would fashion his giant soft sculptures of hamburgers, telephones, and the other common objects that surrounded him.

This manifesto of Oldenburg sounds much like the description of American Art advanced by Robert Coady for *The Soil* in 1916 (see Reading 9) and compares also with the manifesto of George Maciunas that follows. The aim of most all manifestos by twentieth-century American artists is to break down the barriers between art and life— to bring art into direct relationship with ordinary people.

◆

I am for an art that is political-erotical-mystical, that does something other than sit on its ass in a museum.

I am for an art that grows up not knowing it is art at all, an art given the chance of having a starting point of zero.

I am for an art that embroils itself with the everyday crap & still comes out on top.

I am for an art that imitates the human, that is comic, if necessary, or violent, or whatever is necessary.

I am for an art that takes its form from the lines of life itself, that twists and extends and accumulates and spits and drips, and is heavy and coarse and blunt and sweet and stupid as life itself.

I am for an artist who vanishes, turning up in a white cap painting signs or hallways.

I am for art that comes out of a chimney like black hair and scatters in the sky.

I am for art that spills out of an old man's purse when he is bounced off a passing fender.

I am for the art out of a doggy's mouth, falling five stories from the roof.

I am for the art that a kid licks, after peeling away the wrapper.

I am for an art that joggles like everyones knees, when the bus traverses an excavation.

I am for art that is smoked, like a cigarette, smells, like a pair of shoes.

I am for art that flaps like a flag, or helps blow noses, like a handkerchief.

I am for art that is put on and taken off, like pants, which develops holes, like socks, which is eaten, like a piece of pie, or abandoned with great contempt, like a piece of shit.

I am for art covered with bandages. I am for art that limps and rolls and runs and jumps. I am for art that comes in a can or washes up on the shore.

I am for art that coils and grunts like a wrestler. I am for art that sheds hair.

I am for art you can sit on. I am for art you can pick your nose with or stub your toes on.

I am for art from a pocket, from deep channels of the ear, from the edge of a knife, from the corners of the mouth, stuck in the eye or worn on the wrist.

I am for art under the skirts, and the art of pinching cockroaches.

I am for the art of conversation between the sidewalk and a blind mans metal stick.

I am for the art that grows in a pot, that comes down out of the skies at night, like lightning, that hides in the clouds and growls. I am for art that is flipped on and off with a switch.

I am for art that unfolds like a map, that you can squeeze, like your sweetys arm, or kiss, like a pet dog. Which expands and squeaks, like an accordion, which you can spill your dinner on, like an old tablecloth.

I am for an art that you can hammer with, stitch with, sew with, paste with, file with.

I am for an art that tells you the time of day, or where such and such a street is.

I am for an art that helps old ladies across the street.

I am for the art of the washing machine. I am for the art of a government check. I am for the art of last wars raincoat.

I am for the art that comes up in fogs from sewer-holes in winter. I am for the art that splits when you step on a frozen puddle. I am for the worms art inside the apple. I am for the art of sweat that develops between crossed legs.

I am for the art of neck-hair and caked tea-cups, for the art between the tines of restaurant forks, for the odor of boiling dishwater.

I am for the art of sailing on Sunday, and the art of red and white gasoline pumps.

I am for the art of bright blue factory columns and blinking biscuit signs.

I am for the art of cheap plaster and enamel. I am for the art of worn marble and smashed slate. I am for the art of rolling cobblestones and sliding sand. I am for the art of slag and black coal. I am for the art of dead birds.

I am for the art of scratchings in the asphalt, daubing at the walls. I am for the art of bending and kicking metal and breaking glass, and pulling at things to make them fall down.

I am for the art of punching and skinned knees and sat-on bananas. I am for the art of kids' smells. I am for the art of mama-babble.

I am for the art of bar-babble, tooth-picking, beerdrinking, egg-salting, in-sulting. I am for the art of falling off a barstool.

I am for the art of underwear and the art of taxicabs. I am for the art of ice-cream cones dropped on concrete. I am for the majestic art of dog-turds, rising like cathedrals.

I am for the blinking arts, lighting up the night. I am for art falling, splashing, wiggling, jumping, going on and off.

I am for the art of fat truck-tires and black eyes.

I am for Kool-art, 7-UP art, Pepsi-art, Sunshine art, 39 cents art, 15 cents art, Vatronol art, Dro-bomb art, Vam art, Menthol art, L&M art, Exlax art, Venida art, Heaven Hill art, Pamryl art, San-o-med art, Rx art, 9.99 art, Now art, New art, How art, Fire sale art, Last Chance art, Only art, Diamond art, Tomorrow art, Franks art, Ducks art, Meat-o-rama art.

I am for the art of bread wet by rain. I am for the rats' dance between floors. I am for the art of flies walking on a slick pear in the electric light. I am for the art of soggy onions and firm green shoots. I am for the art of clicking among the nuts when the roaches come and go. I am for the brown sad art of rotting apples.

I am for the art of meowls and clatter of cats and for the art of their dumb electric eyes.

I am for the white art of refrigerators and their muscular openings and closings.

I am for the art of rust and mold. I am for the art of hearts, funeral hearts or sweetheart hearts, full of nougat. I am for the art of worn meathooks and singing barrels of red, white, blue and yellow meat.

I am for the art of things lost or thrown away, coming home from school. I am for the art of cock-and-ball trees and flying cows and the noise of rectangles and squares. I am for the art of crayons and weak grey pencil-lead, and grainy wash and sticky oil paint, and the art of windshield wipers and the art of the finger on a cold window, on dusty steel or in the bubbles on the sides of a bathtub.

I am for the art of teddy-bears and guns and decapitated rabbits, exploded umbrellas, raped beds, chairs with their brown bones broken, burning trees, firecracker ends, chicken bones, pigeon bones and boxes with men sleeping in them.

I am for the art of slightly rotten funeral flowers, hung bloody rabbits and wrinkly yellow chickens, bass drums & tambourines, and plastic phonographs.

I am for the art of abandoned boxes, tied like pharaohs. I am for an art of watertanks and speeding clouds and flapping shades.

I am for U.S. Government Inspected Art, Grade A art, Regular Price art, Yellow Ripe art, Extra Fancy art, Ready-to-eat art, Best-for-less art, Ready-to-cook art, Fully cleaned art, Spend Less art, Eat Better art, Ham art, pork art, chicken art, tomato art, banana art, apple art, turkey art, cake art, cookie art. [. . .]

---

Manifesto

2. To affect, or bring to a certain state, by subjecting to, or treating with, a flux. "*Fluxed* into another world." *South.*
3. *Med.* To cause a discharge from, as in purging.

**flux** (flŭks), *n.* [OF., fr. L. *fluxus*, fr. *fluere*, *fluxum*, to flow. See FLUENT; cf. FLUSH, *n.* (of cards).] 1. *Med.* a A flowing or fluid discharge from the bowels or other part; esp., an excessive and morbid discharge; as, the bloody *flux*, or dysentery. b The matter thus discharged.

<u>Purge</u> the world of bourgeois sickness, "intellectual", professional & commercialized culture, PURGE the world of dead art, imitation, artificial art, abstract art, illusionistic art, mathematical art, — PURGE THE WORLD OF "EUROPANISM"!

2. Act of flowing: a continuous moving on or passing by, as of a flowing stream; a continuing succession of changes.
3. A stream; copious flow; flood; outflow.
4. The setting in of the tide toward the shore. Cf. REFLUX.
5. State of being liquid through heat; fusion. *Rare.*

PROMOTE A REVOLUTIONARY FLOOD AND TIDE IN ART.
Promote living art, anti-art, promote <u>NON ART REALITY</u> to be ~~fully~~ grasped by all peoples, not only critics, dilettantes and professionals.

7. *Chem. & Metal.* a Any substance or mixture used to promote fusion, esp. the fusion of metals or minerals. Common metallurgical fluxes are silica and silicates (acidic), lime and limestone (basic), and fluorite (neutral). b Any substance applied to surfaces to be joined by soldering or welding, just prior to or during the operation, to clean and free them from oxide, thus promoting their union, as rosin.

<u>FUSE</u> the cadres of cultural, social & political revolutionaries into united front & action.

**Figure 5-2.** George Maciunas, *Fluxus Manifesto,* February 1963. Courtesy The Gilbert and Lila Silverman Fluxus Collection, Detroit.

**85 ✦** George Maciunas, *Manifesto* (1963), offset on paper, 8 1/4 ×
5 7/8 inches. The Gilbert and Lila Silverman Fluxus Collection, Walker Art
Center, Madison, Wisconsin. [Fig. 5-2]

The charismatic Lithuanian-born George Maciunas was in New York in 1961 organizing
readings and events at the AG Gallery. His antiestablishment politics were "revolution-
ary" in only a vague sort of way, much like the nonpolitical Dada artists in Zurich during
World War I or the Futurist artists.

A loose international group of neo-Dada artists, named Fluxus about 1962 by Maciu-
nas, had already been giving readings and performances in both Europe and New York.
George Brecht explained Fluxus: "Each of us had his own ideas about what Fluxus was
and so much the better. That way it'll take longer to bury us. For me, Fluxus was a group
of people who got along with each other and who were interested in each other's work
and personality" (quoted in Walker Art Center, *In the Spirit of Fluxus,* 1993). Maciunas
provided his own definition with his *Manifesto.*

**86 ✦** Excerpts from 1963 and 1966 notebooks, in Carolee
Schneemann, *More Than Meat Joy: Complete Performance Works and
Selected Writings,* ed. Bruce McPherson (New Paltz, NY: Documentext, 1979).

Painter and media artist Carolee Schneemann studied at Bard College and the Uni-
versity of Illinois before coming in the early 1960s to New York. She was the first
painter to choreograph and compose installations for the Judson Dance Theater.
Her happening event *Meat Joy* was first performed at the Festival de la Libre Ex-
pression in Paris in 1964 and staged again at Judson Church. Unlike the works of
Yvonne Rainer, Trisha Brown, and others, Schneemann's works are sensuously ex-
pressive and erotically charged, even when at times mechanistic and impersonal.
In an entry of December 1965 Schneemann credits a Jim Dine Happening for in-
spiring her work. He was "the first man to use explicitly personal material—his
psychoanalytic tape, uncensored self-exposure . . . just the voice in the dark. The
audience didn't approve of that much actuality! A turning point for me. He had
stripped it all down to bare desire, anger, the lived life. Audience didn't get it or
couldn't stand it." Both Schneeman and Charlotte Moorman made their own
naked bodies central to their performances, as would Hannah Wilke and Ana
Mendieta in the 1970s and 1980s.

*More Than Meat Joy* contains excerpts from Schneemann's notebooks, letters she
wrote, and scripts (or descriptions) of her major performances, such as *Glass Environment
for Sound and Motion* (Living Theater, New York, 1962), *Banana Hands* (New Milton
Drama Center, Winchester, England, 1962), *Eye Body* (1963), and others. In the mid-
1960s Schneemann found herself in frequent disagreements with male artists. Her fem-
inist viewpoint is expressed in the excerpts quoted here from 1963 and 1966.

**Figure 5-3.**   Carolee Schneemann, *Meat Joy,* 1964. Performance, Judson Church, NYC. Photograph courtesy the artist.

*1963*

I want the dancers to reach for extremes. The material I present requires break-throughs in intensity, in emotive location . . . strong feeling for concentration on new movement . . . or familiar movement performed as if it were uniquely present for them. This demands resources of available psychic energy which may never have been called for before in their dancing.

Their bodies are capable of feats; in so far as possible they are—as a group—in-quisitive, adventurous. Grounded in their implacable and moving traditions they scent clearly the forms which they must search to break clear of past traditions. It is not enough to see this necessity; only a few are held by an emotion desperate and strong enough to carry them through. Their own needs are in process; my vi-sions of movement often upset them—they cry "impossible" just as a traditional cellist does when instructions call the bow to the bridge! I have to be able to per-form all I ask of them.

*1966*

BE PREPARED:
to have your brain picked
to have the pickings misunderstood
to be mistreated whether your success increases or decreases
to have detraction move with admiration—in step

to have your time wasted
your intentions distorted
the simplest relationships in your thoughts twisted
to be USED and MISUSED
to be "copy" to be copied to want to cope out cop out pull in and away
if you are a woman (and things are not utterly changed)
they will almost never believe you really did it
(what you did do)
they will worship you they will ignore you they will malign
you they will pamper you
they will try to take what you did as their own
(a woman doesn't understand her best discoveries after all)
they will patronize you humor you
try to sleep with you want you to transform them with your energy
they will berate your energy they will try to be part of your
sexuality they will deny your sexuality/or your work they
will depend on you for information for generosity they will
forget whatever help you give they will try to be heroic for
you they will not help you when they might they will bring
problems they will ignore your problems a few will appreciate
deeply they will be loving you as what you do as what you
are loving how you are being they will of course be strong in
themselves and clear they will NOT be married to quiet
tame drones they will not say what a great mother you would
be or do you like to cook and where you might expect under-
standing and appreciation you must expect NOTHING then
enjoy whatever gives-to-you as long as it does and however and
NEVER justify yourself just do what you feel carry it strongly
yourself

## New York Pop, West Coast Funk, and Chicago "Sub-Pop"

The term "Pop art" was first used by critic Lawrence Alloway in "The Arts and the Mass Media," written for the February 1958 issue of *Architectural Design*. Alloway's catchy phrase designated art that took as its subjects consumer and mass-media products—comics, advertisements, automobile styling, and appliance design. At that time Alloway had been meeting in London with a group of primarily British artists, architects, and writers, who called themselves the International Group and self-consciously aimed to expand the modernist aesthetic to include the imagery and ar-tifacts of the man-made, urban industrial environment they had come to admire. Aware of the low regard that establishment arbiters of taste held for popular culture, artist Richard Hamilton produced in 1956 a small collage that good-naturedly spoofed advertisements, *Just what is it that makes today's homes so different, so ap-*

*pealing?* (collection Kunsthalle Tübingen, Sammlung Zundel). Hamilton's collage, produced for the International Group's *This is Tomorrow* exhibition, presents a home scene filled with kitschy furniture and appliances over which presides a cutout magazine muscleman, holding an enlarged Tootsie "Pop" over his genitals, and his female counterpart from a "girlie" magazine, posing fetchingly on a couch.

In the United States several artists—notably Larry Rivers, Robert Rauschenberg, and Jasper Johns—were already making an art that rejected the existential mood and the transcendental aspirations of some of the abstract expressionists. Rivers, Rauschenberg, and Johns retained, however, some of the earlier artists' individualized touch and gestural style. Of the three, Rauschenberg seems the most connected to Allan Kaprow's developing ideas about assemblage and Happenings. Rauschenberg's own paint-spattered "combines" (paintings with sculptural elements) and his silk-screened paintings emphasized process and painterliness. He used images drawn from New York City streets, the Southeast Asian wars, art museum culture, and the myriad topical matters transmitted through newspapers, magazines, and television. Rauschenberg once said: "I don't want a picture to look like something it isn't. . . . I want it to look like something it is. And I think a picture is more like the real world when it's made out of the real world" (quoted in Calvin Tomkins *The Bride and the Bachelors,* 1968). Rauschenberg's attitude toward the making of pictures was consistent with his activities in the world of avant-garde dance.

Johns, whose work seemed to be the most intellectual and indirect of the three transitional figures, created icons from the most ordinary of images: flags, numbers, targets, maps—all flat forms that exist as signs. It was the concept of signs that Lawrence Alloway focused on in 1974 when he curated the retrospective exhibition of Pop art for the Whitney Museum of American Art. Writing for the Whitney catalogue Alloway assessed the movement in semiotic terms: "The core of Pop art is . . . essentially, an art about signs and sign-systems. Realism is, to offer a minimal definition, concerned with the artist's perception of objects in space and their translation into iconic, or faithful, signs. However, Pop art deals with material that already exists as signs: photographs, brand goods, comics—that is to say, with precoded material."

By the 1962–63 season major exhibitions of Pop art had opened across the country, in New York, Washington, DC, Kansas City, Houston, Los Angeles, Pasadena, and Oakland. The New York artists who invariably participated in these shows included Andy Warhol and James Rosenquist, who had both worked as commercial artists; Jim Dine and Claes Oldenburg, who had staged Happenings; Roy Lichtenstein, who taught at Rutgers; and Tom Wesselman, Robert Indiana, and a handful of others. These artists defied the elitism of high-art modernism, as then defined by critic Clement Greenberg, and aimed to bring the "real world" of advertising, media hype, and mechanistic imagery into painting. In its embrace of commercialism, postwar material abundance, and the hucksterism of Madison Avenue, Pop art rejected the romantic, antibourgeois stance of many of the abstract expressionist painters. Pop artists, in New York at least, were also seen as opposite in spirit (playfully optimistic, when not deadpan ironic) from the neo-Dada artists of the Fluxus group. Moreover, they attracted a new class of patrons—entrepreneurs—rather than the elite who collected high modernism.

West Coast galleries and museums continuously held exhibitions that blended the new Pop Art from New York with regional examples, inspired in part by its own traditions of Bay Area figurative art (see Chapter 4) and the California assemblage

movement. When "Six Painters and the Object," organized for New York's Guggen-heim Museum by Lawrence Alloway, opened at the Los Angeles County Museum of Art, Alloway also organized a complementary show for LACMA called "Six More," highlighting California artists. *Artforum,* a new West Coast magazine run by Philip Leider and John Coplans, was quick to promote West Coast artists and to integrate them into the national scene. The October 1963 issue of *Artforum* carried an article by Coplans, who had organized "Pop art, USA" for the Oakland Museum, an exhibi-tion that included California artists Edward Ruscha, Wayne Thiebaud, Billy Al Bengston, Phillip Hefferton, Mel Ramos, and Joe Goode. Coplans pointed out that whereas abstract expressionism was a New York product, dominated by the spectre of European art, the new Pop art was bicoastal and was making a "complete break from a whole tradition of European esthetics."

California continued to embrace an anti-European "tasteless" art (by New York standards) called Funk Art, which included the collages of Jess Collins, the horrific as-semblages by Bruce Conner, the three-dimensional tableaux of Edward Kienholz, and the witty, social-comment ceramic pieces of Robert Arneson.

In Chicago, artists created their own hybrid art variations. In the 1960s a num-ber of Chicago artists combined an ironic attitude with fantastic, grotesque, some-times hilariously ugly forms. Called by Franz Schulze "Chicago Sub-Pop," and by oth-ers the "Chicago Imagists" or "Chicago Funk," almost all the artists had studied at the School of the Art Institute of Chicago, and all had been influenced by the Chicago metaphysical artists of the previous decade, such as Leon Golub, George Cohen, and others. The difference between the Chicago Imagists and the New York Pop artists was summed up in a September 1978 *Artforum* article by critic Joanna Frueh: "Pop depicts a cultural acceptance of commercialism, whereas Chicago's Funk imagism rebels against it. Both arts exaggerate, but Pop aggrandizes the gluttony of advertising, and imagism coarsens it."

*87* ✦  Robert Rauschenberg, "Artist's Statement," in Dorothy C. Miller, ed., *Sixteen Americans* (New York: The Museum of Modern Art, 1959), p. 58.

During 1959 the Museum of Modern Art mounted three group exhibitions that have oc-cupied a major place in art history: Both *The New American Painting: As Shown in Eight European Countries, 1958–1959,* curated by Alfred H. Barr, Jr., and *New Images of Man,* curated by Peter Selz, looked back to the 1940s and 1950s (see Chapter 4). However, Dorothy C. Miller's *Sixteen Americans,* opening in December, looked forward. Miller's ex-hibition showcased artists in their 20s and 30s, working in styles that pushed beyond ab-stract expressionism, such as Jasper Johns, Ellsworth Kelly, Robert Rauschenberg, and Frank Stella.

Born in Port Arthur, Texas, Rauschenberg studied at the Kansas City Art Institute, at the Académie Julian in Paris, and at the experimental Black Mountain College, run by Josef Albers in North Carolina, where he met John Cage and Merce Cunningham. Dur-ing his career he has painted, made assemblages, and participated in avant-garde per-formance events.

As John Coplans later pointed out in his exhibition "Pop Art, USA," (1963), Rauschenberg and Johns should "be regarded as direct precursors" to Pop Art: "Rauschenberg for his concern with art as a direct confrontation of life . . . and Johns for the potent questions he raised on the discontinuous quality of symbols."

Any incentive to paint is as good as any other. There is no poor subject.

Painting is always strongest when in spite of composition, color, etc. it appears as a fact, or an inevitability, as opposed to a souvenir or arrangement.

Painting relates to both art and life. Neither can be made. (I try to act in that gap between the two.)

A pair of socks is no less suitable to make a painting with than wood, nails, turpentine, oil and fabric.

A canvas is never empty.

## 88 ✦ Leo Steinberg, "Contemporary Art and the Plight of Its Public," *Harper's* 224, no. 1342 (March 1962):31–39; reprinted in *The New Art*, Gregory Battcock, ed. (New York: E.P. Dutton & Co., 1966).

Leo Steinberg was born in Moscow, but lived as a child and youth in Germany and England before coming to the United States in 1945. During the mid-1950s, while getting his PhD at NYU's Institute of Fine Arts, he wrote criticism for *Arts* magazine. He was an early opponent of the criticism of Clement Greenberg. The title of his influential collection of essays, *Other Criteria: Confrontations with Twentieth-Century Art,* 1972, was a direct challenge to Greenberg. Commenting in the preface, Steinberg notes that the earliest essay in *Other Criteria,* "The Eye is a Part of the Mind," (1953), was "a declaration of independence from formalist indoctrination."

In the introductory essay to *Other Criteria,* based on a 1968 lecture, he noted the need felt by contemporary creative artists to subvert or stretch traditional definitions of art: "The process of courting non-art is continuous. . . . American artists seek to immerse the things they make or do in the redeeming otherness of non-art. Hence the instability of the modern experience."

In this essay, reprinted in *Other Criteria,* Steinberg is concerned with what artists actually do when they make their art, not with what they should do according to preconceived aesthetic theories. He first reviews the history of art that shocked its audience, and then confronts the challenge of Jasper Johns's art in the 1950s.

✦

\* \* \*

. . . Contemporary art is constantly inviting us to applaud the destruction of values which we still cherish, while the positive cause, for the sake of which the sacrifices are made, is rarely made clear. So that the sacrifices appear as acts of demolition, or of dismantling, without any motive. . . .

Let me take an example from nearer home and from my own experience. Early in 1958, a young painter named Jasper Johns had his first one-man show in New York. The pictures he showed—products of many years' work—were puzzling. Carefully painted in oil or encaustic, they were variations on four main themes:

Numbers, running in regular order, row after row all the way down the picture, either in color or white on white.

Letters, arranged in the same way.

The American Flag—not a picture of it, windblown or heroic, but stiffened, rigid, the pattern itself.

And finally, Targets, tricolored, or all white or all green, sometimes with little boxes on top into which the artist had put plaster casts of anatomical parts, recognizably human.

A few other subjects turned up in single shots—a wire coat hanger, hung on a knob that projected from a dappled gray field. A canvas, which had a smaller stretched canvas stuck to it face to face, so that all you saw was its back; and the title was *Canvas.* Another, called *Drawer*, where the front panel of a wooden drawer with its two projecting knobs had been inserted into the lower part of a canvas, painted all gray.

How did people react? Those who had to say something about it tried to fit these new works into some historical scheme. Some shrugged it off and said, "More of Dada, we've seen this before; after Expressionism comes nonsense and anti-art, just as in the 'twenties." One hostile New York critic saw the show as part of a sorrowful devolution, another step in the systematic emptying out of content from modern art. A French critic wrote, "We mustn't cry 'fraud' too soon." But he was merely applying the cautions of the past; his feeling was that he was being duped.

On the other hand, a great number of intelligent men and women in New York responded with intense enthusiasm, but without being able to explain the source of their fascination. A museum director suggested that perhaps it was just the relief from Abstract Expressionism, of which one had seen so much in recent years, that led him to enjoy Jasper Johns; but such negative explanations are never adequate. Some people thought that the painter chose commonplace subjects because, given our habits of overlooking life's simple things, he wanted, for the first time, to render them visible. Others thought that the charm of these paintings resided in the exquisite handling of the medium itself, and that the artist deliberately chose the most commonplace subjects so as to make them *invisible,* that is, to induce absolute concentration on the sensuous surface alone. But this didn't work for two reasons. First, because there was no agreement on whether these things were, in fact, well painted. [. . .] And, secondly, because if Johns had wanted his subject matter to become invisible through sheer banality, then he had surely failed—like a debutante who expects to remain inconspicuous by wearing blue jeans to the ball. Had reticent subject matter been his intention, he would have done better to paint a standard abstraction, where everybody knows not to question the subject. But in these new works, the subjects were overwhelmingly conspicuous, if only because of their context. Hung at general headquarters, a Jasper Johns flag might well have achieved invisibility; set up on a range, a target could well be overlooked; but carefully remade to be seen point-blank in an art gallery, these subjects struck home.

It seems that during this first encounter with Johns's work, few people were sure of how to respond, while some of the dependable avant-garde critics applied tested avant-garde standards—which seemed suddenly to have grown old and ready for dumping.

My own first reaction was normal. I disliked the show, and would gladly have thought it a bore. Yet it depressed me and I wasn't sure why. Then I began to recognize in myself all the classical symptoms of a philistine's reaction to modern art. I was angry at the artist, as if he had invited me to a meal, only to serve something uneatable, like tow and paraffin. I was irritated at some of my friends for pretending to like it—but with an uneasy suspicion that perhaps they did like it, so that I was really mad at myself for being so dull, and at the whole situation for showing me up.

And meanwhile, the pictures remained with me—working on me and depressing me. The thought of them gave me a distinct sense of threatening loss or destruction. One in particular there was, called *Target with Four Faces*. It was a fairly large canvas consisting of nothing but one three-colored target—red, yellow, and blue; and above it, boxed behind a hinged wooden flap, four life casts of one face— or rather, of the lower part of a face, since the upper portion, including the eyes, had been sheared away. The picture seemed strangely rigid for a work of art and recalled Baudelaire's objection to Ingres: "No more imagination; therefore no more movement." Could any meaning be wrung from it? I thought how the human face in this picture seemed desecrated, being brutally thingified—and not in any acceptable spirit of social protest, but gratuitously, at random. At one point, I wanted the picture to give me a sickening suggestion of human sacrifice, of heads pickled or mounted as trophies. Then, I hoped, the whole thing would come to seem hypnotic and repellent, like a primitive sign of power. But when I looked again, all this romance disappeared. These faces—four of the same—were gathered there for no triumph; they were chopped up, cut away just under the eyes, but with no suggestion of cruelty, merely to make them fit into their boxes; and they were stacked on that upper shelf as a standard commodity. But was this reason enough to get so depressed? If I disliked these things, why not ignore them?

It was not that simple. For what really depressed me was what I felt these works were able to do to all other art. The pictures of de Kooning and Kline, it seemed to me, were suddenly tossed into one pot with Rembrandt and Giotto. All alike suddenly became painters of illusion. After all, when Franz Kline lays down a swath of black paint, that paint is transfigured. You may not know what it represents, but it is at least the path of an energy or part of an object moving in or against a white space. Paint and canvas stand for more than themselves. Pigment is still the medium by which something seen, thought, or felt, something other than pigment itself, is made visible. But here, in this picture by Jasper Johns, one felt the end of illusion. No more manipulation of paint as a medium of transformation. This man, if he wants something three-dimensional, resorts to a plaster cast and builds a box to contain it. When he paints on a canvas, he can only paint what is flat—numbers, letters, a target, a flag. Everything else, it seems, would be make-believe, a childish game—"let's pretend." So, the flat is flat and the solid is three-dimensional, and these are the facts of the case, art or no art. There is no more metamorphosis, no more magic of medium. It looked to me like the death of painting, a rude stop, the end of the track.

I am not a painter myself, but I was interested in the reaction to Jasper Johns of two well-known New York abstract painters: One of them said, "If this is painting, I might as well give up." And the other said, resignedly, "Well, I am still involved with the dream." He, too, felt that an age-old dream of what painting had been, or could be, had been wantonly sacrificed—perhaps by a young man too brash or irreverent to have dreamed yet. And all this seemed much like Baudelaire's feeling about Courbet, that he had done away with imagination.

The pictures, then, kept me pondering, and I kept going back to them. And gradually something came through to me, a solitude more intense than anything I had seen in pictures of mere desolation. In *Target with Four Faces,* I became aware of an uncanny inversion of values. With mindless inhumanity or indifference, the organic and the inorganic had been leveled. A dismembered face, multiplied, blinded, repeats four times above the impersonal stare of a bull's-eye. Bull's-eye and blind faces—but juxtaposed as if by habit or accident, without any expressive intent. As if the values that would make a face seem more precious or eloquent or remarkable had ceased to exist; as if those who could hold and impose such values just weren't around.

Then another inversion. I began to wonder what a target really was, and concluded that a target can only exist as a point in space—"over there," at a distance. But the target of Jasper Johns is always "right here"; it is all the field there is. It has lost its definitive "Thereness." I went on to wonder about the human face, and came to the opposite conclusion. A face makes no sense unless it is "here." At a distance, you may see a man's body, a head, even a profile. But as soon as you recognize a thing as a face, it is an object no longer, but one pole in a situation of reciprocal consciousness; it has, like one's own face, absolute "Hereness." So then surely Jasper Johns's *Target with Four Faces* performs a strange inversion, because a target, that needs to exist at a distance, has been allotted all the available "Hereness," while the faces are shelved.

And once again, I felt that the leveling of those categories which are the subjective markers of space implied a totally nonhuman point of view. It was as if the subjective consciousness, which alone can give meaning to the words "here" and "there," had ceased to exist.

And then it dawned on me that all of Jasper Johns's pictures conveyed a sense of desolate waiting. The face-to-the-wall canvas waits to be turned; the drawer waits to be opened. That rigid flag—does it wait to be hoisted or recognized? Certainly the targets wait to be shot at. Johns made one painting of a window shade pulled down, which, like any window shade in the world, waits to be raised. The empty hanger waits to receive somebody's clothes. These letters, neatly set forth, wait to spell something out; and the numbers, arranged as on a tot board, wait to be scored. Even those plaster casts have the look of things temporarily shelved for some purpose. And yet, as you look at these objects, you know with absolute certainty that their time has passed, that nothing will happen, that that shade will never be lifted, those numbers will never add up again, and the coat hanger will never be clothed.

There is in all this work, not simply an ignoring of human subject matter, as in much abstract art, but an implication of absence, and—this is what makes it most poignant—of human absence from a man-made environment. In the end, these pic-

tures by Jasper Johns come to impress me as a dead city might—but a dead city of terrible familiarity. Only objects are left—man-made signs which, in the absence of men, have become objects. And Johns has anticipated their dereliction.

These, then, were some of my broodings as I looked at Johns's pictures. And now I'm faced with a number of questions, and a certain anxiety.

What I have said—was it *found* in the pictures or read into them? Does it accord with the painter's intention? Does it tally with other people's experience, to reassure me that my feelings are sound? I don't know. I can see that these pictures don't necessarily look like art—which has been known to solve far more difficult problems. I don't know whether they are art at all, whether they are great, or good, or likely to go up in price. And whatever experience of painting I've had in the past seems as likely to hinder me as to help. I am challenged to estimate the aesthetic value of, say, a drawer stuck into a canvas. But nothing I've ever seen can teach me how this is to be done. I am alone with this thing, and it is up to me to evaluate it in the absence of available standards. The value which I shall put on this painting tests my personal courage. Here I can discover whether I am prepared to sustain the collision with a novel experience. Am I escaping it by being overly analytical? Have I been eavesdropping on conversations? Trying to formulate certain meanings seen in this art—are they designed to demonstrate something about myself or are they authentic experience?

They are without end, these questions, and their answers are nowhere in storage. It is a kind of self-analysis that a new image can throw you into and for which I am grateful. I am left in a state of anxious uncertainty by the painting, about painting, about myself. And I suspect that this is all right. In fact, I have little confidence in people who habitually, when exposed to new works of art, know what is great and what will last. Alfred Barr, of The Museum of Modern Art, has said that if one out of ten paintings that The Museum of Modern Art has acquired should remain valid in retrospect, they will have scored very well. I take this to be, not a confession of inadequate judgment, but an assertion about the nature of contemporary art.

Modern art always projects itself into a twilight zone where no values are fixed. It is always born in anxiety, at least since Cézanne. And Picasso once said that what matters most to us in Cézanne, more than his pictures, is his anxiety. It seems to me a function of modern art to transmit this anxiety to the spectator, so that his encounter with the work is—at least while the work is new—a genuine existential predicament. Like Kierkegaard's God, the work molests us with its aggressive absurdity, the way Jasper Johns presented himself to me several years ago. It demands a decision in which you discover something of your own quality; and this decision is always a "leap of faith," to use Kierkegaard's famous term. And like Kierkegaard's God, who demands a sacrifice from Abraham in violation of every moral standard; like Kierkegaard's God, the picture seems arbitrary, cruel, irrational, demanding your faith, while it makes no promise of future rewards. In other words, it is in the nature of original contemporary art to present itself as a bad risk. And we the public, artists included, should be proud of being in this predicament, because nothing else would seem to us quite true to life; and art, after all, is supposed to be a mirror of life.

* * *

*89* ✦   John Coplans, "An Interview with Roy Lichtenstein," *Artforum* 2, no. 4 (October 1963): 31. © *Artforum*

Roy Lichtenstein studied at Ohio State University during the 1940s and developed into an abstract expressionist, but often used subject matter from American popular culture, such as "cowboys and Indians." Coming East, he taught at Rutgers University and was influenced by Allan Kaprow, who also taught there. Hence, to Lichtenstein the bridge to Pop art was the Happenings that Kaprow and others were then organizing. Lichtenstein forged a distinctive style that 1) appropriated the subject matter of comic strips, magazine ads, and mass-produced reproductions of modern masters of art, such as Picasso and Matisse, and 2) used the techniques of mass-media, four-color printing processes, such as flat primary colors, broad lines and Ben Day dots.

John Coplans was an editor for *Artforum,* when the magazine was published on the West Coast and when it moved to New York. In 1975 he was dismissed by the publisher who allegedly was displeased with the editorial direction in which the magazine seemed to be headed (see Reading 112). Since then Coplans has had a distinguished career as a photographer of minutely detailed body self-portraits.

───────────────── ◆ ─────────────────

* * *

*Q.* How did you paint prior to your current style?

*A.* Mostly reinterpretations of those artists concerned with the opening of the West, such as Remington, with a subject matter of cowboys, Indians, treaty signings, a sort of Western official art in a style broadly influenced by modern European painting. From 1957 onwards my work became non-figurative and abstract expressionist. In the latter part of this body of work I used loosely handled cartoon images. In the summer of 1961 I made a complete break into my current work.

*Q.* What triggered this jump?

*A.* I am not sure what particularly influenced the change, especially as I have always had this interest in a purely American mythological subject matter.

*Q.* Then what gave you the idea of using an impersonal industrial technique?

*A.* Using a cartoon subject matter in my later paintings, some of which I was getting from bubble gum wrappers, eventually led to simulating the same technique as the originals. The early ones were of animated cartoons, Donald Duck, Mickey Mouse and Popeye, but then I shifted into the style of cartoon books with a more serious content such as "Armed Forces at War" and "Teen Romance."

*Q.* Did you find any difficulty in handling the subject matter in an impersonal way?

*A.* It was very difficult not to show everything I knew about a whole tradition. It was difficult not to be seduced by the nuances of "good painting." The important thing, however, is not the technique, but the unity of vision within the painter himself. Then you don't have to worry if everything you "know" will be in the painting.

*Q.* What was the real crisis that precipitated your clean break with the past?

*A.* Desperation. There were no spaces left between Milton Resnick and Mike Goldberg.

*Q.* Did the work of Johns or Rauschenberg provide you with any insights at that time?

*A.* Although I recognize their great influence now, I wasn't as aware at that time. I was more aware of the Happenings of Oldenberg [sic], Dine, Whitman and Kaprow. I knew Kaprow well; we were colleagues at Rutgers. I didn't see many Happenings, but they seemed concerned with the American industrial scene. They also brought up in my mind the whole question of the object and merchandising.

*Q.* In your reply you seem to imply that the Happenings were more important to you than Johns or Rauschenberg. Why?

*A.* Although the Happenings were undoubtedly influenced by Johns and Rauschenberg, an Oldenberg [sic] "Fried Egg" is much more glamorized merchandise and relates to my ideas more than Johns' beer cans. I want my images to be as critical, as threatening and as insistent as possible.

*Q.* About what?

*A.* As visual objects, as paintings—not as critical commentaries about the world. Of course this is all in retrospect. At the beginning I wasn't sure exactly what I was doing, but I was very excited about, and interested in, the highly emotional content yet detached impersonal handling of love, hate, war, etc., in these cartoon images.

*Q.* One of the main attacks on your work is that you don't significantly transform the material you use.

*A.* The closer my work is to the original the more threatening and critical the content. However my work is entirely transformed, in that my purpose and perception is entirely different. I think my paintings are critically transformed but it would be difficult to prove it by any rational line of argument.

---

**90** ✦ G. R. Swenson interview with Andy Warhol, in "What is Pop Art? Answers from 8 painters, part I," *Art News* 62, no. 7 (November 1963): 26, 60–61. © 1963 ARTnews L.L.C.

Andy Warhol may be the best known American artist of the late twentieth century. After studying art at the Carnegie Institute of Technology in Pittsburgh, he came to New York where he established a career as an illustrator, commercial artist, and store window designer. In 1960 he began making paintings of cartoon characters and quickly established himself as the leading Pop artist. In 1963 Warhol set up a studio in a 4000-square-foot former factory at 231 East 47th Street, which he inhabited until 1968. There, at "The Factory," many assistants, under the supervision of poet Gerard Malanga, silk-screened Warhol's celebrity portraits, soup can still lifes, and Brillo-box sculptures. Frequent habitués to The Factory also included his cast of campy actors who starred in the more than fifty films Warhol directed, including *Empire, The Velvet Underground and Nico,* and *The Chelsea Girls.*

Following the lead of *Artforum,* Tom Hess, editor of *Art News,* began publishing interviews with Pop artists. In this issue Gene Swenson also talked with Jim Dine, Robert Indiana, and Roy Lichtenstein. The following February *Art News* published Swenson's interviews with Stephen Durkee, Jasper Johns, James Rosenquist, and Tom Wesselmann.

◆

Someone said that [Bertolt] Brecht wanted everybody to think alike. I want everybody to think alike. But Brecht wanted to do it through Communism, in a way. Russia is doing it under government. It's happening here all by itself without being under a strict government; so if it's working without trying, why can't it work without being Communist? Everybody looks alike and acts alike, and we're getting more and more that way.

I think everybody should be a machine.

I think everybody should like everybody.

*Is that what Pop Art is all about?*

Yes. It's liking things.

*And liking things is like being a machine?*

Yes, because you do the same thing every time. You do it over and over again.

\* \* \*

*Is Pop Art a fad?*

Yes, it's a fad, but I don't see what difference it makes. I just heard a rumor that G. quit working, that she's given up art altogether. And everyone is saying how awful it is that A. gave up his style and is doing it in a different way. I don't think so at all. If an artist can't do any more, then he should just quit; and an artist ought to be able to change his style without feeling bad. I heard that Lichtenstein said he might not be painting comic strips a year or two from now—I think that would be so great, to be able to change styles. And I think that's what's going to happen, that's going to be the whole new scene. That's probably one reason I'm using silk screens now. I think somebody should be able to do all my paintings for me. I haven't been able to make every image clear and simple and the same as the first one. I think it would be so great if more people took up silk screens so that no one would know whether my picture was mine or somebody else's.

*It would turn art history upside down?*

Yes.

*Is that your aim?*

No. The reason I'm painting this way is that I want to be a machine, and I feel that whatever I do and do machine-like is what I want to do.

*Was commercial art more machine-like?*

No, it wasn't. I was getting paid for it, and did anything they told me to do. If they told me to draw a shoe, I'd do it, and if they told me to correct it, I would—I'd do anything they told me to do, correct it and do it right. I'd have to invent and now I don't; after all that "correction," those commercial draw-

ings would have feelings, they would have a style. The attitude of those who hired me had feeling or something to it; they knew what they wanted, they insisted; sometimes they got very emotional. The process of doing work in commercial art was machine-like, but the attitude had feeling to it.

*Why did you start painting soup cans?*

Because I used to drink it. I used to have the same lunch every day, for twenty years, I guess, the same thing over and over again. Someone said my life has dominated me; I liked that idea. I used to want to live at the Waldorf Towers and have soup and a sandwich, like that scene in the restaurant in *Naked Lunch . . .*

We went to see *Dr. No* at Forty-second Street. It's a fantastic movie, so cool. We walked outside and somebody threw a cherry bomb right in front of us, in this big crowd. And there was blood, I saw blood on people and all over. I felt like I was bleeding all over. I saw in the paper last week that there are more people throwing them—it's just part of the scene—and hurting people. My show in Paris is going to be called "Death in America." I'll show the electric-chair pictures and the dogs in Birmingham and car wrecks and some suicide pictures.

*Why did you start these "Death" pictures?*

I believe in it. Did you see the *Enquirer* this week? It had "The Wreck that Made Cops Cry"—a head cut in half, the arms and hands just lying there. It's sick, but I'm sure it happens all the time. I've met a lot of cops recently. They take pictures of everything, only it's almost impossible to get pictures from them.

*When did you start with the "Death" series?*

I guess it was the big plane crash picture, the front page of a newspaper: 129 DIE. I was also painting the *Marilyns.* I realized that everything I was doing must have been Death. It was Christmas or Labor Day--a holiday--and every time you turned on the radio they said something like, "4 million are going to die." That started it. But when you see a grusome picture over and over again, it doesn't really have any effect.

\* \* \*

*Is "Pop" a bad name?*

The name sounds so awful. Dada must have something to do with Pop— it's so funny, the names are really synonyms. Does anyone know what they're supposed to mean or have to do with, those names? Johns and Rauschenberg—Neo-Dada for all these years, and everyone calling them derivative and unable to transform the things they use—are now called progenitors of Pop. It's funny the way things change. I think John Cage has been very influential, and Merce Cunningham, too, maybe. Did you see that article in the *Hudson Review* [*The End of the Renaissance?*, Summer, 1963]? It was about Cage and that whole crowd, but with a lot of big words like medical empiricism and teleology. Who knows? Maybe Jap [Jasper Johns] and Bob [Robert Rauschenberg] were Neo-Dada and aren't any more. History books are being rewritten all the time. It doesn't matter what you do. Everybody just goes on thinking the same thing, and every year it gets more and more alike. Those who talk about individuality the most are the ones who most object to

deviation, and in a few years it may be the other way around. Some day everybody will think just what they want to think, and then everybody will probably be thinking alike; that seems to be what is happening.

◆

**91** ◆  Sidney Tillim, "The Underground Pre-Raphaelitism of Edward Kienholz," *Artforum* 4, no. 8 (April 1966): 38–40. © Artforum

Born in Washington state, Edward Kienholz moved to Los Angeles in 1953, when he was in his mid-20s. A few years later he opened the New Gallery, and in 1957 co-founded the Ferus Gallery, which showed avant-garde art. He became well known for his assemblages and life-sized tableaux with objects grafted onto partial figures, who inhabited environments that suggested the marginalization and alienation of the old and the sick.

Sidney Tillim is both an artist and critic and has written frequently for *Artforum*. In this essay Tillim refers to the snobbery of New York critics—a snobbery he recognizes he shared when he first viewed Kienholz's *The Beanery* at the Dwan Gallery. Tillim contrasts New York artists Claes Oldenburg and George Segal to Kienholz, who presents an art "radically different from conventional Pop art, whose radicalism consists of its insinuation into **formalized** esthetic consciousness of essentially illustrative intentions." To Tillim, "Pop art . . . patronizes kitsch where Kienholz celebrates it or, stuck with it, admits it."

◆

It's difficult to judge with any accuracy just how the New York art world received Edward Kienholz's ultimate assemblage—Barney's Beanery—a bar reconstructed in every detail but living action. [. . .] I had intended to ignore the Beanery, having prejudged it on the basis of advance reports as a desperate latter-day excrescence of Pop art. Fortunately I was prevailed upon by a friend to see it, and when I came out of the outsized packing crate which housed the facsimile of the colorfully dingy pub Kienholz apparently frequents, and after further reflection, I found that my entire perspective on Pop art had changed. [. . .]

Principally, only the ironies of Pop are new. And it is the absence of irony, at least visual irony, that distinguishes the Beanery from "conventional" Pop art. While exploiting Pop precedents, the Beanery is stylistically so ingenuous as to seem esthetically primitive. But if it is naive, it is not in respect to what it wants to say, and succeeds in saying, but naive historically in that it reflects a sense of art that ignores—if it does not misunderstand—the formal development of art since the mid-nineteenth century. Since Americans have always provided the most precarious framework for artistic tradition, one is tempted to say, "Only in America . . . " For Barney's Beanery is simply a giant genre sculpture which exhibits the logical distortion of being emotionally rooted in the past while demonstrating the psychological pressures of the present. [. . .] Kienholz's adult "doll" house is an "emotion machine" which transports the enchanted visitor back to a realm of simple, pre-Freudian camaraderie. What is probably brash and tacky in reality becomes, when invested in a loving simulacrum of it, a poignant wish-

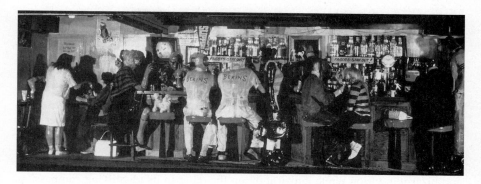

**Figure 5-4.** Edward Kienholz, *The Beanery,* 1965. Mixed media environment. Collection of Stedelijk Museum, Amsterdam. Photograph courtesy and © Delmore E. Scott.

fulfillment that exposes the very real loneliness and alienation motivating an era of popular "camp." The Beanery, however, is not "camp." It has no "style."

As such, it is a momentary irony of criticism, not of the work, that the "form" of Barney's Beanery becomes as important as its subject matter content. For in order to release the latent nostalgia of the work, Kienholz had necessarily to forego a sophisticated structure, in fact, style altogether. He had to stress the illustrative rather than the formal and depend for style on the sheer gaucherie of reproducing, roughly life-size, an entire bar, its habitues, its lights, its smells and its sounds—and by approximating reality in a crude sort of way rather than competing with it. This is definitely not for Madame Tussaud. Thus Barney himself is a slightly less than noble Roman bust anchored to one corner of the bar, thus all the habitues have clocks for faces (same time but different clocks), thus a tape recorder wafts actual sounds of the real Beanery into the magical one, thus the entire assemblage is immured in a coat of plastic which like fingernail polish is ultimately more seductive than it is repellent. For what in conventional Pop becomes banal in the context of ultra-sophisticated formal devices or intentions, becomes in the informal Beanery, the beauty of its particular sentiment. In other words, Kienholz has not produced a work of sculpture in the sense of something that is ultimately profoundly decorative; he has not imposed the artifice of style upon a subject antipathetic to it. Space is directly determined by the narrative function, color is wholly local and the work is unified solely by its psychological ambience.

Obviously this is radically different from conventional Pop art, whose radicalism consists of its insinuation into **formalized** esthetic consciousness of essentially illustrative intentions. Pop art achieves its particular potency by retaining the esthetic ambience—and ambiguity—epitomized by abstractionist art and by accepting the consequent irony as both a working principle and as insulation from its own regressive inclinations. It patronizes kitsch where Kienholz celebrates it or, stuck with it, admits it.

\* \* \*

One is then confronted as much by morality as by esthetics in Barney's Beanery, and the work probably cannot survive either the defensive cynicism or ironic detachment of much modern taste. For at bottom the Beanery is a kind of underground Pre-Raphaelite aberration, idealizing a past of "feeling" and "community," even while exposing its nostalgia in a setting normally associated with escapism. For what is depressing about most American bars, today at least, is that they are ultimately the repositories of unhappiness compensated for by the opportunity offered the wretched and dispossessed to indulge their illusions of some small superiority—over their wives, their bosses, their lives. If there is irony in Kienholz's life-sized toy, it is precisely this union of necessary illusion and unenviable despair, both contained in the immobility of an environmental effigy that on the one hand is stupefyingly innocent and bizarre in vision while intoxicating on the other in its identifying compassion. [. . .]

---

**92** ✦ Franz Schulze, "Chicago," *Art International* 11, no. 5 (May 20, 1967) :41–44.

Popularly called "The Second City," Chicago created a regional art that refused to acknowledge the clichés of "regionalism." Max Kozloff, himself from Chicago before he moved to New York to establish himself as a critic, mused on what the city did to make its artists different. In an essay for *Artforum* (October 1972), he reviewed the exhibition, *Fantastic Images: Chicago Art since 1945,* for which Franz Schulze wrote the catalogue essay. To Kozloff, Chicago artists had unique needs, that

> compel them to burrow within their milieu and their memory. The resulting output is fixated on its urban background, recoiling from or embracing the city, deeply entangled with conflicting moods of resentment or enthusiasm, the like of which has not been so strongly concentrated anywhere in this country. These artists seek an emotional knowledge, not the status of formal innovators, nor, still less, the portrait of a local scene. For them, what primarily distinguishes their place is not where it is on the map, but what it does, or has done, to their minds.

In other words, *mind trips* distinguished them, not their actual journeys through the topographical midwestern landscape and small towns, as had been the case of Regionalists Thomas Hart Benton, Grant Wood, and John Steuart Curry in the 1930s.

Critic and art historian Franz Schulze began writing a regular column on Chicago art and artists for *Art News* in the late 1950s and observed the emergence of The Hairy Who in 1966. His first long article "Chicago Popcycle," published in the November/December 1966 issue of *Art in America,* noted the shaping influence of the World War II veterans who had enrolled in the School of the Art Institute of Chicago. Although they were later called the "Monster Roster," none of them "painted monsters, in the sense of hideosities and freaks, so much as a variety of stark or mysterious heads and figures, dark fantasies, irrational and pre-rational images and myth symbols, whose sources lay more in

ancient, primitive and psychotic art than in modern European painting." The Hairy Who were the heirs of this sensibility—united by a "sub-pop" attitude of muscular crudity, as Schulze explains, rather than by any theory or stylistic consistency.

\* \* \*

There is rather suddenly a new thing in Chicago art, and it is most persuasively articulated by a group of six painters in their twenties called The Hairy Who. The look of their work and the meaning of the new thing are unmistakably related to the kind of place Chicago is for an artist to grow up in, to work in, and either to stay in or get the hell out of.

Of the three largest centers of contemporary art in the United States, New York, Los Angeles, and Chicago, Chicago is the least famous for its art. Its artists are rarely celebrated beyond the immediate radius of the city, and it is expected, or at least understood, that the younger ones among them will flee to New York as soon as they show any plausible signs of promise. The list of emigrés during the past decade includes Claes Oldenburg, Leon Golub, H. C. Westermann, Robert Indiana, John Chamberlain, Irving Petlin, Robert Natkin, Robert Barnes, and Jack Beal. In turn, established artists do not come to Chicago, except on very occasional temporary teaching assignments, following which they invariably go back where they came from without having formed any close attachment to the local scene.

Everybody in Chicago knows this and there is next to nothing anybody can do about it. It would necessitate something more than volition to transform the city into a great magnet in its own right, to give it the stature of an international culture capital like New York, or to provide it with the blandishing physical environment and the youth-oriented mores found on the California coast. So Chicago remains: a fertile producer of talent, but a feeble patron of it; an industrially formidable megalopolis too huge to ignore, yet a stretch of midwestern tableland that is isolated from the wellsprings of the contemporary arts in all realms but an industrial one—architecture.

All this would seem to give Chicago-reared easel painters plenty of reason to abhor their town. Oddly enough, they like it far more often than not. Even as it ignores them and even as they leave it for friendlier places, they go on feeling a kinship with its gritty, common, hard-nosed roughness. Not unconsequently, they frequently remain isolated in their new environments, just as they were isolated in their old.

It is this isolation as much as any factor which makes for an identifiable quality, or strain, or disposition, in the art that comes out of Chicago. The dark, myth-haunted imagery preeminent among the painters of the 1950s was a specific manifestation of this privatism, while the pervasive post-war love of surrealism and dada among both artists and collectors here has been a more general reflection of it. Now there is a new outcropping of the same phenomenon. This is where The Hairy Who comes in.

The first noticeable public appearance of James Falconer, Art Green, Gladys Nilsson, James Nutt, Suellen Rocca, and Karl Wirsum was in the Phalanx Three exhibition at Illinois Institute of Technology in 1965. P3 was a big salon of Chicago painting and sculpture staged by the younger local avant-garde—mostly students at the School of the Art Institute (the ancient mother lode of Chicago talent) with a few sympathetic

older pros added for leavening. It was a spotty exhibition, at times even embarrassing, but it indicated pretty clearly how the Chicago van was adjusting to the international values of the 1960s (late as usual) and refashioning them into something with its own identity. There was little abstraction, and of it less was worth a second glance: an old story in Chicago. There was a lot of figure painting: equally expectably. It was generally more naturalistic than the expressionism of ten years previous, though more parched in handling and coldly impersonal in mood—when it was not, in fact, being downright surly. There was, most of all, a curious species of pop art, dog-eared, like something torn and overused, from a remnant counter. It paid its respects to the symbols and images of trash culture, but it was absolutely and altogether without the cheerful amplitude and soigné brilliance of such New York popsters as Warhol, Rosenquist, and Lichtenstein. It was inward-turned, utterly uningratiating, and much of it looked too clumsy to take very seriously.

The next episode took place in the Hyde Park Art Center, a modestly-endowed South Side neighborhood establishment with a history of displays of Chicago art that is just about the most colorful and original of any local exhibiting agency, private galleries included. The Center's show schedule has been run for years by Don Baum, himself a surrealist sculptor of considerable accomplishment. In the spring of 1966, Baum exhibited six painters at the Center who had been in Phalanx Three and who were both socially and stylistically quite close to one another. The six decided to call their show and themselves The Hairy Who.

The coarseness of the title conveys some of the quality of the work which appeared in the first Hairy Who. The temper throughout ranged from rotgut dada to the vulgarest kind of surrealism. The subject matter was inevitably urban, but it was not, as seems to be the case with New York pop art, related to contemporary middle-class culture. Warhol, after all, is interested in the supermarket and the department store; Rosenquist in the billboard and bourgeois magazine advertising; Lichtenstein in the comic strip and, more recently, even in the printed art reproduction. These interests parallel those of the middle-class, and today's Manhattan middle-class more than any other. The Hairy Who are something else. Their concerns are more atavistic and more proletarian in origin, more ruminatively idiosyncratic, more alienated and off the pace, more lowdown. Suellen Rocca's imagery is based largely on what she finds in her husband's trade catalogs (her husband is a jeweler), which she seems to explore and repeat and chew up, idly, like a dreamily compulsive child. There is a regressiveness to it, and to the work of the other five as well—as if memories of early years were crucial: memories of baseball trading cards, bubble gum orgies, the secret sight of one's parent's arm pits and underwear up close, one's own mucus, tire pumps lying out in the rain in the back yard, broken balloons, misspelled words scrawled on the walls under railroad viaducts, the drawings found in the margins of elementary school text books. Moreover, there is a prevailing semi-literacy in the work of every one of these painters. They love puns and malapropisms in their titles (*Impinging Disaster, Well-Wread Whead, Miss Steak*), but often enough their errors are committed quite unconsciously. Miss Rocca didn't know that *Suellen's Corness Painting* contained a misspelling, but when she learned of it, she liked it well enough to keep it.

Such unconsciousness suggests primitivism, and rightly enough, but it is of a very canny sort. The Who's motives, evidently, are ambivalent. Gladys Nilsson, for example, can be as cool and cynical in her treatment of people as George Grosz, whose work she immediately recalls. Nor is her husband James Nutt any more kindly disposed toward his battalion of warty, ludicrously inelegant and undone ladies. There appears to be no salvation in Karl Wirsum's world of hallucinatory faces, or in James Falconer's cruelly comic discursive fantasies. At the same time, each of these artists seems locked in the grip of an innocence which will not let go. They could all easily be lasciviously erotic, yet the thought never seems to occur to them. (This fact sets them apart from what is known on the east and west coasts as funk art, a visceral and often scatological expressive style. Funk is a word one never hears in Chicago. Probably it hasn't reached here yet.) They remain more wondering than authoritative about sex, but they wonder with a bit of a detached smirk, and without any noticeable carnal desire. They are simply not that involved and not that committed; they are outsiders. Therewith, once again, the isolation and disengagement—and ultimate limitation, perhaps—of traditional post-war Chicago art. All of the dark corners of Chicago, the rude, old, graceless, beat-down precincts of a town shunned by the elite: these are the places where the Hairy Whos play around, where they get their kicks; whence they throw it all back at the lakefront intellectuals, the downtown rich, the East Coast and the West Coast and the whole Exciting World of Art. They are a bunch of delinquents.

To a large extent, this is why they have enjoyed a sudden popularity in Chicago: this, and the fact that they are such skylarks. The image they project publicly is one of cool, knowing ease topped off with a nutty sense of humor. They are cunning promoters of themselves, and they have a gift for making memorable remarks to the press. "If you bomb and blitz enough," said James Nutt recently in explanation of his painting method, "you develop coconut pecs and barndoor lats and that's very important."

Nevertheless, their claim on the attention of the Chicago art world goes beyond mere public relations. After their awkward debut in Phalanx Three, their first Hyde Park Art Center show stamped them as a striking group of painters with a recognizably original point of view, a pungent imagery, and a formal vocabulary that was more than just spastic, flimsy, crude, or derivative. Gladys Nilsson's water colors, if gamey in content, were brittly delicate in handling. Nutt's figures were rendered with equal refinement, though in a harder, more muscular way. Rocca's compendia of merchandise-minutiae at times had the discursive presence of good mural painting. Green and Wirsum looked like promising fantasts and Falconer was capable of mounting a very convincing violence in his work.

And if this were all one had to report about them, they would still deserve to be considered the most provocative representatives of the most vigorous Chicago generation to appear in at least a decade. But the second Hairy Who show, which was held at the Hyde Park Art Center in March of this year, indicated an advance in the sophistication of each of its members that put to rest any notion that they are merely a showboating *Lumpenproletariat* whose moment front and center is inevitably brief [. . .] Given the fact that the oldest of all six painters (Nutt) is

only 28, the future of The Hairy Who remains open to question. But for a group which is unserious in all aspects of their work except its quality, progress has been serious enough to cause an equally earnest interest in them, within a large segment of the avant-garde art public in Chicago.

<div align="center">* * *</div>

## Minimal Art

To anyone reading art magazines or attending art gallery and museum exhibitions in the early 1960s it became evident that new styles were in full swing. Clement Greenberg and critics influenced by him called some of the new non-representational abstract art "post-painterly abstraction." Other names, given by critics who wanted to distance themselves from Greenberg's direct influence, were "A-B-C art" (Barbara Rose), or "systemic painting" (Lawrence Alloway), or "primary structures" (Kynaston McShine). The term "minimal art," used by Richard Wollheim for an article in *Arts* (January 1965), turned out to be the most useful, since it conveniently embraced not only painting but also sculpture, concrete poetry, even music and dance. The term also connected with the international-style architecture of the postwar period; Mies van der Rohe's declaration that "less is more" influenced a generation of architects in the 1950s and 1960s.

"Minimal" painting meant no *illusionism*—no attempt to create the illusion of three-dimensional depth; it also meant no *allusionism*—no reference to symbolic content, transcendent feelings, or narrative meanings. As Frank Stella said (see Reading 94): "What you see is what you see." It had simple unassuming shapes, plain surfaces, and minimal amounts of color. Minimal sculpture consisted of human-made, usually geometric objects existing in relationship to a wall or a floor and in the viewer's own space. It used materials associated with industrial production, such as rolled steel or bricks. (Some of the works were actually produced in factories from telephone orders placed by the artist.) The only flourish in a minimal artwork might be a repetition of elements, such as the stripes of Frank Stella or the serial placement of sculptural parts as with Donald Judd, Carl Andre, and Sol LeWitt.

### The Reductive and Seductive Appeal of Clement Greenberg

Much of what we today call minimal art (which has become the umbrella term) was not endorsed by Clement Greenberg. Nevertheless, his theories as he was refining them in the 1950s and early 1960s had a powerful hold on artists creating this minimalist art, the critics and curators writing about it, and the viewers following the exhibitions—even if they were vigorously rejecting Greenberg's theories.

There was a seductive Apollonian beauty to Greenberg's criticism, with its talk about "purity" and its teleological determinism that all Art (capital "A") "tended toward its own self-definition." And there was also something very heroic in the way that Greenberg persistently championed abstract art, whether writing for *The Nation, Partisan Review,* and *Commentary,* or writing for the mass-marketed *Saturday Evening Post.*

For a *Saturday Evening Post* essay (August 1, 1959), he offered to the general public a most persuasive case for abstract art, a case much like the defense of music. To Greenberg, abstract art sprang out of the conditions of nineteenth-century history, and

he believed those conditions still held for 1959 when abstract art was needed as an "an-tidote" to a materialist and pragmatic culture. He patiently explained to his *Post* reader-ship that abstract art invokes such disinterested, or contemplative activity:

> Abstract art does this in very literal and also in very imaginative ways. First, it does not exhibit the illusion or semblance of things we are already familiar with in real life; it gives us no imaginary space through which to walk with the mind's eye; no imaginary objects to desire or not desire; no imaginary people to like or dislike. We are left alone with shapes and colors.
>
>   Second, pictorial art in its highest definition is static; it tries to overcome move-ment in space or time. . . . [I]deally the whole of a picture should be taken in at a glance; its unity should be immediately evident, and the supreme quality of a pic-ture, the highest measure of its power to move and control the visual imagination, should reside in its unity. And this is something to be grasped only in an indivisible instant of time. . . . [A] picture, I repeat, does not "come out" the way a story, or a poem, or a piece of music does. It's all there at once, like a sudden revelation.

To *Post* readers Greenberg was offering guidelines for purely aesthetic experiences.

  For the art world Greenberg wrote with more erudition; and the message came across with even greater force. In his essay "Modernist Painting," written for *Arts Year-book* in 1961, and frequently anthologized, Greenberg maintained:

> [T]he essence of Modernism lies, as I see it, in the use of the characteristic meth-ods of a discipline to criticize the discipline itself—not in order to subvert it, but to entrench it more firmly in its area of competence. . . . The task of self-criticism be-came to eliminate from the effects of each any and every effect that might con-ceivably be borrowed from or by the medium of any other art. Thereby each art would be rendered "pure," and in its "purity" find the guarantee of its standards of quality as well as of its independence.

Greenberg then lists "the limitations that constitute the medium of painting," that is, those characteristics unique to painting, which were: "flat surface, the shape of the sup-port, the properties of pigment."

  Greenberg found his prime examples of high modernism (as he then defined it) in the work of Helen Frankenthaler, Kenneth Noland, and Morris Louis. But other artists who would seem to exemplify a preoccupation with Greenberg's ideas about flatness, edges, and pig-ment would also include Larry Poons, Ellsworth Kelly, Jules Olitski, and Agnes Martin.

  Greenberg generally did not focus on sculpture in his criticism, however, the theories he raised about the self-definition of each of the arts (and the preoccupation with issues of "flat surface, the shape of the support, the properties of pigment") had a fundamental im-pact on even those sculptors, such as Donald Judd and Robert Morris, who resisted his in-fluence in their own writings. Moreover, the work of Judd, Morris, Tony Smith, Carl Andre, and Donald Bladen seemed at the time to exemplify the "self-definition" of sculpture—objects (not architecture) existing in a palpable three-dimensional space.

  Many younger critics attempted to emulate Greenberg's authoritive stance and clear but nuanced writing, and they sought to engage the issues that he maintained were the defining qualities of art. These critics included Barbara Rose, Kenworth Moffett,

Michael Fried, and Rosalind Krauss—although almost all eventually moved away from the older critic's reductionism and the assumptions of his discourse.

**93 ✦** Carl Andre, statement on Frank Stella with Hollis Frampton photograph, in Dorothy C. Miller, ed., *Sixteen Americans* (New York: The Museum of Modern Art, 1959), 76. [Fig. 5-5]

Frank Stella was only 24 when he showed four of his stripe paintings at the Museum of Modern Art exhibition *Sixteen Americans.* Stella did not submit an artist's statement; instead his friend Carl Andre submitted a brief comment, printed here in its entirety. Stella's paintings seemed as if they were resistant to theory. They were minimal statements, more like painted objects  projected from the wall out into the viewer's space. Later, when the canvases assumed shapes beyond traditional rectangles, as in his "notched" paintings and "Protractor" series, it became evident that Stella was working with a self-consciousness of edges and surfaces. This was commented on by Donald Judd, who observed in *Arts Yearbook,* 1965, "Stella's shaped paintings involve several important characteristics of three-dimensional work. The periphery of a piece and the lines inside correspond. The stripes are nowhere near being discrete parts. The surface is further from the wall than usual, although it remains parallel to it."

By 1983–84, when Frank Stella delivered the prestigious Charles Eliot Norton Lectures at Harvard University, he had theorized the ideas only nascent in his earlier work. Published as *Working Space* in 1986, Stella declared his thesis: "[T]he aim of art is to create space—space that is not compromised by decoration or illustration, space in which the subjects of painting can live." To Stella, Caravaggio's greatness manifested itself in his ability to create "pictorial space that is capable of direction and movement." Compare this to Greenberg's statement in his *Saturday Evening Post* article, quoted in the introduction to this section, that "pictorial art in its highest definition . . . tries to overcome movement in space or time."

Toward the end of the Norton lectures Stella assessed the success of 1960s abstraction:

> The success of abstract painting of the sixties was based on a collective effort which took off from the immediately preceding successes of the giants of abstract expressionism. It sustained its success as well as it did because it was able to reach a little deeper, to be a little less self-conscious about its debt to Cubism and a European past. . . . Abstract expressionism shielded the generation succeeding it from the heavy arm of European modernism. . . . This protection allowed 1960s painting direct access to the founders of abstraction—to Mondrian, Kandinsky, and Malevich.

Stella then lists the abstract painters who benefited from the interference run by Pollock and de Kooning: Jack Youngerman, Ellsworth Kelly, Sam Francis, Helen Frankenthaler, Friedel Dzubas, Morris Louis, Kenneth Noland, and Jules Olitski, and ends with the comment that "Donald Judd, Larry Poons, and I laid the track to literalism." In the mid-1960s "literalism" was exactly the quality that Michael Fried argued was not characteristic of Stella's art (see Reading 96).

Carl Andre has for forty years been a leading minimalist sculptor and writer of concrete poetry.

FRANK STELLA

photograph Hollis Frampton

Preface to Stripe Painting

Art excludes the unnecessary. Frank Stella has found it necessary to paint stripes. There is nothing else in his painting.

Frank Stella is not interested in expression or sensitivity. He is interested in the necessities of painting.

Symbols are counters passed among people. Frank Stella's painting is not symbolic. His stripes are the paths of brush on canvas. These paths lead only into painting. —CARL ANDRÉ

**Figure 5-5.** "Frank Stella" in *Sixteen Americans* (New York: Museum of Modern Art, 1959). Photograph by Hollis Frampton, courtesy the Frampton Estate. Statement by and courtesy Carl Andre. Frampton's Stella in a pin-striped suit contrasts with Namuths's Pollock in T-shirt and jeans [see Fig. 4-3].

**94 ◆**    Lucy R. Lippard, ed., "Questions to Stella and Judd," Interview by Bruce Glaser, *Art News* 65, no. 5 (September 1966): 55–61. © 1966 ARTnews L.L.C. This discussion was broadcast on WBAI-FM, New York, February, 1964, as "New Nihilism or New Art?" on a series of radio programs on art produced by Bruce Glaser. Supplementary statements made by Donald Judd in December, 1975, are included in this revision.

Critic Bruce Glaser wrote on art and also conducted radio interviews for WBAI-FM in New York during the 1960s. Lucy R. Lippard wove in the supplementary statements by Donald Judd when she edited the tapes for the ARTnews article.

Born in Massachusetts, Frank Stella studied at Princeton from 1954 to 1958. His stripe paintings of 1959 (see Reading 96) had already become his signature style. From Missouri, Donald Judd studied at the Art Students League in New York in the late 1940s and early 1950s. Both Judd's writings and his work influenced the development of minimalist art.

Throughout the interview, both Stella and Judd stress the physical qualities of their art and implicitly reject the notion of transcendent meaning as abstract expressionist paintings had been interpreted. They also reject the subject matter of popular culture and consumer goods, which Pop artists had embraced with enthusiasm.

\* \* \*

*Stella:* . . . [T]he European geometric painters really strive for what I call relational painting. The basis of their whole idea is balance. You do something in one corner and you balance it with something in the other corner. Now the "new painting" is being characterized as symmetrical. Ken Noland has put things in the center and I'll use a symmetrical pattern, but we use symmetry in a different way. It's non-relational. In the newer American painting we strive to get the thing in the middle, and symmetrical, but just to get a kind of force, just to get the thing on the canvas. The balance factor isn't important. We're not trying to jockey everything around.

*Glaser:* What is the "thing" you're getting on the canvas?

*Stella:* I guess you'd have to describe it as the image, either the image or the scheme. Ken Noland would use concentric circles; he'd want to get them in the middle because it's the easiest way to get them there, and he wants them there in the front, on the surface of the canvas. If you're that much involved with the surface of anything, you're bound to find symmetry the most natural means. As soon as you use any kind of relational placement for symmetry, you get into a terrible kind of fussiness, which is the one thing that most of the painters now want to avoid. When you're always making these delicate balances, it seems to present too many problems; it becomes sort of arch.

*Glaser:* An artist who works in your vein has said he finds symmetry extraordinarily sensuous; on the other hand, I've heard the comment that symmetry is very austere. Are you trying to create a sensuous or an austere effect? Is this relevant to your surfaces?

*Judd:* No, I don't think my work is either one. I'm interested in spareness, but I don't think it has any connection to symmetry.

*Stella:* Actually, your work is really symmetrical. How can you avoid it when you take a box situation? The only piece I can think of that deals with any kind of asymmetry is one box with a plane cut out.

*Judd:* But I don't have any ideas as to symmetry. My things are symmetrical because, as you said, I wanted to get rid of any compositional effects, and the obvious way to do it is to be symmetrical.

*Glaser:* Why do you want to avoid compositional effects?

*Judd:* Well, those effects tend to carry with them all the structures, values, feelings of the whole European tradition. It suits me fine if that's all down the drain.

\* \* \*

*Judd:* The qualities of European art so far. They're innumerable and complex, but the main way of saying it is that they're linked up with a philosophy—rationalism, rationalistic philosophy.

*Glaser:* Descartes?

*Judd:* Yes.

*Glaser:* And you mean to say that your work is apart from rationalism?

*Judd:* Yes. All that art is based on systems built beforehand, *a priori* systems; they express a certain type of thinking and logic that is pretty much discredited now as a way of finding out what the world's like.

*Glaser:* Discredited by whom? By empiricists?

*Judd:* Scientists, both philosophers and scientists.

\* \* \*

*Glaser:* Could you be specific about how your own work reflects an antirationalistic point of view?

*Judd:* The parts are unrelational.

*Glaser:* If there's nothing to relate, then you can't be rational about it because it's just there?

*Judd:* Yes.

*Glaser:* Then it's almost an abdication of logical thinking.

*Judd:* I don't have anything against using some sort of logic. That's simple. But when you start relating parts, in the first place, you're assuming you have a vague whole—the rectangle of the canvas—and definite parts, which is all screwed up, because you should have a definite *whole* and maybe no parts, or very few. The parts are always more important than the whole.

*Glaser:* And you want the whole to be more important than the parts?

*Judd:* Yes. The whole's it. The big problem is to maintain the sense of the whole thing.

\* \* \*

*Glaser:* There are several other characteristics that accompany the prevalence of symmetry and simplicity in the new work. There's a very finished look to it, a complete negation of the painterly approach. Twentieth-century painting has been concerned mainly with emphasizing the artist's presence in the work, often with an unfinished quality by which one can participate in the experience of the artist, the process of painting the picture. You deny all this, too; your work has an industrial look, a non-man-made look.

*Stella:* The artist's tools or the traditional artist's brush and maybe even oil paint are all disappearing very quickly. We use mostly commercial paint, and we generally tend toward larger brushes. In a way, Abstract Expressionism started all this. De Kooning used house painters' brushes and house painters' techniques.
*Glaser:* Pollock used commercial paint.
*Stella:* Yes, the aluminum paint. What happened, at least for me, is that when I first started painting I would see Pollock, de Kooning, and the one thing they all had that I didn't have was an art school background. They were brought up on drawing and they all ended up painting or drawing with the brush. They got away from the smaller brushes and, in an attempt to free themselves, they got involved in commercial paint and house-painting brushes. Still it was basically drawing with paint, which has characterized almost all twentieth-century painting. The way my own painting was going, drawing was less and less necessary. It was the one thing I wasn't going to do. I wasn't going to draw with the brush.

* * *

*Glaser:* What induced this conclusion that drawing wasn't necessary any more?
*Stella:* Well, you have a brush and you've got paint on the brush, and you ask yourself why you're doing whatever it is you're doing, what inflection you're actually going to make with the brush and with the paint that's on the end of the brush. It's like handwriting. And I found out that I just didn't have anything to say in those terms. I didn't want to make variations; I didn't want to record a path. I wanted to get the paint out of the can and onto the canvas.
*Glaser:* Are you suggesting that there are no more solutions to, or no more problems that exist in painting?
*Stella:* Well, it seems to me we have problems. When Morris Louis showed in 1958, everybody (ARTnews, Tom Hess) dismissed his work as thin, merely decorative. They still do. Louis is the really interesting case. In every sense his instincts were Abstract Expressionist, and he was terribly involved with all of that, but he felt he had to move, too. I always get into arguments with people who want to retain the old values in painting—the humanistic values that they always find on the canvas. If you pin them down, they always end up asserting that there is something there besides the paint on the canvas. My painting is based on the fact that only what can be seen there *is* there. It really is an object. Any painting is an object and anyone who gets involved enough in this finally has to face up to the objectness of whatever it is that he's doing. He is making a thing. All that should be taken for granted. If the painting were lean enough, accurate enough, or right enough, you would just be able to look at it. All I want anyone to get out of my paintings, and all I ever get out of them, is the fact that you can see the whole idea without any confusion. . . . What you see is what you see.
*Glaser:* That doesn't leave too much afterwards, does it?
*Stella:* I don't know what else there is. It's really something if you can get a visual sensation that is pleasurable, or worth looking at, or enjoyable, if you can just make something worth looking at.

**95** ✦ Robert Morris, "Notes on Sculpture," *Artforum* 4, no. 6 (February 1966): 42–44. © *Artforum*

Robert Morris studied at the Kansas City Art Institute in the late 1940s and then spent a decade in California, first studying at the California School of Fine Arts and then working in theater and film as well as painting. He came to New York in 1961.

Morris participated in Judson Dance Theater events, such as *Arizona,* performed in 1963. In one segment of this multipart performance Morris slowly turned his body while a tape played a voice describing cattle sorting in pens before slaughter. Both Robert Morris and Carolee Schneemann performed in *Site,* 1964, during which Morris slowly moved around 4- by 8-foot sheets of plywood to reveal, at the conclusion, a nude Schneemann spread out like Manet's "Olympia" on a platform jutting out from one of the boards.

Morris's involvement with minimal structures led him to focus on sculptural forms and to write up his ideas about literal (non-narrative, non-psychological, non-symbolic) "three dimensionality" in sculpture. His debt to Clement Greenberg is acknowledged not only by direct reference to the older critic, but also through the assumptions of the discourse. Writer Jack Burnham, in *Beyond Modern Sculpture,* 1968, credited Morris for succinctly defining the new literalist art:

> Robert Morris in his series, "Notes on Sculpture," has defined what he has termed the infrastructure of the forming and handling of objects in our culture. This he has done with a precision and insight unrivaled by all other critics of contemporary art. His main contribution has been to define the borderline between the old aesthetic ideals of illusionism and the tacit set of concerns by which we apprehend all objects fabricated and designed by modern industrial technology. This shifting set of values accounts for the severe simplicity, forced modular aspect, and tendency away from anthropomorphism which defines so much abstract sculpture.

The following essay was one of three published in *Artforum;* the second was published in October 1966; the third, in Summer 1967.

"Gestalt," a frequently used term during the 1950s and 1960s (especially with reference to Gestalt Psychology), refers to a focus on the "wholeness" of a situation or object, as opposed to the parts or the details; Greenberg used the word "unity" in much the same way. Morris's remark that the use of color "emphasizes the optical and in so doing subverts the physical" is in direct dialogue with Michael Fried's viewpoint in "Shape as Form."

──────────────────◆──────────────────

"What comes into appearance must segregate in order to appear."

Goethe

There has been little definitive writing on present day sculpture.

\* \* \*

In the interest of differences it seems time that some of the distinctions sculpture has managed for itself be articulated. To begin in the broadest possible way it should be stated that the concerns of sculpture have been for some time not only distinct but hostile to those of painting. [. . .] Sculpture, on the other hand, never having been involved with illusionism could not possibly have based the efforts of fifty years upon the rather pious, if somewhat contradictory, act of giving up this illusionism and approaching the object. Save for replication, which is not to be confused with illusionism, the sculptural facts of space, light, and materials have always functioned concretely and literally. [. . .] Clearer distinctions between sculpture's essentially tactile nature and the optical sensibilities involved in painting need to be made.

Tatlin was perhaps the first to free sculpture from representation and establish it as an autonomous form both by the kind of image, or rather non-image, he employed and by his literal use of materials. He, Rodchenko, and other Constructivists refuted Appollinaire's observation that "a structure becomes architecture, and not sculpture, when its elements no longer have their justification in nature." At least the earlier works of Tatlin and other Constructivists made references to neither the figure nor architecture. [. . .] Today there is a reassertion of the non-imagistic as an essential condition. [. . .] The relief has always been accepted as a viable mode. However, it cannot be accepted today as legitimate. The autonomous and literal nature of sculpture demands that it have its own, equally literal space—not a surface shared with painting. Furthermore, an object hung on the wall does not confront gravity; it timidly resists it. One of the conditions of knowing an object is supplied by the sensing of the gravitational force acting upon it in actual space. That is, space with three, not two coordinates. The ground plane, not the wall, is the necessary support for the maximum awareness of the object. One more objection to the relief is the limitation of the number of possible views the wall imposes, together with the constant of up, down, right, left.

[. . .] The qualities of scale, proportion, shape, mass, are physical. Each of these qualities is made visible by the adjustment of an obdurate, literal mass. Color does not have this characteristic. It is additive. Obviously things exist as colored. The objection is raised against the use of color which emphasizes the optical and in so doing subverts the physical. The more neutral hues which do not call attention to themselves allow for the maximum focus on those essential physical decisions which inform sculptural works. Ultimately the consideration of the nature of sculptural surfaces is the consideration of light, the least physical element, but one which is as actual as the space itself. [. . .] It is necessary to consider for a moment the nature of three dimensional gestalts as they occur in the apprehension of the various types of polyhedrons. In the simpler regular polyhedrons such as cubes and pyramids one need not move around the object for the sense of the whole, the gestalt, to occur. One sees and immediately "believes" that the pattern within one's mind corresponds to the existential fact of the object. Belief in this sense is both a kind of faith in spatial extension and a visualization of that exten-

sion. In other words it is those aspects of apprehension which are not coexistent with the visual field but rather the result of the experience of the visual field. [. . .] But experience of solids establishes the fact that, as in flat forms, some configurations are dominated by wholeness, others tend to separate into parts. This becomes clearer if the other types of polyhedrons are considered. In the complex regular type there is a weakening of visualization as the number of sides increases. A 64-sided figure is difficult to visualize, yet because of its regularity one senses the whole, even if seen from a single viewpoint. [. . .] The simpler regular and irregular ones maintain the maximum resistance to being confronted as objects with separate parts. They seem to fail to present lines of fracture by which they could divide for easy part-to-part relationships to be established. I term these simple regular and irregular polyhedrons "unitary" forms. Sculpture involving unitary forms, being bound together as it is with a kind of energy provided by the gestalt, often elicits the complaint among critics that such works are beyond analysis.
[. . .]

Simplicity of shape does not necessarily equate with simplicity of experience. Unitary forms do not reduce relationships. They order them. If the predominant, hieratic nature of the unitary form functions as a constant, all those particularizing relations of scale, proportion, etc., are not thereby canceled. Rather they are bound more cohesively and indivisibly together. The magnification of this single most important sculptural value, shape, together with greater unification and integration of every other essential sculptural value makes on the one hand, the multipart, inflected formats of past sculpture extraneous, and on the other, establishes both a new limit and a new freedom for sculpture.

---

*96* ✦ Michael Fried, "Shape as Form: Frank Stella's New Paintings," *Artforum* 5, no. 3 (November 1966):18–27. © *Artforum*

During the 1960s Michael Fried emerged as a major theorist of high modernism. During 1962 and 1963 he covered selected exhibitions in a "New York Letter," published in *Art International*, and also began graduate school in art history at Harvard University. Invited to organize an exhibition of contemporary art for Harvard's Fogg Art Museum, he put together *Three American Painters: Kenneth Noland, Jules Olitski, Frank Stella* which opened in April 1965. Fried quickly rose to the first ranks of the theoretical critics, while also making his mark as an art historian with "Manet's Sources," which filled a single issue of *Artforum* in March 1969.

In "An Introduction to My Art Criticism," (*Art and Objecthood: Essays and Reviews*, 1998), Fried acknowledges his debt to Clement Greenberg but emphasizes that his theoretical views are at odds with the older critic's view of modernism. Nevertheless,

Fried wants to make clear to his present audience that "Shape as Form" was critical less of Clement Greenberg than of artists such as Robert Morris and Donald Judd:

> The immediate target of my critique of reductionism in "Shape as Form" was not Greenberg himself so much as the group of artists known as Minimalists [Donald Judd, Larry Bell, et al.] . . . Hence my introduction of the term "literalist" as a way of characterizing their views. . . . [W]ith respect to his understanding of modernism Greenberg had no truer followers than the literalists. . . . And my further claim in "Shape as Form" was that Stella himself had refused the literalist option in favor of a renewed commitment to the enterprise of painting, a commitment that was spelled out, as if in the teeth of the literalist reading of his work, in the irregular polygons.

The reader should refer to the introduction to Reading 93, where Stella two decades later refers to his role in the development of literalism.

In this essay Fried makes the point that the "flatness" of painting never ruled out optical or perceptual illusionism that the viewer experiences when looking at any mark on a canvas. To Fried the awareness of the always present optical illusionism then shifts the viewer's attention to shape. Fried points out that Stella, in his notched paintings of 1960, used shape to determine the form of the stripes. Fried brings Kenneth Noland into the discussion as an artist working along similar lines.

Fried followed "Shape as Form" with his long essay "Art and Objecthood" (*Artforum,* June 1967), in which he elaborated his idea that "literalist" meant non-art "objecthood." He also developed and codified his ideas about theatricality—a concept, to Fried, contrary to the project of modernist painting and sculpture: "Literalist sensibility is theatrical because . . . it is concerned with the actual circumstances in which the beholder encounters literalist work." Fried means that the "literalist" work of Judd or Morris depends on the *situation* of the beholders—where they stand, how they move, and so on. In Fried's words, there is "a special complicity" that such work "extorts from the beholder." To Fried, "*The success, even the survival of the arts has come increasingly to depend on their ability to defeat theater,*" and, moreover, "*Art degenerates as it approaches the condition of theater*" (Fried's emphases). As to art, Fried concludes: "I want to claim that it is by virtue of their presentness and instantaneousness that modernist painting and sculpture defeat theater." The reader might compare this remark with Greenberg's 1959 statement, "ideally the whole of a picture should be taken in at a glance" (quoted in introduction to this Section).

Regardless of Fried's persuasive logic, in the following decade (see Chapter 6) artists increasingly embraced a mode of art that was not instantaneous; they instead demanded the performative participation of the beholder as had the Happenings artists.

◆

\* \* \*

Frank Stella's new paintings investigate the viability of shape as such. By *shape as such* I mean not merely the silhouette of the support (which I will call literal shape), nor merely that of the outlines of elements in a given picture (which I will call depicted shape), but shape as a medium within which choices about both literal and depicted shapes are made, and made mutually responsive. And by the viability of shape, I mean its power to hold, to stamp itself out, and *in*—as verisimilitude and narrative and symbolism used to impress themselves—compelling conviction. Stella's undertaking in these paintings is therapeutic: to restore shape to health, at least temporarily, though of course its implied "sickness" is simply the other face of the unprecedented importance shape has assumed in the finest modernist painting of the past several years—most notably, in the work of Kenneth Noland and Jules Olitski. It is only in their work that shape as such can be said to have become capable of holding, or stamping itself out, or compelling conviction—as well as, so to speak, capable of *failing* to do so. These are powers or potentialities—not to say responsibilities—which shape never until now possessed, and which have been conferred upon it by the development of modernist painting itself. In this sense shape has become something different from what it was in traditional painting or, for that matter, in modernist painting until recently. It has become, one might say, an object of conviction, whereas before it was merely . . . a kind of object. Stella's new pictures are a response to the recognition that shape itself may be lost to the art of painting as a resource able to compel conviction, precisely because—as never before—it is being called upon to do just that.

The way in which this has come about is, in the fullest sense of the word, dialectical, and I will not try to do justice to its enormous complexity in these rough notes. An adequate account of the developments leading up to Stella's new paintings would, however, deal with the following:

1. *The emergence of a new, exclusively visual mode of illusionism in the work of Pollock, Newman and Louis.* No single issue has been as continuously fundamental to the development of modernist painting as the need to acknowledge the literal character of the picture-support. Above all this has tended to mean acknowledging its flatness or two-dimensionality. There is a sense in which a new illusionism was implicit in this development all along. As Clement Greenberg has remarked:

> The flatness toward which Modernist painting orients itself can never be an utter flatness. The heightened sensitivity of the picture plane may no longer permit sculptural illusion, or *trompe-l'oeil*, but it does and must permit optical illusion. The first mark on a surface destroys its virtual flatness, and the configurations of a Mondrian still suggest a kind of illusion of a kind of third dimension. Only now it is a strictly pictorial, strictly optical third dimension. [Greenberg, "Modernist Painting," 1961].

But the universal power of any mark to suggest something like depth belongs not so much to the art of painting as to the eye itself; it is, one might say, not something that has had to be *established* so much as something—a perceptual limitation—that cannot be escaped, whereas the dissolution of traditional drawing in Pollock's work, the reliance on large and generally rather warm expanses of barely fluctuating color in Newman's, and the staining of thinned (acrylic) pigment into mostly unsized canvas in Louis's were instrumental in the creation of a depth or space accessible to eyesight alone which, so to speak, specifically belongs to the art of painting.

2. *The neutralizing of the flatness of the picture-support by the new, exclusively optical illusionism.* In the work of Pollock and Newman, but even more in that of Louis, Noland and Olitski, the new illusionism both subsumes and dissolves the picture-surface—opening it, as Greenberg has said, from the rear—while simultaneously preserving its integrity. More accurately, it is the *flatness* of the picture-surface, and not that surface itself, that is dissolved, or anyway *neutralized,* by the illusion in question. The literalness of the picture-surface is not denied; but one's experience of that literalness is an experience of the properties of different pigments, of foreign substances applied to the surface of the painting, of the weave of the canvas, above all of color—but not, or not in particular, of the flatness of the support. (One could say that here the literalness of the picture-surface is not an aspect of the literalness of the support.) Not that literalness here is experienced as competing in any way with the illusionistic presence of the painting as a whole; on the contrary, one somehow *constitutes* the other. And in fact there is no distinction one can make between attending to the surface of the painting and to the illusion it generates: to be gripped by one is to be held, and moved, by the other.

3. *The discovery shortly before 1960 of a new mode of pictorial structure based on the shape, rather than the flatness, of the support.* With the dissolution or neutralizing of the flatness of the support by the new optical illusionism, the shape of the support—including its proportions and exact dimensions—came to assume a more active, more explicit importance than ever before. The crucial figures in this development are Frank Stella and Kenneth Noland. In Stella's aluminum stripe paintings of 1960, for example, 2 1/2-inch wide stripes begin at the framing-edge and reiterate the shape of that edge until the entire picture is filled; moreover, by actually shaping each picture—the canvases are rectangles with shallow (one stripe deep) notches at two corners or along the sides or both—Stella was able to make the fact that the literal shape determines the structure of the entire painting completely perspicuous. That is, in each painting the stripes appear to have been generated by the framing-edge and, starting there, to have taken possession of the rest of the canvas, as though the whole painting self-evidently followed from, not merely the shape of the support, but its actual physical limits. Noland, on the other hand, cannot be said to have come into contact with the physical limits of the support until his first chevron paintings of 1962. His initial breakthrough to major achievement in the late 1950s came when he began to locate the center of concentric or radiating motifs at the exact center of square canvases. This related depicted shape to literal shape through a shared focus of symmetry. Whether or not Noland recognized that *this* was the significance of centering his rings and armatures

of color is less important than that he experienced the centering itself as a discovery: a constraint in whose necessity he could believe, and in submission to which his magnificent gifts as a colorist were liberated. His shift to chevron motifs a few years later was, I believe, inspired in part by the need to achieve a more active or explicit relation between depicted and literal shape than the use of concentric rings, none of which actually made contact with the framing-edge, allowed. Within a few months Noland discovered that suspending his chevrons from the upper corners of the support (the bottom edge of the lowest chevron running into each corner) empowered him, first, to prize loose the point of the bottom-most chevron from the mid-point of the bottom framing-edge, and second, to pull all the chevrons away from the central axis of the painting—besides enabling him to work with rectangular formats other than the square. In these paintings—the asymmetrical chevrons of 1964—the exact dimensions of the support become important in this sense: that if the edge of the bottom-most chevron did not exactly intersect the upper corners of the canvas, the relation of all the chevrons—that is, of depicted shape—to the shape of the support would be acutely problematic and the ability of the painting as a whole to compel conviction would be called into question. Since that time, apparently in an attempt to make depicted shape relate more generally to the shape of the support in its entirety, Noland too has shaped his pictures. (His recent work includes a number of narrow diamond-shaped pictures which I will discuss further on.) It cannot be emphasized too strongly, however, that Noland's chief concern throughout his career has been with color—or rather, with feeling *through* color—and not with structure: which makes the role that structural decisions and alterations have played in his development all the more significant. This is not to say that Noland's colorism has had to maintain itself in the teeth of his forced involvement with structural concerns. On the contrary, it is precisely his deep and impassioned commitment to making color yield major painting that has compelled him to discover structures in which the shape of the support is acknowledged lucidly and explicitly enough to compel conviction.

4. *The primacy of literal over depicted shape.* In both Noland's and Stella's (stripe) paintings the burden of acknowledging the shape of the support is borne by the depicted shape, or perhaps more accurately, by the relation between it and the literal shape—a relation that declares the *primacy* of the latter. And in general the development of modernist painting during the past six years can be described as having involved the progressive assumption by literal shape of a greater—that is, more active, more explicit—importance than ever before, and the consequent subordination of depicted shape. It is as though depicted shape has become less and less capable of venturing on its own, of pursuing its own ends; as though unless, in a given painting, depicted shape manages to participate in—by helping to establish—the authority of the shape of the support, conviction is aborted and the painting fails. In this sense depicted shape may be said to have become dependent upon literal shape—and indeed unable to make itself felt as shape except by acknowledging that dependence.

<p style="text-align:center">* * *</p>

**97** ✦   Lawrence Alloway, "Agnes Martin," *Artforum* 11, no. 8 (April 1973):32–36. © *Artforum*. Reprinted in Lawrence Alloway, *Topics in American Art Since 1945* (New York: W.W. Norton, 1975).

Agnes Martin left Saskatchewan, Canada, to attend Columbia University, where she took up the study of art. In the late 1950s she showed at "Section Eleven," a space run by the Betty Parsons Gallery along with Paul Feeley, Alexander Liberman, and other "hard-edge" painters. In 1967 she moved permanently to New Mexico.

Unlike the factory-production aesthetic of Robert Morris and Donald Judd, Agnes Martin's hand-ruled vertical and horizontal penciled lines drawn over uniformly colored canvases achieve a hand-crafted effect of unity that differs from what Morris advocated (see Reading 95). Martin's paintings and drawings demand of the viewer a close, personal and quiet examination of the actual art.

Critic and curator Lawrence Alloway moved to the United States from England in 1961 to teach at Bennington College. From 1962 to 1966 he was curator of the Guggenheim Museum, and beginning in 1968 taught at the State University of New York, Stony Brook. He continued to curate exhibitions and write on contemporary art, including a column for *The Nation*. Married to painter and feminist Sylvia Sleigh, he paid special attention to women artists. This essay reviews the exhibition of Martin's work held at the Institute of Contemporary Art in Philadelphia that showcased her 1957–67 work.

\* \* \*

Martin's works thrive in the absence of opticality. Obviously they are visible, but they function without the rhetorical devices of the paintings that seem to resemble hers. Opticality is the property ascribed to Clement Greenberg-approved painters, the supposed special province of painting as opposed to sculpture or drawing. Opticality can be recognized as an artist's aim by a combination of such properties as intensity of color, the relation of one color to another (which includes acute edge control), and the absorption of positive and negative forms into a unified field. In early *Artforum* criticism these properties were signaled by such words as "modernist," "ambitious," and "advanced." The paintings that did not earn these prized adjectives were retrogressive, provincial, or easy.

\* \* \*

Judging from Martin's earlier work she did not reach the symmetrical format of her mature work via geometric art. Her early imagery, on the contrary, was soft, free-form, amorphous, and if linear, digressive and irregular. Her works were always attached to a concept of inwardness and even landscape references imply states of mind, psychic spaces. Thus, when in 1957 her imagery became symmetrical it must be presumed to be talismanic and tabletlike in character. Her paintings by this date, although not openly manifesting a grid form, rested on the definition of painting as a sequence of recurrent points or a holistic form with kinship to the form of the canvas itself.

\* \* \*

With the establishment of the declared grid, rather than an implicit one as in various works since 1957, Martin achieves her mature style. At first, the grid is used to define an area just within the canvas, a few inches from the edges, with a potential for unitary form that Martin was early to realize in American art. As she draws it, the grid is halfway between a rectangular system of coordinates and a veil. It is put down in pencil, so that the network consists of marks far less clearly given than we are accustomed to in American painting, with its usual standard of impact and unrelieved clarity. Thus the grid, though tight, does not close the surface, but establishes an open plane, identified with the surface of the picture but accumulating sufficient differences to suggest, for all its regularity, a veil, a shadow, a bloom. [. . .] Accepting the format of the painting (that is, the shape of the ground) as an absolute, as we must be prepared to do in interpreting painters' ideas of space, it is possible to say that Martin's seamless surface signifies, for all its linear precision, an image dissolving. The uninflected radiant fields are without the formal priorities of figure and field or hierarchic ranking of forms and the skinny grids are set in monochrome colors that make visible the shifting gradients of real light across the painting. The effect is of exactness and elusiveness at once.

Martin has pointed out that "my formats are square, but the grids never are absolutely square, they are rectangles a little bit off the square, making a sort of contradiction, a dissonance, though I didn't set out to do it that way. When I cover the square surface with rectangles, it lightens the weight of the square, destroys its power."[1] The grids vary in size, emphasis, and color from one painting to another. [. . .] The grid is, of course, a network of uniform elements and Martin does not depart from the stimulus domain, the set of rules by means of which each pattern is constructed, but the whole grid is characterized physically by her way of working. Her pencil lines on canvas, for all their modesty, have an inherent sensuous facture, an irreducible blur beyond the theoretical structure of the grid. A play of irregularizing refinements, which never become deviations from the prescribed system, is set up. The legibility of the system is held, the presence of the module never in doubt, though it supports not only a proposition concerning order but unpredictable physical variations as well.

Martin wrote that: "There's nobody living who couldn't stand all afternoon in front of a waterfall."[2] One of her paintings is called *Falling Blue*, but it is not necessary to assume that the words describe this painting or, conversely, that the painting illustrates these words. However, the experience Martin refers to includes factors of repetition and continuity (the changing water in a stable course) and of motion contracted into timelessness. The synonymic forms that she uses, then, may be analogous to geological strata, a handful of sand, the sun reflected on water, or the planting of a grove. "Nature is like parting a curtain, you go into it," to quote Martin again, which is something that can be said about the quivering space of her own paintings.[3]

---

[1]Agnes Martin, "Homage to the Square," *Art in America,* July–August, 1967, p. 55.

[2]Agnes Martin, quoted by Ann Wilson, "Linear Webs," *Art and Artists,* London, October, 1966, p. 48

[3]*Ibid.*

There is some reason not to make too much of Martin's nature metaphors, despite her imagery's smoldering evocative power. To quote the artist: "my paintings have neither objects, nor space, nor time, not anything—no forms. They are light, lightness, about merging, about formlessness breaking down form."[4] She concludes the argument aphoristically: "You wouldn't think of form by the ocean." Allowing for the difference between a compact zone, like a painting, and a boundless field, the continuous space of the world, oceans do have form. And endlessness can be connoted by a contained work of art in one of two ways, either by an all-over field or by a grid with a sufficient number of repetitions. A collection of similar bits, beyond easy counting, implies infinity; that is why the internal area of a Martin painting can seem so highly expansive. It is clear that in her paintings the parts are submitted to the larger structure that the picture constitutes as a whole. Thus the painting is an image of wholeness and this not merely a demonstration of formal completeness but a symbolic value as well. The unitary system of the picture becomes expressive of stability, fullness, and completeness as subject matter.

\* \* \*

There is in her statements . . . an idealistic belief in inspiration and innate ideas and, at the same time, a reluctance to be thought religious or mystical. She wishes to rid herself of pride and the small rectangles or lines of her pictures imply the humble in their modest scale and because they are simple means. "In graphic arts and all the arts technique is a hazard even as it is in living life."[5] This complex of ideas, involving noninstitutional revelation, personal modesty, links between the one and the many, the great and the small, seems distinctively American. Nature is both approached and transcended, respected and rejected. Without nostalgia there are puritan and folk elements in Martin's discourse. . . .

\* \* \*

American postwar art is distinguished by its ostentatious physical presence. The elaboration of gesture by the Abstract Expressionists, the lateral expansion of color by the field painters, the stepping up of hue by the hard-edge painters, and the stress on the objectness of sculpture in Minimal Art are all cases of artists accepting the mutually supportive goals of concreteness and handsomeness. Comparatively few American artists withhold their art from this competitive mode but, as it happens, grids are conspicuous in the case of three artists who do. Martin's square canvases are reserved in appearance and unassuming in their means; LeWitt's drawings, on walls or paper, are diagrammatic in form and undogmatic in their permutations; and Carl Andre's floor sculptures (except for the uncharacteristically showy *37 Pieces of Work* on the floor at the Guggenheim) occupy space firmly but without any drama of protuberance and void. In all three artists, the pleasure of synonymity and the discipline of restraint are essential to achieving a reserved art on a large scale. It should not be thought that this is a complaint about objects as such, only about their escalation. This is not an argument for "dematerialization," only for restraint. An artist like Martin can fill the house with a whisper.

---

[4]*Ibid.*
[5]Agnes Martin, unpublished notes.

# Chapter Six

# 1968—1980

## Cultural and Historical Context
## for the Vietnam War Era

In the popular imagination "the sixties" was a tumultuous time dominated by rock music, drugs, student unrest in Paris and on campuses in the United States, the Black Power movement, and polarized reactions to the war in Vietnam. The events of the years 1967, 1968, and 1969 culminated what had been brewing: student protests against university administrators at Columbia University and other colleges that had cooperated with military research and recruitment; the development of a radical, Marxist left among students and young professors; antiwar demonstrations attended by hundreds of thousands; the rapid growth of the Students for a Democratic Society (SDS) which had formed in 1960 and of other radical groups; the election of Richard Milhous Nixon to the presidency in 1968; the trials of the "Chicago Seven" (Abbie Hoffman, Jerry Rubin, Tom Hayden, Rennie Davis, David Dellinger, Lee Weiner, and John Froines) and of Bobby Seale—all charged with inciting riots at the 1968 Democratic National Convention; the 1969 Woodstock concert attended by over 300,000; and the rise of the Black Panther Party. The decade of the 1960s ended with reports of the My Lai massacre in Vietnam, the occupation of Alcatraz Island by Native Americans, and the murder of Black Panther leader Fred Hampton by Chicago police as he lay sleeping in bed.

Because the U.S. government pursued the unpopular war in Vietnam, the early 1970s witnessed more demonstrations and marches. At Kent State University, Ohio, in May 1970, National Guardsmen opened fire on students protesting the United States bombings in Cambodia; four were killed. In response, a nationwide student strike was held on many college campuses that spring. In New York City artists demonstrated at the Metropolitan Museum of Art and formed a "death march" along the ramps at the Guggenheim Museum led by dancer Yvonne Rainer.

Meanwhile, in June 1970 clandestine operations in Chile were stepped up by the Central Intelligence Agency (CIA) to sabotage the reelection of Salvador Allende, a Marxist running for president. In June 1971 the *New York Times* began to publish the "Pentagon Papers," leaked by Daniel Ellsberg, a staff member of the Rand Corporation; these government memoranda were part of a Pentagon study on strategies for the Vietnam war. In June 1972 a burglary at the Democratic National Committee's headquarters at the Watergate Hotel led to a cover-up and eventually to hearings that would bring down the

Nixon White House. Nixon resigned on August 8, 1974, and Gerald Ford became president. The Vietnam war finally ended when all U.S. troops pulled out in April 1975. Over 58,000 Americans had died in the war, as had an estimated 1.5 million Vietnamese. Activists continued their opposition to U.S. imperialism; U.S. support of dictators in Central and South America became a new focus of antiwar protests in the mid-1970s.

The Cold War did not subside during this period, but it did seem to abate somewhat under a policy of detente. There were exchanges of cultural groups between the two superpowers, such as the Bolshoi Ballet's tour to the United States in the 1960's, and when President Nixon visited China in 1972 some trade restrictions were relaxed.

Even though the FBI and CIA continued covert surveillance of American citizens, they made no serious attempt to block employment opportunities for radicals as they had in the 1950s. In fact, the civil rights movement and the women's movement forced many government agencies to open up job opportunities to a much broader range of people and persuaded universities to introduce black studies and women's studies courses into the curricula.

Activists also focused on other areas that needed redressing, such as racial tensions and government persecution of radical black leaders in the late 1960s and early 1970s. Following the April 4, 1968, assassination of Martin Luther King, Jr., demonstrations, many of them violent, erupted in cities across the country. Many African American protesters abandoned the more multiracial protests of the early 1960s and formed overtly nationalist and separatist groups. In December 1966 the Student Non-Violent Coordinating Committee (SNCC) voted to limit the participation of white members.

A group of more radical black nationalists organized the Black Panther Party, a hybrid of nationalism and Marxism. The Panthers not only set up breakfast programs in African American communities, they also asserted their right to use guns to defend themselves. In September 1970 thirteen Black Panthers went on trial in New York City, accused of conspiracy to bomb police stations and public monuments. The nine-month trial was the longest criminal trial in the history of New York. Evidence of police culpability was revealed during the trial, and, in the end, the jury refused to convict the Panthers when presented with the rule of law for conspiracy charges. The acquittal was the first in a series of court cases in which juries rejected the testimony of police.

Artists became more alert to the court and prison system, and the fact that a disproportionate number of African Americans were being arrested and incarcerated. Some responded with outrage in September 1971, when Governor Nelson Rockefeller called out the National Guard and New York State Troopers to quell a prison riot at Attica State Prison. When the gunfire subsided, thirty-three prisoners and nine guards and prison clerks had been killed. Benny Andrews, acting for the Black Emergency Cultural Coalition, and Rudolf Baranik, acting for Artists and Writers Protest Against the War in Vietnam, put together the *Attica Book,* including prison poetry and reproductions of realist and abstract drawings and paintings by a range of artists, including Jacob Lawrence, Faith Ringgold, Alice Neel, Robert Morris, Carl Andre, Antonio Frasconi, and May Stevens. Andrews and Cliff Joseph organized artists, including Baranik and Camille Billops, to go into the prisons to teach inmates about artmaking.

Focusing on economic issues, rather than radical politics or war resistance, Mexican Americans (the second largest minority according to the 1960 census) concentrated their organizing efforts in the 1960s to the farmlands of the California central valleys. In 1965, Filipino and Mexican grape pickers from Delano, demanding higher wages, walked out of

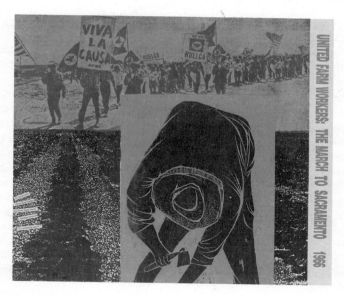

**Figure 6-1.** Antonio Frasconi, *United Farm Workers: The March to Sacramento,* from the portfolio *The Enduring Struggle,* 1990. Woodcut and offset lithograph. Photograph courtesy the artist. Raised in Uruguay, Frasconi has taught printmaking in colleges since 1979. His woodcuts and steel engravings address the struggles of working people—in the United States to end racial discrimination and injustice, in South America to win democracy. His portfolio *The Enduring Struggle* contains 19 woodcuts and color lithographs on union organizing efforts and strikes in the United States during the twentieth century.

grape fields. They were supported by Dolores Huerta of the Agricultural Workers Organizing Committee and César Chávez of the National Farm Workers Association (NFWA). The growers offered modest raises, but not union recognition—a key demand. Chávez called for a national grape boycott, and in March 1966 he organized a 340-mile march from Delano to Sacramento, the California state capital. [See Fig. 6-1]. Along the way a Chicano theater group, El Teatro Campisino, performed in the evenings for the marchers encamped along the route. Music, visual symbols, and culture were important to their union efforts; the black eagle on the white circle against a red background became instantly recognizable as a symbol of union struggles. By 1970, the union, now called the United Farm Workers, had won the right to contract as a union, and had a membership of 50,000.

The collective power of the United Farm Workers' organizing efforts together with a growing consciousness among Chicanos of their Mexican heritage spurred the Chicano art movement of the late 1960s and 1970s. Artists began working in collaboration with community people to paint wall-sized murals on the sides of buildings in the barrios of El Paso, Houston, San Antonio, Santa Fe, Denver, Chicago, San Diego, and Los Angeles [see Fig. 7-15]. Chicano artists' organizations, actors' groups, and community cultural centers sprang up across the West and Southwest, and universities in Arizona, California, Colorado, New Mexico, and Texas acceded to the pressures from students to establish Chicano studies programs.

The most ambitious of the Chicano mural projects, begun in 1976, is *The Great Wall,* which narrates an alternative history of California. Judith Baca and her team of some 200 youth worked with the U.S. Army Corps of Engineers and painted the walls lining the Tujunga Wash drainage canal in the San Fernando Valley—an ongoing summer project that by 1983 extended to 2,435 feet.

In the early 1970s women artists in New York and on the West Coast redirected their social activism toward the women's movement, including agitation to strike down anti-abortion laws—laws finally repealed as a result of the 1973 Supreme Court decision in *Roe vs. Wade.* Women artists, critics, and art historians joined together in consciousness-raising groups, organized the Women's Caucus for Art within the College Art Association, started cooperative galleries, curated their own exhibitions of women's art, published their own journals, and pressed for greater representation in museums—both in the art that hung on the museums' walls and as professional curators on museums' staffs. Women also took a more active role in college art departments—teaching seminars on women's art, leading discussions about gender and sexuality, and exploring such issues as female essentialism versus the social construction of gender. Such activities had a lasting effect. Sympathetic male artists and critics supported the feminists, and the women's movement contributed to the growth of the gay rights movement of the 1970s and 1980s.

## *Dematerialization: Conceptual Art, Systems, Earth Art*

To some observers of the artworld in the mid- to late 1960s, Clement Greenberg's and Michael Fried's aesthetic prescriptions became a challenge to a group of artists (the conceptual artists) to do the exact opposite. Where Greenberg championed an Aristotelian aesthetic of the unities (unity of time and place), artists responded with works displaying disunity, chaos, and systems that proliferated over time and space. Where Greenberg called for aesthetic purity, artists brought disparate elements together and broke down the barriers between art and life, between sculpture and the landscape. Artists rejected the restriction of art to its "area of competence" and explored hybrid forms that mixed painting, sculpture, music, dance, and theater.

Whereas Robert Morris and Donald Judd mounted elaborate counter theories to Greenberg and Fried, other artists took a different path. Sol LeWitt, Robert Smithson, Hans Haacke, and the writers and curators who wrote about them, looked to science, technology, and the writings of Morse Peckham, Thomas Kuhn, and Marshall McLuhan for inspiration. This generation of independent-minded artists also understood that the comprehension of their artworks required active participation by their audience. Art was to be understood as a self-conscious process of experiencing something akin to what an artist conceptualizes when planning, producing, or archiving an artwork.

Looking back on the era from 1986, the artist and theorist Victor Burgin succinctly described the situation: "The conceptualism of the late 1960s was a revolt against modernism—specifically . . . as formulated in the writings of the American critic Clement Greenberg." To the conceptual artists, "Art practice was no longer to be defined as an

artisanal activity, a process of crafting fine objects in a given medium, it was rather to be seen as a set of operations performed in a *field* of signifying practices, perhaps centered on a medium but certainly not bounded by it" ("The Absence of Presence: Conceptualism and Postmodernisms," in *The End of Art Theory,* 1986).

The exhibitions *Anti-Illusion: Procedures/Materials,* curated by James Monte and Marcia Tucker for the Whitney Museum of American Art in 1969, and *Information,* curated by Kynaston L. McShine for the Museum of Modern Art in 1970, brought some of this new conceptual and systems art to the attention of the general public. Tucker, in her catalogue essay for *Anti-Illusion,* laid out the premise of the exhibition, which was to challenge the assumption that "art creates order from the chaos of experience." Instead, Tucker offered "an art that presents itself as disordered, chaotic, or anarchic. Such an art deprives us of the fulfillment of our aesthetic expectations and offers, instead, an experience which cannot be anticipated nor immediately understood." Tucker also disputed Greenberg's concept of the unities of art, by including works in the exhibition that "share with the performing arts the mobile relational character of single notes to series, individuated actions to the fabric of a narrative sequence, or single steps to a total configuration of movement."

McShine's *Information* exhibition pushed some of the *Anti-Illusion* concepts even further. In particular, it made clear that the "archive"—the photographic record of the artwork or of the process, especially after the artwork had exceeded its duration or disappeared—was emerging as a major category for contemporary art. Issues of memory and historical record would become leading features of the art of the 1980s and 1990s.

Earth art became the umbrella term to designate projects that artists conceptualized and, at times, executed, using the actual earth and its surrounds as the medium for their art or as the support upon which to place objects or structures. In either case, the earth's surface (including bodies of water) was integral to the work. The projects took various forms—inspired by the prehistoric burial mounds of the midwest, by groups of large stone blocks and slabs erected in the landscape, such as those found at Stonehenge in England, as well as by mythology and tales of ancient temples and mazes. Some artworks consisted of lines traversing the natural landscape, such as Dennis Oppenheim's *Time Line,* 1968—a three-foot-wide line plowed by a snowmobile that stretched three miles along the middle of the frozen St. John River separating the time zones of the United States and Canada. Other "lines" were chalk lines, cuts in the earth, or aligned blocks of stone, wood or straw placed on top of the ground that articulated the flat expanse of desert, the rolling meadows and woods of the countryside, or the architecture of the built environment. These include Michael Heizer's, *Double Negative,* 1969; Walter de Maria's, *Mile-Long Drawing,* 1968; Michael Heizer's, *Isolated Mass/Circumflex,* 1968; Carl Andre's *Joint,* 1968; Patricia Johanson's *Stephen Long,* 1968; Robert Smithson's *Spiral Jetty,* 1973; and Michelle Stuart's *Stone Alignments/Solstice Cairns,* 1979. Christo's *Running Fence,* 1976, was itself a line of billowing fabric that laced itself over the foothills of Marin County, California. Some earth art projects consisted of patterns of large stones placed on the ground. Still others were built forms on the land, or desertscape, which aligned their structural parts with the movement of the sun and moon, such as Robert Morris's *Observatory,* 1970–77, and Nancy Holt's *Sun Tunnels,* 1973–76 [Fig. 6-2a & 6-2b]. Alice Aycock constructed a 32-foot diameter *Maze,* 1972, on a farm in Pennsylvania, and dug a hole into the earth for her *Williams College Project,* 1974. What earth art artists have in common is

**Figure 6-2 a & b.**   Nancy Holt, *Sun Tunnels,* 1973–76. Length 86 feet overall. Great Basin Desert, Utah. Photographs courtesy the artist. © Nancy Holt/VAGA, NY, NY.

their resistance to the process of commodification imposed on them by the art market. However, the audience for these often geographically isolated projects could not, and cannot, see and apprehend them at first hand. In order to make the imaginative leap to conceptualize the art projects, the "viewer," therefore, must rely on the artist's reports, photographs, and slides or on the mass media's interpretation of the visual construct through art magazine reproductions, newspaper accounts, and documentary films. Like other conceptual art, the archive and official memory assume great importance for the dissemination of our knowledge about most earth art.

**98** ✦  Sol LeWitt, "Paragraphs on Conceptual Art," *Artforum* 5, no. 10, (June 1967):79–83. © *Artforum*

Sol LeWitt was trained in art and worked in the offices of architect I. M. Pei in the mid-1950s. He did his first open modular works in 1964, and a few years later began to arrange them in serial form. Like many other conceptual artists, LeWitt has less interest in art as a finished object than as an idea experienced during the planning stages of art production when he makes his creative decisions: "Conceptual art is only good when the idea is good." Hence, many of his wall drawings, which he began to produce in 1967, are executed by assistants, based on work orders in which he instructs them to cover an area of wall with thick pencil marks of a specific length and color. What the assistants actually do, and the response of viewers, lies beyond his control and hence is not part of his own creative process.

    LeWitt does not agree with the view that art must be utilitarian. By adhering to the Kantian idea of art as disinterested play, he removes himself from the polemical discourse about art's relationship to politics—an issue that was coming to the fore at the end of the 1960s.

---------------◆---------------

The editor has written me that he is in favor of avoiding "the notion that the artist is a kind of ape that has to be explained by the civilized critic." This should be good news to both artists and apes. With this assurance I hope to justify his confidence. To continue a baseball metaphor (one artist wanted to hit the ball out of the park, another to stay loose at the plate and hit the ball where it was pitched), I am grateful for the opportunity to strike out for myself.

    I will refer to the kind of art in which I am involved as conceptual art. In conceptual art the idea or concept is the most important aspect of the work.[1] When an artist uses a conceptual form of art, it means that all of the planning and decisions are made beforehand and the execution is a perfunctory affair. The idea becomes a machine that makes the art. This kind of art is not theoretical or illustrative of theories; it is intuitive, it is involved with all types of mental processes and it is purposeless. It is usually free from the dependence on the skill of the artist as a craftsman. It is the objective of the artist who is concerned with conceptual art to make his work mentally interesting to the spectator, and therefore usually he would want it to become emotionally dry. There is no reason to suppose however, that the conceptual artist is out to bore the viewer. It is only the expectation of an emotional kick, to which one conditioned to expressionist art is accustomed, that would deter the viewer from perceiving this art.

    Conceptual art is not necessarily logical. The logic of a piece or series of pieces is a device that is used at times only to be ruined. Logic may be used to camouflage the real intent of the artist, to lull the viewer into the belief that he understands the work, or to infer a paradoxical situation (such as logic vs. illogic).[2] The ideas need not

[1]In other forms of art the concept may be changed in the process of execution.
[2]Some ideas are logical in conception and illogical perceptually.

be complex. Most ideas that are successful are ludicrously simple. Successful ideas generally have the appearance of simplicity because they seem inevitable. In terms of idea the artist is free to even surprise himself. Ideas are discovered by intuition.

What the work of art looks like isn't too important. It has to look like something if it has physical form. No matter what form it may finally have it must begin with an idea. It is the process of conception and realization with which the artist is concerned. Once given physical reality by the artist the work is open to the perception of all, including the artist. (I use the word "perception" to mean the apprehension of the sense data, the objective understanding of the idea and simultaneously a subjective interpretation of both.) The work of art can only be perceived after it is completed.

Art that is meant for the sensation of the eye primarily would be called perceptual rather than conceptual. This would include most optical, kinetic, light and color art.

Since the functions of conception and perception are contradictory (one pre-, the other post-fact) the artist would mitigate his idea by applying subjective judgment to it. If the artist wishes to explore his idea thoroughly, then arbitrary or chance decisions would be kept to a minimum, while caprice, taste and other whimsies would be eliminated from the making of the art. The work does not necessarily have to be rejected if it does not look well. Sometimes what is initially thought to be awkward will eventually be visually pleasing.

To work with a plan that is pre-set is one way of avoiding subjectivity. It also obviates the necessity of designing each work in turn. The plan would design the work. Some plans would require millions of variations, and some a limited number, but both are finite. Other plans imply infinity. In each case however, the artist would select the basic form and rules that would govern the solution of the problem. After that the fewer decisions made in the course of completing the work, the better. This eliminates the arbitrary, the capricious, and the subjective as much as possible. That is the reason for using this method.

When an artist uses a multiple modular method he usually chooses a simple and readily available form. The form itself is of very limited importance; it becomes the grammar for the total work. In fact it is best that the basic unit be deliberately uninteresting so that it may more easily become an intrinsic part of the entire work. Using complex basic forms only disrupts the unity of the whole. Using a simple form repeatedly narrows the field of the work and concentrates the intensity to the arrangement of the form. This arrangement becomes the end while the form becomes the means.

Conceptual art doesn't really have much to do with mathematics, philosophy or any other mental discipline. The mathematics used by most artists is simple arithmetic or simple number systems. The philosophy of the work is implicit in the work and is not an illustration of any system of philosophy.

It doesn't really matter if the viewer understands the concepts of the artist by seeing the art. Once out of his hand the artist has no control over the way a viewer will perceive the work. Different people will understand the same thing in a different way.

Recently there has been much written about minimal art, but I have not discovered anyone who admits to doing this kind of thing. There are other art forms around called primary structures, reductive, rejective, cool, and mini-art. No artist I know will own up to any of these either. Therefore I conclude that it is part of a secret language that art critics use when communicating with each other through the medium of art magazines. Mini-art is best because it reminds one of mini-skirts and long-legged

girls. It must refer to very small works of art. This is a very good idea. Perhaps "mini-art" shows could be sent around the country in matchboxes. Or maybe the mini-artist is a very small person, say under five feet tall. If so, much good work will be found in the primary schools (primary school primary structures).

\* \* \*

These paragraphs are not intended as categorical imperatives but the ideas stated are as close as possible to my thinking at this time.[3] These ideas are the result of my work as an artist and are subject to change as my experience changes. I have tried to state them with as much clarity as possible. If the statements I make are unclear it may mean the thinking is unclear. Even while writing these ideas there seemed to be obvious inconsistencies (which I have tried to correct, but others will probably slip by). I do not advocate a conceptual form of art for all artists. I have found that it has worked well for me while other ways have not. It is one way of making art: other ways suit other artists. Nor do I think all conceptual art merits the viewer's attention. Conceptual art is only good when the idea is good.

---

**99 ✦** Robert Smithson, "A Sedimentation of the Mind: Earth Projects," *Artforum* 7, no. 1 (September 1968):44–50.

Originally from Passaic, New Jersey, Robert Smithson studied at the Art Students League in the mid-1950s and at the Brooklyn Museum School. Interested in the concept of systems and the ways that humans change the topography of the land, in the mid-1960s Smithson began traveling to urban peripheries and photographing them. He made his art from a combination of earth minerals and man-made artifacts (rocks and mirrors, for example). In 1970 he completed his most famous work, *Spiral Jetty,* sited at the edge of the Great Salt Lake, Utah. Heavy machinery moved rocks, rubble, and dirt to create a jetty in a spiral form that moved into the lake. Eventually the water rose in the lake and *Spiral Jetty* disappeared. Smithson died in 1973 in an airplane accident over Texas as he was photographing a new project, *Amarillo Ramp.*

In this essay Smithson attempts to explain to a gallery-going public the nature and goals of his projects, and those of others involved with similar issues (Ian Baxter, Tony Smith, Walter de Maria, Carl Andre, Michael Heizer, and Dennis Oppenheim). The references in his essay suggest that he followed current theoretical writings: for example, his reference to "Gestalt" suggests Robert Morris (see Reading 95). Smithson's own art is both site-specific, as well as "non-site"—incorporating elements from specific sites and placing them in other situations, such as art galleries. It is Smithson's art that is most often associated with the term "earthworks."

---

✦

---

The earth's surface and the figments of the mind have a way of disintegrating into discrete regions of art. Various agents, both fictional and real, somehow trade places with

---

[3]I dislike the term "work of art" because I am not in favor of work and the term sounds pretentious. But I don't know what other term to use.

each other—one cannot avoid muddy thinking when it comes to earth projects, or what I will call "abstract geology." One's mind and the earth are in a constant state of erosion, mental rivers wear away abstract banks, brain waves undermine cliffs of thought, ideas decompose into stones of unknowing, and conceptual crystallizations break apart into deposits of gritty reason. Vast moving faculties occur in this geological miasma, and they move in the most physical way. This movement seems motionless, yet it crushes the landscape of logic under glacial reveries. This slow flowage makes one conscious of the turbidity of thinking. Slump, debris slides, avalanches all take place within the cracking limits of the brain. The entire body is pulled into the cerebral sediment, where particles and fragments make themselves known as solid consciousness. A bleached and fractured world surrounds the artist. To organize this mess of corrosion into patterns, grids, and subdivisions is an esthetic process that has scarcely been touched.

The manifestations of technology are at times less "extensions" of man (Marshall McLuhan's anthropomorphism), than they are aggregates of elements. Even the most advanced tools and machines are made of the raw matter of the earth. Today's highly refined technological tools are not much different in this respect from those of the caveman. Most of the better artists prefer processes that have not been idealized, or differentiated into "objective" meanings. Common shovels, awkward looking excavating devices, what Michael Heizer calls "dumb tools," picks, pitchforks, the machine used by suburban contractors, grim tractors that have the clumsiness of armored dinosaurs, and plows that simply push dirt around .[. . .] With such equipment construction takes on the look of destruction; perhaps that's why certain architects hate bulldozers and steam shovels. They seem to turn the terrain into unfinished cities of organized wreckage. A sense of chaotic planning engulfs site after site. Subdivisions are made—but to what purpose? Building takes on a singular wildness as loaders scoop and drag soil all over the place. Excavations form shapeless mounds of debris, miniature landslides of dust, mud, sand and gravel. Dump trucks spill soil into an infinity of heaps. The dipper of the giant mining power shovel is 25 feet high and digs 140 cu. yds. (250 tons) in one bite. These processes of heavy construction have a devastating kind of primordial grandeur, and are in many ways more astonishing than the finished project—be it a road or a building. The actual *disruption* of the earth's crust is at times very compelling, and seems to confirm Heraclitus's *Fragment 124,* "The most beautiful world is like a heap of rubble tossed down in confusion." The tools of art have too long been confined to "the studio." The city gives the illusion that earth does not exist. Heizer calls his earth projects "The alternative to the absolute city system."

\* \* \*

## From Steel to Rust

As "technology" and "industry" began to become an ideology in the New York Art World in the late '50s and early '60s, the private studio notions of "craft" collapsed. The products of industry and technology began to have an appeal to the artist who wanted to work like a "steel welder" or a "laboratory technician." This valuation of the material products of heavy industry, first developed by David Smith and later by Anthony Caro, led to a fetish for steel and aluminum as a medium (painted or un-

painted). Molded steel and cast aluminum are machine manufactured, and as a result they bear the stamp of technological ideology. Steel is a hard, tough metal, suggesting the permanence of technological values. It is composed of iron alloyed with various small percentages of carbon; steel may be alloyed with other metals, nickel, chromium, etc., to produce specific properties such as hardness and resistance to rusting. Yet, the more I think about steel itself, devoid of the technological refinements, the more *rust* becomes the fundamental property of steel. Rust itself is a reddish brown or reddish yellow coating that often appears on "steel sculpture," and is caused by oxidation (an interesting non-technological condition), as during exposure to air or moisture; it consists almost entirely of ferric oxide, $Fe_2O_3$ and ferric hydroxide, $Fe(OH)_3$. In the technological mind rust evokes a fear of disuse, inactivity, entropy, and ruin. Why steel is valued over rust is a technological value, not an artistic one.

By excluding technological processes from the making of art, we began to discover other processes of a more fundamental order. The break-up or fragmentation of matter makes one aware of the sub-strata of the Earth before it is overly refined by industry into sheet metal, extruded I-beams, aluminum channels, tubes, wire, pipe, cold-rolled steel, iron bars, etc. I have often thought about non-resistant processes that would involve the actual sedimentation of matter or what I called "Pulverizations" back in 1966. Oxidation, hydration, carbonatization, and solution (the major processes of rock and mineral disintegration) are four methods that could be turned toward the making of art. [ . . .]

Refinement of matter from one state to another does not mean that so-called "impurities" of sediment are "bad"—the earth is built on sedimentation and disruption. A refinement based on all the matter that has been discarded by the technological ideal seems to be taking place.

\* \* \*

## The Wreck of Former Boundaries

The strata of the Earth is a jumbled museum. Embedded in the sediment is a text that contains limits and boundaries which evade the rational order, and social structures which confine art. In order to read the rocks we must become conscious of geologic time, and of the layers of prehistoric material that is entombed in the Earth's crust. When one scans the ruined sites of prehistory one sees a heap of wrecked maps that upsets our present art historical limits. A rubble of logic confronts the viewer as he looks into the levels of the sedimentations. The abstract grids containing the raw matter are observed as something incomplete, broken and shattered.

In June, 1968, my wife, Nancy, Virginia Dwan, Dan Graham and I visited the slate quarries in Bangor-Pen Angyl, Pennsylvania. Banks of suspended slate hung over a greenish-blue pond at the bottom of a deep quarry. All boundaries and distinctions lost their meaning in this ocean of slate and collapsed all notions of gestalt unity. The present fell forward and backward into a tumult of "de-differentiation," to use Anton Ehrenzweig's word for entropy. It was as though one was at the bottom of a petrified sea and gazing on countless stratigraphic horizons that had fallen into endless directions of steepness. Syncline (downward) and anticline (upward) outcroppings and the asymmetrical cave-ins caused minor swoons and vertigos. The

brittleness of the site seemed to swarm around one, causing a sense of displacement. I collected a canvas bag full of slate chips for a small *Non-Site.*

Yet, if art is art it must have limits. How can one contain this "oceanic" site? I have developed the *Non-Site,* which in a physical way contains the disruption of the site. The container is in a sense a fragment itself, something that could be called a three-dimensional map. Without appeal to "gestalts" or "anti-form," it actually exists as a fragment of a greater fragmentation. It is a three-dimensional *perspective* that has broken away from the whole, while containing the lack of its own containment. There are no mysteries in these vestiges, no traces of an end or a beginning.

<p style="text-align:center">* * *</p>

---

**100** ✦ Barbara Rose, "Problems of Criticism, IV: The Politics of Art, Part III," *Artforum* 7, no. 9 (May 1969):46–52. © *Artforum*

Barbara Rose was one of the leading art writers in the 1960s. Her *American Art since 1900,* published in 1967, brought to students a fresh textbook account of American art, even though many historians criticized her formalist bias. Her break with the Greenbergian school of criticism is revealed in this excerpt from the last of a three-part series of essays on criticism. The two epigraphs preceding this essay refer to the general conditions of revolution (Kasimir Malevich and the Russian Revolution) and the specific circumstances of the Vietnam War (Carl Andre) and set the tone for her remarks.

In such times, Rose argues for a pragmatic criticism—one based on the contemporary art actually being produced—rather than a prescriptive criticism that presumes to tell artists what to do or a formalist criticism that ignores experience and the chaos of life. In her argument, she marshalls the authority of the American pragmatist philosopher John Dewey as well as Morse Peckham. (Compare Holger Cahill's reliance on Dewey's ideas to rationalize the Federal Art Project in Chapter 3, Reading 53.)

In her list of artists whom she saw as extending the possibilities for artmaking, she did not mention feminists and artists of color—who, in fact, were already engaged in political and aesthetic issues that would move to center stage in the 1980s.

<p style="text-align:center">✦</p>

> We are revealing new pages of art in anarchy's new dawns . . . You who are bold and young, make haste to remove the fragments of the disintegrating rudder.
> Wash off the touch of the dominating authorities.
>
> —Kasimir Malevich, *To the New Limit,* 1918

> The same fat surplus which burns in Viet Nam feeds us. Let the art armies be disbanded. In the wake of the anarch, all marches are up . . . Art is what we do; culture is what is done to us.
>
> —Carl Andre, statement in "Sensibility of the Sixties," *Art in America,* 1967.

If the pragmatic method is, as William James describes it, "the attitude of look-ing away from first things, principles, 'categories', supposed necessities; and of look-ing towards last things, fruits, consequences, facts," then a pragmatic criticism might begin by examining the consequences of current artistic activity. To begin with, we might list a number of current art objects, or more precisely non-objects:

- arrangements of identical units that exist as an art object only when assembled as such in the proper context (Andre).
- a room full of dirt (De Maria).
- a pile of dirt, grease and metal odds and ends (Morris).
- a grave-size ditch in Central Park (Oldenburg).
- written descriptions for non-sites (Smithson).
- projects for rearranging the surface of the earth (Morris, Heizer, Oppenheim, De Maria, *et al.*).
- proposals for the erection of non-existent monuments (Oldenburg).
- piles of folded felt (Kaltenbach, Morris, Le Va).
- floors and walls of gallery covered with graphite chalkings and sweepings (Bollinger).
- drawings pencilled onto gallery walls (LeWitt).
- paintings stapled to gallery walls (Gourfain, Ryman).
- works for sale for the price of materials or labor (Morris, Andre, LeWitt).
- loose piles of chemicals (Saret, Heizer).
- blown-up statements regarding the nature of art (Kosuth, Baldessari) [See Fig. 6-3]
- the gradual removal of strips of curved plastic from a vacant lot (Levine).
- a "sculpture" made of steam (Morris).
- photographs, documentation, description of non-existent "work" (Barry, Heubler, Kosuth, Ruscha, Smithson, *et al.*).
- a standard Air Force dye marker thrown into the sea (Weiner).
- paint sprayed directly onto floor (Serra, Weiner).
- limp piles of materials, randomly distributed (Morris, Serra, Saret, Hesse, Le Va, *et al.*).
- trenches dug in the desert (De Maria; collection R. Scull).
- ditches dug in driveways (Weiner; collection Mr. and Mrs. Robert M. Topol).
- a series of ellipses scattered throughout the Whitney Museum (Artschwager).
- a label on a bench at the Whitney Museum identifying it as an art work (Anonymous).

We may best test the intention of art "works" such as the above perhaps by con-sidering their practical consequences. What is the outcome, we may ask, of conceiving an "art" not dependent on the creation of objects or discrete material entities? Denying that art is a trading commodity with measurable intrinsic quality translatable into real value erodes the very foundation of the art market. By making immaterial, ephemeral or extra-objective work, the artist eliminates intrinsic quality. This challenges not only

EVERYTHING IS PURGED FROM THIS PAINTING
BUT ART; NO IDEAS HAVE ENTERED THIS WORK.

**Figure 6-3.**    John Baldessari, *Everything Is Purged,* 1966–68. Acrylic on canvas, 68 × 56 in. Used by permission of the artist. Photograph courtesy the Sonnabend Gallery, New York.

the market mechanism, but also the authority of the critic by rendering superfluous or irrelevant his role of connoisseur of value or gourmet of quality.

If criticism is going to exist at all in relation to this art—and whether it should is a question I intend to consider—then it can no longer function as *gourmandise* or *finger-sputzengefühl,* but only as a form of heightened sensitivity or perception, which is not to deprive it ultimately of a judgmental function. Perception, however, must precede evaluation, as opposed to being pursuant to it, because to be a true measure it must proceed, not from an idealist base of fixed absolutes and mechanical theories, but from pragmatic considerations of intention, effect and concrete consequence in practice and experience. Criticism must re-orient itself at this time because younger artists are responding to a new world view which holds far more in common with pragmatism than with idealism. In place of metaphysical absolutes, compartmentalized essences and abstractions, the new art, like pragmatism, focuses on use, function and behavior, both perceptual and experiential.

Interestingly enough, the reaction of many young American artists against the rigidities and proscriptions of an idealist esthetic was anticipated by John Dewey's own rejection of Kant. Before today's revolutionaries saw formal criticism as the cornerstone of the market mechanism they despise (could Marx have foreseen that pictures would be one of the staples of late capitalism?), Dewey was taking Kant apart,

implying that Kantian idealism was tied to a specific set of social, political and eco-nomic factors. In *Art as Experience,* Dewey wrote: "The compartmentalized psychol-ogy that holds to an intrinsic separation between completeness or perceptual experi-ence is, then, itself a reflection of dominant social institutions that have deeply affected both production and consumption or use."

For today's pragmatists, as for Dewey, the esthetic is differentiated from ordi-nary experience in that the latter is typified by apathy, lassitude and stereotype, where art provokes attention, interest and variance. We have seen that the pragmatic focus on art as a kind of human activity rather than an ideal category with norms of deco-rum provides a point of departure for new esthetic attitudes. That such a view meshes perfectly with Duchamp's notion of art as defined by context and completed by the spectator's response makes pragmatist esthetics that much more apposite today.

Dewey's original objections to Kant are equally relevant at this moment: "To de-fine the emotional element of esthetic perception merely as the pleasure taken in the act of contemplation independent of what is excited by the matter contemplated, re-sults . . . in a thoroughly anemic conception of art," he wrote in an early attack on the idealist position that is the basis of formal criticism.

<p align="center">* * *</p>

Dewey's rejection of Kant's "ivory tower" definition of Beauty as remote from all desire, action and stir of emotion in favor of an esthetic response integrated into life, dealing with acts, decisions, and experience is seeing its fulfillment today.

<p align="center">* * *</p>

---

*101* ✦ Lawrence Alloway, Introduction to *Stolen,* by Kathe Gregory, Marilyn Landis, Russell F. Lewis, David Crane, Scott R. Kahn (New York: Multiples Inc., Dwan Gallery, 1970); reprinted in Lawrence Alloway *Topics in American Art Since 1945,* (New York: W.W. Norton, 1975).

After developing a career as a conceptual artist in Japan, Shusaku Arakawa moved to New York in 1961. Other Japanese conceptual artists working in New York in the 1960s included Yoko Ono, mentioned here, as well as On Kawara. Arakawa frequently collaborated with the American artist Madeline Gins on projects: *Mechanisms of Meaning* (begun 1963), *Reversible Destiny Architecture* (1973), and *The Architectural Body* (1973).

Alloway's statement about Marcel Duchamp's and Yoko Ono's "annexation" artworks is one of the first instances of a critic discussing the concept of "appropria-tion"—a concept prominent in the postmodernism debates of the 1980s.

<p align="center">◆</p>

This is the record of a theft of art. A group of five young artists removed from an ex-hibition at the Dwan Gallery a painting by Arakawa inscribed: "IF POSSIBLE STEAL ANY ONE OF THESE DRAWINGS INCLUDING THIS SENTENCE." So they did and their action has esthetic ramifications which should be indicated here. In one sense,

**Figure 6-4.**  Shusaku Arakawa, *Untitled ('Stolen')*, 1969. Oil on canvas, 72 × 48 in. Collection of the Wadsworth Atheneum, Hartford, CT. Gift of 'The Thieves': Gregory, Landis, Lewis, Crane and Kahn.

the group's intervention is in a tradition concerning the annexation of art by artists. Marcel Duchamp is a precedent, with his addition of a beard and moustache to a reproduction of the *Mona Lisa* in 1919 and, also, in this note for a readymade: [*Notes and Projects for the Large Glass,* 1970].

> Use a
> Rembrandt as an
> ironing board.

Yoko Ono's "instruction paintings (meant for others to do)" include the following: [*Grapefruit,* 1970]

> Borrow the Mona Lisa from the gallery.
> Make a kite out of it and fly (it).
> Fly it high enough so the Mona Lisa smile disappears.   (a)
> Fly it high enough so the Mona Lisa face disappears.   (b)
> Fly it high enough so it becomes a dot.   (c)

These examples, two from various precedents, are not a direct influence on the group but a part of the line of thought to which their act belongs. Nor should any of these acts or proposals be assessed as merely destructive. They are part of a larger pattern of annexation, transposition, and collaboration dealing with problems of authorship and meaning.

The action came out of an ongoing conversation about Happenings and Conceptual art and the problems these raise about control and interpretation; there was a series of speculations on art as ideas and actions rather than as an object. The group's act was a participatory one, an amplification of attention into physical terms. A crucial factor is that the idea of collaboration was started inadvertently from the artist's inscription. Arakawa's pseudo-command was intended to put the spectator in an impasse; he received an instruction, but without any expectation of carrying it out. When, suddenly, the command was obeyed, in fact, the artist was disconcerted at the impact of an unexpected feedback. Arakawa's sentence is part of a recurrent theme of his art, the ambiguous threshold of visual images and verbal statements. The group violated the esthetic stasis of the two sign-systems by moving into the realm of illegal action. Arakawa has pointed out that they did not follow his instruction exactly. They took the painting, not "any one of these drawings." The misunderstanding, however, is well within the margin of error that is one of Arakawa's working assumptions. We might consider the group's action as an heuristic interception of the routine set up by the artist in his work. The initiative was removed from the artist and located in the cooperative group.

That the group was involved in an esthetic act is shown by the wording of the telegram by which they recorded the theft: "work complete." In addition to the polemical form of collaboration by annexation, the collaboration between the members of the group is very important. They came to the idea simultaneously and devised a scenario for it; an early plan called for the painting to be deposited in the racks of the Art Students League, but was rejected. Then the scenario was executed with a speed and crispness which suggests the pleasures of group reinforcement, as one member supported another, as might occur within a successful Happening. (The group is, incidentally, sympathetically aware of Allan Kaprow's ideas.) Thus the two forms, of group collaboration and of malicious-philosophical collaboration, run parallel through the whole enterprise.

Arakawa regained the initiative when he sent his telegram, including the line "it has been a great surprise to collaborate with you," proposing the painting be donated to a museum. Thus the group that had taken the painting from the artist were put in the position of donors. The collaboration had entered a second stage and the ironies implicit in their relation to the artist now became ironies in their relation to institutions, as the later correspondence reveals. This is the point at which their action becomes a comedy of communications, including the theft of the painting from the thieves (an unserious act, compared to the motives of the group). The collaboration started as a purposeful sequence of decisions and acts, a solid relationship of agreed-on roles around a participatory center. Then the personal collaboration escalated from the compact operations of a group to the message-system of urban society. The documents of the events, assembled by the participants, is now their work of art.

*102* ✦ Lucy R. Lippard, "Eva Hesse: The Circle," in *From the Center: Feminist Essays on Women's Art* (New York: E. P. Dutton, 1976); first published in *Art in America* 59, no. 3 (May–June 1971):68–73.

Eva Hesse and her family left their native Germany and moved to New York when Hesse was a small child. During the 1950s she studied at both Cooper Union and at Yale University. She returned to Germany and began sculpting in earnest in 1964. She was one of the first of the postminimalist artists to make extensive use of "non-art" materials, such as latex, plastics, cheesecloth, rope, wire, and fiberglass tubes. Her art was considered strong and gritty, if eccentric. Feminists in the early 1970s found the art appealing because it seemed to infuse abstract forms with feminist content (see Hammond in Reading 120). Hesse died of a brain tumor in early 1970—the result, many thought, of the toxic materials with which she worked.

Since the 1960s when she wrote about Pop art, minimalism, and conceptual art, Lucy R. Lippard has been a prolific critic, who focuses on artists, their experiences and their art. During the 1970s and 1980s she continued writing criticism while also taking on the role of activist in the anti–Vietnam War movement and the feminist art movement. In the mid-1970s, she co-founded *Heresies,* and in the 1980s, P.A.D.D. (Political Art Documentation/Distribution). During the 1980s and 1990s her activism kept its focus on feminism while also embracing a broad range of urban political art (see *Get the Message?: A Decade of Art for Social Change,* 1984), multiculturalism in the arts, (see *Mixed Blessings: New Art in a Multicultural America,* 1990), and also environmental and regional issues (see *The Lure of the Local: Senses of Place in a Multicentered Society,* 1997, and *On the Beaten Track: Tourism, Art and Place,* 1999).

Lippard was one of the first critics to recognize Hesse's talents and wrote often about the artist. In this essay she places the artist within the context of other conceptual, minimalist, and postminimalist artists.

\* \* \*

When Hesse returned to New York in the fall of 1965, so-called Minimal Art had just begun to be publicly acknowledged. Encouraged by her friends' reception of the three-dimensional work, she began to refine and clarify her forms and, simultaneously, to generalize considerably the emotions provoked by them. While the visceral and erotic associations of the early reliefs ("It looks like breast and penis, but that's OK," she wrote from Germany of the first construction) related to Surrealism, Hesse's irrationality, undeniably rooted in the subconscious, never approached Dada, as has the work of colleagues such as Bruce Nauman, Richard Serra, and Robert Morris; in this, her proximity to Sol LeWitt and Carl Andre is particularly noticeable. From this time on, LeWitt, whose planar structures had been shown at the John Daniels Gallery in May 1965, was her strongest supporter. His serial permutations, theoretically logical and often visually illogical, though always starkly geometric in style, were a coun-

terpart of Hesse's introduction of chance and randomness into much looser but still systematic frameworks. In various ways, Mel Bochner, Robert and Nancy [Holt] Smithson, Ruth Vollmer, and Robert Ryman were also important to her development.

The years 1965 to 1968 were a period of personal trauma alleviated by increasing esthetic success. By March 1966 Hesse had completed a large group of small sculptures combining a tubular or spherical motif with straight or tangled line. The most important of these was *Hang-Up* (January 1966)—a rectangular frame, six by seven feet, bound in cloth, with a great metal loop protruding about ten feet; it was gray, a graded purple relief several months earlier having been the last "colored" piece she made. She described *Hang-Up* as "the first time my idea of absurdity or extreme feeling came through. . . . The whole thing is absolutely rigid . . . the colors on the frame were carefully gradated from light to dark—the whole thing is ludicrous. It is the most ridiculous structure that I ever made and that is why it is really good. It has a kind of depth I don't always achieve and that is the kind of depth or soul or absurdity or life or meaning or feeling or intellect that I want to get" (interview by Cindy Nemser, *Artforum*, May 1970). [. . .]

The thing that was so impressive about Hesse's work at that time (and it impressed some very differently oriented people) was the fact that the modular and serial frameworks never interfered with, or veiled, or stultified the intensely eccentric core of the work. Always more interested in adding than subtracting (see her titles), in overlapping the visual accretions of her own anxiety, she accepted the much abused "system" for something as simple as it was. [. . .]

At the same time, the system was only an armature; her geometry was always subject to curious alterations, her repetitions to a tinge of fanaticism. In reference to *Addendum* (1967) she wrote: "Series, serial, serial art, is another way of repeating absurdity"; and three years later: "If something is meaningful, maybe it's more meaningful said ten times. It's not just an esthetic choice. If something is absurd, it's much more exaggerated, more absurd if it's repeated." Where her "primary structurist" friends tended to utilize repetition for energy drain (Smithson), visible conceptualism (LeWitt), neutrality or singleness of purpose (Donald Judd), a gestalt measuring device (Morris), or an ongoing process (Andre), Hesse found in it the vehicle for subtle variety that permitted her to distract the modules from their expected norm while placing them in a context for which expectations were quite different. Sometimes within the viewing process itself an ordered armature is transformed into chaos; often the fact that the units are at first glance identical is the only order in the piece, its boundaries being infinitely alterable, as in the lopsided "buckets," poles, spheres of 1967 and 1968. [. . .]

Hesse's involvement with materials has been overemphasized because of her public association with other artists who are more dependent upon the accidents of physical phenomena. Her main interest in fiberglass, latex, and other rubbery synthetics was their near-ugly delicacy and textures, their potential for fusing regular shape and irregular disposition, as exemplified in *Area* (1968), a modular wall piece that folds and flops incongruously from wall to floor. Such pieces conveyed emotion by strangely flawed images, as though striving for a perfection they were destined not to meet.

When a critic wrote in 1966 that the mood of Hesse's work was "both strong and vulnerable, tentative and expansive," her stepmother said it sounded as though Eva herself were being described. In fact, the core of her art was the core of Eva's self; the two were inseparable for her and for anyone who knew both the work and the artist. [. . .]

Eventually even she came to realize that the self she was finding through her work was really worth something. In her emphasis on absurdity, however, she remained an existential artist:

> I could take risks. . . . My attitude toward art is most open. It is totally unconservative—just freedom and willingness to work. I really walk on the edge. . . . Art and work and life are very connected and my whole life has been absurd . . . absurdity is the key word. . . . It has to do with contradictions and oppositions. In the forms I use in my work the contradictions are certainly there. I was always aware that I should take order versus chaos, stringy versus mass, huge versus small, and I would try to find the most absurd opposites or extreme opposites. . . . It was always more interesting than making something average, normal, right size, right proportion.

\* \* \*

---

*103* ✦   Calvin Tomkins, "Christo's Public Art: How to Win Friends, Outlast Enemies, and Make the Social Structure Work for You in Northern California," in Christo, *Running Fence: Sonoma and Marin Counties, California, 1972–1976* (New York: Harry N. Abrams, Inc., 1978):17–35.

Christo, born Christo Javacheff in Bulgaria, left Eastern Europe in 1957, worked in Paris, and then settled in the United States in 1964. His large environmental works began in the 1970s and consisted of wrapped buildings and bridges, draped cliffs, and other "packaged" treatments of the natural environment, including wrapping a million square feet of the Australian coastline (*Wrapped Coast,* 1969).

Like his other projects, *Running Fence* was a massive effort of planning and execution on the part of surveyors, engineers, construction crews, and lawyers. His wife Jeanne-Claude Christo served as his collaborator; art historian Peter Selz was project director. In a fact sheet published in the Abrams book Christo estimated that the costs came to $3,250,000 (1976 money). He did all the fundraising himself through "the sale of his studies, preparatory drawings, collages, scale models, early works and original lithographs. Christo does not accept any kind of sponsorship."

Calvin Tomkins worked for *Newsweek* magazine and has been a staff writer for *The New Yorker* since 1961. His books include *The Bride and the Bachelors* (1962/1965), *Off the Wall: Robert Rauschenberg and the Art World of Our Time* (1989), and *Duchamp: A Biography* (1996). An earlier version of his chronicle on Christo's *Running Fence* appeared in *The New Yorker.*

---

✦

\* \* \*

Triumph was in the air that September morning as Christo and his work force wrestled the shimmering white cloth out to the bobbing raft. Seen from the top of the bluff, the fence, rippling majestically in the wind, emerged glittering from the sea, mounted the cliff in one steep bound, and then stretched away across the sunbaked meadows as far as the eye could follow. It had been designed with enough slack for the fabric to billow out four feet on either side, and near the sea it was almost always in motion. Many spectators were reminded of the Great Wall of China, but not for long. The fence was too fragile, too ephemeral, too alive to be a wall—a fleet of tall ships, perhaps, or (Christo's own early concept) a vast tent city of desert nomads. Running Fence was remarkably close in its visual reality to the many drawings and collages that Christo had made of it over the last four years; even so, it surprised and astonished us all. The way it caught and gave back the changing light, its sensitivity to the wind and to the colors and contours of the landscape, and the vast scale of the thing came as a revelation even to those closest to the project—"*un miracle*," Guido Le Noci kept saying. Christo's "illegal leap" to the ocean, as the San Francisco *Chronicle* subsequently called it, was dazzlingly evident to local sightseers as far away as Dillon Beach, two miles down the coast.

Shortly before noon, when the seagoing section of white nylon had been pulled out as far as it would go, Christo broke away from a phalanx of lenses and microphones for a brief private conversation with Don Dickenson, of the Marin County Planning Department. Dickenson, who liked the Christos and Running Fence, told Christo that he had learned that Christo was working in the forbidden coastal zone, and that he had been obliged in his official capacity to report the violation to the Coastal Commission. It seemed certain that the Coastal Commission would immediately notify the Attorney General, in Sacramento, and Christo had every reason to believe that the Attorney General, whose office had called Stephen Tennis, one of Christo's battery of lawyers, the preceding Friday to warn against any such construction in the absence of a permit, would immediately seek an injunction against all further work in the coastal zone. (From the ocean to a point four miles inland, the fence's route ran through Marin County; the remaining twenty miles was in Sonoma County, but at this time only a small section in Sonoma had been unfurled.)

Christo was determined to finish the coastal portion of the fence before the injunction came. That way, he figured, he could comply with the law by agreeing to remove it, whereas if he received the injunction and went on to build the fence in spite of it he would be in contempt of court. The one certainty at this point was that Christo was going to build his Running Fence, complete, and take whatever legal consequences there might be.

\* \* \*

He had been going at an increasingly furious pace for several months, and for the last two weeks he had averaged about three hours' sleep a night. In a construction worker's white hard hat, well-worn jeans, a plaid shirt, and battered hiking boots (one of which had its sole attached to the upper with a wrapping of silver adhesive tape), Christo was instantly recognizable among a score of similarly dressed workmen, in part because he was always in restless motion. Now, walking to the edge of the wooded area, he looked out over a long, dipping line of his steel fence posts, eighteen feet high and sixty-two feet apart. Starting tomorrow, a brand-new work force of more

than three hundred young workers would start hooking the nylon fabric to an over-head cable that connected the two thousand-odd posts along Running Fence's twenty-four and a half miles—a separate eighteen-by-sixty-eight-foot nylon panel between each pair of posts. Christo stood there for a long time, surveying the line of waiting posts that wound over a neighboring hill, cut back and descended into the valley, and vanished behind a clump of trees in the distance. "It's funny," he said when I joined him. "If I go to jail and people ask why I am there, I will say, 'For building my fence.' "

\* \* \*

It is possible to see in these enormous undertakings a certain degree of similarity to the large-scale earthworks that Michael Heizer, using bulldozers and other heavy equipment, has engineered in the Nevada desert. Like Heizer and other earth artists, Christo has gone outside the system, the official art world, to involve himself in vast projects for which there can be no possible "market"—art works that exist for most viewers only in the still photographs and the films that record them. These artists' work is essentially non-commercial, in a period when soaring prices and shady dealings have made modern art seem far too commercial for its own good, and their work is also, in the word of the moment, "environmental." One large difference between Christo and the earth artists, however, is that Christo's projects alter the environment only briefly. Little Bay is the same today as it was before its ten-week wrapup; so is Rifle Gap, where the Valley Curtain hung for less than forty-eight hours before a freak storm tore the fabric and forced its early removal. Christo's handiwork disappears from the landscape when he is finished. This has led some observers to call what he does Conceptual art, but the phrase is misleading. Most Conceptual artists feel that the originating idea is the only element essential to their art, and a neatly typed statement of intent is often the sole form in which a Conceptual work exists. Christo, on the other hand, always carries out his concepts, usually at great expense, and in a way that more and more has required the collaboration and assistance of large numbers of people. For Christo, the involvement, the whole process, is the crucial element. His recent projects have existed on social, legal, political, and technical (engineering) levels as well as on aesthetic ones, and even people who oppose and try to stop them become, in Christo's mind, participants in the work of art. "I make public art," he says. It is a category all his own, apparently without precedent and—for the moment, at least—without visible followers.

\* \* \*

When Christo settled on Sonoma and Marin counties as the site for his meandering twenty-four-mile ribbon of white nylon, he was warned that although he would probably have no trouble getting the required state and county building permits, he would never manage to talk the ultra-conservative ranchers into letting him cross their land. What happened was more like the opposite. The ranchers—dairy farmers and sheep raisers, for the most part, many of Italian or Swiss descent—proved to be the project's and Christo's staunchest allies. Getting them to listen to the proposal in the first place was no snap, of course. What on earth was the point of an eighteen-foot-high cloth fence that would be taken down after only two weeks? Where was the art in it? The Christos explained it as best they could. Running Fence (it sounded like an Indian name) was a fence without function, a white line running

over the land; nothing would be painted on the cloth, no designs or pictures—just the white shape stretching from the suburbs of Petaluma to the ocean.

\* \* \*

"Running Fence, is a celebration of the landscape," he said in a formal statement that accompanied a two-hundred-and-sixty-five-page Environmental Impact Report, which was prepared at the Christos' expense. "The fabric is a light-conductor for the sunlight, and it will give shape to the wind. It will go over the hills and into the sea, like a ribbon of light."

\* \* \*

The entire process was the work of art, then—four years of planning and organizing, vast expenditures of imagination and money, an incredibly complex marshalling of forces and energies on many levels. And yet, beyond the process, there was that amazing visual image. The ephemeral end product, the great white fence, was far more beautiful than anyone, even Christo himself, had anticipated.

---

# Realism and Figuration

Figurative art and realism did not disappear from the art scene during the late 1940s and 1950s, even though art history survey books have stressed the dominance of abstract expressionism. Socially concerned painters active in the 1930s—Ben Shahn, Philip Evergood, Raphael Soyer, Alice Neel, Jack Levine—continued to paint the figure in styles ranging from naturalism to expressionism. Fairfield Porter (1907-75), who doubled as an art critic, had a steady audience for his suburban scenes done in a loose naturalist style. The generation of artists born in the 1920s, such as Jane Freilicher, Paul Georges, Alex Katz, Alfred Leslie, Philip Pearlstein, Sidney Tillim, James Weeks, and Neil Welliver, chose realism as an alternative to abstract expressionism. Some, such as Leslie, returned to realism after painting abstractly. Moreover, even during the high point of abstract expressionism, many art galleries did not abandon their commitment to figurative and realist art, for example, the ACA, Terry Dintenfass, Fischbach, Forum, Allan Frumkin, Kornblee, Robert Schoelkopf, Allan Stone, and Tibor de Nagy galleries in New York. These galleries not only showed older artists, but in the late 1960s and 1970s also began showing the younger realist artists born in the 1930s and early 1940s—Barkley Hendricks at ACA; Sidney Goodman at Dintenfass; John Moore and Susan Shatter at Fischbach; Gregory Gillespie at the Forum Gallery; Jack Beal, James Valerio, and Willard Midgette at Frumkin; Janet Fish, Michael Mazur, and Rackstraw Downes at Kornblee; Martha Mayer Erlebacher at Schoelkopf; William Beckman at Allan Stone; and George Nick at Tibor de Nagy.

The timing was right for the younger realist artists, who rode onto the art scene through a clearing made by the Pop art movement. In fact, early shows of Pop art were called the "New Realism" and included not only the flat imagery derived from advertisements and magazine reproductions (which we call today Pop), but often paintings of common objects modeled with light and shade, which would eventually be grouped together as realist. The Sidney Janis Gallery organized such a show of "New Realists" in 1962. By February 1969 Sidney Tillim could declare in *Artforum:* "Figurative art is not yet 'in'—far from it. But it is no longer the orphan of modernism that it was until only recently."

In the early 1970s some of the galleries that opened in New York's Soho district specialized in photo-realism, such as the O.K. Harris Gallery (directed by Ivan Karp, who had mounted Pop art shows in the early 1960s as director at the Leo Castelli Gallery), the Louis K. Meisel Gallery, and Nancy Hoffman Gallery. The line between realists and photo-realists was not clearly drawn, but, in general, the photo-realists were those painters appropriating imagery from magazine reproductions, photographs, or slides, and emulating a photographic aesthetic with little display of brushwork or impasto. These artists included Robert Cottingham, Richard Estes, Audrey Flack, Joseph Raffael, John Salt, and the English artist Malcolm Morley.

The figurative sculptors working in the new realist modes brought their figures down from the pedestal and set them as life-sized figures on the floor in the same space as the viewers in the galleries and museums. Instead of working with the permanent, traditional sculptor's media—bronze, terra cotta, stone, or wood—these artists used industrial materials such as cast vinyl, plaster, hydrocal, and plastic. Both Edward Kienholz (see Reading 91) and George Segal placed their figures within tableaux or environments of their own creation; Duane Hanson dressed his polyester and fiberglass working-class figures with actual clothes and included props from the real world; Frank Gallo merged his realistic figures with the actual chairs on which they sat; working in ceramics Mags Harries made realistic boots, gloves, and briefcases that served as surrogates for real people; Robert Graham and Isabel McIlvain made very detailed small figures.

Central to the flowering of the new realism in the late 1960s were college art departments. Some schools, such as the Art Students League and the National Academy of Design in New York, the School of the Art Institute of Chicago, the California School of Fine Arts in San Francisco, and Boston University, to name just a few, continued their strong traditions of figurative art. Even when studio programs, such as that at Yale under Joseph Albers, focused on abstract art, they also taught life-drawing classes. By the end of the 1960s many college art galleries were mounting exhibitions of figurative and realist art because many on their faculties were realist artists. Landmark college shows included Vassar College's *Realism Now,* 1968, curated by art historian Linda Nochlin. From 1969 to 1970 exhibitions of realist art were on view in Tulsa, Milwaukee, New York, Philadelphia, Minneapolis, Stockton, and Chicago.

Nochlin also called attention to the history of realism and its political underpinnings. Her book *Realism,* 1971, opened the eyes of a generation of young art history and studio students to the theoretical ideas associated with the realist movement of the nineteenth century. She reminded her readers that "To be of one's time" had been the rallying cry for Gustave Courbet and other mid-nineteenth-century European realists. Nochlin was joined by feminist art historians, such as Ann Sutherland Harris, who wrote on realist artists emerging within the feminist movement in the early 1970s.

Many of the California artists who seemed so compatible with New York Pop art, such as Wayne Thiebaud and Mel Ramos, continued the styles of the California figurative tradition. They used light and shadow and a loaded brush when painting media-based images and common objects. Moreover, an anti–New York aesthetic continued to have a strong hold on California artists. Whitney Chadwick, looking back at the California art scene of the late 1960s/1970s (*Art Journal,* Winter 1985), placed Robert Colescott (see Reading 108) within a group of artists who "produced works in which social comment, satire, morality plays, puns, and personal mythology combine with flamboyant and

eccentric personal styles to form a visual running commentary on the world and the history of art. Their sources range from autobiography and Surrealism's love of bizarre and evocative juxtaposition to social and cultural taboos. Their paintings exhibit a maverick sensibility, downplay obvious skill, and break the 'rules' of representation in ways often influenced by the directness of naïve art and popular illustration." As to popular illustration as a source, Chadwick points to R. Crumb's cartoons for *Zap Comix* and other underground publications and to the late 1960s psychedelic posters of rock groups performing in San Francisco.

From the perspective of the end of the century, Pop art and the New Realism did have much in common. Both addressed the visual environment that daily confronts the urban spectator as he or she walks down the street, looks at a billboard or sign, shops at a supermarket, reads a magazine or channel surfs through T.V. programs.

*104* ✦ Philip Pearlstein, "Figure Painters Today Are Not Made in Heaven," *Art News* 61, no. 3 (Summer 1962):39, 51–52. © ARTnews L.L.C.

Philip Pearlstein studied at the Carnegie Institute of Technology in his hometown, Pittsburgh. In the 1950s he came to New York, where he received a Master's degree in art history from the Institute of Fine Arts, NYU, and also continued to paint. He taught at Brooklyn College.

In this article he argues that there are "two tyrannies" faced by realists: first, the tyranny of the flat picture plane, promoted by modernist critics such as Clement Greenberg; and second, the tyranny of the "roving point-of-view," characteristic of expressionism. Although published in 1962, the essay enjoyed considerable status over the next ten years for its clear articulation of the new realist's point of view.

Pearlstein has many differences with other realists in that he insists on painting from the model without the use of photographs—even capturing the specific gradations of shadows created by the three spotlights attached to the ceiling in his studio that illuminate his models. However, by using the photographer's technique of cropping the image (often the heads and feet of his models) he subjects his compositions to the same strategies used by modernist painters primarily concerned with formal design. Hence, his paintings often appeal to formalist critics who care little for the expressive and symbolic qualities or sociological dimensions traditionally associated with figurative art and portraiture.

\* \* \*

It seems madness on the part of any painter educated in the twentieth-century modes of picture-making to take as his subject the naked human figure, conceived as a self-contained entity possessed of its own dignity, existing in an inhabitable space, viewed from a single vantage point. For as artists we are too ambitious and conscious of too many levels of meaning. The description of the surface of things seems unworthy.

\* \* \*

Yet there will always be those who want to make paintings of the human form with its parts all where they should be, in spite of Progress.

Two tyrannies impose themselves on the artist who would try. One is the concept of the flat picture plane; the other may be termed the "roving point-of-view." Both have radically changed our way of seeing pictures and have conditioned those values that lead us to judge what a "convincing painting" is. We all bow low to them for it seems that we cannot overthrow them. But our battles with them sometimes produce paintings that are exciting in the resulting tensions. Unfortunately, too many easy compromises are being applauded in certain fashionable quarters.

There are ways to make the figure "acceptable" to the taste-makers of today. All paintings have implied meanings, but some implications are more in line with current popular sympathies than others, and one path towards acceptability lies in the artist's choosing the proper kind of implication.

\* \* \*

A moralistic ban has been placed on spatial illusionism. But it is an arbitrary ban. The flatness of the picture plane is no more a truth than was the flatness of the world before Columbus. It's all a matter of how you look at it. Of course, the surface of the canvas is tangibly present, and if one chooses to concentrate only on the outside edges of the blank, white canvas one can persuade oneself to remain true to the flat geometric rectangle.

\* \* \*

The second great tyranny can be termed the "roving point-of-view," in contrast to the single vantage point determined by Brunelleschi around 1420. The late nineteenth century taught us that reality consists of constant change. As we move, the objects around us seem to change position; the world moves and things are constantly revealed in new aspects. Our visual experiences are usually cinematic sequences of not necessarily related views of details. The Impressionists, Cubist and Futurists were all excruciatingly aware of this kinetic experience of reality and taught us ways of projecting it onto canvas. And the early Abstract-Expressionists taught us how to achieve this sense of swift urgent movement through paint forms alone, without reference to the objective world. Today it seems impossible to paint a canvas that is not conceived as a total field of action. Our eyes are adjusted to being pushed and pulled from one area of concentrated energy or descriptive fragment to another, dwelling on each only so long as it takes to recognize it. That which as recently as the time of Eakins was a matter of course—the viewing and recording of the complex human form as a unified entity of continuously modulated surfaces—has become extraordinarily difficult for us.

[. . .]

Why bother with fidelity to the model? A nagging urge for fidelity to the game of painting the figure as it is while dealing with the rules imposed by the flat picture plane and the roving point-of-view demands it. The flat picture plane seems easier to break than does the habit of the roving point-of-view. Both, perhaps, are too ingrained to leave behind; the battle with them is for me the most meaningful experience in painting the figure.

The naked human body is the most familiar of mental images, but we only think we know it. Our everyday factual view is of the clothed body, and on those occasions when our dirty mind will strip a person, it will see something idealized. Only the mature artist who works from a model is capable of seeing the body for itself, only he has

the opportunity for prolonged viewing. If he brings along his remembered anatomy lessons, his vision will be confused. What he actually sees is a fascinating kaleidoscope of forms; these forms, arranged in a particular position in space, constantly assume other dimensions, other contours, and reveal other surfaces with the breathing, twitching, muscular tensing and relaxation of the model, and with the slightest change in viewing position of the observer's eyes. Each movement changes as well the way the form is revealed by light; the shadows, reflections and local colors are in constant flux. The relationship of the forms and colors of the figure to those of the background becomes mobile and tenuous. New sets of relationships continuously reveal themselves.

This experience in seeing can be as hypnotic as the swaying head of a cobra about to strike, and, if the artist so chooses, success in making some kind of faithful record of this experience can seem to be as important as it would be to avoid the cobra's strike. The experience, in fact, approaches the total identification with the image that the Indian artist achieved.

<p style="text-align:center">* * *</p>

In the battle of painting the figure, to pry open the flat picture plane and control the roving eye, the weapons must be chosen carefully and wielded skillfully. A human being, a profound entity, is to be represented.

---

**105** ✦ Alice Neel, excerpts from Patricia Hills, *Alice Neel*. (New York: Harry N. Abrams, 1983).

Raised in a suburb of Philadelphia, Alice Neel attended the Philadelphia School of Design for Women, now called Moore College of Art. During the 1930s she associated with politically left artists and intellectuals, painting portraits of the communist Mike Gold, editor of *The New Masses,* the poet Kenneth Fearing (see Reading 42), and others. During the 1940s and 1950s, as a single mother raising two sons in Spanish Harlem, her career faltered, but she still attended meetings of artists in Greenwich Village. Alfred Leslie and Robert Frank asked her to play a role in their underground film *Pull My Daisy* in 1959.

In the 1960s Neel's productivity increased, and in the next two decades she painted such artworld notables as Frank O'Hara, Robert Smithson, Linda Nochlin, Red Grooms, Benny Andrews, Andy Warhol, Duane Hanson, Marisol, and Faith Ringgold, as well as her neighbors and her family. All these she called "the human comedy," after Balzac's phrase. Women artists and scholars associated with the women's movement promoted Neel in their exhibitions, their writings, and in the classroom as a "survivor"—a woman who never stopped painting even in the face of adversity.

During the 1970s Neel went on the college lecture circuit, giving two-hour slide shows to art students across the country and becoming famous for her candid comments on critics, artists, her lovers, and on the politics of the artworld. These excerpts, pieced together from audio tapes recorded by the author in 1980 and 1982, capture the language of Neel's talks to students.

---

✦

\* \* \*

All my favorite painters are abstractionists: Morris Louis and Clyfford Still. I don't do realism. I do a combination of realism and expressionism. It's never just realism. I hate the New Realism. I hate equating a person and a room and a chair. Compositionally, a room, a chair, a table, and a person are all the same for me, but a person is human and psychological. The work of the New Realists is boring to me because of no psychological acumen. They don't show a soul out in the world doing things.

You know, for a while, when I gave my slide lectures, I had to apologize for being psychological. That was ten years ago. They don't care anymore. Because now that they're going to blow up the world, they realize that there is psychology.

\* \* \*

I do not pose my sitters. I never put things anywhere. I do not deliberate and then concoct. I usually have people get into something that's comfortable for them. Before painting, when I talk to the person, they unconsciously assume their most characteristic pose, which in a way involves all their character and social standing—what the world has done to them and their retaliation. And then I compose something around that. It's much better that way. I hate art that's like a measuring wire from one thing to the next, where the artist goes from bone to muscle to bone, and often leaves the head out. I won't mention who does that.

When I paint it's not just that it's intuitive, it's that I deliberately cross out everything I've read and just react, because I want that spontaneity and concentration on that person to come across. I hate pictures that make you think of all the work that was done to create them.

\* \* \*

Art is a form of history. That's only part of its function. But when I paint people, guess what I try for? Two things. One is the complete person. I used to blame myself for that, do you know why? Because Picasso had so many generalities. And mine were all—mostly a specific person. I think it was Shelley who said: "A poem is a moment's monument." Now, a painting is that, plus the fact that it is also the *Zeitgeist,* the spirit of the age. You see, I think one of the things I should be given credit for is that at the age of eighty-two I think I still produce definitive pictures with the feel of the era. Like the one of Richard, you know, caught in a block of ice—*Richard in the Era of the Corporation.* And these other eras are different eras. Like the '60s was the student revolution era. Up until now, I've managed to be able to reflect the *Zeitgeist* of all these different eras.

---

**106** ✦ Audrey Flack, "Color," in *Audrey Flack on Painting* (New York: Harry N. Abrams, Inc., 1981).

Audrey Flack studied at Cooper Union in New York City and then went on to Yale University at the time when Josef Albers taught there. Flack found herself at odds with the older artist, but his theories on color influenced her. After painting realist images from models and still-life arrangements in the 1960s, she moved on to four-color magazine reproductions as sources for her art and then to slides because of the vividness of the hues. She began to set up her own still lifes, assisted by photographer Jeanne Hamilton, and

**Figure 6-5.**   Audrey Flack, *Marilyn (Vanitas)*, 1977. Oil over acrylic on canvas, 96 × 96 in. Courtesy of the University of Arizona Museum of Art, Tucson. Museum purchase with funds provided by the Edward J. Gallagher, Jr., Memorial Fund.

would shoot many slides. Projecting a selected slide onto the canvas, Flack would mask parts of the canvas, then spray on separate pure hues of paint to emulate the colors in a slide. This created a brilliancy of effect explained in the following passage.

◆

Color does not exist in and of itself. All through my life as an artist, until I began to experiment with the air brush, I accepted color as a fact—something to be squeezed out of a tube and resupplied when the tube was empty. It could be a crayon, a pastel chalk, jars of Rich Art tempera, but always "color" was "color." "Cadmium Red" was a fact. I was well aware of the subtle differences between brands—Shiva Alizarin Crimson was oilier than Winsor Newton Alizarin. Winsor Newton Cadmium Red was richer than Grumbacher Cadmium Red. My concept was that color was a material substance. It is not!

Color should be thought of in terms of light. Webster's dictionary says that color is "the sensation resulting from stimulation of the retina of the eye by light waves of certain lengths." My definition of color is: "Color is created by light waves of various lengths hitting a particular surface. The surface may be absorbent, reflective, textured, or smooth. Each surface will affect the wave lengths differently and thereby create different colors. These wave lengths will affect the retina, and the eye will perceive color."

Each color has its own wave length, or better still, each wave length has its own color. The light which Newton separated into seven distinct colors with individual wave lengths is called a spectrum—red, orange, yellow, green, blue, indigo, violet. Light travels at 186,000 miles per second in wave lengths and as it travels it *vibrates*. It is these reflective rays or vibrations we perceive as color. Color does not exist in and of itself. Objects themselves are colorless. They appear to be colored because they absorb certain wave lengths and reflect others. In 1969, while analyzing a projected slide on a white, smoothly sanded canvas, I noticed that what appeared to be color really was dots of red, yellow, and blue, mingled together to produce all other shades. Nowhere was there a flat opaque mass of color; rather, there were dots or globules which gave the effect of color. As I stood in my semi-darkened studio I realized that all of this color was being produced by a single light (250-watt halogen bulb) being projected through a gelatinous slide. Without the light there would be no color.[. . .]

Black is fascinating in that it contains greater amounts of reflected light than many light colors. There is much white in black. Velázquez knew this and used it in painting the terraced skirt of the Infanta. [. . .]

When I began working with the air brush, I realized that spraying—Cadmium Red light, for instance—produces a completely different color than applying it with a brush. Spraying produces small beads of color and the density of the application affects the intensity of the color.

No matter how densely I sprayed the surface, it still appeared different from the painted Cadmium Red light. Both were acrylic, both were applied to a similar surface, but the air-brushed paint appeared foamy, lighter, smoother, and alive in another way. Yet the colors came from the same jar of paint. Light was reflecting differently when bounced off thousands of tiny particles than off a brush-painted surface.

Compare the brilliance of a slide with the opacity of a photograph. The photograph is dull in comparison. I wanted to make a painting as luminous as a color slide. I had to deal with light in order to accomplish that.

Color depends on a myriad of surrounding conditions. Whether the surface is smooth or rough, absorbent or reflective, what kind of air brush—tip or needle . . . what kind of paint brush—sable or bristle . . . what kind of pigment—oil or acrylic, gouache, pastel, watercolor, crayon, pencil, etc. . . . what kind of light . . . and whose eyes—for ultimately we all perceive color differently. What we hope for is an acting norm within a certain range for comparison purposes. [. . .]

When an artist selects a color, that pigment contains the potential of producing a particular wave length. When that pigment is applied to a surface, the wave length which is reflected back to our retina is perceived as color. It is *vibrating*, and we feel that vibration. When we look at a Raphael or a Piero della Francesca, the *Baptism of Christ*, for example, we are receiving the wave length of cool blues, muted gray whites and yellow whites, soft pinks rather than harsh reds. In Piero's *St. Michael* the sword tip is bathed in a soft pinkish red, whereas the same sword painted by Carlo Crivelli or Rubens would be virtually dripping with blazing red blood. These wave lengths are shorter and produce a calming and soothing effect. Classical artists tend to select these colors, and thereby produce more harmonious paintings than do Baroque artists. Rubens's palette contained brilliant reds, lumi-

nous oranges, golden yellows, colors that have longer wave lengths. Red has the longest, violet the shortest. This is a strong contributing factor to the vibrating excitement in his paintings.

<p style="text-align:center">* * *</p>

---

***107*** ✦ Robert Bechtle, "Artist's Statement," 1973. Courtesy of the artist.

Robert Bechtle studied at the California College of Arts and Crafts in Oakland from 1950-54 and from 1956-58. He has also taught there from 1957 to 1985 and at San Francisco State University from 1968 to 1999. He was included, along with Audrey Flack, in the Whitney Museum's *22 Realists,* 1971, an exhibition that introduced the general public to the realist and photo-realist movement.

In this artist's statement, Bechtle relates how the use of photographs freed him to think about issues other than the mere transcription of three-dimensional objects to the two-dimensional canvas surface. In a sense, he asks the viewer to work from the canvas back to a recollection of a real thing, and to bear in mind that any realist painting is just a reconstructed representation.

---◆---

I was not originally interested in "realism" as such. Painting things as they looked—as accurately as I could and without the pretense of a painterly style—was a way of rejecting the attitudes and appearances of painting that I had learned in school. I was trying to avoid the look of the expressive marks and the kinds of decisions one was expected to make. I think, though, that I have always been interested in how things looked rather than in the uses of materials or a search for form. I suppose it entails a feeling that something of substance is to be found in the details of appearance. At any rate, when my painting began to divorce itself from the influence of the Bay Area Figurative style in the early sixties, it seemed logical and felt natural to move in the direction of observation and "objectivity."

I had people pose for me (I did a lot of self portraits) or painted objects around the house. I began to use photographs originally as a way of getting my models to sit still longer but soon became aware of their potential for expanding the range of things I could paint. I had begun to be interested in automobiles as subjects and found the photograph the only way I could get the authenticity I felt I needed. (I did do one painting of my own car through the front room window while it was parked in front.)

Photographs allow me to paint with enough accuracy that the reference to the "real thing" is direct and not distracted by the inevitable distortions of drawing from the actual object. I am not particularly interested in those subtle differences between the way we perceive a three dimensional object and the way we might translate it into two dimensional marks, but rather in having those marks make up as convincing a reminder of that object as possible. (Even if the finished painting reminds us of the photograph, that is close enough since we tend to believe in the veracity of the camera.)

I try for a kind of neutrality or transparency of style that minimizes the artfulness that might prevent the viewer from responding directly to the subject matter. I would like someone looking at the picture to have to deal with the subject without any clues as to just what his reaction should be. I want him to relate to it much as he would the real thing, perhaps to wonder why anyone would bother to paint it in the first place.

I think of the photograph, in addition to its being a reference source, as a kind of structure of system for the painting which limits the choices of color and placement. It allows me to keep some of the traditional concerns of the painter—drawing, composition, color relationships—from assuming too important a role, for they are not what the painting is about. Most of the choices are made when the photograph is taken. I try to avoid composing too obviously, aiming for an off hand and casual look. But something about the situation had to attract me to it in the first place, something that suggested that there might be a painting there. Perhaps whatever "art" the painting might have is given to it at that moment of initial choice. On the other hand, the rather subtle choices that are made as the painting progresses, as I try to reinvent the information in the photograph and make it convincing as painting may be what gives it its "art." Whatever the cause, the painting ends up being different from the photograph and certainly different from the "real thing." When it is successful the picture can be evocative in a way that has nothing to do with the processes of making it nor with the subject matter as such.

**Figure 6-6.**   Robert Bechtle, *'71 Buick,* 1972. Oil on canvas, 47 7/8 × 68 in. Solomon R. Guggenheim Museum, NY. Purchased with funds contributed by Mr. and Mrs. Barrie M. Damson, 1979. Photograph courtesy of the artist.

My subject matter comes from my own background and surroundings. I paint them because they are a part of what I know and as such I have affection for them. I see them as particular embodiments of a general American experience. My interest has nothing to do with satire or social comment though I am aware of the interpretations others might give them. I am interested in their ordinariness—their invisibility through familiarity—and in the challenge of trying to make art from such commonplace fare.

*108* ✦ Lowery Stokes Sims, "Bob Colescott Ain't Just Misbehavin'," *Artforum* 22, no. 7 (March 1984):56–59. © *Artforum.*

Born in Oakland, Robert Colescott served in France during World War II. After the war he studied at the University of California at Berkeley, then in Paris with Léger. He returned to Berkeley to get a Master's degree. He taught at Portland State University and at the American University in Cairo, but came back to the San Francisco Bay area in 1970 and associated with like-minded artists Joan Brown, William T. Wiley, and Roy De Forest.

Miriam Roberts, who organized the 1997 exhibition of Colescott's paintings for the 47th Venice Biennale, where he represented the United States, wrote in the catalogue about Colescott's myriad influences: "By the mid-1970s Colescott's work had taken on some of the formal aspects of pop art, but the burgeoning of feminist art with its insistence on content did the most to improve the climate for his paintings. It was feminist artists more than anyone else who were dealing with personal content within a social framework and addressing subjects people care about, and many of them, such as May Stevens and Sylvia Sleigh, were using the same strategies Colescott used—narrative, gender and race reversal, art-historical parody, and the use of stereotypical images to subvert stereotypical views."

Lowery Stokes Sims was Associate Curator of Twentieth-Century Art at the Metropolitan Museum of Art when she left that post in 1999 to assume the directorship of the Studio Museum in Harlem. She frequently writes criticism and has served as a contributing author for exhibition catalogues produced by many institutions.

✦

*The humor is the bait. It's the price you pay to get in.*[1]

—Joe Lewis, 1982

Although Robert Colescott's work is impelled by one overriding purpose—to interject black people into Western art—an important component of his art is consistent with the satirical approach. If we perceive a marked defensiveness in such a stance, a chip-on-the-shoulder attitude regarding official "culture," then we can have a handle on Colescott's work. His esthetic affinities are with Dada, Surrealism, and Pop art; the

[1]Joe Lewis, "Those Africans Look Like White Elephants: An interview with Robert Colescott," East Village Eye, October, 1983 p. 18 (reprinted from handout for exhibition at Semaphore Gallery, New York, Fall 1982).

prediction of the phenomenon that Marcia Tucker isolated as "bad painting" is key. The politics are those of exclusion:

> If George Washington crossing the Delaware is Carver, should I cry for the solitary hero and history because it allowed only one or maybe two heroes, but a multitude of buffoons (me included?). Or, on the other hand, how about all the hat-changing, no-boat-rocking softshoe, no-wave-making ball-jiggling routines "everybody's man" might be doing to be "everybody's man"? . . . Now that's entertainment.[2]

The methodology involves devising quotations from masterpieces of art history and inserting his figures in these compositions, or transposing racial and sexual identities within images from the popular market. A physical distance from the political and intellectual centers of black life in America may have allowed Colescott (who lives in Arizona) to feel freer about taking on such "difficult" issues as sex, black stereotypes, and the more embarrassing aspects of bourgeois American life, both white and black. The satirical digs and twists that imbue his imagery have rendered it suspect in more orthodox black political circles; in addition, his representation of women has raised eyebrows where there is feminist consciousness.

Colescott himself is the interlocutor in his work—not as the master of ceremonies or the choral commentator of Greek theater, but as the buffoon/jester. Exercising a voyeuristic license as artist, he provokes an unmasking, an exposure—of the burnt-cork makeup of the black minstrel or the obsequious deference of an Uncle Tom/Stepin Fetchit, both of which mask their true selves. This protective camouflage (wrought in the wake of repression during the post-Reconstruction era) was so successful that the blacks did indeed become invisible. So when Colescott seeks to render blacks visible again he takes the viewer through a deciphering of an elaborate system of messages encoded as the secret communication of an underground culture.

One of Colescott's most successful paintings, which may be used as a paradigm, is *George Washington Carver Crossing the Delaware*, 1975. On the most elementary level the humor is sourced by a familiarity with Emmanuel Leutze's original 1851 composition; Colescott replaces the white male revolutionaries (including one black man) with a boatload of black cooks, sporting lifes, mammies, and banjo players, under the leadership of a scholarly, bespectacled "colored gentleman." The title also refers to the black American custom of naming male children after American presidents. On a deeper level, though, it is an angry protest against the tokenism of traditional American history, which allows only one black hero (Crispus Attucks) and buries the rest. It goes on to illuminate the existence of George Washington Carver, a botanist at Tuskegee Institute who distilled more uses out of the common peanut than it took to put Jimmy Carter in the White House. By taking on the contrasting images predicated by the American class system, Colescott makes a hero of the ordinary man and woman (even these stereotypes) and takes note of the social pressures on the "super niggers" isolated from each generation by the power structures as tokens to "represent the race."

<p align="center">* * *</p>

[2]Robert Colescott, catalogue statement in *Not Just for Laughs: The Art of Subversion*, by Marcia Tucker, New York: The New Museum, 1981, p. 29.

Colescott blows the toughness and strength and subversion behind his elusive postures wide open in *I Gets a Thrill Too When I Sees de Koo*, 1978. Here he creates a brilliant transposition of the image of Aunt Jemima while in turn playing off of Mel Ramos' *I Still Get a Thrill When I See Bill*, 1977, a slick pinup reinterpretation of the gestural, grimacing women of Willem de Kooning. It is exceptionally effective. If it had been a firsthand transposition, it would have merely equated the overwhelming presence of the black mammy with de Kooning's ferocious, devouring women. But with this double critique—of Ramos' penthouse pet and of de Kooning's grimacing women—he suggests a radical change in the imagery of all women, and in particular, liberates the asexual, ultramaternal Aunt Jemima image of black women, who have been subject to the most deeply victimising imagery of any group in our culture.

\* \* \*

Colescott's paintings can be seen as a chronicle of his feelings, which are inextricably caught up in his perceptions of himself as a black male and as an artist in America today. It is the hypocrisy of the American Ideal in particular that is his prey, and like the outlaws of Saturday afternoon westerns, he raids the "sacred cows" of the "high culture" corral, and subverts it through the artful transposition of icons. He exploits kitsch and popular clichés to expose the greater vulgarity that lies, menacing, beneath the veneer of cultivation that affords America's upper class (and those who aspire to it) an illusory sense of superiority. Even more importantly, Colescott flouts taboos in art, sex, race, money, power, and politics. That his methodology involves the skillful manipulation of culturally enshrined visual messages demonstrates his shrewd perception of the role these images play in reinforcing this country's tenuous sense of identity, and defining the power relationships of our social order. By exchanging the racial and sexual identities within familiar compositions, exalting or debasing one group for another, robbing from the rich to give to the poor, Colescott wreaks havoc with the accepted social and sexual order in a manner more cogent—and perhaps in the long run more effective—than more overtly destructive social protest.

---

# The Vietnam War, Political Art, Political Criticism

During the 1930s and up through World War II, socially concerned art was a major category of contemporary art and was consistently shown at exhibitions and written about by critics. During the Cold War era of the late 1940s and 1950s, however, this art all but disappeared; when artists, such as Ben Shahn, did turn to social themes, critics discussed the content in language invoking universalized ideas, for example, the phrase "the human condition."

A political and socially informed art and culture began to emerge again in the late 1950s and 1960s during the period witnessing the Civil Rights movement and the beginnings of the protests against the Vietnam War. This was an oppositional culture committed to action and to changing the consciousness of others so that they, too, would be

committed to action. Julian Beck's and Judith Malina's Living Theater, based in Brooklyn, had such a commitment, much like the WPA "living newspaper" theater productions of the 1930s.

The focus of many oppositional artists in the late 1960s was the Vietnam War. As early as 1965 a group formed in New York called Artists and Writers Protest Against the War in Vietnam (later shortened to Artists and Writers Protest). At the same time a group of artists in Los Angeles formed a similar Artists Protest Committee and conducted demonstrations in the spring and summer of 1965. In early 1966, working closely with New York artists and critics, they sent out a call in five languages for artists to contribute to the "Artists Tower Against the War in Vietnam" to be erected in Los Angeles. In 1967 the New York group organized an "Angry Arts" week. Artists and Writers Protest kept up their agitation and staged various poetry readings and discussions. A protest wall called "Collage of Indignation," consisting of artworks on uniformly sized panels, was set up at the Loeb Student Center of New York University at that time.

By 1969, an umbrella group had formed, the Art Workers' Coalition, which held large mass meetings in lower Manhattan. The most active, street performance group within the AWC was the Guerrilla Art Action Group (GAAG), which carried out a number of agitational performances within museums; another group was the Black Emergency Cultural Coalition, which protested the 1969 exhibition *Harlem on My Mind* at the Metropolitan Museum. The organizers of the BEEC also set up storefront museums.

One action that artists took that was guaranteed to elicit a response from public authorities was to "desecrate" the American flag. In early 1971 the artist Marc Morrell had an exhibition at the Stephen Radich Gallery in Manhattan that consisted of several constructions in which he shaped actual flags, as described by Fred Graham (*Art in America,* March/April 1971), into "a phallus, a cannon barrel, a hanging figure and other expressions of Mr. Morrell's distaste for the Vietnam war." The dealer was fined $500 and the New York City courts upheld the conviction. In 1972 another notorious exhibition, the *People's Flag Show,* held at the Judson Memorial Church gallery, featured the work of many artists. In that case, Jon Hendricks, Jean Toche and Faith Ringgold [see Fig. 6-7] were arrested. Eventually the Supreme Court ruled that such artwork was protected by the First Amendment.

Art historians and art history students also became involved with the antiwar movement, especially after May 4, 1970 when four protestors at Kent State University were shot and killed by National Guardsmen and nine more were wounded. In New York City, graduate students draped the building of the prestigious Institute of Fine Arts with black bunting. Students at Columbia University held mass meetings. Out of their activity came the New Art Association, which also included museum professionals. From the newsletter of the New Art Association grew the *New Art Examiner,* published today in Chicago.

In 1976 several art historians, previously active in the New Art Association, joined with artists from Artists Meeting for Cultural Change to create a collective to protest against the Whitney Museum of American Art, which was mounting the collection of John D. Rockefeller, Jr., in the Bicentennial Year of 1976. *An Anti-Catalog,* 1977, published by the Catalog Committee of the collective is a permanent reminder of their protest against museum practices and canonical art history.

Museum culture—the construction of knowledge through museums—was one of many issues that engaged artists, art historians, critics, and museum workers after the

seum's "Machine" show, on the grounds that an artist had the right to control the exhibition and treatment of his work whether or not he had sold it. Not a revolutionary proposition, except in the art world.

Despite the specific subjects announced for the Open Hearing, taped and later published verbatim by the AWC, the real content of the night was the airing of general complaints about The System, keynoted by Richard Artschwager's use of his two minutes to set off firecrackers instead of talk. The picture of frustrated violence that emerged from this motley cross-section of the art community (seventy artists, architects, film-makers, and critics, a number of them black, spoke) surprised the establishment at which it was aimed. As well it might, since art-world complaints are made loudly, but in the relative privacy of studios and bars, rarely in public. Those who voiced them were immediately accused of opportunism by some of those who remained closet protestants. A number of speakers considered the Museum of Modern Art an unworthy object of artists' attention, but a grudging consensus agreed it was the best place to start if only because it is the seat (in all senses) of power; not enough people, time, and energy were available then to tackle all the museums at once and MOMA qualified by its rank in the world, its Rockefeller-studded Board of Trustees with all the attendant political and economic sins attached to such a group, its propagation of the star system and consequent dependence on galleries and collectors, its maintenance of a safe, blue-chip collection, and, particularly, its lack of contact with the art community and recent art, its disdain for the advice and desires of the artists that filled its void. The demands made in February, 1969, were boiled down from thirteen to eleven in June, and revised slightly as the nine-plus below to apply to all museums in March, 1970:

## A. With Regard to Art Museums in General the Art Workers' Coalition Makes the Following Demands:

1. The Board of Trustees of all museums should be made up of one-third museum staff, one-third patrons and one-third artists, if it is to continue to act as the policy-making body of the museum. All means should be explored in the interest of a more open-minded and democratic museum. Artworks are a cultural heritage that belong to the people. No minority has the right to control them; therefore, a board of trustees chosen on a financial basis must be eliminated.

2. Admission to all museums should be free at all times and they should be open evenings to accommodate working people.

3. All museums should decentralize to the extent that their activities and services enter black, Puerto Rican, and all other communities. They should support events with which these communities can identify and control. They should convert existing structures all over the city into relatively cheap, flexible branch-museums or cultural centers that could not carry the stigma of catering only to the wealthier sections of society.

4. A section of all museums under the direction of black and Puerto Rican artists should be devoted to showing the accomplishments of black and Puerto Rican artists, particularly in those cities where these (or other) minorities are well represented.

5. Museums should encourage female artists to overcome centuries of damage done to the image of the female as an artist by establishing equal representation of the sexes in exhibitions, museum purchases, and on selection committees.

6. At least one museum in each city should maintain an up-to-date registry of all artists in their area that is available to the public.

7. Museum staffs should take positions publicly and use their political influence in matters concerning the welfare of artists, such as rent control for artists' housing, legislation for artists' rights, and whatever else may apply specifically to artists in their area. In particular, museums, as central institutions, should be aroused by the crisis threatening man's survival and should make their own demands to the government that ecological problems be put on a par with war and space efforts.

8. Exhibition programs should give special attention to works by artists not represented by a commercial gallery. Museums should also sponsor the production and exhibition of such works outside their own premises.

9. Artists should retain a disposition over the destiny of their work, whether or not it is owned by them, to ensure that it cannot be altered, destroyed, or exhibited without their consent.

## B. Until Such Time as a Minimum Income Is Guaranteed for All People, the Economic Position of Artists Should Be Improved in the Following Ways:

1. Rental fees should be paid to artists or their heirs for all work exhibited where admissions are charged, whether or not the work is owned by the artist.

2. A percentage of the profit realized on the resale of an artist's work should revert to the artist or his heirs.

3. A trust fund should be set up from a tax levied on the sales of the work of dead artists. This fund would provide stipends, health insurance, help for artists' dependants, and other social benefits.

The extent to which each "member" agrees with each "demand" fluctuates to the point where structural fluidity of the organization itself is unavoidable. The AWC has as many identities as it has participants at any one time (there are no members or officers and its main manner of fund-raising is a "Frisco Circle" at meetings), and the number of participants varies as radically as does their radicality, according to the degree of excitement, rage, guilt, generated by any given issue. It has functioned best as an umbrella, as a conscience and complaint bureau incorporating, not without almost blowing inside out, groups and goals that are not only different, but often conflicting.

\* \* \*

The real value of the AWC is its voice rather than its force, its whispers rather than its shouts. It exists both as a threat and as a "place" (in people's heads, and in real space as a clearinghouse for artists' complaints). Its own silent majority is larger than is generally realized. More important than any of our "concrete" achievements is the fact that whether or not we are popular for it, the Coalition has brought up issues that American artists (since the '30s) have failed to confront together, issues concerning the dignity and value of art and artist in a world that often thinks neither has either.

\* \* \*

*110* ✦ Guerrilla Art Action Group, "Communiqué," leaflet dated November 18, 1969. Courtesy Jon Hendricks.

Grass roots political activists have always communicated their opinions and their actions directly to their audiences through leaflets and hastily mounted posters. This mode of communication influenced many artists in the 1980s and 1990s to make an art that was itself posters or self-stick labels. The Guerrilla Art Action Group (GAAG) was protesting the war in Vietnam and what they perceived as the "Art as usual" attitude of MoMA.

---

## Communique

Silvianna, Poppy Johnson, Jean Toche and Jon Hendricks entered the Museum of Modern Art of New York at 3:10 pm Tuesday, November 18, 1969. The women were dressed in street clothes and the men wore suits and ties. Concealed inside their garments were two gallons of beef blood distributed in several plastic bags taped on their bodies. The artists casually walked to the center of the lobby, gathered around and suddenly threw to the floor a hundred copies of the demands of the Guerrilla Art Action Group of November 10, 1969.

They immediately started to rip at each other's clothes, yelling and screaming gibberish with an occasional coherent cry of "Rape." At the same time the artists burst the sacks of blood concealed under their clothes, creating explosions of blood from their bodies onto each other and the floor, staining the scattered demands.

A crowd, including three or four guards, gathered in a circle around the actions, watching silently and intently.

After a few minutes, the clothes were mostly ripped and blood was splashed all over the ground.

Still ripping at each other's clothes, the artists slowly sank to the floor. The shouting turned into moaning and groaning as the action changed from outward aggressive hostility into individual anguish. The artists writhed in the pool of blood, slowly pulling at their own clothes, emitting painful moans and the sound of heavy breathing, which slowly diminished to silence.

The artists rose together to their feet, and the crowd spontaneously applauded as if for a theatre piece. The artists paused a second, without looking at anybody, and together walked to the entrance door where they started to put their overcoats on over the bloodstained remnants of their clothes.

At that point a tall well-dressed man came up and in an unemotional way asked: " Is there a spokesman for this group?" Jon Hendricks said: "Do you have a copy of our demands?" The man said: "Yes but I haven't read it yet." The artists continued to put on their clothes, ignoring the man, and left the museum.

—According to one witness, about two minutes into the performance one of the guards was overheard to say: "I am calling the police!"

—According to another witness, two policemen arrived on the scene after the artists had left.

*111* ✦    Hans Haacke, "To: All Interested Parties—Re: Cancellation of Haacke one-man exhibition at Guggenheim Museum," leaflet dated April 3, 1971. Collection the author.

Hans Haacke visited the United States in 1961–63, and moved to the United States permanently from his native Germany in 1965. From 1966 to 1969 he showed regularly at the Howard Wise Gallery in New York, a gallery that specialized in kinetic art. Unlike many other artists inspired by ecological systems, Haacke turned increasingly to the political and economic aspects of human social systems. In his 1969 exhibition at the Howard Wise Gallery, he surveyed the residence/birthplace profile of gallery viewers—a project that pointed to the link between social class and artworld participation. Another poll taken at the 1970 *Information* exhibition at the Museum of Modern Art attempted to link the status of museum viewers (members, attendees on the free nights, etc.) with their political attitudes.

**Figure 6-9.**    Hans Haacke, *Shapolsky et al. Manhattan Real Estate Holdings, a Real-Time Social System, as of May 1, 1971,* 1971. Collection of the artist. Photograph courtesy of the artist and the John Weber Gallery, NY. © 2000 Artists Rights Society (ARS), NY/VG Bild-Kunst, Bonn.

Invited to have a Guggenheim Museum exhibition, he proposed to the curator, Edward Fry, and the director, Thomas Messer, an exhibition on "real-time" physical, biological, and social systems. As the exhibition took shape, Messer realized that two components of the exhibition focused on photographs of New York real estate, accompanied by wall labels that listed statistics for each property and named the owners and mortgage holders. One of the two works mentioned in Haacke's second and fourth paragraphs focused on a real-estate group specializing in properties on the lower East Side and in Harlem. Among the mortgage holders was the American Baptist Convention. Messer wrote to Haacke on March 19, 1971, stating that Haacke's "muckraking venture" opened the Museum to charges of libel. In his reply to Messer, Haacke pointed out that the wall labels only had information gleaned from the public record with no interpretive comment, and he proposed excising the names of the real-estate people. Messer cancelled the exhibition anyway, Fry protested the decision and then was fired. Haacke made public all of the letters between himself and Messer. The Press Release, printed here, was distributed at a demonstration held on May 1, 1971, by Haacke's friends on the inside ramp of the Museum.

---

◆

---

From: Hans Haacke

To: All interested parties

Re: Cancellation of Haacke one-man exhibition at Guggenheim Museum

Date: New York, April 3, 1971

---

On April 1, 1971, I was informed by Thomas Messer, Director of the Solomon R. Guggenheim Museum, that he had cancelled the exhibition of my work scheduled to open on April 30, 1971, because three major works for the show dealt with specific social situations. In his opinion, such subjects do not belong in museums unless they come in a generalized or symbolic form.

Despite my offer to modify two of the works in ways that would not affect their integrity, but which eliminated all grounds for Mr. Messer's charge of "muckraking", he persisted in his position.

Mr. Messer is wrong on two counts: First, in his confusion of the political stand which an artist's work may assert with a political stand taken by the museum that shows this work; secondly, in his assumption that my pieces advocate any political cause. They do not.

Two of the three works are presentations of large Manhattan real estate holdings (photographs of the facades of the properties and documentary information collected from the public records of the County Clerk's office). The works contain no evaluative comment. One set of holdings are mainly slum-located properties owned by a group of people related by family and business ties. The other system is the extensive real estate interests, largely in commercial properties, held by two partners.

On March 25, I met Mr. Messer's objections of possible libel and "muckraking" by substituting fictitious names for the principals and generalizing their addresses.

The third work is a poll of the Guggenheim Museum's visitors, consisting of ten demographic questions (age, sex, education etc.) and ten opinion questions on current socio-political issues ranging from "Do you sympathize with Women's Lib?" to "In your opinion, should the general orientation of the country be more conservative or less conservative?" The answers to the questions are to be tabulated and posted daily as part of the piece. Following standard polling practices, I tried to frame the questions so that they do not assert a political stance, are not inflammatory and do not prejudge the answers. I have conducted polls of the art public previously at the Howard Wise Gallery, at the Museum of Modern Art and the Jewish Museum.

The three pieces in question are examples of the "real-time systems" which have constituted my work for many years. A brief explanatory statement about my work was contained in the announcement for my last New York show at the Howard Wise Gallery in 1969:

> "The working premise is to think in terms of systems; the production of systems, the interference with and the exposure of existing systems. Such an approach is concerned with the operational structure of organizations, in which transfer of information, energy and/or material occurs. Systems can be physical, biological or social, they can be man-made, naturally existing or a combination of any of the above. In all cases verifiable processes are referred to."

Since the Guggenheim invitation resulted from that show, Mr. Messer could have had no doubts about the nature of my work. In turn, I had no reason to suspect that any of my work was unacceptable to the Museum. Reference to our social and political environment by many different artists and in many different forms are a frequent feature at exhibitions in New York Museums.

It was only during this past January that I learned, for the first time and after working on the show for more than 6 months, that Mr. Messer had any qualms about my work with social systems, and it was not until mid-March, that he told me specifically that the Guggenheim Museum had a strict policy of barring work that referred to the social environment in other than symbolic, indirect or generalized ways.

After accepting the Guggenheim inviation a year ago, I deferred invitations to three other museum shows in Paris, Krefeld and Buenos Aires, so that I could concentrate my energies upon this project.

If I wanted to remain true to my philosphical premises, I could not comply with Mr. Messer's insistent demands to essentially modify or eliminate the three works. Verifiability is a major ingredient of the social, biological and physical systems which I consider as mutually complementary parts of an encompassing whole.

Whatever one's esthetic opinion may be, it would seem to be obvious that the Museum has no right to ban or censor the work of an invited artist just because it may deal with political or social issues. By doing so, Mr. Messer is guilty of censorship and infringes on the artist's right to free expression within the walls of the Guggenheim Museum.

Mr. Messer has taken a stand which puts him completely at variance with the professed attitudes of all of the world's major museums, except for those located in countries under totalitarian domination and must put him in potential conflict with every artist who accepts an invitation to show his work at the Guggenheim Museum.

---

*112* ✦ Max Kozloff and John Coplans, "Art Is a Political Act," *The Village Voice,* January 12, 1976, p. 71.

During the 1970s the major political imbroglio in the world of art magazine publishing occurred in December 1975, when Max Kozloff, the Executive Editor of *Artforum,* published an editorial statement calling attention to the group of essays in that month's issue—essays that analyzed the politics of art production. Kozloff's statement reads in part:

> The articles in this issue imply that certain aspects of authoritarian art are broader in scope and more effective in impact than has been supposed. [. . .]
> Even from these few articles, an important theme emerges that must challenge art criticism: the degree to which "high" cultural artifacts are designed or utilized to uplift, indoctrinate, or intimidate a mass audience often rivals the extent to which a mass medium is thoroughly colonized as a technique of control and domination. Marxist historians, of course, have long insisted on this "worldliness," which the American professoriate prefers to see in a more spiritual light. [. . .]
> American artists, historians and critics may not find the perspective of the following essays particularly congenial. Where the profession wants to snuff out, these writers desire to expand our insight into the political values art activates: an act of historical synthesis. . . .

Kozloff then briefly summarized the articles by Allan Sekula, David Antin, Carol Duncan, Manuela Hoelterhoff, and Peter Walch.

Hilton Kramer, chief critic of the *New York Times* fired off a Sunday article (December 21, 1975), in which he excoriated what he saw as 1960s political rhetoric, but now "institutionalized" and "more raucous, ambitious and vulgar" in the December *Artforum:* "I speak of the new editorial regime at *Artforum* magazine, in the pages of which a muddled and strident Marxism, insistent upon a tendentious sociopolitical analysis of all artistic events and deeply suspicious of all esthetic claims, has now routed all but the last traces of the formalist criticism that was once a house specialty in that journal." After briefly criticizing the individual essays, Kramer ends his article by doubting if advertisers "will support its new line," and applauds the resignation of Annette Michelson, Rosalind Krauss, and Joseph Masheck as Associate Editors of *Artforum* and their plans to initiate a new journal, *October.*

After Kramer's attack, Charles Cowles, the owner of *Artforum,* did not renew the contract of John Coplans, the editor who had jointly shaped editorial policy with Kozloff. Kozloff in solidarity, resigned.

In the meantime, letters poured into the *New York Times,* several of which were published in the January 4, 1976 "Letters" column. David Bourdon published an article in the January 5, 1976, *Village Voice,* repeating many of Kramer's points.

In response and to clarify their position, ex-editors Max Kozloff and John Coplans published a rebuttal in *The Village Voice.*

---

What is it that frightens and angers David Bourdon ("*Artforum* Goes Political," *Voice,* January 5) about recent editorial policy at *Artforum,* "the nation's most influential journal for contemporary art"? Since we have also steamed up Hilton Kramer of the *New York Times,* readers may like to know what has really brought these gentlemen to a boil. Is this simply another catfight among critics? No!

In the last year, *Artforum* has published some articles that have dealt critically with aspects of the market system and institutional structures of the art world. Other more theoretical pieces have appeared, questioning beliefs that have long insulated the avant-garde. We've run discussions of popular culture, the treatment of the image of women and feminist issues in art, the politics of filmmakers, problems of African and Peruvian art, scholarly essays on photography, as well as studies of historical retrospectives and art-in-progress. Reviews of gallery shows continue as before. To us, this roster of subjects reflects characteristic interests of 1975, broached in other art journals as well.

The articles in the December *Artforum,* though not originally planned as an ensemble, happened to address themselves to unfree conditions in art (Nazi, Maoist, American television, Napoleonic painting), and potently illuminated art's bondage to strong governmental, corporate, and museological agencies. In short, the overall contents of the magazine typify the dissent to which modern artists are generally committed. [. . .]

Messrs. Bourdon and Kramer do not form a movement, but they do reflect a syndrome. Both their articles dwelled on the following points: (1) Dismissal of our move toward sociopolitical analysis as faddist—"in" as compared to "out". (It

must be an odd fashion that has taken us on a course, as Bourdon says, "much more inflammatory and potentially ruinous than mere aesthetics"—so inflammatory that we have been socked with an $8 million libel suit for criticizing some architects.) Nor do these critics acknowledge the squeezed economy that yokes artists into miserable competition with each other, and the turmoil in this country that has radicalized so many of them over the years. To be concerned with these matters, apparently, is to betray an inexplicable, doomsday resentment of the status quo. (2) A tactical bind. In the '60s, legitimizing a dozen or so artists and their careers according to a reductive view of art history was very wrongheaded of *Artforum*; today, regarding art ideologies, including taste hierarchies, as valid objects of study rather than as positions to endorse or reject, is plain horrifying. In other words, our erstwhile bully-boy methods were preferable to enlightened alternatives. (3) A complete refusal to discuss the findings and intellectual contents of any article in the issue under attack, an avoidance most startling in view of the rhetoric unloaded against them. (4) Pleased anticipations that the new, unblindered *Artforum* will lose advertisers. (5) Plugs for a journal to be founded by disgruntled and departed *Artforum* writers, bent on continuing the formalist tradition.

We feel that the complacent, decaying agencies and shopworn myths of the art world are more noteworthy than discords between critics. One observes museum spaces increasingly hired out to private galleries and collectors; museum staffs forced to bow under improper pressures; critics anesthetizing themselves. Such deeds compromise the independence and good faith the public has a right to expect from the art scene.

Underlying these dysfunctions are more serious difficulties, located as usual in the head. What is the ground upon which one may erect a *critical* understanding, if not the plane of human conduct, in all its resources and predicaments? Works of modern art confront us with the issue of freedom, and the penalties and guilts that go with freedom. How dismaying to recognize that fact when it is much easier to avoid the reckonings of authentic experience by passively maintaining the status quo. Yet the overlapping interests of writers and dealers are coincidental, not ordained. And critics have responsibilities to a wide range of readers, quite aside from their professional alliances.

The December *Artforum* threw Mr. Kramer into a red-baiting tantrum. For Mr. Bourdon, the editors were shown to be philistines, people who cannot love contemporary art, and have turned spiteful. If he had looked again at that issue, instead of nattering on, he would have noticed an effort to scrape away stale eulogy in the literature about works of art, past and present, so as to retrieve their impact. And if negative discoveries are made in the process, they, too, are sensitizing, and contribute to our knowledge of ourselves as well as art.

Created by vulnerable fellow creatures, modernism cannot always be humane. It is disappointing to be tagged as critically reactionary whenever this is observed, or when strengths are found outside the vanguard tradition. The avant-garde defines itself as alive only when credible in dissent, and when it voices fresh values. Any time it reaffirms those values, it regains its striking edge.

---

**113** ✦ Joseph Kosuth, "The Artist as Anthropologist," *The Fox* 1 (1975):18–30.

*The Fox* was a theoretical journal edited in New York by a group of artists—Sarah Charlesworth, Michael Corris, Preston Heller, Joseph Kosuth, Andrew Menard, and Mel Ramsden—affiliated with the London group *Art and Language.* To them, conceptual art was intimately linked to linguistics and to ideology. The first issue of *The Fox,* printed on newsprint in 1975, declared on the first page: "It is the purpose of our journal to try to establish some kind of community practice. Those who are interested, curious, or have something to add (be it pro or con) to the editorial thrust . . . the revaluation of ideology . . . of this first issue are encouraged, even urged, to contribute to the following issues" [ellipses in original]. The second issue was also published in 1975; the third and final issue, in 1976. The articles written for the three issues, like those of the London-published *Art and Language,* were informed by a Marxist approach.

Born in Ohio, Joseph Kosuth moved to New York in the mid-1960s and developed a conceptual art that used photographs and dictionary texts. In this article Kosuth proposes that the artist become an anthropologist by studying the language and the patterns of his or her own social group and convert the findings into artwork. Kosuth felt that the artist risks perpetuating an oppressive bourgeois culture by *not* offering a sharp critique of it. He was critical of recent art, such as photo-realism, which celebrated "objectivity" and therefore glorified the status quo. He also differentiated between conceptual art by "stylists" concerned with form (he may have had Sol LeWitt in mind) and conceptual art by "theorists"—those attempting to work out a dialectical materialist and anthropological approach within their art—using both language and images. The following excerpts are by Kosuth; interspersed in his article are excerpts from the writings of Albert Einstein, Karl Polanyi, Martin Jay, Max Weber, William Leiss, Stanley Diamond, Bob Scholte, Alvin Gouldner, Max Horkheimer, Edward Sapir, and Johannes Fabian.

This essay has been reprinted in Joseph Kosuth, *Art after Philosophy and After: Collected Writings, 1966–1990,* ed. with introduction by Gabriele Guercio (Cambridge, MA: The MIT Press, 1991).

---------------------✦---------------------

\* \* \*

### Part II
### Theory as Praxis: A Role for an "Anthropologized Art"

> *The highest wisdom would be to understand that every fact is already a theory.*

> —Goethe

1. The artist perpetuates his culture by maintaining certain features of it by "using" them. The artist is a model of the anthropologist *engaged.* It is the implosion Mel Ramsden speaks of, an implosion of a reconstituted socio-culturally mediated overview. [. . .]

2. Art in our time is an extension by implication into another world which consists of a social reality, in the sense that it is a believable system. It is this holding up what is often said to be a "mirror" to the social reality which attempts to be believable and real. Yet the mirror is a *reference* which we take as being real. To the extent that we take it as being real, it is real. It is the manifestations of internalizations which connect an "anthropologized art" to earlier "naive" forms of art activity. Our "non-naiveness" means we are aware of our activity as constituting a basis for self-enlightenment, self-reflexivity—rather than a scientistic attempt at presenting objectivity, which is what a pictorial way of working implies. Pictorial art is an attempt to depict objectivity. It implies objectivity by its "other world" quality. The implication of an "anthropologized art," on the other hand, is that art must internalize and *use* its social awareness. The fallacy of Modernism is that it has come to stand for the culture of Scientism. It is art outside of man, art with a life of its own. It stands and fails as an attempt to be objective. [. . .]

3. Thus the crisis Modernist abstract painting finds itself in is that it can neither provide an experientially rich fictive reality, the kind of quasi-religious "other world" believability which the traditional form of painting was still capable of maintaining earlier on in the Modernist period *nor*, by virtue of its morphological constriction and traditional semantic form has it been able to contribute *in any way* to the emerging post-Modern debates of the late sixties and early seventies. Modernist abstract painting now finds itself as a collapsed and empty category, perpetuated out of nostalgia that parades as a self-parody, due to the necessities of bankrupt mythic historical continuums, but ultimately settling for its meaning in the marketplace.

\* \* \*

7. Because the anthropologist is outside of the culture which he studies he is not a part of the community. This means whatever effect he has on the people he is studying is similar to the effect of an act of nature. He is not part of the social matrix. Whereas the artist, as anthropologist, is operating within the same socio-cultural context from which he evolved. He is totally emmersed, [sic] and has a social impact. His activities embody the culture.

\* \* \*

9. Artistic activity consists of cultural fluency. When one talks of the artist as an anthropologist one is talking of acquiring the kinds of tools that the anthropologist has acquired—insofar as the anthropologist is concerned with trying to obtain fluency in another culture. But the artist attempts to obtain fluency in his *own* culture. For the artist, obtaining cultural fluency is a dialectical process which, simply put, consists of attempting to affect the culture while he is simultaneously learning from (and seeking the acceptance of) that same culture which is affecting him. The artist's success is understood in terms of his praxis. Art *means* praxis, so any art activity, including "theoretical art" activity is praxiological. The reason why one has traditionally not considered the art historian or critic as artist is that because of Modernism (Scientism) the critic and art historian have always maintained a position outside of praxis (the attempt to find objectivity has necessitated that) but in so doing they made culture

*nature.* This is one reason why artists have always felt alienated from art historians and critics. [. . .]

As we said, the anthropologist has always had the problem of being outside of the culture which he is studying. Now what may be interesting about the artist-as-anthropologist is that the artist's activity is not *outside,* but a mapping of an internalizing cultural activity in his *own* society. The artist-as-anthropologist may be able to accomplish what the anthropologist has always failed at. A non-static "depiction" of art's (and thereby culture's) operational infrastructure is the aim of an anthropologized art.

\* \* \*

## Part III Epilogue

*The savage has his life within himself; civilized man, in the opinions of others.*

—Jean-Jacques Rousseau

1. [. . .] In the face of the conspicuous absence of any sophisticated (that is, real in terms of its complexity) alternative Marxist model, we must use as a given the model of art as it has come to us in this Post-Modern period. We cannot do so uncritically, but in terms of an "anthropologized art" such a critique is (along with the study of primitive culture) basic to the activity.

2. It is almost truistic to point out that the "non-naive" artist-as-anthropologist is forced to become politically aware. This should not be confused with art which uses political subject-matter or which estheticizes the necessity of political action. "Protest art" is not artistically radical (it is oblivious to the philosophical self-reflective historical relationship between the artist and the concept of art in this society) but is more likely an *ad hoc* expressionistic ad media appeal to liberalism.

3. The life-world of abstracted experience of which I speak would be total and all embracing if not for the fact that we are all involved within the context of a culture, which means that insofar as the culture consists of a generalization of experience which we have grown up in (and have been mediated by) then that generalization of experience becomes an aspect of us. It orders and forces our experiencial world to correlate to and exemplify the generalized experience.

\* \* \*

8. The artist-as-anthropologist, as a student of culture, has as his job to articulate a model of art, the purpose of which is to understand culture by making its implicit nature explicit—internalize its "explicitness" (making it, again, "implicit") and so on. Yet this is not simply circular because the agents are continually interacting and sociohistorically located. It is a non-static, in-the-world model.

\* \* \*

---

**114** ✦  Donald B. Kuspit, "Art of Conscience: The Last Decade," in *Art of Conscience: The Last Decade.* (Dayton, OH: Wright State University, 1981).

Donald Kuspit has doctoral degrees in both art history and philosophy and was also trained in psychoanalysis. While much of his recent criticism makes use of psychoanalyt-

ical interpretations, he has also had a long-term interest in the subject of art and politics and has curated exhibitions that allow him to explore issues in political art. In this essay, written for the catalogue to an exhibition at Wright State University, he reflects on two generations of political artists: the generation of artists born in the 1920s—Rudolf Baranik, Leon Golub, Nancy Spero, and May Stevens—and the generation born in the late 1930s and 1940s—Vito Acconci, Hans Haacke, Adrian Piper, and Martha Rosler. He points out that avant-garde art often means "political as well as artistic radicalism."

◆

Like Faust who had two hearts in conflict in his breast, modernism has always had two arts competing in its breast. The beat of one, the art of conscience, has been smothered in the sound of the other, the art of pure form, which imagines itself to be redemptive of art as such. Despite this, the art of conscience persists. Its beat has been strong since the realism of Courbet and echoes as far afield as the heroic abstractions of Barnett Newman. More to the point, bringing together some of the political art of the 70s makes it clear that not only is modernist art of conscience alive and well, but it is more important in its impact than 70s art of pure form, especially the neopeinture pure that has dominated the last half of the decade. It is the art of pure form that has come to seem sentimental, while the art of conscience burgeons with unexpected meanings for art as well as life. The day when "avant-garde" meant political as well as artistic radicalism—when artistic radicalism was recognized as inherently political—is again upon us. Once again the body politic is the major stimulus for significant artistic change, the permutations of a no longer radical artistic avant-garde, which has become business as usual, being replaced by the mutation of an explicitly political art of protest. The system of radical abstract art had to "give" in the face of momentous historical events, and the emergence of political art represents that "giving." It may be a safety valve for the social system as a whole, but more visibly it represents the beginning of a change in direction and the emergence above ground of the art of conscience that has always been underground.

This is not to deny the validity of art of pure form, but only to note that modernist art of conscience uses its techniques to better advantage, making style count in a more than aesthetic way. Of course for many people a disinterested sensation, aesthetic purity, is the be-all and end-all of art. But . . . with the recognition of the inadequacies of the art of pure form as defined modernistically by Clement Greenberg, there is practical pressure to find an alternative to it—to find an art that can bypass the increasing inertia of purist production and the ensuing ennui it evokes. [. . .]

In the 70s, then, partly under the pressure of social events, partly in deliberate search for an alternative to an increasingly sterile principle of art, art of conscience emerges with a new vigor and rigor, in effect restoring what since 30s' Social Realism was regarded as traditional American art. [. . .]

The art of this exhibition falls into two groups: one, that of Rudolf Baranik, Leon Golub, Nancy Spero, and May Stevens, more (but far from exclusively) traditional in its means; the other, that of Vito Acconci, Hans Haacke, Adrian Piper, and Martha Rosler, more vanguard on a formal or stylistic level. All eight artists offer an information-based art. Each starts from the morally indifferent abundance of information available in a society of free speech, making a selection, an image or text, that becomes a moral point of

departure. Above all, a sense of contradictory information, information from the same frame of reference, becomes a means of creating art of conscience. This sense of contradiction is most explicit in the artists of the second group. Acconci's piece is an explicit demonstration of inescapable contradiction, and the works of Haacke, Piper, and Rosler are dominated and framed by an awareness of the discrepancy between the ideal and the historical, the emotionally expected and the socially experienced. In Haacke, Piper, and Rosler, information about reality is used to disillusion us, thereby demythologizing it, showing reality with a nakedness that makes it unbearable and yet liberating, "consciousness raising." All three extend the Enlightenment spirit of empirical research that has made for "realistic" understanding. Haacke's demonstration that, by the corporations' own admission, their pursuit of culture is not as disinterested as it claims to be (profit rather than purity being the motive that wins out); Piper's attempt to put the white bourgeoisie on its uneasy guard, even knock it off balance, when confronted by black in a kind of interrogation chamber (*Aspects of the Liberal Dilemma*); and Rosler's empathetic mockery of such pathetic, socially approved "ideals" as being a gourmet cook, having culture, the "new woman"—all are important examples of the way seemingly neutral information can create confrontation, become a powerful explosive. Each reveals, in an indirect yet influential way, the questionableness of American society, for the doubts raised by the contradictions cannot be erased. Again, it must be emphasized that the discrepancy between appearance and reality in which their art revels is the result of an obvious presentation of information.

<p style="text-align:center">* * *</p>

The stridency or blatancy of Baranik, Golub, Spero, and Stevens, in contrast to the calmer if more sinister demonstrations of Acconci, Haacke, Piper, and Rosler, seems to indicate not only a more militant and as such more optimistic spirit, but also a traditional belief in a kind of absolute, "striking" imagery, as profound in its personal meaning as it is unique in public appearance. And yet the demonstrative and obviously empirical character of Acconci, Haacke, Piper, and Rosler makes for a more confrontational art—an art which is a more direct social action and public communication than the visually aggressive works of Baranik, Golub, Spero, and Stevens. That visual aggression, with its implication of anguished possession of reality, assumes the traditional expressionist belief in a suffering self—the primacy of suffering over the data and cause of suffering. Suffering is the most cherished and sacred of private possessions—this art almost seems to have a vested interest in suffering. It becomes subconsciously absorbing as well as consciously experienced and recorded, to the extent that the social reality that is its origin seems instrumental and even incidental to it. In other words, the art of Baranik, Golub, Spero, and Stevens is a kind of participation mystique in social suffering, while that of Acconci, Haacke, Piper, and Rosler conveys—by the very directness with which it deals out and manipulates its data, which is more or less allowed to speak for itself—a certain detachment from the "misery" that is its subject matter. The sense of being caught in a social trap, rather than social suffering as such, is the subject matter of Acconci, Haacke, Piper, and Rosler. It is in this sense a much more practical matter-of-fact art than that of Baranik, Golub, Spero, and Stevens, which is more meditative. Their art seems more frustrated by the facts it deals with than that of Acconci, Haacke, Piper, and Rosler, and, for all its activism, seems to hypostatize suffering as a coign of vantage from which to perceive reality—

the secret yet true perspective on all reality. In fact, their art seems to speak with a more personal voice than that of Acconci, Haacke, Piper, and Rosler, where the personal seems less evident because it is presented as a fundamentally social product.

*  *  *

The artist must be aware of a total social system, not simply share a current social interest, conceived as a temporary "hot spot" or limited breakdown of the system. That is, there must be an awareness of the system as a structure of contradictions or conflicts, not simply a set of competing social interests. The one is the world historical approach, the other the topical approach. War, exploitation of culture, racism, and sexism are not limited disturbances that can be contained and that imply vested interests that sooner or later can be satisfied, but the self-contradictions that are the condition of the system's existence. The contemporary art of conscience—the word is used with its ambiguous meaning in French, implying simultaneity of conscience and consciousness, and consciousness as a form of conscience—tells us that the contradictions of the social system are inescapable, that privacy is a form of political existence, and that the investigation of the workings of what Durkheim called social coercion can produce a major art. Indeed such subject matter is the most resistant to artistic treatment, and so the most worthy of it. [. . .]

---

## Black Arts Movement

Against the background of the Civil Rights movement and the protests against the war in Vietnam, most African American artists during the 1960s and 1970s struggled to reconcile their own racial identities with their philosophy of what art should be or might become. In what ways could they, as African American artists, confront the "double consciousness" that W.E.B. Du Bois spoke about? (See Reading 8.) Or should they forget about the "American," that is the "white," European aesthetic part of the equation, in order to focus on forging a vital, nationalist "black art" that would absorb African aesthetic legacies as well as African American folk and street culture? Or should they actively propagandize against discrimination and for Black Power with whatever aesthetic choices seemed most relevant? Moreover, who should be the audience for such works? (See Readings 35 and 36 for 1920s versions of the debates.) Books avidly read at the time—for example, Stokely Carmichael's and Charles V. Hamilton's *Black Power: The Politics of Liberation in America* (1967)—encouraged people to transform their consciousness as well as to become activists.

African American playwrights, poets, and writers, such as Addison Gayle, Jr., and Larry Neal, advocated new artistic styles to match a new consciousness of power and self-esteem. William L. Van Deburg, in *New Day in Babylon: The Black Power Movement and American Culture, 1965–1975* (1992), noted: "Having declared the oppressor's aesthetic to be clinically dead, Black Arts writers abandoned 'proper' literary style, creating their own communicative medium. Poets, for example, attempted to capture the flavor of black American speech—its sounds, rhythms, and style—in verse that was written for performance. Presented with all the improvisational spirit and flair of a backroom jam session, the new black expression often lapsed into exultant screams and jazz-like scats." Artists attempted to create an analogous situation, by recycling pictorial images from

popular magazines (e.g., Romare Bearden with his collages), or by using found objects assembled into three-dimensional boxes (e.g., Betye Saar) or welded together as sculptural pieces (e.g., Mel Edwards).

Most significantly, artists got together to form groups to deal with civil-rights social issues and to discuss ways that art might be at the service of a liberated consciousness. Romare Bearden, inspired by the March on Washington in 1963, invited to his Greenwich Village studio a number of his friends—Charles Alston, Ernest Crichlow, Reginald Gammon, Felraith Hines, Alvin Hollingsworth, Norman Lewis, Richard Mayhew, Hale A. Woodruff, and Emma Amos, the only woman. They formed the group called Spiral and mounted an exhibition, *Black and White,* in 1965. Other artists joined, including Merton Simpson, Earl Miller, William Majors, Perry Ferguson, Calvin Douglass, and James Yeargens. Spiral seems to have had its biggest impact on Bearden himself, for he embarked on a project—originally suggested as a collective project—to make a socially responsive art using collage techniques.

In Harlem another set of artists formed a group in 1965 called Weusi (Swahili for "people") and established a gallery collective called Nyumba Ya Sanaa. In Chicago a group had already existed called Organization of Black American Culture (OBAC), which painted the *Wall of Respect* mural on Chicago's South Side (destroyed in 1971). In 1968 five members of OBAC decided to call themselves the Coalition of Black Revolutionary Artists (COBRA). A further name change resulted in African Commune of Bad Relevant Artists (AfriCOBRA), which also mounted exhibitions. And in 1971 Faith Ringgold founded the group "Where We At," which addressed feminist issues of African American women.

The late 1960s also saw the creation of the Studio Museum in Harlem (1967) and the Museum of the National Center of Afro-American Artists (1968) in Boston. But traditional museums had a rocky relationship with African American activists. In January 1969 the Metropolitan Museum of Art mounted *"Harlem on My Mind": The Cultural Capital of Black America, 1900–1968,* which elicited a storm of protests. Outraged artists Benny Andrews, Russ Thompson, Cliff Joseph, and Reginald Gammon hastily organized the Black Emergency Cultural Coalition (BECC) to protest the Metropolitan's show. As JoAnn Watley expressed it, the BECC objected to "the Museum's brazen omission of black expertise in setting up the show—which they felt had deteriorated into a white man's view of Harlem, emphasizing socio-economic aspects at the cost of all esthetic considerations" (*ABA: A Journal of Affairs of Black Artists,* No. 1, 1971).

The Whitney Museum also came under attack in 1971 when staff curator Robert Doty mounted *Contemporary Black Artists in America,* which was picketed by BECC because of the Whitney's failure to invite an African American to curate the show. In solidarity with BECC several African Americans decided to withdraw from the show at the last minute. After the exhibition, in a show of support, the Whitney began a series of solo exhibitions by African American artists.

Finally, in 1976, the artist and art historian David Driskell organized *Two Centuries of Black American Art,* which situated contemporary African American art in a historical framework. The Studio Museum's exhibition of 1985, *Tradition and Conflict: Images of a Turbulent Decade, 1963–1973,* focused on both the history and the art of what was indeed "a turbulent decade."

**Figure 6-10.** Elizabeth Catlett, *Malcolm X Speaks for Us,* 1969. Lithograph, 37 3/8 × 27 1/2 in. © Elizabeth Catlett/VAGA, NY, NY.

*115* ✦ Amiri Baraka [Le Roi Jones], "A Poem for Black Hearts" [April 1965], *Negro Digest* 14, no. 11 (September 1965):58.

Amiri Baraka was born Le Roi Jones in Newark, New Jersey, and after high school enrolled for a time in Howard University, where he studied with poet Sterling A. Brown. Baraka served in the Air Force and then moved to Greenwich Village in 1957, where he met Diane DiPrima, Allen Ginsberg, Gregory Corso, other Beat poets, and jazz musicians. During the next few years he wrote music criticism and poetry. By the late 1960s he had become a major American poet and playwright.

In "A Poem for Black Hearts" Baraka refers to Malcolm X (1925–1965), a militant and controversial minister who inspired African Americans to take pride in themselves and their accomplishments. Malcolm X was gunned down on the stage of the Audubon Ballroom in Harlem as he was preparing to speak; the motives and identities of his assassins have never been clarified. Baraka wrote the poem shortly thereafter. Malcolm X inspired a number of artists, such as Elizabeth Catlett, who incorporated his image into their artwork [see Fig. 6-10].

✦

### A Poem for Black Hearts

*For Malcolm's eyes, when they broke*
*the face of some dumb white man. For*
*Malcolm's hands raised to bless us*
*all black and strong in his image*
*of ourselves, for Malcolm's words*
*fire darts, the victor's tireless*
*thrusts, words hung above the world*
*change as it may, he said it, and*
*for this he was killed, for saying,*
*and feeling, and being/ change, all*
*collected hot in his heart, For Malcolm's*
*heart, raising us above our filthy cities,*
*for his stride, and his beat, and his address*
*to the grey monsters of the world, For Malcolm's*
*pleas for your dignity, black men, for your life,*
*black men, for the filling of your minds*
*with righteousness, For all of him dead and*
*gone and vanished from us, and all of him which*
*clings to our speech black god of our time.*
*For all of him, and all of yourself, look up,*
*black man, quit stuttering and shuffling, look up,*
*black man, quit whining and stooping, for all of him,*
*For Great Malcolm a prince of the earth, let nothing in us rest*
*until we avenge ourselves for his death, stupid animals*
*that killed him, let us never breathe a pure breath if*
*we fail, and white men call us faggots till the end of*
*the earth.*

---

*116* ✦ Larry Neal, "Any Day Now: Black Art and Black Liberation," *Ebony* 24, no. 10 (August 1969):54–58, 62.

Larry Neal wrote on the black arts movement as it was unfolding in the late 1960s. With Amiri Baraka in 1968 he edited *Black Fire,* a collection of poetry, and in 1969 published *Black Boogaloo: Notes on Black Liberation.*

In November 1945 Chicago publisher John H. Johnson debuted the first issue of the monthly magazine *Ebony,* modeled on *Life* and *Look.* Through photo spreads and good journalism it reached a growing African American readership under the editorship of Lerone Bennett, Jr. *Ebony* featured essays on the growing black arts movement in the late 1960s and 1970s.

Neal's essay expresses the current quarrel among black activists toward W.E.B. Du Bois's idea of "double consciousness." To Neal, the black woman's "natural" hair style meant a rejection of "double consciousness" in favor of Eldridge Cleaver's demand for a "unitary image" for African Americans. To Neal, black "nationalism" is a state of mind,

collectively felt, that will emerge after psychic liberation from the white man's culture. Nevertheless, many conservative people were horrified when they heard or saw African Americans vociferously declaring their independence from the social and political status quo (as the Black Panthers were doing); leftists worried that black nationalism would divide the working class along racial lines. Black feminists had their own objections and became increasingly critical of the machismo of the black arts movement.

◆

We bear witness to a profound change in the way we now see ourselves and the world. And this has been an ongoing change. A steady, certain march toward a collective sense of who we are, and what we must now be about to liberate ourselves. Liberation is impossible if we fail to see ourselves in more positive terms. For without a change of vision, we are slaves to the oppressor's ideas and values—ideas and values that finally attack the very core of our existence. Therefore, we must see the world in terms of our own realities.

Black Power, in its most fundamental sense, stands for the principle of Self-Definition and Self-Determination. Black Power teaches us that we must have ultimate control over our own lives. It teaches us that we must make a place on this Earth for ourselves, and that we must construct, through struggle, a world that is compatible with our highest visions.

\* \* \*

Now along with the Black Power movement, there has been developing a movement among Black artists. This movement we call the Black Arts. This movement, in many ways, is older than the current Black Power movement. It is primarily concerned with the cultural and spiritual liberation of Black America. It takes upon itself the task of expressing, through various art forms, the Soul of the Black Nation. And like the Black Power Movement, it seeks to define the world of art and culture in its own terms. The Black Arts movement seeks to link, in a highly conscious manner, art and politics in order to assist in the liberation of Black people. The Black Arts movement, therefore, reasons that this linking must take place along lines that are rooted in an Afro-American and Third World historical and cultural sensibility. By "Third World," we mean that we see our struggle in the context of the global confrontations occurring in Africa, Asia and Latin America. We identify with all of the righteous forces in those places which are struggling for human dignity.

Lately, Black artists have been concerned with the development, for lack of a better term, of a "Black Esthetic." Esthetic sounds like some kind of medical term. It might just as well be for all that its dictionary definition tells us: "Esthetic: 1) A branch of philosophy relating to the nature of forms of beauty, especially found in the fine arts. 2) Study of the mental and emotional responses to the beauty in art, nature, etc." —*Standard College Dictionary.*

For the most part, this definition is worthless.

\* \* \*

The Black Arts movement seeks to give a total vision of ourselves. Not the split vision that Du Bois called the "Double Consciousness": ". . . this sense of always looking at one's self through the eyes of others, of measuring one's soul by the tape of a world that looks on in amused contempt and pity. One ever feels his two-ness—an

American, a Negro—two souls, two thoughts, two unreconciled strivings; two warring ideals in one dark body, whose dogged strength alone keeps it from being torn asunder . . . "

These words are from *The Souls of Black Folk* which was published in 1903. Now, in 1969, Du Bois' sons and daughters in the Black Arts movement go forth to destroy the Double Consciousness, go forth to merge these "warring ideals" into One Committed Soul integrated with itself and taking its own place in the world. Can you dig it?

But this is no new thing. It is the road that all oppressed peoples take enroute to total liberation. In the history of Black America, the current ideas of the Black Arts movement can be said to have their roots in the so-called Negro Renaissance of the 1920s. The '20s was a key period in the rising historical and cultural consciousness of Black people. This period grooved with the rise of Garvey's Black Nationalism, danced and made love to the music of Louis Armstrong, Bessie Smith, Jelly Roll Morton, King Oliver, Perry Bradford, Fats Waller and the Holy Father, Duke Ellington. There was a flowering of black poets, writers and artists. And there was the ascendancy of hip, blues-talking Langston Hughes who came on singing songs about Africa, Haiti, and Harlem. . . . [. . .]

There were other writers of that period: Claude McKay, Jean Toomer, James Weldon Johnson, Countee Cullen . . . But Langston best personifies the Black artist who is clearly intent upon developing a style of poetry which springs forcefully and recognizably from a Black life style; a poetry whose very tone and [concrete] points of reference is informed by the feelings of the people as expressed in the gospel and blues songs.

It is here that any discussion of a Black esthetic must begin. Because Black music, in all of its forms, represents the highest artistic achievement of the race. It is the memory of Africa that we hear in the churning energy of the gospels. The memory of the Motherland that lingers behind the Christian references to Moses, Jesus and Daniel. The Black Holy Ghost roaring into some shack of a church in the South, seizing the congregation with an ancient energy and power. The Black Church, therefore, represents and embodies the transplanted African memory. [. . .]

At the pulsating core of their emotional center, the blues are the spiritual and ritual energy of the church thrust into eyes of life's raw realities. Even though they appear to primarily concern themselves with the secular experience, the relationships between males and females, between boss and worker, between nature and Man, they are, in fact, extensions of the deepest most pragmatic spiritual and moral realities. Even though they primarily deal with the world as flesh, they are essentially religious. Because they finally celebrate life and the ability of man to control and shape his destiny. The blues don't jive.

* * *

So when *we* speak of an esthetic, we mean *more* than the process of making art, of telling stories, of writing poems, of performing plays. We also mean the destruction of the white thing. We mean the destruction of white ways of looking at the world. For surely, if we assert that Black people are fighting for liberation, then everything that we are about, as people, somehow relates to it.

[. . .]

So the function of artistic technique and a Black esthetic is to make the goal of communication and liberation more possible. Therefore, Black poets dig the blues and Black music in order to find in them the means of making their address to Black America more understandable. The Black artist studies Afro-American culture, history, and politics and uses their secrets to open the way for the brothers with the heavy and necessary political rap. We know that art alone will not liberate us. We know that culture as an abstract thing within itself will not give us Self-Determination and Nationhood. And that is really what we all want, even though we fail often to admit it openly. We want to rule ourselves. Can you dig it? I know you can.

But a cultureless revolution is a bullcrap tip. It means that in the process of making the revolution, we lose our vision. We lose the soft, undulating side of ourselves—those unknown beauties lurking rhythmically below the level of material needs. In short, a revolution without a culture would destroy the very thing that now unites us; the very thing we are trying to save along with our lives. That is, the *feeling* and *love-sense* of the blues and other forms of Black music. The *feeling* of a James Brown or an Aretha Franklin. That is the *feeling* that unites us and makes it more possible for us to move and groove together, to do whatever is necessary to liberate ourselves. John Coltrane's music must unquestionably be a part of any future revolutionary society, or something is diabolically wrong with the fools who make the revolution.

\* \* \*

The Black Arts movement is rooted in a spiritual ethic. In saying that the function of art is to liberate Man, we propose a function for art which is now dead in the West and which is in keeping with our most ancient traditions and with our needs. Because, at base, art is religious and ritualistic; and ritual moves to liberate Man and to connect him to the Greater Forces. Thus Man becomes stronger psychically, and is thus more able to create a world that is an extension of his spirituality—his positive humanity. We say that the function of art is to liberate Man. And we only have to look out of the window to see that we need liberation. Right on, Brothers. And God Shango, help us!

\* \* \*

The Black Arts movement preaches that liberation is inextricably bound up with politics and culture. The culture gives us a revolutionary moral vision and a system of values and a methodology around which to shape the political movement. When we say "culture," we do not merely mean artistic forms. We mean, instead, the values, the life styles, and the feelings of the people as expressed in everyday life. The total liberation of Blues People can not be affected if we do not have a value system, a point of reference, a way of understanding what we see and hear every day around us. If we do not have a value system that is, in reality, more moral than the oppressor's, then we can not hope to change society. We will end up taking each other off, and in our confusion and ignorance, calling the murders of each other revolutionary. A value system helps us to establish models for Black people to emulate; makes it more possible for us to deeply understand our people, and to be understood by them.

\* \* \*

*117* ✦  Edmund B. Gaither, "A New Criticism Is Needed," *The New York Times,* June 21, 1970, Section 2, p. 21.

In the wave of exhibitions of African American artists in the late 1960s and 1970s, the most acclaimed and thoughtful was organized by an African American curator, Edmund B. Gaither, for the Museum of Fine Arts, Boston, in 1970. Called *Afro-American Artists: New York and Boston,* the exhibition included leading artists of those two cities. The controversy was supplied by *New York Times* critic Hilton Kramer, who found fault in the merging of aesthetics and politics in three articles he wrote (May 22, 1970; May 31, 1970; and June 7, 1970). The responses of Gaither and artist Benny Andrews were published in the June 21 issue. The excerpts here come from Gaither's letter.

Gaither has written extensively on African American art and directs the Museum of the National Center of Afro-American Artists in Boston.

<center>✦</center>

BOSTON.

If I understand the essentials of Hilton Kramer's criticism of the exhibition, "Afro-American Artists: New York and Boston," they are (A) that there is a conflict between works "conceived as an esthetic end" and works "conceived as a *medium* of social and political action"; (B) that works of the latter order have no esthetic purpose "since quality judgments are reserved to the mainstream" (esthetic pieces), and (C) that black art, as defined in my introductory essay to the exhibition, is stylistically staid, or to put it another way, a return to the social realism of the pre-World War II period.

Implicit in the critical notes of Kramer is a preference for art for art's sake ("objects having a purely esthetic end"), as well as a suspicion that, programmatically, social and/or political art cannot advance valuable formal or esthetic statements. Such a critical concept results in an unfortunate rigidity and inflexibility which then makes it improbable that its advocate could sympathetically and justly criticize the body of socially motivated art. A blindness results in which the critic misreads the art and incorrectly labels it. Moreover, esthetic values in such works are obscured by their radical or "objectionable" content.

At this point, what is needed is a new criticism, one which is esthetically demanding but which is sympathetic to content in socio-political art. And, of course, such a new criticism must recognize the total matrix in which, and out of which, the art comes. Sensitively attuned to the necessary dialogue between art and society, the new criticism would distinguish between effete social realism of the Old Left and the socio-political art of current nation builders.

Fundamental to the proper understanding and the appropriate criticism of "black art" is the canon: valuable artistic statements may be made in *any visual language* and about *any subject* if the artist has sufficient grasp of techniques and skills, if he has penetrating conceptual power, and if he has wit. Thus the artist who is black may employ any style, but those who choose to address their art to social and politi-

cal issues are not in the least diminished artistically. Was not Goya an artist? Is not *Guernica* art? Moreover, styles in themselves do not die. If certain contents suggest elements of earlier styles, it is left to the artist to unite the two and infuse the product with life. That which lives creatively is always au courant. Certainly a successfully resolved visual statement, drawing elements from existing styles, is qualitatively and esthetically more significant than facile, trite visual tricks and contraptions which amount to elegant pollution.

The social artist, whether he is called that or not, is crucially important for living, growing cultures. His visual product is not just something to look at, or for the élite to swoon over; rather it is an integral part of the cement of society.

The social artist is part of the creative tension out of which growth proceeds, for in a positive or negative way, he is radically committed to and involved with the living world, that is, the socio-political matrix which supports or denies his culture. Who could discount the function of Western artists in the promotion of religions, of Houses (Medici), of monarchs and dukes, of wars and revolutions? And are these not the works which, now that their social raison d'etre is dead, form the basis for the discussion of esthetics? The role those men played in bringing the Western World to today is, in its essentials, not unlike that of the black artist who understands the significance of art in culture.

Perhaps the surest sign of cultural decay is the segregation of art into the category of nonessential objects existing only for esthetic or monetary purposes. And simply because white America has come to such decadence and sterility, there is no need for committed black artists to surrender their role in shaping tomorrow's role. Who needs more empty shells and hollow forms?

\* \* \*

---

*118* ✦ Michele Wallace, "For the Women's House" [1972 interview with Faith Ringgold], in *Invisibility Blues: From Pop to Theory* (New York and London: Verso, 1990).

Both a feminist and a political activist in the 1960s and 1970s, Ringgold campaigned to bring black women into the feminist movement and feminism into the male-dominated black arts movement. In 1968 she took part in the picketing of the Whitney Museum for its exclusion of African American artists in its exhibitions. In 1969 she agitated for the Museum of Modern Art to create a Martin Luther King, Jr., Center that would highlight the works of black and Puerto Rican artists. In 1970 Ringgold, Jon Hendricks, and Jean Toche were arrested for their works in "The People's Flag Show," held at the Judson Memorial Church, famous as the site for happenings and avant-garde performances (see Chapter 5). Ringgold, Hendricks, and Toche (the "Judson Three") were found guilty of desecrating the American flag.

In 1971 Ringgold, along with Kay Brown, Jerrolyn Crooks, Pat Davis, Mai Mai Leabua, and Dindga McCannon, began organizing an exhibition of black women artists, *Where We At*, which included six more artists as well. They continued to meet as the Where We

At group and later exhibited at the Nyumba Ya Sanaa Gallery in Harlem. At this time Ringgold began to incorporate fabric into her artworks—a direction that would lead to her story-quilts.

Michele Wallace, a feminist writer and theorist, is Ringgold's daughter; together in 1970 they founded the Women Students and Artists for Black Art Liberation (WSABAL). When Ringgold received a Creative Artists Public Service (CAPS) grant in March 1971, the artist decided to pursue the project of painting a mural for the Women's House of Detention on Rikers Island. The mural was installed in January 1972. In the full interview Ringgold comments in detail on all eight sections of her interracial mural. Other artists involved with teaching art to Riker's Island inmates included Camille Billops, Benny Andrews, Rudolf Baranik, and Cliff Joseph.

---

\* \* \*

*Michele:* What made you decide to do a mural for the Women's House of Detention?

*Faith:* My first ideas were to do something about women and to put it in a public place. I asked some colleges but when I spoke to the Deans I would get a lot of "Who are you?" It was just like going to museums. Then I asked myself, do you want your work to be somewhere where nobody wants it or do you want it to be somewhere it is needed? Then I thought, a women's prison would be the best bet because nobody wants to go there, therefore they'll let me go there. [. . .] I met with the warden and supervisor who were both women and eventually with the architects and representatives of the Correction Department. Finally the project was finalized and the mural was installed. So it turned out that it wasn't easy to do a mural there but it was possible to do it there. There were no power plays and confusion, although there was a lot of bureaucracy and institutional standoffishness.

*Michele:* Did your idea of doing a mural for the Women's House, rather than for a men's prison, meet with any resistance?

*Faith:* Oh yes I got a lot of "why don't you go to the men's prison, it would be so much easier. What difference would it make?" Well, I knew there was a difference because I was aware that the problems of rehabilitating women are different. The stigma attached to having been in jail for a woman is still a very threatening one because of the idea of how dare she not be a good wife and mother. She goes to jail because she is not able to play her traditional role as a woman.

*Michele:* I understand that you asked the inmates what they would like to see in the painting. What did they say?

*Faith:* They said they wanted to see justice, freedom, a groovy mural on peace, a long road leading out of here, the rehabilitation of all prisoners, all races of people holding hands with God in the middle, 85 percent black and Puerto Rican, but they didn't want whites excluded. There was a kind of universality expressed by their feelings.

*Michele:* How did you come about the decision to make everybody in the mural a woman?

*Faith:* I had decided that I was going to do a feminist mural, which meant that it was going to be about women being equal. Then I decided that, if I put men in it, it would be read wrong in this society where everyone thinks of men as being superior to women. If I put men in a subordinate role then they'll say, "oh that's propaganda." That's the kind of painting I might do later but not for an institution where people are captive audiences, as it were.

*Michele:* The mural is 8 × 8 foot and the design is BaKuba, of an African tribe called the Kuba. The mural divides into two 4 × 8 foot oblong rectangular canvases each of which is divided into two 4 × 4 foot sections, each of which in turn is divided into two triangles, which means that the painting is split into eight triangular sections. In each of these sections, a different aspect of the existence of woman is depicted. The first section shows an older white woman driving a bus, the 2A which is bound for Sojourner Truth Square. Why did you choose to show a woman driving the bus?

*Faith:* The busdriver is a fiftyish lower-class white woman. Even though she's got the race thing together, she falls low on the class and the sex, so she gets to drive a bus. However, busdriving is not a bad job for a woman. It's a way in which she can make quite a lot of money without an education so that she can take care of herself and her children, send them to college or whatever. It's a job that doesn't demand a great deal of physical prowess and it is a pleasant job in some respects. I think women would be less threatened by the job than men are. Men often get very angry with us when we don't know what stop to get off or on. Women are more accustomed to being asked silly questions. I wanted to show more women going to work, doing things, but I didn't want to become too literal.

*Michele:* Why did you give the viewer such a close-up view? You could have just shown the bus at some distance with the sign saying "To Sojourner Truth Square" visible.

*Faith:* Yes, all of them are close-ups because the faces are very important. I never knew why I always used to paint big faces and heads and littler bodies until I became aware of African sculpture and found out that all natural peoples make a big thing of heads because the head is the seat of character, and I guess I follow in that tradition. It is much more Greek to make a big thing of bodies, but the body doesn't serve any kind of a function of a spiritual nature; the body is for doing and the head is for thinking and being which is why I have always focused on facial expressions.

\* \* \*

*Michele:* You have got women of all races and all ages in this mural and they are doing a lot of things that women still have never been permitted to do under this or any other government. However, they are all "working within the system". Why?

*Faith:* What I have painted is not the system as we ordinarily know it. This is obviously a new kind of society that we don't know anything about, a society where women are allowed to take aggressive roles, are allowed to fulfill themselves. I think it's unreal to say that you don't want to have anything to do with existing institutional structures because all our people are in those institutions. So we may turn our backs on the prisons and say they're oppressive, part of the oppressive bureaucratic system that runs this country and say we don't want to have anything to do with it. But I'm afraid that there are a great many women who can't say that because they've been arrested and they are in those institutions.[. . .]

*Michele:* It seems to me that the most important criterion for a successful society is that it meets the needs of its people, and the realization of many of the things going on in this painting would be a step in that direction. And if a society is meeting the needs of the people, what difference does it make whether you call it the United States or the United Peoples' Republic or whatever. You are dealing with correcting the situation from where we are now, which is important because the revolution is too abstract—as it has turned out, far more abstract than any of us might have suspected. Therefore, the revolution has been too conveniently removed from our daily actions.

<div align="center">* * *</div>

*Michele:* What are you doing next in the prisons?

*Faith:* We're getting together a group of artists and concerned people to go into the prisons at least once a month and perform services and bring the women things they need. The group is called "Art Without Walls." I have been asked, also, to do a mural for the Adolescents Remand Shelter, which is also out on Riker's Island.

## Women's Movement

Women played a major role in the antiwar actions of the 1960s and were vocal members of the Art Workers Coalition in New York. However, they soon began to redirect their energies to an analysis of their own situation as women. Having become skilled at organizing meetings and participating in antiwar protest demonstrations, they now began to get together to investigate their own status as women artworkers. Consciousness-raising meetings sprang up that offered women forums in which they could share experiences, build self-esteem, and receive support for their work and professional lives. Thus emboldened, they joined together to create their own cooperative galleries and to publish literature that addressed issues of concern to women.

"The personal is the political" became the slogan that stirred women to consider the ways their own personal circumstances were, in fact, not unique. "Political" became broadly defined to mean the awareness of the structures of power and of the societal norms that had imposed specific and common experiences on women and that had kept women subordinate to men. To be a feminist came to mean not just questioning patriarchal authority but engaging in social change. They took to heart Marx's thesis: "The

philosophers have only *interpreted* the world in various ways; the point, however, is to change it." And as these women changed their world and themselves, they also wrote a new history—one that featured women in the center and not at the margins.

One of the first cooperative galleries, Artists in Residence (A.I.R.), was started in 1971 (opened 1972) by Barbara Zucker and Susan Williams, whose resolve to take the issue of exhibition space into their own hands was strengthened by the consciousness-raising group to which they belonged. In October 1973 another women's cooperative, SoHo 20, opened a few blocks from A.I.R.

Part of rethinking artworld issues included revising the college studio curriculum. On the West Coast Judy Chicago started up a women's class in the Art Department of Fresno State College (now California State University, Fresno) in 1970. Chicago and her students rented an off-campus studio space and structured classes as non-hierarchical, consciousness-raising sessions. They explored taboo subjects, such as female sexuality and menstruation. In their paintings and multimedia environments, they incorporated the imagery of the vagina, as opposed to the time-sanctioned imagery of the phallus. In 1971 Chicago moved on to the California Institute of the Arts (CalArts) in Valencia where she and Miriam Schapiro, a visiting artist from New York, set up the Feminist Art Program and began a collaborative, site-specific project they called Womanhouse. This was a real house in Los Angeles transformed into an experimental environment where women students, such as Faith Wilding, could create installations and organize performances that contrasted real experiences with parodies of timeworn stereotypes of women.

In the mid-1970s Chicago organized a team of women artists and supporters and in five years produced "The Dinner Party," an elaborate installation that celebrated women notables of history, such as Mary Wollstonecraft, Emily Dickinson, Artemesia Gentileschi, and Sacajawea. The format consisted of a large triangular-shaped table set on a white-tiled platform bearing the names of 999 women from "herstory." The table was covered with embroidered place cloths and thirty-six elaborate ceramic plates fashioned into forms based on Chicago's theories of "central core imagery," which would remind women of their sexual and reproductive strengths.

Back in New York in the late 1970s, Miriam Schapiro became a leading figure in the emerging pattern and decoration movement when she began stitching aprons and bits of embroidered cloth into lush, colorful canvases. At this time Joyce Kozloff abandoned her improvisational abstract style for repetitive, decorative patterns inspired by non-Western art. Kozloff then began designing tile ensembles to cover the walls of train stations and of other public spaces (see Reading 154). The turn to craft was a way to recognize the traditions of women's art forms, and the sewing machine was much in evidence. Faith Ringgold abandoned the political protest imagery of "bleeding flags" to explore the craft forms of Africans and African Americans. After constructing her *Widow Masks* in 1976, Ringgold began to work with her mother, Willi Posey, who quilted Ringgold's images into wall hangings; soon Ringgold was doing her own quilts with social themes.

Many women artists raided art history for suitable subjects to subvert. In their parodic appropriation of time-sanctioned, male-gendered imagery they asserted a feminist egalitarianism. Mary Beth Edelson used a reproduction of Leonardo's *Last Supper* and substituted mugshots of Georgia O'Keeffe as Christ and other women artists as the disciples in her offset poster *Some Living American Women Artists/Last Supper,* 1971. May Stevens painted herself into the center of *Artist's Studio (After Courbet),* 1974, with friends and

**Figure 6-11.**   Joan Semmel, *Mythologies and Me,* 1976. Oil and collage on canvas, 3 panels, overall 60 × 148 in. Archer M. Huntington Art Gallery, The University of Texas at Austin, gift of Buffie Johnson, 1978. Photograph courtesy of the artist.

critics flanking her as in Courbet's 1855 version. Joan Semmel painted the nude body of herself as the center panel of a triptych, flanked by a *Playboy*-magazine type "soft-porn" image, representing popular macho culture, and a de Kooning-type "woman," representing the elite high art of the recent past; [see Fig. 6-11]. In the tradition of Dutch group portraiture, Sylvia Sleigh painted two life-size group portraits of the women artists' collective to which she belonged—*SoHo 20 Gallery (Diptych),* 1974. Stevens, Sleigh, Alice Neel, and June Blum joined with nine other painters to create the Sister Chapel, an architectural enclosure consisting of twelve life-sized portraits of famous women with an 18-foot ceiling. Audrey Flack painted the attributes of conventionally defined femininity—jewelry, perfume, cosmetics, and roses—in *Jolie Madame,* 1971, and *Chanel,* 1974, as an alternative to the automobiles painted by her photo-realist contemporaries.

Women art historians joined with the artists. Linda Nochlin wrote the groundbreaking article, "Why Have There Been No Great Women Artists?," first published in the January 1971 issue of *Art News.* Nochlin and others also spearheaded the Women's Caucus for Art within the College Art Association. Women artists and art historians helped to organize exhibitions, such as the *Women Choose Women* show held at the New York Cultural Center in early 1973. Art historian Ann Sutherland Harris and others also researched statistics regarding women's exclusion from professional opportunities in the artworld and in academia. They also contributed their talents to new journals such as *The Feminist Art Journal, Women Artists News,* and *Heresies* and wrote books on women artists. Nochlin and Harris's major retrospective show, *Women Artists: 1550–1950* opened at the Brooklyn Museum of Art in 1976. The art historians also challenged in their classrooms the canon of "great" (white, male) artists and made special efforts to make slides of both historic and contemporary women artists to show to their students. To 1970s feminists there was an urgency that women artists needed to be discovered, written about, and placed in the history of art.

Among critics the most consistent advocate for women artists was Lucy Lippard; when her reviews and essays were republished in *From the Center: Feminist Essays on Women's Art* in 1976, she dedicated the book "for all the women artists coming out from

the center everywhere." But male critics such as Max Kozloff and Lawrence Alloway also focused on writing about women's art and in helping to organize exhibitions of their work.

As the 1970s turned into the 1980s many artists, critics, and art historians moved away from their initial mission to celebrate women and toward a critique of the structures of power relations that led to discrimination. In the early issues of *Heresies* a new discourse could be detected, which insisted that gender was primarily a social construction of the ruling classes.

*119* ✦ Lucy R. Lippard, "Judy Chicago Talking to Lucy R. Lippard," *Artforum* 13, no. 1 (September 1974):60–65. © *Artforum*

Born Judy Cohen in Chicago and taking her husband's name, Gerowitz in 1961, she adopted the surname "Chicago" in 1970 as a conscious rejection of patriarchal name designations. Also in 1970 Chicago set up the first women's program at Fresno State College (now California State University, Fresno). In 1971 she moved to the California Institute of the Arts (CalArts) in Valencia, where she codirected the Feminist Arts Program and its Womanhouse project with Miriam Schapiro.

In her interview with Lippard, Chicago narrates her experiences of being a woman artist in the 1960s, before the women's movement, and its emphasis on consciousness-raising, hit the country with full force. She began to search for ways to extract feminist principles from seemingly formalist works. As her shapes became circular and donut-shaped, she developed the theory that women's imagery was inherently centralized, like the vulva, rather than phallic, and she encouraged other feminists to explore this "central core imagery." Chicago's "Through the Flower Series" of the mid-1970s reflects her aim to go beyond the well-known flower imagery of Georgia O'Keeffe and to make explicit the sexual connotations. At the end of the interview, Chicago is actually making the point that women have to deal with the ways gender is "constructed" by the culture—a concept not yet fully articulated in the art world in 1974 (see Chapter 7, pp. 366-67).

In *Sniper's Nest*, the catalogue of her art collection, Lucy Lippard recalled that she was not much interested in feminism until the early 1970s, at which time she embraced the aims of the movement with a passion. Her essays on women's art were anthologized in *From the Center: Feminist Essays on Women's Art* (New York: E. P. Dutton, 1976).

———————————————— ✦ ————————————————

[. . .] When I first started my professional life, in 1963, I was making these very biomorphic paintings and sculptures; I went to auto-body school, because I wanted to learn to spray paint, and because it seemed another way to prove my "seriousness" to the male art world. While I was there, I put my very sexually feminine images on this car hood, which in itself is quite a symbol. Over the next few years, I retreated from that kind of subject matter because it had met with great ridicule from my male professors. There was no radical departure, just a slow moving away from a content-oriented work to a more formalist stance; then, much later, a slow moving back.

[. . .] It's no accident that it was during this whole period when I was least overt about my womanliness—1965—that I made my reputation as an artist. It was a period in L.A. when no women artists were taken seriously. [. . .] A lot of the women artists I've talked to since had little conception that their isolation had anything to do with the fact that they were women. I refused to believe there was something wrong with me personally, and I think that saved me.

* * *

Anyway, I had kept on thinking that if my work got better, everything would change. I wanted it to be seen as a body, so I had this big show at Cal State Fullerton. I also changed my name at that time from Judy Gerowitz to Judy Chicago, after my hometown. I wanted to make a symbolic statement about my emerging position as a feminist. And I wanted to force the viewers to see the work in relation to the fact that it was made by a woman artist. Now I can see that the years of neutralizing my subject matter made it difficult to perceive the content in my work. Even for women.

I believe that if one allows oneself to meet my paintings on an emotional level, one can penetrate the plastic and the formalism and find that soft center I was trying to expose, though with difficulty. But I wasn't prepared for the total misunderstanding that greeted the show in 1970. I had to face the fact that my work *couldn't* be seen clearly in the male art world with its formalist values. So I was faced with a real dilemma. I wanted other women to profit from what I'd gone through and I wanted men to change their conception of what it was to be a woman, of how to relate to women, through my work. But where was I going to go?

* * *

I felt the only thing I could do was to commit myself to developing an alternate community based on the goals and ideas of women, built out of all I'd discovered from our own heritage. So I went to Fresno and set up the women's program and a year later brought it back to L.A. and set up the Feminist Art Program at Cal Arts with Mimi Schapiro. These programs were the first step in building an alternate art community. We went from education to exhibition space to consciousness raising in the community, and then, finally, this year, to establishing a coherent alternative, the Woman's Building, which allows us to deal with the whole process—education, exhibition, criticism, documentation of feminist values. . . .

* * *

*What about your emphasis on central imagery, or "female imagery," which is wildly controversial, to put it mildly?*

In my mind if something wasn't named it didn't exist. I wanted to name the subject matter I was involved with. Other women told me they too were trying to deal with subject matter about their own identities, behind a kind of neutralized abstract structure. I never meant all women made art like me. I meant that some of us had made art dealing with our sexual experiences as women. I looked at O'Keeffe and Bontecou and Hepworth and I don't care what anybody

says, I identified with that work. I knew from my own work what those women were doing. A lot of us used a central format and forms we identified with as if they were our own bodies. I'd say the difference between *Pasadena Lifesavers* and a Noland target is the fact that there is a body identification between me and those forms, and not between Noland and the target. I really think that differentiates women's art from men's.

*At least that particular kind of identification with a central image is closed off to men, simply because their body forms don't contain.*

Reading and studying for the past five years in women's history and literature and art, I discovered a coherent body of information, a whole subcultural perception of the world that differs from men's. Once I established this context, I could plug into it, into a dialogue with those other women. What has happened to all of us over and over is that our work has been taken out of our historical context and put into some mainstream context it doesn't belong in; then it is ridiculed, or incorrectly evaluated. It's also important to remember what the climate was when I said women made art different from men. That was a real tabu. Everybody flipped out.

*In New York it's still 99 percent tabu, even though everybody* has *to admit a woman's biological and social experience is entirely different from men's in this society, and since art comes from* inside, *it must be different too. But people are still ashamed to say they're women people.*

I've done a lot of thinking about why there's resistance to the idea. I think it's unconsciously based on the notion that if women make art differently from men, it means that women are in actual fact independent from men. [. . .]

The way women have been oppressed has revolved around our sexuality, either by turning us into sexual objects altogether or by denying our independent sexuality. Men's work in this area is not informed by that incredible urge to say "I am, I am, I am, and this is who I am," which is basic to a lot of women's work whether they work abstractly or figuratively. Our sexual identities are very basic to our whole perception of the nature of reality. To change that basic ordering of things, to reevaluate what it is to be a man and what it is to be a woman, actually leads you into a reevaluation of everything.

\* \* \*

*A lot of work you find dehumanized and still neutralized, I find very moving, because I see so much neutralized work. There is plenty of women's art that formally resembles men's art, but often there's a very different aspect under there somewhere. That's what gets to me. I want to find out what that is, that sensibility which exists even in the "middle ground" women's work you find it hard to deal with. I want to try to be more specific about that, find ways of looking at women's work that provide insights and make more people aware and able to deal with it, even if no conclusions are drawn. I don't really care about conclusions, or theories; they contradict each other too convincingly, too easily.*

There's a difference between female point of view and feminine sensibility. You're talking about feminine sensibility, something about the female personality structure that informs the works.

*I'm also curious about how much of that is conditioning, and how much is highly conscious female, i.e. feminist, point of view. I think it's going to be years before we can really put our finger on female sensibility. I like the idea of isolating it, but once I do, I may just be isolating what's happened or happening to women, rather than what we are.*

Absolutely, but of course you could say the same thing about men.

*On the other hand, we may be seeing female sensibility in a purer and more innocent form right now, because of the isolation of women until now.*

What we're really talking about is not the subject matter, but where the approach to the work is conditioned. Those women involved in weaving and sewing and all—that's informed by feminine *sensibility,* by role conditioning, and a certain sensitivity to surface, detail. You see it in writing, too. My investigation of women's art has led me to conclude that what has prevented women from being really great artists is the fact that we have been unable so far to transform our circumstances into our subject matter. That is the process of transformation men have been able to make while we have been embedded in our circumstances, unable to step out of them and use them to reveal the whole nature of the human condition. I feel that I'm just about to make that step, but it wouldn't be possible without the alternate structure of the Woman's Building.

---

**120 ✦** Harmony Hammond, "Feminist Abstract Art—A Political Viewpoint," *Heresies: A Feminist Publication on Art and Politics,* no. 1, (January 1977):66–70.

Harmony Hammond, a New York sculptor, edited the first issue of *Heresies* along with Joan Braderman, Elizabeth Hess, Arlene Ladden, Lucy Lippard, and May Stevens. The first issue declared that the editorial collective "shares not a political line but a commitment to the development of coherent feminist theory in the context of practical work. . . . The time for reformulating old positions or merely attacking sexism is past. Now we must take on the most problematic aspects of feminist theory, esthetic theory and political theory. We are not only analyzing our own oppression in order to put an end to it, but also exploring concrete ways of transforming society into one that is socially just and culturally free." In its many issues, *Heresies* published provocative articles as well as "page art," art done specifically for the themes of each issue.

In her article, Hammond first makes the point that artists need to share ideas through published articles. She then points out that artists' views of abstract art have been dominated by formalist theories formulated by male critics and artists and by the association of abstract art with Cold War propaganda. Like Meyer Schapiro in "The Liberating Quality of Abstract Art" (see Reading 64), Hammond argues that abstract art has the potential to be expressive and liberating. But more than that, to Hammond abstract art can be feminist and revolutionary.

＊＊＊

In this article I wish to focus on abstract art and show that it can have a feminist basis and therefore be political. Feminists are not [the] only people to attempt political or revolutionary art, but because certain ideas and issues occur over and over, they are of interest to us and worth exploring. I will focus on one area of abstract art by discussing concepts of marking and language in feminist drawing and painting—to show its origin, meaning, and political potential.

[. . .] The way in which Abstract Expressionist art was defined and developed by the artists and then used by others to further cold war politics in the fifties is only one example of the manipulation of abstract art to create the illusory separation of art and politics. Thus when women continue to respond to abstract art as "apolitical," they are reinforcing and maintaining myths established by men.

[. . .] Abstract art has become taboo for most artists who consider themselves political feminists. Because of the history outlined above, it is difficult to determine abstract painting's relationship to feminist ideology. There are radical feminists who are making abstract art. Radical feminism operates from the belief that women as a class are oppressed, and that a mass political women's movement is necessary to overthrow male supremacy. Therefore, we might ask, how are the visions of radical feminists analyzed and portrayed in this art?

[. . .] It is by talking about our work and work processes that we will not only begin to develop a new language for interpreting abstract art, but also to integrate this work with society. This language, which I see evolving from consciousness-raising techniques, will be able to be shared with any woman, regardless of class background. For artists, such a dialogue with the audience is essential, as it offers valuable feedback for the development of our art.

I want to reclaim abstract art for women and transform it on our own terms. It is interesting to note that much of women's past creativity, as well as the art by women of non-western cultures, has been abstract. I'm thinking of the incredible baskets, pottery, quilts, afghans, lace and needlework women have created. Many of the motifs used were based on "the stitch" itself. The repetition and continuity of the stitch or weaver formed the individual shape and also the pattern resulting from its repetition. Usually these motifs and patterns were abstract and geometric. [. . .]

As we examine some contemporary abstract art by women, it is important to develop a sense of identity and connection with our own past creativity rather than that of the oppressor who has claimed "fine art" and "abstract art" for himself. In fact, the patriarchal putdown of "decorative" traditional art and "craft" has outright racist, classist, and sexist overtones. [. . .]

Until recently, decorative art, or craft techniques and materials, have been valid only as sources for contemporary male artists. [. . .] But times have changed. Today many female artists are connecting to a long line of creativity by proudly referring to women's traditional arts in their own work. They are recording the ritual of women's

artmaking both in the past and the present, thereby reflecting a feminist concern not only with the end product but with the daily process and function of making art. Sewing techniques and materials as both process and content are used in a variety of ways in the abstract works of Sarah Draney, Pat Lasch, Nina Yankowitz, Paula Tavins, Patsy Norvell, Rosemary Mayer, and many other women. Barbara Kruger says that she first learned to crochet and sew when she decided that these techniques could be used to make art. For women, the meaning of sewing and knotting is "connecting"— connecting the parts of one's life, and connecting to other women—creating a sense of community and wholeness. Other women, drawing on women's traditional arts, make specific painterly reference to decoration and craft. Miriam Schapiro utilizes remnants of fabric, lace, and ribbon along with handkerchiefs and aprons in large collages, thus making the very material of women's lives the subject of her art. Joyce Kozloff and Mary Gregoriadis explore decoration as fine art, basing their paintings on the abstract patterning of Islamic architecture and tiles, Tantric art, Caucasian rugs, and Navaho weaving.

The way many women *talk* about their work is revealing, in that it often denies formal art rhetoric. Women tend to talk first about their personal associations with the piece, and then about how these are implemented through visual means; in other words, how successful the piece is in its *own* terms. This approach to art and to discussing art has developed from the consciousness-raising experience. It deals primarily with the work itself, what it says and how it says it—rather than with an imposed set of esthetic beliefs.

* * *

In much of this work the reoccurring stitch of women's traditional artmaking becomes the repetitive mark, taking on a new form as a "visual diary." Such works are daily records of thoughts and are used as such by the artists. Just as the weaver continues from day to day, from one physical and psychic location to another, materials and dyes changing slightly, irregularities and tension showing, the painted marks also reveal daily emotional changes and tensions. They are a record of present feeling, a ritual giving in to the repetitive gesture, a language to reveal self—a woman's mantra.

* * *

Their painting surfaces are often violated or mutilated; cut, gouged, ripped, scratched, or torn. The reversal of the usual additive process of painting refers to the violation of the traditional painting surface and also to the physical and psychic violation of women. The thick paint applied with a palette knife in [Louise] Fishman's work, for instance, acts both as poultice for wounds and cement for holding self together. In Joan Snyder's recent work the marks, cuts and burning combine with words and color to make a passionate statement about sexuality.

* * *

As abstract artists, we need to develop new abstract forms for revolutionary art. The women's work I've discussed here, and I include my own, is moving in this direction. We are not yet there. Hopefully, as we create art within the context of other women's art, and within the context of evolving feminist theory, we will develop a new visual language. Art in transition is political, for it both *is* our devel-

opment and *describes* our development. In a sense we are coming out through our art, and the work itself is a record of the ongoing process of developing a feminist esthetic ideology.

---

### *121* ✦ Betsy Damon, "The 7000 Year Old Woman," *Heresies,* No. 3 (Fall 1977):11.

Betsy Damon, a performance artist, staged performance works in both galleries and the streets of New York. Her *7000 Year Old Woman* performance took place in Lower Manhattan in March 1977. Like Mary Beth Edelson and Ana Mendieta, Damon drew on contemporary ideas about "spiritual feminism," which related femaleness to nature and to the Earth Goddess. Art historian Gloria Orenstein has been the most influential theorist of the Earth Goddess archetype. She began an essay for the Spring 1978 issue of *Heresies* with the statement: "As the archetype of the Great Goddess reemerges into consciousness today, women artists, through transpersonal visionary experiences, are bringing to light energic phychic forces, symbols, images, artifacts, and rituals whose configurations constitute the basic paradigm of a new feminist myth for our time. . . . This new Goddess consciousness might be described most effectively as a holistic mind-body totality."

Damon describes the choreography of her performance and provides the reader with a way to visualize the actual art event.

---

Description of the piece:

I painted my body, face and hair white and blackened my lips. Hanging from and covering my body were 420 small bags filled with 60 pounds of flour that I had colored a full range of reds from dark earth red to pink and yellow. To begin the piece I squatted in the center of the gallery while another woman drew a spiral out from me which connected to a large circle delineated by women who created a space with a sonic meditation. Very slowly I stood and walked the spiral puncturing and cutting the bags with a pair of scissors. I had in mind the slow deliberateness of Japanese Noh theater, but none of the gestures were planned and at one point I found myself feeling so exposed that I tried to put the bags back on. The ponderous slowness combined with the intrinsic violence of the cutting and the sensuous beauty of the bags created a constant tension. By the end of the performance the bags on my body were transformed into a floor sculpture. I invited the audience to take the bags home and perform their own rites.

The 7000 year old woman will exist in many places and many aspects in the future.

This piece is about time; remembering time; moving out through time and moving back through time; claiming past time and future time. At the end of the piece I had a certain knowledge about the metaphysical relationship of time; the

**Figure 6-12.**  Betsy Damon, *The 7000 Year Old Woman,* 1977. Performance, New York City. Photograph courtesy of the artist.

accumulation of time, and women's relationship to time past. I came out of the piece with a knowledge about the burden of time. A woman sixty years old is maybe twenty times more burdened than the thirty-year-old by her story. While I don't understand the mathematics of this I did feel it to be true. If we had had 7000 years of celebrated female energy this would be different.

> During the performance I was a bird
> > a clown
> > a whore
> > a bagged woman
> > an ancient fertility goddess
> > heavy-light
> > a strip-tease artist
> > sensuous and beautiful

After the performance I was certain that at some time in history women were so connected to their strength that the ideas of mother, wife, lesbian, witch as we know them did not exist.

---

**122** ✦ Moira Roth, "Visions and Re-Visions: Rosa Luxemburg and the Artist's Mother," *Artforum* 19, no. 3 (November 1980):36–39. © *Artforum*

Moira Roth, a critic and art historian who writes often on performance art, here sums up the art writing done during the 1970s on behalf of the feminist movement and calls for a more critical approach in the decade of the 1980s. Roth maintains that a "feminist" is first and foremost a woman who "practices feminism outside her studio and thus comes to her work with a developed feminist sensibility," whether or not the work itself is feminist. As examples, Roth focuses on the work of the New York painter May Stevens (see Reading 123) and California performance artist Suzanne Lacy (see Reading 160).

In an endnote to the original article, Roth refers to the "spiritual feminism" advocated by Adrienne Rich in *Of Woman Born,* 1976. Roth adds: "Mary Daly's *Gyn/Ecology* and Susan Griffin's *Woman and Nature,* both 1978, are some of the most notable explorations of the mystical side of feminism. Most of this literature argues for a separatist reading of history and nature, emphasizes the intimate, unique relationships of women with nature, and invokes the Great Goddess as the literal or symbolic statement of women's ancient powers and future destiny. This is a highly complex and controversial issue, and so is the question interlocked with it: Are there, in fact, unique forms which characterize women's thinking, writing and art-making?"

In the next decade, the 1980s, feminists would depart from the woman-as-nature path to explore the ways gender has been socially constructed.

---

\* \* \*

At the beginning of the feminist movement, the artists, art, issues and audiences were fresh. Women artists plunged into previously taboo subjects and materials—autobiography, politics, rape, silk and blood—and exhibited these in the new feminist alternative spaces and all-women shows to be seen by the new audience of other women. (At the same time, these taboo subjects and materials assailed the bewildered, frequently hostile audiences of the established and sexist art world.) Everything was grist for the feminist art mill. Simply taking on such subjects and materials produced, with astonishingly high frequency, effective feminist art. In 1980 this is no longer the case. What constitutes effective feminist art *now?*

In 1980 we can and should celebrate the spectacular achievements of a decade of women's art. Yet, it is high time that we take critical stock of the present state and future direction of both feminist art and feminist art criticism. As the criteria for feminist art (let alone for effective feminist art) have changed radically in the last couple of years, so have those for feminist art criticism. The urgent central question confronting feminist critics in 1980, parallel to that for artists, is: What constitutes effective feminist art *criticism* now?

**Figure 6-13.**   Suzanne Lacy and Leslie Labowitz, *In Mourning and In Rage,* 1977. Media event, Los Angeles. Photograph courtesy Suzanne Lacy. This media event critiqued sensationalized news coverage of the Hillside Strangler case, in which ten women were raped and strangled in Los Angeles. This one-hour performance included a media analysis, was covered by all local news stations, and is a model for media intervention in art.

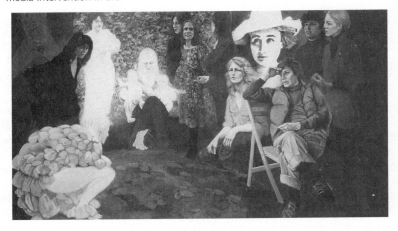

**Figure 6-14.**   May Stevens, *Mysteries and Politics,* 1978. Acrylic on canvas, 78 × 142 in. The San Francisco Museum of Modern Art, gift of Mr. and Mrs. Anthony Grippa. Photograph used by permission and provided courtesy the artist. The figures represented are, clockwise from bottom left: Betsy Damon, Pat Steir, painting of Mary Beth Edelson's torso, photograph of Stevens's mother holding the artist as a baby, Poppy Johnson holding her twin babies, Carol Duncan, Patricia Hills pregnant with Andrew, Stevens (face averted), Suzanne Harris, painting of Rosa Luxemburg, Amy Sillman, Elizabeth Weatherford, and Joan Snyder seated on chair.

At the beginning of the '70s, courageous feminist critics and historians—Lucy Lippard and Linda Nochlin among others—took on, with passion and intelligence, three tasks:

1. the discovery and presentation of art by women, past and present.
2. the development of a new language for writing about this art—often polemic and poetic, always anti-formalist.
3. the creation of a history of and theories about the forms and meanings of this rapidly growing, astonishing quantity of art by women.

Today these tasks continue to legitimately occupy much of feminist critical writing, and passion and intelligence are still the order of the day. But there is a new task which must be taken on—which many feminists, including myself, have been hesitant to address—or feminist art criticism will at best flounder and at worst fail to be effective any longer. To the list of earlier tasks must be added another:

4. the undertaking of a far more critical mode of writing about this art than was possible or necessary in the last decade.

Surrounding this new task is the highly volatile issue of support. Should feminist critics protest against ineffective feminist art and against the use of the word "feminist" when it is not an appropriate description? *Yes.* And will such feminist critics risk incurring the often paralyzing accusation that they are being unsupportive to women artists and to the feminist art movement in particular? *Yes.*

As I see the state of feminist art in 1980, there are several critical issues that need tackling. For me, two are paramount:

1. Should we redefine what we mean by "feminist art"?
2. Is it possible to be a feminist artist without making overtly feminist art?

Around 1970, after a decade of heated politics but for the most part of super cool art, women artists led the way in exploring autobiography, unorthodox "feminine" materials, ritual and politics. These explorations provided the exciting, fresh and appropriate staple fare of early feminist art. Highly successful then, these subjects and media are now in trouble.

As critics and artists, we are faced by the dangers of boredom and co-optation. Currently, in feminist art, there is the problem of quantity: the sheer surfeit of such material. There is also the problem of quality: the frequency of overworked and exhausted statements and forms. There is the problem of feminist art that has become neutralized: so much genuinely good feminist art, originally effective in a feminist context, has been appropriated by an art world fascinated a priori with autobiography, narration, Marxism and decoration. And there is the final problem, misrepresentation: on occasion, both artist and critic claim certain works as feminist when others believe that they are not. So what is "feminist art"?

Suzanne Lacy, the feminist performance artist and theorist, talked recently of the need to qualify the definition of feminist art:

> At first we defined feminist art as all art which reflects a woman's consciousness, but as our politics evolved some of us chose stronger definitions. For me, now, feminist art must show a consciousness of women's social and economic position in the world. I also believe it demonstrates forms and perceptions that are drawn from a sense of spiritual kinship between women.

Lacy's statement articulates one of the more thorny issues in contemporary discussions among feminists, including feminist artists: the relationship and balance between the overtly political and spiritual strains of current feminist theory and practice. Within these two major territories are a multitude of further divisions.

The spectrum of political feminism ranges from the liberal aspirations (associated with the National Organization for Women), which are concerned with the ratification of ERA, with the protection of women's abortion rights, etc., to the more radical goals of socialist feminists, who are working according to theoretical structures which attempt to encompass Marxism and women's issues. The spectrum of spiritual feminism ranges from an all-out, literal adoration of the Great Goddess to a more abstract belief in intense, emotional and mystical bonds among women, which create a women's spiritual community. How should feminist art respond to such different directions in feminist energy? As I am writing this essay in the summer of 1980, ERA and abortion rights are in an increasingly beleaguered position (the Republican Party platform has come out against both), and at the same time the summer solstice rites for the Great Goddess have just been celebrated in various parts of the country. What should feminist art *do* in 1980?

[. . .]

I would define a feminist artist as a woman who believes in and practices feminism outside her studio and thus comes to her work with a developed feminist sensibility; *however,* that does not mean inevitably that her work should be called "feminist."

[. . .] Should we redefine what we mean by "feminist art"? *Yes.*

I think we need to address this question by recognizing that the tasks of feminist art today differ profoundly in their priorities from those in the early '70s, even though they are continuous with them. In 1970, there were two principal tasks: to describe and to demand. One main undertaking for the emerging feminist artist was to make art about women from the woman's point of view. Feminist art took on this task of description in tones that ranged from despair to extreme anger. A second major objective was to teach others about the conditions of women in a way that would lead to changing those conditions. In 1980, the objectives of feminist art must be redefined to encompass the collective, interactive character of women's political and spiritual strengths. This means that the main tasks for current feminist art include:

1. the creation of visual symbols of women's unity and power.

2. the making of connections and bonds among women previously separated by race, class, age, geography and history.

3. the portrayal of past, present and future obstacles to women's power and unity, and the analysis and criticism of such impediments in the light of feminist theories.

4. the invention of a visual language to help forge the political and spiritual components of feminism.

5. the development of effective strategies for protecting feminist art from co-optation and misrepresentation.

6. the creation of feminist visions of and for the future.

Among the women working in these areas of feminist art are Hèlene Aylon, Judith Barry, Judy Chicago, Mary Beth Edelson, Feminist Art Workers, Leslie Labowitz, Suzanne Lacy, Faith Ringgold, Martha Rosler, Carolee Schneemann, Miriam Schapiro, May Stevens and Faith Wilding. I have decided to focus here on Lacy and Stevens—partly because they represent strikingly different theoretical backgrounds and different arenas of geography and mediums, but primarily because these two artists are working out some of the most effective strategies in contemporary feminist art for combining and balancing the strains of politics and spirituality, a dualism that I view as absolutely central to the making of effective feminist art today.

Both Lacy and Stevens are deeply involved in the intense and lively feminist art communities of Los Angeles and New York, respectively. In these areas (and in many others outside of the two major coastal centers for feminist art), women are spending an enormous amount of time, energy and passion in developing networks and communities for women artists—locally, nationally and increasingly internationally. (They are also struggling with the question: How do you extend this network outside the art world? How do you reach other women and other women's communities?)

Communities and networks among women also constitute a pivotal theme in the art of Lacy and Stevens, as they do in that of many others in the movement. Such artists are working on the creation of powerful visual forms for, and images and symbols of, these past, present, future, imagined and real networks and communities. And, through their art, the artists are further intensifying and broadening these connections—both inside of and beyond the art world.

In the future, as the networks multiply, surely more and more feminist artists will respond to this theme. As it is, over the last decade an impressive body of feminist art has already been developed to represent such networks and communities: Faith Ringgold in *For the Women's House*, 1971, responded to the needs and visions of the inmates of a women's prison; Miriam Schapiro in *Connections*, 1976, and Sheila Levrant de Bretteville in *Pink*, 1974 have explored the grid format to symbolize the connection of information and objects, gathered from many women; Judy Chicago with *The Dinner Party*, 1979, formed a women's community through which to shape a work of art; and Faith Wilding with *Seed Piece*, 1980, created rites based on sowing and harvesting to connect a worldwide community of women.

Two of the most powerful visions of women's spiritual and political communities to emerge in feminist art of the '70s are *Mysteries and Politics*, a painting by Stevens,

and *In Mourning and In Rage,* a collaboration between Lacy and Leslie Labowitz. One can see the symbolic connection between the two works: the ten giant female mourning figures of *In Mourning and In Rage,* their stance and garb simultaneously expressing grief and enraged strength, could well act as the mythic guardians of the tranquil community of women in *Mysteries and Politics.*

<p style="text-align:center">* * *</p>

In 1978 Stevens painted *Mysteries and Politics,* in which feminist politics and feminist mysteries meet. In this large painting a group of 13 women are arranged in a semicircle according to their primary commitment and concern for either politics or mysteries. Stevens appears in it twice: once as a child in her mother's arms on the "mysteries" side, and once as a mature artist, standing near the large disembodied head of Luxemburg on the "politics" side. Revealingly, the adult Stevens is turned toward the center of the group in which the literal and symbolic meeting of mysteries and politics takes place. I feel that this potent combination in Stevens' art was made possible by the politically and psychologically motivated juxtaposition of her mother and Rosa Luxemburg.

Stevens credits three sources of inspiration for her painting *Mysteries and Politics:* first, her reading of *Of Woman Born* by Adrienne Rich (a key work in the literature of "spiritual" feminism); second, her "desire to reproduce consciousness as we experience it, on many levels"; and third, her experience of working within the *Heresies* collective. Recent feminist "spiritual" literature, a greater sensitivity to the multifaceted nature of feminist perceptions, and the experience of working in a theoretically-oriented feminist collective—the three "inspirations" of Stevens' painting—are important wellsprings for exploring the highly complex relationship of politics and mysteries in feminist art.

In 1980, women need to unite the ordinary and extraordinary woman, to unite the past and the present, the public and the private, politics and mysteries, and to act on these necessities. Feminist art can be a powerful force for symbolizing these unities and for inspiring action among women.

---

**123** ✦ May Stevens, "Taking Art to the Revolution," *Heresies* no. 9 (1980): 40–43.

May Stevens studied at the Massachusetts College of Art. She married artist Rudolf Baranik in 1948, and the two went to Paris to study for three years. She taught for many years at the School of Visual Arts in New York City before moving to Santa Fe in 1997. Stevens and Baranik were antiwar activists during the 1960s; in the early 1970s she was drawn into the feminist movement and became one of the founders of the *Heresies* collective. At the time she wrote this essay, she was engaged in her series "Ordinary/Extraordinary," which contrasted her mother, a working-class housewife from Quincy, Massachusetts, then living in a nursing home, and Rosa Luxemburg, the Marxist theorist who cofounded the German Communist Party, was imprisoned for her antiwar agitation during World War I, and murdered by proto-Nazi thugs in January 1919. Luxemburg has been a constant inspiration to Stevens.

The issue of *Heresies* in which this essay appeared focused on the theme "Women: Organized/Divided—Power, Propaganda and Backlash." Stevens's essay points out the constant tension, or dialectic, between art and history, between theory and intuition, between the need for structure and the desire for experience. What she wants most to see in other artists and her students is active engagement—with art and with life.

◆

**Art as propaganda**   All art can be placed somewhere along a political spectrum, supporting one set of class interests or another, actively or passively, at the very least supporting existing conditions by ignoring other possibilities, silence giving consent.

**Art as not propaganda**   The meaning of art cannot be reduced to propaganda; it deals with many other things in addition to those revealed by class and sociological analysis.

Both definitions are true; they are not opposites, but ways of measuring different properties.

**Philistinism**   Fear of art. Unclarity of meaning, inability to demonstrate immediate social usefulness, difficulties of definition and standards make art seem untrustworthy to the philistine mind (which may be highly trained in other areas of culture). An activity that encourages emotion and individuality, that permits eccentricity and obsession, is necessarily suspect. But art is not subject to social engineering—in this sense: there is no formula for artmaking; art schools do not produce artists (in any positive numerical ratio); high morals do not produce art; effective propaganda does not constitute a definition of art. (Witness art produced under Soviet control.)

\* \* \*

[. . .] The problem is not with people's taste (often called "kitsch" by superior minds) but with defining art as one thing only. Art is that which functions as aesthetic experience, for you. If a certain art works that way for enough people, there is consensus; that becomes art. For a while.

\* \* \*

**Theory**   A proposed pattern to understand the world by. We look for patterns (meaning) in the world. When we think we see one that works (fits our experience), we apply it for as long as it holds up. But when it begins not to fit, we re-examine the pattern, correct it, refine it—if it is salvageable. Mystification of theory prevents its organic development; anti-individualism prevents users of mystified theory from matching it to their own experience. Theory is for *us*, not the other way round. Example: The Women's Liberation Movement causes socialists to re-think the words *liberation, class, family, sexuality*. Socialist theory must meet the feminist challenge or give way to a fuller theory, a fairer practice. Similarly, feminists must meet the challenge of the economic theory of class.

**Individualism**   The society we want to build will be composed of politically sophisticated women and men, conscious of history, of their own needs, of social responsibility, and of sharing, learning and growing together. We can become that kind of human by practicing and developing those skills along the way. The pluralism of the "hundred flowers" impulse, the patience to go slow and not force compliance, the

concern for process and feeling—these are the things women can bring to socialist practice, attitudes so badly needed, so shockingly absent.

**Feeling**   The touchstone. Our theory must fit our feeling. Puritanism, "should" and "ought" won't work, won't—ultimately—help. We have to deal with the individual and with feeling, sensitively, not condescendingly. If we are not attuned to feeling, our own and others', the theory will not hold. It will not have taken into account power-ful forces that will drag it down and eventually defeat it—as indeed it must be when it is one-sided (indifferent to women, indifferent to individual conscience, to personal feeling).

**Relation between feeling and theory**   Theory cuts off its roots, loses its connection to reality when it ignores feeling; feeling needs structuring, a means of evaluating be-tween conflicting feelings. A *balancing act* where contempt has no place since it is not theoretical and is not a feeling that can exist between equals.

\* \* \*

Art as propaganda must help to bring about the conditions under which it can achieve its fullest propaganda function. This means propagation of respect for art, respect which can help bridge the gap between art of the highest order and working-class experience. When Mary Kelly makes art out of baby nappies and documents her child's develop-ment with Lacanian theory, she attempts to integrate the artifacts of a woman's daily re-ality, charged with complex emotional affect (Marxist/feminist/artist/mother raising a male child on the edge of the working class), with the keenest contemporary intellectual analysis she can bring to bear. This art swings between the nursery and the tower and shows again the way we are split—worker from knowledge, woman from science.

\* \* \*

Art *is* political. But one also has to understand that the uses to which it is put are not its meaning. Its status as object and commodity is not its meaning: there are many ob-jects and commodities. They are not all art. What makes art different? Exactly the ways in which it is not an object, can never in its nature be a commodity. (Humans can be sold as slaves: to be human is essentially not to be a slave, in one's nature.)

A socialist and feminist analysis of culture must be as careful as it is angry—fierce *and* responsible.

# Chapter Seven

## 1980s–1990s

## Cultural and Historical Context for the Age of Reagan and Postmodernism

The final two decades of the twentieth century saw major sociological, economic, and political changes in the world. The average American became increasingly aware of national and international events, thanks to speedier transmission of video clips from all parts of the world to CNN and other television news stations. Significant changes included the retreat from the welfare state and liberal politics in the Western industrialized countries; the collapse of the Soviet Union (U.S.S.R.) and the creation of new independent Eastern European countries; and the rise of a global economy affected more by economic instability in Hong Kong, Japan, and Brazil than by Wall Street fluctuations.

The end of the welfare state could be symbolized by a beaming Margaret Thatcher, acknowledging her victory as the new Prime Minister of Great Britain on the night of May 4, 1979. She quickly began dismantling social services and drastically reduced the budgets of educational and cultural institutions in Britain. Ronald Reagan, elected on the Republican ticket on November 4, 1980, launched a similar program for the United States. During the eight years that Reagan was in office a massive redistribution of power and wealth took place, both in the United States and in all the developed nations.

For many in the United States the early and mid-1980s was a period of growing prosperity. Expansion of high-tech companies and financial institutions promised ambitious college students with computer skills high-salaried jobs in expanding fields. This stratum of young upwardly mobile professionals, dubbed yuppies, had money to spend. *The Yuppie Handbook,* 1984, gave tongue-in-cheek advice to this new, highly visible class, reputedly concerned only with developing their career potential, eating in upscale restaurants, buying art in chic Manhattan galleries, and indulging in expensive weekend jaunts. The image of the yuppie was in sharp contrast to the homeless—a newly created class of people without housing, out of work or unable to work, who appeared in increasing numbers because of the cutbacks and the withering away of the safety nets provided by the welfare state. Most of the country ignored the homeless. Instead, technology captured the eye and imagination of the middle classes. For a relatively small class of businessmen, professionals and their families the purchasing of technological entertainment and gadgets leaped ahead. In

fact, so popular were computer games among middle-class youth that in 1982 "Pac-Man" was *Time* magazine's "Man of the Year." During the early 1980s video stores sprang up to rent cassettes of the latest movies and Sony "Walkman" portable radios became widespread. In August 1981 MTV was introduced; televised video versions of singers performing recent pop songs added an intense visual experience to the music. Michael Jackson's hugely successful music video *Thriller,* released in 1983, went to the top of the charts.

As the twentieth century ended most middle-class Americans and their children had embraced the computer culture of e-mail, CD-ROMS, and internet surfing. With the growing availability of computer technology and its culture, many visual artists turned to computer graphics and began working with digitized images. Art departments began to offer courses that computer science departments had earlier developed. To many artists the democratic possibilities for this new art form seemed immense, especially when art was circulated on the internet.

Throughout the 1980s, the United States, in spite of its setback in Vietnam, continued to intervene in civil wars around the world—opposing governments or insurgent groups not judged favorable to U.S. military and trade interests. However, the so-called Vietnam syndrome made the United States hesitant to commit ground troops in pursuing these interventions. Many artists actively protested U.S. involvement in Latin American politics, notably the covert operations to destabilize the elected government of Nicaragua. Artists raised money and formed "artist brigades," such as Arts for a New Nicaragua, a group that traveled to the country to lead art workshops and to paint murals.

The move toward a new international order was also evident in Africa. In the 1980s, responding to boycotts and protests within the United States against the apartheid policies of the government of South Africa, the United States imposed partial sanctions. Some universities divested themselves of stocks, and some companies ceased operations in South Africa altogether. Eventually, in February 1990, the South African government, reacting to popular unrest and foreign pressure, released from prison Nelson Mandela, the head of the African National Congress, a group that had fought underground for decades against apartheid. The following year all the apartheid laws were repealed, yet the economic situation barely changed for many South Africans.

The fall of apartheid coincided with the major event of this period: the collapse of the Soviet Union in 1989 and the subsequent reorganization of the communist countries of Eastern Europe. The "official end" of the Cold War was jointly declared by President George Bush of the United States and President Mikhail Gorbachev of the U.S.S.R. on December 2, 1989. Events moved swiftly. By early 1991 many formerly Soviet countries had declared their independence, had held elections, and were being led by non-communists: Lithuania, Estonia, Latvia, Uzbekistan, Georgia, Czechoslovakia, Hungary, Romania, Bulgaria, Yugoslavia, and Russia itself. On December 25, 1991, Gorbachev resigned as president of the U.S.S.R. The Soviet Union had ceased to exist.

The collapsing of rigidly patrolled national borders during the early 1990s meant greater freedom for Eastern Europeans to travel from country to country. One of the results was a steady flow to the United States of professionals, including artists, art students and curators, who took up permanent residence and made an impact on the cultural life of the country.

After the demise of the Soviet Union, in 1991 the United States was left as the only "superpower" on the planet, although Russia and the Ukraine still held thousands of nu-

clear arms in storage. President Bush and then President William Jefferson Clinton, with the aid of the United Nations, perpetuated the image of the United States as the defender of the peace—especially in the oil-rich Middle East. When the Iraqi government invaded and occupied Kuwait and after months of sanctions still refused to withdraw its troops, the United States and its allies retaliated. On January 16, 1991, the United States launched an air offensive, "Operation Desert Storm." American ground troops landed at the end of February, and liberated Kuwait within a few days. On February 28 President Bush announced that fighting had ceased and that there were few American casualties. However, the actual success of U.S. involvement in the Persian Gulf seemed inconclusive, since the Iraqis were not defeated, only contained.

Not surprisingly, the Gulf War elicited some anti-government demonstrations within the United States; unlike Vietnam which dragged on for years and for which young men were drafted into the Army, the Persian Gulf War was concluded so quickly and news about it was so tightly controlled (see Reading 148) that little anti-war momentum developed. Still, Americans were urged toward patriotism by pro-war politicians and their supporters. This took a cultural twist when these politicians began to denounce a revisionist art exhibition, *The West as America* mounted at the National Museum of American Art in the spring of 1991. Revisionist historians were accused of "political correctness"—of raising issues of racism and sexism and class exploitation in American history and in contemporary social policies.

In the late 1970s and early 1980s a disease began to strike many young people, mostly male, that often led to death. By 1981 the Center for Disease Control recognized it as Acquired Immune Deficiency Syndrome (AIDS), a disease transmitted through transference of blood and other body fluids. In 1983 the HIV virus, which causes AIDS, was isolated. But the government was slow to address the issues and to allocate the necessary funds for research. When a backlash against homosexuals developed, activists such as Act-Up (see Reading 159) began to organize public education campaigns to protest the slow progress of research; government inaction is chronicled in Randy Shilts's *And the Band Played On: Politics, People and the AIDS Epidemic* (1987).

The ongoing struggles of women for social and economic equality also characterized the last two decades, but with mixed successes. Although Congress passed the Equal Rights Amendment in 1972, it failed to get the vote for ratification in the majority of states by the 1982 deadline, and, hence, was never enacted into law. There were some token changes. In 1981 a woman justice, Sandra Day O'Connor, was appointed to the Supreme Court. On the other hand, women were not yet paid comparable wages, although the figure rose from 57 percent of men's wages in the 1970s to 75 percent at the end of the 1990s.

The situation for minorities and immigrants echoes or overlaps that of women. A backlash against affirmative action policies characterized the 1990s and was symbolized in California's Proposition 209. Approved by voters in November 1996 and implemented in August 1997, Proposition 209 prohibited considerations of race or gender in public university admissions policies or in government hiring and contract bidding. When California's Proposition 187 was enacted in 1994 undocumented workers were denied public services and education for their children. Even though the agribusiness in California depended on these workers, they were constantly in fear of being deported. Art has reflected such concerns; California artists have been in the forefront in incorporating issues about immigration into their artworks (see Reading 145).

The 1990s ended with a mix of pessimism and optimism, of cynicism mixed with altruism. The culture wars of the early 1990s seemed to have subsided. Unemployment was down, and the domestic economy, fueled by exuberance on Wall Street, was booming. Still the divisions between rich and poor were widening; the prisons held over two million men and women; educational reforms and managed health care provoked bitter controversies, and racism had not been eliminated.

As the twenty-first century dawned, artists and writers continued to address the broad issues and controversies confronted by earlier generations. To be "modern" still meant to be engaged with the vital questions of art, culture, and society. Artists and writers continued to deal variously with the formal issues of artmaking, with the controversies over realism and representation, and with the attraction of the common-place—the everyday vernacular, the explicitly vulgar and the popular—in their efforts to communicate to their audiences their experiences of modern life.

# Exit Modernism, Enter Postmodernism

By the 1980s it became evident in the artworld that entirely new ways of making art and looking at art were emerging. The pluralism of styles of the 1970s, many championed by women and people of color, had already challenged the hegemony of a high modernism that had been rigidly defined as exclusive. Artists, critics, and curators recognized the necessity to analyze the recent art with a more inclusive and flexible definition. Many began to use the term "postmodernism" to distinguish the noncanonical objects of their studies. At the same time cultural critics needed a term to describe a new global culture.

By the mid-1980s the literature describing postmodernism and the postmodern condition was burgeoning. In its April 1988 issue *Spy* magazine did a computer search through a data bank focused on the leading American newspapers (including *The New York Times, The Washington Post,* and *The Los Angeles Times*) and discovered that the number of articles on postmodernism had grown from 21 in 1980 to 247 in 1987. *Spy* concluded that postmodernism "is the current version of groovy—except that using it makes you sound smart."

However tempting it is to spoof postmodernism, one realizes that *Spy*'s debunking of "postmodernism" is one aspect of the postmodernist mindset. Yet, like every new way of looking at art, culture, and nature, the insights of writers and artists could be quickly co-opted to the needs of the market and the politics of reaction. Hal Foster, who edited one of the first anthologies of essays on postmodernism, *The Anti-Aesthetic: Essays on Postmodern Culture,* 1983, warned that whereas there could be a "postmodernism of resistance," there could also be a "postmodernism of reaction" that accommodated itself to the status quo. The photographer and theorist Allan Sekula, in "Dismantling Modernism, Reinventing Documentary (Notes on the Politics of Representation)" (*The Massachusetts Review,* 1979), found the term somewhat suspect. To Sekula, " 'Pure' artistic modernism collapses because it is ultimately a self-annihilating project, narrowing the field of art's concerns with scientist rigor, dead-ending in alternating appeals to taste, science and metaphysics. Over the past five years, a rather cynical and self-referential mannerism, par-

tially based on Pop Art, has rolled out of this cul-de-sac. Some people call this phenomenon 'postmodernism.' " At that point—1979—Sekula saw postmodernism as a "chic vanguardism, by artists who suffer from a very real isolation from larger social issues."

Most commentators, like Sekula, first defined modernism and its history before launching into a meditation on the ways that postmodernism disrupted or subverted modernism. Indeed, the prefix "post" seems to demand that process. But in matching adjectives to categorizations, many critics, including Kim Levin, decided that an intermediate step was needed, that is, "late modernism"—a hybrid transitional state between the two. A further preoccupation was distinguishing postmodern art from postmodern critique.

Postmodern critique considered its project not just the description and formal analysis of objects but an interrogation of a complicated process that includes, first, the circumstances of production; second, the initial display and critical reception; and third, the assimilation or distribution of the ideas and visual imagery into the general culture. Postmodern critique becomes anthropological in its investigations, with a large debt to the legacies of Marxism, French post-structuralist theories, and British cultural studies. For example, when critics noted the frequency of the organizing principles of repetition, appropriation, and simulation, they related these principles to the workings of the transnational economics of the West and the postcolonial societies of the so-called "Third World," and they used dialectical methodologies to explore those connections. From the early 1980s to the late 1990s the discourse about postmodernism was, of course, both refined and extended to incorporate theories of postcolonialism by such writers as Edward Said, Homi Bhabha and Aijaz Ahmad.

**124** ✦ Kim Levin, "Farewell to Modernism," *Arts* 54, no. 2 (October 1979):90–93.

As contributing editor, Kim Levin wrote frequently for *Arts*. Looking back on the '70s she admits that "it was obvious that something was over," because recent art had become all those things deplored in Greenberg/Fried criticism. Levin's words were on the mark: "The question of imitation, the gestural look of Abstract Expressionism, and all the words that had been hurled as insults for as long as we can remember—illusionistic, theatrical, decorative, literary—were resurrected, as art became once again ornamental or moral, grandiose or miniaturized, anthropological, archaeological, ecological, autobiographical or fictional." Also jettisoned, Levin notes, are the concepts of "style" and "originality" (a theme analyzed in Rosalind Krauss, "The Originality of the Avant-Garde," *October,* Fall 1981). If the grid was modernist (Krauss's idea), then the map is postmodernist, according to Levin. Levin's essay summarizes the transition from modernism to a new era of postmodernism, with late modernism a viable category.

In the late 1970s and into the 1990s *Arts,* under the editorship of Richard Martin, was one of the best, and most inclusive, eclectic art magazines published in New York. It blended together scholarly essays on pre-1945 European and American art with footnoted, longer essays on contemporary art, plus one-page reviews of New York gallery shows by recent artists.

✦

The '70s has been a decade which felt like it was waiting for something to happen. It was as if history was grinding to a halt. Its innovations were disguised as revivals. The question of imitation, the gestural look of Abstract Expressionism, and all the words that had been hurled as insults for as long as we could remember—illusionistic, theatrical, decorative, literary—were resurrected, as art became once again ornamental or moral, grandiose or miniaturized, anthropological, archeological, ecological, auto-biographical or fictional. It was defying all the proscriptions of modernist purity. The mainstream trickled on, minimalizing and conceptualizing itself into oblivion, but we were finally bored with all that arctic purity.

The fact is, it wasn't just another decade. Something did happen, something so momentous that it was ignored in disbelief: modernity had gone out of style. It even seemed as if style itself had been used up, but then style—that invention of sets of forms—was a preoccupation of modernism, as was originality. The tradition of the New, Harold Rosenberg called it. At the start of the '70s there were dire predictions of the death of art by modernist critics and artists. By now it is obvious that it was not art that was ending but an era.

We are witnessing the fact that in the past ten years modern art has become a period style, an historical entity. The modernist period has drawn to a close and re-ceded into the past before our astonished eyes. And because the present was dropping out from under us, the past was being ransacked for clues to the future. The styles of modernism have now become a vocabulary of ornament, a grammar of available forms along with the rest of the past. Style has become a voluntary option, to be scav-enged and recycled, to be quoted, paraphrased, parodied—to be used as a language. Modernist and pre-modernist styles are being used as if they were decorative possi-bilities or different techniques—breeding eclectic hybrids and historicist mutations—by narrative artists and pattern painters, by post-conceptualists and former minimal-ists and unclassifiable mavericks. For many artists, style has become problematic: it is no longer a necessity.

The art establishment is still uneasy with the idea. It is more comfortable search-ing short-sightedly for the trends of the decade—as if it were just another decade—or calling it "pluralistic," or proclaiming, as Philip Lieder did recently, that pure ab-straction is still the new paradigm.

Nevertheless, post-modernism is fast becoming a new catchword, and it is full of unanswered questions and unacknowledged quandries. What is it that has so ir-revocably ended, and why, and when did the break occur? If we are going to talk about post-modernism, we should start by defining modernism, by questioning how we can recognize whether something is—or isn't—modernist. For those who have stepped outside modernism, the successive styles of the modern period, which seemed so radically different from each other at the time, are beginning to merge to-gether with shared characteristics—characteristics that now seem quaintly naive.

Modern art was scientific. It was based on faith in the technological future, on belief in progress and objective truth. It was experimental: the creation of new forms was its task. Ever since impressionism ventured into optics, it shared the method and logic of science. There were the Einsteinian relativities of Cubist geometry, the tech-nological visions of Constructivism and Futurism, de Stijl and Bauhaus, the Dadaists' diagrammatic machinery. Even Surrealist visualizations of Freudian dream-worlds

and Abstract-Expressionist enactments of psychoanalytical processes were attempts to tame the irrational with rational techniques. For the modernist period believed in scientific objectivity, scientific invention: its art had the logic of structure, the logic of dreams, the logic of gesture or material. It longed for perfection and demanded purity, clarity, order. And it denied everything else, especially the past: idealistic, ideological, and optimistic, modernism was predicated on the glorious future, the new and improved. Like technology, it was based all along on the invention of man-made forms, or, as Meyer Schapiro has said, "a thing made rather than a scene represented."

By the 1960s, with Pop art embracing the processes and products of mass production, and Minimalism espousing the materials and methods of industry, the ultimate decade of technology had arrived. By the time men were traveling to the moon, art was being assembled in factories from blueprints, Experiments in Art and Technology (E.A.T.) was showing the results of its collaborations at the Armory and the Brooklyn Museum, the Whitney had a light show, MOMA had a machine show, Los Angeles had a technology show, and at the ICA in London there was an exhibition of cybernetic art made by machines. It seemed as if the glorious technological future the early modernists dreamed of had arrived.

But at the height of this optimism, modernism fell apart. The late '60s was also the time of Vietnam, Woodstock, peace marches, race riots, demonstrations, and violence. 1968 may have been the crucial year, the year we stopped wanting to look at art as we knew it, when even the purest form began to seem superfluous, and we realized that technological innovation wasn't enough. The work of a great many artists underwent radical changes. Minimalism, the last of the modernist styles, collapsed in heaps of rubble on gallery floors as scatter pieces proliferated, the Castelli Warehouse opened, the Whitney had its anti-form anti-illusion exhibition, earthworks went into the wilderness, Conceptualism came out of the closet, and art became documentation. In a sense it was the ultimate god-like act of modernism: creating a work out of nothing. In another sense it was obvious that something was over.

[. . .]

It has taken ten years to realize we had walked through the wall that was blocking out nature. Modernism, toward the end of its reign, came to be seen as reductive and austere. Its purity came to seem puritanical. It was in the terminology—in a word, formalism—which implied not only the logical structures of modernist invention but also the strictures of rigid adherence to established forms. "There is no other democracy than the respect for forms," one of the new French philosophers has remarked. Like democracy, modernist art is now being reinterpreted in terms of its insistence on forms and laws rather than in terms of liberty and freedom. The modernist vision may have had democratic aims—a progressive emancipation of the individual from authority in an age of unlimited possibilities, as Schapiro has noted—but in practice it was elitist: the public never understood abstract art. It was as specialized as modern science. And emphasis on structure rather than substance is what we came to see in it. Like science, modernist art has begun to seem dogmatic and brutal.

Because it was competitive and individualistic, it saw everything in terms of risk. Like capitalism, it was materialistic. From its collage scraps and fur-lined teacup to its laden brushstrokes, I-beams, and Campbell's soupcans, modernist art insisted increasingly on being an object in a world of objects. What started as radical physicality turned

into commodity; the desire for newness led to a voracious appetite for novelty. Post-modernism began, not just with a disillusionment in the art object, but with a distrust of the whole man-made world, the consumer culture, and the scientific pretense of objectivity. It began with a return to nature. The mood was no longer optimistic. Logic no longer sufficed. Technology has undesirable side-effects and in a world threatened by defoliated land, polluted air and water, and depleted resources, by chemical additives, radioactive wastes, and space debris, progress is no longer the issue. The future has become a question of survival.

Only now can we begin to realize just how widespread this shift of consciousness was. In 1967 the art magazines were full of sleek cubic forms; by 1969 those steel and plastic objects had been replaced by natural substances, ongoing processes, photographic images, language and real time systems. It wasn't simply the appearance of another new movement, as in the past. It was a crucial change that affected artists of all persuasions. For a large cross-section of the artworld it was a turning point. And all the changes can be traced, by various circuitous routes, to a strong desire to make things real, to make real things. Those photographs from the moon of a marbleized little blue earth may have altered our perception. In diverse and unexpected ways, art was going back to nature. But having been absent for so long, nature was unrecognizable. In the beginning it looked like demolition. [. . .] Returning materials to their natural state, subjecting them to natural forces, sending art back to the land or internalizing it within the body, they were evidence that time and/or place were becoming crucial, clearing the way for the psychological and the narrational, for personal content, lifelike contexts, and subjective facts. The feeling against style and objectivity proved more subversive than the antipathy toward objects and form: post-modernism arose out of conceptualist premises—that art is information—while protesting its modernist aridity.

Post-modernism is impure. It knows about shortages. It knows about inflation and devaluation. It is aware of the increased cost of objects. And so it quotes, scavenges, ransacks, recycles the past. Its method is synthesis rather than analysis. It is style-free and free-style. Playful and full of doubt, it denies nothing. Tolerant of ambiguity, contradiction, complexity, incoherence, it is eccentrically inclusive. It mimics life, accepts awkwardness and crudity, takes an amateur stance. Structured by time rather than form, concerned with context instead of style, it uses memory, research, confession, fiction—with irony, whimsy, and disbelief. Subjective and intimate, it blurs the boundaries between the world and the self. It is about identity and behavior. [. . .] The return to nature is not only an involvement with the natural world but an acceptance of the frailties of human nature. Which may have something to do with the fact that, if the artist as god-like Creator was the leitmotif of modernism, the absent artwork—non-visual, shrunken or expanded beyond visibility, hiding out in the world or within the artist—has been a theme of the '70s.

But just what is post-modernist? Separating late modernist works from post-modern ones is no easy task at this juncture of periods. As in late Roman and early Christian art, or late Gothic and early Renaissance, they coexist. And right now a great deal of what is passing as post-modern is really late modernist or else transitional—a confusing mixture of both. The '70s has been a hybrid decade in more ways than one.

\* \* \*

If the grid is an emblem of modernism, as Rosalind Krauss has proposed—formal, abstract, repetitive, flattening, ordering, literal—a symbol of the modernist preoccupation with form and style, then perhaps the map should serve as a preliminary emblem of post-modernism: indicating territories beyond the surface of the artwork and surfaces outside of art; implying that boundaries are arbitrary and flexible, and man-made systems such as grids are superimpositions on natural formations; bringing art back to nature and into the world, assuming all the moral responsibilities of life. Perhaps the last of the modernists will someday be separated from the first post-modernists by whether their structure depended on gridding or mapping. But because the substructure of any terrain recreated on another scale depends on lines of longitude and latitude (the grid with which we have ordered the earth), maps are the secret and not-so-secret grids of reality, grids gone back to nature, hugging the earth, delineating content. [. . .]

And if psychoanalysis is the mode of self-discovery analogous to modernism, perhaps we should look to the self-awareness movements that have become popular during the '70s for a terminology appropriate to the new art. Based not on scientific reason and logic and the pretense of objectivity but on presence, subjective experience, behavior, on a weird kind of therapeutic revelation in which it is not necessary to believe or understand—it is enough if it works. [. . .]

Ten years after the end of the modernist age—but end sounds too final, age too grand—ten years after, the last modernists are still clinging to power and the postmodern forces are still a ragged band lurking in the underbrush, to put it in purple art prose. They don't always even recognize themselves, or each other, for mostly they are caught in the middle with sympathies on both sides of this metamorphosis that is taking place. Post-modernism has barely begun. It is too early to predict whether it will open a new era in art's history, or merely provide a final perverse coda to modernism.

---

**125** ✦ Peter Halley, "Nature and Culture," *Arts* 58, no. 1 (September 1983): 64–65.

Peter Halley is both a theorist and a painter, one of a group of artists (Ross Bleckner, Sherrie Levine, and Philip Taaffe) called "Neo-Geo" in the mid-1980s, who explored ideas of appropriation, simulation, and pastiche in opposition to the "originality" of modernist painting. A major exhibition that surveyed these ideas was *Endgame: Reference and Simulation in Recent Painting and Sculpture* (Institute of Contemporary Art, Boston, 1986).

Halley does not use "postmodern" in this essay; instead he relates the "abrupt" change at the end of the 1970s to a late industrial society that generated the theories of Roland Barthes, Michel Foucault, Jacques Derrida, and Jean Baudrillard. Whereas Levin sees the shift from science and modernism to nature and postmodernism, Halley sees a different shift—from the era of abstact expressionism with its "transcendentalist, phenomenologically oriented approach" that valued nature to "a new practice that looks exclusively to the mass media for its repertory of images." The art theorists that interest Halley are steeped in cultural studies and ally themselves either with the ideas of Baudrillard (and the study of surfaces) or Foucault (and the study of structures of power). Halley warns

against the mind-set that sees destructions such as World War II as "natural disasters" rather than directed by human agency; to Halley, the manipulation of language codes is the only form of power to be feared.

---

◆

---

Just a decade ago, having "soul" was said to be the cure for the alienation with which consciousness in the industrialized world was plagued. In the mechanized, repressed bourgeois world, it was argued, people had been stripped of their vitality, their spontaneity, their emotionality. Thus, an utterance that had "soul," that was endowed with spirituality, could be said to play a role in returning to humankind its oneness with nature, its "essence."

Today, however, thinking about these issues has changed, at least in the art world. The concepts of "soul" and spirituality are viewed by many as a means by which bourgeois culture has consolidated its position by denying its historicity. To say that a work of art is spiritual is to attribute to it universal, timeless value, and to suggest that the society which encourages and validates works with such attributes is itself timelessly and universally valid.

That opinion could be so radically transformed in so short a period provokes examination, for such transformed judgments are the result of a tidal wave of intellectual change that has washed over the art world in the present decade and has seen the practice of art which had been dominant since the Second World War completely swept away and replaced by another.

The practice of art from World War II to the end of the last decade was dominated by ideas derived from phenomenology, existentialism, and Jungian transcendentalism. This period attributed to modernism a vanguard, heroic role, not in the political sense, but in the sense that it claimed that art at times was capable of reuniting humans with some lost essence and that at other times art was able to release hidden, heretofore unaccomplished potentialities in the human being.

\* \* \*

Reigning over this entire [postwar] era, one finds the philosophical tenets of phenomenology and existentialism. The art of this period is overwhelmingly concerned with the situation of the individual as a perceiving and deciding entity. But before one can dismiss the production of this epoch as merely a typical manifestation of late industrialism concerned with preserving the mythic importance of the individual and of some absolute nature upon which the individual can act, one must remember that this era was formed and determined by another historical event, an event whose influence must be considered separately from the smooth progression of the stages of the development of capital.

If the art of this period can be seen as positing a relationship between the individual and nature, it is perhaps because World War II constituted an event that acted upon those who experienced it as nature. This mammoth event, although certainly caused by social forces, eventually gathered, for a considerable portion of the world's people, into a phenomenon not very different from a devastating flood or fire. World War II constituted a "natural disaster" insofar as it tore asunder the seamless web of signs that constitutes modern civilization. It left countless persons in a situation in

which they were faced not with the codes that their societies had invented for them but rather with a hole in the "empire of signs," an accidental nature. [. . .]

Why then, at the end of the '70s, did this transcendentalist, phenomenologically oriented approach which was dominant for thirty years abruptly disappear to be replaced by a new practice that looks exclusively to the mass media for its repertory of images, that rejects the phenomenology of art-making as pretentious and mandarin, that interprets language as a closed set without reference to any extra-human reality, a new practice that substitutes for phenomenological study a fascination with sociological and political reality, rejects the positivism of both the physical and social sciences, and replaces the cult of originality with myriad variations on the theme of repetition?

\* \* \*

Advertising's recent appropriation of the vocabularies of nature and post-war modernism makes apparent the extent of this change, which is a triumph of the market over nature. That beer, detergent, and make-up are now called "natural" is significant. Today the name "Nature Valley" refers to a kind of breakfast cereal; cigarettes have been given such transcendentalist labels as "True," "Light," and "Now." [. . .]

Fredric Jameson has observed that cultural analysis is today dominated by two separate trends.[1] On one hand, there is the theory of the simulacrum, as developed by Baudrillard. On the other, there is the work of Michel Foucault, which sees contemporary culture not as a shimmering surface of autonomous signs but as a place in which the technologies of surveillance, normalization, and categorization have ever broadening control over social life. In contrast to Baudrillard's vision of the detached signifier, Foucault finds hidden behind the various signifiers of contemporary society the veiled signified of power, in the form of the consolidation of class position. One questions why artists and art theorists today have been attracted so exclusively to Baudrillard's rather than to Foucault's interpretation of social relationships. One wonders if perhaps Baudrillard's brilliant world of surfaces is not more seductive than Foucault's bleak excavation of the spaces of regimentation. And one wonders if artist and audience, seduced by this shimmering world, have not been deflected away from the investigation of crucial issues about society's structure. [. . .]

Currently on television there is an advertisement for an investment services company admonishing the viewer that "Some investments require discipline, some require courage." Clearly this advertisement addresses the potential "investor" as if he were a kind of warrior needing the traditional martial traits. Here, as in so many sectors of contemporary society, including perhaps the present art world, the successful manipulation of the codes to gain social power is treated as if it were a life and death matter. To acknowledge only the existence of language has created an unfortunate limitation on the range of actions that are thought to make sense.

The final image that emerges from these reflections is the image of destruction. One thinks of the Second World War, that "natural disaster" brought about by social players, and one shudders at imagining the torrent of destruction that may be unwittingly released by the inhabitants of our own empire of signs if, in their struggles to gain power over the codes, they unleash forces beyond everyone's controlling.

---

[1] Fredric Jameson, *The Political Unconscious* (Ithaca, NY: Cornell University Press, 1981), p. 92.

***126*** ✦ Hal Foster, "Whatever Happened to Postmodernism?" in *The Return of the Real: The Avant-Garde at the End of the Century.* (Cambridge, MA: The MIT Press, 1996).

Hal Foster has been an influential theorist through his position as editor of *Art in America* and *October* and for his books: *Anti-Aesthetic: Essays on Postmodern Culture,* 1983, which he edited, *Recodings: Art Spectacle, Cultural Politics,* 1985, and *Compulsive Beauty,* 1993. In this essay from the end of a recent book, Foster reviews postmodernism as a concept and considers it no clearer in the late 1990s than in the early 1980s. Yet, to Foster, the term "may still possess explanatory, even critical power" in the hands of certain theorists when developing their ideas.

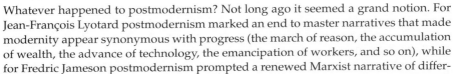

Whatever happened to postmodernism? Not long ago it seemed a grand notion. For Jean-François Lyotard postmodernism marked an end to master narratives that made modernity appear synonymous with progress (the march of reason, the accumulation of wealth, the advance of technology, the emancipation of workers, and so on), while for Fredric Jameson postmodernism prompted a renewed Marxist narrative of different stages of modern culture related to different modes of capitalist production. Meanwhile, for critics committed to advanced art, it signaled a move to break with an exhausted model of modernist art that focused on formal refinements to the neglect of historical determinations and social transformations alike.

Thus even within the left, especially within the left, postmodernism was a disputed notion. Yet not long ago there was a sense of a loose alliance, even a common project, particularly in opposition to rightist positions, which ranged from old attacks on modernism in toto as the source of all evil in our hedonistic society to new defenses of particular modernisms that had become official, indeed traditional, the modernisms of the museum and the academy. For this position postmodernism was "the revenge of the philistines" (the happy phrase of Hilton Kramer), the vulgar kitsch of media hucksters, lower classes, and inferior peoples, a new barbarism to be shunned, like multiculturalism, at all costs. I supported a postmodernism that contested this reactionary cultural politics and advocated artistic practices not only critical of institutional modernism but suggestive of alternative forms—of new ways to practice culture and politics. And we did not lose. In a sense a worse thing happened: treated as a fashion, postmodernism became *démodé.*

The notion was not only emptied by the media; again, it was disputed within the left, often with good reason. Despite its *adieu* to master narratives, the Lyotardian version of postmodernism was sometimes taken as the latest proper name of the West, now melancholically obsessed with its postcolonial decline (or the premature reports thereof). So, too, despite its focus on capitalist fragmentation, the Jamesonian version of postmodernism was sometimes considered too totalizing, not sensitive enough to cultural differences of many sorts. Finally, the art-critical version of postmodernism was sometimes seen to seal modernism in the formalist mold that we wanted to break. In the process the notion became incorrect as well as banal.

But should we surrender it? Apart from the fact that the left has already conceded too much in this war, the notion may still possess explanatory, even critical power. Consider the influential model of postmodernism developed by Jameson over the last decade. He adapts the long-wave theory of economic cycles elaborated by the economist Ernest Mandel, according to which the capitalist West has passed through four fifty-year periods since the late eighteenth century (roughly twenty-five years each of expansion and stagnation): the Industrial Revolution (until the political crises of 1848) marked by the spread of handcrafted steam engines, followed by three further technological epochs—the first (until the 1890s) marked by the spread of machined steam engines; the second (until World War II) marked by the spread of electric and combustion engines; and the third marked by the spread of machined electronic and nuclear systems. Mandel relates these technological developments to economic stages: from market capitalism to monopoly capitalism around the last fin de siècle, to multinational capitalism in our millennial moment. Jameson in turn relates these economic stages to cultural paradigms: the worldview of much realist art and literature incited by the individualism encouraged by market capitalism; the abstraction of much high-modernist art and literature in response to the alienation of bureaucratic life under monopoly capitalism; and the pastiche of much postmodernist practice (in art, architecture, fiction, film, fashion, food) as a sign of the dispersed borders, the mixed spaces, of multinational capitalism. His model is not as mechanical as my précis makes it sound: Jameson stresses that these developments are uneven, that each period is a palimpsest of emergent and residual forms, that clean breaks do not occur. Nevertheless, his narrative is often condemned as too grand, as if capital were a great reaper that swept up everything in its path. For my purposes it is too spatial, not sensitive enough to the different speeds as well as the mixed spaces of postmodern society, to the deferred action as well as the incessant expansion of capitalist culture.

. . . I borrow the notion of deferred action (*Nachträglichkeit*) from Freud, for whom subjectivity, never set once and for all, is structured as a relay of anticipations and reconstructions of events that may become traumatic through this very relay. I believe modernism and postmodernism are constituted in an analogous way, in deferred action, as a continual process of anticipated futures and reconstructed pasts. Each epoch dreams the next, as Walter Benjamin once remarked, but in so doing it revises the one before it. There is no simple *now:* every present is nonsynchronous, a mix of different times; thus there is no timely transition between the modern and the postmodern. In a sense each comes like sex(uality), too early or too late, and our consciousness of each is premature or after the fact. In this regard modernism and postmodernism must be seen together, *in parallax* (technically, the angle of displacement of an object caused by the movement of its observer), by which I mean that our framings of the two depend on our position in the present *and* that this position is defined in such framings.

This notion is abstract, so let me apply it in one reading of the never-complete passage to the postmodern. . . . I will focus on three moments thirty years apart within the twentieth century: the middle 1930s, which I take to be the culmination of high modernism; the middle 1960s, which mark the full advent of postmodernism; and the middle 1990s. I will treat these moments in a discursive sense, to see how historical shifts may be registered in theoretical texts—which will thus serve as both objects and

instruments of my history. This idiosyncratic narrative will not address art directly; instead, in addition to the relation of technology and culture (which tends to be privileged in these accounts), I will trace crucial shifts in Western conceptions of the individual subject and the cultural other.

My reason for this focus is simple. The quintessential question of modernity concerned identity: in the famous query of Paul Gauguin, *Where do we come from? Who are we? Where are we going?* . . . Answers often came through an appeal to otherness, either to the unconscious or to the cultural other. Many high modernists felt truth was located there: hence the significance of psychoanalysis and the profusion of primitivisms throughout this century. Indeed, many high modernists conflated these two natural preserves, the unconscious and the cultural other, while some postmodernists argue that they are acculturated in advanced capitalism. In short, the discourses of the unconscious and the cultural other, psychoanalysis and anthropology, are the privileged modern discourses because they speak to identity in these terms. In doing so they may also register more seismographically than any other discourses the epistemological changes that demarcate the postmodern.

Each moment at issue here represents a significant shift in discourses on the subject, the cultural other, and technology. In the middle 1930s Jacques Lacan was concerned with the formation of the ego, especially in the first version of "The Mirror Stage." Claude Lévi-Strauss was involved in the Brazilian fieldwork that revealed the mythological sophistication of "the savage mind." And Walter Benjamin was concerned with the cultural ramifications of modern technologies in "The Work of Art in the Age of Mechanical Reproduction." By the middle 1960s each of these discourses had changed dramatically. The death of the humanist subject, not its formation, was considered variously by Louis Althusser, Michel Foucault, Gilles Deleuze, Jacques Derrida, and Roland Barthes (whose signal texts on the topic swirl around the revolts of 1968). So, too, the cultural other, inspired by the liberation wars of the 1950s, had begun to talk back—to be heard for the first time—most incisively in the rewriting of master-slave dialectic in Hegel and Marx by Frantz Fanon, whose *The Wretched of the Earth* was published in 1961. Meanwhile, the penetration of media into psychic structures and social relations had reached a new level, which was seen in two complementary ways: fatalistically by Guy Debord as an intensity of reification in *The Society of the Spectacle* (1967) and ecstatically by Marshall McLuhan as an "extension of man" in *Understanding Media* (1964).

What has changed in these three discourses since then? In a sense the death of the subject is dead in turn: the subject has returned in the cultural politics of different subjectivities, sexualities, and ethnicities, sometimes in old humanist guise, often in contrary forms—fundamentalist, hybrid, or . . . "traumatic." Meanwhile, at a time when first, second, and third worlds are no longer distinct (if they ever were), anthropology is critical of its protocols regarding the cultural other, and postcolonial imbrications have complicated anticolonial confrontations. Finally, even as our society remains one of spectacular images as outlined by Debord, it has become one of electronic discipline—or, if one prefers the technophilic version in the spirit of McLuhan, one of electronic freedom, of the new possibilities of cyberspace, virtual reality, and the like. My purpose is not to prove that one position is right, the other wrong, nor to assert that one moment is modern, the next postmodern, for again these events do not

develop evenly or break cleanly. Instead each theory speaks of changes in its present, but only indirectly, in reconstruction of past moments when these changes are said to have begun, and in anticipation of future moments when these changes are projected to be complete: thus the deferred action, the double movement, of modern and postmodern times.

\* \* \*

---

*127* ✦ Robert C. Morgan, "The End of the Art World," in *The End of the Art World*. (New York: Allworth Press, 1998).

With both MFA and PhD degrees, Robert Morgan has had a career as both an artist and critic. He has curated numerous exhibitions and has taught full time at several colleges and art schools. He is currently Professor of the History and Theory of Art at the Rochester Institute of Technology. His recent books include *Art into Ideas: Essays on Conceptual Art*, 1996, and *The End of the Art World*, 1998.

In this essay, Morgan deplores the market-driven artworld that privileges certain ideas and art styles over others. If artists are to exert a force in culture, they must be able to resist "the fashion system" and maintain "a certain ethical relationship to art." He cautions about the art of cyberspace: "Instead of art, we are receiving the signs of art." Nevertheless, he recognizes that the internet is an important means of communication. Morgan concludes that "postmodern" better describes a postmodern condition of the present, rather than any style of art itself.

✦

---

*III.*

Whether the struggle is an internal or an external one, there are important artists who are not being shown, promoted, or advertised in the delimited infrastructure of today's art world. There is a problem when art becomes an overtly market-driven enterprise, contingent upon mystique, as it has become since the eighties. To make art happen as a vital force within culture despite the rhetoric that supports this mystique through the sale of escapist spectacles, is to recognize that artists may still have a community in which to muster strength and mutual support. This community may be defined as one that maintains as its basis an open sense of internal critique. It is only though a sense of dialogue within the community that artists can hope to contribute a presence in relation to the cultural context that exists outside.

Over the years—since art has become "radicalized," or, rather, acquiescent to theory—some advocates of postmodernism have tried to diminish the separation between serious art and the conformist phenomenon of the wider market-driven art world, as if the need for any kind of real dialogue among artists and critics were insignificant. It is precisely the artist's dialogue that offers a spontaneous urgency and a necessary point of resistance to the conditioning processes inherent in an advanced capitalist world. If I understand the message of Joseph Beuys correctly, this is what he

advocated in his "social sculpture." For Beuys, the puritanical isolation of the art world, based solely on materialism, was a negative force in culture. Instead, he incited the activation of what he called "power fields" within the society, and artists were the instigators.

I would argue that to be an artist in the most fundamental sense is ultimately a task of liberation. This is to suggest that to be an artist in the international sense is not simply about marketing one's logo, but is about maintaining a certain ethical relationship to art. It is about positioning oneself in opposition to the assumption that the information network carries its own "natural" momentum and will automatically improve life. It would seem that artists cannot escape the ethical responsibility to resist this omnipresent pressure, the wholesale seduction that the art world assumes in its desire for a revisionist informational environment. To be an artist—regardless of how one's success is measured—has always been a matter of intelligence, passion, constraint, shrewdness, and wit. This implies a position of resistance, but not one of denial. The power of art lies in its oblique angle to the accepted cultural norm. Artists define themselves as artists in terms of both their attraction and repulsion to this norm. The crucial issue here is in finding what sustains the necessity of one's liberation, because artists will move in relation to this necessity more than in the pursuit of ideas.

Art must be willing to resist what Barthes designated as "the fashion system" or it will gradually deconstruct itself under the guise of political slogans and social codes. In doing so, art will cease to exist as a cultural force of any remarkable consequence. Becoming an artist is a matter of priorities. Again, one must be willing to ask, What is the motivation for doing what one is doing? It is within the context of a community that these priorities can be tested and better understood. Liberation through art is both social and psychological. To this extent, art is a force that resists institutionalization. Art is a force close to life.

While the term "postmodern art" may have been useful in architectural theory in the late seventies, it does not fit seamlessly within a generalized discourse on the current situation in art. In fact, postmodern art does not exist. It is not a style because its very premise, being one of historicist appropriation, refutes style. As a prerequisite to modernism, the concept of style can no longer bear the weight of postmodernism. The only reason to discuss style in the nineties is to offer another marketing device to sell a politicized form of art. Put another way, the concept of style has often been used to sell derivative art that lacks insight, force, and qualitative significance. To clarify: we are not talking about an individual artist's historical orientation or approach to artmaking; rather, we are talking about the imposition of a nuance by which to maneuver certain ideological and economic interests. It is a problem that could relate as much to formalist modernism as to neo-conceptualism. It is an over-determined method that tries to deny its sources and, in doing so, merely becomes another marketing device—a metonym for advanced capital.

Postmodernism signifies repetition within the reification of objects. In a cultural climate fraught with cybertechnical gadgets, the current art world constitutes an abundance of signs caught within a tautological system of privileged referents. The same signs get repeated; thus, there is no forward motion. There is an illusion of motion. There are few cause-and-effect relationships of any consequence associated with artistic intent. This is one of the fundamental problems with regard to art made for the In-

ternet. The experiential dimension is limited to the program, and the program is finite
to the extent that the variables are only as good as the moment they were determined.
At this juncture, I would have to conclude that the vast majority of art on the Internet
is merely another aspect of formalism that employs electronics instead of canvas.

This is not to discount the spectacular effects of visual culture as induced by in-
teractive computer programs. The question being raised here is more about the lin-
gering effect of these images. It would seem that the force of ideas in art has largely
depended on what might be called the tactility of the image. The exceptions that I
have seen are largely video installations where the interactive aspect of the work is
truly an engagement with the immediate space in which one is situated; but this is a
much larger, speculative issue than I can address here.

Just as images of the rock star Madonna have the apparent power to replace sex
with the signs of sex, so art has been given a surrogate status in relation to theory. Put
another way, art has come to play second fiddle to another level of rhetorical justifica-
tion. The signs of art exist in a state of flotation—automatist signifiers within a non-
context of a burgeoning commercial cyberspace. The endgame is directed toward pur-
chases that are made to vanish the very instant we dial the toll-free number. Instead of
art, we are receiving the signs of art—signs that lead nowhere, signs without certainty.

## Conclusion

One could argue that this paradigm describes the condition of society as it has come
to frame corporate culture. In this sense, we could say that the postmodern condition
exists, but not postmodern art. The packaging of art as "postmodernism" has been
mistakenly understood as if it were another modernist style. Such maneuvers have
contributed, in large part, to an overinformed and undereducated art audience. Post-
modernists, of course, disclaim the modernist notion of the indelible trace of the
artist's hand or mind as having any relevance to today's visual culture—again, an-
other topic for another time.

Postmodern culture is the rule, the predictable spectacle, the cycle of entertain-
ment and arousal—all aspects of predictability that artists must be willing to both ac-
cept and finally reject. Artists are both transformers and resistors, capable of recog-
nizing themselves both as decentered and recentered subjects. Being an artist is a
matter of trying to locate one's position in postmodern culture. It requires an inner-
directed sense of reality, one that resists the loss of self-esteem. The artist's identity is
contingent on a functional dialectical means, not a factionalized programming. The
challenge for the artist is to rejuvenate the aura in art and thereby to rediscover the
transmission of the creative impulse. In contrast to the more utopian aspects of mod-
ernism, artists today may become socially and politically involved not within an iso-
lated and paranoid cultism, but with a community of artists willing to question the as-
sumptions wrought by postmodern culture. Being an artist has the ethical dimension,
in the Spinozan sense, of attending to specifics first and of avoiding the generalized
moral imperatives of a puritan social taxonomy.

For the inner-directed artist, skepticism will come to replace cynicism in art. To
be skeptical is to have a necessary aesthetic distance in relation to one's practice. To
by cynical is a severe detachment in relation to one's experience with a work of art. In

the latter case, art is negatively transformed into a system of politicized representations. Cynicism assumes privilege as the condition of art without ever confronting the effect of privilege in relation to content. This privilege often disguises itself through arrogance and projection and mindless, larger-than-life spectacles.

Dialogue between artists will become essential to the task of identifying the evolving possibilities for art in the future. Certainly, the Internet is one way of facilitating communication within a globalized context; yet artists should exercise caution. The digital dialogue is important if it allows experience to be articulated and if it further opens the door to a critical discussion on the qualitative standard in art. Quality in art can no longer be dismissed, and it can no longer be confused with privilege. It is a matter of a heightened sensory cognition, and it is for this reason that the notion of quality will persist. It will persist as an informed subjective idea. The experience of art cannot be proven, but it can be communicated. I would suggest that to be an artist today means, above all, to offer a purposeful and deeply intuitive resistance to the enormous influx of cultural programming that has become an assumed liability of the informational superhighway. This alone should be enough for artists to insist on an independent, yet interactive position in the era of a burgeoning globalization. Artists can still resist, and by resisting they can make the future possible through the determination of their own deeply personal creative efforts.

---

## New Painting and Sculpture

As a direct outcome of President Reagan's economic policies in the early 1980s, a clientele of newly rich businessmen, media stars, and Wall Street traders found themselves with money to spend on art. The galleries in SoHo (the area south of Houston Street in Manhattan) went into a boom phase, particularly along West Broadway, where the Mary Boone Gallery became a most highly publicized success. Most noticeable in the galleries was a surfeit of international art: neoexpressionist paintings, figurative and narrative art, graffitti-inspired art, and painting called "New Image." Michael Cannell, writing for the June 1983 issue of *Arts,* began his review of exhibitions of the Italian painter Francesco Clemente at both the Mary Boone and the Sperone Westwater galleries:

> Images and figuration, taboo throughout the reign of Conceptualism and Minimalism, have returned with a vengeance. As if to make up for the lack of decoration in the last twenty years, a group of young artists has opted for the scenic route; their works reinstate an opulence and untamed imagery that were programmatically weeded out by their predecessors. Known intermittently as "trans-avantegarde," "New Imagery," or "Post-Minimalism," this movement is a final anathema to the extinguished impetus of Modernism.

The word "trans-avantegarde" referred to a group of Italian painters who were becoming well known in the United States: Francesco Clemente, Sandro Chia, Enzo Cucchi, and Mimmo Paladino.

Among the Europeans, the Germans were probably the most noticeable of the neoexpressionist group: Georg Baselitz, Anselm Kiefer, Gerhard Richter, Sigmar Polke, A.R. Penck, and Jörg Immendorff. Their paintings had a strong connection to the German expressionists of the early century, such as Ernst Ludwig Kirchner, Franz Marc, and George Grosz. Kiefer's paintings probably made the most impact; they contained imagery that suggested postwar desolate landscapes and the Holocaust and indicated that Germans were confronting their own war past. At the end of the 1980s a new group of neo-expressionist artists moved into focus—the East German artists, who had authentic reasons for expressing their intense responses to the turmoil of Eastern European nations on the verge of breaking with the Soviet Union.

The American contingent of expressionist-influenced artists included Julian Schnabel, Eric Fischl, and David Salle, who became stars overnight; Schnabel sold out all his paintings at his 1979 show at the Mary Boone Gallery. Much was made in the press of the inflated prices of the large, aggressive paintings of this group. Fischl painted disturbing quasi-narrative images of naked figures engaged in less-than-innocent activities; Salle included a mix of images appropriated from both high art and popular culture, with vaguely misogynist overtones. Schnabel incorporated into some of his canvases shards of broken plates but declared the primacy of the paint and surface qualities: "All my images are subordinate to the notion of painting . . . and basically they are not about anything except painting" (quoted by Jeanne Siegel, *Arts,* June 1983).

For all their popularity at the upscale galleries, the paintings of Salle, Schnabel, Fischl, and their Italian contemporaries did not receive unanimous critical praise. Thomas Lawson saw these artists as pseudo-expressionists, who "play on a sense of contrariness, consistently matching elements and attitudes that do not match. . . . A *retardataire* mimeticism is presented with expressionist immediacy. The work claims to be personal but borrows devices and images from others. There is a camp acknowledgment that what was once considered bad art can now be fun. . . . It is cynical work with a marketing strategy, and therefore extremely fashion-conscious" ("Last Exit: Painting," *Artforum,* October 1981).

Not mentioned by Lawson was the growing alternative art scene of cheap, self-consciously "kitschy," exuberant expressionism that first began to appear in storefront art galleries in the East Village in 1981 and 1982. The galleries that sprang up in the Tompkins Square area of Lower East Side tenement housing included Gracie Mansion, Civilian Warfare, Nature Morte, P.P.O.W., The New Math Gallery, the Fun Gallery, the Executive Gallery, and the Sharpe Gallery—some of which had short life spans; others, however, were still in business in 1999. This exuberant art drew its inspiration from the imagery, lettering, and compositional idiosyncrasies of graffiti, vandalized commercial billboards, and neighborhood wall murals. Some of the art was specifically and angrily political, such as the work of Sue Coe and David Wojnarowicz; other art was political but restrained, such as John Fekner's ironic one-liner-word-plus-image works. Less overtly political were Kenny Scharf and Keith Haring, who used cartoon styles, while Jean-Michel Basquiat developed his own codings from the graffiti tradition (see Reading 130).

None of it looked expensive; all of it rejected the pristine look of high modernism. However, even at the time (1984) Carlo McCormick, writing for the Santa Barbara University Art Museum exhibition catalogue for *Neo York: Report on a Phenomenon,* voiced

**Figure 7-1.**   "New Art, New Money: The Marketing of an American Artist,"
cover *New York Times Magazine* (February 10, 1985). Photo by Lizzie Himmel/
NYT Pictures.

the opinion of many when he called the East Village gallery scene "the mass co-opting
of the most avant-garde and intentionally offensive developments of Modernism by an
art-market industry that is as corporate as any bureaucratic structure." (McCormick uses
the term "Modernism" not in the way that theorists throughout this book have discussed
it, but as synonymous with "contemporary art.") One "heroic outsider," Basquiat, was
unable to resist the commodification of himself and his art, with tragic results [see
Fig. 7-1]. Other "heroic outsiders" such as Sue Coe and David Wojnarowicz were able to
maintain their anti-commercial and anti-establishment stance.

  Although the East Village waned as an art scene (with galleries such as Gracie Man-
sion and P.P.O.W. relocated to the Village proper), much of that exuberantly colored
and patterned art migrated to exhibitions held at major museums. The Whitney Mu-
seum, under the direction of Tom Armstrong in the 1980s and David Ross in the
1990s, epitomized the staying power of graffiti-inspired paintings and installations in its
program of solo exhibitions and in its biennials. Criticism of the 1993 Whitney Biennial

was particularly sharp and dismissive. One suspects that the criticism was less concerned with the Dionynsian chaotic elements than with the "multicultural" aspects of that particular biennial. What had happened during the 1980s and early 1990s was that African American and especially Latino/Latina artists, who found inspiration in the popular culture and religious imagery of their family neighborhoods, had moved from the margins into central positions in museum exhibitions.

By the end of the 1990s painting seemed to have settled down. Some serious young painters looked to Philip Guston's figurative work of the 1970s. His imagery—with its hooded figures, upturned shoes, floating heads with large eyes, and pointing cartoon fingers, along with his distinctive palette of cadmium red, blue-grey, black and white—suggested modern morality plays, with vague references to an alienated world where Klu Klux Klan figures merrily went about their covert businesses while innocents could only stare with tearless eyes. The frequent exhibitions of Guston's paintings during the 1980s and 1990s kept his influence active on a number of younger artists including Katherine Porter, Terry Winters, and Aaron Fink.

Exploring some of the same ideas and issues as contemporary painters, in the last twenty years sculptors have continued to use the human figure and figuration, but these sculptors have with great invention gone outside the traditional materials of sculpture and have combined wax, plastics, ceramics, rubber, papier-mâché and found objects. These include Charles Ray, with his fully clothed, mannikin-like sculptures jarring in their scale; Kiki Smith with her vulnerable naked bodies made of wax; and Robert Gober with `is fragments of realistic-looking body parts often set in juxtaposition with industrial objects. Jeff Koons, deplored by "high art" critics, appropriates images from popular culture in his porcelain sculptures. Mike Kelley has assembled children's worn, stuffed animals into large tableaux that are meant to disturb the viewer's complacency about childhood "innocence." Renee Stout, David Hammons (see Reading 136), Betye Saar, and Alison Saar incorporate elements of African American folk and street culture, and sometimes artifacts from slavery, into their sculptural works. Jimmie Durham and Luis Jimenez have fused Christian iconography with, respectively, references to Native American and Chicano culture as well as issues of colonialism. James Luna (see Reading 144), David Avalos (see Reading 145), and Guillermo Gómez-Peña (see Reading 138) have also made elaborate tableaux that comment on their current identities within American life.

Other sculptors have worked with more traditional materials: stone, which they carve or inscribe with words, and wood, to which they bring skills of carpentry. Mary Miss, Martin Puryear, Alice Aycock, Jackie Ferrara, and Patricia Johanson have made works in wood, some of which seek to blend with or contrast with the outdoor environment. Steel has been industrially crafted into sculpture by artists as varied as Joel Schapiro, with his anthropomorphized blocky forms, and Nancy Holt, with her steel frames constructed to align with solar and lunar trackings. Louise Bourgeois's abilities include stone carving as well as fashioning elaborate constructions in wood and steel. Bourgeois has had an increasingly large number of admirers, who marvel at her continuing formal inventiveness and the psychoanalytical implications of her work, as well as her respect for materials (see Reading 132).

At the end of the 1990s imagism and figuration in painting and sculpture (both the human figure and landscape) as well as abstract styles continued to be displayed side by side in art galleries and museums of contemporary art, along with installation art,

video art, and theoretically based postmodern "pictures" (see Reading 133). The staying power of painting and sculpture has much to do with the fact that instruction in traditional media is still basic to most studio art programs and painting and sculpture receive steady patronage from private collectors, corporate patrons, and museums reluctant to give up a history of art in which both painting and sculpture have served as the major forms of cultural expression.

*128* ✦   Susan Rothenberg, "Artist's Statement," in Richard Marshall, *New Image Painting.* Exhibition Catalogue (New York: Whitney Museum of American Art, 1978).

In December 1978 curator Richard Marshall mounted an exhibition for the Whitney Museum of American Art called *New Image Painting,* which brought together a group of artists working with recognizable imagery but who were not realist artists in the traditional sense. They borrowed freely from abstract expressionism, Pop art, minimalism and conceptual art but worked with a postmodern sensibility. As curator Richard Marshall explained it: "[The paintings] clearly represent things that are recognizable and familiar, yet they are presented as isolated and removed from associative backgrounds and environments. The paintings do not attempt to duplicate an object as it exists in nature or to interpret reality, but to depict an image that is drastically abbreviated or exaggerated, retaining only its most basic identifying qualities. . . . The image becomes released from that which it is representing." The artists included in *New Image Painting* were Nicholas Africano, Jennifer Bartlett, Denise Green, Michael Hurson, Neil Jenney, Lois Lane, Robert Moskowitz, Susan Rothenberg, David True, and Joe Zucker.

   Susan Rothenberg received a B.F.A. from Cornell, lived for a time in Washington, DC, and in 1969 moved to New York, where she showed at 112 Greene Street. Rothenberg stopped doing the horse imagery for a few years, but in the 1990s she returned to images of animals. In this statement she uses a formalist language to explicate her preoccupations in painting.

———————————————◆———————————————

I am an image maker who is also an image breaker—trying for a little more. The geometries in the paintings—the center line and other divisions—are the main fascinators. They were there before the horse. The subject of my paintings has to be able to carry the concern with the divisions. First I do the lines and then the horse may have to push, stretch, and modify its contours to suit the ordered space; the space, in turn, may have to shift to accommodate a leg, or split a head, until a balance is achieved.

   Working with wholes and parts has always been important. The interest in the horse image is because it divides right. Each half can hold its own, and I can get as much weight out of the back half as I can from the head half. It is important that on each side of the middle line there is a good, solid form. Where divisions become more complex, it is a matter of making certain that each section has individual solidarity as well as a working contribution to the wholeness of the picture.

The lines and bars are intended to flatten and clarify what is happening with the image and also allow the viewer to read, reassemble, or in some way get involved with two different kinds of occurrences. The center line keeps one from illusionism, from reading depth into the painting. It can only be read from side to side so that the image is kept very flat.

For the first three years that I worked with the horse, the divisions related mostly to the givens of the rectangle. In 1976 I started to make the geometry relate more intensely to the horse itself. In *IXI*, the geometry of the painting is its title— line-X-line. The vertical lines function to hold the rectangle, and the X locks the horse into itself, tying it up in a knot and flattening it out—relating it to its own extremeties as strongly as it relates to the shape of the stretcher bar. In *Butterfly*, the geometry is a heavy black X whose crossing point inside the horse's black body disappears in black paint. The black paint that forms the horse's body also forms the geometry, and there is some confusion between the legs and the bars. It is interesting that the black line disappears and then reemerges so that the X and the horse become one and the same.

---

*129* ✦ Christopher Knight, "Popeye Meets Picasso in MoCA Survey" [on Elizabeth Murray], *Los Angeles Herald Examiner,* August 16, 1987; reprinted in Christopher Knight, *Last Chance for Eden* (Los Angeles: The Foundation for Advanced Critical Studies, Inc., 1995).

Elizabeth Murray's paintings have a visual affinity to New Image painting: the same paint manipulation and suggestion of imagery. Christopher Knight here describes Murray's paintings in her 1987 mid-career exhibition, organized by the Dallas Museum of Art and the MIT List Visual Arts Center in Cambridge, Massachusetts.

Knight started writing regular art columns for the *Los Angeles Herald Examiner* in May 1980 and continued until November 1989 when the newspaper folded. The next month he began writing for the *Los Angeles Times.* He has also contributed essays on contemporary art to exhibition catalogues and art magazines. Malin Wilson, in charge of selecting Knight's reviews and essays for *Last Chance for Eden,* described the critic as having from the beginning "a clear line of argument, humor, a Pop sensibility, a highly developed ethical code, historical depth, and an assertion that art is essential to a free and democratic society." Malin also points out that Knight's "career at the *Herald* coincided with the international art mania of the 1980s, and a burgeoning museum and gallery scene in the Los Angeles metroplex." Hence, to Malin: "There is no doubt that he changed the course of cultural events in Southern California through persuasive commentary, including incisive analysis of bureaucracies and museums and a courage to engage in public brawls with large institutions and established powers."

---

✦

A decade ago, Elizabeth Murray grabbed hold of a number of dangling artistic threads that, although concurrent in an art world suddenly fragmented and becalmed, seemed wholly incompatible with one another. The bright, flashy, cartoonish quality

of Pop art was one thread. The material rigor of Minimalist abstraction was another. And painting on canvas itself, which was widely considered a moribund and hopelessly old-fashioned medium in a world of space travel and electronics, was still another. Tentatively at first, but with steadily increasing skill and complexity, Murray began to weave these threads together in her art. [. . .] Those various threads came together in her work to form a kind of cat's cradle—one that is forever metamorphosing, playfully rearranging itself, occasionally tying itself in knots and always ready to engage the spectator in another twist in the pattern.

[. . .] Richly populated with imagery that is never wholly abstract yet never quite figurative, her often eccentrically shaped canvases speak with a compellingly quirky voice.

Murray, who was born in Chicago in 1940, was still an art student when the brash glamour of Pop, followed by the stripped-down rigor of Minimalism, came to center stage in 1962 and 1964, respectively. Those were precisely the years she received her B.F.A., from the Art Institute of Chicago, and her M.F.A., from Mills College in Oakland. At a young artist's point of entry into serious work, it's common for the new art of the moment to form the substructure of whatever will follow. For Murray, as for certain others of her generation, the twin phenomena of Pop and Minimalism were to form a dual platform on which she subsequently was to build her own idiosyncratic art.

You won't find consumer brands or movie stars in her paintings, because it's not the specific repertoire of Murray's images that is Pop in nature. [. . .] Throughout her career, a level of ordinariness and attention to the everyday has marked her subject matter, while she's long painted in a bright, broad, often high-keyed palette. As with the work of Claes Oldenburg and certain others, the Pop aspect of Murray's subject matter centers on emphatically domestic objects. The kitchen table, the coffee cup, the family dog—these signs of domesticity are everywhere to be seen in Murray's art. Significantly, they merge in her paintings with signs of the artist's studio—paintbrushes, palette, and even the artist's hand are equally commonplace images. (The overlay might well be traced to her involvement with feminism in the late 1960s and early 1970s.) Begun at a moment when faith in the radical possibility of abstract painting had disappeared, even her emphasis on abstraction seems well-worn.

In addition to the range of subject matter, the Pop aspect of Murray's style is found in its cartoonishness. One can rightly cite all manner of educated references to Cézanne and Cubism and Surrealism in these paintings, but more often than not it's the overexcited rambunctiousness of the common cartoon that swamps the art-historical homages. Popeye, as much as Picasso, is her hero. Often it's the eccentric shape of Murray's canvas that seems cartoonlike. The bulbous, swelling shapes of all three interlocking canvases in *Sail Baby*, for instance, look like comic strip thought-balloons; the shape repeats and gets larger from left to right, suggesting some sort of odd narrative about the big, yellow coffee cup that is the central image. The bright blue interior of the cup is painted in such a way that it appears to be a solid, not a liquid or a void, and it seems to swell toward the left; at the bottom, a similar shape in glowing purple (a saucer?) does the same, except it pulls visually toward the right. An undulating ribbon of vivid green wraps all the way around the picture, visually holding together the splintered painting while looking for all the world like a cartoonist's rendering of an aroma.

Both in form and in image, Murray's paintings are like giant jigsaw puzzles whose crazily shaped pieces want very much to merge seamlessly together, yet they never quite fit. Simultaneously explosive and implosive, they seem caught in a tense and prickly moment of possible transformation or appeasement. Even the images are poised between total abstraction and descriptive representation; with one foot in each camp, the image could go either way. That sense of possibility gives Murray's best paintings their resonance: You feel that, with enough careful attention and mindful nudging, everything may suddenly click into harmonious place. This fundamental structural sense derives from Minimalism, and it provides the rock-solid underpinning for all of Murray's art.

*  *  *

---

**130 ✦** Rene Ricard, "The Radiant Child" [on Jean-Claude Basquiat], *Artforum* 20, no. 4 (December 1981):35–43. © *Artforum.*

Jean-Claude Basquiat's career had a metereoric rise in the artworld of the 1980s. He had grown up in the New York suburbs; his father was an accountant originally from Haiti, and his mother was Puerto Rican. Basquiat dropped out of high school and kept company with the young men who painted their graffiti "tag names" in public places, particularly New York subway cars. In the late 1970s, at first with his friend Al Diaz and then alone, Basquiat put his "SAMO" texts (a mix of scrawled images and scraps of text along with his tag name "SAMO") in subway cars and on buildings in the East Village. (At this time his friend Keith Haring was drawing his outline barking dogs in New York's subway stations.) Basquiat split with Diaz and began showing with other underground artists. He participated in the "Times Square Show" of 1980 and the "New York/New Wave" show at P.S. 1, the alternative exhibition space in Long Island City. The dealer Annina Nosei invited him into her gallery, gave him a successful show in March 1982, and arranged for shows in Los Angeles, Zurich, Rome, and Rotterdam. In 1984 he switched to Mary Boone, who also promoted his career on an international scale. In fact, during the mid-1980s more was written on the phenomenon of his fame and the prices his canvases commanded than on the art itself [see Fig. 7-1]. Basquiat's complex friendship with Andy Warhol was shattered with Warhol's death in 1987, and the young artist became more reclusive. Unable to control his fast-track, drug-dependent life, Basquiat died of an overdose in 1988.

In this essay Ricard, a poet who regularly contributed to *Artforum,* writes about several East Village artists, including Judy Rifka and Haring. "Tags" are the signatures of people who write graffiti on walls in public places; the "radiant child" refers to Haring's visual tag—the outline of a crawling baby. Ricard focuses on Basquiat, then 21 and a promising talent. Basquiat's inventive iconography rooted in popular culture, his references to racial identities, his sexual puns, and his seemingly spontaneous technique captivated many critics, although others remained skeptical.

---
✦

\*\*\*

The graffiti style, so much a part of this town, New York, is in our blood now. It's amazing that something so old can be made so new. There is an instant appeal in the way spray paint looks, ditto markers. Any Tag by any teenager on any train on any line is fairly heartbreaking. In these autographs is the inherent pathos of the archaeological site, the cry down the vast endless track of time that "I am somebody," on a wall in Pompeii, on a rock at Piraeus, in the subway graveyard at some future archaeological dig, we ask, "Who was Taki?"

Graffiti refutes the idea of anonymous art where we know everything about a work except who made it: who made it is the whole Tag. *Blade, Lady Pink, Pray, Sex, Taki, Cliff 159, Futura 2000, Dondi, Zephyr, Izzy, Haze, Daze, Fred, Kool, Stan 153, Samo, Crash.* (*Crash* is still bombing.) But trains get buffed (the *damnatio memoriae* of the Transit Authority), and with the need for identity comes the artist's need for identification with the work, and to support oneself by the work is the absolute distinction between the amateur and the pro. Therefore, the obvious was to raise oneself by the supreme effort of will from the block, from the subway, to the Mudd, to the relative safety and hygiene of the gallery. Because an artist is somebody. Say what you will about group shows and collaborative enterprise: *Das Kapital* was written by one man. This is no graffito, this is no train, this is a Jean-Michel Basquiat. This is a Keith Haring.

Both these artists are a success in the street where the most critical evaluation of a graffito takes place. Jean-Michel is proud of his large *Samo* Tag in a schoolyard, surrounded by other Tags on top of Tags, yet not marked over. This demonstrates respect for the artist as not just a graffitist but as an individual, the worth of whose Tag is recognized. There's prestige in not being bombed over. There are also fake *Samos* and Harings as well as a counter-Haring graffitist who goes around erasing him. The ubiquity of Jean-Michel's *Samo* and Haring's baby Tags has the same effect as advertising; so famous now is that baby button that Haring was mugged by four 13-year-olds for the buttons he was carrying (as well as for his Sony Walkman.) [. . .] I'm always amazed at how people come up with things. Like Jean-Michel. How did he come up with the words he puts all over everything, his way of making a point without overstating the case, using one or two words he reveals a political acuity, gets the viewer going in the direction he wants, the illusion of the bombed-over wall. One or two words containing a full body. One or two words on a Jean-Michel contain the entire history of graffiti. What he incorporates into his pictures, whether found or made, is specific and selective. He has a perfect idea of what he's getting across, using everything that collates to his vision.

[. . .]

I asked Jean-Michel where he got the crown. "Everybody does crowns." Yet the crown sits securely on the head of Jean-Michel's repertory so that it is of no importance where he got it bought it stole it; it's his. He won that crown. In one painting there is even a © copyright sign with a date in impossible Roman numerals directly under the crown. We can now say he copyrighted the crown. He is also addicted to the copyright sign itself. Double copyright. So the invention isn't important; it's the patent, the transition from the public sector into the private, the monopolizing personal usurpation of a public utility, of prior art; no matter who owned it before, you own it now.

\*\*\*

An artist's attitude toward the work is telling. It's all hype, sure, but there can be quality in hype and I've caught some sleazy acts. A guy came to my house to deliver a small picture. With a friend. No picture. Broke. "Give me the money I'll come back later with the picture." "OK." While he was there he told me that he was entertaining the idea of giving Andy Warhol a picture. Well, Andy is everyone's culture parent, it's true, but I'm just a poor poet and Andy's turnover must be thousands and thousands a week in prints alone, and it hurt my feelings that I had to pay 50 clams and Andy would get it free. I could see, though, that this boy's climb was on. This was my advice: don't give him the picture. Kids do that. Trade. That's what real artists do with each other. Since Andy's a press junkie, and I see you're getting the taste, call up page six of the *Post* and get a photographer to the Factory on the "Graffiti goes legit/street kid trades Tag for Soup Can" angle. You both get your picture in the paper, Andy comes off looking like friend of youth, you get a press clipping, and it's gravy for all parties. Easily $50 worth of advice. So he left with the money, and, like copping drugs in the street, beat me for the picture. A month or so later, after some friends put on a little muscle, I finally got the doodad, and promptly gave it away. Foolish way to hype yourself. When you're climbing a ladder, don't kick out the rungs.

As much as undervaluation can kill, so can a false sense of the value of your work. Jean-Michel was advised to stop giving it away. But if your friends can't have it, why live? Overprotection is deadly; the stuff has to get out there to be seen. Making money is something between artists and their stomachs. To turn one's work into fetish that is almost indistinct from oneself, to overpersonalize and covet one's own work, is professional suicide. Fear of rip-off is paralysis. One is always ripped off. Keeping work a secret is the psychology of the applied artist, not the fine artist who must live in a dialogue.

\* \* \*

---

**131 ✦**  Jonathan P. Binstock, "Mark Tansey," in Jacquelyn Days Serwer, *American Kaleidoscope: Themes and Perspectives in Recent Art.* Exhibition Catalogue (Washington, DC: National Museum of American Art, Smithsonian Institution, 1996).

From California Mark Tansey moved to New York and worked as an art handler at the Whitney Museum while also painting and getting his M.F.A. degree from Hunter College. In the 1980s, when narrative painting was again being shown at the art galleries, Tansey received considerable attention. With a craftsman's preoccupation with technique, he combined some of the characteristics of postmodern painting—photo-based imagery, appropriation, historicity, and ironic references to art.

In the catalogue essay on Tansey for the exhibition *American Kaleidoscope,* held at the National Museum of American Art, Jonathan Binstock focused on the unique techniques and obsessive methods Tansey uses to achieve his ends.

---

In major paintings of the early 1990s, Mark Tansey uses irony and surreal combinations of places and historical figures to make uncanny but coherent connections between ideas and events. By unifying frankly illustrational imagery with the analytical terms of literary criticism, Tansey crafts paintings that amount to nothing less than philosophical incursions into widely held beliefs about the nature of representation, art, and history. Inasmuch as the artist approaches painting from at least two points of entry, the illustrational and the conceptual, his works encompass modes of artistic thinking traditionally considered to be the antithesis of each other.

<p style="text-align:center">* * *</p>

Mark Tansey has assumed the serious task of analyzing the way in which the past, in this case art history, is recorded and consequently remembered, but he does it with a wry intelligence and uncommon wit. This is not to say he seeks to undermine the value of historical inquiry or to separate his work from the past. Indeed, the intellectual prowess of his paintings depends upon the history of ideas, as well as a long tradition of highly crafted artistic technique, for the force of its effect.

Tansey's paintings are the results of a calculated system of opposition, reversal, and contradiction. This is evident not only in the content of his finished works, but also in the process by which he creates them. The artist's studio provides a key to understanding his art. In one area he keeps his library of books and files of art-historical images and popular illustrations. Here published sources range from popular journals of the 1940s and 1950s to manifestos by post-structuralist writers Jacques Derrida, Paul de Man, Jacques Lacan, and Roland Barthes, all of whom have played an important role in defining the character of continental philosophical discourse and literary criticism since the 1960s. Also present are art-historical tomes such as Helen Gardner's *Art Through the Ages*, revised many times in part by his father, art historian Richard G. Tansey.

The artist begins his work with a thumbnail sketch of a composition expressing an idea. He then elaborates by juxtaposing images and figures culled from his collection of iconographic illustrations, which he began compiling in the late 1970s as a graduate student at Hunter College. Clipped from popular magazines and journals, these illustrations represent a distinctly American graphic visual consciousness developed over the last century. As a group they are an encyclopedia of figural sources from the mass media, the key to the conceptual problems posed by Tansey's pictorial narratives. With the photocopier he keeps in his studio, Tansey reproduces, enlarges, shrinks, lightens, and otherwise manipulates the figures to cohere as a collage within the composition previously sketched out. Seen in their new context, these singular visual elements contribute to hyperrealized, intensely conflicted pictorial statements.

After appropriating and recontextualizing the images, Tansey initiates a "toner drawing," the next stage in the long process of producing a painting. Building upon previous developments in the evolution of his pictorial notion, the artist photocopies the collage, along with whatever else might enhance the drawing he envisions. But before the photocopy machine finishes its task, before it heats the toner so that the dry black ink fuses with the surface of paper, Tansey turns off the copier and delicately removes the sheet from the paper path. The slightest jarring movement can upset the page and destroy the image, which at this moment sits precariously on the sheet, affixed to the surface only by electrostatic charges. Tansey then selectively manipulates and alters the image. He may use turpentine and various found tools to remove the

toner or merely suspend a brush above the surface, which often provides sufficient static attraction to lift the fine black powder. Ultimately the image is secured with four or five layers of fixative. Captured somewhere between the realms of the machine and unique artistic expression, the drawing frequently prevents us from knowing whether it was mechanically reproduced or finished by hand.

Similar to this method of manipulation and removal is the artist's monochromatic painting technique. Beginning with a layer of oil-based pigment, Tansey again uses turpentine and found tools—what he calls his "extended," or "unlimited" brush—to remove what has already been applied to the surface of the support. He describes his unlimited brush as

> anything from crumpled paper or Kleenex to brushes to carved wood to lace to wadded-up cloth or string. The game in a sense is to invent or find a tool that has a tactile resonance with the object it will be used to denote. If, for instance, I want to depict a tree, well, maybe there is something that feels a little bit like foliage, that has the same complexity of detail and natural form—like a knotted ball of string or crochet work, something that can be used if a direct tactile impression leaves a visual result that is uncannily like a tree.[1]

The nature of oil paint, which dries after a period of time, makes it difficult to remove, so that Tansey must limit his work at any given time to a particular part of the canvas. He divides the composition into sections and then applies no more paint than he can remove before it dries—a method borrowed from Italian Renaissance fresco painters, who applied only as much wet plaster as they could paint in one day. Straddling the fault lines of tradition, Mark Tansey is a cultural scavenger and stylistic handyman. Just as he combs his archives for the scraps of paper and bits of imagery that will ultimately constitute his monumental painting, he uses a variety of tools and techniques to make his images visually convincing.

One would think that these craft-intensive methods, laborious to the point of obsession, would result in thoroughly convincing, illusionistic representations of the three-dimensional world. Tansey, however, never represents what is visible per se. His pictorial realities are invented; we cannot rightly call them realistic. Nonetheless it is fair to say that his paintings suggest a reality of a different order. The techniques of paint and toner removal—a kind of archaeological excavation for the hidden truth beneath the surface—produce images that appear to have always been buried there, waiting to be extracted. Though seemingly self-evident glimpses into a familiar world, these images rarely make sense. They are always both matter-of-fact *and* abstruse, redolent of the effects of documentary photography in their monochromatic character and attention to texture, while depicting wholly impossible situations—the result of previously inconceivable juxtapositions. By representing a tree with the look and feel of foliage, Tansey seduces the viewer into entering into and believing in his paintings. At the same time, he positions an obstacle for us—an underlying and sometimes obscure concept, the surface of which can be difficult to penetrate.

<p style="text-align:center">* * *</p>

---

[1] Mark Tansey, "Notes and Comments," interview by Christopher Sweet, in Arthur C. Danto, *Mark Tansey: Visions and Revisions* (New York: Harry N. Abrams, 1992), 127–28.

**132** ✦ Robert Storr, "The Matter at Hand," in Peter Weiermair, Lucy Lippard, Rosalind Krauss, et al., *Louise Bourgeois.* Exhibition Catalogue. (Barcelona: Fundació Antoni Tàpies Foundation, 1989/1995).

In the 1970s and 1980s French-born Louise Bourgeois came into her own as a major sculptor: She had the stature associated with the French Surrealist movement (from which she actually distanced herself), was frank about the autobiographical origins of her art, and played with an imagery both sexually charged and ambivalent, with continuously transmutating male and female forms. Not surprisingly, feminists were among the first to discuss her art at length. As Storr points out, her goal is expressive form, even though she is unparalleled as a craftsperson wielding chisel on stone or manipulating liquid substances, such as latex, to harden according to her plastic ideas.

Robert Storr is both an artist and writer; since 1990 he has worked at the Museum of Modern Art in New York where he is currently Senior Curator of Painting and Sculpture.

———————————————◆———————————————

[. . .]

To see art whole one must begin again from new premises. Louise Bourgeois's work requires this redeparture. Although apparently ripe for theoretical slicing and dicing, Bourgeois does not gladly suffer the dismemberment she so enthusiastically practices on her sculptures. Conceived in distinct episodes of cathartic creation, the key to the formal and the psychological dynamics embodied in her *oeuvre* lies not just in referenced shapes or pedigreed images but in the specific choices of materials she has made and the specific ways in which she has addressed each.

To be sure, Bourgeois has repeatedly denied any interest in technique for its own sake. Moreover, as she told William Rubin in 1968, "I have never believed in the romanticism of 'truth to materials,' the only thing that counts is whether the result has plastic validity." That and whether the process of making a work responds to the urgencies of her emotional life. Turning passive anxiety into active physical and intuitive effort, Bourgeois seeks through her art to purge herself of sudden fears and irrepressable anger. To that extent form follows therapeutic function. The intractibility or responsiveness of the stuff of which each piece is made thus informs the quality and degree of her sublimation. Rather than adopt a Neo-Platonic attitude toward her medium—in which case the act of sculpting wholly subordinates itself to the revelation of an inspired essence inherent in a given block of stone or lump of earth—Bourgeois projects her fantasies onto these and other materials without regard for their "natural" shape or "innate" imagery. Instead the particular properties of obduracy or compliance typical of each serve in distinctive ways to channel and exhaust her febrile energies as she comes to terms with the images she has in the process conjured up.

Despite her disclaimers, then, the materiality of her work remains all important to its meaning. To accurately take stock of her sculptures is therefore to inventory the substances, tools and procedures that gave rise to them, paying special attention to the distinct resistances or determining limitations of each. It is also to catalogue the

"styles of will" that each required of or revealed to the artist. For example, stone carving, frequent in Bourgeois's mid to late work, offers the maximum of resistance and yet paradoxically demands the maximum of finesse as well. Marble does not readily surrender its given contour to the artist. Hard as it is and the perfect foil, it would seem, for the release of violent feeling, nevertheless marble's fault-lines once struck expose its inner weakness while its crust renders the subtlest of surfaces. Simultaneously frustrating to the sculptor's direct intention and hypersensitive to uncalculated gesture or unforeseen injury, stone in its very make-up thus invokes the dialectic of aggression and vulnerability that is Bourgeois's central preoccupation.

[. . .]

If carving suggests opposition and violence, assemblage by contrast entails the adjustment and cooperation of elements. In the case of Bourgeois's stacked and threaded figures, these elements are often unlike in color and configuration, requiring on her part the careful fitting together of seemingly antagonistic units. Psychologically speaking this process is a kind of sculptural "knitting," an obsessive, repetitive and ultimately quieting activity that permits a gradual calming as distinct from furious venting of emotion. "Assemblage," Bourgeois has said, "is a coming to terms with things," indicating not only a reconciliation between objects which in isolation exist in the alienated fullness of their difference but a ritualized reconciliation between the artist and the world as it is. Still this symbolic alignment suggests it[s] antithesis. Routine breeds restlessness. Paradoxically, moreover, and the greater the similarity of the modules used in her cumulative pieces, the more agitated they appear. Articulating the relation of part to part—of "One and Others"—assemblage thus constitutes a restorative or nurturing function even as the juxtaposition of oddments or the crowding of kindred forms evokes a sense of subliminal friction and incongruity.

As with the assemblage, the use of liquid media—that is[,] materials such as latex, synthetic resin, plaster and molten metal which are shaped soft and then allowed to harden—requires an attentiveness to the laws of additive as distinct from subtractive creation. In them the resistance of matter consists of an uncontrollable coursing through and filling of space rather, as in the case of stone, than an intransigent occupation of it. Anticipating the "process" or "anti-form" work of Robert Morris and his contemporaries on the one hand, on the other her puddling, drooling and mounding land-and-bodyscapes arrive by direct physical means at a universal biomorphism illustrated but rarely manifest in the works of the classic Surrealists. Growing from within, Bourgeois's poured "Lairs" meanwhile subsume in one and the same type of object and its consistent, fluid evolution the principles of geometry and organic structures.

Of course, it is to the metamorphosis of hard into soft, rigid into pliable, tumescent into flaccid, self-sustaining into earth bound and back, that all of Bourgeois's works point. Each state or opposing pair of states represents a distinct psychic condition or tension. Hence, at stake in the choice of a given medium and procedure is the particular options it affords the artist for converting inchoate rage or desire into acted-upon form.

\* \* \*

# Word-Based, Photo-Based, and Theory-Based Art

In the 1970s the most successful break with modernism was made by artists who incor-
porated into their art the elements and the techniques of the mass media (pictures and
printed words). Their strategies wholly skirted such Greenberg/Fried-mandated require-
ments as a focus on surface, self-definition, purity of medium, or the avoidance of "the-
atricality." In part, these artists extended the ideas implicit in the 1960s photo/text works
by conceptual artists John Baldessari and Joseph Kosuth. Work by the younger artists came
at a time when theorists and academics were being increasingly influenced by semiotics,
psychoanalytical theories, deconstruction, and theoretical feminism coming from Europe.

Since much of contemporary art was now dealing with both images and language,
the discourse of semiotics permeated much of the discussions. Semiotics studies the na-
ture of the sign, which it divides into a signifier (the object, text, or image) and a signi-
fied (what is meant).

The work of these artists went beyond "late modernism," as some early 1980s
painting was being called. By using words or photographs or a combination of both to
create their artistic statements, these word-and-image artists subverted many of the tra-
ditional concerns of art. Their aim was to challenge the authority of commonly held ideas
about social and cultural life in a postmodern, urban, and globalized world. These artists
thought about the construction of knowledge (epistemology, or how we come to know
about the social world) and had no inhibitions about appropriating whatever was at
hand—other art, reproductions of advertisements from popular culture, well-known car-
toons, written punchlines from vaudeville comedy, and aphorisms—to make a point.

Their strategies included a variety of techniques taken from photographic practice
and wordsmithing, including repetition, detailed realism, and punning both of words and
images. The content of this art was at times indirect (speaking to a subculture), at other
times blatantly direct (challenging a white male-dominated world), and sometimes ironic.
For the codings to be communicated, these artists depended upon their audience's fa-
miliarity with the visual culture of contemporary life, including posters and film.

Underneath these strategies was an awareness of the nature of representation it-
self. In the 1980s "representation" was used self-consciously by critics and artists to
mean a re-presentation of the material world (both its images and its language) through
art in order to interpret that world—to valorize it, to control it, to criticize it, or even to
fantasize upon it. Hence, representations are constructions, or, as Roland Barthes re-
marks, "Representations are formations, but they are also deformations" (quoted in
Brian Wallis, ed., *Art after Modernism: Rethinking Representation,* 1984).

What makes the art of a group of contemporary artists so compelling is their ques-
tioning of "normative" behavior and social constructions through their re-presentations of:

gender: Cindy Sherman
middle-class illusions and entrapment: Robert Longo
the artworld: Guerrilla Girls
photographic history: Sherrie Levine, Yasumasa Morimura

cultural and political knowledge: Barbara Kruger, Jenny Holzer, Martha Rosler

racial typing: Lorna Simpson, James Luna, Kara Walker

racial "passing": Adrian Piper, Emma Amos

racial communities, heritages and memories: Carrie Mae Weems, Pat Ward Williams, Lorraine O'Grady, Fred Wilson, Edgar Heap of Birds

class privilege and restraint: Tina Barney, Martha Rosler

sexual orientation: Deborah Bright, Catherine Opie, Lyle Ashton Harris

These artists, however, are not constrained only to the above issues/themes.

When artists and writers expose the actual social, economic, and political conditions that give rise to what heretofore had seemed normative, they also challenge the concept of essentialism. That is, they deny that there is an essential human nature, an essential woman, an essential beauty, an essential man of wisdom, an essential purpose of power. In other words, what we had once thought was different in its essence (or "natural") was in fact constructed by a specific society at a specific time and place. To grasp the full import of "social constructions" leads to a denial of universalisms. Many people, however, have resisted giving up that earlier, idealist view of the world, perhaps because the consequences may prove too uncomfortable.

An influential anthology with writings that address these issues is Brian Wallis's *Art After Modernism: Rethinking Representation* (1984). The journal *October* also consistently publishes articles on these issues.

## 133 ✦ Douglas Crimp, "Pictures" [on Cindy Sherman, Robert Longo, Sherrie Levine], *October,* no. 8 (Spring 1979):75–88.

Douglas Crimp organized an exhibition of work by Troy Brauntuch, Jack Goldstein, Sherrie Levine, Robert Longo, and Philip Smith for Artists Space in the Fall of 1977. He wrote on the same artists for *October,* adding a discussion of Cindy Sherman. He prefaced his 1979 essay with the remark: "I think it is safe to say that what I am outlining is a predominant sensibility among the current generation of younger artists, or at least of that group of artists who remain committed to radical innovation." Indeed, artists working in similar ways were the focus of several articles in *October* during the 1980s and 1990s. Crimp himself wrote a sequel, "The Photographic Activity of Postmodernism," *October* 15 (Winter 1980).

On the staff of *October* Douglas Crimp was the managing editor (1977–83), executive editor (1983–86), and editor (1986–90). During the 1980s and 1990s he became active in ACT-UP, an organization aimed at educating people about AIDS. He edited *AIDS: Cultural Analysis, Cultural Activism,* 1988 (originally an issue of *October,* no. 43, 1987) and wrote *AIDS Demo Graphics,* 1990. He teaches at the University of Rochester.

In this essay Crimp writes against the art criticism of Michael Fried, who rejected "theatricality" (see introduction to Reading 96). Crimp argues that the kind of art "that was . . . to become exemplary during the seventies was performance—and not only that narrowly defined activity called performance art, but all those works that were constituted

**Figure 7-2.**   Cindy Sherman, *Untitled Film Still #10,* 1978. Photograph courtesy the artist and Metro Pictures, NY.

*in a situation* and *for a duration* by the artist or the spectator or both together." He points out that we often need to ask the question: Where is the artwork?

◆

Art and illusion, illusion and art
Are you really here or is it only art?
Am I really here or is it only art?

—Laurie Anderson

In his famous attack against minimal sculpture, written in 1967, the critic Michael Fried predicted the demise of art as we then knew it, that is, the art of modernist abstract painting and sculpture. "*Art degenerates,*" he warned us, "*as it approaches the condition of theatre,*" theater being, according to Fried's argument, "*what lies* between *the arts.*"[1] And indeed, over the past decade we have witnessed a radical break with that modernist tradition, effected precisely by a preoccupation with the "theatrical." The work that has laid most serious claim to our attention throughout the seventies *has* been situated between, or outside the individual arts, with the result that the integrity of the various mediums—those categories the exploration of whose essences

---

[1]Michael Fried, "Art and Objecthood," *Artforum,* V. 10 (Summer 1967), 21; reprinted in *Minimal Art: a Critical Anthology,* ed. Battcock, New York, E. P. Dutton, 1968, pp. 116–47. All subsequent quotations from Fried are from this article; the italics throughout are his.

and limits constituted the very project of modernism—has dispersed into meaning-lessness. Moreover, if we are to agree with Fried that *"the concept of art itself* . . . [is] *meaningful, or wholly meaningful, only* within *the individual arts,"* then we must as-sume that art, too, as an ontological category, has been put in question. What remain are just so many aesthetic activities, but judging from their current vitality we need no longer regret or wish to reclaim, as Fried did then, the shattered integrity of mod-ernist painting and sculpture.

What then are these new aesthetic activities? Simply to enumerate a list of medi-ums to which "painters" and "sculptors" have increasingly turned—film, photogra-phy, video, performance—will not locate them precisely, since it is not merely a ques-tion of shifting from the conventions of one medium to those of another. The ease with which many artists managed, some ten years ago, to change mediums—from sculp-ture, say, to film (Serra, Morris, et al.) or from dance to film (Rainer)—or were willing to "corrupt" one medium with another—to present a work of sculpture, for example, in the form of a photograph (Smithson, Long)—or abjured any physical manifestation of the work (Barry, Weiner) makes it clear that the actual characteristics of the medium, per se, cannot any longer tell us much about an artist's activity.

But what disturbed Fried about minimalism, what constituted, for him, its the-atricality, was not only its "perverse" location *between* painting and sculpture,[2] but also its "preoccupation with time—more precisely, with the *duration of experience.*" It was temporality that Fried considered "paradigmatically theatrical," and therefore a threat to modernist abstraction. And in this, too, Fried's fears were well founded.

For if temporality was implicit in the way minimal sculpture was experienced, then it would be made thoroughly explicit—in fact the only possible manner of expe-rience—for much of the art that followed. The mode that was thus to become exem-plary during the seventies was performance—and not only that narrowly defined ac-tivity called performance art, but all those works that were constituted *in a situation* and *for a duration* by the artist or the spectator or both together. It can be said quite lit-erally of the art of the seventies that "you had to be there." For example, certain of the video installations of Peter Campus, Dan Graham, and Bruce Nauman, and more re-cently the sound installations of Laurie Anderson not only required the presence of the spectator to become activated, but were fundamentally concerned with that reg-istration of presence as a means toward establishing meaning.[3] [. . .]

An art whose strategies are thus grounded in the literal temporality and pres-ence of theater has been the crucial formulating experience for a group of artists cur-rently beginning to exhibit in New York. The extent to which this experience fully per-vades their work is not, however, immediately apparent, for its theatrical dimensions have been transformed and, quite unexpectedly, reinvested in the pictorial image. If many of these artists can be said to have been apprenticed in the field of performance as it issued from minimalism, they have nevertheless begun to reverse its priorities,

[2]Fried was referring to Donald Judd's claim that "the best new work in the last few years has been neither painting nor sculpture," made in Judd's article "Specific Objects," *Arts Yearbook,* 8 (1964), 74–82.

[3]Rosalind Krauss has discussed this issue in many of her recent essays, notably in "Video: the Aesthetics of Narcissism," *October,* 1 (Spring 1976) and "Notes on the Index: Seventies Art in America," Parts 1 and 2, *October,* 3 (Spring 1977) and 4 (Fall 1977).

making of the literal situation and duration of the performed event a tableau whose presence and temporality are utterly psychologized; performance becomes just one of a number of ways of "staging" a picture.

* * *

Here is a picture: It shows a young woman with close-cropped hair, wearing a suit and hat whose style is that of the 1950s. She looks the part of what was called, in that decade, a career girl, an impression that is perhaps cued, perhaps merely confirmed by the fact that she is surrounded by the office towers of the big city. But those skyscrapers play another role in this picture. They envelop and isolate the woman, reinforcing with their dark-shadowed, looming facades her obvious anxiety, as her eyes dart over her shoulder . . . at something perhaps lurking outside the frame of the picture. Is she, we wonder, being pursued?

But what is it, in fact, that makes this a picture of presentiment, of that which is impending? Is it the suspicious glance? Or can we locate the solicitation to read the picture as if it were fiction in a certain spatial dislocation—the jarring juxtaposition of close-up face with distant buildings—suggesting the cinematic artifice of rear-screen projection? Or is it the details of costume and makeup that might signal disguise? It is perhaps all of these, and yet more.

The picture in question is nothing other than a still photograph of/by the artist Cindy Sherman, one of a recent series in which she dresses in various costumes and poses in a variety of locations that convey highly suggestive though thoroughly ambiguous ambiences. We do not know what is happening in these pictures, but we know for sure that *something* is happening, and that something is a fictional narrative. We would never take these photographs for being anything but *staged*.

The still photograph is generally thought to announce itself as a direct transcription of the real precisely in its being a spatiotemporal fragment; or, on the contrary, it may attempt to transcend both space and time by contravening that very fragmentary quality. Sherman's photographs do neither of these. Like ordinary snapshots, they appear to be fragments; unlike those snapshots, their fragmentation is not that of the natural continuum, but of a syntagmatic sequence, that is, of a conventional, segmented temporality. They are like quotations from the sequence of frames that constitutes the narrative flow of film. Their sense of narrative is one of its simultaneous presence and absence, a narrative ambience stated but not fulfilled. In short, these are photographs whose condition is that of the film still, that fragment *"whose existence never exceeds the fragment."*[4]

The psychological shock that is registered in this very special kind of picture can best be understood when it appears in relation to normal film time as the syntagmatic disjunction of a freeze frame. The sudden abjuration of narrative time solicits a read-

[4]Roland Barthes, "The Third Meaning: Research Notes on Some Eisenstein Stills," in *Image-Music-Text*, trans. Heath, (New York, Hill and Wang, 1977), p. 67. The appearance of the film still as an object of particular fascination in recent artistic practice is so frequent as to call for a theoretical explanation. Both Sherman's and Robert Longo's works actually resemble this odd artifact, as does that of John Mendelsohn, James Birrell, among others. Moreover, many of its characteristics as discussed by Barthes are relevent to the concerns of all the work discussed here. In this context, it is also interesting to note that the performances of Philip Smith were called by him "extruded cinema" and had such revealing titles as *Still Stories, Partial Biography,* and *Relinquish Control.* They consisted of multiple projections of 35-mm. slides in a sequence and functioned as deconstructions of cinematic narrative.

ing that must remain inside the picture but cannot escape the temporal mode of which it is a fragment. It is within this confusion of temporalities that Robert Longo's work is situated. The central image of his three-part tableau performance, *Sound Distance of a Good Man*, presented last year at Franklin Furnace, was a film, showing, with no motion at all (save for the flickering effect of light that is a constant feature of cinema) the upper torso of a man, body arched and head thrown back as if in convulsion. That posture, registering a quick, jerky motion, is contrasted, in this motionless picture, with the frozen immobility of the statue of a lion. As the film unwound it continued to show only this still image; the entire film consisted of nothing but a freeze frame. But if the film's image does not traverse any temporal distance other than that literal time of the performed events that framed it on either side, its composition followed a rather complex scenario. Longo's movie camera was trained on a photograph, or more precisely a photo-montage whose separate elements were excerpted from a series of photographs, duplicate versions of the same shot. That shot showed a man dressed and posed in imitation of a sculpted aluminum relief that Longo had exhibited earlier that year. The relief was, in turn, quoted from a newspaper reproduction of a fragment of a film still taken from *The American Soldier,* a film by Fassbinder.

The "scenario" of this film, the scenario just described, the spiral of fragmentation, excerptation, quotation that moves from film still to still film is, of course, absent from the film that the spectators of *Sound Distance of a Good Man* watched. But what, if not that absent scenario, can account for the particular presence of that moving still image?

Such an elaborate manipulation of the image does not really transform it; it fetishizes it. The picture is an object of desire, the desire for the signification that is known to be absent.

* * *

Although the manipulations to which Sherrie Levine subjects her pictures are far less obsessive than Brauntuch's, her subject is the same: the distance that separates us from what those pictures simultaneously proffer and withhold and the desire that is thereby set in motion. Drawn to pictures whose status is that of cultural myth, Levine discloses that status and its psychological resonances through the imposition of very simple strategies. In a recent tripartite series, for example, Levine cropped three photographs of a mother and child according to the emblematic silhouettes of Presidents Washington, Lincoln, and Kennedy. The currency of the myths with which Levine deals is exemplified by those profiles, taken as they are from the faces of coins; the photographs are cut out of a fashion magazine. The confrontation of the two images is structured in such a way that they must be read *through* each other: the profile of Kennedy *delineates* the picture of mother and child, which in turn *fills in* the Kennedy emblem. These pictures have no autonomous power of signification (pictures do not signify what they picture); they are provided with signification by the manner in which they are presented (on the faces of coins, in the pages of fashion magazines). Levine steals them away from their usual place in our culture and subverts their mythologies.

[. . .]

At the beginning of this essay, I said that it was due precisely to this kind of abandonment of the artistic medium *as such* that we had witnessed a break with modernism, or more precisely with what was espoused as modernism by Michael Fried.

Fried's is, however, a very particular and partisan conception of modernism, one that does not, for example, allow for the inclusion of cinema ("cinema, even at its most experimental, is not a *modernist* art") or for the preeminently theatrical painting of surrealism. The work I have attempted to introduce here is related to a modernism conceived differently, whose roots are in the symbolist aesthetic announced by Mallarmé, which includes works whose dimension is literally or metaphorically temporal, and which does not seek the transcendence of the material condition of the signs through which meaning is generated.

Nevertheless, it remains useful to consider recent work as having effected a break with modernism and therefore as postmodernist. But if *postmodernism* is to have theoretical value, it cannot be used merely as another chronological term; rather it must disclose the particular nature of a breach with modernism.[5] It is in this sense that the radically new approach to mediums is important. If it had been characteristic of the formal descriptions of modernist art that they were topographical, that they mapped the surfaces of artworks in order to determine their structures, then it has now become necessary to think of description as a stratigraphic activity. Those processes of quotation, excerptation, framing, and staging that constitute the strategies of the work I have been discussing necessitate uncovering strata of representation. Needless to say, we are not in search of sources or origins, but of structures of signification: underneath each picture there is always another picture.

\* \* \*

**134** ✦  Sheila Tebbatt, "Women in Theory" [Barbara Kruger], *Ten 8*, no. 31 (Winter 1988):22–27.

In this essay Sheila Tebbatt discusses the work of Barbara Kruger, Mary Kelly, and Marie Yates. This excerpt, however, focuses on Kruger's work, within the context of the theories of Valentin Volosinov and Jacques Lacan.

Tebbatt assumes her reader is familiar with ideas advanced in Laura Mulvey's famous essay, "Visual Pleasure and Narrative Cinema," *Screen* (Autumn 1975) and with the ideas of other feminist, mostly British, theorists who drew on and challenged the ideas of Sigmund Freud and Lacan. Mulvey had pointed out that psychoanalytic theory assumed the subject of study was male, and moreover, a male who had typically overcome his castration anxieties—anxieties originally induced in him as a child by the sight of a naked woman, whom he had childishly interpreted as a castrated being. Hence, the need of the boy to distance himself from women (usually through dominance) in order to show his mark of "maleness."

There were concerns that Mulvey's feminist viewpoint might be pushed to "essentialist" conclusions—that is, it might wind up asserting that there did exist an "essential" woman versus an "essential" man. Marxist feminists warned that essentialism was a

[5]There is a danger in the notion of postmodernism which we begin to see articulated, that which sees postmodernism as pluralism, and which wishes to deny the possibility that art can any longer achieve a radicalism or avant-gardism. Such an argument speaks of the "failure of modernism" in an attempt to institute a new humanism.

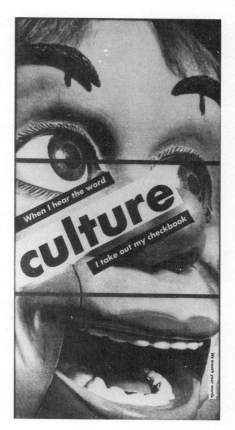

**Figure 7-3.** Barbara Kruger, *Untitled (When I Hear the Word Culture, I Take Out My Checkbook)*, 1985. Photograph, 138 × 60 in. © Barbara Kruger. Courtesy Mary Boone Gallery, NY. Zindman/Fremont photo.

dangerous ideology that had given rise to inequalities. They also cautioned against an ahistorical definition of patriarchy.

To classical Marxists, patriarchy had an historical explanation (see Frederick Engels, *Origin of the Family, Private Property, and the State,* 1884). Patriarchy did not itself create the power relations in class society; it was instead a symptom of class society. Patriarchy is strongest at times of intense social conflict when ruling elites are forced to intensify every aspect of the culture that sanctions their right to rule.

As Tebbatt points out, Valentin Volosinov, a Marxist, would locate the power of the "sign"—anything constructed (or agreed upon) to signify another thing—within the terms of class society. It was, in his view, the ruling classes who determined the correct signs or codings. It was through the process of "naturalizing" the signs and codes that the ruling classes reinforced their power (hegemony) over the working classes. Tebbatt ends by choosing Volosinov over Lacan as a more useful theorist for feminist issues.

We do not easily notice how much stylisation and codification have gone into making an image seem as natural as possible; precisely because of this we can easily slip into Roland Barthes' 'analogon' view that a photograph is equivalent to a segment of the 'world outside'[1]. As Stuart Hall suggests,[2] it is not that no codes have intervened between the outer world and the photograph, but that the *habitual* use of certain codes makes them *appear* profoundly naturalised.

It is this seeming naturalness of the photograph which makes it such a powerful tool for patriarchy: it naturalises concepts of femininity and attempts to fix representations of women by binding together certain signs and ways of interpreting them, certain signifiers and [that which is signified]. It is this binding which feminist photographers are deconstructing, thus enabling a feminist discourse to develop, and an oppositional reading of images to take hold—oppositional, that is, to patriarchy. The feminist critique makes us aware of the ways in which a sign is functioning patriarchally, and negotiates with or challenges such uses outright.

This awareness of the ideological nature of the sign was very forcefully argued by Valentin Volosinov in his study *Marxism and the Philosophy of Language,*[3] and feminist theoreticians such as Toril Moi and Julia Kristeva have derived much impetus from his work.[4] Volosinov argued that a signifier could never be bound permanently to signified, in as much as the sign was, he felt, an area for the class struggle. It was the fluid intersecting point of ideologies. Volosinov uses the term 'ideology' to mean that which operates as a vehicle for our beliefs, what we understand as meaning.

His importance to feminist theoreticians and practitioners lies in the fact that he opens up for us an awareness that signs are social constructs; attaching meaning to a sign is not a fixed process, so that any political struggle accents the sign in different ways—we have the power to determine meaning.

[. . .] The problems inherent in the structuralist view which Volosinov was attacking surface when we examine the feminist photography produced from within the psychoanalytic framework of Jacques Lacan, who places women firmly and squarely in a negative relationship to language and the whole symbolic order.

Volosinov's view was that signs are not arbitrary. They are just as physical and material as any aspect of reality; they arise out of the interaction between people. Hence, for example, we do not as listeners/readers/viewers recognise forms, words, images; we respond to them from our ideological positioning; we read them from within discourses. [. . .] So feminist photographers working from within a feminist politic, are devising many techniques for contesting the signs available for use in photography and attempting to wrench them from the grasp of patriarchy. [. . .]

[1] Roland Barthes, *The Photographic Message.* Whilst Barthes says initially that there is this 'first order' denoted message of a photograph (the photographic analogue), he then claims that this first order co-exists with the second order, coded or connoted message. Eventually he questions whether a pure denotation is possible, as all readings are filtered through our culturally determined perceptions. This does somewhat throw into doubt the existence of his hypothetical 'analogon'.

[2] Stuart Hall, *Culture, Media, Language,* Hutchinson 1984, p. 132.

[3] Valentin Volosinov, *Marxism and the Philosophy of Language,* Seminar Press, 1973.

[4] See particularly: Toril Moi, *Sexual/Textual Politics,* Methuen 1985.

One of the photographers vigorously at work in such a deconstruction is Barbara Kruger, an American artist whose work is explicitly intended to expose what she calls 'the rhetoric of realism' that photographs purport to deal with depictions of what is real, but that they operate within a patriarchal ideology and that they themselves are not natural representations of the real. She specifically takes issue with patriarchy's 'naturalisation' of the feminine.

She works through a wide range of what she terms 'market place' media formats—billboards, matchbooks, T-shirts, as well as galleries and art institutions. Her imagery is 'borrowed'—like cars for deliberate wrecking—from advertisements and magazines, enlarged or edited, and provided with a cut-up, newsprint type-face, usually in lower case, black on white, or white on black. Her work regularly uses the scripto-visual technique of text and image juxtaposition or superimposition to produce a forceful declarative, often parodic, message. She employs the veristic connotation of journalism, and the menacing resonances of anonymous 'threat' messages assembled from newspapers in order to subvert the realism of the image, to establish its essentially rhetorical nature.

The effect of the strategy is to fission the discourse, to 'open it up a little' in her own words; to reveal simultaneously the operation of the ideology underlying the discourse, and the invisible female hidden by its machinations.

<center>* * *</center>

The majority of Kruger's works are parodies of advertisements, and she succeeds in deconstructing them or revealing their constructions by appropriating the disembodied voice of patriarchal authority and then making these verbal statements into superimpositions over the found images. She reveals the invisibility of women in . . . YOUR COMFORT IS MY SILENCE. She illuminates the fragmentation of women in I AM YOUR SLICE OF LIFE—a work with harrowing references to the systematic castration of women. She attacks the explicit aggression of scopophilia (a condition initially described by Freud which concerns the pleasure in looking which always remains outside, detached) in YOUR GAZE HITS THE SIDE OF MY FACE. There the masculine gaze is shown as a metamorphosing slap that punishes and transfigures the women into a lifeless ideal, a bust. She draws attention to the subsuming of women's art by patriarchal culture in WHEN I HEAR THE WORD CULTURE I TAKE OUT MY CHECKBOOK. The female artist is made into a marionette or ventriloquist's dummy by the power of the masculine art institutions. Barbara Kruger has justified her own commercial successes by pointing out the need to have her messages reiterated in as many contexts as possible. If they are *in* the system they can begin to work *against* the system.

[. . .]

Barbara Kruger's work, then, undermines the certainty with which those other great combiners of images and words—television, newspapers and magazine editors—go about their work of defining masculinity and femininity. . . . Kruger's work declaims that we have no unmediated access to the real; it is through representations that we know the world and women.

What she is offering us is certainly not a visual codification of women's experience which acts as a *counter* to that portrayed by men, but a deconstruction of predominant discourses so that we look at the world of women and its classification by

the media in particular with fresh eyes, creating a new perceptual framework, a feminist practice, a discourse within which images can be read from a feminist ideological perspective.

\* \* \*

The psychoanalytic work of Jacques Lacan has influenced some contemporary feminist photographers. His theories have been appropriated by them precisely because they offer an account of the cultural production of sexual difference, without recourse to a pre-given conception of femininity as that which is 'essential' or 'natural'. Not that Lacan is a pro-feminist thinker; on the contrary—his attitudes to the Women's Movement are in the main arrogant and contemptuous. But his interest in the question of the human subject, its place in society and, of course, the negative positioning of women in relationship to language, have proved formative for some photo-artists who target the oppressiveness of the patriarchal and sexist social order and women's negative place in this order.

\* \* \*

By contrast with Lacan, Volosinov has guided the force of feminist ideology to the central issue, to the materiality of the sign as the site for ideological struggle. He is so much more appropriate as a theorist for feminist photographers because the photograph is by definition a material polysemic artefact. We have seen the ideas of Volosinov at their most effective in the interrogative and disruptive works of Barbara Kruger and Marie Yates, where the photograph is oppositional, and patriarchal photographic discourse has suffered a permanent dislocation.

Now that contemporary feminist photographers have elaborated a discourse which has provided them with a 'conceptual homeland' from which to challenge received patriarchal ideology, the next phase must be to disseminate this feminist photographic methodology throughout the various educational and professional institutions where the photograph is still studied primarily as a documentary and aesthetic artefact. The end result should not be a new pantheon of imagery, but a choice of ways of seeing, ways of feeling, ways of creating photographs.

---

## 135 ✦ Kate Linker, "Went Looking for Africa: Carrie Mae Weems," *Artforum* 31, no. 6 (February 1993):79–82. © *Artforum*

Carrie Mae Weems was trained in folklore and anthropology at the University of California/Berkeley, and she brings that knowledge, including postcolonial theory, to her art. The power of her work lies in its attempt through words and her own photographs to retrieve the historical memory of peoples (such as the Gullah on the Sea Islands off Georgia and South Carolina) who have few written documents. Indeed, in studies of African Americans, material culture and oral traditions (both nonwritten memory) provide the most compelling evidence for reconstructing African American experiences.

Kate Linker has written art criticism from a theoretical base. Her essay "Representation and Sexuality," published in *Parachute* (Fall 1983) and reprinted in Brian Wallis, ed. *Art after Modernism* (1984), took on the psychoanalytic theory of Lacan, particularly in relationship to Mary Kelly and Victor Burgin and film. Her analysis continued in "Eluding

Definition," *Artforum* (December 1984), in which she relates contemporary feminism to the theories of Lacan. In this 1993 essay Linker turns her attention to the strategies of representation in Weems's work when the artist focuses on racial issues. Linker praises the artist for drawing on ethnographic theory and "recovering black American experience through the formative encounter with Africa, or, rather, with its survivals in African-American culture." Linker points out that this is a project that is not unproblematical, as Weems's art reveals. Linker also praises Weems's "critique of feminist theory's avoidance of the issues of black representation and spectatorship."

◆

In a text panel in her recent photographic series "Sea Islands," 1992, Carrie Mae Weems traces the African derivation of the Gullah dialect spoken on the Sea Islands off Georgia and South Carolina. "Gola Angola Gulla Gullah Geechee": Weems' citation performs a historical ellipsis, rhythmically connecting the region's indigenous speech to the West African lands from which the inhabitants' ancestors traveled, as slaves, in the 17th and 18th centuries. The artist's allusion is also rife with ethnographic associations, however, inasmuch as Gullah is a key text in studies of the African contribution to American speech. To earlier, European scholars, Gullah appeared as a weak and simplified form of English, acquired by slaves through imitation of their captors, its reductions and elisions furnishing unequivocal proof of the English origins of "Negro" speech. But the concurrent erasure and appropriation of language implicit in this view were performed, as later research indicates, by outsiders without knowledge of the conditions of slavery, or of the distinctive character of African dialects. In this manner, the interpretation of Gullah presents yet another instance of the Eurocentric tendency to claim and subvert the cultures it confronts, reducing their status to one that is secondary, submitted, derived.

Weems is a folklorist by training, and much of her art tends toward the condensed form of the narrative vignette that encapsulates many-sided issues. The appropriation of the Gullah language, for example, is a metaphor for the confiscation of a history, and, with it, of African-American people's claims to experience. The subjection of black people to white standards of imitation and the cultural colonization of black subjectivity result from this suppression—one that Weems would rectify by recovering black American experience through the formative encounter with Africa, or, rather, with its survivals in African-American culture. The difficulty of this quest for collective, rather than colonial, representations is obvious—how can black experience be "spoken" when there is no language to articulate it? Weems' answer lies in intricate and imbricated textures of image and utterance, idiom and folkloric tale, that reposition the cultural past.

Weems defines herself as an image-maker, and her expansive and hetero-elite vocabulary, which encompasses verbal systems, photographs, and mass-produced objects, can be seen as a strategic attempt to transform the representation of African Americans, reconfiguring the experience of race. The scope of this effort to reclaim control over the imaging of blackness is evident in the current traveling exhibition of her work organized by the National Museum of Women in the Arts, in Washington, DC. Covering an array of pieces extending from the early phototexts in the "Family

Pictures and Stories" series, 1978–84, to the recent "Sea Islands," the exhibition comprises a meditation on the violence that is exerted through point of view. The notion of perspective that is central to anthropology is joined here to its photographic parallel, in a rereading of the documentary tradition. Although Weems did not begin her formal studies of folklore until 1984, when she enrolled in the University of California at Berkeley, the echo of the folkloric notion of an alternative history is audible in the first-person narratives of "Family Pictures and Stories." Reading through the exhibition's catalogue essays, one finds it easy to imagine Weems as an art student in the late '70s, engaged in a critical examination of her sanitized Western intellectual inheritance, noting its silence on questions of race and color in issues of authorship and reader address.

"Family Pictures" takes two practices as points to resist: first, the imaging of black people as "other" in the photodocumentary tradition (a tradition that is almost the exclusive property of white photographers); second, the official sociological studies commissioned by the U.S. government in the '60s. Both are notable for their inscription of blackness as a sign of victimization and powerlessness. The informing influences of "Family Pictures," in contrast, are the practices of the generations of Harlem photographers, and in particular of Roy DeCarava, whose disciplined yet sensitive rendering of his community is reflected in Weems' careful domestic portraits of her family. Accompanying verbal narratives—audiotapes, played in the exhibition space, of Weems reading the words of her mother, grandmothers, and cousins, along with her own interpretative comments—make use of the associative ramblings and colloquialisms of direct speech and interpose a female viewpoint into the narration. A rich, subjective portrait of community life is opposed to the distortions of objective history, as rendered by the outside observer.

"Family Pictures" traces the migrations of the Polk and Weems families, who were sharecroppers on plantations in the South in the '40s, north to Portland, Oregon, the artist's first home. This trajectory recapitulates the history of the many black American families that dispersed across the United States following the breakdown of the cotton industry in the '50s, "distancing themselves," as Weems notes, "from their historical past." The image of the sharecropper, shadowed by white culture, is of course a shadow for the figure of the slave, its close neighbor in time. For Weems, this slave past, with all its intimations of Africa, is central to black experience, and it forms a leitmotif running through her oeuvre. In the "Sea Islands" series, for example, the viewer may mentally elide the empty, echoing spaces of plantations and the crumbling native dwellings with three triptychs of 19th-century daguerreotype portraits of slaves, their haggard features riddled with age and pain. This mental putting-into-place, narratively speaking, rehearses the thematic of the ancestral accounts in "Family Pictures."

More broadly, Weems' work describes the notion of slavery's formative role in the black experience by tracing the endurance, in language, of images and representations of racial domination. If the macro form of the inscription of power relations in languages is the master discourse of theory and science, with its exclusions and reifications of "otherness," the micro form is the more widespread and insidious profusion of racial stereotypes, innuendoes, and epithets. These dirty little missives from one culture to another recur throughout the story lines of "Family Pic-

**LOOKING INTO THE MIRROR, THE BLACK WOMAN ASKED, "MIRROR, MIRROR ON THE WALL, WHO'S THE FINEST OF THEM ALL?" THE MIRROR SAYS, "SNOW WHITE, YOU BLACK BITCH, AND DON'T YOU FORGET IT!!!"**

**Figure 7-4.** Carrie Mae Weems, "Mirror, Mirror," from the *Ain't Jokin'* series, 1987–88. Silverprint, 20 × 16 in. Photograph courtesy P.P.O.W., New York.

tures" and the kitchen-table groups of "Untitled," 1990; in "Ain't Jokin," 1987–88, which catalogues racial stereotypes and slurs; and in "Colored People," 1989–90, which enumerates the vast range of skin colors that are collapsed into the governing denomination "black." The masked though palpable violence of this imagery reminds us of the art historian Norman Bryson's admonition that in Western societies, control assumes the nonphysical form of signifiers [Norman Bryson, *Vision in Painting* (1983)]. The explicit coercions of the slave trade are subsumed within the traffic in disembodied representations.

Weems has alluded in writing to the "little packages of consumer racism" that are the stock-in-trade of our collective psyche. Weems' reference is obvious—ideology is constructed and reproduced through consumption—but it also encompasses the more subtle racism of black Americans who unconsciously internalize white-supremacist norms. This complicity of black people in their own victimization (a similar role to that of many women) is perpetuated by the uninterrupted sway of racist

representations in the media. The colonization of black subjectivity by whiteness is configured in "Colored People," which deals with the color hierarchies adopted by African-Americans: in the complex sexual dynamics of "Untitled"; and in some of the inscriptions celebrating African origins that accompany the "Sea Islands" series on a group of china plates ("Went looking for Africa . . . and found uncombed heads acrylic nails & Afrocentric attitudes Africans find laughable"). The tone of the latter works is cautionary—"Afrocentrism" is an inverted form of Eurocentric focus—and points toward the need for non-Western, nonhegemonic models that reconfigure black identity as different from its stereotypical other. The multiple and discordant discursive forms that Weems privileges—folk tales, blues lyrics, superstitions, dialects, and colloquialisms—approximate collective, rather than colonial, speech. Identity, then, is constructed, shaped, "spoken." Experience is *not* prediscursive.

* * *

# Identities Unmasked,
# Classifications Resisted

Since the late 1960s artists have explored issues of their own identities—the gender, racial and ethnic, and sexual orientation identities by which they define themselves. They have not only celebrated their self-defined identities but have also challenged the stereotypes and prejudices that thwart their individualities. Artists not only give the viewer the "sight" of themselves within their artworks, they also position—"site"—themselves, their friends, and surrogate objects symbolic of themselves, squarely and self-consciously at the center of their artistic production.

Women painters raid art history for suitable subjects. In their parodic appropriation of traditional male-gendered imagery they assert a feminist egalitarianism. The African American artist Robert Colescott did the same by substituting blacks for whites in his parodies of earlier art, such as Leutze's *Washington Crossing the Delaware* (see Reading 108). Other black artists have brought in references to African art (kente cloth, fertility objects) as a way of paying homage to their African roots and constituting their subjectivity.

This recent focus on identity differs from the individualism of the early and mid decades of the twentieth century when artists sought to express in unique artistic styles their own personal feelings or anxieties (see pages 160–76). In other words, this new sense of identity does not mean "personal identity" as used in psychology. Instead, "identity" and "identity politics" is a collective entity that commits one to acts of solidarity with the gender, racial, ethnic, and sexual orientation groups with whom one feels a strong association. To artists and critics at the end of the twentieth century, the exploration of a collectivist identity begins with bringing such groups into mainstream culture—naming and giving visual representation to them.

Acknowledged, even if covert, was the flip side of identity: "otherness." In her book *Mixed Blessings: New Art in a Multicultural America* (1990), a survey of the contemporary art of people of color, Lucy R. Lippard observed: "Three kinds of naming operate culturally through both word and image. The first is self-naming, the definition one

gives oneself and one's community, reflected in the arts by autobiography and statements of racial pride. The second is the supposedly neutral label imposed from outside, which may include implicitly negative stereotyping and is often inseparable from the third— explicit racist namecalling." Lippard's last two categories concern otherness, or "alterity."

The concept of alterity is not new; what is new is our consciousness of the inherent negativity of the concept, of its instrumental use to disempower, to subjugate, and to demean those different from the so-called "norm." Before the black arts movement and the women's movement we were hardly aware that so much of art's history consisted of images of women and blacks as the "Other," as objects of male desires or white fears, rather than as subjects in their own right. Not surprisingly, in the age of imperialism, the female "Other" was often also racialized as non-European, and the black "Other" was often gendered as female.

What became evident by the 1980s was that women and people of color were representing themselves self-consciously the way the dominant culture had represented them— in order to heighten the contradictions between what they knew themselves to be and the negative stereotyping imposed on them. In order to challenge alterity, they began to depict themselves exaggeratedly as the "Other" of mainstream America, flaunting or parodying the images promoted in the media, in popular culture, and in traditional art history.

Artists of color led this challenge to alterity by openly confronting the politics of race. When African American women used the materials, imagery, emblems, and rituals of African American traditions and community life to celebrate the diverse components that made up their dual identities as women and as African Americans, they also had to confront the racism that had produced the American version of apartheid. For example, although Betye Saar worked with scraps of material and artifacts to create collages and assemblages that evoked the rich traditions of African American folk culture, she also often included well-known racist stereotypes, as in her classic work, *The Liberation of Aunt Jemima* (1972). Adrian Piper and Howardena Pindell [see Fig. 7-5] portrayed themselves as racialized subjects in videos that focused on assumptions of "whiteness" and "passing." Lorraine O'Grady raised the issue of the intersection of race and class in her angry performance piece *Mlle. Bourgeoise Noire Goes to the New Museum,* 1981. Emma Amos parodies the issue of "crossing" in *Worksuit,* 1992, which depicts her nude body encased in the thin transparent skin of a white male body (that of the British artist Lucien Freud) complete with genitalia. Lorna Simpson also uses photographs and texts to call into question the inward and the outward re-presentations of race [see Fig. 7-6].

During the late 1980s and 1990s other groups of so-called "hyphenated artists" asserted their visibility in the artworld by participating in circulating group exhibitions such as *Chicano Art: Resistance and Affirmation, 1965–1985* (1990); *Our Land/Ourselves: American Indian Contemporary Artists* (1990); *We, The Human Beings: 27 Contemporary Native American Artists* (1992); and *Identities in Contemporary Asian American Art* (1996). But even now, such identities are being contested. More precise terms of identification such as Lakota Sioux, Arapahoe, and Navajo are preferred to "Native American," and Chinese American, Japanese American, and Korean American are preferred to "Asian American." "Hispanic American" has been criticized because it gives undue emphasis to a Spanish heritage; many insist on Latino/Latina or Chicano/Chicana. The contradiction—implicit in identity politics—is that the more precisely identity is specified, the more narrowly exclusive it becomes. As Daryl Chin cautioned: "At a time when reactionary values threaten to regain cultural ascendancy, we can ask that any theory of cul-

**Figure 7-5.**   Howardena Pindell, *Contact Sheet: Free, White and Twenty One,*
stills from color video, 1980. Photographs by and courtesy the artist.

ture difference be vigilant about the qualifications and the exclusions within that theory"
("Some Remarks on Racism in the American Arts," M/E/A/N/I/N/G, May 1988).

One does not have to be a member of a specific group to understand and em-
pathize with the injustices under which that group must live and labor. One does not have
to be born female to be a feminist. One does not have to be born a person of color to
be antiracist. In this spirit curator Richard J. Powell included Berenice Abbott, Diane Ar-
bus, Stuart Davis, Robert Frank, Robert Gwathmey, Keith Haring, Jackson Pollock, and
Larry Rivers in his exhibition *The Blues Aesthetic* (1989), and Thelma Golden included
Leon Golub and Jeff Koons in the exhibition *Black Male* (1994).

Cultural blending was the organizing principle behind a number of exhibitions
in the 1990s. *The Decade Show: Frameworks of Identity in the 1980s* (1990), organized

**Figure 7-6.** Lorna Simpson, *Untitled (Two Necklines),* 1989. Two gelatin silver prints, eleven engraved plastic plaques, edition of three, each print 36 in. diameter. Photograph courtesy the Sean Kelly Gallery, NY.

by the Museum of Contemporary Hispanic Art, The New Museum of Contemporary Art, and The Studio Museum in Harlem, boldly focused on, but was not exclusive to, non-Anglo artists. The Institute of Contemporary Art in Boston mounted *El Corazón Sangrante/The Bleeding Heart* (1991), which emphasized less the lineal heritages and blood lines of specific racial and ethnic group identities than it did the hybridization that comes when cultures in close geographical proximity appropriate forms and motifs from each other. The show focused on "border art," a syncretic culture that had developed along the border of the U.S.A. and Mexico. Another term coming into use is "Pacific Rim," used to describe the blend of Asian, Californian, and South American cultures rimming the Pacific. The syncretic quality of all of contemporary American urban life and art was at the heart of the 1993 Whitney Museum Biennial. Exhibitions held in New York at Exit Art Gallery, the Alternative Museum, the Queens Museum, and the Bronx Museum of the Arts have led the way in showcasing the art of hybridization.

*136* ✦ Judith Wilson, "Seventies into Eighties—Neo-Hoodooism vs. Postmodernism: When (Art) Worlds Collide," in *The Decade Show: Frameworks of Identity in the 1980s.* (New York: Museum of Contemporary Hispanic Art, The New Museum of Contemporary Art, The Studio Museum in Harlem, 1990).

A major event in New York in the summer of 1990 was *The Decade Show,* shown at three museums, consisting of the work of 105 painters, sculptors, and photographers, plus 25 additional performance artists and 21 additional video artists (some participated

in more than one category), with the catalogue including 18 writers. Julia P. Herzberg, curator of the Museum of Contemporary Hispanic Art (and speaking for the other curators, Laura Trippi and Gary Sangster of the New Museum and Sharon F. Patton of the Studio Museum), put forth the rationale for the exhibition: "The Decade Show acknowledges the need for contemporary art to embrace a range of artistic voices in the anticipation of a meaningful cross-cultural dialogue. Based on the premise of comprehensive inclusion, our collaboration challenges the arts communities in this country to recognize and integrate the many cultural voices in their policy and exhibition practices."

Critic and art historian Judith Wilson teaches at the University of California/Irvine and has written widely on African American artists and cultural issues. In this essay she criticizes theorists of the 1970s who ignored artists of color and ends with remarks on the African American artist David Hammons, as an exemplar of a new kind of postmodern artist.

\* \* \*

For black artists aware of their own recent history, the most fruitful aspects of "postmodernism"—its legitimization of diversity, rejection of absolutes, and assault on traditional boundaries—are in many ways a recapitulation (disguised by an imported critical jargon) of cultural premises that, by the late 1970s, figures like Ishmael Reed and Ntozake Shange had already voiced. Reed's 1969 discussion of "neo-hoodooism" as a literary phenomenon was one of, if not *the* first persuasive descriptions of a new African American aesthetic that can now be recognized as extending to activity in the visual and performing arts during the past two decades. His introduction to *19 Necromancers From Now,* a collection of contemporary multiethnic literature subtitled *An Anthology of Original American Writing for the 1970s* contained a crucial observation: "What distinguishes the present crop of Afro-American . . . writers from their predecessors is a marked independence from Western form."

Instead of referencing European literary traditions or relying upon European literary structures, Reed contended, a number of contemporary black writers were turning to black vernacular sources and employing the resulting material as "found" poetry. Labeling this practice "neo-hoodooism," he offered an instructive parallel.

> Julia Jackson, a New Orleans soothsayer, when asked the origin of the
> amulets, talismans, charms, and potions in her workshop, [said]: "I make
> all my own stuff. . . . People who has to buy their stuff ain't using their
> heads."[1]

Since the late 1960s, when he began using his own margarine-smeared body as the equivalent of a lithographer's stone, David Hammons has taken a ceaselessly experimental approach to media. In a 1986 profile, Hammons explained his choice of such materials as hair from a barbershop floor, used bottle caps, and discarded wine bottles to *New York Times* critic Douglas McGill.

---

[1]Ishmael Reed, "Introduction" *19 Necromancers From Now: An Anthology of Original American Writing for the 1970s* (Garden City, NY: Doubleday Anchor Books, 1970), xvi–xvii.

> You can't miss if you use something people use everyday.... I never buy anything new because it has no spirit. The bottle caps already have a story to them.[2]

In an interview with curator-critic Kellie Jones, Hammons amplified his interest in the quotidian, asserting his preference for "doing things in the street" as opposed to making art for exhibition in galleries and for "the street audience" as opposed to "the art audience," which he declared "the worst audience in the world [because] it's overly educated."[3] In the same article, Hammons claimed he had to abandon his use of black hair because of its excessive potency. "You've got tons of peoples' spirits in your hands when you work with that stuff," he told Jones. "The same with the wine bottles. A Black person's lips have touched each one of those bottles, so you have to be very, very careful."[4]

Populist in orientation and animist in character, Hammons's art is in fundamental accord with the radical egalitarianism, enraptured sensuousness, and disenchantment with Western materialism that, during a 1981 broadcast, radio personality and cultural critic David Jackson assigned to neo-hoodooism.

> Neo-hoodoo believes that every person is an artist and every artist is a priest. In neo-hoodoo, Christ, the landlord deity, is on probation.... The drum, the ankh, and the dance are the center of neo-hoodoo, while Christianity is centered on the organ and the grave.[5]

Hammons's 1986 public sculpture *Higher Goals* consisted of three telephone poles studded with 20,000 or so bottle caps and topped with basketball hoops, backboards, and nets. His untitled May 1989 installation at Exit Art not only employed "objects with a past," it also recycled symbols—railroads, coal mines, trains—that have great cultural weight for black Americans, conflating verbal, visual, and musical puns in the process. In these and many other works of the period, Hammons arrived at a kind of "concrete abstraction"—or visual equivalent of concrete poetry—in which real objects function as emblems steeped in black cultural history.

In contrast, his ill-fated December 1989 outdoor piece *How Ya Like Me Now?* was a rare return to representational imagery in the form of a billboard "mural" featuring a blue-eyed, blond image of Jesse Jackson. Both its figurative imagery and its overt political content made the mural reminiscent of early works, like Hammon's 1970 body print, *In Justice Case*, which commented on the treatment of Black Panther Bobby Seale at the Chicago Seven trial. Neither portable nor saleable, however, the billboard inadvertently became the artist's most widely resonant work—a national news item and subject of debate far beyond the narrow confines of the art world—when a group of Washington, DC blacks, who failed to register its bitter irony, added their own Dadaist twist by assaulting what they deemed an insult to an esteemed leader.

---

[2]David Hammons quoted in Douglas C. McGill, "Art People: Hammons's Visual Music," *The New York Times*, (July 18, 1986): C15.
[3]David Hammons, quoted in Kellie Jones, "David Hammons," *Real Life Magazine*, no. 16 (Autumn 1986): 8.
[4]*Ibid.*, p. 4.
[5]Author's notes, David Jackson, *The Stormy Monday Show*, WBAI, New York, NY December 14, 1981.

In all these works, Hammons's referents—jazz, rhythm and blues, Jesse Jackson's 1988 presidential bid, basketball as inner-city cult—are African *American*. But his treatment of them coincides with Levi-Strauss's designation of non-Western myth and magic as "the science of the concrete."[6] As such, it seems characteristically *African*. Thus, able to elude what James Clifford has called "the salvage paradigm," with its intrinsic aura of cultural nostalgia, stasis, decay,[7] Hammons manages to fulfill Reed's description of the neo-hoodooist as practitioner of an art demonstrating "a marked independence from Western form" and, as the term's prefix implies, as innovator. A funk shaman and Dadaist trickster, the artist successfully fuses the vitality of lived experience with the authority of ancient tradition.

\* \* \*

As a scholar-critic of color whose views were shaped by the 1970s and first voiced in the 1980s, I would like to close with the following "wish list" for the 1990s.

1. May the tribe of theoretically informed, aesthetically sophisticated, and ideologically astute art writers of color increase and multiply.
2. May the white-dominated art establishment and its journalistic organs give this invaluable pool of talent the open-armed welcome it deserves.
3. May there arise a new generation of white scholars and critics capable of learning from their nonwhite counterparts and of fully acknowledging their intellectual debts to people of color.
4. May the result of all this be a critical-historical framework that enables us to adequately account for the production of artists of color.

---

*137* ✦  Edgar Heap of Birds. *Sharp Rocks*. Buffalo, NY: CEPA Gallery, 1986.

Edgar Heap of Birds was born in Kansas and studied at the Royal College of Art, London, the Tyler School of Art, Philadelphia, and the University of Kansas. A member of the Cheyenne and Arapaho nation, he now lives in Oklahoma. Although a painter, he is best known for his language installations. Borrowing the concept of terse slogans, developed by contemporary advertising, he posts placards in public places. Space rented on public buses in San Jose, California, in 1990 carried his placards with the following words:

SYPHILLIS
SMALLPOX
FORCED BAPTISMS
MISSION GIFTS
ENDING NATIVE LIVES

Each individual word signified both a mental image and a context; the actual sequencing of the words from top to bottom synthesized the history of white/Indian relations and encouraged the bus riders to reflect on that history.

[6]Claude Levi-Strauss, *The Savage Mind* (Chicago: The University of Chicago Press, 1966), p. 13.
[7]James Clifford, "Of Other Peoples: Beyond the 'Salvage' Paradigm," *DIA Art Foundation: Discussions in Contemporary Culture, Number One*, ed. by Hal Foster (Seattle: Bay Press, 1987), p. 122.

In 1982 he installed *In Our Language* on the spectacolor computer light billboard mounted on the edge of a Times Square Building in New York City; this work commented on the words used by the Tsistsistas (Cheyenne) to describe the white man.

The first excerpt, from the catalogue *Sharp Rocks,* comments on *Don't Want Indians,* a painted die-cut language installation of 1982 that included the following text.

<div align="center">

⅃AЯUTAИ

WE DON'T WANT
INDIANS
JUST THEIR NAMES
MASCOTS
MACHINES
CITIES
PRODUCTS
BUILDINGS

LIVING PEOPLE?

</div>

<div align="center">◆</div>

The word installation entitled "Don't Want Indians" exposes the prevailing attitude of America to its Native peoples.

Over the last 400 years the dominant white culture has attempted to crush the lives of Indian people, rendering many entire tribes extinct, through brutal wars and governmental policies.

Today Indian people must still struggle in order to survive in America. We must battle against forces that have dealt us among the lowest educational opportunities, lowest income levels, lowest standards of health, lowest housing conditions, lowest political representation and *highest* mortality rates in America.

Even as these grave hardships exist for the living Indian people, a mockery is made of us by reducing our tribal names and images to the level of insulting sports team mascots, brand name automobiles, camping equipment, city and state names, and various other commercial products produced by the dominant white culture.

This strange white custom is particularly insulting when one considers the great lack of attention that is given to real Indian concerns.

In "Don't Want Indians" the pinkness of the words *mascots, machines, cities, products,* and *buildings* is a symbol for the true color of the Anglo American (which is much more pink than white) and also eludes to the pink, cool and uncaring attitude that the majority of America feels toward the serious crisis that faces the American Indian.

At the bottom of the word installation the words *living people* are presented in yellow-green to give the sense of the living, vital and *growing* American Indian. Such color is found through out the Cheyenne Sundance earth renewal. The yellow-green cottonwood and willow trees spring forth from the rivers, creeks and streams of the American plains. These trees grow fresh and strong from the water each spring.

Water and growth are the true concepts that represent the American Indian and give life to all things.

is Anglo-Italian, but speaks Spanish with an Argentine accent, and together we walk amid the rubble of the Tower of Babel of our American postmodernity.

The recapitulation of my personal and collective topography has become my cultural obsession since I arrived in the United States. I look for the traces of my generation, whose distance stretches not only from Mexico City to California, but also from the past to the future, from pre-Columbian America to high technology and from Spanish to English, passing through "Spanglish."

As a result of this process I have become a cultural topographer, border-crosser, and hunter of myths. And it doesn't matter where I find myself, in Califas or Mexico City, in Barcelona or West Berlin; I always have the sensation that I belong to the same species: the migrant tribe of fiery pupils.

My work, like that of many border artists, comes from two distinct traditions, and because of this has dual, or on occasion multiple, referential codes. One strain comes from Mexican popular culture, the Latin American literary "boom," and the Mexico City counterculture of the '70s . . . the other comes directly from fluxus (a late-'60s international art movement that explored alternative means of production and distribution), concrete poetry, conceptual art, and performance art. These two traditions converge in my border experience and they fuse together.

In my intellectual formation, Carlos Fuentes, Gabriel García Márquez, Oscar Chávez, Felipe Ehrenberg, José Agustín, and Enrique Cisneros were as important as Burroughs, Foucault, Fassbinder, Lacan, Vito Acconci, and Joseph Beuys.

[. . .]

I am a child of crisis and cultural syncretism, half hippie and half punk. My generation grew up watching movies about cowboys and science fiction, listening to *cumbias* and tunes from the Moody Blues, constructing altars and filming in Super-8, reading the *Corno Emplumado* and *Artforum,* traveling to Tepoztlán and San Francisco, creating and de-creating myths. We went to Cuba in search of political illumination, to Spain to visit the crazy grandmother and to the U.S. in search of the instantaneous musico-sexual Paradise. We found nothing. Our dreams wound up getting caught in the webs of the border.

Our generation belongs to the world's biggest floating population: the weary travelers, the dislocated, those of us who left because we didn't fit anymore, those of us who still haven't arrived because we don't know where to arrive at, or because we can't go back anymore.

Our deepest generational emotion is that of loss, which comes from our having left. Our loss is total and occurs at multiple levels: loss of our country (culture and national rituals) and our class (the "illustrious" middle class and upper middle). Progressive loss of language and literary culture in our native tongue (those of us who live in non-Spanish-speaking countries); loss of ideological meta-horizons (the repression against and division of the left) and of metaphysical certainty.

In exchange, what we won was a vision of a more experimental culture, that is to say, a multi-focal and tolerant one. Going beyond nationalisms, we established cultural alliances with other places, and we won a true political conscience (declassicization and consequent politicization) as well as new options in social, sexual, spiritual, and aesthetic behavior.

[. . .]

We witness the borderization of the world, by-product of the "deterritorialization" of vast human sectors. The borders either expand or are shot full of holes. Cultures and languages mutually invade one another.

\* \* \*

The term Hispanic, coined by techno-marketing experts and by the designers of political campaigns, homogenizes our cultural diversity (Chicanos, Cubans, and Puerto Ricans become indistinguishable), avoids our indigenous cultural heritage and links us directly with Spain. Worse yet, it possesses connotations of upward mobility and political obedience.

The terms *Third World culture, ethnic art,* and *minority art* are openly ethnocentric and necessarily imply an axiological vision of the world at the service of Anglo-European culture. Confronted with them, one can't avoid asking the following questions: Besides possessing more money and arms, is it that the "First World" is qualitatively better in any other way than our "underdeveloped" countries? That the Anglos themselves aren't also an "ethnic group," one of the most violent and antisocial tribes on this planet? That the five hundred million Latin American *mestizos* that inhabit the Americas are a "minority"?

Between Chicanos, Mexicans, and Anglos there is a heritage of relations poisoned by distrust and resentment. For this reason, my cultural work (especially in the camps of performance art and journalism) has concentrated itself upon the destruction of the myths and the stereotypes that each group has invented to rationalize the other two.

With the dismantling of this mythology, I look, if not to create an instantaneous space for intercultural communication, at least to contribute to the creation of the groundwork and theoretical principles for a future dialogue that is capable of transcending the profound historical resentments that exist between the communities on either side of the border.

[. . .]

Anglo artists can contribute their technical ability, their comprehension of the new mediums of expression and information (video and audio), and their altruist/internationalist tendencies. In turn, Latinos (whether Mexican, Chicano, Caribbean, Central or South American) can contribute the originality of their cultural models, their spiritual strength, and their political understanding of the world.

Together, we can collaborate in surprising cultural projects but without forgetting that *both should retain control of the product,* from the planning stages up through to distribution. If this doesn't occur, then intercultural collaboration isn't authentic. We shouldn't confuse true collaboration with political paternalism, cultural vampirism, voyeurism, economic opportunism, and demogogic multiculturalism.

We should clear up this matter once and for all:

We (Latinos in the United States) don't want to be a mere ingredient of the melting pot. What we want is to participate actively in a humanistic, pluralistic and politicized dialogue, continuous and not sporadic, and that this occur between equals that enjoy the same power of negotiation.

For this "intermediate space" to open, first there has to be a pact of mutual cultural understanding and acceptance, and it is precisely in this that the border artist can contribute. In this very delicate historical moment, Mexican artists and intellectuals as well as Chicanos and Anglos should try to "recontextualize" ourselves, that is to say, search for a "common cultural territory," and within it put into practice new models of communication and association.

*139* ✦   Margo Machida, "Out of Asia: Negotiating Asian Identities in America," in *Asia/America: Identities in Contemporary Asian American Art* (New York: The Asia Society Galleries, 1994).

In 1994 The Asia Society organized the exhibition *Asia/America: Identities in Contemporary Asian American Art;* artist and writer Margo Machida curated it and wrote the lead essay for the catalogue. Machida selected twenty foreign-born artists, whose parents were Asian, and who presently work in the United States. The countries of their heritage are China (Ken Chu; Hung Liu; May Sun; Tseng Kwong Chi; Baochi Zhang), India (Zarina), Japan (Takako Nagai; Masami Teraoka; Mitsuo Toshida), Korea (Sung Ho Choi; Y. David Chung; Jin Soo Kim; Yong Soon Min), Laos (Sisavath Panyathip), the Philippines (Pacita Abad; Marlon Fuentes; Manuel Ocampo), Thailand (Toi Ungkavatanapong), and Vietnam (Long Nguyen; Hanh Thi Pham). The exhibition traveled throughout the country for two years.

Machida herself is a third generation Japanese American who was raised in Hawai'i before coming to New York in 1968. In her essay she provides the demographic information that "Asians have become the fastest growing immigrant group, and if present trends continue, people of Asian origin will be nearly 10 percent of this nation's population by the middle of the next century."

Machida's essay weaves together various issues that concern Asian American artists followed by clusters of brief biographies and descriptions of the artwork of the twenty artists. The excerpts here articulate some of those issues and include a section on the Chinese American artist Tseng Kwong Chi.

* * *

Whatever a person's reasons for migrating to America, immersion in this culture can be difficult and confusing. As a result, a number of first generation Asian artists have made negotiating a relationship with America their primary subject. Whether it takes months, decades, or, for some, a lifetime, the complex process of situating oneself in an adopted nation often stimulates a search for new meanings and definitions that will bestow sense and clarity on an altered life. No matter how optimistic and accepting of the West an Asian migrant might be when seeking fresh opportunities, the ambiguity and tensions inherent in cultural and racial differences usually ensure that their adjustment to this society will be discomforting. Frequently unanticipated, such stresses induce many Asian-born artists to contend with the emotional dimension of their changing circumstances in America.

* * *

*The Experience of Displacement*

The state of displacement itself, unconnected to an artist's reasons for coming here, can generate intense feelings of loss, nostalgia, even unexpected resentment. In grappling with the often inchoate and ambivalent feelings involved in adjusting to a new

life, many Asian-born artists link personal concerns with the cultural, historical, and political issues that induced them to leave their homelands.

\* \* \*

## The Experience of Living in America

When Asian artists perceive that their presence in America has begun to have a strong influence on their sense of identity, they are often compelled to address changing relationships—with Asia, with other Asians in America, and with the larger society in which they have settled. Yet, even as they shift their focus from their homelands to active engagement with this nation, the convoluted process of making a place for oneself in the West can, at the extremes, be framed as an optimistic response to new opportunities in a dynamic setting where influences from around the world converge, or as an irate reaction to unanticipated adversity.

\* \* \*

## Components of Identity

Even when Asian artists actively endeavor to find meaningful ways to position themselves in the West, the lingering emotional aftereffects of having not only crossed political boundaries but also the invisible psychosocial frontiers separating societies from one another can be considerable, even after years in America. To evoke such an anomalous condition, an inner dialogue between continuity and change that is often rooted in a loss of a sense of psychic wholeness, some artists find it necessary to devise self-referential means of locating themselves within the texture of their current surroundings. In this, they often enlist tangible items closely associated with their sense of self: facial and bodily features, personal items held dear, tokens of knowledge like texts or diagrams, emblems and cultural icons, signs of their presence in the West, as well as commonplace objects affiliated with their earlier life in Asia. Such work, arising from an urge to transcend insecurity and anxiety by synthesizing new schema out of components identified with both Asia and the West can provide an artist with stable reference points while adjusting to America.

\* \* \*

## Self-Assertion

A number of artists in this exhibition contradict common Western presumptions that Asians would invariably downplay public expressions of individuality because of the greater emphasis placed on social harmony in their homelands. They not only deliberately magnify their visibility through self-representation, but by linking conspicuous images of the self to the social and physical fabric of this nation, these artists also assert that what it means to be Asian in America is open to negotiation—neither entirely fixed in the legacy of their immigrant predecessors nor dependent on stereotypic Western expectations of Asian behavior.

Tseng Kwong Chi, who died in 1990, was born in Hong Kong in 1950, a year after his parents fled Shanghai when Communist forces assumed power. Even though his family prospered in their new setting, by 1966 growing local agitation, inspired by the

outbreak of the Cultural Revolution, raised the specter of radical forces loyal to the main-
land also seizing power in their new home. As a result, when Tseng was sixteen, his fam-
ily again relocated, this time to Vancouver, Canada. Beginning college as a physics major,
he soon transferred to art, despite parental disapproval, and within a year of graduating
left for Europe at age twenty-two. After studying painting and photography in France,
Tseng worked for an advertising agency, but, unable to extend his visa, he returned to
Canada. By 1979, yearning for the sophisticated atmosphere he had known in Hong Kong
and Paris, the artist moved to New York City, and quickly immersed himself in the then-
burgeoning avant-garde art and performance scene centered on lower Manhattan.

Once in New York, however, Tseng unexpectedly found himself drawn to ob-
serve Asian tourists and was soon perturbed to discover that not only were there few
Chinese sightseers at the time, but the majority appeared to be so "completely West-
ernized that you cannot really tell if they are Chinese, or Korean, or Japanese." Long
aware that for years after diplomatic relations between the People's Republic of China
and the United States were reopened in 1972 by President Nixon's groundbreaking
visit, most Americans allowed to travel in his parents' homeland were members of
"an elite . . . famous artists, musicians, scientists, politicians,"[1] he grew increasingly
uncomfortable with a situation he didn't consider "a very fair exchange."[2] Conse-
quently, merging his dual interests in photography and performance, Tseng, with
tongue firmly in cheek, appointed himself an "unofficial ambassador of China"[3] and
inaugurated a "lifetime project" wryly titled "East meets West."[4]

To summon a figure with a stature comparable to those Americans who initially
had ready access to China and, hence, to metaphorically invert the position of Chinese
and Westerners, in 1979 Tseng started to dress in a "Mao suit," a costume he believed
would be instantly recognizable as an emblem of modern China. Donning dark, mir-
rored sunglasses to depersonalize his features, he attended major social events posing
as a Chinese dignitary and also began to photograph himself in association with ob-
vious cultural signposts—first around New York City, then on extended "expedi-
tions" across North America, Europe, and eventually the Caribbean, Brazil, and
Japan. By choosing to play "the role of a very formal Chinese tourist" and take snap-
shotlike images of himself in association "with the monuments and icons that West-
erners consider to be the symbols of their power and glory" (such as the Statue of Lib-
erty [see Fig. 7-7], Mount Rushmore, Disneyland, Hollywood, and Notre-Dame
cathedral),[5] the artist sought, albeit mischievously, to counter the long history of Ori-
entalist painting and photography by explicitly re-presenting the West as if seen
through a possessive "Occidentalist" gaze.

---

[1]Christine Larrain, "Tseng Kwong Chi," *Zoom Magazine* (American edition) (January 1984):15.
[2]Michael Kaplan, "East Meets West," *American Photographer* 5, no. 4 (October 1985):14.
[3]Ibid.
[4]Tseng Kwong Chi, "Cities," *Inside* no. 2 (Spring 1989):5–13.
[5]Kaplan, "East Meets West," 14.

**Figure 7-7.** Tseng Kwong Chi, *Statue of Liberty, New York,* 1979. Gelatin Silver print, 36 × 36 in. © Muna Tseng Dance Projects, Inc. NYC. All rights reserved.

***140*** ✦ James Hannaham, "The Shadow Knows: An Hysterical Tragedy of One Young Negress and Her Art" [Kara Walker], in *New Histories.* Exhibition Catalogue. Milena Kalinovska, curator; Lia Gangitano and Steven Nelson, eds. (Boston: The Institute of Contemporary Art, 1996).

Kara Walker studied art at the Atlanta College of Art and received her MFA from the Rhode Island School of Design in Providence. In the fall of 1994 a 50-foot long installation of her silhouettes was mounted at the Drawing Center in New York City, and her work immediately aroused curiosity and sparked controversy.

Underneath the elegant style of Kara Walker's cut-out black silhouettes are representations of African Americans that draw on racist stereotypes. At a Harvard University symposium, *Slip the Joke,* held in the spring of 1998, that focused on Walker and her controversial work, Edmund B. Gaither, Director of the Museum of the National Center of Afro-American Artists, was critical. He questioned not the art, but the venues in which Walker's art is found—invariably museums and art centers in which the staff and the patrons are overwhelmingly white and in which the race discourse does not necessarily

include the voices of people of color. Do the images evoke the kinds of hilarity that Hannaham would wish? What do black children think of the images? Do the images pander to deep-seated racism in white people? Gaither also questioned the timing. Why, now, are Walker's representations privileged over the work of other African American artists? Who is setting the agenda for the discussion? During 1998 the controversy over stereotypes in Walker's work was also aired on the pages of the *International Review of African American Art* (see Volume 15, No. 2).

James Hannaham is a cultural critic, who writes for the *Village Voice* and other publications. He also happens to be Kara Walker's cousin.

--------------------------◆--------------------------

A friend of mine has this theory about comedy. "Things are funny, either because they refer to a common experience that normally goes unrecognized, or because they sound too horrible and/or absurd to be true." Maybe this partially explains why media tragedies always produce a slew of tasteless jokes: that pain plus ironic distance equals hilarity. [. . .]

Surely it explains why Jewish-American director Mel Brooks felt, that a mere twenty years or so after the Holocaust, he could put dancing Nazis into *The Producers* and get laughs. It also explains why some black people can look at what I sometimes call Kara Walker's "sex pickaninnies" and laugh out loud, whereas most white Americans can only manage a kind of nervous twitter. The act of turning racist imagery back on the culture that once gorged itself on such icons—look closely at Mickey Mouse for example—is an ironically giddy revenge not unlike what the Native American owners of highly successful casinos must feel every time they buy large tracts of land from white people.

Rendered meticulously in silhouette, Walker's free-floating, figurative cut-outs seduce the eye immediately, like anything black and beautiful does in contrast with a white background—the walls of an art gallery in this case. If someone skimmed through an exhibit without letting the eye settle anywhere, one could leave feeling she/he had simply seen a very pretty display.

The boldness and elegance of Walker's technique serves a number of subversive purposes. The first barb in her blatant craft is the old bait-and-switch—she uses an innocuous form to conceal the disturbing content of her work. Few forms could be more seemingly harmless than the quaint silhouette, a cheap, rapid method of portraiture popular in the nineteenth century, that also had another life as a component of early American home furnishings. But Walker has transformed this roadside attraction, and making it articulate a sinister nature, using it to represent the shadows of repression born in those eras that still linger in the USA of today. These heirlooms—the sort that you never take down from the attic—really loom. Her fractured narratives emphasize the sexual side of war, the violent side of romance, the joy of genocide and the dormant power in shame. Children—usually miniaturized, cartoonish versions of Negroes—cut their own hands off, delight in scatalogical activity, cart around severed heads, and engage in dangerous forms of "play." Adults fare no better, often appearing as driving forces in her unsettling *tableaux.*

As if that weren't enough, Walker frames these images in the theater of the Civil War, the Civil War that "occurred between the dusky thighs of one young negress and her heart," as she subtitled one installation. Hers are the campy wars of *Gone With the Wind*, *Mandingo*, and *The Klansman*. Hers are the ones we remember not through battles or body counts but rather through fear, misinformation and stereotypes. The parody of history accumulates more validity than "objective fact" because we may never have experienced the agricultural economy of South Carolina in the 1860s, but we all have sinned.

Accordingly, people have begun to think of Walker as a Southern artist. The preceding Walker generation hails from La Grange, Georgia, and the artist spent her adolescence in Stone Mountain, Georgia—birthplace of the Klan. It's probably more accurate to see her work stemming from a Californian's culture shock, as the prodigal daughter who, in "coming home," confronts her very plausible past. Her work is written in the visual language of the South, but that dialect has never been used to describe the vulgar mayhem she illustrates—that requires more distance. She dreams her Negro League versions of the Cyclorama, Atlanta's gaudy, rotating Civil War mural, because black Americans are forbidden to romanticize the past, particularly in the earnest yet scary way that white Southerners will, for example, spend the afternoon re-enacting Civil War battles. Blacks must acknowledge struggle. Our caucasian counterparts, however, have candy coated a violent, repressive history with icons like Johnny Appleseed, Daniel Boone, Norman Rockwell and Frank Capra's films. We know better than that—after all, we cleaned up their dirt. Walker seems to ask, "Is it not also an inequality—an injustice—that blacks are denied that privilege of reminiscence, even while we focus on the horror?"

In addition to masking the gore, Walker's technique dispels any notion that she's coasting on negritude, that affirmative action has gotten her further than skill. This insecurity is warranted or even *there*. Walker has been an artist life-long, and certainly received nothing but encouragement from her environment, especially her father, the painter Larry Walker. But her highly developed sense of irony wastes no time exploiting both the work and its context with equal bite. Painfully aware of such contextual foregone conclusions as that age-old tokenism conundrum, she can't keep herself from blowing them out of proportion, exposing their ridiculousness yet embracing them at the same time.

She takes this to an extreme at once archly cynical and extremely playful. "The nigger wench," she says of a recurring caricature, "is the body that I sort of inhabited accidentally . . . that somebody else placed over me at some point in my waking life."[1] In other words, the nigger wench is her and not her, a heightened interpretation of the way she fears the world sees her. It is an image born of what I call "race paranoia"— reading too closely between the lines for racism that might not be there, but as my brother is fond of saying, "Sometimes when you think they're out to get you, they are." When I mentioned this to the comedian Paul Mooney, a master of race paranoia, he replied, "What do you mean, 'out to get you?' They've already *got* you."

---

[1]Quoted in Kara Walker, interview with Sydney Jenkins, in *Look Away! Look Away! Look Away!: Kara Elizabeth Walker*, exhibition catalogue (Annandale-on-Hudson, NY: Center for Curatorial Studies, Bard College, 1995).

By usurping control of her inner nigger wench, Walker dares to raise questions so horrible they're valid, so frightening they're funny—What if slaves were titillated by their own bondage? Would that, by some backward-bent logic, result in their mental liberation? Did slaves who chose oppression over risking death actually exert a kind of psychological power over their masters?

Both black and white America would have all black artists take race and identity as subject matter for their work. One must uplift the race on the black hand side, while reassuring white liberals that you don't *really* want to snatch their purses and slit their throats. Walker wriggles free of this double bind—a sort of slavery of the imagination—by giving neither contingent what it expects from a political standpoint. She mines the history of desire, which both contradicts and influences political histories. As if to make sure the point hits home, she does it in a style readable by any American: bad taste.

The figures she depicts are all black—in her images, race becomes a matter of signifiers other than skin color: clothing, stance, the way in which one figure relates to another. Technically, Walker levels the battlefield, lets the dichotomies—white vs. black, male vs. female, young vs. old, dominant vs. submissive, North vs. South— cock their guns and try to win the war by shooting *themselves* in the heads. I like to imagine her responding to the society that enforces these fraudulent polarities by meticulously cutting out black holes.

---

***141*** ✦ Deborah Bright, Introduction, *The Passionate Camera: Photography and Bodies of Desire* (London and New York: Routledge, 1998).

Deborah Bright is an artist and theorist who teaches photography and art history at the Rhode Island School of Design. Working both with her own still photography and with installations, she has explored the political issues of gender, nuclear waste in the landscape, and unemployment, as well as autobiographical themes such as confronting breast cancer on the one hand and romantic desire, on the other. *The Passionate Camera,* which she edited, is the first collection of writings that focus on photographic representations of gender and of sexual orientation. In her introductory overview, Bright situates this genre of photographic practice and writing within the larger political context of the collapse of the Soviet Union, the growth of conservativism in the United States, and the AIDS epidemic.

✦

### *Pictures, Perverts, and Politics*

Decadent or liberating? Elitist or profoundly democratic? Trendy fashion statement or lasting revolution? Over the past decade, photographs explicitly contesting normative representations of sexuality and desire have stirred passionate public debate within and without the art world. Whether it concerned photographs of erotic subcultures, gay men and lesbians, transgendered and transsexual subjects, sex workers, preadolescent children, or provocatively posed teenagers in fashion spreads, these

two-dimensional constructions on paper and film became, willy nilly, protagonists in what right-wing populist and ex-presidential candidate Patrick Buchanan termed "the war for America's culture." The social instabilities produced by the collapse of the Soviet Union, a changing domestic economy and the political ascendancy of social and religious conservatives in the 1980s created a climate ripe for scapegoating—not of the policies that promoted local disinvestment and the rapid redistribution of wealth, but of the corrupting "enemies within": immigrants, those on public assistance, young unemployed black men, unwed mothers, and gay men and lesbians who had gained significant political visibility since the late 1960s and who were making slow and fitful progress toward fuller recognition of their civil rights.

While the poor, urban blacks, and immigrants could be "managed" through punitive legislation, incarceration, and the roll-back of affirmative action, sexual dissent—most clearly articulated by educated middle-class feminists and queers—was assailed at the symbolic level through the repeated public invocation of "traditional family values," organized media assaults on "political correctness" and "victim politics," and highly publicized political attacks on publicly funded art (particularly by women and queers) with sexual content. The name of Jesse Helms, Republican southern senator and flag-bearer for the Christian right, became synonymous with calls for national legislation to protect "the vast middle-American population" from the kind of "patently offensive collection of homo-erotic pornography and sexually explicit nudes of children" being financed by the National Endowment for the Arts.

What was it about photographs of sexually charged subjects that made them so vulnerable to accusations of "pornography" and "obscenity"—as though these qualities were self-evident and inhered in the images, and not in the eyes of the beholder? Why did the stakes seem so high where photographs were concerned? The dearth of critical and historical perspectives on photography's agency in the social construction of sexuality (in favor of appeals to "common sense" and "knowing pornography when I see it") that characterized so much of the emotionally polarized debate over the NEA and other censorship scandals indicated the urgent need for a book like *The Passionate Camera*. As editor, I sought to assemble a thoughtful and accessible collection of essays and works exploring a range of historical and contemporary photographic practices which challenge and disrupt the dominant social consensus around sexuality and its representations.

However, my intention for *The Passionate Camera* was not only to respond to political attacks. Another, more positive impetus for producing this book was to document and celebrate what conservatives and religious fundamentalists so fervently wish to suppress: the explosive growth of independent photographic works since the mid-1980s by a critical mass of artists and cultural producers who openly challenge the sexual status quo. This grassroots production was fostered, to a significant degree, by the atmosphere of militance and extreme urgency that accompanied the AIDS pandemic.

Many AIDS activists were members of the arts community which had been devastated by the epidemic. As public censorship accelerated and as social conservatives enacted punitive cultural legislation—exemplified in Britain by the passage in 1988 of Section 28 of the Local Government Act which prohibited state funding for cultural works "promoting homosexuality" or "the acceptability of homosexuality as a pretended family relationship"—a number of artists chose to put their cultural

production in the service of an activist politics. They also challenged (less success-fully) the prevailing myth that works of art should address only what is "transcen-dent" and "universal"—that is, disengaged from immediate social struggle. What could be more universal, AIDS activists demanded, than survival itself? As Douglas Crimp put it, "We don't need to transcend the epidemic: we need to end it."

AIDS activism's imperative to historicize and critique the dominant sex-gender system that produces and polices (even as it is produced and policed by) homopho-bic categories of "normality" and "deviance," and to strategize effective political and cultural resistances to it, gave added impetus to the growth industry within the acad-emy of what has come to be called "queer studies"—a wide-ranging, energetic, cross-disciplinary critique of heteronormativity and its effects. Radical revisions of histories and theories of gender and sexuality by Michel Foucault, Jeffrey Weeks, Gayle Rubin, Monique Wittig, Eve Kosofsky Sedgwick, Teresa De Lauretis, and Judith Butler had an enormous impact on the work of younger artists by the mid-1980s, particularly those emerging from MFA programs in more progressive departments and art schools. Queer production is young: many of the contributors to *The Passionate Cam-era* are in their twenties and thirties.

Confronted with the imperative to act and show solidarity in the face of con-servative attacks on artistic expression, the integrity of museum curatorship, the Na-tional Endowments, and academic freedom, historically conservative disciplines such as art history cautiously opened their conferences, symposia and publications to queer perspectives. An active gay and lesbian caucus organized within the College Art Association in 1990 to promote awareness of queer issues and activism among arts professionals. As I write this, the mail brings the latest copy of the organization's ac-ademic quarterly, *Art Journal*—a special theme issue on "the Gay and Lesbian Pres-ence in Art." A decade ago, this could not have happened.

---

## *Bodies Reclaimed*

In the 1950s one turned to Kenneth Clark's *The Nude: A Study in Ideal Form* (1956) to learn that artists did not paint "naked ladies and men," but, rather "the Nude" as an ex-pression of their appreciation for classical form and the Western tradition. To raise the question in those days that there might be less than "ideal" motives behind the produc-tion and collecting of artistic representations of the nude would incur the accusation that one was either a philistine or a prude. When de Kooning painted his *Women* series in the early 1950s, perplexed artworld people had to acknowledge that he had, among other things, subverted the time-honored tradition of the nude.

In the 1960s Pop artists such as Tom Wesselmann commodified and packaged the female nude; Mel Ramos's girlie pin-ups were only slightly less prurient than *Playboy* mag-azine centerfolds. Artists also began to get specific with regard to those who posed, and they painted not nudes but "naked people." Larry Rivers painted poet and critic Frank O'Hara standing naked but for his socks. In the early 1970s Sylvia Sleigh appropriated the artistic, controlling gaze—previously permitted to male artists only—when she painted her male friends Paul Rosano, Scott Burton, Carter Ratcliff, and husband Lawrence Al-

loway in the buff, although she idealized such images by linking them to well-known art historical precedents. Alice Neel also painted naked artworld men and women (John Perreault, Cindy and Chuck Nemser) but with sardonic relish. John Coplans turned his camera to his own aging body and clicked the shutter at odd corners of flesh and body hair. Joan Semmel looked down at her own body and painted the truncated torso and limbs from the vantage point of her own controlling eyeball; the contradictions inherent in her juxtapositions in *Mythologies and Me* [see Fig.6-11] highlight the ways both popular culture and high art appropriate the female body for consumer purposes.

In the late 1960s, however, Americans saw more flesh in public—real flesh, not just painted flesh. What made the unashamed display of flesh so pervasive in these years included miniskirts, breast feeding in public, hot tubs at ashrams, and nude beaches, among other public phenomena. In the entertainment sector, there was a breakdown of movie-industry codes that had formerly censored scenes of nudity and sexuality. In the theater, naked bodies cavorted across the stages of Broadway in musicals such as *Oh, Calcutta,* in the Living Theater's *Paradise Now,* and in the Performing Garage's *Dionysius in 69.* The anarchist Yippies, led by Jerry Rubin and Abbie Hoffman, revived "streaking"— running naked through a public space. When Rubin published his 1970 book *Do It: Scenarios of the Revolution,* he included a two-page photographic spread of a reclining naked two-year-old female—long before Mapplethorpe's offending photograph *Rosie* became one of the legal exhibits in the 1990 trial of Dennis Barrie and the Cincinnati Contemporary Arts Center, which he then directed.

During the 1960s at the Judson Memorial Church and downtown art galleries, performance artists used nudity as an expressive component of their art. Carolee Schneemann (Reading 86) did *Eye Body* in 1963, which consisted of her own eroticized body covered with paint, grease, ropes, and chalk. She later recalled: "In 1963 to use my body as an extension of my painting-constructions was to challenge and threaten the psychic territorial power lines by which women were admitted to the Art Stud Club" (Schneemann, *More Than Meat Joy,* 1979).

Since the 1960s performance artists have continued to use their bodies as the canvas upon which they inscribe their conceptual ideas. Amelia Jones, in *Body Art/Performing the Subject,* 1998, calls this art of the 1970s and early 1980s "body art practices, which enact subjects in 'passionate and convulsive' [Antonin Artaud's phrase] relationships (often explicitly sexual) and thus exacerbate, perform, and/or negotiate the dislocating effects of social and private experience in the late capitalist, postcolonial Western world." Jones also makes the point that these artists refuse to acknowledge the Cartesian split between mind and body; in their art, mind/body is one.

As artists rejected Cartesian dualism they also became aware of the ideas of Maurice Merleau-Ponty, set forth in his *Phenomenology of Perception,* 1945 (English translation, 1962). Although most philosophers challenge Merleau-Ponty's use of the term "Phenomenology" as elaborated by Edmund Husserl, Merleau-Ponty was popular within the artworld. Artists and critics understood him to mean that the acquisition of knowledge comes through acts of the body and those phenomena that can be considered extensions of the body. To such an audience, the works of Bruce Nauman (e.g., *Self Portrait as a Fountain,* 1966–67), Vito Acconci (e.g., *Seedbed,* 1972), and Chris Burden (e.g., *Trans-Fixed,* 1974), made through their own bodily functions, gestures, and submissions to the gestures of others, seemed to have an existential—and phenomenological—authority.

Women artists reacted differently to the Cartesian mind/body split. Many celebrated those experiences of bodily processes that seemed to have rhythms of their own: menstruation, pregnancy, giving birth, and nursing. To them, the body was not alien—not something outside. When the artist/theorist Trinh T. Minh-ha commented, "We do not *have* bodies, we *are* our bodies," she was expressing an existential awareness of women's own power. Women artists became cognizant that their own bodies and the representations of their bodies were invariably controlled by a patriarchical culture, an issue about which they are still vigilant. When the Supreme Court struck down antiabortion laws in 1973, the new freedom symbolized more than trips to clinics.

Artists of color had other issues that the human body symbolized. Informing many African American artists is the historical knowledge that for many centuries the enslaved African body was the site of the whims of sadistic and/or lustful masters. Lorna Simpson's series of photographs of views of her own simply clothed person suggests that heritage of enslavement. Jimmie Durham and James Luna have their own memories of issues relevant to the display and humiliations of Native American bodies throughout American history.

*142* ✦ Lowery Stokes Sims, "Hannah Wilke: 'The Body Politic' or 'The Adventures of a Good-Looking Feminist,'" in *Art and Ideology* (New York: The New Museum of Contemporary Art, 1984).

Hannah Wilke was well known to the art scene in the 1970s and 1980s. Although not an active member of women's groups, her artwork very much touched on feminist issues. She had movie-star good looks, an attribute she used to explore the interface between beauty and power. One of her strategies was to act out a symbolic scarification/mutilation by covering her naked body with twists of chewing gum. Her posthumous exhibition at the Ronald Feldman Gallery, *Intra-Venus* in 1994, consisted of photographs of herself as she was dying of cancer but still attempting to cope with the most elemental activities such as bathing.

In this essay for *Art and Ideology* Lowery Stokes Sims (see Reading 108) paired Wilke with the less well known artist Kaylynn Sullivan. These excerpts focus on Wilke.

In a statement prepared for the performance *Intercourse With* . . . in 1977, Hannah Wilke referred to her own early awareness of the ambiguity and power of language: "As an American girl born with the name Butter in 1949, I was often confused when I heard what it was like to be used, to be spread, to feel soft, to melt in your mouth." Throughout her work and in conversation, Wilke conveys an almost compulsive concern with metaphorical modes of expression, with the sounds and nuances of the words as both a totem of truth and an infinitely transmutable medium, an instrument of social control and of political provocation. For Wilke, language represents the structuring of experience through politics, art, and other forms of socialization, whereas images from the most abstract to the most realistic biological forms, are the individual organism, the living self. This conflict is the source of the ideological tension and passion in Wilke's work.

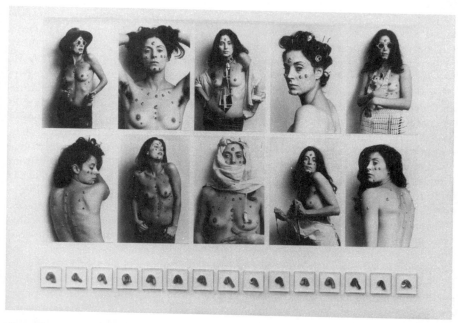

**Figure 7-8.**   Hannah Wilke, *SOS—Starification Object Series*, 1974–82. Mixed media, 401/2 x 58 in. framed. © The Scharlatt Family, 1999. Photograph by D. James Dee, courtesy Ronald Feldman Fine Arts, Inc., New York.

Although Wilke is perhaps best known for her more public performances and videos, she is, even in those mediums, fundamentally a sculptor who shares some concerns with the minimalists and conceptualists of her generation, though shaped into a feminist ideology.

* * *

The constant sexual content of Wilke's work associated her early on with the feminist art movement. And within that movement she has maintained a controversial presence.

> Since 1960, I have been concerned with the creation of a formal imagery that is specifically female. . . . Its content has always related to my own body and feelings, reflecting pleasure as well as pain, the ambiguity and complexity of emotions. Human gestures, multi-layered metaphysical symbols below the gut level translated into an art close to laughter, making love, shaking hands. Eating fortune cookies instead of signing them, chewing gum into androgynous objects. . . . Delicate definitions. . . . Rearranging the touch of sensuality with a residual magic made from laundry lint, or latex loosely laid out like love vulnerably exposed.[1]
> [. . .]

[1]Hannah Wilke, statement for performance of *Intercourse With* . . . at the London Art Gallery, London, Ontario, 1977.

The ability to engage us viscerally in her life and work is experienced most directly in Wilke's videos and performances. From an early phenomenological video in which she slowly and progressively touched and then pulled her face (*Gestures,* 1974), to the scarification works and the sensational nude dance to the camera in *So Help Me Hannah*—brandishing a gun, and wearing only high heels—Wilke's projection of herself contrasts markedly with the more impersonal impersonations of Eleanor Antin and the recent work of Cindy Sherman, whose "dress-up" masquerades are *au fond* no less narcissistic, but somehow easier to accept or digest as art, because they disguise the self and parody the suffering, pain, and pleasure we sense is real in Wilke's art. In costume it is no longer the artist but a character "created" by her. In the performance video *Intercourse With.* . . Wilke is seen listening to recordings of phone messages from friends, lovers, her mother, as she removes the names which have been attached to her nude torso. Disturbingly personal, it insists on a "one-to-one relationship" to the artist's biography. Wilke's performances nonetheless maintain an elegiac quality. They are alternately self-involved, even narcissistic, and yet universal in their sculptural, operatic expression of emotional states. There is a ritualistic aura about the slow unfolding of Wilke's choreography and gesticulation. They are spontaneous and intuitive, but seem studied and highly rehearsed, like the movements of a No play. In this respect her work relates to the "chance" aspects that have characterized modern performance and dance. The body becomes a vehicle of sculptural form and of spatial and sensual as well as emotional interplay.

That Wilke always uses herself in her art is the point, and this makes her and others such as Carolee Schneemann and Lynda Benglis, who, like Wilke are good-looking and have appeared nude in their work, vulnerable to accusations of narcissism and what Lucy Lippard dubs "political ambiguity." [. . .]

> A woman using her own face and body has a right to do what she will with it, but it is a subtle abyss that separates men's use of women for sexual titillation from women's use to expose that insult.[2] [. . .]

As Gloria Steinem has observed, it was difficult to be a good-looking feminist back in those days. If we consider the issue of clothing, of unfettering the body, in the context of popularist and feminist movements over the last 150 years, it is obvious that it was germane to the public bra-burnings of the 1960s. But the line between unfettering the body and flaunting it in public was narrow indeed, and Wilke was accused by some feminists of sensationalism. [. . .]

At this point I would like to return to Wilke's signature cunt/scar forms and to elucidate their relationship to the ideological content of her work. Bruno Bettelheim has observed that modern practices of scarification—i.e., cosmetic surgery—parallel precisely those of African women who endure hundreds of cuts without anesthesia to achieve prized keloided designs on their bodies. In one context, cosmetic surgery, scarring, tattooing, and dieting relates to the concept of suffering to be beautiful; in another—not so far removed—they are preludes to death. These dichotomies must be recognized in Wilke's work if its meaning and portent are to be fully comprehended.

[2]Lucy R. Lippard, "European and American Women's Body Art," in *From the Center* (New York: E. P. Dutton, 1976), p. 125.

Photographs of Wilke's mother, Selma Butter, with the real scars of cancer and a mastectomy, are seen in conjunction with photographs of the artist marked by symbolic scars. Although Wilke's artistic scars may be removed, the psychological scars they also represent (like the ravages on the image of Dorian Gray) nonetheless remain. That Wilke is an attractive woman renders the sense of scarification—suffering to be beautiful—almost ironic if not mocking. But the internal wounds are those of a child, little Hannah Butter, conscious of the time/space coincidences that saved her from the bodily suffering of Jews in Europe—suffering that included mutilation, tattooing, starvation, and annihilation.

The relationship of mother and daughter is made more poignant by the contrast of their postures. The artist, head flung back, shoulder thrust forward, "body physick" lean, intact, gum scars arranged in symmetrical patterns across her breasts and abdomen. Her mother sits in front of us, an unflinching portrait of the ravages of cancer—scars of her mastectomy inflamed, establishing their own pattern across her torso. Her tousled wig, mimicking her daughter's tresses, hides the consequences of chemotherapy. If viewers found Wilke's flaunting of her attractive body disturbing, how much more so the sight of the emaciated, sagging, wearied body of Selma Butter. In the exclusively erotic context that we accept the nude, an aged body is often deemed tasteless and inappropriate. (A comparable audacity is Alice Neel's nude self-portrait done two years ago when the artist was over eighty years old.) But eroticism can also be a matter of intimacy and love, and, in fact, it is clear from photographs of the youthful, and even the aging Selma, that the artist's flirtatious mugging is inherited. So the juxtaposition of Wilke, with symbolic scars, and her mother, her body ravaged by cancer-caused scars, is particularly poignant and downright neo-Platonic. It suggests allegorical contrasts of the ages of (Wo)man, and reminds us of the fragility of her existence, the absurdity of life, but also of its extraordinary presence in the face of death.

\* \* \*

**143 ✦** Robin Winters, "An Interview with Kiki Smith," in *Kiki Smith* (Amsterdam: Institute of Contemporary Art, 1990); reprinted in MIT List Visual Art Center, *Corporal Politics* (Boston: Beacon Press, 1992).

Kiki Smith grew up in an artist's family. From the beginning of her art career, she settled on the nude body as the site for her explorations into systems. For the catalogue, *"This Is My Body: This Is My Blood"*, 1992 (Herter Art Gallery, University of Massachusetts) she wrote: "I intend my work as a meditation on the varied systems and functions of the body through which we decipher meaning and bear witness to life, which enables us to examine the responsibilities to that primary vehicle as a user and part of a collective whole of humanity." Her figures are fragile creatures—such as *Blood Pool*, 1982, a sculpture of an almost life-size wax female figure curled on the floor near a wax pool of blood. Sometimes the art consists of installations of an old-fashioned table, on which are placed a row of large laboratory bottles inscribed with the names of bodily fluids. To the viewer these bottles take on eerie associations. One imagines them as surrogates of the people who may have excreted those bodily fluids.

Most of the functions of the body are hidden or separated from society, like sex or bowel movement. Not eating—intake—is still public, I guess. So much is separated from our consciousness or in our consciousness; we separate our bodies from our lives. But, when people are dying, they are losing control of their bodies. That loss of function can seem humiliating and frightening. But, on the other hand, you can look at it as a kind of liberation of the body. It seems like a nice metaphor—a way to think about the social—that people lose control despite the many agendas of different ideologies in society, which are trying to control the body(ies) . . . medicine, religion, law, etc. Just thinking about control—who has control of the body? does the body have control of itself? do you?—it's kind of schizophrenic, to be separated from the body. Does the mind have control of the body? Does the social?

---

***144*** ✦   James Luna, "The Artifact Piece," in *Fiction International* 18, no. 1 (Spring 1988):38–42.

James Luna, who lives on the La Jolla reservation in California, uses his own body to remind his viewers of the very corporeal presence of Native Americans in both present-day America and in memory. In 1986 he installed and performed *The Artifact Piece* at the San Diego Museum of Man. The five-page spread of pictures and text in *Fiction International,* based on that performance/installation, must be thought of as "page art" since text, photographs, layout, and the sequencing of those three elements are all part of the art.

In the original performance piece, as well as the spread in *Fiction International,* Luna plays with the concept of "the artifact," defined in the *Random House Dictionary* as "any object made or modified by humans, esp. one reflecting workmanship in ancient cultures." Using his own body displayed prone in a museum specimen case as an "artifact," he is thus treating his body not as "natural" but as something created by anthropologists as a curiosity, much like ethnographers in the nineteenth and early twentieth centuries exhibited in natural history museums the peoples of other cultures. Labels on card stock surrounded his body in the case and contained a non-fictionalized text that drew on the reality and on the stereotypes of Native Americans. The text, too, should be thought of as an artifact—not "natural" but constructed as ethnographic and social/political spectacle.

For the page-art spread, Luna uses five views of himself in the case along with the text from the case labels. The five pages bring the reader into the situation, as were the spectators at the San Diego Museum of Man. On the first page there is only the title and a photograph showing five spectators in a museum setting staring down at some object. On the second page we read three sentences and the object then becomes clear—a photograph of a figure lying prone on a slab-like surface perpendicular to the picture plane. His feet and body are foreshortened in much the same way as Mantegna's *Dead Christ.* The words—about the protagonist's getting burned while on a drunken binge—contradict the Christ-like image or the stereotype of the "Noble Savage." The third page shows another foreshortened view—this angled so that spectators looking down on the prone figure become themselves elements in the performance. The three sentences beneath the photograph narrate the protagonist's "emotional" state upon hearing the news that his father is dying, just at the time when

**Figure 7-9 a.**   a, b, c, d & e (5 pages) James Luna, "The Artifact Piece," installation and performance at The Museum of Man, San Diego, CA. Published in *Fiction International,* 18, no. 1 (San Diego: State University Press, 1988).

The burns on the fore and upper arm were sustained during days of excessive drinking. Having passed out on a campground table, trying to walk, he fell into a campfire.

Not until several days later, when the drinking ceased, was the seriousness and pain of the burn realized.

**Figure 7-9 b.**   Continued

he has begun a new relationship. Another drinking binge ensues. The text on the fourth page reflects on the pattern of his relationships; the photograph looks down at the prone figure and the spectators. Finally, the fifth page presents a photograph with a lateral view of Luna and a label affixed to the case: "James A. Luna/Born February 9, 1950/ Suiseño Indian." Three sentences conclude the narrative: the protagonist's admission of his vulnerability when drunk and his resolve never to trust "relatives and other Indians." The five-page spread invites the viewer to explore deeper levels of understanding about issues of ethnography, identity, and the social worlds they construct.

## Censorship and Propaganda in Art and Visual Culture

Censorship has existed for centuries. It provides controls for governments and powerful authorities to suppress the words, images, and actions considered subversive to those in

Having received a telephone call that his father had returned to the veterans hospital (where he did not recover) and having excellent feelings about a new relationship, the total impact of the news was excessively emotional.

He proceeded to drink a fifth of whiskey, fell on his face. A slight scar and a lump under the skin document the event.

**Figure 7-9 c.**   Continued

power. Censorship heats up during periods of social unrest, when ruling elites determine that the defense of the public "order" requires the imposition of a cultural or political orthodoxy.

During the Cold War period of the late 1940s, 1950s, and early 1960s, nationwide anticommunism created a climate wherein even reform-minded artists committed to the ideals of social justice popular in the 1930s were suspect. Persecution typically meant the loss of jobs and of friends and patrons. The trials in the late 1940s and 1950s of the Communist Party leadership, of Alger Hiss, and of Julius and Ethel Rosenberg further exacerbated the situation. Many previously politically engaged artists resigned from left-wing groups, exercised self-censorship, and turned in their art to nonpolitical themes. Others moved to Mexico and Europe, where the intellectual climate provided greater freedom.

When the Civil Rights Movement accelerated in the early 1960s, however, ideas promoting justice, community self-determination, and the fight against racism could no longer be dismissed as foreign-instigated communism (although Herbert Hoover did keep an FBI file on Martin Luther King, Jr., and other activists). In the mid-1960s, as social unrest erupted in Detroit, New York, and other cities, President Lyndon Johnson recognized

Having been married less than two years, emotional scars from alcoholic family backgrounds were cause for showing fears of giving, communicating and mistrust.

Skin callus on ring finger remains, along with assorted painful and happy memories.

**Figure 7-9 d.** Continued

that those calling for the necessity for reforms could not simply be labeled as communists. Johnson responded by launching the "Great Society" with its programs for low-income housing, job training, and summer jobs for youth. In this more open atmosphere artists and writers returned to social themes.

As part of the government's liberal outreach effort the National Endowment for the Arts was authorized by Congress in 1965 "to help create and sustain not only a climate encouraging freedom of thought, imagination, and inquiry but also the material conditions for facilitating the release of this creative talent"(quoted in Richard Bolton, ed., *Culture Wars*, 1992). Grants were dispensed to individuals, institutions, and states' art councils. With funds many artists had time off to make art and to develop ideas about public art. For example, in the early 1970s Faith Ringgold received a grant to paint a prison mural for the Women's House of Detention at Rikers Island (see Reading 118).

The NEA, however, began to be criticized by congressional critics and newspaper journalists, who railed against giving money to artists and who argued that private philanthropy should take care of the financial needs of local museums, orchestras, theaters, and dance groups. In the late 1980s a crisis developed as more and more artists produc-

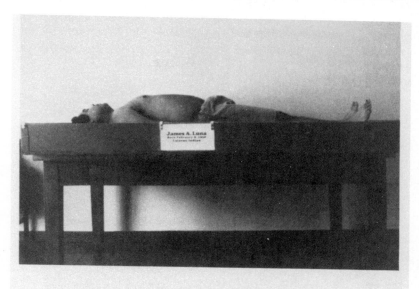

Drunk beyond the point of being able to defend himself, he was jumped by people from another reservation.

After being knocked down, he was kicked in the face and upper body. Saved by an old man, he awoke with a swollen face covered with dried blood.

Thereafter he made it a point not to be as trusting among relatives and other Indians.

**Figure 7-9 e.**   Continued

ing sexually explicit art or politically critical art were being given grants. In the spring of 1989 Senator Jesse Helms of North Carolina, together with other congressmen, began scrutinizing recently funded grantees and museums. They singled out for attack Philadelphia's Institute of Contemporary Art, which had used NEA funds to mount and travel the exhibition *Robert Mapplethorpe: The Perfect Moment* (see Reading 146), and the Southeastern Center for Contemporary Art, located in Winston-Salem, North Carolina, which had used NEA funds to give photographer Andres Serrano one of their prestigious Awards in the Visual Arts. Serrano's offending photograph, *Piss Christ,* depicted a cheap plastic crucifix submerged in urine. Congressmen claimed that Mapplethorpe's sexually explicit photographs offended standards of morality; Serrano's offended the church.

Helms persuaded a majority in Congress to pass an amendment in July 1989 barring the NEA from using federal funds to "promote, disseminate or produce —obscene or indecent materials, including but not limited to depictions of sadomasochism, homo-eroticism, the exploitation of children, or individuals engaged in sex acts; or —material which denigrates the objects or beliefs of the adherents of a particular religion or nonreligion; or—material which denigrates, debases, or reviles a person, group, or class of

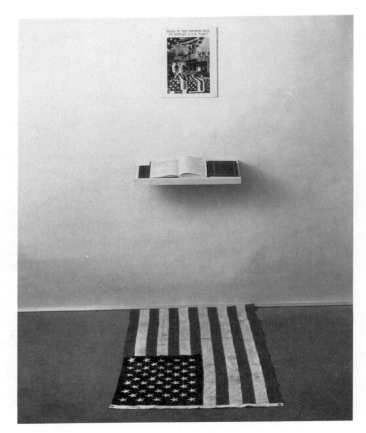

**Figure 7-10.**    Dread Scott, *What Is the Proper Way to Display a U.S. Flag?*, mixed media, installed at the School of the Art Institute of Chicago, 1989. Photograph courtesy the artist.

citizens on the basis of race, creed, sex, handicap, age or national origin" (Congressional Record–Senate, July 26, 1989, p. S8806). The Senate later reversed itself, but a House-Senate compromise bill introduced the requirement that grant recipients sign a pledge not to use NEA funds to create obscene art. The courts subsequently ruled this requirement to be unconstitutional. Nevertheless, the political climate was sufficiently chilled that NEA directors remained cautious, as evidenced in spring 1990 when John E. Frohnmayer overturned a National Council on the Arts recommendation to fund performance artists Karen Finley, Holly Hughes, John Fleck, and Tim Miller.

Sexually explicit images and what some call religious blasphemy are not the only targets in censorship. The flag desecration issue returned in February 1989 when artist Dread Scott [Scott Tyler] created an installation for audience participation, *What Is the Proper Way to Display a U.S. Flag?*, [Fig. 7-10], for a student exhibition at the School of the Art Institute of Chicago. The installation consisted of an American flag placed flat on the floor and abutting a wall, on which was nailed a shelf holding "visitor" books for view-

ers to sign. Above that was a photomontage with images of U.S. flags being burned by South Korean students and flag-draped coffins. Sylvia Hochfield (*Artnews,* Summer 1989) reported that when word spread about Scott's exhibit, some "2,500 veterans and supporters marched on the school to demand that officials remove the flag. About a dozen students holding a counterdemonstration were attacked; one veteran and four students were arrested. President Bush called the work 'disgraceful.' " However, demonstrations also supported Scott; veterans from Vietnam Veterans Against the War Anti-Imperialist stood with Scott as an honor/body guard during some of the demonstrations (letter from Scott to author, February 21, 2000). The school did not remove Scott's installation and protests eventually died down, but the incident encouraged efforts by Congressmen to propose another round of flag desecration laws.

Censorship issues became enmeshed with the culture wars of the early 1990s. After the Soviet Union's collapse there was no longer an "evil empire" for the United States to justify large military appropriations. The old and new Cold Warriors seized on a new adversary—the "enemy within." They targeted not only artists subversive of traditional sexual mores, of patriotism, and of religious orthodoxies, but also the so-called "tenured radicals," specifically, revisionist historians at colleges and universities who had emerged from the student movement of the 1960's.

Complaints about, as well as out-and-out censorship of, revisionist history surfaced in 1991 from Lynne V. Cheney, chair of the National Endowment for the Humanities. Like her predecessor William Bennett, she was vocal about the kind of traditional scholarship she favored. While she gave "scholarly merit" as her main criterion, her critics saw a political agenda. In the spring of 1991 immediately following the Gulf War, the National Museum of American Art came under the gun for its putative disrespect of patriotic icons. Curator William H. Truettner had mounted *The West as America: Reinterpreting Images of the Frontier, 1820–1920,* a revisionist look at nineteenth-century paintings and photographs of the western landscape, pioneers, and Native Americans. The catalogue text and wall labels commented on the ideological climate of nineteenth-century expansionism that had been the context of such art. While the NMAA never sought NEH funding, it was still vulnerable to cuts in its budget by Congress. What raised the ire of traditionalists were the wall labels, which advanced a revisionist interpretation of the history of the U.S. West. The labels' commentary contrasted the idealized vision of the West seen in most of the paintings with the actual historical record—including land grabs and broken treaties with Native American tribes. At stake was the writing and interpretation of history and control of the historical record. Historian Daniel J. Boorstin called Truettner's show "a perverse, historically inaccurate, destructive exhibit" (quoted in Alan Wallach, *Exhibiting Contradiction,* 1998). Truettner disagreed; his aim was to engage museum visitors and encourage them to make connections between problems of the past and the present.

While the NMAA exhibition was allowed to run its course, another exhibition slated for the National Air and Space Museum was censored—the *Enola Gay* exhibition, named after the B-29 that dropped the atomic bomb over Hiroshima in August 1945. The curators had originally planned to focus on the decisions that led to the use of the atomic bomb against the Japanese and to include the Japanese interpretation of events. Veterans' groups and politicians, however, protested, and exhibition plans stalled. When the exhibition finally went on view—from January 1995 to May 1998—it was sanitized to present only the American military's rationale for the bombing.

In October 1999, when Arnold Lehman, the director of the Brooklyn Museum of Art, mounted the controversial exhibition from England, *Sensation,* no less a person than the Mayor of New York, Rudolph Giuliani, vigorously objected. The target of the Mayor's wrath was a work by Chris Ofili, an English painter of African descent, who had incorporated dried and shellacked elephant dung into a mixed media painting of a black Virgin Mary, which was blasphemous to the Mayor. Giuliani then attempted to revoke New York City's funding for the museum and launched legal proceedings. As the controversy was daily reported in the newspapers, attendance soared and religious opponents staged protest demonstrations outside the museum. An issue that soon emerged was the nature of the commercial funding for the exhibition; Charles Saatchi, a leader in the international public relations field who owned all the artwork in *Sensation,* and Christie's, the auction house which had been negotiating sales of Saatchi's collection, reputedly stood to gain from the publicity. Eventually the museum won in court, but serious questions had been posed—not just about censorship but also about the close connection between curatorial decisions and the vested interests of commercial-minded patrons of art.

**145** ✦ Placard on rear of a San Diego Transit Bus during January 1988, with a 3-color silk screen on vinyl, 21 × 72 in. poster, *Welcome to America's Finest Tourist Plantation,* by Elizabeth Sisco, Louis Hock, and David Avalos.

Not all issues of censorship created a *national* furor. At the grassroots level, artists began using their grants to comment on local conditions. In January 1986 David Avalos, with a display permit, set up an installation outside a San Diego Federal courthouse, which consisted of a donkey cart (a common conveyance to transport workers) and photographs of Immigration and Naturalization Service agents arresting Mexicans attempting to cross the border while tourists looked on. Judge Gordon Thompson, Jr., ordered the installation removed on the grounds that it was a security risk. Supporters of Avalos countered that this constituted censorship because the artwork was clearly critical of INS activities. However, within the week the installation moved to Centro Cultural de la Raza, a neighborhood cultural center (see *New York Times*, January 21, 1986).

Two years later, in January 1988, San Diego artists Elizabeth Sisco and Louis Hock teamed up with Avalos. At the very time when the city was hosting Super Bowl XXII, they rented advertising space on the back of 100 San Diego Transit District buses, where they could place placards. Through a montage of images of hands and significant motifs *Welcome to America's Finest Tourist Plantation* the placards made the point that the economic success of San Diego's tourist industry rests on the labor of "undocumented" workers: to the left the hands of a kitchen worker scrape a dinner plate; to the right the hand of a hotel maid enters a room with towels draped over her arm; prominent in the center are the handcuffed hands of an undocumented worker and the hand and holstered gun of an INS agent. City authorities demanded the placards be removed, but transit officials who had a contractual agreement with the artists refused. Because the project had received funding indirectly from NEA, the objections were brought to the attention of the state legislature, which found no violations of funding guidelines.

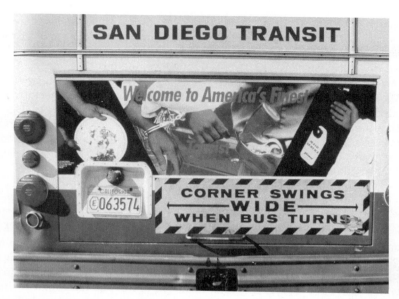

**Figure 7-11.** Elizabeth Sisco, Louis Hock, David Avalos, *Welcome to America's Finest Tourist Plantation,* January 1988. Three-color silk screen on vinyl, 21 × 72 in. poster, rear of a San Diego Transit Bus. Photograph courtesy the artists.

In April 1989, Sisco, Hock, and Avalos, along with Deborah Small, were back in the news when they installed a billboard with another version of *Welcome to America's Finest Tourist Plantation*—this time commenting on the debate that surrounded the defeat of a referendum to name the convention center after Martin Luther King, Jr. The project initially received funding from city, state, and federal grants through Installation Gallery, an alternative gallery. After denying further funding to Installation Gallery, the Public Services and Safety Committee of San Diego then reinstated funds—but only to finance such nonpolitical works as "Artwalk." (See Richard Bolton, ed., *Culture Wars*, 1992).

Discussion about *Welcome to America's Finest Tourist Plantation* is as relevant to issues of public art as to issues of censorship.

*146* ✦ Michael Brenson, "The Many Roles of Mapplethorpe, Acted Out in Ever-Shifting Images," *New York Times,* July 22, 1989:11, 16.

Christina Orr-Cahall, director of the Corcoran Gallery of Art in Washington, DC, decided to cancel the NEA-funded *Robert Mapplethorpe: The Perfect Moment,* which had originated at the Institute of Contemporary Art in Philadelphia and was scheduled to open at the Corcoran in July 1989. Her decision came about because she thought the show might create a backlash against other Corcoran proposals to the NEA. Orr-Cahall's action exploded into the hot *cause célèbre* of the summer of 1989. Jock Reynolds, director of the

Washington Project for the Arts, brought the show to his institution so that everyone could judge for themselves. Senator Jesse Helms and his supporters denounced Mapplethorp's sexually explicit work.

When the exhibition moved to Cincinnati and opened at the Contemporary Art Center in April 1990, controversies again flared over Mapplethorpe's homoerotic sexual content. The County Prosecutor demanded that Dennis Barrie, the CAC's Director, remove seven offending photographs. When Barrie refused, he was backed up by the U.S. District Judge. Nevertheless, Barrie and the CAC were indicted on obscenity charges and the case went to trial. On October 5, 1990, the jury in Cincinnati found both Barrie and the CAC not guilty. In the summer of 1990, following Cincinnati, the Mapplethorp exhibition went to the Institute of Contemporary Art, Boston, where no incidents occurred.

---

The first photograph in "Robert Mapplethorpe: The Perfect Moment" (yes, *that* Mapplethorpe retrospective), which opens tonight at the Washington Project for the Arts, is a 1988 self-portrait. Floating like an apparition in the darkness at the upper right is the pale face of the artist, who had been ill for some time; he died of AIDS in March at the age of 42. His lips are pursed, his eyes fixed. His drawn face has begun to wither.

At the lower left, the artist's fist is wrapped around a cane with a skull knob. The fist, too, floats; because it is more sharply focused than the head, it pushes toward us. The cane and skull are phallic; a fist served as a sexual organ in one of Mapplethorpe's most notorious images. So if this self-portrait is vulnerable and timid, it is also defiantly unrepentant. The last laugh may appear to be on him, but if you look long enough the face begins to smile.

Much of this difficult, uneven and important artist is in this work. While deadly serious, Mapplethorpe often had a twinkle in his eye. His photography is not so much shameless as beyond shame. Formally and psychologically, he was fascinated by the relationship between light and dark, black and white. Like Andy Warhol, whom he admired, he was raised a Roman Catholic and he continued to depend upon Catholic iconography and ritual: in this self-portrait, he presents himself as bishop or priest.

Mapplethorpe had the imagination to find the edge between lucidity and pathology, seductiveness and cruelty, submission and domination. And he had the gift to make photographs in which the expression and even the condition of a face seem to be in the process of change. One of Mapplethorpe's most remarkable works is a 1980 self-portrait with naked torso and made-up face in which there is a sense of actually watching a woman trying to get out of a man's body.

This exhibition should be seen. It is extremely unfortunate that the Corcoran Gallery of Art canceled it last month in the hope of averting a political outcry. It is a blessing for Washington, a city still struggling to remove the stigma of provincialism, that the Washington Project for the Arts—a contemporary arts organization founded in 1975 and partly run by artists—jumped in.

The storm over the exhibition involved the $30,000 that the National Endowment for the Arts gave the Institute of Contemporary Art in Philadelphia, the organizing institution. The question for some politicians was whether an artist who produced X-rated work that seemed to spit in the face of middle-class mores and values

should receive Government funds. The endowment should be applauded for contributing to this show.

As much as he has been made out to be a renegade and outlaw, Mapplethorpe is an utterly mainstream artist. He loved freshness and glamour and was obsessed with the moment, which his photographs always reflect. In his restricted spaces and his feeling for abstraction and attentiveness to every shape, edge and texture, Mapplethorpe is a child of the Formalism of the 1960's. In his commitment to images that could deal directly with his life, he shared the hunger for subject matter and narrative that helped shape the art of the 1970's. In his insistence upon total control, his photographs reflect the austerity of some of the most widely discussed art of the past few years.

Mapplethorpe is also part of his time in his hope—expressed in the catalogue interview with Janet Kardon, who put the show together—that his work would "be seen more in the context of all mediums of art and not just photography." He fought all forms of isolation. He was determined to blur boundaries between genres, genders and races. The effectiveness with which he captures the sexual, racial and social instability of the 1980's is one reason his work is so valuable and threatening.

It also helps explain why we are not close to understanding him fully. Mapplethorpe was always moving in different directions. He was attracted to flowers that were both male and female. He liked to see breasts as buttocks and arms as legs. He did a book with Lisa Lyons, a bodybuilder who changed identities from picture to picture. He photographed himself as dandy, thug and diva. On the stage of his photography, he could play any role he wanted.

The power of the Mapplethorpe esthetic has a great deal to do with sex and death. Mapplethorpe was most interested in the moment just before full flowering. He wanted the human body before it bore a trace of decay. His images of figures moving toward ripeness are a rejection of death, of which there is no sign.

But to capture that moment, Mapplethorpe had to freeze it. Everything, down to the tiniest detail, is controlled. Nothing is left to chance. Mastery is total. Figures and flowers turn into statues in a space without air. They are, in a sense, dead. Mapplethorpe's art is at the same time a bitter struggle against death and a wholehearted embrace of it.

The exhibition includes more than 150 works spanning 20 years, from the early appropriation of religious and pornographic images; to the recurring photographs of the singer Patti Smith; to the self-portraits and portraits of celebrities; to the tiresome flowers and seminal nudes for which Mapplethorpe may be best known.

The exhibition ends with the "X, Y and Z Portfolios." The 1978 "X Portfolio" documents a lust for domination and submission that ends in sexual humiliation and mutilation. Even in the most objectionable image, Mapplethorpe sees clearly, suggesting that the fear of sexual amputation and the need for sexual power go hand in hand. There is nothing else in the show even remotely as extreme as the images here.

The 1978 "Y Portfolio" is only flowers, tenuous and sexual. In the 1981 "Z Portfolio," Mapplethorpe places on a pedestal the sexuality of black men. Each of the three portfolios has 13 photographs that measure a little more than a foot square. The portfolios were meant to be seen together.

They were not included in the Mapplethorpe retrospective last year at the Whitney Museum of American Art in New York City. They need to be here. Mapplethorpe fought against sexual secrets. He saw sexuality as the root of everything, and seems,

at least at one point, to have held the widespread assumption that it is only by realizing all sexual fantasies and liberating all sexual energy that full freedom and ecstasy are possible. In the "X Portfolio" the obsession with sexuality and death is pushed almost to the end.

Mapplethorpe is not a marginal figure. On television, desire is turned loose in a hundred different directions and there is hardly a product that is not sold by arousing a wish for sexual possession and power. American culture swings back and forth between domination and submission—rushing to put people on pedestals and then rushing just as hard to prove they are indeed no different and perhaps worse than you and I. Mapplethorpe found an edge that cuts deep, and it is not going to be blunted for a while.

---

*147* ✦  Rudolf Baranik, "Disinformation," created for *Disinformation: The Manufacture of Consent,* Gino Rodriguez, curator. Exhibition Catalogue (New York: The Alternative Museum, 1984).

Censorship imposed on citizens is only one form of repression of information and artistic expression; governments have also released to the population altered or fabricated information in order to propagandize for their projects. In the 1980s a new word appeared in the lexicon, "disinformation," although the tactic must date to the beginning of human history. "Disinformation" was a program of purposeful lies issued by governments to confuse people and divert the enemy.

When Gino Rodriguez organized *Disinformation: The Manufacture of Consent,* an exhibition held at the Alternative Museum in March, 1985, thirty-three artists submitted works. Noam Chomsky wrote the lead essay. Rodriguez founded The Alternative Museum in 1975 and has mounted major political shows. His motto (quoted in the *Disinformation* catalogue) is that "art is the by-product of a people's culture and that a people's culture was the by-product of a people's health, education and social well-being." In 1988, Rodriguez curated *Foreign Affairs: Conflicts in the Global Village,* including essays by Noam Chomsky and Edward W. Said.

Other New York galleries consistently exhibiting art critical of the status quo are Exit Art/The First World, directed by Papo Colo and Jeanette Ingberman, and The New Museum, directed by Marcia Tucker until her retirement in 1999 and then by Lisa Phillips.

One of the founders of Artists and Writers <u>Protest Against the War in Vietnam</u>, Rudolf Baranik was an influential presence in the New York political art scene from the mid-1960s until he moved to Santa Fe in 1997. His best known paintings were abstractions with elegiac evocations of war imagery, such as his *Nalpalm Elegies* series. His witty definitions were published in Jim Drobnick, ed., *Rudolf Baranik's Dictionary of the 24th Century,* 1990.

---

✦

---

DIS·IN·FOR·MA·TION n. (a) An intentional form of misinformation practiced by the Agency of Inter-Human Oppression known as *State* (archaic) until the withering away of same in the early part of the 23rd Century, as predicted in the 19th Century by

Marxists and strived for by anarchists of that time. Disinformation was also used extensively as a means to increase private material profits in the late stages of the *Capitalist* (obsolete) system during the 20th and early parts of the 21st Century, especially in the late North American Empire.

DIS·IN·FOR·MA·TION (b) The title of an exhibition held during the last decade of the 20th Century in the most populous city of the North American Empire in an institution described as the Alternative *Museum* (archaic). Remaining archaic documentation in microfilm and video show that the aim of the organizers of the event was to unmask the extent of disinformation, largely through satire and documentary exposure. Researchers have been unable to discover the connection between the intention of the event and the activities known at that time as art, though it is surmised that the elusive nature placed it within the realm.

---

***148*** ✦ Patricia Johnston, "War Stories: Narrative Reporting of the Gulf War," *Views: The Journal of Photography in New England,* 12, no. 3 (Summer 1991):5–9, 20.

In the winter of 1991, Operation Desert Storm, known as the Gulf War, raised many criticisms toward the media reporting the conflict. Patricia Johnston here focuses on the imagery that came out of the war. Like World Wars I and II, but unlike the Vietnam War, photographs and video clips released by the press and television were strictly controlled and primarily served U.S. propaganda purposes. Johnston's statement that "as many as 100,000 Iraquis may have been killed" comes from reporting by *The Boston Globe*. The actual statistics of casualities on both sides may never be known.

Johnston is a photographic historian who wrote *Real Fantasies: Edward Steichen's Advertising Photography,* 1997, which documents and interprets the power of visual imagery in the selling of both products and the American dream. Like many recent art historians, she has turned her attention to visual culture—not only analyzing the ways that visual images influence attitudes but also investigating the ideologies of the agencies and institutions (such as the media) that privilege some visual images over others.

---✦---

[. . .]

The coverage of the war [Operation Desert Storm] that the public saw was shaped by the process of its gathering and production—restricted access, censorship of copy and pictures, and editing at publications whose owners for the most part supported the government's actions in the Gulf. The result is a textbook example of how the mainstream media construct simple narratives to explain and interpret world events as they unfold: real life events gather heroic and fictive qualities as they bend to the demands of the straightforward, linear story.[. . .]

[. . .]Over time, media narratives of world events shape the way we understand and form opinions about them.

But the ways that the media work are complex. To say that public opinion is formed by the media alone is too simplistic. There was and is a substantial antiwar sentiment throughout the country, although it was little recognized nor reported in the establishment press. This anti-war sentiment did not disappear because it was ignored by the press, but one might argue that it did not prosper as it might have under other conditions. Descriptions in the media shaped public experience of the war itself, that is, the public perceptions of how it was conducted, not political attitudes towards it. However, this public perception of how the war was conducted—with constant reminders of its technological efficiency—may have lessened dissent.

In its depictions of dead and wounded, including civilian casualties, the imagery of the Gulf war built on the very earliest iconography and narrative structures for media coverage of war, despite significant technological advances over the past century in the recording capabilities of the camera, and certainly in weaponry. Thus it is clear that culture and historical context, more than even technology, shaped the visual experience of this latest military campaign. That the Gulf war in photographs looks more like the Civil War, the Spanish-American War, and the world wars than the two most recent large-scale U.S. military conflicts, Vietnam and Korea, is the result of overt military censorship combined with a complicit media self-censorship. The mainstream media's actions were based on an unwillingness to alienate either their military partners in news gathering or their corporate sponsors, in accord with their perceptions of the boundaries of public opinion.

* * *

Despite the vast difference in scale, World War I was remarkably similar to its much smaller Middle Eastern counterpart 75 years later. It was a trench war, highly censored, and characterized by the introduction of new technology—tanks, airplanes and poison gas were used by both sides. And again, the American press showed little of the realities of combat.

[. . .]

Susan Moeller, in her book *Shooting War: Photography and the American Experience of Combat* has argued that discretion in the representation of American dead lasted through the Korean War, but that the "team" relationship between the military and the press had started to break down. By the Vietnam War, media inquisitiveness and vastly fewer official restrictions led to more direcl and revealing imagery. Images of American dead from Vietnam have more drama and immediacy than images from the wars that preceded it, both because of the new close-up imagery of fighting and death, and a new photographic style that derived from the less formal "street documentary" of the 1960s.

Moeller argues that Vietnam combat scenes drew their horror not from images of weary but determined soldiers locked in combat, but from the new inclusion of civilians in the story of combat. In the most famous icons of the Vietnam War, in those photographs that were credited with turning the American public against the war, most of the imagery concerns the impact of the war on the Vietnamese people. TV, radio, and the print media depicted such cruelties of war as mothers carrying their dead children, an off-course napalm attack dropping burning gasoline on innocent children, and the cold-blooded murder of a prisoner of war by a South Vietnamese general. The Americans are offstage, the unseen and assumed perpetrators or collaborators of acts of violence.

Photography of the Persian Gulf conflict offers no such powerful indictments of war, no documentation of its horrors, no questions of its justice. Combat photographs emphasize routine, though still dangerous, tasks. We have been repeatedly told in the press that the American military "learned their lesson" in Vietnam. The military were determined to set the terms of the debate and to avoid such emotionally-charged representations as American dead, suffering civilians, unavoidable accidents, grotesque human wounds inflicted by their sanitized machinery, perceptions of incompetence or mismanagement, and the disclosure of potentially valuable tactical information. Public relations officers set strict limits on photographers' activities and the censors closely monitored the images transmitted from the Gulf region. Images of American dead in the Gulf war, like their World War I counterparts, have been limited to formal studio portraits taken before the fighting began. The small number of images of wounded Americans have followed the time-honored conventions of all American wars: wounded are always shown with a medic nearby.

\* \* \*

Because of the general restraint in the representation of the brutality of this war, and due to the almost complete lack of any graphic evidence of the suffering of citizens in Basra and Baghdad, the press was able to perpetuate the myth that no one was hurt in this war, although as many as 100,000 Iraqis may have been killed.

\* \* \*

Rules and practices governing recent war reporting—for American military actions in Grenada, Panama, and the Gulf—were the most restrictive since World War I. During the Gulf War, the military controlled the movements of reporters and photographers by assigning them to journalistic "pools"—an old World War II concept first introduced to save magazines and newspapers money on travel expenses for reporters. The use of pools for news control was refined after news blackouts accompanying the invasion of Grenada. During the latest war, pools were escorted and transported: what they saw and what they were able to write about was carefully monitored. Pentagon rules stated that reporters were not even permitted to interview enlisted men without public relations brass standing nearby.

Fewer than 1 in 7 of the correspondents who arrived in the Gulf were lucky enough or famous enough to be assigned to a pool. The rest were relegated to watching military briefings and CNN (Cable News Network) in a room in the Dhahran International Hotel. Only representatives from the major wire services, TV and radio networks, and a few magazines and newspapers managed to fanagle pool assignments. In theory, their discoveries became the property of all accredited news outlets covering the war. But in effect, as *New York Times* reporter and photographer Malcolm Browne has pointed out, the private news media became an extension of the Public Relations functions of the Department of Defense.

[. . .]

Throughout the Gulf war, censorship was no secret. Public debate centered around whether or not it protected specific missions and national security, or merely avoided scrutiny and potential embarrassments for the military. Yet the awareness of censorship—and the constant reminders by the media that the public was not witnessing the full story—was not aggressively protested by the media or the public. The surprise is that it was simply acknowledged, rarely with a vocal complaint, despite

continual reports of obstructed coverage, and despite the knowledge that death and destruction are just as real even when unseen and unphotographed. For the moment, we know what has been reported about the Gulf War, but we don't yet fully know what happened.

---

***149*** ✦ Bill Viola, "Statement 1992," in *Reasons for Knocking at an Empty House: Writings 1973–1994* (Cambridge, MA: The MIT Press,1995), pp. 211–12; originally a comment on art for television, and/or idea for a future TV art channel, for 3rd Video Television Festival at Spiral Hall, Tokyo, February, 1992. First published in *Japan 92*, eds. Haruo Fukuzumi and Keiko Tamaki (Tokyo: Video Gallery SCAN, 1992), pp. 152–53.

Bill Viola has worked with multimedia technologies since the early 1970s. His video installations have been shown in museums across the country and abroad, and in 1995 he represented the United States at the 46th Venice Biennale. Typically he installs his video projections in blackened rooms or long halls, and they are triggered by the movements of the spectator moving toward or away from the video image. The aesthetic experience of the viewer comes from the viewer's heightened awareness of space, of his or her own body and ability to participate actively with Viola's own creation.

In this comment Viola criticizes multimedia technologies, particularly commercial television, which appropriate ideas and imaginative imagery for the purposes of commerce or propaganda. To Viola, television's misuse of creativity and open dialogue subverts the ideals of a democratic society and art itself.

---◆---

I do not accept the category of "television art." Television is a means of transmitting ideas in the form of moving images and sounds. To say that it has a special case called "television art" is to accept the political consequences of commercial television's present hegemony (particularly in America) over the full spectrum of imagery representing the infinitely varied, rich, often chaotic, conflicting, and contrasting forms of consciousness that make up the full range of human experience on this planet. The American media writer Gene Youngblood has called television "perceptual imperialism," underscoring the fact that the medium is not only a political tool but a physiological one as well, and that its effects in conforming each individual's psychophysical makeup cannot be underestimated.

Art that conforms to established rules, specifically those rules that have been instituted outside of the practice of art, becomes a form of propaganda. Even if its "message" is subversive, its form will always be conformist, underlying form being the true residing place of power in any system of communication. Whoever controls the rules of the conversation controls the conversation. This is why people talk about the phenomenon of interesting innovative ideas or new image forms getting "swallowed up" or "co-opted" by the media powers-that-be. In political terms, propaganda is a form of obscenity in relation to the original idea of democracy, where contrasting

ideas were meant to be discussed openly and rationally and not coerced or deviously misrepresented, and where individual voices were meant to be heard and not modified or suppressed.

Television has always been fearful of unrestricted individual expression. Until the television system gives artists total open creative freedom and control over the form and content of their works, either by open acceptance of existing works or the commissioning of new works, there will be no "television art." Until artists who work with video become, through self-discipline, devoted practice, and selfless knowledge, deeply aware and compassionate human beings, there will be no "television art." The rules for the artist ultimately do not come from art history, or from current trends, ideas, and fashions, or even from the materials themselves. These are merely resources to draw on. The real rules come from the Self. The only method is Self-knowledge, and its only parameters are that of the Gift, of receiving and in turn passing it on. These rules are the same and only rules for the creation of a true "television art."

---

# The Construction of Knowledge: Museums, Art History, and Studio Practices

Against the backdrop of the Civil Rights movement, social unrest in the cities, and the escalating war in Vietnam, historians at colleges and universities began to direct their energies away from intellectual history and biographies of "great men" toward the social histories of everyday working people: "history from below." It was not subject matter alone that differed but also the approach. Whereas a previous generation of historians stressed the role of consensus in social and political life and could speak of "the American mind" with complete confidence, the 1960s generation approached history dialectically. The new history maintained that historical moments were the result of discordant ruptures, social struggles, and contradictions in the body politic. These "revisionist historians," moreover, believed that their own personal involvement with social issues was necessary for intellectual life, that theory needed practice. Hence, many went out to the streets to march against racism and the Vietnam War, for women's rights, and for affordable housing and other welfare benefits.

Brian O'Doherty, editor of *Art in America,* published a special museum number for the magazine's July–August 1971 issue. The contributors to the issue included academics and art critics, including Edward Fry, who lost his job at the Guggenheim because of the aborted Hans Haacke exhibition (see Reading 111). In his introduction, O'Doherty observed: "Museums, once permanent fixtures by which to negotiate our spiritual journeys, have suddenly revealed infirmities in their foundations that have threatened them with collapse. Like many institutions in the late sixties, they were abruptly thrust from their historical context into the vicissitudes of contemporary life, where the problems of the entire society—many of them irrelevant to art museums— were brought to bear on them. This exposure has provoked a self-examination that may prove profitable."

The examination of museums continued through the 1970s. As mentioned in Chapter 6, p. 288, members of Artists Meeting for Cultural Change, including Rudolf Baranik, Sarah Charlesworth, and Joseph Kosuth, as well as art historians Carol Duncan and Alan Wallach, formed a collective to write *An Anti-Catalog,* a document growing out of their protests against the Whitney Museum's John D. Rockefeller III exhibition shown in 1976. *An Anti-Catalog* criticized the show's catalogue (authored by Edgar Richardson, Rockefeller's personal consultant) for the selection of historic American art. On the cover of *An Anti-Catalog,* the writers explained: "Our effort is not intended simply as a critical exercise. Culture has the power to shape not only our view of the past but also the way we see ourselves today. Official culture can only diminish our ability to understand the world and to act upon that understanding. The critical examination of culture is thus a necessary step in gaining control over the meaning we give our lives."

Museums, however, were slow to go public with their own critical self-examinations of their display techniques and collecting practices and to address the issue of trustees' conflicts of interest. Susan Vogel was one of the first directors to take on such a self-examination. Trained in anthropology and art history, she mounted the *ART/artifact* exhibition for the Museum of African Art in 1988. The exhibition recreated different kinds of display settings for the African objects: a bare room with white walls and minimal wall labels that displayed the objects as "art"; a room with a videotape that explained that the artifact could only be comprehended in situ—in the field in Africa; a "curiosity" room as a private collection might have; and a "natural history" display that included plant and animal specimens. The visitor got the point: through display techniques museums influence the viewing experience and knowledge gained by the visitor.

Exploding into controversy was the *West as America* exhibition, on view at the National Museum of American Art in the spring and summer of 1991, right after the cease-fire of the Gulf War (see Reading 148). Political Washingtonians, conservative historians, and newspaper pundits saw the show as an attack on patriotic beliefs about the "winning of the West."

Performance artists have also offered critiques of museums. Artist Andrea Fraser, posing as a docent, produced gallery talk performances in 1989 at the Philadelphia Museum of Art and in 1991 at the Wadsworth Athenaeum, in which she made her audience aware that by controlling "the museum experience" she was producing culture. In her view, "The primary operation of art museums is the turning of bourgeois domestic culture and specialized artistic culture into public culture." These words were printed in the catalogue of the exhibition *The Museum as Muse: Artists Reflect,* organized for the Museum of Modern Art in the spring of 1999 by Kynaston McShine. *Museum as Muse* consisted of artworks that commented on museums, collecting, and display.

Art history and studio departments in colleges and universities have also subjected themselves to self-scrutiny. In the early 1970s Ann Sutherland Harris compiled statistics for the Women's Caucus for Art about inequities in hiring, promotion, and salaries between men and women in art departments; later Howardena Pindell did the same for people of color. The content of art history textbooks was also reappraised.

Much has changed in the almost thirty years since the dialogue began. Literary and cultural studies, the "new historicism" in history, and anthropological studies have all influenced the recent discussion about how we come to believe and interpret our experiences and knowledge.

*150* ✦ Alan Wallach, "Revisionism Has Transformed Art History but Not Museums," in *Exhibiting Contradiction: Essays on the Art Museum in the United States* (Amherst: University of Massachusetts Press, 1998).

Trained at Columbia University, art historian Alan Wallach is a pioneer in the field of critical museum studies. In this article he singles out exhibitions on nineteenth-century American art, but his insights are relevant to any exhibitions that choose to present either a "masterpiece" approach to paintings and objects or a contextual approach that weaves in social and cultural history.

The essay appeared in a slightly different version in *The Chronicle of Higher Education* (January 22, 1992), which throughout the late 1980s and 1990s diligently reported on the culture wars in academia.

---------------------------- ◆ ----------------------------

. . . [T]he Smithsonian Institution's National Museum of American Art became embroiled in a bitter controversy over "The West as America" when it attempted a revisionist interpretation of images of the frontier. The show became a national issue when Senator Ted Stevens of Alaska, after accusing exhibition organizers of promoting a leftist political agenda, threatened to curtail Smithsonian funding. Neoconservative columnists spewed invective, calling the exhibition "Marxist," "perverse," "simplistic," "destructive," and, predictably, "politically correct." Publicity surrounding the controversy implied that art historical revisionism was on the verge of taking over the museum world.

Unfortunately, this is hardly the case. Indeed, "The West as America" represented one of the very few attempts in recent years to mount an exhibition along revisionist lines. Despite the prestige revisionist art history now enjoys in colleges and universities, museums have for the most part done everything in their power to ignore it.

"Revisionist" or "new" art history grew out of the crises of the 1960s. Younger scholars—many of whom were taking part in the civil rights, antiwar, and women's liberation movements—criticized the discipline's narrow focus on problems of connoisseurship and artistic "influence." In a field that prided itself on upholding standards of "civilization," the "new" art history seemed rough-edged and argumentative. It engaged in confrontational politics, took issue with built-in assumptions and biases, and exposed pervasive sexism and elitism. It also called for increased attention to the theories underlying the practice of art history and for the recovery of the discipline's intellectual heritage—the focus on the historical and philosophical problems that had made the field central to the humanities in the early decades of the century.

I do not exaggerate when I say that "new" art history was responsible for the discipline's revitalization. Revisionist art historians insisted on discussion and debate in place of the usual numbing silence. Their probing and questioning opened the field to new areas of inquiry and to new theoretical perspectives. [. . .]

Thus revisionism has transformed academic art history; yet its impact on museum exhibitions remains slight.

In 1987 the Metropolitan Museum of Art put on a blockbuster exhibition, "American Paradise: The World of the Hudson River School Painters." The first large-scale retrospective since 1945 of Hudson River school landscapes, the exhibition brought together eighty-eight works, and featured rooms devoted to canvases by Thomas Cole, Frederic E. Church, and Asher B. Durand.

A few months later, the Hudson River Museum of Westchester (N.Y.)—an institution little known outside its immediate area and generally ignored by New York reviewers—staged its own Hudson River school exhibition, "The Catskills." Organized by Kenneth Myers, a young American studies professor at Middlebury College, "The Catskills" brought together more than 150 objects—landscape, genre and portrait paintings, prints, drawings, photographs, maps, postcards, books, china, railway timetables, hotel bills, and other artifacts relating to nineteenth-century Catskill tourism. [. . .]

"American Paradise" was all glossy spectacle. The spacious galleries, the brilliant lighting, the lush setting combined to produce an experience in which visitors were overwhelmed by the beauty and power of the paintings. Yet something was missing. By viewing Hudson River School landscapes as so many timeless masterpieces, viewers gained no sense of the paintings' history or historical role. Patronage, contemporary response to the works, the art market, tourism, religious beliefs, industrialization, Jacksonian politics, Manifest Destiny, slavery, the Civil War—all these topics were largely absent from, or rather absorbed by, the exhibition's pseudohistorical theme. Instead, the show promised visitors gleaming visions of a conflict-free American past—a "return to Paradise," in the words of the advertisement put out by Chrysler Corporation, the exhibition's sponsor.

"American Paradise" exemplified traditional art historical wisdom: Choose the best works, gather them together under a familiar if tendentious label ("Treasures," "Masterpieces," "Genius," "Paradise"), add wall texts with a smattering of background information, and, violà, success is pretty much assured. But what if you depart from formula? What if you seriously want to explore the relationship between art and its historical context? This was the problem the Hudson River Museum set for itself.

The exhibition was laid out in the museum's large central gallery. Paintings hung on temporary walls facing cases with books, prints, and other artifacts related to the paintings. Wall texts set forth basic premises. Visitors followed a roughly chronological path. At almost every step one encountered fascinating juxtapositions—for example, stereoscopic images of the Catskill Mountain House, a rendering of it on Staffordshire china, Frederic Church's painting of the view from the Mountain House, and so forth. There was nothing forced or self-consciously didactic about the installation. Nor did the presence of objects in different media—traditionally a curatorial taboo—detract from the enjoyment of individual artifacts.

Still, as you worked your way through the exhibition, you became increasingly aware of how the materials on display derived from, and also helped to constitute, a touristic culture. Seen in this light, landscapes by Cole, Church, Durand, and others began to make greater artistic and historical sense. No longer reified masterpieces, objects of a disembodied aesthetic contemplation, they connected with a range of

nineteenth-century cultural practices such as tourism, nature worship, and patriotic beliefs equating American nature with American identity.

"The Catskills" demonstrated one way in which museums can break out of the "masterpiece-treasure-genius-paradise" syndrome.

\* \* \*

Why don't larger national institutions like the Metropolitan, the Museum of Modern Art, and the National Gallery mount similar exhibitions? Why have they generally failed to take advantage of the large body of revisionist scholarship now available? Why are they so irrevocably attached to their formulaic blockbusters and treasure-house displays?

\* \* \*

I believe that the real reason for museums' reluctance to draw upon revisionist scholarship has to do with their deep-seated fear of controversy and critical thought. Museums like the National Gallery thrive on the notoriety that comes with cheap stunts such as the exhibition of Andrew Wyeth's prurient "Helga Pictures." Genuine controversy is something else entirely: it raises basic questions, involves people in issues, makes them care passionately about ideas. In a society in which culture is ultimately controlled by corporate elites, controversy is too dangerous—it cuts too close to the nerve.

I am aware, of course, that museums have always been deeply conservative institutions. Dependent upon corporations, government agencies, and wealthy donors, and presided over by well-heeled trustees usually more interested in prestige and the fate of their personal art collections than in the public good, they have every reason to avoid anything that would bring down the wrath of their financial backers.

This built-in conservatism has been reinforced in the last few years by the appearance of dour, neoconservative culture guardians who have taken upon themselves the task of insulating the public from radical or even mildly dissenting views. Their wild-eyed assault on "The West as America"—whatever the exhibition's flaws, its historical premise was hardly novel—will no doubt inspire even greater caution on the part of curators and museum directors.

Thus, prospects for revisionist exhibitions are not especially bright. Still, this should not be cause for despair: revisionism is here to stay. And this means its specter will continue to haunt museum corridors.

---

*151* ✦ Martha Buskirk, Interview with Fred Wilson, in "Interviews with Sherrie Levine, Louise Lawler, and Fred Wilson," *October* 70 (Fall 1994): 99–112.

Artist and curator Fred Wilson was invited to mount an exhibition at the Maryland Historical Society in 1992. He featured the Society's own collection of "high art" works from antebellum Maryland along with artifacts of slavery, such as iron collars. His wall labels for the exhibition, *Mining the Museum,* commented on the individual exhibits from a somewhat ironic, postmodern stance that sharpened the viewer's awareness of the acute divisions between the races. The exhibition had no catalogue—only handouts for school children—when on view from April 4, 1992, to February 2, 1993. Lisa Corrin, curator at

Baltimore's Contemporary Museum, the cosponsor of the show, responded to critical in-
terest and produced the book by Fred Wilson, *Mining the Museum: An Installation*, 1994.
Wilson later was invited to design installations for the Seattle Art Museum with objects
drawn from its collections.

The interview with Fred Wilson conducted by art historian and critic Martha Buskirk
on June 14, 1994, was part of a series of interviews conducted by *October* staff that
probed artists to discuss the influence of Marcel Duchamp on their own work. Wilson ac-
knowledges that as an artist-curator he has greater freedom to present controversial
ideas through his creative installations than would be the case for in-house curators, who
are often expected to be more circumspect in their criticisms of their own institutions.

◆

*Martha Buskirk:* The intersection of the work of art and the museum is an issue
of increasing importance for twentieth-century artists—both for Duchamp and
for contemporary work. You have focused very specifically on how the mu-
seum is assembled and how meaning is constructed in that context. I'm also in-
terested in the conjunction between being an artist and being a curator, and the
degree to which the two overlap.
*Fred Wilson:* I've been asked if my work came from various theoretical discus-
sions, but actually it didn't; it came from my experience in museums. Having
worked as both a curator and an artist, there is a big difference between the two.
With curating, the whole notion of irony is not involved, often for good rea-
son—because the public in the museum space often expects some form of uni-
versal truth or knowledge, a notion I hold suspect. The fact that I'm an artist in
an institution gives the viewer a certain leeway in how to respond to this work.
All my work is extremely personal. In curating, that is forced more to the back-
ground because of the emphasis on so-called objective scholarship which tends
to make the viewers passive in their experience of the exhibition. I'm always try-
ing to push the exhibitions farther than I would expect a museum curator to go.
*Buskirk:* Though of course some of what could be understood as personal vision
in *Mining the Museum* was really based on scholarship, on a close examination
of the details of the collection and its archive, which allowed you to come up
with identifications and other information that had not been found, or perhaps
sought, before.
*Wilson:* I have nothing against scholarship. It's important that, in my work, I'm
not making grandiose claims from nowhere. But I do like the audience to think
about scholarship in a more open way. In *Mining the Museum*, I'm not trying to
say that *this* is the history that you should be paying attention to. I'm just point-
ing out that, in an environment that supposedly has *the* history of Maryland, it's
possible that there's another history that's not being talked about. It would be
possible to do an exhibition about women's history, about Jewish history, about
immigrant history based on looking at things in the collection. I chose African
American and Native American information because that was impossible for
me to overlook. But it was never to say that this was *the* history you had to be
looking at. And certainly that exhibition was not about a straight black history.
If I'd wanted to, I could have borrowed things from other museums around

Maryland and around the country and made a more cohesive black history in the linear fashion, the way museums do. But that's not what I was trying to do.
*Buskirk:* There seems to be a foregone conclusion in your work that you are working from within the institutional space—that you are not trying to make a gesture that exists entirely in another space, but that you're working with histories that have to some degree already been constructed. Did that always seem self-evident to you as a direction?
*Wilson:* After *Mining the Museum* and the work in Seattle, it seemed to make the most sense. I'm really interested in surprise and how one reacts on an emotional and intuitive level before the intellectual self kicks in. That synapse seems to happen best when you feel that you understand the situation that you're involved in, and the museum setting is one where people feel that they know what to expect and how they're supposed to act. It's a way, once I have people disarmed, to get them to push past their comfort zone. Otherwise, if they walk into a space that's already an environment where they're on their guard, you can lose a lot.
*Buskirk:* What you've done in working with the rhetoric of already established spaces has been related by critics to Conceptual art. I was wondering how self-consciously you were positioning yourself in relation to Conceptual art of the 1960s and '70s, or to art of earlier periods.
*Wilson:* Being schooled in college in the mid-1970s, Conceptual art was in the dialogue of the art school, and I had an interest in it. But more recently I've seen a lot that I was not familiar with then. So I guess I could say that I was generally familiar with it, but not immersed in it.
*Buskirk:* Yet, whether or not you were referring explicitly to Conceptual art, one could say that Conceptual art created a space in which people could understand the issues that you have dealt with in your work.
*Wilson:* In being a curator for a number of years, I honed this particular craft. Certain people like Broodthaers were doing work based on the museum, but I wasn't aware of it until later, so I really came to this from my experience.

Even though I do consider myself a Conceptual artist, I also work totally from the visual—how the things relate to me, and how the environment that I'm in works with me. Every environment that I do is for me very much a visual relationship of objects, and how they are placed in the space.

<div align="center">* * *</div>

*Buskirk:* I am interested in this idea of taking the objects that are already in the fine art museum and recombining them to create a sense of surprise. There have been so many other moments already in the twentieth century when artists have attempted to raise questions or to create a sense of shock by bringing objects or images that would not normally be considered art into the space of the exhibition or gallery, and later the museum. On the other hand, you are trying to work with what is already in the museum.
*Wilson:* That's true. I am in many ways responding to the history of art and trying not to do what has been done before, which has a lot to do with notions of the exotic. If anything, I'm trying to expose that notion for what it is by showing things that are familiar and making people see them differently. What

can you bring into a museum now that wouldn't belong in a museum? There's basically nothing. So that whole approach is out the window. To me it's much more rigorous to look at the museum itself and to pull out relationships that are invisibly there and to make them visible. That, to me, is much more exciting.

---

*152* ✦   Mark Miller Graham, "The Future of Art History and the Undoing of the Survey," *Art Journal* 54, no. 3 (Fall 1995):30–34.

The Fall 1995 issue of *Art Journal* focused on the theme, "Rethinking the Introductory Art History Survey." The consensus among its contributors was to jettison the art history survey, as traditionally taught at colleges. Although the survey introduces students to the formal analysis of art works, it rarely stimulates students to think critically about what is behind our knowledge of art and history.

Mark Miller Graham teaches at Auburn University and has written about art in Central America before Columbus. Graham refers to the Renaissance art historian James Ackerman and quotes the latter's 1963 remarks on the "survey mentality" that organizes courses "almost invariably in terms of established epochal styles presented frequently in such rapid succession that time does not permit the instructor to represent his examples in any terms but the conventional."

Erwin Panofsky, back in the 1930s, had noted that American universities are "haunted by the spectre of completeness"; in art history departments that means generalized knowledge of all of art history with little in-depth understanding. The solutions are not easy: to teach a thematic or a media-based survey is often to lose sight of the connectedness art has to its historical moment. On the other hand, a history or humanities survey, when it even shows slides of art, often reduces the art to mere illustrations of social history. Graham here offers his own suggestions.

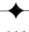

\* \* \*

Any discipline creates subjects in the course of its discourse, and in the case of the art history survey, subjects are created in part through the authoritarian nature of its texts that consistently represent culture as a Western-oriented march of progress with winners and losers, reducing the complexities of world history to the economic and political triumphs of the industrial democracies. Within the classroom, the locus of professorial authority and the monologic interpretation of art, students actively create their own subjectivity as they accommodate themselves to the hierarchical cultural order that is perpetually reproduced in the typical survey of art history. [. . .]

Thus, it is no surprise that the image of culture created by the art history survey is too often estranging and intimidating to the student. The survey is authoritarian in suppressing the political motivations and dimensions of art to the point that for many students their estrangement from art is understood as the natural order of things. [. . .] In the world of the survey text, art is always acclaimed; most survey texts belong to the genre of hagiography. Little wonder that we so often treat the canon of the art history

survey as a sacred thing: it appears before us as a given that preexists art history and not as the ideological sedimentation of the practices of art historians.

<center>* * *</center>

So, if we were to start over and to imagine new ways of introducing students to art history, here are some suggestions:

1. Stop using the present generation of survey textbooks. [. . .] There are short introductions to periods, traditions, and cultures of global art history written by specialists that can easily and more cheaply replace the single-volume survey texts. These books are not perfect, but their errors are those of specialists.

2. Stop fetishizing completeness. Our models here should probably be literature courses, not world-history courses and history in the narrow, linear sense. Avoiding the completeness issue also undermines and problematizes notions of canonical works and forces us to rethink basic models of artistic creation and influence.

3. Rethink the content of the introductory art history courses. The content of the surveys is chronology and narrative, "the story of art." But if we no longer feel bound to uphold the old narrative, we can eject the canon and thematize the content. Among the obvious themes that could be used to structure segments of a two- or three-course introduction are the art of early states, cities of the ancient world, art of the age of discovery, and individuality and tradition in the modern world. None of these themes is inherently Western (except for the age of discovery, where the inclusion of non-European civilization is implicit), and each is sufficiently broad to allow for a natural mainstreaming of the traditional Others of the survey.

4. Embody and engender the discipline of art history. The art history of the survey texts is a bodiless and genderless art history, one deprived of its own history: the names of those who made it. It is little wonder that our students have so little understanding of what the art historian does, since for them the art historian exists only as the generic representative behind the podium.

5. Teach the conflicts. Our students are seldom exposed to the actual debate and disagreement that constitute the scholarly process. Still less frequently are topics actually designed around a fundamental disagreement. [. . .]

## *A Last Look Around*

[. . .] If one judges the course from the texts available, the art history survey in American colleges and universities is evidently one or two generations behind the advanced sectors of the discipline. Stylistic analysis (description, really) remains the paradigm, and the discourse of choice remains a teleological narrative of celebration. Surveys are marked by an obsessive adherence to fossil notions like cultural period and cultural style. [. . .]

Eventually, we will have to decide whether the art history survey and its texts do not all belong to a waning paradigm of art history. The art history survey is at an impasse and may perhaps have reached the end of its own history. The paradigm is waning. I, for one, say, let it wane.

*153* ✦  Amalia Mesa-Bains, "Teaching Students the Way They Learn,"
in *Contemporary Art and Multicultural Education,* Susan Cahan and Zoya
Kocur (New York: The New Museum of Contemporary Art, 1996), pp. 31–38.

Artist Amalia Mesa-Bains was born in California to Mexican parents. She participated
in the Chicano art movement of the 1960s and 1970s, and for some 20 years taught Eng-
lish as a Second Language (ESL) and multicultural education in the San Francisco public
schools. She has written general essays on art and culture and curricula guides. She ed-
ited *Diversity in the Classroom: A Casebook for Teachers and Teacher Education.* Her most
published artwork is *An Ofrenda for Dolores del Rio,* 1984/1990, a mixed-media altar in-
stallation that celebrates the Mexican actress Dolores del Rio. She currently teaches at
California State University, Monterey campus.

　　*Contemporary Art and Multicultural Education* was a book project undertaken by the
Department of Education at The New Museum of Contemporary Art and consists of two
parts. First, general essays address innovative education and are followed by a portfolio
of reproductions of artists' work and artists' statements; and second, 43 lesson plans for
"connected learning" are printed in a workbook format with lists of suggested slides.
These lesson plans outline projects to encourage students to combine artmaking with a
greater awareness of social and cultural issues and are as appropriate for college-level
classes as for high school.

────────────────◆────────────────

The current debate on multiculturalism in America's public schools runs the gamut
from issues of culturally inclusive textbooks to Afrocentric curriculum. Whatever the
model, there is no doubt that there is a cultural classroom revolution taking place. The
greatest wave of immigration since the turn of the century, accompanied by escalat-
ing birth rate, has brought a diversity of language, culture, race, and class never be-
fore seen in this country. The school has become the front line in this demographic rev-
olution. Consequently, we as teachers have to be even more flexible and ready to
innovate in response to changing student needs.

\* \* \*

### Instruction and Connected Learning

When we begin to examine how learning takes place in our classrooms, we often re-
alize how much our instructional practices rest on our routine interactions with stu-
dents. It is often in this personal interaction that we create receptivity or resistance in
our students. At the same time, we struggle as teachers with an increasingly complex
system of expectations with textbook adoption cycles, state subject area frameworks,
and the new demands of diversity and inclusiveness in the resource materials that we
use. We must begin to look at how even our basic means of teaching—lesson plan-
ning, presenting information, and involving students in learning—can be changed to
reach all of our learners.

\* \* \*

## Culture and the Curriculum

As we look at the ways in which communication and culture affect learning we also have to consider the social and historical realities of different cultural groups. Our struggle to bring together our teaching and learning to respond to specific cultural groups and their ways of learning means we have to begin to understand the experiences and histories of these cultural groups.

\* \* \*

## Multiple Aesthetics

Changing the arts curriculum is easier with the active participation of artists whose experiences are intercultural. The acute lack of teachers of color to serve as symbols of potential for young students makes the role of artists of color even more critical; their very presence serves as a model of intercultural value. As art practitioners these artists bring a living cultural aesthetic to the classroom.

The debates over artist as teacher often fail to recognize that in many non-Western traditions, artists are scholars and community models. Artists of all backgrounds have long been advocates, activists, and scholars in cultural advocacy movemefts, ethnic studies programs, and community cultural centers, and have worked to make systemic changes in schools and community institutions. In this sense, these artists serve as the connectors from community to school to arts institutions. Artists also function as connectors with the international arts communities in the countries of origin for many of our immigrant students. Many have had long careers in cross-cultural art networks both in the U.S. and as part of larger global communities of Latin America, Africa, and the Pacific Rim. The artists' statements in this book attest to the social responsibility of artists. Art that has come out of the struggle for better living conditions is art that speaks of history, human condition, and hopefulness. Its form and content reflects a multiplicity of aesthetics that can be woven through an integrated curriculum.

\* \* \*

When we begin with an art education application that is based on multiple aesthetics we simply give ourselves more opportunities to teach and more opportunities for our students to learn. Diversity is an unfolding reality. We are only now becoming comfortable with diversity. The resources we bring to bear and the craft we apply as teachers will make this "becoming" an opportunity, not a problem. The classroom is our cosmos and we are learning a new cosmology that will help us establish what the philosophy of this universe entails. New phenomena, new elements of understanding are before us and all learning in this new universe is possible.

# Art in Public Spaces

The term "public art" expanded considerably over the twentieth century. In the nineteenth century, art in spaces to which the public had free access might either be the permanent statues of military generals, statesmen, famous entrepreneur/inventors, or

allegorical women placed in cemeteries, parks, plazas, and at the entrances to buildings. In general, such sculptures took as their subject extraordinary men, heroes of science and nation, which younger people should aspire to be, or else female figures personifying virtues, such as patriotism and labor solidarity, or memorializing the wounded and dead of a war. Public art could also be temporary spectacles such as parades and pageants—the orchestration of hundreds of costumed people, often choreographed with brass bands and accompanied by firework displays—or temporary structures such as the Dewey Arch of 1899. These usually commemorated a single event: a military victory, an inaugeration of a statesman, or an anniversary.

In the early years of the twentieth century, more inclusively democratic political attitudes generated a populist art in which ordinary citizens were valorized. The focus shifted from the celebration of a singular hero to the ordinary soldier or worker. For example, Douglas Tilden did *The Mechanics Fountain*, 1901, installed on lower Market Street in San Francisco, that represented highly skilled mechanics performing an operation on a gigantic press. Tilden's sculptural group was commissioned by city government. Ten years later it was workers themselves who organized the Paterson Pageant of 1913 to celebrate the silk industry workers' strike for higher wages in New Jersey.

During the 1930s, the production of murals and sculpture for public buildings and public spaces (see Readings 53 and 55) was encouraged by the U.S. government, through the Federal Art Project of the Works Progress Administration and Treasury Section projects. In these murals, ordinary workers or farmers were the rule, not the exception.

Since World War II many municipal governments, nonprofit institutions, and private corporations have set aside up to 1 percent of building costs to commission art to adorn buildings and their surrounding spaces. Abstract and nonfigurative art seems to dominate such commissions. The abstract artist Alexander Calder was among the most popular artists producing freestanding pieces for buildings and arts centers. Sculptors Isamu Noguchi, Patricia Johanson, Athena Tacha and others have been commissioned to sculpt the land by designing parks, public gardens, playgrounds, and installations of cascading water. These designs enhance the visitors' aesthetic engagement with the urban environment. In the early 1980s the most influential and high-profile, though controversial, landscape/monument design that used stone and the earth was Maya Lin's Vietnam Veterans Memorial on the Mall in Washington, DC. The most controversial free-standing sculpture was Richard Serra's *Tilted Arc* done for Federal Plaza in New York City.

When the National Endowment for the Arts was created in the 1960s, as well as the various councils for the arts in the individual states, artists were encouraged through grants to make art that would serve taxpayers. (See Reading 118 for a discussion of Faith Ringgold's mural for the Women's House of Detention on Rikers' Island in New York City.) Public art projects were also sponsored by municipalities. In Cambridge, Massachusetts, "Arts on the Line" provided city funds to hire regional artists, such as Mags Harries, Susan Thompson, and William Wainwright, and outside artists, such as Sam Gilliam and Joyce Kozloff, to bring art to the transit system.

Local communities also supported artists who organized teams of youngsters to bring mural art to empty walls. Eva Cockcroft in lower New York and Judith Baca in Los Angeles spearheaded the mural movement in their respective cities. David Fichter in Cambridge, Massachusetts, with the aid of neighborhood youth, has done murals that present images of a working-class multiracial community. Frequently outside artists are invited

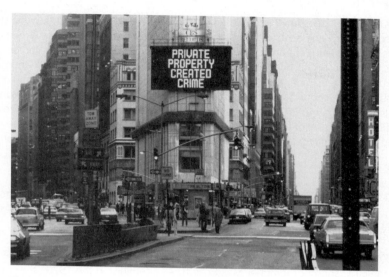

**Figure 7-12.** Jenny Holzer, *Selections from "Truisms",* 1982. Spectacolor board, Times Square, NY. Sponsored by the Public Art Fund. Photograph courtesy the artist. © Jenny Holzer. When this photograph was taken the text on the spectacolor computer light billboard read "Private Property Created Crime."

in, such as the Texas artist John Biggers, who was called to Minneapolis to organize a mural program in the African American community.

With or without outside funding, artists working singly or in groups have rented space on commercial billboards. With the sponsorship of Greenpeace, John Craig Freeman displayed *Operation Greenrun II,* a series of digital mosaic laser prints erected on eleven billboards along Highway 93, near the Rocky Flats nuclear facility in Colorado, from November 1990 to April 1991 (reproduced in Lucy R. Lippard, *The Lure of the Local,* 1997). Edgar Heap of Birds rented space within San Jose buses where he placed placards that contained his word-art in 1990 (see Reading 137). In the early 1980s Jenny Holzer rented the space at the edge of a Times Square building to display on a spectacolor board her "truisms," such as "Abuse of Power Comes as No Surprise" and "Private Property Created Crime" [see Fig. 7-12].

Groups of artists, such as Gran Fury and the Guerrilla Girls, have used the tactics of theater companies advertising performances and radical groups announcing demonstrations. They have pasted up posters on sides of city buildings and construction fences where their targeted audiences would be likely to see them [see Figs. 7-17, 7-18, 7-19].

Performance works are increasingly being staged in outdoor public spaces. Throughout the 1980s and 1990s Suzanne Lacy created public performances that orchestrated the media, institutions, and large groups of people to focus on social issues (see Reading 160).

Ordinary citizens have also made their own public art by affixing flowers, stuffed animals, clothing, and scribbled messages onto fences and walls at public memorials, such as the Vietnam Veterans Memorial in Washington, DC, or sites of tragic disasters, such as the "Memorial Fence" enclosing the site of the Federal Building in Oklahoma City where 168 women, men, and children lost their lives in the April 1995 bombing and Columbine High School in Colorado where 13 people were killed by two students in April 1999. Impromtu memorials along highways locate places where loved ones lost their lives in traffic accidents. With mixed reactions, government agencies have confronted or acquiesed to the demands of communities for more public and participatory memorials.

*154* ✦ Hayden Herrera, "A Conversation with the Artist," in Patricia A. Johnston, *Joyce Kozloff: Visionary Ornament* (Boston: Boston University Art Gallery, 1986).

Joyce Kozloff received an MFA degree at Columbia University, where she met her husband, the critic and photographer Max Kozloff. As a feminist in the 1970s she was part of the *Heresies* collective and became well known in the pattern and decoration movement. In 1977 she began to do installations of her tiles and was soon commissioned by municipalities and transit companies across the country to design walls in the public spaces of airports and train stations.

Hayden Herrera writes on artists, including Frida Kahlo, Mary Frank, and Henri Matisse. This interview took place at P.S. 1 in Long Island City, where Kozloff's tiles were installed prior to their permanent placement as an 80-foot mural along an underground passageway in the Harvard Square Transit Station in Cambridge, Massachusetts [Fig 7.13].

✦

*H.H.:* In 1977 you gave up painting and began to concentrate on architectural installations. How did you make this decision?

*J.K.:* I didn't give up painting. I'm painting on tiles instead of canvas. I wanted to break down the hierarchy between high and low art. I'm a very didactic artist: either I had to stop saying I wanted to destroy this distinction, or I had to stop painting on canvas. In the same way, if I was doing public art, I had to think through all the implications of the word "public" as well as the word "art." Now I'm more relaxed about the issue of high/low art. I don't feel polemical like I did ten years ago.

*H.H.:* How did you get involved with public art?

*J.K.:* It was just by accident. I received a form to submit slides for the Cambridge Arts on the Line program, and I sent slides and forgot about it. About six months later I was asked to submit a proposal for Harvard Square. Then I got interested and put a lot of work into it, but I didn't make a decision like "Now I want to do public art." I was asked to do several other proposals for public projects, and I got farther and farther away from studio art.

The public pieces satisfied me on two levels. One was the ambitious artist: grand scale decoration had been a historical model for me, but it wasn't being done today. I could compete with my influences. There was also a political level.

**Figure 7-13.**   Joyce Kozloff, *New England Decorative Arts: Harvard Square Subway Station Mural,* pedestrian ramp, Cambridge, Massachusetts, 1979–85. Hand-painted glazed tiles, 8 × 83 ft. Commissioned by the Massachusetts Bay Transportation Authority through the Arts on the Line program of the Cambridge Arts Council. Photograph courtesy the artist, © Cymie Payne, 1985.

Like many artists, I have trouble with the notion of art as an elitist commodity item. Most of the time you don't talk about that. There's nothing you can do about it, and it's too depressing to think about. But the public projects provided a way of doing something that I didn't have to apologize to myself for.

H.H.: What are you trying to do in your public projects?

J.K.: I feel differently about public art than I do about private work. It's important to communicate, so I want the subject matter to be recognizable to the average viewer. It's an attempt to have a dialogue with the audience, to involve them.

\* \* \*

H.H.: What kind of context are you trying to get across?

*J.K.:* I make cultural portraits of the cities in which the pieces are situated. The Buffalo subway station is about Buffalo. It's a combination of decorative forms taken from Seneca Indian jewelry, from Art Deco buildings in the city, and from local Louis Sullivan and Frank Lloyd Wright landmarks. They are all mixed in a quirky Kozloffian way. Exploring the sources is a big part of the experience for me. Sometimes I find them easily. The Wilmington, Delaware, train station is a 1908 Frank Furness building. I love his work, and the motifs just fell into place. In the San Francisco Airport, the subject matter—Bay Area Victorian, Bay Area Deco, Bay Area Funk—was something I just knew I wanted to do. In Boston, I had to seek my subject matter out. I worked on it as I went along, passage by passage. Unlike the other three projects, this piece is more of a mural than an architectural decoration. It tells a story, but in a different language from traditional historical narrative. It's about Boston's history and culture, New England crafts, the relationship of city to country. I am very particular about my sources, because the work can only be as good as they are.

\* \* \*

*H.H.:* Ideally, what do you want the public's response to be [to the Harvard Square mural]?

*J.K.:* A lot of people are going to pass through these stations twice a day every day of their lives. I didn't want to bore them. I didn't want the commuters to say, "Oh, that again!" I wanted to give them as much incident and variation as possible, and maybe one day they'll see something they hadn't seen before, and another day they'd see something else. It seemed to me that if the piece was the same all the way through, they would never see it after the first encounter.

*H.H.:* Your paintings have tended to have a great density of detail.

\* \* \*

*H.H.:* Are there some artists making public art with whom you feel a kinship?

*J.K.:* I find myself more interested in people whose work takes into consideration its environment and that communicates something to the audience who sees it: those artists who think about context and content. I see the *trompe l'oeil* walls of Richard Haas as one example: very often they re-create a beautiful landmark building that was destroyed to make way for a newer, more anonymous structure. Another example is Maya Lin's Vietnam Veterans Memorial in Washington, D.C. I like the way it fits into the land and how you approach it and read it. Its simplicity makes such a powerful statement. It's an untraditional notion of a monument, and it tells the story of the war.

\* \* \*

*H.H.:* When you make public art, are you trying to strengthen people's sense of belonging within a particular culture?

*J.K.:* I am concerned about how my work is going to be read. In each of these projects there were certain things I started to examine, for instance, in Buffalo, the differences between the Seneca Indians as an historic fact, the original inhabitants of the area, and the Seneca Indians who are a vital part of today's community. Originally, I was thinking about their artistic legacy. Then I went to their reservation and community center and saw that their present reality was not the

same as my romantic notion about their past. I had to rethink what I was doing. These political issues are important to me. I don't want to be so naive that my work can be misread and upset a group of people.

*H.H.:* Does the nonhierarchical structure of your public works and your pattern paintings have any political content?

*J.K.:* Pattern painting was a reaction against the pieties of modernist thinking, and I saw the politics of art as connected with larger political issues. Also, non-hierarchical patterns make you think automatically of other cultures. There's an underlying Western way of thinking and putting elements together, and an overlay of non-Western ideas and materials in my work.

\* \* \*

*H.H.:* Do you see any other political attitudes in your work?

*J.K.:* Using motifs from local cultural history and from the decorative arts doesn't have to be intimidating or only for the super-educated. It's conversational. You can understand it and participate. For example, some of the construction workers who installed the San Francisco piece recognized a lot of motifs in the funk section. They laughed, and they brought their friends over and discussed it with them. Then they became more open to looking at the less accessible sections.

---

*155* ✦ Elizabeth Hess, "An Interview with Maya Lin (1983)," in "Vietnam: Memorials of Misfortune, Part I: 1983," in *Unwinding the Vietnam War: From War into Peace*, ed. Reese Williams for Washington Project for the Arts (Seattle: Real Comet Press, 1987). A version was printed in *Art in America* 71, no. 4 (April 1983).

As an architectural student at Yale, Maya Lin submitted a design to the competition for the Vietnam Veterans Memorial, planned for the Mall in Washington, DC, between the Washington and Lincoln Memorials. Over 1400 entries were submitted in a blind competition to the Vietnam Veterans Memorial Fund jury (seven architects and one writer), a jury approved by the American Institute of Architects, the Fine Arts Commission, and the Department of the Interior. When they chose Lin they did not know she was young, female, and Chinese American. Her winning design met the criteria for a monument that should harmonize with the landscape and contain the names of the 57,692 Americans killed in the Vietnam war. Lin's statement accompanied her submission: "Brought to a sharp awareness of such a loss, it is up to each individual to resolve or come to terms with this loss. For death is in the end a personal and private matter and the area contained within this memorial is a quiet place, meant for personal reflection and private reckoning."

The memorial as designed and built was a V-shaped wedge of two 246-foot-long walls of black granite that abutted one side of a ramp gradually sinking into the earth from the Mall's lawn and coming out again at a 125 degree angle. The memorialized names were carved into the black granite. The Memorial was dedicated on November 13, 1982.

Many did not like the abstract quality of the design; veterans' groups protested that heroes were not represented in a naturalist style. In spite of appeals to protect the integrity of Lin's design, a compromise was reached with Veterans' groups. Sculptor Frederick Hart received the commission to create a naturalist bronze sculptural group, *Three Fightingmen*, consisting of one white, one black, and one purposely racially ambiguous soldier, which was dedicated in November 1984. Because Hart represented only men, the Vietnam Women's Memorial Project protested. They commissioned Glenna Goodacre to create another bronze group to celebrate the women of the war. Goodacre's *Vietnam Women's Memorial* included three women nurses attending a wounded male soldier, who is spread out across a pile of sandbags. This monument was dedicated in 1993.

Hess's interview with Lin is published along with an interview with Frederick Hart within the essay "Vietnam: Memorials of Misfortune, Part I: 1983." Part II was written in 1987 and provides a follow-up on some of the issues.

In Hart's interview, he defended his own work and criticized Lin: "I don't like blank canvases. Lin's memorial is intentionally not meaningful. It doesn't relate to ordinary people and I don't like art that is contemptuous of life. . . . Maya Lin's design is elitist and mine is populist. People say you can bring what you want to Lin's memorial. But I call that brown bag aesthetics. I mean, you better bring something, because there ain't nothing being served." Hart was, however, off the mark. Thousands have visited Lin's Memorial, have made rubbings of the names, have left flowers, and have taken away an emotional experience in part generated by the stark simplicity and quiet power of Lin's Memorial.

Elizabeth Hess is a journalist and author who covered art during the 1980s and 1990s for the *Village Voice*. She also wrote on art for the *Washington Post*, the *New York Observer, Art in America, Art News,* and *Artforum*. She was a founding editor of *Heresies*: *A Feminist Journal on Art and Politics,* and *Seven Days* magazine.

*Certain people are outraged by your memorial. They read it as a statement against the Vietnam War.*

The worst thing in the world would have been indifference to my piece. The monument may lack an American flag, but you're surrounded by America, by the Washington Monument and the Lincoln Memorial. I don't design pure objects like those. I work with the landscape, and I hope that the object and the land are equal players.

*Is your piece political?*

The piece itself is apolitical in the sense that it doesn't comment directly on the war—only on the men that died. For some people—especially right-wing politicians—that's political enough. It's like the emperor's new clothes: what people see, or don't see, is their own projection.

*Were you involved in the antiwar movement?*

No. But I think any war is pretty sad. People killing each other because they can't resolve their differences. I don't make judgments about the Vietnam War though, because I don't know enough about it.

*Why do you think veterans like Tom Carhart dislike your memorial?*

I haven't gotten one negative letter from a veteran. Most of them are not as conservative as Carhart. It's the administration that would like to remember Vietnam the same way it remembers other wars—through the heroes. Well, one of the things that made this war different is the fact that the veterans got screwed. They came back and their country called them "murderers." Nothing can make up for that. You can't pretend that this war was the same as others.

*What do you think about the decision to add Hart's piece?*

It was a coup. It was a power play. It had nothing to do with how many veterans liked or disliked my piece. Ross Perot has powerful friends who managed to get a compromise through. Even Jan Scruggs said, "We've been ambushed." The vice-president of the Fund called what happened a "rape" of my decision. I didn't even find out that they had made a "few modifications" until I saw it announced on TV! Perot flew in fifty people who hated the design from all over the country and they spread rumors in the White House that the designer was a leftist, that the jurors were all communists, and people believed it.

*How has the memorial fund treated you?*

The fund has always seen me as female—as a child. I went in there when I first won and their attitude was—okay, you did a good job, but now we're going to hire some big boys—boys—to take care of it. I said no! I wanted to help put together a team that knew about landscape, granite. Their basic attitude was I gave them the design and they could do what they wanted with it. They expected me to take the money [$20,000] and run.

*How has the fund treated the veterans?*

The fund has really gone show biz and it's upsetting a lot of vets. My attitude is that you shouldn't spend tons of money on the memorial—7 million has been spent so far. The money should be given to the vets who need it—like Agent Orange victims—because it's obvious that the government isn't going to help them out.

*You haven't sat down with Hart to work something out?*

No. But from what I gather, Hart thought a long time before accepting the commission. It wasn't necessarily going to be good for his reputation, but the price was right. They seem to be paying him twenty times what they paid me. He goes on and on about working with my piece rather than against it. But you can't really work with a piece if you don't have a dialogue with it. He claims that my memorial is "rude in its neglect of the human element." How can someone like that work with my design?

*What do you think of Hart's sculpture?*

Three men standing there before the world—it's trite. It's a generalization, a simplification. Hart gives you an image—he's illustrating a book.

*But do you think the veterans will have an easier time relating to Hart's work?*

No! I don't think the veterans are as unintelligent as some people would like to judge them.

*Why did you choose black for the color of the stone?*

Classical Greek temples were never white. They were highly colored. At some point much later, someone decided that white signified classical architecture. Black for me is a lot more peaceful and gentle than white. White marble may be very

beautiful, but you can't read anything on it. I wanted something that would be soft on the eyes, and turn into a mirror if you polished it. The point is to see yourself reflected in the names. Also the mirror image doubles and triples the space. I thought black was a beautiful color and appropriate for the design.

*Has this situation radicalized you in any way?*

There were certain things I was aware of intellectually that I had never seen before. In the academic world where I grew up, my femaleness, the fact that I was Oriental, was never important. You didn't see prejudice. People treated you first as a human being. When I first came to Washington my biggest shock was that no one would listen to me because I had no power—no masculinity.

*Do you think the memorial has a female sensibility?*

In a world of phallic memorials that move upwards, it certainly does. I didn't set out to conquer the earth, or overpower it, the way Western man usually does. I don't think I've made a passive piece, but neither is it a memorial to the idea of war.

---

*156* ✦ Alan Wallach, Manuscript, dated April 6, 1985; printed as "Editorial: Which Way the Tilted Arc?," in *Art and Artists* 14, no. 3 (May/June 1985):2.

Richard Serra's *Tilted Arc,* installed in the plaza in front of the Federal building at Foley Square in New York City in 1981, hit the news in February 1985. Originally commissioned by the Art-in-Architecture program, for which the General Services Administration allocated one-half percent of building costs to art, the sculpture had long simmered as a controversial issue. A panel of three art experts, well respected in the contemporary art world, had selected Serra and the project had gone ahead. But within two months of its installation in Federal Plaza about 1300 government employees who worked in the area had signed a petition protesting it. Apparently, the decision-making process to install the 12-foot high by 120-foot long continuous curving piece of Cor-Ten steel had not included employees who daily were confronted by the sculpture.

As reported by Grace Glueck, writing "What Part Should the Public Play in Choosing Public Art?" for the *New York Times* on February 3, 1985, one of the chief protestors was Judge Edward D. Re, who had an office facing *Tilted Arc.* Judge Re wrote: "Even if we were to assume for the sake of argument that this 'piece' once had some semblance of artistic 'shock' value, this minimal value has long since dissipated, and we who work here are left with a once beautiful plaza rendered useless by an ugly, rusted, steel wall." The result of the protests was a hearing called by the General Services Administration to debate removing the sculpture. Serra countered by maintaining that to remove the work was to destroy it, since the piece had been designed specifically for Federal Plaza. Glueck commented: "To this viewer, who admires Mr. Serra as a sculptor, 'Tilted Arc' is still one of the ugliest pieces of public art in the city, a domineering work that bullies, rather than enhances, the open plaza—itself blighted by a large, nonworking fountain bowl. But then, the Federal Plaza complex, designed in the 60's, is surely one of the city's least distinguished works of architecture, and no one has made

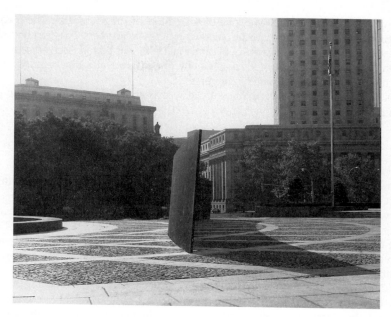

**Figure 7-14.** Richard Serra, *Titled Arc,* 1981. Weatherproof steel, 12 ft × 120 ft × 2 1/2 in. Installed Federal Plaza, NY, collection General Services Administration, Washington, DC. Destroyed 1989. Photograph courtesy the artist. © Glenn Stiegelman, Inc. Photography.

a move to relocate *it.*" To Glueck one of the main issues coming to the forefront in the mid-1980s was the demand to be included in decision making by a public long ignored by developers and government officials.

The controversy to remove the sculpture dragged on for years. A committee was appointed by the National Endowment for the Arts in 1986 to advise the G.S.A., the owner of *Tilted Arc,* of other possible sites. In 1987 Clemson University and Long Island University expressed interest; however, Serra opposed the plan and argued that *Tilted Arc* was site-specific to Federal Plaza in Manhattan (see "'Tilted Arc' Gains Adherents," *New York Times,* December 16, 1987). Serra's position was that the G.S.A. should honor the terms of its acquisition of the sculpture and protect the sculpture from damages. After pursuing several legal avenues, Serra gave up his fight, and *Tilted Arc* was dismantled on March 15, 1989 (see "Artist Abandons Fight to Bar Uprooting of Plaza Sculpture," *New York Times,* March 16, 1989), and the plaza was restored to open space.

In *Art in America* (May 1989), Serra wrote defending the sculpture, maintaining that its removal was an act of government censorship: "The governmental decree to destroy *Tilted Arc* is the direct outcome of a cynical Republican cultural policy that only supports art as a commodity. Relocation would, in fact, transform *Tilted Arc* into an exchange commodity in that it would annihilate the site-specific aspects of the work. *Tilted Arc* would become exactly what it was intended not to be: a mobile, marketable product."

In April 1985 Alan Wallach was one of the editors of *Art and Artists*. The magazine succeeded *Artworkers News,* which folded when the Art Workers Coalition became inactive. *Art and Artists* itself ceased publication in 1989. This editorial served as an introduction to a Supplement devoted to a "variety of opinions" at a time—spring 1985—when the issue was hotly debated in the press.

This reading about the *Tilted Arc* controversy is as appropriate to discuss with issues of censorship as with issues of public art.

◆

Richard Serra's Tilted Arc was commissioned at a time when government funding for the arts was still on the rise and those responsible for public sculpture believed that society could take modernist work pretty much in its stride. Today, with government support for the arts on the wane, Serra's work is being called into question. The attempt now being made to have the Tilted Arc removed from Federal Plaza—an act which the sculptor claims would be equivalent to destroying the work—raises a host of interrelated questions.

Opponents of the Tilted Arc see the piece as an impediment blocking direct access to the Jacob K. Javits Federal Office Building. They complain that they were never consulted about the commission and that the public played no role in the decision-making process, which was entirely in the hands of government bureaucrats and an elite group of art world consultants.

These complaints should be taken seriously. In our society the public is rarely asked what it wants or needs. Indeed, it possesses no real mechanisms for formulating its needs. The resentment against Serra's Tilted Arc derives from accumulated experiences of political helplessness, of things always being imposed from above. For those members of the public who daily experience the Tilted Arc as a gratuitous addition to the New York City obstacle race, the work emblematizes their powerlessness in the face of government authority.

As a work of art, Serra's minimalist piece lends itself to such interpretations. It is as if the government had demanded a work that would symbolize an immense, despotic force. Vast, impersonal, unyielding, a steel wall set up directly in the path of those trying to enter or exit the building, the Tilted Arc seems the very embodiment of all that is hateful about the government's power over our lives.

It probably wasn't intended that way. Still, the realm of public art is often the place where power relations, unacknowledged elsewhere, get their due. By commissioning public works, governments seek to legitimatize their authority and the particular form it takes, making it seem a natural part of everyday life. They do this by habit, by instinct, not always by conscious design. A hundred years from now, historians looking back at the controversy over Serra's piece probably would give little weight to current descriptions of the Tilted Arc as yet another example of minimalism. Nor would they be impressed by the claim that attempts to remove the work constitute "censorship." Instead they would consider the obvious issues: the role of public art in our society, the mechanisms of government patronage, the government's ideological needs and the nature of its power. Very likely they would arrive at conclusions very similar to those already arrived at by a resentful public.

The public's opposition to the Tilted Arc has engendered a good deal of outrage in the art world. Despite widespread indifference to Serra's actual work, many artists, critics, dealers and curators have vehemently protested the attempt to have the Tilted Arc removed. With reason, they see in the controversy a threat to their livelihoods, and they fear that the Serra case will provide the Reagan administration with yet another excuse to cut back government funding for the arts and another justification for official hostility to modernism.

In the U.S. modernism à la MOMA has long been identified with "enlightened" authority: the Rockefeller wing of liberal capitalism. In a world of few real choices, many members of the art world feel that the paternalism traditionally practiced by the Rockefellers and the Eastern Establishment is preferrable to the present administration's policy of massive cutbacks in the public sector. The art world also has esthetic reasons for opposing the administration. With its cultural witch hunting and its efforts to resurrect outmoded ideals of Western Civilization, Reagan and Co. stand for a return to the Academy, in this case a debased, pseudo-popular Academy in which the old academic deities would be replaced by the likes of Norman Rockwell and Walt Disney.

On one level, the controversy over the Tilted Arc represents a battle between two factions within the government. On another, it pits the practical, everyday needs of the public against the long-term interests of the New York art world. The controversy admits no satisfactory outcome, save perhaps for the victorious government faction. As for the rest of us: in a world in which every alternative is fraught with contradiction, it's probably impossible for either artists or the public to come up with a winning combination.

\* \* \*

---

*157* ✦ Marcos Sánchez-Tranquilino, "Murales del Movimiento: Chicano Murals and the Discourses of Art and Americanization," in *Signs from the Heart: California Chicano Murals,* ed. Eva Sperling Cockcroft and Holly Barnet-Sánchez (Albuquerque: University of New Mexico Press, 1996).

Art historian Marcos Sánchez-Tranquilino, who studied at the University of California/Los Angeles, writes and lectures on Chicano art. He co-organized the exhibition *Chicano Art: Resistance and Affirmation, 1975–85,* which originated in 1990 at the Wight Art Gallery at UCLA and traveled throughout the United States through the summer of 1993. Sánchez-Tranquilino is part of a movement to encourage scholarship on Chicano art. Over the past twenty years the field has blossomed and includes the writings of Eva Sperling Cockcroft, Shifra M. Goldman, Holly Barnet-Sánchez, Tomás Ybarra-Frausto, and Amalia Mesa-Bains.

*Signs from the Heart* focuses on the history and motivations behind the Chicano mural movement, particularly the murals seen throughout the Los Angeles area, including the outside walls of the Estrada Courts Housing Project in East Los Angeles [see Fig. 7-15]. Sánchez-Tranquilino's essay focuses on the issues of self-definition and community identity. In a footnote to another part of the essay not excerpted here, Sánchez-Tranquilino cites James Clifford's observation of the current state of the world: "where syncretism and parodic invention are becoming the rule, not the exception, an urban

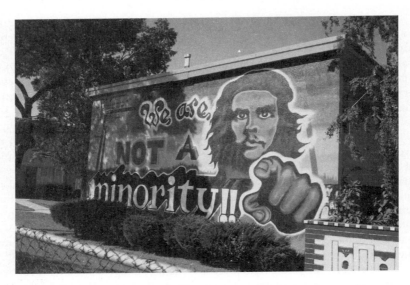

**Figure 7-15.** Congresso de Artistas Chicanos en Aztlán (Mario Torero with Zapilote, Rocky, El Leon, Zade), *We Are Not a Minority,* 1978. About 20 by 30 feet. Estrada Courts Housing Project, East Los Angeles.

**Figure 7-16.** Judith F. Baca, detail: *La Memoria de Nuestra Tierra: Colorado,* 1999. Denver International Airport, Denver, Colorado and www.sparcmurals.org. The mural is the result of research and interviews Baca and her students conducted on the history, the customs, and property holdings of Mexicans in Colorado.

multi-national world of institutional transience—where American clothes made in Korea are worn by young people in Russia, where everyone's 'roots' are in some degree cut—in such a world it becomes increasingly difficult to attach human identity and meaning to a coherent 'culture' or 'language.'" In other words, the erasure of nationalized identities is becoming ever more obvious (see also Reading 138).

Sánchez-Tranquilino works with the Social and Public Art Resource Center (SPARC), a non-profit Los Angeles arts organization founded in 1976. SPARC has successfully raised funds to organize community efforts to repair and maintain existing murals in the Los Angeles area. Judith Baca, artistic director of SPARC, in the mid-1970s initiated the *Great Wall of Los Angeles* project; in 1988, another project got underway, *Neighborhood Pride: Great Walls Unlimited.* She currently has her studios in the SPARC building. In the late 1990s she and her students began working with digital imagery and produced more murals for the Estrada Courts Housing Project. Baca's 50-foot-long digitally produced mural, *La Memoria de Nuestra Tierra: Colorado,* 1999, is installed at the Denver International Airport [Fig. 7-16].

Sánchez-Tranquilino's essay was first published in 1990.

---

A Chicano is a Mexican American who does not have an Anglo image of himself.

Rubén Salazar, 1970

"ORALE RAZA!," the textual focus of Frank Fierro's colorful 1974 mural at the Estrada Courts Housing Project in East Los Angeles, is an exuberant greeting to all Chicanos. The literal English translation of this greeting is awkward, meaning "Right On! Mexican American People." However, the idiomatic Chicano translation would be closer to "Right on! my People," or even "my Community." The greeting immediately establishes a cultural recognition between the Chicano muralist and the Chicano viewer, acknowledging both as belonging to the national Chicano community. The murals as well as the other arts of this community played a seminal role in the establishment of this important intra-cultural bridge, the effects of which ultimately had significant implications for United States society in general and Chicanos in particular. As with the majority of Chicano murals of its period, "Orale Raza!" articulated a cultural representation of both regional and national political agendas for *el movimiento,* the Chicano civil rights movement which began in the mid-1960s and continued through various transformations into the late 1970s and beyond.

* * *

The Americanization of Mexicans in this country can be seen as a history of both resistance and affirmation in their struggle to survive not as an alien resident underclass, but rather as a multiplicity of citizen classes contributing to the American social whole. Unfortunately, their history also has until very recently been circumscribed by social assignment on the part of the dominant class. Although classified as an American minority, U.S. Mexicans nevertheless found little acceptance unless they would assimilate. This meant that acceptance was predicated upon the expressed display of a preference for Anglo culture—especially the use of English—over Mexican culture.

While some members of this group could and would assimilate, others were not willing or able.

<div align="center">* * *</div>

Striving to meet the needs of the Chicano community through the visual articulation of its newly constructed political positions, the painting of virtually thousands of Chicano murals throughout the Southwest and Midwest were instrumental in the demystification of popularly held notions of Mexican Americans as politically passive and lacking history as well as culture. Much of the work to be done in this arena meant the supplanting of negative images of U.S. Mexicans by portrayals based on a more realistic and complete interpretation of a broader-based and ethnically diverse American history. Muralists became important educators as they painted Chicano contributions to American society not included in school textbooks. Through *chicanismo,* they also highlighted the ancient cultures of Mexico in order to show historical continuity and cultural legitimacy. Throughout, these artists inspired everyone with their sizable talents.

Chicano murals, along with other artistic and political efforts of the Movement, attempted to radically change many of the misperceptions previously mentioned regarding Chicanos, their art, their artists, both within and without the community. Chicano murals go beyond signifying artistic accomplishment, they stand as a testament to the capacity of U.S. Mexicans to organize, plan and direct themselves toward the process of social change and the production of art, including the reconstruction of meaning of their exploited and abused ethnic pre-Chicano period imagery. In particular, the prolific creation of murals represented successful collective efforts on the part of the community toward national self-definition through political and cultural activism. As they put into effect the ideals of Chicano liberation through this organizing process, artists and members of the Mexican American communities served to educate each other, while also educating non-Chicanos.

<div align="center">* * *</div>

At the present time, Chicanos throughout the United States continue to make murals. Although the type of Chicano mural which was created by grass roots organizing is no longer produced, murals by Chicanos articulating a social awareness of that community brought on by the Movement are still being made. In 1984, The Olympics Organizing Committee commissioned several murals for the freeways of Los Angeles of which three were done by Chicanos—*Hitting the Wall* by Judy Baca, *Luchas del Mundo* by Willie Herrón, and *Going to the Olympics* by Frank Romero. That same year the East Los Streetscapers created the *New Fire* mural which connected the 1984 Olympics with a pre-Columbian ritual on a three-story building in the heart of the city. In 1989, Yreina Cervántez created *La Ofrenda,* a city-funded mural administered through the Social and Public Art Resource Center (SPARC) which connected the plight of Central Americans with those of Chicanos by honoring Dolores Huerta, co-founder of the United Farmworkers Union.

<div align="center">* * *</div>

Assimilation through the Hispanic model is a legacy of Americanization efforts inherited from the Nixon administration, which sought to replace Johnson's

War on Poverty programs with the Office of Minority Enterprise in an effort to "encourage Black and brown capitalism."[1] It represents a process of Americanization by default for the convenience of the administrative and business sectors which tend to traditionally support conservative political and cultural agendas. For Chicanos the term is especially insensitive. For it robs them of the opportunity to acknowledge their indigenous Mexican heritage while it privileges the colonialist European culture of Spain.

The question must remain open whether these sectors, in addition to all of this country's citizens who consider themselves American, can appreciate the legacy of the Chicano Movement in this context: that the Chicano experience represents a model for all Americans to acknowledge their current identity as an outcome of two (or more) living histories coming together; that there is a multiplicity of ways to be American; that the word "Chicano" is an American word (not only an English, or only a Spanish word) because it signifies the unique amalgamation of the old and new identities without the denial of one in favor of the other. That is Chicano; that is American.

---

***158*** ✦ Guerrilla Girls, *The Advantages of Being a Woman Artist,* 1988, and *Do Women Have to Be Naked to Get into the Met. Museum?* 1989. Posters. Courtesy of the Guerrilla Girls [Figs.7-17 and 7-18].

The Guerrilla Girls, a group of New York women artists and writers, was organized in 1985 to carry out artworld guerrilla actions opposing the backlash against feminism of that decade. Keeping their identities anonymous, these women worked in three areas of activity: plastering city walls and buying space in magazines for their posters; picketing exhibitions at museums that they considered sexist and racist; and donning gorilla masks to give lecture/performances, primarily at art schools, in which they voiced their outrage about discrimination against women and people of color in the art world—while tossing bananas at the audience. Elizabeth Hess interviewed one of the artists, using the name of the eighteenth-century painter Rosalba Carriera as her *nom de guerre,* who explained that the Girls wanted to avoid the cult of personality that had attached to some women artists, therefore the anonymity: "When we attack something, we want what we're saying to be heard, not who's saying it" (quoted in Elizabeth Hess, "Guerrilla Girl Power," in *But Is It Art?: The Spirit of Art as Activism,* ed. Nina Felsen, 1995). Calling themselves the "conscience of the art world," the Girls may have had some favorable effect. Certainly statistics about women in exhibitions were better at the end of the twentieth century, and also for artists of color.

---

[1] Rodolfo F. Acuña, *A Community Under Siege: A Chronicle of Chicanos East of the Los Angeles River 1945–1975* (Los Angeles: Chicano Studies Research Center Publications, University of California, Los Angeles, 1984), p. 180.

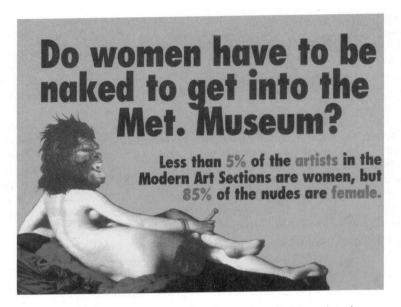

**Figure 7-17.** Guerrilla Girls, *Do women have to be naked to get into the Met. Museum?*, 1989. Poster. Courtesy the Guerrilla Girls.

# THE ADVANTAGES OF
# BEING A WOMAN ARTIST:

- Working without the pressures of success.
- Not having to be in shows with men.
- Having an escape from the art world in your 4 free-lance jobs.
- Knowing your career might pick up after you are eighty.
- Being reassured that whatever kind of art you make it will be labeled feminine.
- Not being stuck in a tenured teaching position.
- Seeing your ideas live on in the work of others.
- Having the opportunity to choose between career and motherhood.
- Not having to choke on those big cigars or paint in Italian suits.
- Having more time to work after your mate dumps you for someone younger.
- Being included in revised versions of art history.
- Not having to undergo the embarrassment of being called a genius.
- Getting your picture in art magazines wearing a gorilla suit.

A PUBLIC SERVICE MESSAGE FROM **GUERRILLA GIRLS** CONSCIENCE OF THE ARTWORLD
532 LaGUARDIA PLACE, #237 · NY,NY 10012

**Figure 7-18.** Guerrilla Girls, *The Advantages of Being a Woman Artist,* 1988, Poster. Courtesy the Guerrilla Girls. This poster was translated into many languages worldwide.

*159* ✦ Gran Fury, ACT UP poster, reproduced in *AIDS Demo Graphics*, Douglas Crimp with Adam Rolston (Seattle: Bay Press, 1990) [Fig.7-19].

ACT UP was founded in New York in March 1987, and chapters quickly spread to Chicago, Los Angeles, San Francisco, and all the major cities in the United States, as well as to Berlin, London, and Paris. Members and their supporters came from all walks of life. According to Douglas Crimp ("AIDS Activist Graphics: A Demonstration," *AIDS Demo Graphics*), art projects were a part of ACT UP from the beginning. Six gay men had printed posters with the legend "Silence = Death." They offered them to ACT UP, which produced T-shirts, buttons, and stickers with the graphic image. In 1988 William Olander, curator at The New Museum, arranged for a display, *Let the Record Show,* in The New Museum's street window. The people involved in the window project formed themselves as a group. Crimp explains: "Calling themselves Gran Fury, after the Plymouth model used by the New York

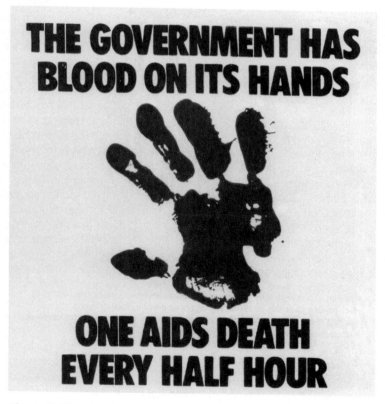

**Figure 7-19.** Gran Fury, *The Government Has Blood on Its Hands,* 1988. ACT-UP poster. Photograph courtesy the New York Public Library, Astor, Lenox and Tilden Foundations.

City police as undercover cars, they became, for a time, ACT UP's unofficial propaganda ministry and guerrilla graphic designers." Soon Gran Fury's posters were in all the mass demonstrations protesting the government's sluggish response to the AIDS pandemic.

*160* ✦ Suzanne Lacy, "Comments on *Code 33: Emergency, Clear the Air*," Letter to author, May 23, 2000.

From 1977 to 1980 California performance artists Suzanne Lacy and Leslie Labowitz organized large teams of women to participate in "media performances"—political art actions performed in public spaces, such as *In Mourning and in Rage* [see Fig. 6-12]. Lacy and Labowitz's essay "Feminist Media Strategies for Political Performance," printed in Douglas Kahn and Diane Neumaier, eds. *Cultures in Contention*, 1985, serves as a useful "how-to manual" to guide artists toward effective media interventions.

In the 1980s and 1990s Lacy organized public performances that focused on violence, racism, stereotyping, and community building. In Oakland in 1992 Lacy began a series of large-scale public art events with a variety of collaborators that advocated for the city's youth. After over a year of community meetings, youth workshops and production planning, *Code 33* was performed on October 7, 1999, on a rooftop garage in downtown Oakland. A press release distributed before the event announced it as: "An important public art event featuring 150 Oakland Youth, 100 Police Officers, 57 Neighborhood Crime Prevention Councils, Mayor Jerry Brown, Police Chief Richard Word, Oakland City Council, Parents, Neighbors, Mentors and You." Describing the choreography planned for the event, it continued: "Dozens of black, red, and white cars, headlights blazing, will converge on the rooftop. . . . In the spotlight of these beams, [small groups of] . . . police officers and . . . young people . . . will talk candidly and intensely about issues that affect them both—crime, authority, power and safety. The expected audience of 1000 community members will roam freely between cars witnessing the spontaneous dialogue of youth and police coming together to explore their realities and stereotypes in this unique public event." The evening's events included videos made by youth of eight different Oakland communities. Over 80 community representatives participated who commented on the relationship between youth, police, and the community and who signed up for a mentoring program. Thirty youth dancers and a helicopter completed the spectacle. Here follows Lacy's assessment of the project.

———————————————✦———————————————

In the past nine years in these Oakland projects I've explored the ways in which we marginalize young people and through our public policies, social processes and institutions, fail youth. These failures have come about as a result of the rapidly changing ethnic composition of young people, and resulting poverty, among other factors. For many years this work has taken me into City Hall, the Police Department, the Health Department and public schools. Changes here are slgw, and part of a much larger movement where artists work alongside activists from many other disciplines. This work has been perplexing, speeded up by information, increasingly engaged with

complicated political forces, and more and more expansive—each project was a collaboration with a large and diverse group of artists, youth, community members—we consistently put ourselves into compromising situations, caught between radical politics and the institutions we wanted to change.

I think Code 33 will prove to be pivotal in my work. Since I began working in Oakland, I have become more alert to the possibilities and pitfalls of working within institutions. It's a treacherous terrain, one filled with opportunities for imperfection. But it is an inevitable trajectory for public/political artists. If efficacy is one means of evaluating public art, then eventually we have to take on the institutionalization of change. When we do, we run the risk of the art disappearing altogether.

In the case of Code 33, I spent so much time in the past two years on the institutional relationships and community building that I often wondered if there would be any art left. Conversely, the extravagance of the final performance and the economic expenditures in making it aesthetically powerful made it questionable to some community activists, although their political goals were the same as ours.

Code 33 was quite beautiful, in terms of visual elements and the interactions that took place, during and before the performance event. (The complete work is not the performance, for which all else was a preparation. The art is the process—the political maneuvering, the relationships, the teaching and learning, and the collaborative aesthetic decisions—all part of the "craft" of this work.) There were intense and highly symbolic public relationships as well as intimate and private ones—between the youth and police, artists and activists, youth and adults, and people of different races. The process created its own rather extensive community of collaborators, including Julio Morales, the installation artist, and Unique Holland, the young woman artist who has collaborated with me since she was 16, and is now graduating from college.

Two drives—aesthetic and political—come together for me when making a work of art: my need to create form is a very powerful drive, as is outrage at injustice that results in a desire for communication across difference, for connection through empathy. In an aesthetic experience, the boundary between oneself and what is being apprehended dissolves. There is the shock of recognition, of awe, of new connections. The drive for social justice is the desire for connection, and the desire to share and make equal—to experience a oneness. So for me those two drives come together because when you are making a work of art, you are trying to shape wholeness.

Of course, aesthetic pleasure is strongest during the performance. I love it when the helicopter flies overhead at exactly the right moment! A powerful moment for me in Code 33 was overlooking a field of white, red, and black cars on the seventh floor, and below on the fourth floor a giant "X" (the tables for mentorship) with little patches of green grass and white picket fences (where the community members would sit)—and across the street, the huge Federal Building with two towers, and right in-between the Mumia protesters, who were gathered there in a rather picturesque fashion. Balanced, well framed, and visually complex! Another powerful moment was when the sun set and the lights went on—thirty television monitors on the walls, headlights of the cars, the vast expanse of city lights from North to West Oakland, and in the distance the Bay Bridge lights. The helicopter lights played across the surface signaling youth dancers to explode the tension through celebration.

In such performances, questions always surface about the difficulty of bringing diverse people together, in circumstances that often reflect unequal balances in power and money, diversities based on race, national origin, class, and political agendas. Once people come together, do they share or differ over strategies, agendas and expectations? Who is the artist? Who speaks? Who is the audience(s)? In critical discourse we've reified these questions, but the answers are harder to construct, because we will need to evolve a language to describe relationship, social interconnections, and political strategies as aesthetic issues.

\* \* \*

So the basic question for me with this Oakland work is not, how can you make a difference in the lives of one or two young people, or change the perceptions of five or six audience members? Those are important goals. But we should challenge ourselves further, to match the effects of our work with our rhetoric of social change. How can we work as artists on a broader scale, to create change that will penetrate and affect the institutions, public spaces, and political processes that make up our public culture?

# For Further Reading

Note: The reader should bear in mind that the following books and catalogues are as much documents of the time period when they were first published as they are interpretations of the art that is their subject. Hence, dates of first publication, included here, may provide good starting points for discussion. Monographs about single artists are not included, for they are easily found through Internet searches and in the bibliographies of books and articles listed here.

## General History Reference Books

Buhle, Mari Jo, Paul Buhle, and Dan Georgakas, eds. *Encyclopedia of the American Left*. 2nd. ed. New York: Oxford University Press, 1998.

Foner, Eric, and John A. Garraty, eds. *The Reader's Companion to American History*. Boston: Houghton Mifflin, 1991.

Morris, Richard B. and Jeffrey B. Morris, eds. *Encyclopedia of American History*. New York: Harper-Collins, 1996.

## Anthologies and Art Reference Books

Baigell, Matthew. *Dictionary of American Art*. London: John Murray, 1980.

Harrison, Charles, and Paul Wood, eds. *Art in Theory, 1900–1990: An Anthology of Changing Ideas*. Oxford, England: Blackwell Publishers, 1992.

Johnson, Ellen, ed. *American Artists on Art*. New York: Harper and Row, 1982.

Nelson, Robert S., and Richard Shiff, eds. *Critical Terms for Art History*. Chicago: The University of Chicago Press, 1996.

Rose, Barbara, ed. *Readings in American Art, 1900–1975*. New York: Holt, Rinehart and Winston, 1975.

Stiles, Kristine, and Peter Selz, eds. *Theories and Documents of Contemporary Art: A Sourcebook of Artists' Writings*. Berkeley: University of California Press, 1996.

## Subjects, Themes, and Broad Chronological Studies

Bearden, Romare, and Harry Henderson. *A History of African-American Artists: From 1792 to the Present*. New York: Pantheon Books, 1993.

Boime, Albert. *Unveiling the National Icons: A Plea for Patriotic Iconoclasm in a Nationalist Era*. New York: Cambridge University Press, 1998.

Bronx Museum of the Arts. *The Latin American Spirit: Art and Artists in the United States, 1920–1970*. Exh. Cat. New York: Harry N. Abrams, 1988.

Cassidy, Donna. *Painting the Musical City: Jazz and Cultural Identity in American Art, 1910–1940*. Washington, DC: Smithsonian Institution Press, 1997.

Dabakis, Melissa. *Visualizing Labor in American Sculpture: Monuments, Manliness and the Work Ethic, 1880–1935*. New York: Cambridge University Press, 1999.

Eldredge, Charles C., Julie Schimmel, and William H. Truettner. *Art in New Mexico, 1900–1945: Paths to Taos and Santa Fe.* Exh. Cat. Washington, DC: National Museum of American Art, Smithsonian Institution, 1986.

Goldman, Shifra M., *Dimensions of the Americas: Art and Social Change in Latin America and the United States.* Chicago: University of Chicago Press, 1994.

Haskell, Barbara. *The American Century: Art and Culture, 1900–1950.* Exh. Cat. New York: Whitney Museum of American Art in Association with W. W. Norton, 1999.

Hills, Patricia, and Roberta K. Tarbell. *The Figurative Tradition and the Whitney Museum of American Art.* Exh. Cat. New York: Whitney Museum of American Art, 1980.

LeFalle-Collins, Lizzetta, and Shifra M. Goldman. *In the Spirit of Resistance: African-American Modernists and the Mexican Muralist School/En el espíritu de la resistencia Los modernistas africanoamericanos y la Escuela Muralista Mexicana.* Exh. Cat. New York: The American Federation of Arts, 1996.

Oles, James. *South of the Border: Mexico in the American Imagination, 1914–1947.* Exh. Cat. Washington DC: Smithsonian Institution Press, 1993.

Patton, Sharon F. *African-American Art.* New York: Oxford University Press, 1998.

Phillips, Lisa. *The American Century: Art and Culture, 1950–2000.* Exh. Cat. New York: Whitney Museum of American Art in Association with W. W. Norton, 1999.

Powell, Richard J. *The Blues Aesthetic: Black Culture and Modernism.* Exh. Cat. Washington, DC: Washington Project for the Arts, 1989.

Powell, Richard J. *Black Art and Culture in the 20th Century.* New York: Thames and Hudson, 1997.

Rushing, W. Jackson, III, ed. *Native American Art in the Twentieth Century.* London: Routledge, 1999.

Scott, William B., and Peter M. Rutkoff. *New York Modern: The Arts and the City.* Baltimore: Johns Hopkins Press, 1999.

Stange, Maren. *Symbols of Ideal Life: Social Documentary Photography in America, 1890-1950.* New York: Cambridge University Press, 1989.

Wallach, Alan. *Exhibiting Contradiction: Essays on the Art Museum in the United States.* Amherst: University of Massachusetts Press, 1998.

Wardlaw, Alvia J., ed. *Black Art: Ancestral Legacy: The African Impulse in African American Art.* Exh. Cat. Dallas: Dallas Museum of Fine Arts, 1989.

## Chapter 1: 1900–1920

Berman, Avis. *Rebels on Eighth Street: Juliana Force and the Whitney Museum of American Art.* New York: Atheneum, 1990.

Brown, Milton W. *The Story of the Armory Show.* New York: Abbeville Press, 1988.

*Camera Work,* Alfred Stieglitz, ed. Volumes 1–50 (1903–1917).

Green, Jonathan, ed. *Camera Work: A Critical Anthology.* Millerton, NY: Aperture, Inc., 1973.

Hills, Patricia. *Turn-of-the-Century America: Paintings, Graphics, Photographs, 1890–1910.* Exh. Cat. New York: Whitney Museum of American Art, 1977.

Homer, William Innes. *Alfred Stieglitz and the American Avant-Garde.* Boston: New York Graphic Society, 1977.

Milroy, Elizabeth. *Painters of New Century: The Eight and American Art.* Exh. Cat. Milwaukee, WI: Milwaukee Art Museum, 1991.

Naumann, Francis M. *New York Dada, 1915–23.* New York: Harry N. Abrams, 1994.

Tashjian, Dickran. *Skyscraper Primitives: Dada and the American Avant-Garde, 1910–1925*. Middletown, CT: Wesleyan University Press, 1975.

Versaci, Nancy R., and Judith E. Tolnick. *Over Here! Modernism, The First Exile, 1914–1919*. Exh. Cat. Providence, RI: David Winton Bell Gallery, Brown University, 1989.

Zurier, Rebecca. *Art for the Masses: A Radical Magazine and Its Graphics, 1911–1917*. Philadelphia: Temple University Press, 1988.

Zurier, Rebecca, Robert W. Snyder and Virginia M. Mecklenberg. *Metropolitan Lives: The Ashcan Artists and Their New York*. Exh. Cat. Washington DC: Smithsonian Institution Press, 1995.

## Chapter 2: The 1920s

Baigell, Matthew. *The American Scene: Paintings of the Twenties and Thirties*. New York: Praeger, 1974.

Brown, Milton W. *American Painting from the Armory Show to the Depression*. Princeton, NJ: Princeton University Press, 1955.

Chave, Anna C. "O'Keeffe and the Masculine Gaze," in Marianne Doezema, and Elizabeth Milroy, eds. *Reading American Art*. New Haven: Yale University Press, 1998.

Corn, Wanda M. *The Great American Thing: Modern Art and National Identity, 1919–1935*. Berkeley: University of California Press, 1999.

Lemke, Sieglinde. *Primitivist Modernism: Black Culture and the Origins of Transatlantic Modernism*. New York: Oxford University Press, 1998.

Locke, Alain. *The New Negro: Voices of the Harlem Renaissance* [1925]. Intro. by Arnold Rampersad. New York: Atheneum, 1992.

Lucic, Karen. *Charles Sheeler and the Cult of the Machine*. Cambridge: Harvard University Press, 1991.

Lynes, Barbara Buhler. *O'Keeffe, Stieglitz and the Critics, 1916–1929*. Chicago: University of Chicago Press, 1989.

Marter, Joan M., Roberta K. Tarbell, and Jeffrey Wechsler. *Vanguard American Sculpture, 1913–1939*. Exh. Cat. New Brunswick, NJ: Rutgers University Art Gallery, 1979.

Smith, Terry. *Making the Modern: Industry, Art, and Design in America*. Chicago: University of Chicago Press, 1993.

Tashjian, Dickran. *William Carlos Williams and the American Scene, 1920–1940*. Exh. Cat. New York: Whitney Museum of American Art in association with the University of California Press, 1978.

Tsujimoto, Karen. *Images of America: Precisionist Painting and Modern Photography*. Exh. Cat. San Francisco: San Francisco Museum of Modern Art, 1982.

Turner, Elizabeth Hutton. *American Artists in Paris, 1919–1929*. Ann Arbor: UMI Research Press, 1988.

Wilson, Richard Guy, Dianne H. Pilgrim, and Dickran Tashjian. *The Machine Age in America, 1918–1941*. Exh. Cat. New York: The Brooklyn Museum in association with Harry N. Abrams, Inc., 1986.

## Chapter 3: The 1930s

*Art Front*, Vols. 1–3 (December 1934–December 1937)

Baigell, Matthew, and Julia Williams, eds., *Artists Against War and Fascism: Papers of the First American Artists' Congress*. New Brunswick, NJ: Rutgers University Press, 1986.

Berman, Greta. *The Lost Years: Mural Painting in New York City under the WPA Federal Art Project, 1935–1943*. New York: Garland, 1978.

Daniel, Peter, Merry A. Foresta, Maren Stange, and Sally Stein. *Official Images: New Deal Photography*. Washington, DC: Smithsonian Institution Press, 1987.

Doss, Erika. *Benton, Pollock, and the Politics of Modernism: From Regionalism to Abstract Expressionism*. Chicago: University of Chicago Press, 1991.

Harris, Jonathan. *Federal Art and National Culture: The Politics of Identity in New Deal America*. New York: Cambridge University Press, 1995.

Harrison, Helen A. "John Reed Club Artists and the New Deal: Radical Responses to Roosevelt's 'Peaceful Revolution,' " *Prospects* 5 (1980):240–68.

Hills, Patricia. *Social Concern and Urban Realism: American Painting of the 1930s*. Exh. Cat. Boston: Boston University Art Gallery, 1983.

Hurlburt, Laurence P. *The Mexican Muralists in the United States*. Albuquerque, NM: University of New Mexico Press, 1989.

Lane, John R., and Susan C. Larsen, eds. *Abstract Painting and Sculpture in America, 1927–1944*. Exh. Cat. Pittsburgh: Museum of Art, Carnegie Institute in association with Harry N. Abrams, 1983.

Marling, Karal Ann. *Wall to Wall America: A Cultural History of Post Office Murals in the Great Depression*. Minneapolis: University of Minnesota Press, 1982.

McCoy, Garnett. "The Rise and Fall of the American Artists' Congress," *Prospects* 14 (1988):325–40.

McKenzie, Richard D. *The New Deal for Artists*. Princeton, NJ: Princeton University Press, 1973.

O'Connor, Francis V., ed. *Art for the Millions: Essays from the 1930s by Artists and Administrators of the WPA Federal Art Project*. Boston: New York Graphic Society, 1973.

O'Connor, Francis V., ed. *The New Deal Art Projects: An Anthology of Memoirs*. Washington, DC: Smithsonian Institution Press, 1973.

Park, Marlene, and Gerald E. Markowitz. *Democratic Vistas: Post Offices and Public Art in the New Deal*. Philadelphia: Temple University Press, 1984.

Platt, Susan Noyes. *Art and Politics in the 1930's: Modernism, Marxism, Americanism—A History of Cultural Activism During the Depression Years*. New York: Midmarch Arts Press, 1999.

Reynolds, Gary A., and Beryl J. Wright. *Against the Odds: African-American Artists and the Harmon Foundation*. Exh. Cat. Newark, NJ: The Newark Museum, 1989.

Shapiro, David. *Social Realism: Art as a Weapon*. New York: Frederick Ungar, 1973.

Schwarz, Lawrence. *Marxism and Culture: The CPUSA and Aesthetics in the 1930s*. Port Washington, NY: Kennikat Press, 1980.

Studio Museum in Harlem. *Harlem Renaissance: Art of Black America*. Intro. by Mary Schmidt Campbell; essays by David Driskell, David Levering Lewis, and Deborah Willis Ryan. Exh. Cat. New York: Harry N. Abrams, Inc., 1987.

Whiting, Cécile. *Antifascism in American Art*. New Haven: Yale University Press, 1989.

## Chapter 4: 1940s to mid-1950s

Ashton, Dore. *The New York School, A Cultural Reckoning* [1972]. New York: Penguin, 1984.

Berman, Greta, and Jeffrey Wechsler. *Realism and Realities: The Other Side of American Painting, 1940–1960*. Exh. Cat. New Brunswick, NJ: Rutgers University Art Gallery, 1982.

Craven, David. *Abstract Expressionism as Cultural Critique: Dissent During the McCarthy Period.* New York: Cambridge University Press, 1999.

Gibson, Ann Eden. *Abstract Expressionism: Other Politics.* New Haven: Yale University Press, 1997.

Gibson, Ann Eden. *Issues in Abstract Expressionism: The Artist-Run Periodicals.* Ann Arbor, MI: UMI Research Press, 1990.

Guilbaut, Serge. *How New York Stole the Idea of Modern Art: Abstract Expressionism, Freedom, and the Cold War.* Translated by Arthur Goldhammer. Chicago: University of Chicago Press, 1983.

Institute of Contemporary Art. *Dissent: The Issue of Modern Art in Boston.* Essays by Elisabeth Sussman, Reinhold Heller, Serge Guilbaut, David Joselit, and Benjamin H. D. Buchloh. Exh. Cat. Boston: The Institute of Contemporary Art, 1985.

Leja, Michael. *Reframing Abstract Expressionism: Subjectivity and Painting in the 1940s.* New Haven: Yale University Press, 1993.

Phillips, Lisa. *The Third Dimension: Sculpture of the New York School.* Exh. Cat. New York: Whitney Museum of American Art, 1984.

Polcari, Stephen. *Abstract Expressionism and the Modern Experience.* New York: Cambridge University Press, 1991.

Rosenberg, Harold. *The Tradition of the New.* New York: Horizon Press, 1959.

Sandler, Irving. *The Triumph of American Painting: A History of Abstract Expressionism.* New York: Harper and Row, 1970.

Selz, Peter. *New Images of Man.* Exh. Cat. New York: The Museum of Modern Art, 1959.

Shapiro, David, and Cecile Shapiro. *Abstract Expressionism: A Critical Record.* New York: Cambridge University Press, 1990.

## Chapter 5: 1955–1967

Alloway, Lawrence. *Topics in American Art Since 1945.* New York: W. W. Norton, 1975.

Armstrong, Elizabeth, and Joan Rothfuss. *The Spirit of Fluxus.* Exh. Cat. Minneapolis: Walker Art Center, 1993.

Battcock, Gregory, ed. *Minimal Art: A Critical Anthology.* New York: E. P. Dutton, 1968.

Battcock, Gregory, ed. *The New Art: A Critical Anthology.* New York: E. P. Dutton, 1966.

Burnham, Jack. *Beyond Modern Sculpture: The Effects of Science and Technology on the Sculpture of This Century.* New York: George Braziller, 1968.

Chave, Anna C. "Minimalism and the Rhetoric of Power," *Arts* 64, no. 5 (January 1990):44-63.

Crow, Thomas. *The Rise of the Sixties.* New York: Harry N. Abrams, 1996.

De Salvo, Donna, and Paul Schimmell. *Hand-Painted POP: American Art in Transition, 1955–62.* Exh. Cat. Los Angeles and New York: The Museum of Contemporary Art and Rizzoli International Publications, 1992.

Frueh, Joanna, "Chicago's Emotional Realists," *Artforum* 17, No. 1 (September 1978): 41–47.

Greenberg, Clement. *The Collected Essays and Criticism.* 4 vols. John O'Brian, ed. Chicago: University of Chicago Press, 1986–1993.

Haskell, Barbara. *Blam! The Explosion of Pop, Minimalism, and Performance 1958–1964.* Exh. Cat. New York: W. W. Norton and the Whitney Museum of American Art, 1984.

Jones, Caroline A. *Bay Area Figurative Art: 1950–1965.* Exh. Cat. Berkeley: University of California Press, 1990.

Jones, Caroline A. *Machine in the Studio: Constructing the Postwar American Artist.* Chicago: University of Chicago Press, 1996.

Kaprow, Allan. *Assemblage, Environments and Happenings.* New York: Harry N. Abrams, Inc., 1965.

Lippard, Lucy R. *Changing: Essays in Art Criticism.* New York: E. P. Dutton, 1971.

Lippard, Lucy R., with contributions by Lawrence Alloway, Nancy Marmer and Nicolas Calas. *Pop Art.* New York: Frederick A. Praeger, 1966.

Mamiya, Christin J. *Pop Art and Consumer Culture: American Super Market.* Austin: University of Texas Press, 1992.

Schimmel, Paul, and Judith E. Stein. *The Figurative Fifties: New York Figurative Expressionism.* Exh. Cat. New York: Rizzoli/Newport Harbor Art Museum, 1988.

Schulze, Franz. *Fantastic Images: Chicago Art Since 1945.* Chicago: Follett Publishing Company, 1972.

Steinberg, Leo. *Other Criteria.* New York: Oxford University Press, 1972.

Whiting, Cécile. *A Taste for Pop: Pop Art, Gender and Consumer Culture.* New York: Cambridge University Press, 1997.

## Chapter 6: 1968–1980

Alberro, Alexander, and Blake Stimson, eds. *Conceptual Art: A Critical Anthology.* Cambridge: The MIT Press, 1999.

Arthur, John. *Realists at Work.* New York: Watson-Guptill, 1983.

Battcock, Gregory, ed. *Idea Art: A Critical Anthology.* New York: E.P. Dutton, 1973.

Broude, Norma, and Mary D. Garrard, eds. *The Power of Feminist Art: The American Movement of the 1970s, History and Impact.* New York: Harry N. Abrams, 1994.

Campbell, Mary Schmidt. *Tradition and Conflict: Images of a Turbulent Decade, 1963–1973.* Exh. Cat. New York: The Studio Museum in Harlem, 1985.

Del Castillo, Richard Griswold, Teresa McKenna, and Yvonne Yarbro-Bejarano, eds. *Chicano Art: Resistance and Affirmation, 1965–1985* Exh. Cat. Los Angeles: Wight Art Gallery, University of California, 1991.

Fried, Michael. *Art and Objecthood: Essays and Reviews.* Chicago: University of Chicago Press, 1998.

Goldstein, Ann, and Anne Rorimer. *Reconsidering the Object of Art, 1965–1975.* Exh. Cat. Los Angeles: Museum of Contemporary Art, 1995.

Klüver, Billy, ed. *Nine Evenings: Theatre and Engineering.* New York: New York Foundation for the Performing Arts, 1966.

Krauss, Rosalind E. "Sculpture in the Expanded Field," in *The Originality of the Avant-Garde and Other Modernist Myths.* Cambridge, MA: The MIT Press, 1985.

Lippard, Lucy R. *A Different War: Vietnam in Art.* Exh. Cat. Seattle: Real Comet Press, 1990.

Lippard, Lucy R. *From the Center: Feminist Essays on Women's Art.* New York: E.P. Dutton, 1976.

Lippard, Lucy R. *Overlay: Contemporary Art and the Art of Prehistory.* New York: Pantheon, 1983.

Martin, Alvin. *American Realism: Twentieth-Century Drawings and Watercolors from the Glenn C. Janss Collection.* Exh. Cat. New York: San Francisco Museum of Modern Art in association with Harry N. Abrams, 1985.

McShine, Kynaston L., ed. *Information.* Exh. Cat. New York: The Museum of Modern Art, 1970.

Nemser, Cindy. *Art Talk: Conversations with 12 Women Artists.* New York: Charles Scribner's Sons, 1975.

Queens Museum of Art, New York. *Global Conceptualism: Points of Origin, 1950s–1980s.* Foreword by Luis Camnitzer, Jane Farver, and Rachel Weiss. Exh. Cat. New York: Queens Museum of Art, 1999.

Robins, Corinne. *The Pluralist Era: American Art, 1968–1981.* New York: Harper and Row, 1984.

Roth, Moira, ed. *The Amazing Decade: Women and Performance Art in America 1970–1980.* Los Angeles: Astro Artz, 1983.

Tucker, Marcia, and James Monte. *Anti-Illusion: Procedures/Materials.* Exh. Cat. New York: Whitney Museum of American Art, 1969.

## Chapter 7: 1980s–1990s

Bolton, Richard, ed. *Culture Wars: Documents from the Recent Controversies in the Arts.* New York: New Press, 1992.

Chadwick, Whitney, and Isabelle de Coutivron, eds. *Significant Others: Creativity and Intimate Partnership.* London: Thames and Hudson, 1993.

Doss, Erika. *Spirit Poles and Flying Pigs: Public Art and Cultural Democracy in American Communities.* Washington, DC: Smithsonian Institution Press, 1995.

Felshin, Nina, ed. *But Is it Art?: The Spirit of Art as Activism.* Seattle: Bay Press, 1995.

Ferguson, Russell, William Olander, Marcia Tucker, and Karen Fiss. *Discourses: Conversations in Postmodern Art and Culture.* New York and Boston: The New Museum of Contemporary Art and The MIT Press, [1990].

Ferguson, Russell, Martha Gever, Trinh T. Minh-ha, and Cornel West, eds. *Out There: Marginalization and Contemporary Cultures.* New York and Boston: The New Museum of Contemporary Art and The MIT Press, 1990.

Golden, Thelma. *Black Male: Representations of Masculinity in Contemporary American Art.* Exh. Cat. New York: Whitney Museum of American Art, 1994.

Heiferman, Marvin, and Lisa Phillips, with John G. Hanhardt. *Image World: Art and Media Culture.* Exh. Cat. New York: Whitney Museum of American Art, 1989.

Institute of Contemporary Art, Boston. *Endgame: Reference and Simulation in Recent Painting and Sculpture.* Exh. Cat. Cambridge, MA: The MIT Press, 1986. [Essays by Thomas Crow, Yve-Alain Bois, Elisabeth Sussman, David Joselit, Hal Foster, and Bob Riley.]

Institute of Contemporary Art, Boston. *New Histories.* Exh. Cat. Boston: The Institute of Contemporary Art, 1996. [Curated by Milena Kalinovska; Lia Gangitano, and Steven Nelson, eds.]

Institute of Contemporary Art, Boston. *Utopia, Post Utopia: Configurations of Nature and Culture in Recent Sculpture and Photography.* Exh. Cat. Boston: The Institute of Contemporary Art, Boston, 1988 [Essays by Frederic Jameson, Eric Michaud, Elizabeth Sussman, David Joselit, Abigail Solomon-Godeau, and Alice Jardine.

Jacob, Mary Jane, with Michael Brenson, eds. *Conversations at the Castle: Changing Audiences and Contemporary Art.* Exh. Cat. Arts Festival of Atlanta Program [1996]. Cambridge, MA: The MIT Press, 1998.

Jones, Amelia. *Body Art/Performing the Subject.* Minneapolis: University of Minnesota Press, 1998.

Kahn, Douglas, and Diane Neumaier, eds. *Cultures in Contention.* Seattle: The Real Comet Press, 1985.

Kardon, Janet. *The East Village Scene.* Exh. Cat. Philadelphia: Institute of Contemporary Art, University of Pennsylvania, 1984.

Karp, Ivan, Christine Mullen Kreamer, and Steven D. Lavine, eds. *Museums and Communities: The Politics of Public Culture.* Washington, DC: Smithsonian Institution Press, 1992.

Karp, Ivan, and Steven D. Lavine, eds. *Exhibiting Cultures: The Poetics and Politics of Museum Display.* Washington, DC: Smithsonian Institution Press, 1991.

Kleeblatt, Norman L., ed. *Too Jewish? Challenging Traditional Identities.* Exh. Cat. New York: The Jewish Museum and Rutgers University Press, 1996.

Kruger, Barbara, and Phil Mariani, eds., *Remaking History.* Dia Art Foundation Discussions in Contemporary Culture, No. 4. Seattle: Bay Press, 1989.

Kuspit, Donald B. *Idiosyncratic Identities: Artists at the End of the Avant-Garde.* New York: Cambridge University Press, 1996.

Levin, Kim, ed. *Beyond Walls and Wars: Art, Politics, and Multiculturalism.* New York: Midmarch Arts Press, 1992.

Lippard, Lucy R. *The Lure of the Local: Senses of Place in a Multicentered Society.* New York: W. W. Norton, 1997.

Lippard, Lucy R. *Mixed Blessings: New Art in a Multicultural America.* New York: Pantheon, 1990.

Lovejoy, Margot. *Postmodern Currents: Art and Artists in the Age of Electronic Media.* Englewood Cliffs, NJ: Prentice Hall, 1992.

McShine, Kynaston. *The Museum as Muse: Artists Reflect.* Exh. Cat. New York: The Museum of Modern Art, 1999.

Mitchell, W. J. T., ed. *Art and the Public Sphere.* Chicago: University of Chicago Press, 1990.

Moore, Sylvia, ed. *Gumbo Ya Ya: Anthology of Contemporary African-American Women Artists.* New York: Midmarch Arts Press, 1995.

Museum of Contemporary Hispanic Art, The New Museum of Contemporary Art, The Studio Museum in Harlem. *The Decade Show: Frameworks of Identity in the 1980s.* Exh. Cat. New York: Museum of Contemporary Hispanic Art, The New Museum of Contemporary Art, The Studio Museum in Harlem, 1990. (Essays by multiple authors.)

Nye, Deborah. *The Committed Print.* Exh. Cat. New York: The Museum of Modern Art, 1988.

Plous, Phyllis, and Mary Looker. *Neo York: Report on a Phenomenon.* Exh. Cat., with Supplement. Santa Barbara: University Art Museum, 1984.

Rush, Michael. *New Media in Late 20th-Century Art.* New York: Thames & Hudson, 1999.

Serwer, Jacquelyn Days. *American Kaleidoscope: Themes and Perspectives in Recent Art.* Exh. Cat. Washington, DC: National Museum of American Art, Smithsonian Institution, 1996.

Tucker, Marcia. *Bad Girls.* Exh. Cat. New York: The New Museum of Contemporary Art, 1994.

Tucker, Marcia. *Bad Girls West.* Exh. Cat. Los Angeles: Wight Art Gallery, UCLA, 1994.

Wallis, Brian, ed. *Art After Modernism: Rethinking Representation.* New York and Boston: The New Museum of Contemporary Art and David R. Godine 1984.

Wallis, Brian, ed. Foreword by Marcia Tucker. *Blasted Allegories: An Anthology of Writings by Contemporary Artists.* New York and Boston: The New Museum of Contemporary Art and The MIT Press, 1987.

Whitney Museum of American Art. *1993 Biennial Exhibition.* Curated by Elizabeth Sussman, Thelma Golden, John G. Hanhardt, Lisa Phillips. New York: Whitney Museum of American Art, 1993.

Whitney Museum of American Art. *2000 Biennial Exhibition.* Curated by Maxwell L. Anderson, Michael Auping, Valerie Cassel, Hugh M. Davies, Jane Farver, Andrea Miller-Keller, Lawrence R. Rinder. New York: Whitney Museum of American Art, 2000.

# Acknowledgments

The author wants to thank the many colleagues, former and present students, artists, critics, art historians, curators, art dealers, friends, and others who helped the project in many ways. I first want to thank those who early on reviewed versions of the table of contents and/or read portions of the manuscript: David Brody, Andrew Hemingway, Patricia Johnston, Caroline A. Jones, Richard J. Powell, Phyllis Rosenzweig, May Stevens, Steven Nelson, Stephanie L. Taylor, and Kevin Whitfield. In addition, reviewers for Prentice Hall include Jo-Anne Berelowitz, David Cateforis, David Craven, and Elwood C. Parry III; I found their anonymous reports very useful. Pat and Kevin were particularly helpful at the end of the project when I needed to trim down the book to a manageable size; I am grateful for the many hours they each spent arguing with me over the edits. Historians David Hall and Bruce Schulman graciously agreed to read over the history sections and cautioned me about inaccuracies and potential misinterpretations; I do, of course, take responsibility for any overlooked errors that may still remain. Since 1993 Stephanie L. Taylor has helped me gather articles for this project. Her good judgment and especially her candor in voicing her preferences, based on her teaching experiences, have been invaluable. In the past year Stephanie heroically and with good humor organized the permissions files, located photographs and far-flung copyright holders, helped prepare the index, and in every way assisted me. I cannot thank her enough.

Many others passed along to me suggestions, ideas, and photocopies of articles and archival materials, which I added to my enormous file of potential entries; others helped me in the painstaking task of tracking down copyright holders. They are, in addition to those mentioned above: Ben Alexander, Richard Anderson, Tom Armstrong, India Artis, Judith Baca, Dirk Bakker, Gloretta Banes, Rudolf Baranik, Peter Barr, Beverly Brannon, Robert Brown, Donna Cassidy, Whitney Chadwick, David Craven, Douglas Crimp, Earl Davis, Sheila Dollente, Linda Downs, Anita Duquette, Michele Furst, Alison Gallop, Henry Louis Gates, Jr., Ann Gibson, Robert Hawkins, Richard Hellman, Jon Hendricks, Janet Hicks, Fred Hills, Breck Hostetter, Tom Hudspeth, Andrew Kelly, Meg Larned, Neil Larsen, Tom Lasanti, Tammi Lawson, Michelle Lamuniere, Amy Lyford, Will Moore, Robert C. Morgan, Angi Mosseau, Sarah Murkett, Richard Newman, Francis V. O'Connor, Debra J. T. Padilla, Frances Pohl, David Rosand, Laura Rosenstock, Sydelle Rubin, Steve Sarceoni, Grace L. Scalera, Delmore E. Scott, Mira Shor, Stuart Steck, John Stomberg, Judy Throm, Eric Trump, Sarah Vure, Alan Wallach, Cathy Wilcox-Titus, and Mel Wiseman. Gilberto Díaz helped with translations and last-minute copyright problems. Carla Munsat, editor of *Art New England,* needs also to be thanked for persistently pressing me to write reviews and feature articles on contemporary art issues. Colleagues at Boston University who lent support in various ways were Susan Jackson, Keith N. Morgan, and Jen Gaman. Caroline A. Jones has been especially generous as a friend who knows how to wield a red pencil with intelligence and precision.

At Prentice Hall I want to thank: Bud Therien, Acquisitions Editor, who had faith I would finish this project; Wendy Yurash, Bud's assistant, who handled my many e-mail queries; and especially Louise Rothman, Production Editor, who steered me through the editing process with great patience and tact.

Some sentences and paragraphs in Chapter 1, "Cultural and Historical Context for the First Twenty Years, " have been rewritten from portions of my own text originally published in Patricia Hills, *Turn-of-the-Century America: Paintings, Graphics, Photography 1890-1910* (New York: Whitney Museum of American Art, 1977). A few sentences and paragraphs in Chapter 4, "Cultural and Historical Context for World War II and the Cold War," "The Figurative Artists in the Postwar Years," and a part of a paragraph in Chapter 5, "New York Pop, West Coast Funk, and Chicago 'Sub-Pop'," have been drawn from my texts in Patricia Hills and Robert K. Tarbell, *The Figurative Tradition and the Whitney Musem of American Art* (New York: Whitney Museum of American Art, 1977). I gratefully acknowledge these Whitney Museum publications. The Chapter 3 sections, "Cultural and Historical Context for the Depression Years," "Revolutionary Theory and Practice—The Search for Styles," "Mexican Artists in the United States," and "Government Projects," have paragraphs revised from my text in Patricia Hills, *Social Concerns and Urban Realism: American Painting of the 1930s* (Boston: Boston University Art Gallery and the Bread and Roses Cultural Project of the National Union of Hospital and Health Care Employees, 1983). Chapter 7 sections, "Identities Unmasked, Classifications Resisted, "Bodies Reclaimed," and "Censorship and Propaganda in Art and Visual Culture," drew on paragraphs first published in *Art New England* essays, particularly: "The Naked Body, Censorship, and the NEA," (August/September 1992) and "Sighting/Siting/Citing Women: Issues of Identity and Alterity in Contemporary Women's Art and Criticism," (February/March 1996).

I want also to extend my gratitude to Dean Dennis D. Berkey, College of Arts and Sciences at Boston University, who granted me a subvention to help pay the costs of copyright and reproduction fees. I am also grateful to the Society for the Preservation of American Modernists for another grant to offset fees. To those artists, writers, museums and galleries, arts organizations, magazines, and copyright holders who waived, or substantially reduced, their fees I am also most appreciative. Finally, I thank those students who served as test subjects for the readings. Their comments and enthusiasms helped to shape the present book.

# Additional Credits

The author has rigorously attempted to secure all permissions prior to publication. Unacknowledged copyright holders should get in touch with the publisher, so that corrections can be made in future editions. Those credits noted in the headers to the Readings are not repeated here.

## Chapter 1

**3.** Excerpts from John Sloan, *John Sloan's New York Scene: From the Diaries, Notes and Correspondence 1906–1913,* ed. Bruce St. John with an introduction by Helen Farr Sloan. New York: Harper & Row, 1965. Used with permission of Helen Farr Sloan. **8.** Excerpts from W. E. B. Du Bois, "Of Our Spiritual Strivings," in *The Souls of Black Folk: Essays and Sketches.* Chicago: A. C. McClurg & Co., 1903. Used with permission of the estate of W. E. B. Du Bois. **19.** Marcel Duchamp, quoted in Katherine S. Dreier, *Collection of the Société Anonyme: Museum of Modern Art 1920.* New Haven: Yale University Art Gallery, 1950. © 2000 Artists Rights Society (ARS), New York / ADAGP, Paris / Estate of Marcel Duchamp.

## Chapter 2

**24.** Excerpts from Louis Lozowick, "The Americanization of Art," in catalogue for *Machine-Age Exposition,* ed., Jean Heap. New York: 119 West 57th Street, May 16–28, 1927. Used with permission of Lori Lozowick. **28.** Excerpts from Thomas Hart Benton, "My American Epic in Paint," *Creative Arts* 3 (December 1928). © T. H. Benton and R. P. Benton Testamentary Trusts/VAGA, NY, NY. **32.** Excerpts from Edward Alden Jewell, "A Negro Artist Plumbs the Negro Soul," *The New York Times* (March 25, 1928). Copyright © 1928 by the New York Times Co. Reprinted by permission. **36.** Excerpts from Langston Hughes, "The Negro Artist and the Racial Mountain," *The Nation* 122 (June 23, 1926). Reprinted by permission of Harold Ober Associates Incorporated. Copyright © 1926 by Langston Hughes. **39.** Excerpts from Stuart Davis, Unpublished Letters, 1928 and 1929. Used with permission of Earl Davis.

## Chapter 3

**40.** Excerpts from Raphael Soyer, "An Artist's Experiences in the 1930s," in Patricia Hills, *Social Concern and Urban Realism: American Painting of the 1930s.* Boston: Boston University Art Gallery and the Bread and Roses Cultural Project of the National Union of Hospital and Health Care Employees, 1983. Used with permission. **41.** Excerpts from Philip Evergood in John I. H. Baur, "Interview with Philip Evergood," Frances Mulhall Achilles Library, Philip Evergood Exhibition, 1960; Archives Whitney Museum of American Art. Printed with permission. **42.** Kenneth Fearing, "American Rhapsody (2)," 1940, from *Collected Poems of Kenneth Fearing* (New York: AMS Press, Inc., 1977). Reprinted by the permission of Russell & Volkening as agents for the author. Copyright © 1934 renewed 1962 by the Estate of Kenneth Fearing. **43.** Excerpts from Jacob Lawrence, "An Interview with Jacob Lawrence" conducted by David C. Driskell and James Buell, February 4, 1982, in Jacob Lawrence, *The "Toussaint L'Ouverture" Series.* New York: Church Board for Homeland Ministries, 1982. Used with permission of Jacob Lawrence. **45.** Excerpts from Stuart Davis, "Why an Artists' Congress?" *First American Artists' Congress 1936.* New York: American Artists' Congress, 1936. Used with permission of Earl Davis. **46.** Excerpts from Grace Clements, "New Content—New Form," *Art Front* 2, no. 4 (March 1936). Roll NDA 28, Archives of American Art, Smithsonian Institution. Used with permission. **47.** Excerpts from Louis Lozowick, "Towards a Revolutionary Art," *Art Front* 2, no. 7 (July–August 1936). Used with permission of Lori Lozowick. **48.** Isamu Noguchi, "What's the Matter with Sculpture," *Art Front* 2, no. 9 (September–October 1936). Reprinted by permission of the Isamu Noguchi Foundation. **49.** Excerpts from Berenice Abbott, "Civic Documentary History," from the Proceedings of the Conference on Photography, The Institute of Women's Professional Relations, New York City: The Biltmore Hotel, Feb 9, 1940. Used with permission of Berenice Abbott/Commerce Graphics, Ltd. **50. and Fig. 3-3:** The image and text by Diego Rivera are copyright © 2001 Banco de México Diego Rivera & Frida Kahlo Museums Trust. Av. Cinco de Mayo No. 2, Col. Centro, Del. Cuauhtoc 06059, México, D.F. Used with permission. **52.** Excerpts from André Breton, "Frida Kahlo de Rivera," in *Surrealism and Painting,* trans. Simon Watson Taylor, 1938. London: Macdonald, 1972. Reprinted with permission of Little, Brown and Company (UK), London. **53.** Excerpts from Holger Cahill, "American Resources in the Arts," in Francis V. O'Connor, ed., *Art for the Millions: Essays from the 1930s by Artists and Administrators of the WPA Federal Art Project.* Boston: New York Graphic Society, 1973. Used with permission of Francis V. O'Connor. **54.** Excerpts from Gwendolyn Bennett, "The Harlem Community Art Center," reprinted in Francis V. O'Connor, ed., *Art for the Millions: Essays from the 1930s by Artists and Administrators of the WPA Federal Art Project.* Boston: New York Graphic Society, 1973. Used with permission of Francis V. O'Connor. **55.** Excerpts from Elizabeth Noble [Elizabeth McCausland], " 'Official Art'," *Art Front* 2, no. 10 (November 1936). Roll NDA 28, Archives of American Art, Smithsonian Institution. Used with permission. **57.** Excerpts from Thomas Craven, *Modern Art: The Men, The Movements, The Meaning.* New York: Simon and Schuster, 1934. Copyright ©

1934, 1940 by Thomas Craven; copyright renewed 1962, 1968 by Thomas Craven. Reprinted with permission of Simon & Schuster, Inc. **58.** Excerpts from Stuart Davis, "Reviews: The New York American Scene in Art, *Art Front* 1, no. 3 (February 1935). Used with permission of Earl Davis. **59.** Excerpts from Romare Bearden, "The Negro Artist and Modern Art," *Opportunity* 12 (December 1934). © Romare Bearden Foundation/VAGA, NY, NY. **60.** Excerpts from Meyer Schapiro, "Race, Nationality and Art," *Art Front* 2, no. 4 (March 1936). Used with permission of the Meyer Schapiro Estate.

## Chapter 4

**61.** Clement Greenberg, "Abstract Art," *The Nation* 158 (April 15, 1944). Used with permission of Janice Van Horne. **64.** Excerpts from Meyer Schapiro, "The Liberating Quality of Avant-Garde Art," *Art News* 56 (Summer 1957):36–42. Used with permission of the Meyer Schapiro Estate. **65.** Arshile Gorky, "Garden in Sochi," Collection File [Artist's Statement, June 1942]. The Museum of Modern Art, New York, Department of Painting and Sculpture. © 2000 Estate of Arshile Gorky/Artists Rights Society (ARS), New York. **66.** Norman Lewis, "Thesis," 1946. Used with permission of the Norman Lewis Estate. **67.** Excerpts from Robert Motherwell, "The Modern Painter's World," *DYN* 1, No. 6 (November 1944). © Dedalus Foundation, Inc./VAGA, NY, NY. **68.** Mark Rothko, "The Romantics Were Prompted," *possibilities* 1 (Winter 1947–48). © 2000 Kate Rothko Prizel & Christopher Rothko/Artists Rights Society (ARS), New York. **69.** Jackson Pollock, "My Painting," *possibilities* 1 (Winter 1947–48). © 2000 Pollock-Krasner Foundation/Artists Rights Society (ARS), New York **70.** "Artist's Statement," in *The Ideographic Picture.* Betty Parsons Gallery, January 20–February 8, 1947. Reprinted in John P. O'Neill, ed. *Barnett Newman: Selected Writings and Interviews.* Berkeley, CA: University of California Press, 1992. © Barnett Newman Foundation/Artists Rights Society (ARS), New York. **71.** Grace Hartigan, "Artist's Statement," *12 Americans.* New York: The Museum of Modern Art, 1956. Used with permission of Grace Hartigan. **73.** Henry Koerner, "A Taped Interview between Henry Koerner and Dr. Paul A. Chew," in *Henry Koerner Retrospective Exhibition.* Greensburg, PA: Westmoreland County Museum of Art, 1971. Used with permission of Joseph Koerner. **74.** Elizabeth Catlett, "Negro Artists," *New Masses* 59 (April 30, 1946). Used with permission of Elizabeth Catlett. **76.** Excerpts from Stephen Greene, "Artist's Statement" in Whitney Museum of American Art, *The New Decade: 35 American Painters and Sculptors.* New York: The MacMillan Company, 1955. Printed with permission of the Whitney Museum of American Art. **77.** David Park, excerpts from a statement, quoted in Alfred Frankenstein, "Northern California," *Art in America* 42, no. 1 Winter 1954). Printed with permission of Natalie Park Schutz. **78.** Leon Golub, "Artist's Statement," in Peter Selz, *New Images of Man.* New York: The Museum of Modern Art, 1959. Used with permission of Leon Golub.

## Chapter 5

**82.** All lines from "America" from *Collected Poems 1947–1980* by Allen Ginsberg. Copyright © 1956, 1959 by Allen Ginsberg. Copyright Renewed. Reprinted by permission of HarperCollins Publishers, Inc. **84.** Claes Oldenburg, "I am for . . . ," in Claes Oldenburg and Emmett Williams, *Claes Oldenburg's Store Days* (New York, Ville Franche-sur-Mer, and Frankfurt am Main: Something Else Press, 1967). Printed with permission of Claes Oldenburg. **86.** Excerpts from Carolee Schneemann, *More than Meat Joy: Complete Performance Works and Selected Writings,* ed. Bruce McPherson. New Paltz, NY: Documentext, 1979. Used with permission of Carolee Schneemann. **87.** Robert Rauschenberg, Artist's Statement, in Dorothy C. Miller, ed., *Sixteen Americans.* New York: The Museum of Modern Art, 1959. © Untitled Press, Inc./VAGA, NY, NY. **88.** Excerpts from Leo Steinberg, "Contemporary Art and the Plight of Its Public," in *The New Art,* Gregory Battcock, ed. (New York: E.P. Dutton, 1966). Used with permission of Leo Steinberg. **89.** Excerpts from John Coplans, "An Interview with Roy Lichtenstein," *Artforum* 2, no. 4 (October 1963). © *Artforum.* Used with permission of John Coplans. **91.** Excerpts from Sidney Tillim, "The Underground Pre-Raphaelitism of Edward Kienholz," *Artforum* 4, no. 8 (April 1966). © *Artforum.* Used with permission of Sidney Tillim. **92.** Excerpts from Franz Schulze, "Chicago," *Art International* 11, no. 5 (May 20, 1967). Used with permission of Franz Schulze. **95.** Excerpts from Robert Morris, "Notes on Sculpture," *Artforum* 4, no. 6 (February 1966). *Courtesy Artforum.* © 2000 Robert Morris/Artists Rights Society (ARS), New York. **96.** Excerpts from Michael Fried, "Shape as Form: Frank Stella's New Paintings," *Artforum* 5, no. 3 (November 1966). © *Artforum.* Used with permission of Michael Fried. **97.** Excerpts from Lawrence Alloway, "Agnes Martin," *Artforum* 11, no. 8 (April 1973). © *Artforum.* Used with permission of Sylvia Sleigh.

## Chapter 6

**98.** Excerpts from Sol LeWitt, "Paragraphs on Conceptual Art," *Artforum* 5, no. 10 (June 1967). © *Artforum.* Used with permission of Sol LeWitt. **99.** Excerpts from Robert Smithson, "A Sedimentation of the Mind: Earth Projects," *Artforum* 7, no. 1 (September 1968). Used with permission of Nancy Holt. © Estate of Robert Smithson/VAGA, NY, NY. **100.** Excerpts from Barbara Rose, "Problems of Criticism, IV: The Politics of Art, Part III," *Artforum* 7, no. 9 (May 1969). Used with permission of Barbara Rose. **101.** Lawrence Alloway, Introduction to *Stolen,* by Kathe Gregory, Marilyn Landis, Russell F. Lewis, David Crane, Scott R. Kahn (Multiples Multiples, Inc., Dwan Gallery, New York, 1970); reprinted in *Topics in American Art since 1945.* New York: W. W. Norton & Company, Inc., 1975. Used with permission of Sylvia Sleigh. **102.** Excerpts from Lucy R. Lippard, "Eva Hesse: The Circle," in *From the Center: Feminist Essays on Women's Art.* New York: E. P. Dutton, 1976. Used with permis-

sion of Lucy R. Lippard. **103.** Excerpts from Calvin Tomkins, "Christo's Public Art: How to Win Friends, Outlast Enemies, and Make the Social Structure Work for You in Northern California," in Christo, *Running Fence: Sonoma and Marin Counties, California, 1972–1976.* New York: Harry N. Abrams, Inc., 1978. Used with permission. **105.** Alice Neel, excerpts from Patricia Hills, *Alice Neel.* New York: Harry N. Abrams, Inc. 1983. Used with permission. **106.** Excerpts from Audrey Flack, "Color," in *Audrey Flack on Painting.* New York: Harry N. Abrams, Inc., 1981. Used with permission of Audrey Flack. **107.** Robert Bechtle, "Artist's Statement," 1973. Courtesy the artist. Used with permission. **108.** Excerpts from Lowery Stokes Sims, "Bob Colescott Ain't Just Misbehavin'," *Artforum* 22, no. 7 (March 1984). © *Artforum.* Used with permission. **109.** Excerpts from Lucy R. Lippard, "The Art Workers' Coalition: Not a History," *Studio International* 180, no. 927 (November 1970). Used with permission of Lucy R. Lippard. **111.** Hans Haacke, "To: All Interested Parties - Re: Cancellation of Haacke one-man exhibition at Guggenheim Museum," press release dated April 3, 1971. Collection the author. Used with permission of Hans Haacke. **112.** Excerpts from Max Kozloff and John Coplans, "Art Is a Political Act," *The Village Voice* (January 12, 1976). Used with permission of Max Kozloff. **113.** Excerpts from Joseph Kosuth, "The Artist as Anthropologist," *The Fox* 1, (1975). Used with permission of Joseph Kosuth and the MIT Press. **114.** Excerpts from Donald B. Kuspit, "Art of Conscience: The Last Decade," in *Art of Conscience: The Last Decade.* Dayton, OH: Wright State University, 1981. Used with permission of Donald B. Kuspit. **115.** Amiri Baraka [Le Roi Jones], "A Poem for Black Hearts" [April 1965], *Negro Digest* 14, no. 11 (September 1965). Used with permission of Amiri Baraka. **116.** Excerpts from Larry Neal, "Any Day Now: Black Art and Black Liberation," *Ebony* 24, no. 10 (August 1969). Used with permission of Mrs. Evelyn Neal. **117.** Excerpts from Edmund B. Gaither, "A New Criticism Is Needed," *The New York Times* (June 21, 1970). Used with permission of Edmund B. Gaither. **118.** Excerpts from Michele Wallace, "For the Women's House," reprinted in *Invisibility Blues.* New York and London: Verso, 1990. Used with permission of Michele Wallace. **119.** Excerpts from Lucy R. Lippard, "Judy Chicago Talking to Lucy R. Lippard," *Artforum* 13, no. 1 (September 1974). © *Artforum.* Used with permission of Lucy R. Lippard. **120.** Excerpts from Harmony Hammond, "Feminist Abstract Art—A Political Viewpoint," *Heresies: A Feminist Publication on Art and Politics,* No. 1, (January 1977). Used with permission of Harmony Hammond. **121.** Betsy Damon, "The 7000 Year Old Woman," *Heresies,* no. 3 (Fall 1977). Used with permission of Betsy Damon. **122.** Excerpts from Moira Roth, "Visions and Re-Visions: Rosa Luxemburg and the Artist's Mother," *Artforum* 19, no. 3 (November 1980). © *Artforum.* Used with permission of Moira Roth. **123.** Excerpts from May Stevens, "Taking Art to the Revolution," *Heresies* 9 (1980). Used with permission of May Stevens.

**Chapter 7**

**124.** Excerpts from Kim Levin, "Farewell to Modernism," *Arts* 54, no. 2 (October 1979). Used with permission. © Kim Levin. **125.** Excerpts from Peter Halley, "Nature and Culture," *Arts* 56, no. 1 (September 1983). Used with permission of Peter Halley. **126.** Excerpts from Hal Foster. "Whatever Happened to Postmodernism?" in *The Return of the Real: The Avant-Garde at the End of the Century.* Cambridge, MA: MIT Press, 1996. Used with permission of Hal Foster and The MIT Press. **127.** Excerpts from Robert C. Morgan, "The End of the Art World," in *The End of the Art World.* New York: Allworth Press, 1998. Used with permission of Robert C. Morgan. **128.** Susan Rothenberg, "Artist's Statement," in Richard Marshall, *New Image Painting.* New York: Whitney Museum of American Art, 1978. Used with permission of the Whitney Museum of American Art. **129.** Excerpts from Christopher Knight, "Popeye Meets Picasso in MoCA Survey," *Los Angeles Herald Examiner,* August 16, 1987; reprinted in Knight, *Last Chance for Eden.* Los Angeles: The Foundation for Advanced Critical Studies, Inc., 1995. Used with permission of Christopher Knight. **130.** Excerpts from Rene Ricard, "The Radiant Child," *Artforum* 20, no. 4 (December 1981). © *Artforum.* Used with permission. **131.** Excerpts from Jonathan P. Binstock, "Mark Tansey," in Jacquelyn Days Serwer, *American Kaleidoscope: Themes and Perspectives in Recent Art.* Washington DC: National Museum of American Art, Smithsonian Institution, 1996. Used with permission. **132.** Excerpts from Robert Storr, "The Matter at Hand," in Peter Weiermair, Lucy Lippard, Rosalind Krauss, et al., *Louise Bourgeois.* Barcelona: Fundació Antoni Tàpies Foundation, 1995. Used with permission of Robert Storr. **133.** Excerpts from Douglas Crimp, "Pictures," *October,* No. 8 (Spring 1979). Used with permission of Douglas Crimp. **134.** Excerpts from Sheila Tebbatt, "Women in Theory," in *Ten 8,* no. 31 (Winter 1988). Used with permission of Sheila Tebbatt. **135.** Excerpts from Kate Linker, "Went Looking for Africa: Carrie Mae Weems," *Artforum* 31, no. 6 (February 1993). © *Artforum.* Used with permission of Kate Linker. **136.** Excerpts from Judith Wilson, "Seventies into Eighties—Neo-Hoodooism vs. Postmodernism: When (Art) Worlds Collide," in *The Decade Show: Frameworks of Identity in the 1980s.* New York: Museum of Contemporary Hispanic Art, The New Museum of Contemporary Art, The Studio Museum in Harlem, 1990. Used with permission of The New Museum of Contemporary Art. **137.** Excerpts from Edgar Heap of Birds. *Sharp Rocks.* Buffalo, NY: CEPA Gallery, 1986. Used with permission of Edgar Heap of Birds. **138.** Excerpts from Guillermo Gómez-Peña, "Documented/Undocumented," from Rick Simonson and Scott Walker, eds., *Graywolf Annual Five: Multi-Cultural Literacy: Opening the American Mind.* Saint Paul, MI: Graywolf Press, 1988. Used with permission of Guillermo Gómez-Peña. **139.** Excerpts from Margo Machida, "Out of Asia: Negotiating Asian Identities in America," in *Asia/America: Identities in Contemporary Asian American Art* (New York: The Asia Society Galleries, 1994). Used with permission. **140.** James Hannaham, "The Shadow Knows: An Hysterical Tragedy of One Young Negress and Her Art," in *New Histories.* Boston: The Institute of Contemporary Art, 1996. Used with permission. **141.** Excerpts from Deborah Bright, Introduction to *The Passionate Camera: Photography and Bodies of Desire.* London and New York: Routledge, 1998. Used with permission of Deborah Bright. **142.** Excerpts from Lowery Stokes Sims,

"Hannah Wilke: 'The Body Politic' or 'The Adventures of a Good-Looking Feminist,' " in *Art and Ideology*. New York: The New Museum of Contemporary Art, 1984. Used with permission of The New Museum of Contemporary Art. **143.** Robin Winters, "An Interview with Kiki Smith," in *Kiki Smith*. Amsterdam: Institute of Contemporary Art, 1990; reprinted in MIT List Visual Art Center, *Corporal Politics*. Boston: Beacon Press, 1992. Used with permission of Kiki Smith. **144.** James Luna, "The Artifact Piece," in *Fiction International* 18, no. 1 (Spring 1988). Used with permission of the artist and San Diego State University Press. **146.** Michael Brenson, "The Many Roles of Mapplethorpe, Acted Out in Ever-Shifting Images," *The New York Times* (July 22, 1989). Copyright © 1989 by the New York Times Co. Reprinted by permission. **147.** Rudolf Baranik, "Disinformation," *Dictionary of the 24th Century*, 1984. Used with permission of Estate of Rudolf Baranik. **148.** Excerpts from Patricia Johnston, "War Stories: Narrative Reporting of the Gulf War," *Views: The Journal of Photography in New England*, 12, no. 3 (Summer 1991). Used with permission of Patricia Johnston. **149.** Bill Viola, "Statement 1992," in *Reasons for Knocking at an Empty House: Writings 1973–1994*. Cambridge, MA: The MIT Press, 1995. Used with permission of Bill Viola and The MIT Press. © 1995 Bill Viola and Anthony d'Offay Gallery. **150.** Excerpts from Alan Wallach, "Revisionism Has Transformed Art History but Not Museums," in *Exhibiting Contradiction: Essays on the Art Museum in the United States*. Amherst: University of Massachusetts Press, 1998. Used with permission of Alan Wallach. **151.** Martha Buskirk, "Interviews with Sherrie Levine, Louise Lawler, and Fred Wilson," *October* 70 (Fall 1994). Used with permission of Martha Buskirk. **152.** Mark Miller Graham, "The Future of Art History and the Undoing of the Survey," *Art Journal* 54, no. 3 (Fall 1995). Used with permission of Mark Miller Graham. **153.** Amalia Mesa-Bains, "Teaching Students the Way They Learn," in Susan Cahan and Zoya Kocur, eds., *Contemporary Art and Multicultural Education*. New York: The New Museum of Contemporary Art, 1996. Used with permission of The New Museum of Contemporary Art. **154.** Hayden Herrera, "A Conversation with the Artist," in Patricia A. Johnston, *Joyce Kozloff: Visionary Ornament*. Boston: Boston University Art Gallery, 1986. Used with permission of Hayden Herrera. **155.** Elizabeth Hess, "An Interview with Maya Lin (1983)," in "Vietnam: Memorials of Misfortune, Part I: 1983," in *Unwinding the Vietnam War: From War into Peace*, ed. Reese Williams for Washington Project for the Arts (Seattle: Real Comet Press, 1987). Used with permission of Elizabeth Hess. **156.** Alan Wallach, "Editorial: Which Way the Tilted Arc?," in *Art and Artists* 14, no. 3 (May/June 1985). Used with permission of Alan Wallach. **157.** Marcos Sánchez-Tranquilino, "Murales del Movimiento: Chicano Murals and the Discourses of Art and Americanization," in *Signs from the Heart: California Chicano Murals*, ed. Eva Sperling Cockcroft and Holly Barnet-Sánchez (Albuquerque: University of New Mexico Press, 1996). Used with permission of Marcos T. Sánchez © 1990 and 1996. **160.** Suzanne Lacy, "Comments on *Code 33: Emergency, Clear the Air*," Letter to author, May 23, 2000. Used with permission of Suzanne Lacy.

## Additional Credits to Photographers

**Figs 1.2, 4.2, 4.4:** Geoffrey Clements; **Fig 1.4:** Graydon Wood; **Fig 2.5:** Hillel Burger; **Fig 3.1:** Eric Pollitzer; **Figs 3.2, 4.3a&b, 5.1, 5.6, 7.16:** Patricia Hills; **Fig 5.3:** Al Giese; **Fig 6.9:** Malcom Varon; **Fig 6.10:** George Holmes; **Fig 6.11:** Susan Friedrich; **Fig 6.12:** Susan Mogul.

# Index

474    *Index*

Lange, Dorothea (1895–1965), 125, 128
Lawrence, Jacob (1917–2000), 79, 91, 97–99, 176, 181, 183, 254
Lawson, Ernest (1873–1939), 4
Lawson, Thomas, 353
Le Va, Barry (b. 1941), 265
Lee, Russell (1903–1986), 125, 126, 128, [3–5]
Lee-Smith, Hughie (1915–1999), 176, 181
Lehman, Arnold, 414
Lemann, Nicholas, 201
Leo Castelli Gallery, 276
Leslie, Alfred (b. 1927), 202, 275, 279
Leuchtenburg, William E. (b. 1922), 89
Lévi-Strauss, Claude, 348, 386
Levin, Kim, 339–43
Levine, Jack (b. 1915), 176, 177, 182, 183, 275
Levine, Lawrence, 265
Levine, Sherrie (b. 1947), 343, 366, 367, 371
Lewis, David Levering (b. 1936), 64
Lewis, Norman (1909–1979), 79, 163–64, 306
Lewis, Sinclair, 73
LeWitt, Sol (b. 1928), 236, 252, 256, 259–61, 265, 270, 271, 300
Lichtenstein, Roy (1923–1997), 219, 226–27, 228, 234
Lieder, Philip, 340
*Life* magazine, 91, 141, 142, 143, 170, 176, 177, 183, 198, 205
Lin, Maya (b. 1959), 434, 438, 439–42
Linker, Kate, 376–80
Lippard, Lucy R. (b. 1937), 54, 240–3, 270–2, 289–92, 318, 319–22, 329, 380
Lissitzky, El (1890–1941), 44, 167
The Little Galleries of the Photo-Secession. *See* "291"
*The Little Review*, 41, 49
Living Theater (Julian Beck and Judith Malina), 288, 401
Locke, Alain (1886–1954), 64, 72, 73–76, 99, 130, 134
Long, Richard (b. 1945), 369
Longo, Robert (b. 1953), 366, 367, 371
*Look*, 176
Louis, Morris (1916–1962), 237, 238, 242, 248, 280
Lovejoy, Arthur O., 63
Loving, Pierre, 83, 84
Lozowick, Louis (1892–1973), 44, 48–50, 64, 101, 107–8, 192
Luce, Henry R. (1898–1967), 91, 143

*Luchas del Mundo* (W. Herrón), 448
*Ludlow Massacre* (J. Sloan), 5, [1–1]
Luks, George B. (1866–1933), 4, 10
Luna, James (b. 1950), 355, 367, 402, 406–11, [7–9a, b, c, d, e]
Lynd, Helen M. and Robert S., 55
Lyotard, Jean-François, 346

**M**
McAlmon, Robert (1896–1956), 83, 84
Macbeth Gallery, 4, 10
McBride, Henry (1856–1937), 82, 83
McCarthy, Joseph (1903–1957), 141, 142, 189, 191, 200
McCausland, Elizabeth [Elizabeth Noble] (1899–1965), 101, 110, 123–25
McCormick, Carlo, 353
McCray, Porter, 143
Macdonald-Wright, Stanton (1890–1973), 14, 22, 57
McGill, Douglas, 384
Machida, Margo, 392–94
*Machine-Age Exposition* 1927 exhibition, 48, 49
McIlvain, Isabel, 276
Maciunas, George (1931–1978), 207, 215, 216, [5–2]
McKay, Claude (1891–1948), 72, 310
McLuhan, Marshall (1911–1980), 201, 256, 262, 348
McMahon, Audrey, 118
McShine, Kynaston, 236, 257, 424
Malcolm X (1925–1965), 307
*Malcolm X Speaks for Us* (E. Catlett), 307
*Man at the Crossroads. See* Rockefeller Center mural
*Manhatta* (film), 45
Mapplethorp, Robert (1946–1989), 411, 415–18
March on Washington (August 1963), 306
Marcuse, Herbert (1898–1979), 200
Marey, Jules-Étienne (1830–1904), 36–37
*Marilyn (Vanitas)* (A. Flack), 281, [6–5]
Marin, John (1870–1953), 21, 22, 24–25, 56, 133, 176
Marsh, Reginald (1898–1954), 91, 92, 129, 131, 132, 133, 183
Marshall Plan, 143

Marshall, Richard (b. 1947), 356
Martin, Agnes (b. 1912), 237, 250–52
Martin, Richard, 339
Mary Boone Gallery, 352, 353, 359
Mason, Charlotte, (?–1945) 64
Massachusetts College of Art, 332
*The Masses*, 4, 5, 9, 85, 99, 103
*Maze* (A. Aycock), 257
Matta [Roberto Sebastian Antonio Matta Echaurren] (b. 1911), 160
*Meat Joy* (C. Schneemann), 216, 217, [5–3], 401
*The Mechanics Fountain* (D. Tilden), 434
Mecklenburg, Virginia (b. 1946), 187
*La Memoria de Nuestra Tierra: Colorado* (J. Baca), 446, [7–16]
Memorial Fence, Federal Building, Oklahoma City, 436
Mencken, H. L. (1880–1956), 73, 130
Mendieta, Ana (1948–1985), 216
Merleau-Ponty, Maurice (1908–1961), 401
Mesa-Bains, Amalia (b. 1943), 432–33, 445
Messer, Thomas (b. 1920), 295–297
Metropolitan Museum of Art, 288, 306, 426
Meyer, Agnew Ernst, 17, 38
*Mile-Long Drawing* (W. de Maria), 257
Miller, Dorothy C. (b. 1904), 144, 162, 220
Miller, Douglas T., 199
Miller, Tim, 412
Minh-ha, Trinh T., 402
*Mining the Museum* 1993 exhibition, 427–30
*Mirror, Mirror* (C. M. Weems), 379, [7–4]
Miss, Mary (b. 1944), 355
Moeller, Susan, 420
Moffett, Kenworth, 145, 161, 237
Moi, Toril, 374
*Monogram* (R. Rauschenberg), 206
Moore College of Art [formerly Philadelphia School of Design for Women], 279
Morgan, Robert C. (b. 1943), 349–52
Morimura, Yasumasa (b. 1951), 366
Morrell, Marc, 288